THE PELICAN HISTORY OF ART

EDITOR: NIKOLAUS PEVSNER
ASSISTANT EDITOR: JUDY NAIRN

Z 31

PAINTING AND SCULPTURE IN GERMANY AND
THE NETHERLANDS: 1500–1600
GERT VON DER OSTEN AND HORST VEY

Pieter Bruegel: Homecoming of the Herd in January, 1565 (detail).
Vienna, Kunsthistorisches Museum

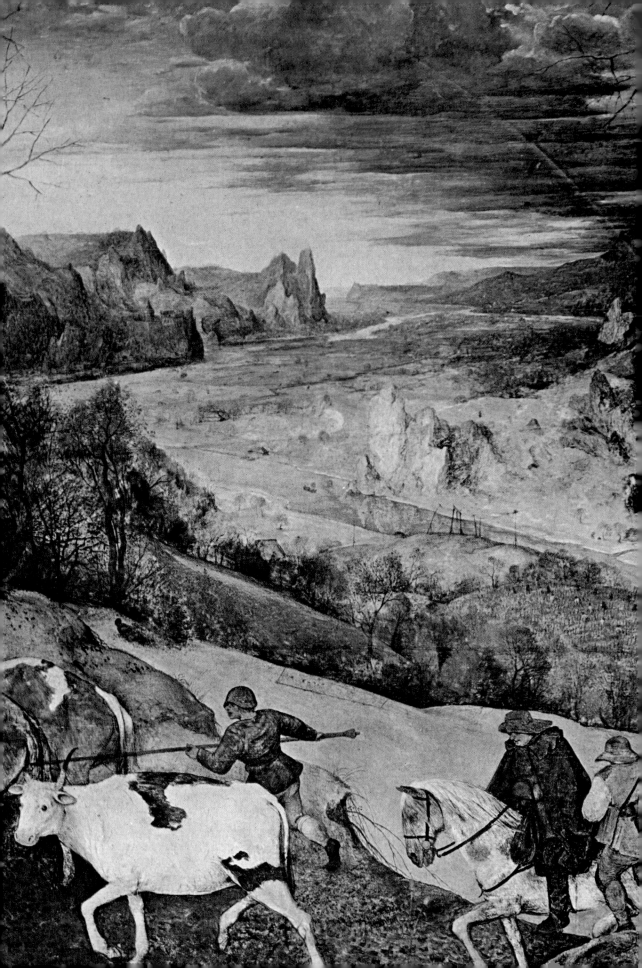

GERT VON DER OSTEN AND HORST VEY

PAINTING AND
SCULPTURE IN GERMANY AND
THE NETHERLANDS
1500 TO 1600

PENGUIN BOOKS

BALTIMORE · MARYLAND

WRITTEN FOR THE PELICAN HISTORY OF ART
TRANSLATED FROM THE GERMAN BY MARY HOTTINGER

Penguin Books Ltd, Harmondsworth, Middlesex
Penguin Books Inc., 7110 Ambassador Road, Baltimore, Maryland 21207, U.S.A.
Penguin Books Australia Ltd, Ringwood, Victoria, Australia

★

Text printed by Richard Clay (The Chaucer Press) Ltd, Bungay, Suffolk
Plates printed by Balding & Mansell Ltd, London
Made and printed in Great Britain

★

CONTENTS

v

CONTENTS

Part Two

The Early Years of Charles V: Late Gothic and Post-Classic Mannerism

CONTENTS

CONTENTS

Part Three

The End of the Age of Charles V and Ferdinand I and the Early Years of Philip II: Academic Mannerism

Part Four

The Age of Philip II, Maximilian II, and Rudolf II: Later Mannerism

The Plates

LIST OF PLATES

Where not otherwise acknowledged, copyright in photographs belongs to the museum, gallery, or owner cited as location

LIST OF PLATES

196 Wolf Huber: Ottheinrich von der Pfalz(?), c. 1552–3. *Merion, Penn., Barnes Foundation* (Copyright 1969 by The Barnes Foundation)

197 Hans Baldung: Twenty-nine-year-old Man, 1526. *Nuremberg, Germanisches National-Museum*

198 Wolf Huber: View of Feldkirch, 1523. Pen and ink. *London, British Museum*

199 Christoph Amberger: Charles V, c. 1532. *West Berlin, Staatliche Museen*

200 Hans Holbein the younger: Niklaus Kratzer, 1528. *Paris, Louvre* (Service de Documentation Photographique)

201 Hans Baldung: Two Witches, 1523. *Frankfurt, Städelsches Kunstinstitut* (G. Busch-Hauck)

202 Hans Baldung: The Seven Ages of Woman, 1544. *Leipzig, Museum der bildenden Künste*

203 Hans Holbein the younger: Thomas More, 1527. *New York, Frick Collection*

204 Hans Holbein the younger: Erasmus of Rotterdam, c. 1523. *Longford Castle, Earl of Radnor* (Royal Academy of Arts; Photo Studios Ltd)

205 Hans Holbein the younger: The Man of Sorrows and the Mater Dolorosa, c. 1519–20. Tempera. *Basel, Kunstmuseum*

206 Hans Holbein the younger (after?): Design for the frescoes on the Haus zum Tanz, c. 1520–5. Water-colour. *West Berlin, Staatliche Museen* (W. Steinkopf)

207 Master of Messkirch: St Benedict, 1538 or later. *Stuttgart, Staatsgalerie* (Württembergische Staatsgalerie)

208 Hans Holbein the younger: Portrait of his Wife and two elder Children, 1528(?). *Basel, Kunstmuseum*

209 Hans Holbein the younger: The Dead Christ, 1521/2. *Basel, Kunstmuseum*

210 Hans Holbein the younger: The Virgin of Burgomaster Meyer, c. 1526–30. *Basel, Kunstmuseum*

211 Georg Pencz: Unknown Man, 1544. *Darmstadt, Hessisches Landesmuseum*

212 Hans Holbein the younger: Anthony of Lorraine(?). *West Berlin, Staatliche Museen* (W. Steinkopf)

213 Hans Holbein the younger: Anne of Cleves, c. 1539–40. *Paris, Louvre* (Service de Documentation Photographique)

214 Bartel Beham: The Umpire, 1529. *Vienna, Kunsthistorisches Museum*

215 Bartel Beham: Leonhard von Eck, 1527. *New York, Metropolitan Museum of Art*

216 Hans Holbein the younger: The French Ambassadors, 1533. *London, National Gallery*

217 Conrat Meit: Mars and Venus, c. 1520. *Nuremberg, Germanisches National-Museum*

218 Conrat Meit: Portraits of a Man and of Margaret of Habsburg (?), c. 1518. *London, British Museum*

219 Conrat Meit: Virgin, c. 1520–5. *Brussels, Sainte-Gudule* (Paul Bijtebier)

220 Jean Mone: Alabaster altar, 1533. *Halle (Hal), St Martin (Notre-Dame)* (A.C.L.)

221 Levin Storch: Temperance, c. 1533–5. *Hannover, Niedersächsische Landesgalerie*

222 Guyot de Beaugrant: Chimneypiece with Charles V and his Ancestors, 1528/31. *Bruges, Franc* (A.C.L.)

223 Heinrich Douvermann: Mary Magdalen, c. 1530–40. *Kalkar, Nikolaikirche* (Rheinisches Bildarchiv)

224 Heinrich Douvermann: Tree of Jesse, predella of the Altar of the Virgin, c. 1536. *Xanten, St Victor* (Rheinisches Bildarchiv, Cologne)

225 Master Paul: St Christopher, 1542. *Gdańsk (Danzig), Artushof*

226 Claus Berg: St Andrew, c. 1530–40. *Güstrow Cathedral* (Staatliche Bildstelle, Berlin)

227 Apostle, c. 1525. *Halle Cathedral* (Institut für Denkmalpflege, Halle)

228 Claus Berg: High altar, c. 1517–22. *Odense, church* (Nationalmuseum, Copenhagen)

229 Benedikt Dreyer: Monk with an Almsbox, c. 1520. *Lübeck, St Marien* (W. Castelli)

230 Benedikt Dreyer: St Anthony altar (central part), 1522. *Lübeck, Annen-Museum* (Dr F. Stoedtner)

231 Master of Zwettl: Altar from Zwettl, 1516–25. *Adamov (Adamsthal) near Brno, church* (Bavaria Verlag, Foto Čestmir Šila)

232 Master HL: Coronation of the Virgin, high altar, 1526. *Breisach Minster* (Landesbildstelle Baden, Karlsruhe)

233 Pieter Coecke(?): Sacrifice of Isaac. *Amsterdam, Rijksmuseum*

234 Andreas Lackner: St Benedict, from Salzburg, c. 1520. *Vienna, Private Collection* (Kunsthistorisches Museum, Vienna; Photo E. Schwenk)

235 Hans Leinberger: St James the Greater, c. 1525. *Munich, Bayerisches Nationalmuseum*

236 Hans Leinberger: Christ in Distress, c. 1525–30. *West Berlin, Staatliche Museen*

237 Leonard Magt: Margaret of Habsburg, c. 1522. *Innsbruck, Hofkirche* (Vinzenz Oberhammer)

xiv

FOREWORD

THE present volume covers the period from about 1490 to 1600 and extends geographically to Germany, Austria, Switzerland, and the Netherlands. This scheme was laid down by the editor in the general programme of the series.

To treat the material in this way is, on the whole, unusual. There are not many works which deal with painting and sculpture side by side and few books on the art of either the Netherlands or Germany which take in the whole of the sixteenth century. Most of the books come to an end with the deaths of Dürer and Grünewald, which are alleged to have ushered in the 'great dying' of German art. As regards painting in the Netherlands, they take it up to the end of Bruegel's work, or else regard the sixteenth century as a prelude to the Golden Age of Netherlands painting. Obsolete ideas of the 'end of the Middle Ages', of the Renaissance as a sudden eruption, or of the beginning of the Baroque, played their part too. In the same way the combination of art in the Netherlands and in Germany has, as far as the present writer is aware, not been ventured on before, and the risks inherent in the combination will make themselves felt in the present volume. The neutrality of the subdivision into parts, governed, as far as possible, by common historical factors, was intended to facilitate this combination of the two areas. To subdivide the material by rulers may have far less meaning in German and Netherlandish art than, say, in French art of the seventeenth and eighteenth centuries, though Maximilian I and Rudolf II did leave some mark on the art of their periods. The subdivision of this long period has, I hope, made it possible to reveal distinctions between styles which have not generally been recognized before.

My sub-grouping is by regions, and this seemed reasonable for a country where there was little centralized authority. There is in fact only one important jump from one region into another: Conrat Meit, in his mature years, appears in a geographically different chapter from that which records his beginnings.

As a matter of fact, it was the peculiar boundaries of the volume which attracted me to the work. I had realized for a long time past that there exists a stylistic conception which makes of the century a relative whole. This conception is that of a Mannerism of the north, a conception not yet adequately investigated. But unfortunately I was, in the end, unable to pursue my story to the end. The director of a German museum today cannot find breathing-space for writing intricate books.

That I was able to finish four-fifths of the book is due to the generosity of the authorities of Lower Saxony at Hannover and the City of Cologne. But that I could even begin it at all, and finish a large part of the work, I owe to the hospitable invitation by the Institute for Advanced Study, Princeton, for the academic year 1957-8, and to the liberality of my friend the late Erwin Panofsky. Even so, when I came to Cologne in 1960, I realized that, in spite of my fervent wish, the completion of the work would take a very long time. So, at my suggestion, the editor asked Dr Horst Vey, Curator of the Wallraf-Richartz-Museum, to do the missing fifty or sixty years, for which he was allotted one-fifth of the available space and two years' time for

writing, of which his day-to-day duties left him a much smaller share than he would have preferred to devote to this task. His chapters are numbered 32–5 and 37–40.

In addition to him, I have to thank many others for kind help and interest. I have often discussed the aim and plan of the book with the late Erwin Panofsky and Paul Frankl, and I also owe a great deal to a discussion with Wolfgang J. Müller. On single aspects of my subject I had enlightening conversations with Carl Koch and Jaap Leeuwenberg, and I am also indebted to Georg Schnath for his critical reading of the historical introductions, all of which I wrote myself. I gained great insight from the collection of photographs in the Rijksbureau voor Kunsthistorische Documentatie in The Hague, in the Staatliche Kunstbibliothek, Berlin, in the Instituto Amatller de Arte Hispanico at Barcelona, and the Frick Collection, New York.

As regards the translation, Nikolaus Pevsner has made especial efforts to adjust it to my rather difficult text. We are both very grateful to him, to Stefan Muthesius, who made a complete check of the translation, and also to Judy Nairn who worked with an extraordinary precision on the translation of the notes, on the index, and on the maps. By her kind but insistent pressure much has become more accurate than it had been. Practical help was given in the checking of the English version by several helpers, namely Tilman Falk, Irmgard Hiller, Magdalena Nobel, Ulrike von der Osten, Evelyn Weiss, Marie-Rose von Wesendonk.

Last but not least, I have to thank many of my colleagues for hints and help, as well as for the host of details to be found in the nameless catalogues of museums and exhibitions and the Kunstdenkmäler volumes.

The great museums are only referred to by their cities; thus ‘London’, for sculpture, is the Victoria and Albert Museum, for painting, the National Gallery; ‘Munich’ means the Bayerisches Nationalmuseum and the Alte Pinakothek respectively, ‘Cologne’ the Schnütgen-Museum and the Wallraf-Richartz-Museum, ‘Hamburg’ the Museum für Kunst und Gewerbe and the Kunsthalle. In the case of Berlin Museums, the mention of Berlin alone indicates West Berlin, i.e. the Staatliche Museen. In the few cases where works of art are in the east of the town, this is indicated by the mention of East Berlin. If a Nuremberg or Lübeck artist worked for his own city, then St Sebald, St Lorenz, the Marienkirche, and the Town Hall refer to buildings in Nuremberg or Lübeck. In any case of doubt the reader is referred to the index, where museums, churches, etc., and the works in them referred to in the text, are listed in full. The notes are mainly references to literature; they lay no claim to completeness and embody little critical comment.

To readers who expect more on principles of style in the sixteenth century, particularly on Mannerism, it must be said that ‘pure’ specimens of Mannerism, something, for instance, that would correspond to Bronzino, does not come within the scope of this volume. It may well lie in the variegated nature of Late Gothic Mannerism that it produced extreme, but not ‘pure’, specimens.

G. v. d. O.

THE MAPS

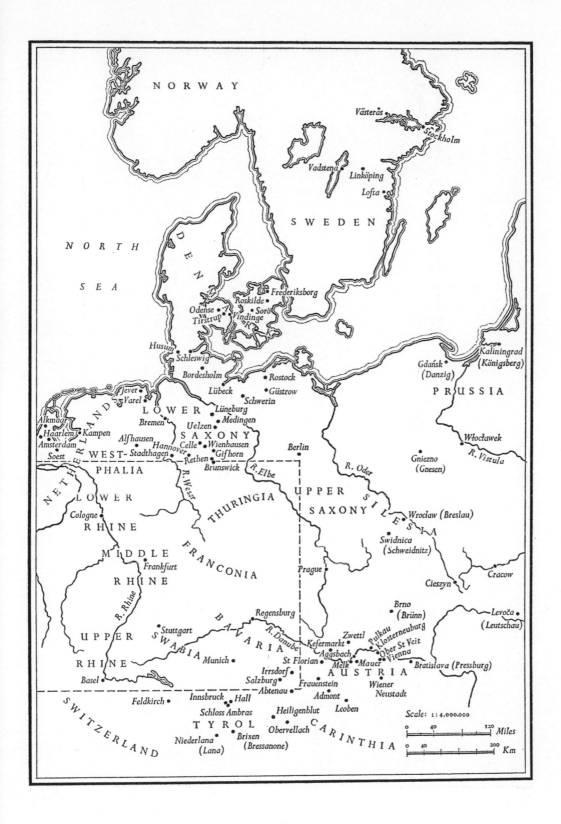

NORWAY

Västerås
Stockholm

Vadstena
Linköping
Lofta

SWEDEN

NORTH

SEA

DENMARK

Frederiksborg
Roskilde
Odense Sorö
Tirstrup Vindinge

Husum
Schleswig
Bordesholm
Rostock
Lübeck Güstrow
Jever Schwerin
Varel LOWER
 Lüneburg
Bremen Medingen
Alkmaar Uelzen
Haarlem Kampen SAXONY
Amsterdam Alfhausen Celle Wienhausen
Soest Hannover Gifhorn Berlin
WEST- Stadthagen
NETHERLAND Rethen
PHALIA Brunswick R. Elbe

Kaliningrad
(Königsberg)

Gdańsk
(Danzig)

PRUSSIA

Włocławek
R. Vistula

Gniezno
(Gnesen)

LOWER
RHINE
Cologne

R. Weser

THURINGIA

UPPER
SAXONY

R. Oder

SILESIA

Wrocław (Breslau)

Świdnica
(Schweidnitz)

MIDDLE
RHINE
Frankfurt

FRANCONIA

Prague

Cieszyn

Cracow

R. Rhine

UPPER

RHINE

Basel

SWABIA

BAVARIA

Stuttgart

Regensburg

R. Danube

Munich

Irrsdorf
Salzburg
Abtenau

Kefermarkt
Aggsbach
Melk
Frauenstein

Zwettl
Pulkau
Klosterneuburg
Ober St Veit
St Florian Vienna
Mauer

Brno
(Brünn)

Levoča
(Leutschau)

Bratislava (Pressburg)

AUSTRIA

Wiener
Neustadt

Admont
Heiligenblut Leoben

SWITZERLAND

Feldkirch

Innsbruck Hall
Schloss Ambras

Niederlana Brixen
(Lana) (Bressanone)

TYROL

Obervellach

CARINTHIA

Scale: 1:4,000,000

0 40 120 Miles

0 40 200 Km

xxi

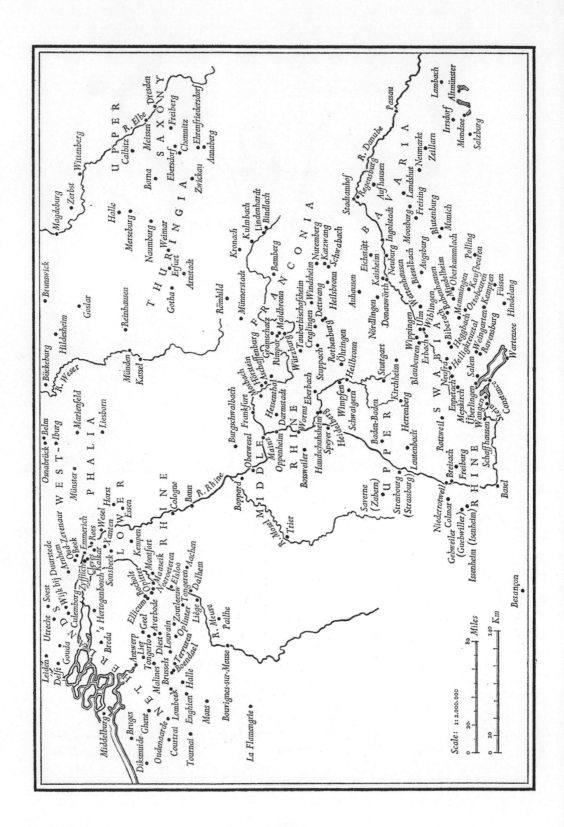

Scale: 1:2,000,000

Miles

Km

xxii

PART ONE

THE AGE OF MAXIMILIAN I: LATE GOTHIC, CLASSICISM, AND PROTO-BAROQUE

CHAPTER I

THE REIGN OF MAXIMILIAN I, 1493–1519

THE age of Maximilian I, who was born in 1459, comprises the period of the late fifteenth and early sixteenth centuries.[1] That is true both of Germany and the Netherlands, and it was through his work that the Netherlands became once more a visible part of the Holy Roman Empire. The period bears the name of the emperor more justifiably than that of his father, Friedrich III, and even than that of the French and English kings of the fifteenth century.

In this respect Maximilian could stand comparison with the great dukes of Burgundy in the fourteenth and fifteenth centuries, especially Philip the Bold and Philip the Good. It was, up to a point, natural for him to follow in their footsteps, seeing that he married Mary, the last of the Burgundians. Like them, he played a considerable part in shaping the civilization of his time. That is why, looking back on it, his age seems brilliant and rightly bears his name. In his own time, however, the results of his work must have seemed rather uncertain and only partially successful. For the most part they were legacies to the succeeding age, which he did not live to see.

Maximilian was elected Roman King in 1486, during the lifetime of his father; it was one of the weakest moments in the history of the House of Habsburg. The long reign of Friedrich, which had not been a prosperous time either for the Empire or the Habsburg lands, had only survived by his stubborn endurance. In the end, however, their far-sighted plans were crowned with success.

Maximilian's marriage in 1477 to Mary, the heiress of Duke Charles the Bold, who fell at Nancy, remained for a century a turning-point in the policies of the Habsburgs, the Netherlands, and Germany. It is true that the monarch, in the vicissitudes of his battles for Mary's heritage, and, after his wife's death, for that of his son Philip the Fair, was involved in adventures in which he had no real power and which were hardly worthy of an emperor's son. But in the peace treaties of Arras and Senlis, in 1482 and 1493, he finally succeeded in establishing his son's claim to Greater Burgundy (with the exception of Bourgogne), i.e. the Netherlands, so that after his son's early death in 1506 his grandson Charles met with no opposition. Thus the accession of Maximilian inaugurated, to a certain extent, a new epoch for the Netherlands, which were, except for the western parts, ancient imperial territory. He himself, however, never ruled them in person.

His policy in the south was far less successful. The useless war with the Swiss in 1499 brought about the final rupture with the Confederation. The necessity of moving to Rome for the imperial coronation, a medieval practice still observed, turned Maximilian's mind to Italy. His second marriage in 1493 to Bianca Sforza seemed to offer him the opportunity of reviving old imperial rights over the duchy of Milan. Yet he met with no success on either route into Italy. In Lombardy, he was forestalled by

Charles VIII, and initially François I was able to hold the Milanese base for France, through all the fluctuations of war. When the Venetians, in 1508, refused him passage, he turned it to his own account by assuming the title of 'Roman Emperor Elect' without a papal coronation. But an attack on Venice finally came to grief for the want of funds which so often frustrated his ambitious plans. An influence on Venice would have been invaluable for Maximilian's imperial duty of protecting Christendom against the Turks. Yet his policy, for all its sudden, opportunistic turns, did not finally enable him to follow up German trade and the Oriental trade-routes to Italy, where the Fuggers of Augsburg were just about to oust the house of Medici, the papal bankers.

On the other hand, Maximilian's years of struggle to establish ancient rights over Bohemia and Hungary were crowned with success. As the ruler of Austria, he could not but strive to occupy these natural bastions against the Turks. In the course of these enterprises he revived the Order of St George. In the Treaty of Vienna of 1515, he held out the hope of gaining Bohemia and Hungary for his house by the double betrothal of his grandchildren Ferdinand I and Mary to the Jagiellon heirs of those countries. That hope was realized in 1526.

As a whole, Maximilian's dangerous and erratic policy, though it brought him fame and gain, was not congenial to the Empire. The princes, who still had no insight into humanistic feeling, regarded politics as essentially a matter of character and stability, and were mainly concerned to increase the powers of their own territories, which meant of their peoples too. Even the Elector Friedrich the Wise of Saxony was an outstanding example of this paternalism. But Maximilian's ideas of empire did not always tally with what were, strictly speaking, the interests of Germany. Thus to us they look as tragic as they were idealistic, because they were never fulfilled. He certainly established himself to a certain extent in the provinces on the fringes of the Empire, but in the interior he succeeded neither in winning over a majority of princes to his designs, nor in obtaining any considerable increase of territory to fill up the gap between his possessions to east and west. However, he prepared the way for his grandchildren to take possession of Württemberg in 1520, and so to bridge the gap, for a time at any rate.

The internal policy of Germany was mainly directed by the efforts 'to provide the Empire with a better constitution'[2] than the one that had developed in the course of the late Middle Ages. These attempts, old plans of anti-imperial princes and of the emperor himself, were pursued with greater energy in Maximilian's day, but petered out in his lifetime, about 1517. In the end, no real centralization of the dispersed and feeble power of the ancient 'Reich' was achieved from within, whether in the emperor's own hands or as a federalistic régime. A modern state, a national kingdom, like France and England at the time, did not develop in Maximilian's Empire. Yet some reforms secured the continued existence of the old, unwieldy imperial organism; they prevented it from falling apart into a loose confederation of local dynasties. This relic of medievalism, however, could only endure if it were guided by a powerful hand, supported by loyal princes, and not exposed to severe shocks.

It was only in his own territories that Maximilian was able to impose more modern ideas of the state. He lived there as a great duke rather than as an emperor, more in the

country than in the city. His years in the Netherlands had given him the opportunity of realizing the value of a strict administrative and financial system; in the Tyrol, a subsidiary territory of the Habsburgs, he met a new kind of administration based on Italian models. Quite logically, he applied these principles throughout his territories along the Rhine and the Danube, set up a common government without taking much account of native constitutions, and even managed to assimilate to this growing state the small territories he had acquired in regulating his frontiers. To its governments he welcomed up-and-coming young burghers just as much as ambitious nobles who had abandoned the customs of chivalry. These men were governed by unscrupulous greed coupled with lively energy. Some of them were highly cultivated and loyal subjects in their realistic view of things. The vigorous promotion of the study of Roman law gave impetus to centralizing aims.

The Fuggers, with their vast financial power, stood by the emperor. He had been shrewd enough to win their loyalty to the Habsburg government by profitable mining concessions. In other places too, newer forms of economic development shifted the centre of gravity; Upper Saxony, for instance, found new prosperity in its silver mines. The economic situation was altogether flourishing. In the Netherlands, Bruges and Ghent declined, while Antwerp raced ahead to become the world port of the north. It found support in the far-sighted trade policy of the Burgundian–Habsburg suzerain governments, the most outstanding of which was that of Margaret, the emperor's daughter. Augsburg, the free (i.e. imperial) city, ousted its ancient sister Ulm. It became the economic centre of South Germany, and, situated at the actual centre of the Habsburg dominions, it was Maximilian's real capital. In a similar way, Nuremberg rose by its trade connexions with the east. The multiplicity of free imperial cities continued to exist; most of them had long since become independent, for instance, Lübeck, Cologne, Frankfurt, Strassburg, Basel, and Regensburg, and capital cities of standing which had not quite managed to expel their princes, such as Utrecht, Louvain, Brunswick, Erfurt, Mainz, Heidelberg, Stuttgart, and Passau. For the most part a fresh wind was blowing in the cities, but some of them were still stifled by obsolete communal and social institutions.[3]

In close connexion with all this, the regional variety of institutions in the German lands continued to exist, uniting and dividing in ever-new combinations faceted with territorial disruption. In the wealth and variety of its component elements, late medieval Germany can only stand comparison with Italy. Indeed, it excelled Italy in colourfulness, for there was in Germany no Rome to be the ancient centre. In this orchestra, which ceaselessly changed its conductor, the leagues even of smaller cities, like the Swabian League, were able to keep order for a time, while princes could introduce new themes, sometimes ephemeral, like the efflorescence of Halle, sometimes of some duration. Important universities appeared on the scene; Heidelberg was supported by the Palatinate, which had long been in opposition to the imperial policy; Wittenberg had Saxony behind it, while Freiburg and Vienna looked to Austria. It was there that Maximilian founded the first purely philosophical faculty; for the emperor was not indifferent to the new scientific and philosophic trends of his time, a thing that was rare among German sovereigns.

If the period under discussion did not bear the name of Maximilian it might be called the Age of Erasmus (c. 1465–1536). A native of Rotterdam who, as the son of a priest, was hostile to the ecclesiastical hierarchy and had no real roots in society, he was brought up in Holland and Paris; his education was thoroughly Latin, and later Greek too. He was steeped in the universality of the classical and Christian *logos*. He was as much in love with words as he was with the printed book, which at that time was just making its power felt by its exclusive use of the one international language, Latin, which had to be rescued from its medieval debasement. He loved that work, for it provided him with a form for a more general purpose – the cleansing of intellectual life of all mis-understandings and many formal errors, and its refinement by purity and tolerance, so that a new world could be created with man as its substance. What mattered was the education of man. Erasmus's *Praise of Folly* of 1509 was an attack on one-sided intellect-ualism in the name of sound purpose and common sense, his *Enchiridion militis christiani* of 1504 was a call to study classical thought in order to liberate Christian thought from medieval doctrines.

A few years spent in Italy in 1506–9 made him an ardent adherent of the reform of the Church. It was under the aegis of the reformers that he made his translation of the New Testament into Latin at Basel in 1514–16, hoping, like the great philologist he was, that it would replace the Vulgate. His translation carried his name all over the world. For Prince Charles, whose councillor he was, he wrote in 1515 an *Institutio* which opened up to him the prospect of implanting his new, intellectual Christianity in the mind of the future ruler of the world, and held, perhaps, the hope of future world peace. Vast hopes seemed to be on the point of fulfilment, hopes which, in the course of the centuries, have again and again inspired the spiritually minded, namely that it might be possible to plan a new, pure, and noble life founded on all that was best in the old. For many years Erasmus was the centre of this spiritual life.[4]

Within certain limits, Erasmus stands for a generation of great humanists who occupied chairs at German universities or held office as councillors or ministers of state – lawyers, philologists, antiquaries, theologians. They devoted their labours to restoring and translating ancient texts of great intellectual force and even destructive potential. They were equally versed in historical evidence, in the arguments for the new code of law, and in polemic epistles to the German world, which was shaken to its foundations. 'Science flourishes, minds awake, it is bliss to be alive.' In these words Ulrich von Hutten described these men's feeling for life.

In 1511, Dominicans at Cologne had tried to destroy Reuchlin because he had attempted, in the name of learning, to prevent the Hebrew books from being burnt by the Inquisition. In 1517–18 they were utterly routed by the publication of *Epistolae obscurorum virorum*, in which the humanists themselves drew a merciless picture of the aggressors' bigotry. For Hutten, poet, pamphleteer, and dramatic romantic, praised by Erasmus and crowned poet laureate in 1517 by Maximilian, the goal of the new age was rather a restitution of the greatness of medieval Empire; he rejected everything Italian in the same way as the arch-humanist Conrad Celtis, who had been called to Vienna in 1497 by Maximilian.

Thus in its spiritual wealth this fermenting age contained every potentiality, though none had as yet taken shape – the feudal state of the Middle Ages, the makings of national organisms on a federal and centralized base, and the new supra-national powers which seemed to be settling in the traditional form of the Empire. Christian thought, in the many forms in which it had been handed down, was faced with an intellectualism purified by satire and philosophy which regarded itself as Christian, and actually had the right to do so, but was neighboured not only by the depths of paganism and indolence but also by the intricacies of romantic German rhetoric. The storm that broke when Luther launched the challenge of his Theses in 1517 was too much for such a world to bear; in that respect Luther was a man of destiny, though his destiny was only to be fulfilled later. He could only just make his entry into history in the libertarian epoch of the old emperor.

Maximilian's world and age were multifarious rather than conflicting. After the free Swiss had defeated the Burgundian chivalry of his father-in-law with their citizen soldiers, and the non-professional had overcome the professional, he conducted his wars mainly with hired mercenaries, but he still bore the name of 'the last of the knights'. Most of the cities were loyal to him; the peasantry set their hopes on him in the same way as the minor nobility of the Empire, whose tottering standing Franz von Sickingen seemed destined to shore up once more. Yet Maximilian had to keep on good terms with the princes, and in Austria behaved absolutely as a prince. Thus he remained in the national memory by the plans he forged but never fulfilled, was important for a few real achievements, but was actually great only in a third respect, namely that, like his father, he cast his nets for coming events but did not live to see what was caught in them.

Maximilian, in the last twenty years of his life, became deeply interested in art.[5] It may have been in 1499, on the occasion of the visit of Lodovico Moro, the empress's uncle, that Maximilian conceived the idea of erecting an equestrian monument to himself at Augsburg. Work on the funerary monument and on a monument in the imperial cathedral of Speyer was soon set going. All three reflect, in manifold variations, his own encounter with the ideas and forms of humanism and the Renaissance. The connexion between Maximilian, his artists, and Italy began as early as that of Charles VIII of France (1470–98), but it was less sudden, broader in scope, and on a higher level; for Augsburg, Nuremberg, and even Ulm were not far away from what was going on in Italy, and in Dürer Germany had soon found a serious and independent interpreter.

The emperor, however, did not feel called upon to build churches or castles or to found cities. But he cultivated the art of printing, both in words and pictures, and with that the writer and editor awoke in him; for he was a connoisseur and practitioner in many fields, an *uomo universale* of the new age. He planned the publication of a hundred and thirty books, many for the purposes of learning, but just as many to the glory of his own person. He was the first monarch to realize the importance of printing for influencing cultivated minds and securing posthumous glory. The best artists in Germany were employed on woodcuts for his more or less autobiographical works, *Weisskunig*, *Freydal*, and *Theuerdank*, and on the *Heiligen aus der Sipp- und Magenschaft*,

a picture-book combined with genealogical tables and mythological inventions; they also worked on the marginal sketches of the costly prayer-book which was probably intended for the Order of St George. An offshoot of these autobiographical works is Joseph Grünpeck's *Historia Friderici et Maximiliani*. The *Triumphal Arch* (*Ehrenpforte*) and the *Triumphal Procession* (*Triumphzug*), with humanists like Peutinger, Pirckheimer, and Stabius as contributors and editors, were intended merely as pictures and as dignified propaganda, but the emperor reserved the right of putting the final touches. Thus his personal share in all these books must have been considerable, whether he was actually their author or merely an inspiring and critical patron. When he died not much was finished, and of that his grandchildren considered not much worthy of completion; all the rest remained splendid fragments. Nor was any attempt made to give the works any wide publicity.

Thus Maximilian may be regarded as the representative of an age which seemed to harbour every potentiality for the future. His activity was not only the most brilliant but also the most important and in the end the most successful of that of any German emperor for more than a century. Yet in detail it all looks like a series of adventurous beginnings, of over-dimensioned projects. We must be careful not to regard his occasional failures and aimlessness, his political vacillations, as weakness, like the devout princes of the Empire and the stricter-minded humanists. He was as restless and romantic as Charles VIII, but he did not lack a streak of plain common sense, as did the ambitious Louis XII. Thus Maximilian's behaviour often looks ambiguous. In actual fact he granted his imperial protection, in a kind of tolerance which might almost be called free thought, to various personalities and movements. It is for that reason that his name stands for the age which was probably the most productive in the history of German art and culture, and up to a point stands even for the work of his daughter Margaret at Malines, with her great promotion of Dutch and German art, as it does for the patronage of Friedrich the Wise of Saxony.[6]

This great time of ferment and promise has also been called the age of Dürer;[7] rather perilously, it took the *pars pro toto*. The supreme expression of the period was not in what are generally called the acts of an emperor, but in the writings of the humanists, whom he encouraged and tolerated, and above all in the works of sculpture, painting, and the graphic arts.

SCULPTURE IN NUREMBERG AND FRANCONIA

Veit Stoss

IN 1496 Veit Stoss, after twenty years spent at Cracow (Krakau), returned to Nuremberg. It was an important date in the history of German sculpture.

He was past his first youth. Neudörffer states that he died, a blind old man, in 1533. Possibly his age has been exaggerated, and he may have been born about 1447/8 rather than in 1437/8.[1] He was born at Horb, but it is not certain whether this means Horb in Swabia or Horben, near Aarau in Switzerland.[2] His style stems from the Upper Rhine, in particular from Nicolaus Gerhaerts of Leiden, the chief representative and practitioner of the mid-century naturalism of the Netherlands in Upper Germany. When Stoss first settled in Nuremberg is not known, and it is uncertain whether any work of his belonging to that period has been preserved.[3] What is certain is that he resigned his citizenship of the town in 1477.

By 1496 he had nearly twenty years of active work behind him at Cracow; he had carved the altar for St Mary, completed in 1489, and done other work at Cracow, Włocławek, and Gnesen (Gniezno), including, among other things, the monument of King Casimir IV Jagiello in the cathedral (1492). In these works Stoss carried Late Gothic naturalism a great step forward. The huge shrine of the altar is conceived as a deeply recessed stage peopled with over-life-size and profoundly expressive figures, and the effect is enhanced by the vivid polychromy. The Death of the Virgin is represented with unprecedented *verismo*. In the monument, the effigy of the king is seen with all the insignia of his temporal and spiritual dignity. The mottled red of the marble plays its part in an intimate blend of spiritual elevation and the pathos of a fleeting moment. The head, all pomp abandoned, is turned sideways, and bears moving marks of the defencelessness of man in his last hours. This admission of the pitifulness of death was quite absent from the tomb of Friedrich III in Vienna, which Nicolaus Gerhaerts left unfinished at his death about 1473, and which was certainly known to Stoss. But what Stoss created was absolutely new.

These carvings were a milestone in fifteenth-century sculpture. From Cracow, a first wave of Stoss's influence swept over art in the east and south-east,[4] transmitted by his engravings, which became public property when his workshop was wound up in 1495-6, and also by workers in his shop who lost their employment with him at that time. The altar of the Virgin in the Nonnberg church at Salzburg[5] (1498) and the relief of St John the Baptist from Cieszyn, now at Poznań (1499),[6] both bear witness to this early radiation. But he himself seems to have owed a great deal to his activity in an outpost of German civilization in the Polish east. The fresh wind blowing in an active and pioneering foreign country left more room for adventurousness, and important

commissions were to be had for talented young men. Stoss obtained a connexion with a royal court and its humanistic councillors. That continued. We cannot really say how much it meant to him. But one thing is certain: he came into contact with a different people which may have had some affinity with Stoss's own hasty and choleric temperament, and enriched his native power of observation with new human types.

When he was about fifty, Stoss returned to Nuremberg. He had remained in touch with it, in particular by a visit in 1486–7. He was now a wealthy man. But life in Nuremberg, an older town, was more limited, and the fortune he had made in Poland was to be his downfall. Shamefully defrauded in large business schemes, he tried to obtain justice by forging a document. The forgery was unsuccessful, and in 1503 and the following years he was convicted, lost his rights as a citizen, was subjected to grave limitations of his freedom of movement, and entirely lost his social status. His workshop was again wound up. A second wave of Stoss influence, probably reinforced by a second edition of the engravings,[7] must have spread over Germany at the time. An amnesty from Maximilian in 1506 and his audience with the emperor at Ulm in 1507 certainly raised Stoss out of the utter depths of his degradation. But both his sense of justice, which blinded him to the distinction between civil and criminal law, and his confidence in himself, seem to have suffered permanent injury.

Thus all his life Stoss remained 'a shiftless and garrulous fellow'. At Nuremberg, he never held office either on the municipal council or in his guild. Yet in spite of his stiff-neckedness, he was given a commission by the emperor – a wooden model, which was probably never cast, and which was possibly intended for the emperor's tomb. The model is not preserved. It brought him fame which spread beyond the frontiers of Germany and restored his material fortune. We can see in his work marks of the vicissitudes and shocks he experienced in his later years, and particularly of his own unpredictable and irascible nature.

In comparison with the mighty designs made in Cracow, his first dated work in Nuremberg, the Volckamer monument in St Sebald of 1499, is not entirely satisfying as a composition. It may be that Stoss was held up by having to plan the work in stages. But the detail of the stone reliefs, rich in harmonious contrasts, is all the more splendid: the Last Supper, the Mount of Olives, the Arrest, and two wooden figures, the Man of Sorrows appearing to the Virgin – all unpainted from the beginning and relying solely on the effect of the carving.[8] A type of drapery with eddying folds, already present in Stoss's graphic works done at Cracow, reaches its climax in the engraving of the Lamentation and in these figures. However expansive Stoss's way of expressing himself, he is never loquacious. A huge and meaningful wheel of folds encircles the pointing hand of Christ with the wound of the nail, and the head of Christ and the head of Judas are set in superb counterpoise in the Last Supper. St John, asleep on the Mount of Olives, is huddled round his bent hand, and the mob of soldiers appears inescapable by their few harshly carved limbs round the figure of Christ.

Stoss's tumultuous genius seems to have reached its greatest heights of tranquillity in the next ten years. In the Virgin from his house at Nuremberg, probably made in 1499 (now Germanisches National-Museum), he replaced the blossoming flutter of the

Cracow engraving by a comparatively block-like figure with simpler contours and a more self-contained form of the cloak. Virgin and Child are lovely and real. This classical feeling is present also in the herculean corporeality of the Crucifix in St Lorenz, as it is in the Heiliggeist Hospital, where the dying Christ, terrifyingly racked, seems to be breathing his last. It may have been these two figures which gave rise to the legend that Stoss used dead bodies as models. It is probably true that this work, and the group of the Virgin and St John in St Sebald, were executed in Stoss's darkest hours, that is, between 1505 and 1510. In the self-contained forms grief reaches its climax and an intense inwardness. St John, an almost heroic figure, weeps.

In Stoss's classical period there is no substantial trace of Dürer's influence.[9] This is all the more remarkable as decorative works after Dürer's designs (w708, 445) seem to have been executed twice in Stoss's workshop, about 1500 the Dragon Chandelier for the Council Chamber, and about 1508 the frame for Dürer's Holy Family and Saints, the first truly Renaissance frame to be made in the north (both in Nuremberg). The unpainted relief of the Death of the Virgin (Bielefeld, private collection) probably also belongs to this classical phase.

We have four certain dates for Stoss's later work: The Archangel Raphael and Tobias (1516), the Annunciation (1517–18), the Crucifix in St Sebald (1520), and the Bamberg altar (1520–3).

The limewood group of Raphael and Tobias (Nuremberg) had been commissioned by Raffaello Torrigiani, an Italian living in Nuremberg. Once again, though more spiritually than before, a swirl of drapery envelops the radiant, upright figure of the Archangel (Plate 3); the pert yet obedient lad follows him, turning in his steps; the fall of the wide, decorative sleeves is the only vertical in his groping, uncertain figure. It was probably not by chance that this carving became, for its owner, a work of art in the southern sense; indeed, in the delicate details there is a touch of artificiality. According to the documentary evidence, Stoss must have executed several works of the kind, especially on a small scale. Similar to this group is the St Roch, also uncoloured, which found its way to the Cappella Guadagni in the Annunziata in Florence and was admired by Vasari there as a *miracolo di legno*. It is closely akin to the St Andrew in St Sebald, which is probably the most remarkable single figure carved by Stoss. The bodily presence of this gigantic saint makes itself felt through the spatially conceived, deeply riven drapery, and the spiritual energy in the face rises to unprecedented heights, the craggy face and the right hand pointing, the left hand clutching the book with the little finger stretched out like a thorn.

In spite of the vast difference in theme, the same spirit dwells in the Annunciation of 1517–18 (Plate 1). It hangs in the Late Gothic choir of St Lorenz and once formed part of an iron candelabrum there. Light flows through it, and it hangs free in space. The composition has something of the precision of filigree work; the pointed arch formed by the sixty beads of the Paternoster chaplet, the oval garland of the fifty roses, the seven medallions of the Joys of Mary, raising the weight to the top, the whole culminating in the figure of God the Father with angels – it all produces an immediate and convincing effect of floating in space, which is reinforced from within, not only by

C

the supporting angels, but still more by the upward drive of the drapery and Gabriel's wings. In this way Stoss was able to impart to the archangel's movement a vehemently earthly energy, to the Virgin a sweetness of this world, and to give to the two over-life-size figures sculptural fullness yet small heads. The feeling of other-worldliness is not impaired by these realistic touches, and it is deepened by the radiant gold of the colouring. The Cracow conception of the altar as a stage is here enhanced to incomparable impressiveness.

For Veit Stoss, the middle and late second decade of the century was the period of a proto-Baroque of his own which succeeded his own form of classicism. To that belong, after the Italian group, St Andrew, the Annunciation, and also the Crucifix of 1520 in St Sebald, with a huge, heavy-hanging body enveloped in a swirling loincloth.

In 1520–3 Stoss made the great altar of the Virgin for the Carmelites of Nuremberg; it was not accepted by the monastery, as the Reformation intervened. Finally it went to Bamberg Cathedral. It was not intended to be coloured, and either remained unfinished or has come down to us incomplete. It is the work of a very old man who had remained true to the ancient faith at Nuremberg, a city of the Reformation, but Italian forms have entered into it and appear very clearly in a design which has been preserved. The reliefs carry on, though very freely, Dürer's Life of the Virgin. What this altar has to show us is a majestic and highly personal last stage in the development of its creator's style, which was, as it were, enriched by the tranquillity and measure gained from nature. The shallow relief of the Flight into Egypt is startlingly economical; a simple twist liberates Joseph from the ground, just as the Virgin's movement is indicated by a single, sparse, eddying fold. The open landscape in this relief speaks as it does in the great paintings of the time. Stoss can still be felt as belonging to the Late Gothic here too, and a Quattrocento head in the relief of the Virgin's birth is in keeping with that.

His position was that of a great man who, in the solitude of old age, was projected into a new era, an era in which to be 'advanced' did not guarantee superior quality. In the Bamberg altar we can feel the spontaneity of his manner, accompanied by a mastery of execution which never failed him. Veit Stoss was an elemental creature, and in spite of all the outbursts of his turbulent nature, in spite of all his obsessiveness, he remained simple in the highest sense. It is just at this point that we can realize the differences between the works of the master and those of his followers.

Tilman Riemenschneider

The other great Franconian master of the altarpiece, a wood-carver and stone-sculptor, worked at Würzburg. Tilman Riemenschneider[10] was born about 1460, probably at Osterode on the Harz or at Heiligenstadt. His family seems to have come from Thuringia. He had most likely gone through a training in alabaster work at Erfurt, its great centre, and also as a sculptor in general. He made at least two works in alabaster for Erfurt, and sometimes made use of the material in his later work.

Later, Riemenschneider went through another period of training as a wood-carver, obviously at Ulm and probably under Michel Erhart. It was at that time that he made his Wiblingen altar. Thus the beginnings of his career coincided with those of his master's son, Gregor Erhart; they clearly passed through the same school. That is what made Riemenschneider a master of South German art, a position which may have been strengthened by a somewhat obscure connexion with the Upper Rhine region, though it was certainly not as important for him as for Stoss. Nor did a contact with art in the Netherlands bring about any real change in the basic structure of his style. He first appeared at Würzburg in 1479, obviously during his *Wanderjahre* as a journeyman, and reappeared as a fully fledged artist in 1483. In 1485 he became a citizen and was registered master. He hardly ever left Würzburg again, and it was through him that the city became an important artistic centre. Quite unlike Stoss, he rose steadily in social status, acquired a fortune, and was elected to the Council. In 1520–1 he was Burgomaster. Faithful to his various offices, he did not hesitate to stand up for the rights of the city against the nobles and higher clergy of Würzburg. When the Peasants' War spread to the Main in 1525, he was on the peasants' side and did all he could to keep the bishop's forces out of the town. After the princes' victory he lost his seat on the Council and was imprisoned. It was only his steadfastness under torture that saved him from still more serious suspicion and execution. But the experience neither broke him nor affected his social standing. On the contrary, in the succeeding years he was able to work outside Würzburg, although the extent of that work is difficult to judge from the documents. He died at Würzburg in 1531.

So this is the story of a native of North or Central Germany, who trained at Erfurt and Ulm and then settled at Würzburg. Later, some part of his formal idiom came from the Upper Rhine, through Schongauer. He had practically no training in Franconia, and even later his connexion with Nuremberg was slight. A model for a piece of goldsmiths' work made by him was rejected there in 1518 as being childish.[11] Yet he seems to have been quite in touch with the spirit of Würzburg. The funerary monument he made for Eberhard von Grumbach (d. 1487) at Rimpar follows the tradition of Franconian monuments.

On the whole, however, Riemenschneider left so deep a mark on the style of Würzburg sculpture that it is almost impossible to draw any clear distinction between Würzburg and Riemenschneider's art at that time. He seems to have worked from the outset with a much larger shop than Stoss and to have steadily increased its size, employing journeymen wood-carvers to work after his own models.[12] Thus there has come down to us a very large number of prentice works with all kinds of traditions behind them and of uncertain authenticity. A distinction must therefore be drawn between work done partly by journeymen in his shop, for which he took the responsibility, and carvings by his own hand.

His own handiwork must have meant a great deal to him, however often he may have had his designs executed by assistants. As far as we can see, he was the first wood-carver in Germany to let the uncoloured wood stand as the final form, and in many cases only to give a hint of colour in the eyeballs and the lips. The surface cutting of

limewood by his own hand is unhesitating and pure, yet of great formal perfection. This contributed largely to the effect of his great altars.

The altar of Münnerstadt, dating from 1490–2, was uncoloured when first set up; in 1504 Stoss consented to colour it and added painted wings. Whether Riemenschneider agreed or not we do not know. The carving in the parts now in Munich and Berlin – the story of the Magdalen and the Four Evangelists – is the work of a master. There is no trace of the late-fifteenth-century realism which was still perceptible in the Wiblingen altar and the Rimpar monument. At Münnerstadt Riemenschneider proved himself an artist of restraint, of delicate gesture, of spiritualized form. By an unforgettably simple upsweep of the drapery, the slight, almost welcoming gesture of Christ's right hand has become gently forbidding: *noli me tangere*. The feast at the house of Simon, superbly composed of very few types, is bursting with form, and the filling of the tankard, the only sound to break the silence, betrays the conflicting feelings underlying the silence, while Christ has just raised his hand to quell the conflict. It is superb, how the filling of the tankard underlines the Magdalen's pouring out of the precious ointment. All the details are sparse; the space is merely hinted at. Thus Riemenschneider has composed his work over a void and with an almost bare surface, and that with a restraint which Stoss did not command in his Volckamer reliefs. Yet Riemenschneider did not possess, from the outset, that fullness of life which the great artist of Nuremberg finally pressed into his work. The Four Evangelists of the predella differ in age and temperament, and probably in social class. They are certainly the most exciting group of single-minded men that Riemenschneider ever made. Yet in the last resort it is a set of variations on one theme – the lean figure, the thin-lipped mouth, the big, beaked nose – spiritual seekers all. The amount of realism which entered into this work is very small indeed.

Here we encounter what has always been felt as the spirituality of Riemenschneider's art. This spirituality is just as much the result of elimination as of the perfect artistry which was his natural manner of expression. The abysses of the human condition which Stoss laid bare are not to be found, and the supreme exaltation of vital natures is absent too. Christ Crucified is not he that has overcome and is now dying in agony: he is thin, the legs are tense, there is suffering in the face, but it is peaceful, pardoning, and consoling. In an age of realistic rendering of the body, Riemenschneider's types are for the most part clothed, or rather so heavily draped that only the ascetic heads, the over-long, narrow hands, hover over the fine, sharp-edged drapery, which is in a very high degree what Late Gothic drapery generally is – a mode of characterization.

Even the stone figures of Adam and Eve of 1491–3 from the south porch of the Marienkapelle (now in the museum) have nothing to tell us about elementary life. They are almost the only nude figures made by Riemenschneider, and they stand naked in their shame. But it is not the fig-leaves which create the feeling of coolness and chastity. The figures are fully rounded out of the stone and are not in the least unstable in the architectural whole of the porch. They are the work of a competent sculptor, and not the product of a medieval mason's lodge. The curve of Eve's hips is flat, the breasts are small, and the figure is not unlike Rizzo's Eve on the Doge's Palace at Venice. The

outline of Adam's body is very precise. For all their nudity, these bodies are as totally unsensuous as Riemenschneider's drapery, and the effect is enhanced by the large heads. What has been discovered is the indwelling contrast between the bodies, and it is probably here, more than anywhere else, that we can feel that Riemenschneider's encounter on the Upper Rhine with the characteristic pairs of arguing figures, or at least figures in opposite moods, has had its influence. It is, in particular, the fall of Eve's hair which compresses the figure into a vegetable form. She is more self-contained than Adam, whose figure points out beyond itself. His timorous and irresolute gait, the deliberate turn of his neck and the matted curls round his stone-grey face betray the spiritual conflict within. In that sense he is brother to Riemenschneider's saints. Except for touches on the nose and mouth the figures are without colour, yet unmistakably fair-haired, and at odds within themselves; thus they express the Christian aspect of the subject.

The serious, lean youth, fragile and elusive, with something of the angel about him, the aged man, chastened and thoughtful, are simply Riemenschneider's main figures with slight variations. Yet among his portraits are some examples of a convincing approach to the specific individuality of a human face. The monument of Bishop Rudolf von Scherenberg (1496–9; Plate 6) gains so much personality, so much living reality, from the extremely delicate working of the lines of the face and from the paint which tones down the mottling of the red marble that it becomes not only a grand countenance of old age but also a true portrait.[13]

For the monument of the humanist Johannes Trithemius in the Neumünster (1506–16), a very lifelike portrait-drawing by Riemenschneider has come down to us.[14] Yet the face is also that of the St Philip among the statues of the Marienkapelle (1492–1506), and in the Windsheim altar (Heidelberg). He is the most worldly of Riemenschneider's apostles. And however we look at it, whether Trithemius's face contributed to the life-like quality of the Apostle's, or whether Riemenschneider was able to pour so much life-blood into the head of Trithemius because it was so closely akin to his one, pre-conceived type of broad worldliness, it is a clear proof of the small part that vitality played in Riemenschneider's economy.

The figure of Bishop Lorenz von Bibra (d. 1519, begun before his death) is also dominated by the emblems of his office, his dignity, his noble birth, and perhaps his age. This cool self-assurance is underlined by the accessories of a Renaissance aedicule which, though not very architecturally conceived, and blended with relics of Late Gothic forms, do not really create a new unity of style, as Backoffen had done in his Gemmingen monument not long before. The Scherenberg monument is Riemen-schneider's closest approach to Late Gothic realism. Probably he had seen by that time products of the art of the Netherlands. One thing, however, is certain – he had to paint the marble in order to impart life to the venerable countenance of his first bishop. Yet Veit Stoss's royal tomb at Cracow, in spite of the flicker in the red marble, is a more living portrait of an aged man at the hour of death. In Riemenschneider's portrait there are traces of veneration; in the royal portrait at Cracow, Stoss reveals himself as a man who, though rich in fellow-feeling, is superior as a human being. Riemenschneider's

strength did not lie in Late Gothic realism. But neither could he invest his human beings with the worldly dignity conveyed by the new Italian forms. That is clear from the Bibra monument. Riemenschneider's field was cramped between Late Gothic and Renaissance.

Tales of the past, legends of saints, simple but moving Christian subjects – such things appealed to his creative power, and it is, so to speak, the historical factor which removed his best works from too much reality and raised them above the banalities of realism. He had stories to tell, without eloquence but with feeling. In his Family of Christ there are no children except Christ himself, and so any homespun family chat is eliminated. When he did occasionally go into detail, as in the reliefs of the imperial tomb at Bamberg (1499–1513), when he was at his best – say in the Healing of the Gallstones or in Emperor Henry's Dream – he remained supremely concise. Nor had he any bent to the fantastic. His works hover, like fairy-tales, between past and present. They are not cut out of real life, after the manner of Late Gothic realism; they owe their beauty to the thought of the past and to meditation on it. He never sought to transcend the commonplace by quantity or size; even his statues are never larger than life. In all these respects he was far removed from Stoss and most of his contemporaries.

There lies the source of his spiritual achievement, of the incisiveness of his great altars, the works of his maturity and old age. Their idealism is lyrical and remote. These most mature works are, in particular, the Rothenburg altar of 1501–5, with its shrine originally in the form of a chapel constructed to allow a flood of light from the west through glass, the Creglingen altar, then the Sending Forth of the Apostles in the Windsheim altar (1507–9, Heidelberg Museum), the Crucifixion altar at Dettwang, the stone relief of the Lamentation at Maidbronn (before 1523), and the Gramschatz altar (Hannover; Plate 2), which, though it consists of three figures, yet does not give them as quite free-standing, but keeps them still as late medieval saints in their spiritual union.

Nevertheless, a new spirit breathes in these works. The altars had no movable wings, even that at Münnerstadt before Stoss altered it. If there are wings, as at Windsheim and Creglingen, they did not have carved exteriors or could not be shut. From that time on the altar presented a single, total picture. In the Rothenburg and Dettwang altars, the very low relief of the wings sets off the modelling of the middle panel, which is very vigorous. In the Windsheim altar the middle scene is actually carried on to the reliefs. And finally at Creglingen the Assumption became a single event in a way far excelling Stoss's Cracow altar (Plate 4). It was Riemenschneider who first made the Virgin the dominating figure. So far as we know, Stoss only made such a 'carved picture' for the first time in the altar niche at Bamberg.

The majority of these works of Riemenschneider's were originally uncoloured, and some figures that have been preserved show his preference for fine-grained, light lime-wood, even though some works with old paint on have come down to us. All testify to the joy of the artist, and of his patron, in the carver's skill. In that respect this perfect representative of Late Gothic was in tune with the century of the Renaissance.

On the other hand, this limewood monochromy undoubtedly helped him, more and more, to eliminate any excess of realism. When Riemenschneider was realistic, as in

the Scherenberg monument, he used paint, but his painted altars – Gramschatz, for instance – are removed from the *verismo* of the period by lavish, polished gilding. Though endowed with the same supreme perfection, Riemenschneider could not produce 'Italian works', as Stoss did.

Thus Riemenschneider's life moved on the fringe of the great events of the time.[15] The figures of Münnerstadt were restless in outline; the forms advancing into the space pointed out beyond themselves. Soon after 1500 the outlines of the individual figures, for instance the St Matthew in Berlin, quietened down; the shoulders can be sensed, the structure is firmer, and the language of the drapery, still vivid, has passed, as it were, into internal outlines. The Rothenburg shrine contains a double stratum of single figures, elaborated with precision, superior to Stoss's Last Supper, if more monotonous; this was Riemenschneider's approach to the classic spirit of his contemporaries. But at Creglingen, the shrine, with just as much openwork, consists of more clearly arranged formal blocks which, though deeply hollowed out, unite the individual figures in a single mass. The figure has become a component part of one governing, moving whole; this was achieved mainly by means of the solid wood. The deeper the spaces of his altars became in actual fact, the less they represented space. This came to a climax in the Maidbronn relief,[16] where there is no dramatic feeling whatever in the even rows of figures. Riemenschneider's old talent for the gap, for formal relations created over a void, with which he made his début at Münnerstadt, was working itself out. Women at the edge, the Magdalen kneeling, and a standing, draped figure, the true quintessence of grief, turn away from the Virgin's lamentation, out of the picture; they are compositional cornerposts of the row and point out beyond it. Yet in their mourning they are something like representatives of the spectators, who were originally Cistercian nuns.

While Riemenschneider, in his development after the Late Gothic of Rothenburg, approached the early phase of the classic period, which was making itself felt at Nuremberg at the time, and in the Bibra monument he came hesitatingly to terms with the formal idiom of Renaissance architecture, the Maidbronn relief has hints of Mannerism.

They become clearer if we follow the series of his Virgins, which probably came to an end in the smaller figure in Berlin (probably from Tauberbischofsheim). The beauty of the female figure had never been of paramount interest to him, and Gothic touches in the folds of the drapery gave them a touch of abstractness; yet in their spatial vibration their femininity could be felt. But in the Berlin figure the body is dried out behind the ridges of the garment. These ridges literally repeat those of earlier Virgins, but they are much less sensuous. The figure, however, with a head which is unusually small for Riemenschneider, is much enhanced by the abstractness of these folds. The practically convex face is as regular as a mask. The Child, with little playfulness left in him, might have been turned on a lathe. The Virgin's right hand might be gloved, it is so stiff. The whole is wooden, and not only because it is made of wood. In this piece the board is an intentional medium. Ugly, sublime, almost terrifying, we may have here Riemenschneider's last style after the Peasants' Revolt. It seems not unlikely that his Late Gothic legacy of abstraction should be transformed into a personal kind of Mannerism in the post-Maximilian period at the end of his life.

17

Adam Kraft and Peter Vischer and his Sons

When Stoss returned to Nuremberg in 1496, two younger masters – not counting Dürer – were making a name for themselves: Peter Vischer the elder, the bronze-caster, and Adam Kraft, the stone-carver. The novelty of their manner was bound to prevent Riemenschneider ever coming into closer touch with Nuremberg. But it is not impossible that Stoss, with his primeval force, made these younger men feel he was old-fashioned, colonial, or even provincial. In spite of his loose connexion with the classic wave which came out in the work of the younger men, he was almost out of touch with the events of the day. It is also possible that Stoss, when he quarrelled with the Nuremberg bronze-foundries about the casting of a figure, may have come into particular conflict with the interests of the Vischer workshop.

Adam Kraft appears to have been a native of Nuremberg, born about 1460. He may have had his training as a stone-carver in the masons' shop of St Lorenz. There are traces in his work which show that he had seen the art of the Upper Rhine and Swabia when a young man. His own works were created in his native city and chiefly intended to be displayed there. His name first appears in the documents in 1490 as having been given an important commission. Throughout his life he never lacked work. In 1506–8, not long before his death, he rebuilt the façade of the Frauenkirche for the Council, the most honourable commission Nuremberg had to award. Yet the documents speak of money difficulties, which even culminated in the confiscation of his house after he had died in 1508/9 in the Schwabach Hospital, near Nuremberg, obviously after a long illness. This meagre outline of a lower-class craftsman's life takes on some colour from Neudörffer's narrative: Sebastian Lindenast, the Nuremberg coppersmith, 'and Peter Vischer the elder, bronze-caster, also Master Adam Kraft, grew up together and were like brothers', 'spent all their free days together even as old men, and, just as if they were still apprentices, practised together'. It is very likely that this connexion with the master metal-workers might be one of the origins of Kraft's art.[17]

His work in stone displays its whole power from the beginning, in the monuments to the Schreyer and Landauer families at St Sebald (1490–2). Compositionally, there are in them obvious echoes of Rogier, Schongauer, and Wolgemut, perhaps because Kraft had been commissioned to transpose older murals into stone. But from the first he showed his mettle as a sculptor. The landscape backgrounds in relief are full of life, but their variety is balanced by large, rounded, and eminently sculptural figures.

And yet he was a stone-carver of a thoroughly medieval kind. It would seem that in the case of his most famous work, the tabernacle in St Lorenz of 1493–6, he was not only the sculptor but designed and executed the bold and imaginative architecture as well, of course with the assistance of his workshop. For the tabernacle is all of a piece. It is most closely akin to that of Ulm Minster of 1462–71, and to the pulpit in Strasbourg Cathedral of 1484. The wreath of twisted finials over the squarish shrine was known at Nuremberg: Vischer's first design for the shrine of St Sebald (1488) employed the same

motif. But Kraft's structure is quite peculiar, a miniature steeple of several diminishing tiers, designed for an interior and visible all round, and rising, here closed, there open, to the famous rolled finial high in the vaulting of the church. The whole is of most accomplished artistry.

Three almost life-size male figures, kneeling on the ground, play their part in the general effect; they are the master (Plate 16) and his two assistants. Possibly they are genuine portraits, a general custom in tabernacles, especially dear to Anton Pilgram. Squeezed in under the weight of the slender tower, they lighten this weight by seeming to support it, and proclaim their responsibility for a work which might have been produced by a cathedral mason's lodge. Yet they take their due place in the lowest storey of the structure. As the focus of the whole, however, they are more outstandingly sculptural than almost anything in Germany before them. They assume reality in space, as Erasmus Grasser's dancers in the town hall at Munich did twelve years before, but they have a far greater sculptural cohesion in their limbs, which reach out in all directions but return to the core from which they spring; they do not dance, but are firmly self-contained; they bear weight. In spite of all the tracery of his tabernacle, Kraft had a strong feeling for mass. Grasser had endeavoured to hollow out the wooden core in such a way that space could flow through it everywhere, and the bodies of his dancers seemed to project into it like Late Gothic ribs. Kraft's figures, on the contrary, are wonderfully at rest. In their earthly corporeality they stand in full contrast to the diversity of form in the abstract structure they support. This contrast marks the moment at which German sculpture entered on the age of Maximilian. It made classicity possible.

That was the way Kraft took. The Pergenstörffer funerary relief in the Frauenkirche of c. 1498 is clear in structure. The simple reliefs with St George and the Dragon, and with the City Scales (1497, Museum; Plate 15), are uncomplicated and strongly convex. A homely streak of humour enabled Kraft to produce works of this kind; the amount of observation he admitted was limited. The St Anne with the Virgin and the Child, originally at a street corner, and now in the Museum, is his last word on the new conception of sculpture which had made its first appearance in the bearers of the tabernacle. In Kraft's work, realism did not blend with the fussy intricacies of Late Gothic but with a feeling for simplicity, and thus a new unity came into being which may best be called Late Gothic classicism.

It may simply be due to their badly weathered condition that his seven reliefs of the Stations of the Cross with the Crucifixion, completed in 1508 (Museum), bring this out specially clearly. In the Carrying of the Cross, which occupies six panels, Christ is the hero rather than the meek sufferer: he accepts help, pauses to teach, and even when the bystanders mock, drag, or beat him, the scene is not noisy. The background, which by this time has become almost neutral, plays a great part in this pregnant silence. After this overture, Kraft ventured, in the Sixth Station, to formulate the rarely depicted scene of Christ's fall with power and simplicity, as a kind of prelude to the Lamentation which follows. Once again, in this scene, the dignity and the pre-eminence of Christ's helpless, supine body over the bystanders is rendered by purely sculptural means. The crucifix, the only part of the Crucifixion group to survive, is one of the

finest works executed by the younger generation of sculptors of the time in southern Germany. Kraft was not radiant; Veit Stoss's fire was not in him, and even the work which has the greatest claim to genius, the tabernacle, is, in spite of all its artistry, muted. Yet he was one of the most important masters, and just because he was essentially a craftsman, he was a representative of the more virile aspects of the age of Maximilian. And he was one of its pioneers. That would be especially true if his new style in sculpture was really developed by him without contact with Italy, which, however, is very much open to doubt. It is a fact that no Italian sources of form can be traced in Kraft's work. But does that necessarily imply that no direct contact with Italy or Antiquity took place at all?[18] In the eighties, the only time at which a contact of the kind can be imagined, developments in Italy and Germany were so far removed from each other that any immediate gain, any of the small change of the craft of sculpture, could not be expected. But a much deeper experience of the south, an *Urerlebnis*, may well have enabled a sculptor like Kraft to work as he did.

The question whether Kraft was a pioneer in the north brings us to the so-called Bough-Breaker of 1490 in Munich, which was long ascribed to Peter Vischer, and more recently, though erroneously, to Kraft. But it is in this figure that we can find the source of the art of these two Nuremberg sculptors.[19] If none of the older generation had lived on into old age, the Bough-Breaker would have had to stand at the beginning of this chapter. It contains a great deal which the generation dominant at the time must have regarded as essential: the development of a new sculptural density, subject to no laws but its own. It is, in the full sense of the term, a three-dimensional work; it has, of course, a main view, but all aspects speak a very vigorous language which is elaborately developed. It has been surmised that this figure was made in connexion with Vischer's first projects for the St Sebald monument. In any case, here is a representative of low life, probably a peasant – a subject that was then coming into prominence – but he is dull-witted and probably meant as an allegory of oafishness. This extraordinary figure may have been inspired by some Antique bronze. And though it is a mere fragment, it takes its place as the true beginning of German bronze sculpture. It certainly came from Vischer's workshop, and was probably modelled by his own hands, but we can perhaps assume that the idea was conceived in collaboration with Kraft.

Peter Vischer the elder,[20] who inherited his father's bronze foundry at Nuremberg in 1488–9, was probably born at Nuremberg about 1460, and he died there in 1529. It was he who made the foundry famous far and wide; later he was apparently assisted by his two elder sons Hermann the younger (born in 1486 at the latest, d. 1517) and Peter the younger (1487–1528).

About 1505 Peter Vischer the elder was the owner of a collection of three or four hundred 'altfränkisch Bild',[21] a most unusual thing for a German craftsman. They were probably sculpture of some earlier time, perhaps with a few genuine Roman pieces among them. The question of what they were doing in Vischer's possession confronts us at once with the problem of his artistic personality. Were they a collection of models which a master-craftsman thought he could use on occasion in executing his commissions? For he is known to have used old models at times. Or did the collection,

whatever it contained, help him to what was actually attained by his workshop in the space of twenty years, namely to remove their work from the time and place of its creation at Nuremberg, and place it in that characteristically timeless and unregional position between the Middle Ages and the new age? Between Germany and Italy? A good deal of his work shows Peter the elder to have been an artist of rank who made models himself, though he often had wooden models made by wood-carvers for his wider circle of patrons.

His sons, both extremely gifted too, can only have taken their share in this efflorescence at a later date; there is evidence of an unfolding of high quality in the shop from 1488 on. It was at that time that the design was made for the shrine of St Sebald. It was the first step in an enterprise which was not completed at once, though in connexion with it perhaps models and casts were being made for figures of the Apostles which Vischer used later for the monument of Archbishop Ernst of Saxony at Magdeburg (1494–5).

Even before 1490 a bronze was cast in the Vischer foundry in which the lion showed his claws, namely the monument of Otto IV of Henneberg at Römhild, a bronze figure, hard and angular, of a man in armour standing detached from the stone – a work of the utmost density of form. If Peter Vischer designed this tomb – which we do not know – he is proved capable, in a moment of inspiration, of producing the Bough-Breaker too.

We can feel the momentum of the young master's rise in these years by a comparison between the Henneberg figure and the statuettes of St Stephen and St Maurice on the Magdeburg monument of 1494–5, which were certainly designed for it. St Maurice in particular displays Vischer's early bent to the classic. The Magdeburg saint stands firm in a contrapposto which is intended, but not fully carried out by the relaxed leg. The stance in the round-toed shoes which had then become the usual wear looks more resolute than it had done in the pointed, Late Gothic shoes of Henneberg. The figure is more rounded, partly because of the change in the shape of the armour. The shield, with a touch of affectation, is supported on the thigh, but the reverent, upturned head of the Moor is a powerful piece of life. The whole is so impressive that Vischer recast it later as a free-standing statue. The culmination of convincing form in this tomb, however, is the figure of the archbishop. The full form with the emblems of its spiritual dignity chased on beautiful vestments, the prominent head with the seeing eyes in deep sockets resting on cushions laid crosswise, like flames, contains the whole passionate earthliness of the early Dürer period.

The output of the Vischer workshop for monuments in relief or chased, to be sent to South, Central, and East German patrons, increased very much during these years; in many cases the models seem to have been made by Vischer himself. True, about the turn of the century there was a great increase in the number of gifted modellers, and the perfection of the casts which issued from the Vischer foundry is due to them. There is evidence that Vischer was in touch with Dürer – nobody in Nuremberg, in fact, was so spiritually akin to him as Vischer, not even Kraft.

After 1500, however, new aspects of Dürer's influence began to make their

appearance in the foundry which most likely reflected the personalities of Vischer's sons, Hermann and Peter. Both maybe were by way of being disciples of Dürer's and younger contemporaries of Baldung's: Hermann certainly was. On the other hand, they had been, if not apprentices, at any rate pupils and fellow-workmen of their father, and their work was so much part of his that it will never be possible to distinguish it clearly in the production of what was after all still a craftsman's concern.

Hermann, who was probably the elder, is responsible for a number of funerary monuments, for instance the beautifully engraved tomb slab of Duchess Sidonie (d. 1510) at Meissen, which is a masterpiece of decorative art; and above all for the double tomb of Elisabeth and Hermann VIII of Henneberg at Römhild, which was probably commissioned after the countess's death in 1507 (Plate 5). It is in these things that we seem to sense the freshness and absolutism of the younger generation, which, if it made use of Dürer's drawing (w489), handled it with great freedom. The figures burst out with power from the flat, trefoil-headed niche; the brocade of the countess's dress and the count's armour give a feeling of coolness and self-control. All meaning is concentrated in the faces, though there are not many eloquent forms in them either. The way in which Elisabeth's convexly shaped and wimpled head fits into the background is superb. Her eyes are downcast. The count wears a helmet and chin-piece; the feathers on the helmet set off the simplicity of its shape. The bronze makes the iron credible. In spite of its powerfulness, there is a touch of sorrow in the face. The background is bare, and only the pennant on the lance brings a hint of spring. A monument of love? – the idea would be too personal. The man's eyes look away over his companion. Yet there is an overtone of feeling in the work, however brusque and terse it may be.

Later, in 1515, Hermann Vischer visited Siena and Rome and brought back architectural drawings which were definitely Renaissance in form. He also made designs for the rebuilding of the choir of St Peter at Bamberg, to be carried out in a kind of Renaissance–Romanesque style, which came out still more clearly in the shrine of St Sebald. Possibly he was going too far, and the leap from a budding classicism into the High Renaissance surpassed the powers of the young Nuremberger. But there is no clear trace of a genuine conflict. At the beginning of 1517 he died. He seems to have completed only two more works of any importance. The first was the grand pediments with the battle of the Centaurs, begun at the end of 1515 for the bronze screen of St Anna at Augsburg commissioned by the Fuggers (parts preserved in the Château Montrottier at Annecy). The second was the finishing of the shrine of St Sebald with a final depressed top, essentially a piece of architecture with many inevitable compromises, both compositionally and in the choice of forms. In a still deeper sense than Hans von Kulmbach, who also died young, Hermann Vischer the younger was the tragic youth among the artists of Nuremberg.

Peter the younger must have had a happier disposition, yet these heights were not for him. He too had seen Italy. In the Vischer foundry, he was the wax-modeller. Moreover, he could be relied on to finish his work. This brings us back once more to the heart of the Vischers' activity, both of the father and the sons – the great shrine of St Sebald (Plates 8, 9, and 11). It was in 1507, nearly twenty years after the first plans, that

the commission was finally given to Peter Vischer the elder. The very large work was put in hand at once, and after a pause of about three years, from 1512 to 1514, was continued, and set up in 1519. It is not quite a 'whole chapel', as a contemporary described it, but both architecturally and ornamentally a huge and wonderful sight.

The base bears the dates 1508 and 1509; thus at that time there were definite ideas of what the finished whole was going to be. Yet in the course of the twelve years one change was made in the plan which affected its architectural form, if nothing else. The top is certainly lower than was originally intended, the arches are more depressed, the many tiers of the crowning spire are certainly more flattened out than would have corresponded to the Late Gothic sense of proportion of the design of 1488 and after all still of the structure in its final form. Romanesque and Antique forms are woven into the original design, and the result is a peculiarly fantastic, almost visionary edifice with many Mannerist details. Otherwise no joint can be detected in the sculpture as a whole. Nor did the sons, as Dürer's disciples, with their eyes on Italy or just returning from it, necessarily rebel against their father's *altfränkisch* manner. The gap in the activities of the foundry from 1512 to 1514 can be accounted for in many ways and need not be interpreted as delay or stoppage of the work caused by internal dissensions.

However, though it is true that there is no clear breach, there are far-reaching changes in a workshop where two generations and at least three master-hands worked as one. Of the figures, the oldest in style and perhaps the first to be made are the twelve statuettes of the Apostles arranged round the reliquary. They show the master – in all probability Peter the elder – remarkably detached from time and place. They are slender, yet firmly shaped and rounded figures in the toga which always drapes cathedral statuary. Features of German sculpture of the thirteenth and fourteenth century can be noted, and they again recall Vischer's collection and the liberation they probably brought to his style. There is a touch of earlier Gothic in the Apostles' faces too; they lack the abruptness of characterization which Late Gothic wood-carvers gave to their subjects. All that was adventitious in the living model has been eliminated. However much they may differ among themselves, the Apostles share a common mildness; there is a kind of elevation in their spiritual bearing. Something like a Ghiberti stage was attained here in German sculpture. Could that have been done without Italy?

The characterization of St Sebald, in the lower storey, is a good deal more pithy and gnarled; that is probably due to the wish to set off the spirituality of the Apostles' world. Their counterpart in this lower section is the 'self-portrait' of the master made about 1508, a craftsman in the prime of his manhood, with distinctive facial characteristics.

The reliefs of the life of St Sebald, on the other hand,[22] which cover the long sides of the shrine, are so free in their re-telling of this little-known story, so freshly caught in the varying depths of the relief, that they can only be the work of a new generation (Plate 10). They seem to be by Peter the younger. Not only the unerringness of tone in the Healing of the Blind Man points to him, but also the feeling for the nude in the female figures in this relief. The background, as in Kraft's last works, is neutral. This comparison reveals the distance between almost contemporary works of two

contemporaries; Vischer the father, the friend of Kraft's youth, could not have reached that far.

The hand of Peter the younger can be followed still farther. He may have collaborated in the Apostle statuettes. One can also ascribe to him the Prophets in the upper range, and especially the great wealth of small Old Testament, mythological, and allegorical figures which spread all over the shrine. The subjects are often difficult to interpret, but the modern connotation of the term 'genre' would be out of place here.[23] There are the four heroes of Antiquity, the four cardinal virtues, planets, sea-gods, putti, sphinx-like candelabra figures, and many musicians appear on the scene. There is, especially in the female figures, intensity in the gaze; they seem to be yearning, adoring, musing. As a whole the subject is not clear. What was at work here was a talent in full efflorescence, and it seems inexhaustible. Southern forms are used with a freedom alien to Dürer. There is a kind of weightlessness about the designs. The execution is swift and unerring. Some sketchy touches enhance the impression of form in flux. This Vischer was no lover of compactness; he was a master of improvisation.

It is here that we seem to be standing at the birthplace of the German bronze statuette, the delight of the humanists. The work of Peter the younger also comprises medals and plaques, among them variations on the theme of Orpheus and Eurydice. His two ink-stands (Oxford), with representations of Vita, the later dated 1525, show how these statuettes developed. The first Vita is composed of beautifully shaped individual forms; the figure of 1525 is more a single whole, and the body is grasped as a unity. A Late Gothic touch appears in the diagonal plan of these inkstands; this diagonal is emphasized by the frontality of the female figures which are placed away from the centre. It was only Peter the younger's last work, the monument of Friedrich the Wise in the Schloss-kirche at Wittenberg, dated 1527, which first displayed the concentrated power of frontality which the shape and seriousness of the work required. The face is magnificently and broadly moulded, the drapery is Mannerist and somewhat lacking in form.

And yet it would seem that we must not dismiss the old master as an active crafts-man towards the end of the first decade. The Apostle statuettes are a superb achievement of German sculpture, and, just by their contrast with the shrine of St Sebald and the 'self-portrait', strike so living a note in this single wide span, that the idea of a man ceasing work with still twenty years to live is hardly tenable.

The last important production of his workshop may still have come from his hands entirely: the two statues of Theodoric and Arthur, at Innsbruck (Plate 12), dated 1513, which Emperor Maximilian had commissioned from the Vischers for his funerary monument (and it may well be the work on these statues which explains the hiatus in the continuation of the shrine). The two statues have always been understood as a contrast, and they actually seem to have been executed in that relation to each other, as the double commission implied. They are of bronze, and, as they are in armour, also represent metal. They are immensely alive. Arthur stands upright in the stance which was by that time fully accepted. He bears a fanciful cuirass richly ornamented with reliefs; his posture is determined and terse, his form rounded and forbidding – a virile hero of legend who unites the bright idealism of the Apostles with the muted other-

worldliness of the 'self-portrait'. Theodoric, on the contrary, stands leaning on his shield. The contour of his body follows the Gothic curve, with a deep break at the hip; it is rich, with a hint of openwork. The face with its aquiline nose is shadowed. He is really a knightly saint of the Middle Ages. The bent to the past which obviously had a special appeal for old Vischer's nature is here fully developed. If many hands really worked on this pair of statues of Maximilian's 'ancestors', they must have done so under the guidance of a master who intended the group to form a whole. And recent studies of Vischer make it seem not quite certain whether Dürer, the influence of whose Paumgartner altar is unquestionably traceable, actually made designs for this pair.[24] This work of the highest significance could without doubt be the achievement of the Vischers' own development.

SCULPTURE ON THE MIDDLE AND UPPER RHINE
AND IN SWITZERLAND

ON the Upper Rhine, the most important sculptor in the age of Maximilian was Niclas Hagnower. In 1493 he was registered citizen of Strassburg, and there is documentary evidence of him there till 1526. He was probably born about 1445, and was therefore a near-contemporary of Veit Stoss; hence he was one of the very old men who saw the advent of the new age as mature and aged artists. Little is known about him. Stone-carvings on the tabernacles in Ulm Minster (1471–3) and St Lucius at Chur (1484) and corbels in St Jodocus at Ravensburg have been attributed to him. They reveal a savage, hard, and virile nature. If these were really the beginnings of Hagnower's work, he did not change very much in fundamentals. Even what he did at Strasbourg, including the wood-carvings, was done in 'a manner of handling stone so that the sparks fly'.[1] The figure of a man in lay dress on the eastern parapet in the south transept of the minster is probably a portrait of a master mason.

His wood-carving is represented by four busts of the Fathers of the Church at Saverne (Zabern), and remains of the Fron altar, once the high altar of the minster (1500–1), are more or less certainly Hagnower's work. Then followed the great wood-carvings in the shrine of the Isenheim altar, now at Colmar.

The Lamentation of the Fron altar, which in composition follows the work of the much younger Riemenschneider, is outstanding in its formal power. It is not so much a scene as a *presentatio* of the Corpus Christi, which is seen frontally and looks gigantic. If there is anything superficial in this art, it has nothing to do with story-telling. In his robust, untroubled assertion of the truth of reality Hagnower can only be compared with one contemporary, Bernt Notke of Lübeck, who was not much older. Both avoided the abyss of triviality which may have opened under their eyes at that stage of Late Gothic; the spiritual factor in their commissions remained unforgotten, and they raised it to a supreme perfection of a kind of art for art's sake. Yet while Notke granted reality a large share in his work as the effect of the actual material of which it is made, Hagnower gave the subject a certain precedence, making it certainly more brilliant than Notke's, but not more spiritual. Hagnower's works are not set in a key of tenderness; their aim is to render the truth of real characters. That is why he took up the male bust, which Gerhaerts had brought to such a perfection of dialectical characterization. One of the prophets on the Fron altar at Strasbourg has an angry expression; his lower lip is thick and leathery, and the furrowed scalp lies free on the skull, obeying laws of its own. Opposite him is Tobias, his eyes blind and unseeing – a sensitive, listening figure. But there is no sentimental feeling for this figure either.

The same *verismo* produced the shrine of the Isenheim altar (Plate 21). In the centre St Anthony is enthroned upright, an embodiment of the patriarch. There may be

portrait touches in him. This fullness of life is tempered in the execution by the harmony of the curling beard, which recalls the decorative function of ornamental veils. St Augustine and St Jerome, the two Fathers of the Church who stand beside him, are intentionally set in contrast. This is done partly by the straight, faint swing of St Jerome's vestments as against St Augustine's cloak, which is thrown shield-wise over his arm and enhances the contrast by its jagged outline, while the hat and hood of St Jerome surround his face with shadowy hollows. St Augustine, hardened by experience, strong as a peasant, stands like 'a tower in a battle'; St Jerome is more passive, he is worshipping and nocturnal. But both contribute to the other-worldly kind of 'truth' which was the goal of all Hagnower's art. The figure of Jean d'Orliac, the donor, at St Augustine's feet is rendered so dryly and tersely that there is almost a hint of the Quattrocento. Two figures which once knelt at St Anthony's side, a pious peasant with a cock and a gross swineherd, gave common life its rights even here; these two bringers of gifts are a stroke of genius which brings the characters of the Fathers back to earth in reversed roles. There is no cheap humour or anti-clericalism in Hagnower. In his work he drew on a huge reserve of vital energy, and carried his virile type of truth almost to the verge of melodrama. The bliss and suffering of the Virgin and the Passion of Christ – all that was mystical and tragic – were left to Grünewald.

The most prominent successor of Hagnower was Hans Wydyz the elder, the wood-carver, who, according to the evidence, worked at Freiburg im Breisgau from 1497 till about 1514–15.[2] The small Annunciation in Berlin, originally at Heilbronn, is probably by him. That, and his altar of the Magi at Freiburg of 1505, show much of the sculptural density then achieved on the Upper Rhine, though they lack the pungency of the Strassburg master. Wydyz's forte was tranquillity. In the Schnewlin altar in the minster, made about 1514/15 in collaboration with Hans Baldung the painter, he was able to follow Dürer in depicting the Rest on the Flight into Egypt as an enchanted idyll (Plate 24). Its placing is brilliant; the three-dimensional form is set where the planes of the shrine join in the middle. These were the factors which gave their significance to the type of the small-scale figure or group which he introduced to the Upper Rhine. His Adam and Eve in the Historisches Museum at Basel, datable about 1510, of un-painted beechwood, is, though terse in form and small in scale, extremely substantial. Whether Wydyz knew Italy is open to question.

Finally the artist who signed with the monogram HL, who was born about 1480 at the latest and died about 1532, should be mentioned here.[3] His masterpiece, the high altar at Breisach, was not finished till 1526. Where he lived, we do not know. Some of his graphic work – twenty-four engravings and nine woodcuts – bears dates between 1511 and 1522; some undated sheets are certainly older. This part of his work shows early influences of Barbari, Dürer, and Mantegna. Then Dürer comes to the fore, until a splendid St Paul of 1522 bears the mark of a late turn to Mannerism.

The origins of HL's sculpture, like those of Wydyz, are to be found on the left bank of the Rhine not far from the great centre, Strassburg. The Virgin in the Louvre, which seems to have originally been at Isenheim, is a youthful masterpiece by HL, made at the beginning of the century; it shows his kinship to the Master of the Lautenbach Altar,

on the Upper Rhine. The lower part of the body is clothed in a splendid formal shield which foretells the future Mannerist. A Man of Sorrows from Gebweiler (Guebwiller; now Colmar) and two St Johns in East Berlin, also set in the contrast typical of the Upper Rhine, are clearly akin to the woodcut of the Virgin and St Christopher. It is probable that HL was an assistant of Stoss until the latter's workshop was wound up about 1503. But the loose, leathery scalps, especially in the figure of St John the Baptist, are of the same substantiality as the Fron altar and the Isenheim shrine.

While HL continued Hagnower's *verismo*, it underwent in his hands a metamorphosis. The Martyrdom of St Catherine (Colmar), like the engravings of 1511 and the woodcut of St Florian, are bursting with reality. What these works really show, however, is that HL had by that time definitely digested matter from Italy. The impetuous movement of this style reached its climax in the St George at Munich (Plate 23). His eruptive gesture stands out against the smooth roundness of the early classic armour. There is movement everywhere; the cap-feathers curve, the tip of the cloak swings, the feet stamp in the youthful hero's joy in victory. The woodcut of St Christopher must also belong to the second decade. It is perhaps the first formulation of Baroque fantasy applied by the South Germans to the Saint of the Fords. In a general way, HL's forms are closely related to the Bavarian and Austrian productions of the time. Yet neither Leinberger nor the Masters of Mauer and Zwettl can be equated with HL: they were different, both as personalities and as artists.[4]

The work of Hans Seyfer,[5] which is to be found in the Middle Rhine and Neckar regions, obviously stems from Strassburg too, though there is no certain evidence. Seyfer probably died young. The dates we have for him are all late; the high altar in St Kilian at Heilbronn is of 1498, and the Crucifixion in St Leonhard at Stuttgart of 1501. He became a citizen of Heilbronn in 1502 and died in 1509. He may have come under the influence of Conrat Seyfer, presumably his brother, who was master mason of Strassburg Minster in 1491 and continued in the line of Nicolaus Gerhaerts.[6]

His earliest work, the Entombment of the von Loenstein monument (d. 1491) in Worms Cathedral, links up Hans Seyfer's work with Strassburg. He pursued his way on the heights; its end was a great style. He is an Adam Kraft of the Neckar region and may be regarded as his superior. His Heilbronn altar with the powerful group of five figures in the shrine rising up to the middle, yet does not deny its Upper Rhenish heritage in the busts in the predella and canopy, it merely transforms it (Plate 20). His carvings are concrete and taut; the clothing is not flabby, it is tranquil in its total mass and quiet in contour. The faces, almost like Hagnower's, bear the stamp of great truth to life, but they are calm. This tranquillity, this Gothic spirituality, is an achievement; it was not innate, and it does not come from a naturally even temper. The effort is palpable, and it is that which gives so much vigour to the clear, tactile forms. Figures in the top canopy derive from Schongauer. One of them may be an early work of Conrat Meit's.

Heilbronn, where Anton Pilgram seems to have been living at the time, owes particularly to Seyfer its brief, but unforgettable appearance in the history of German sculpture. For Seyfer also received commissions which show that he was in the forefront of sculptors in stone. In the Stuttgart Crucifixion (1501), the Virgin and St John show

the same tautness of outline, which gives enhanced dramatic effect to the swirling loincloth on Christ's body, as it hangs on the cross, dumb and dead, the legs hideously stretched. The greatness of Seyfer's form comes out even more if one looks at his torsos only. The heroic head of Christ (Heilbronn) and the fragments of his last work, the practically ruined Mount of Olives outside Speyer Cathedral – consisting mainly of fragments of drapery – have the sculptural force of works of Antiquity.

A few years after Seyfer's death a Crucifixion by Hans Backoffen was erected in the churchyard at Wimpfen am Berg. With that, the influence of Mainz, the spiritual capital of the region, began to make itself felt too. Backoffen's work may have been largely based on Seyfer's. Such works of his as are known to us, and date from the first twenty years of the century, show him as a practitioner of that vital kind of early classicism which he probably encountered at the time of its full development. He seems to have been born in the seventies and certainly died in 1519.[7]

Other stone sculpture of the kind, mostly gigantic in size like that at Wimpfen, and made in part in the master's own shop and by his school, can be seen at Mainz and up the Main outside Frankfurt Cathedral and in the church at Hessenthal (1519). But the centre of his work is in or near Mainz. The funerary monuments of the Archbishops Bertold von Henneberg (d. 1504), Jacob von Liebenstein (d. 1508), and Uriel von Gemmingen (d. 1514) (Plate 7) show the growth of his art. It seems to have originated in the old and famous stone sculpture of Mainz and to have been enriched by impressions of Seyfer's work, and borrowings from Riemenschneider. Perhaps Backoffen linked up with the local tradition at some point unknown to us. The result was the Henneberg monument. The Liebenstein monument shows considerable progress; the figure of the elector, once imprisoned in Late Gothic curves, now stands upright. The clothing, treated with greater simplicity, is developed in breadth, and, with its shallower relief, allows the body greater forcefulness. This is again reinforced by the lateral statuettes of the saints, which are placed in a row. While Henneberg stands in the space of a tabernacle under a flamboyant four-centred arch, the foreground is now dominated by Liebenstein. It is a masterpiece of succinct presentation.

The monument of Canon Petrus Luthern (d. 1515) at Oberwesel has the same robust substantiality, the *verismo* of the period in the lively version of the Middle Rhine, with a magnificent absence of spiritual complications. Nothing in the monument even verges on the melodramatic, which Hagnower did not always avoid. In Backoffen's monument of Wigand von Hynsberg (d. 1511) at Eberbach, on the other hand, a touch of Riemenschneider's sentiment can be felt.

The Gemmingen monument shows the elector kneeling before the Crucifix, presented by his patron saints, St Martin, the man of peace, and St Boniface, the man of action (Plate 7). However manfully they stand there, they do not really belong to earth. Their robes are no longer drawn taut, but are deeply cloven and full of shadows, as Leinberger's were at the time. Their heads droop forward, as if out of niches; in spite of the precision with which the gloves are rendered, there is a touch of magic about them. The curious entanglement between Late Gothic tabernacle forms and the niche enclosing the whole, which must be called an aedicule, is a parallel to the fluctuation

between different degrees of reality. Backoffen's achievement did not lie in the increase of these Renaissance forms, which can already be noted in the Liebenstein monument, but in the masterly blend of two formal idioms in one inseparable whole. What resulted was something like a building in movement, far more dynamic than the top of the St Sebald shrine, an organism which should really be called proto-Baroque and which forms the ideal frame for the wonderful picture within.

The chief masters of the Middle Rhine did not spend their gifts on wood.[8] They loved stone and the nobler materials. The little alabaster Judith in Munich (Plate 19) is signed in full: Conrat Meit von Worms. Meit seems to have been a contemporary of Backoffen's. He was apparently at work in 1496, but he survived Backoffen by many years. Between 1506 and 1510 he was at the court of Friedrich the Wise at Wittenberg, collaborating with Cranach; soon afterwards he settled in the Netherlands, and may first have entered the service of Philip of Burgundy. In 1514 he received at Malines, where he was court sculptor, a considerable payment from Margaret of Austria, the regent. It was in her service that he executed his chief works. He died at Antwerp in 1550/1. Yet his early work, which has come down to us in a fragmentary condition, shows him to have been one of the prominent figures of the age of Maximilian.[9]

From the very beginning Meit's importance lay in work on a small scale. There is nothing juvenile, except for their boldness, in the Entombment at Munich, dated 1496, and in the Falconer in Vienna, which have been erroneously ascribed to Pilgram. They are masterpieces, maybe of a precocious youth. Even in these pieces, in spite of the Late Gothic and Christian formal repertory of the eighties, he achieved a degree of sculptural cross-tensions and density, combined with a rich spatiality, which was almost unique in his time. The faces of St John and the Falconer, broad and vital and impetuous, may show that he had seen works of Anton Pilgram in Lower Swabia, but they show, too, how much he was in sympathy with the *verismo* of the Upper Rhine. From the beginning he made little use of paint. The traits of earthiness and of conscious artistry are so powerful that they seem to hark back to Gerhaerts's origins in the Netherlands. There are even grounds for believing that Meit worked in Seyfer's shop at Heilbronn. No other wood-carvings seem to exist.[10]

From that time on, Meit appears to have worked only in metal, boxwood, and fine stone. What he made are mainly pieces on a small scale, created for amateurs of humanistic leanings; mythologies and portraits, all delicious. There seems to be a great breach between his Late Gothic wood-carvings and the bronze Judith(?) in the Kunstgewerbemuseum at Cologne (Plate 18), yet there is in her bearing much in common with the Falconer. Her nude is still that of a Gothic maiden, there is a touch of Cranach's chic about her, and yet it all paves the way for the outstripping of the 'Gothic'. The figure was made shortly before or during the Wittenberg years.

The splendid Judith in Munich marks a climax in Meit's development (Plate 19). Never again did he achieve such corporeality. Supreme sensuousness in the form, firm Düreresque proportions, blend with the soft bloom of the alabaster surface and the skilfully economical hints of colour in the hair, lips, and eyes. In this figure, sculpture exists for its own sake in a manner unprecedented in the north, with no relation to or

support by architecture. It has no need of allotted space; it creates its own. This feat seems to have come to the sculptor by nature, yet it may be questioned whether it issued entirely out of his own artistic environment of the north, or whether he had seen Italian work in the first decade of the century. Or did the new, sculptural style in German drawing and painting, especially in the new vision of Dürer, help him to attain this end? In any case, the 'von Worms' in the signature on the alabaster seems to have been intended for a German reader.

The boxwood figures of Adam and Eve in Vienna seem to link up here. They are rendered even more in the sturdiness of proportion which Dürer practised in the first decade of the century. The contrapposto is a purely sculptural invention. Meit reduced corporeality to its most succinct form while retaining as much detail as he possibly could, for instance the same folds of flesh as on Judith's shoulder. That is Dürer's excess of modelling. Never before had the progenitors of the human race been depicted so absolutely as creatures of instinct. The work is difficult to date, but the middle of the second decade of the century seems most probable.

The boxwood figures of the same subject at Gotha and the bronze group of Mars and Venus at Nuremberg (Plate 217) go farther. It is in them that Meit perfected his Netherlands style before and about 1520. He has passed beyond the compactness and precision of Dürer's work. The proportions have taken on greater slenderness, and there is generosity in the forms. The surfaces no longer echo the materials and colours of the real world, but their mirroring smoothness has the charm which lies in any transposition into another medium. On this level of supreme perfection a touch of self-conscious artistry creeps in. The artistic scheme is cleverly devised. Mars embraces Venus with a vigorously outlined shoulder; she yields with tenderness. Yet the sculptural independence of the two figures is fully respected. Nowhere else in the art of the north does paganism look so free and innocent. The worldly court of Malines probably enjoyed both groups for their erotic connotations. There may also be hints of portraiture in them, as in Gossaert's Neptune and Amphitrite.

Meit's Renaissance is probably the most satisfying that the north ever saw. He had certainly met Barbari and borrowed from his work; he was no doubt familiar with Dürer's graphic works, if not with Dürer himself until Dürer visited him in 1520–1. His relations with Gossaert probably led to mutual influence; his Mars is imitated from the Hercules torso in the Belvedere, yet it was all absorbed by him almost imperceptibly. Meit's forms are all of a piece; they have no trace of effort about them.

He also made small portrait-busts during his first years at Malines; a couple in the British Museum (Plate 218), the husband repeated in Berlin, and a woman in Munich. She is almost certainly Margaret of Austria, while the man may possibly be identified as a posthumous portrait of her husband, Philibert of Savoy (d. 1504). Outwardly, they are on the smallest possible scale. Their spiritual scale is monumental. They are far superior to the portrait of Margaret made by Orley, the court painter. The forms are fully rounded and living, yet they are succinct and simple. There is an extraordinarily convex tension in them which lifts them above prosaic reality. In his Mannerist period Meit continued his formal independence.[11]

SCULPTURE IN SWABIA AND AT AUGSBURG

SWABIAN sculpture about 1500 also belongs to the span of Late Gothic development. The production was very large, and it is sometimes difficult to determine which of the many imperial and provincial cities of the region pieces come from.

At Memmingen, the Strigel family of painters and sculptors was active; the member of the family who comes into consideration here is Ivo, the wood-carver, believed to have been born in 1430; he died in 1516. His workshop was extraordinarily productive till well on into the sixteenth century, and exported to the south and to the north of Italy, especially the Grisons, altars of a harmonious, Late Gothic type.[1] Hans Thoman broke with that conservatism when he made the fresh and realistic craftsmen's busts on the choir stalls for St Martin at Memmingen in 1501–7.[2]

A competitor of the Strigel workshop was Jörg Lederer, first at Füssen (from 1499) and later at Kaufbeuren, where there is evidence of him from 1507 to 1513. He was born about 1470 and died in 1548/50. His chief exports went to the Swabian Alps, i.e. the western Tyrol, the Vorarlberg, and Switzerland.[3] He started out from the Late Gothic style of Syrlin the younger at Ulm; he also came under the influence of Gregor Erhart at Augsburg, and took to Dürer's graphic style after about 1510. He then developed an animated, Early Baroque style, which perhaps reached its climax in the altar at Hindelang of 1519, but from then on remained the hallmark of his work. In the post-Maximilian period this spirited basic bias was transformed by harder, but generously conceived Mannerist forms. It was only then that Lederer really came into his own.

The Master of the Biberach Family[4] was an outstanding wood-carver. The surfaces of his work are shaped with the utmost sensitiveness, and the details are beautifully harmonious. His work belongs most probably to the first ten years of the century. He began with a fully developed Late Gothic, which he retained in his crisp and angular line. Yet he was so close to the first phase of the Augsburg Renaissance that he must be regarded as an immediate forerunner of Sebastian Loscher. His activity at Biberach cannot have been much more than a halt on his way.

In the fifteenth century, Ulm had taken the lead in Swabian art. The city possessed a number of excellent sculptors' workshops. The origins of the Syrlin shop reach far back into the previous century. There is documentary evidence of Jörg Syrlin the younger's activity at Ulm from 1475 to 1521.[5] He was probably born in 1455. The enormous output of his workshop and those around him continued the muted style of the nineties in a noble version of Late Gothic which, in the Thalheim altar (Stuttgart, Landesmuseum), flows into an animated but mild classicism. This must be by a younger hand and date from the second decade.

The work of Martin Schaffner (1478–1546/9), who was primarily a painter, but

probably a wood-carver and medallist too,[6] has a graceful and composed gravity which is not unlike that of the master of the Thalheim altar, for instance in the Hutz altar in Ulm Cathedral of 1521, and in the former high altar at Wettenhausen of 1523–4. Thus there was in the artistic production of Ulm at the beginning of the sixteenth century no great originality but an unerringness of effect.

Daniel Mauch's manner was more individual; he worked about the end of the nineties, at the same time as Schaffner, in the workshop of Jörg Stocker, the Ulm painter.[7] He was born in 1477 and died at Liège in 1540; in 1529 he had gone to the Netherlands 'to earn his daily bread', apparently because he, like Schaffner, remained loyal to the ancient faith, while the conflicts of the Reformation at Ulm were approaching the iconoclasm of 1531. Mauch's progress in his art led from the Magmannshofen Coronation of the Virgin (Kempten) by way of the altar at Wippingen of 1505 to the altar of the Holy Kinship at Bieselbach, probably of 1510; it is not surprising that, being so close to Italy, there should be Italian elements in this Late Gothic formal repertory. From that time on, Mauch's art was delightful, whether in his single figures or in his groups at Munich and in the Lorenzkapelle at Rottweil, or in the lovely St Dorothy in the Barber Institute at Birmingham. Yet it probably only reached its climax in his delicious late works, the Virgins of his years in the Netherlands. The statuette in the church at Dalhem, near Liège, was made on the commission of a humanist prelate. The figure is wreathed with sweeping parallel folds of drapery which envelop its fully sculptural forms in their own wilful, but very musical fashion.

The most outstanding artist of the age, however, was Gregor Erhart.[8] He was probably born in the mid sixties, the son of Michel Erhart, the Ulm sculptor, and must have grown up in his father's workshop. In 1494 he left Ulm for Augsburg, a more promising centre to which his father often exported works, the last in 1510. Gregor died at Augsburg in 1540, having far outlived his own role as an artist. Gregor Erhart was closely bound to his father, a great and original sculptor first mentioned in 1469 and for the last time in 1522. Gregor's *Wanderjahre* in the Netherlands and his meeting with Riemenschneider, probably at Ulm, certainly did not mean so much to him.

Michel Erhart may have been the master of the high altar at Blaubeuren of 1493–4. His chief assistant was certainly his son. The altar must be regarded as essentially the work of the latter. It follows the Netherlands scheme with the upper frame of the shrine raised in the middle, though not with Riemenschneider's steepness. The reliefs on the wings are devised for a considerable contribution to their spatiality by painting, and the whole is radiant with superb colouring in which gold predominates. On each side of the Virgin there are two saints in a row, not a stepped-up composition, as they were soon after at Heilbronn. In Seyfer's work, there is great inward tension but the prevailing effect is calm. In Erhart's the forms are at rest within themselves. The faces, most of which are generally related to Netherlandish painting, convey a rich sense of life. They are charged with feeling and personality. The Virgin's nose is delicate in her broad and radiant face, her fingers are slender. St John is ascetic. Yet the group of the five figures and the chubby-cheeked Child, taken as a whole, is harmonious in its proportions, universal in its truth, and almost monumental.

This group prepared the way for greatness of form without any attempt at the sublime, and greatness of form became intensified in the following Virgins by Gregor until the climax was reached in the Virgin of the Misericord formerly in Berlin, which Gregor made in 1502–3 in collaboration with his brother-in-law, Adolf Daucher, the cabinet-maker, and the painter Hans Holbein the elder for the high altar at Kaisheim near Donauwörth. The intimate loveliness of his earlier works has here expanded into full-toned harmony. The full, firm body of the Child lies across the floating, space-creating mantle. Yet in spite of this, and other contrasting motifs, the work breathes repose; it is robust in its rotundity. The Virgin is full-blooded, and there is power in her expression. Here we see the contribution made by Swabia to classicism about 1500.

Towards the end of the first decade, the same subject was again taken up in the enthroned Virgin of the Misericord in the church at Frauenstein in Upper Austria (Plate 33). Erhart based his design on a superb flat triangle. Under the mantle, slightly raised by angels, the kneeling donors, Emperor Maximilian among them, find their place in the broad and sculptural whole. This motif is echoed in the Fieer monument (d. 1512 or 1525) in St Georg at Nördlingen.

The so-called *Belle Allemande*, the Magdalen in the Louvre, was probably made in the second decade. She is borne aloft in her assumption, since the weight-bearing and relaxed legs give her figure something like an earthly counterpoised stance. And her body, as in Dürer's woodcut B121, breaks with tradition in a way which is unusual in an altarpiece; it is nude except for the waves of her hair, and it is the body of the beautiful sinner. Erhart had already depicted innocent nakedness with charm in the small Christ Child with the orb from Heggbach (Hamburg), a subject especially beloved by the women mystics of Upper Germany.

But he had studied the nude also in the context of Vanity representations. In the small, three-figure group in Vienna this is actually the subject of the last bead of the rosary[9] which has grown into an independent statuette, so that it is open to question whether it was made only for the art-lover. The couple has all the beauty of youth in its Gothic curves; on the reverse side the withered hag is near to death. This small group was probably made about 1500 on a Habsburg commission.

The figure of the seated old woman in London probably gives us an idea of Gregor Erhart's late style; the cutting has become finer, there is no colour, and the total effect is left to the bare wood. It is an allegory of earthly transience; the master of Augsburg must have had connexions with the contemporary art of Padua. Yet we can feel the Swabian sense of control, the fellow-feeling of the artist himself, already ageing, which enabled him to create this figure without a trace of the ugliness of age. In this subject Erhart was himself a classicist. Further, the small heads of a young couple in London[10] – the man akin to the youth in Vienna – may be counted among the works of Erhart's old age.

His most famous work hardly got beyond the stage of roughing-out; it is the equestrian statue of Maximilian beside St Ulrich and St Afra at Augsburg, designed in 1500 and nearing completion in 1509. The emperor's idea may have been inspired by Leonardo's Sforza Monument in Milan. Peutinger was adviser in the enterprise, in

1503 Hans Burgkmair made a pen-and-ink drawing for it, but neither was of great use to a sculptor. It was lack of funds that prevented the work being completed. Erhart, the 'Emperor's Sculptor', was capable of creating a life-size statue of the kind, as we can see in his stone memorial tablets of the Augsburg period. The horse, and probably only the horse, was cast in bronze after his model (Plate 26).[11] Above its mighty rump, which would offer the true aesthetic support for an equestrian figure not yet modelled, it has the small, back-tilted head of the Renaissance. The foreleg is mighty, the heraldic effect of the side-view most eloquent, and yet the impression of the whole is fully three-dimensional. It is a work of indwelling monumentality.

Erhart must have visited Italy about the turn of the century; the sweetness of the Virgin of Kaisheim, and the relief-like setting in the landscape which may be seen in the tabernacle at Donauwörth of 1503, probably gained by the experience. Yet there are no Italianate forms in these works, just as there are none in the bronze horse; there is no breach, no sudden new direction in Gregor's art. He simply absorbed something for which he was inwardly prepared. In 1531 he gave up his shop, and he may have retired from active work before that. Yet this creator of mighty form, with his profound but controlled feeling, remained the most outstanding sculptor, the *ingeniosus magister*, of Augsburg, and his influence was passed on by Hans Daucher, whose teacher he seems to have been in 1500.

There was no wood-carver of standing at Augsburg when Michel Erhart delivered work to the city and Gregor Erhart settled there. Stone-carvings such as the monument of Bishop von Lichtenau in the cathedral (1505–8) have the simplicity of presentation of the late medieval period, which was practised by a competent master there, namely Hans Beierlein the elder (d. 1508), who became the teacher of Loy Hering in 1499.[12]

But Augsburg had a good portrait sculptor who seems to have made models especially for bronze-casting: Jörg Muscat. He was a good deal older than Erhart. He was born about 1450 and died at Augsburg before 1527. Having been banished from the town, he lived at Ehingen on the Danube from 1491 to 1504. He worked for Maximilian from 1498 on.[13] It was probably Muscat who cut the model for the portrait head of the emperor, the bronze cast of which is now in Vienna (Plate 27). There are also bronze busts of Maximilian's mother, Eleanor of Portugal (Vienna), and of his first wife's grandfather, Philip the Good (Stuttgart, Landesmuseum). What these busts were for is not known. The two figures of the ancestors were probably made after paintings and not until 1510; Philip is extremely effective. The portrait of the emperor is both lifelike and forceful, and it is as full of detail as of spreading, yet self-contained form. Late Gothic had reached its classic phase.

Later, Muscat was given a Renaissance commission of a specifically Augsburg kind. He collaborated in another of Maximilian's plans for perpetuating his memory during his lifetime; this was the great funerary monument already mentioned. According to its long and detailed programme, the monument was to include thirty-four busts of Roman emperors to the greater glory of the House of Habsburg and the Empire. The busts were made at Augsburg under the superintendence of Peutinger, but were not used when the monument was finally erected at Innsbruck. The best of them appear to

35

have been modelled by Muscat; the humanist historian helped and coins were studied. Yet the best part of this retrospective approach must be due to the sculptor. He had a keen feeling for the clarity of the modelling in Antique sculpture. A face as expressive as that of Emperor Probus could not be imagined without some knowledge of a Roman portrait bust of the age of Constantine, and yet there is in it something of the contemporary personality of the bust of Maximilian.

This dry and forceful portrait style, which Muscat probably created on a basis of historical feeling and contemporary observation, must have had an influence on the great Augsburg enterprise of the time, the statues ornamenting the Fugger Chapel adjoining St Anna (1512–18). It comes out most clearly in some of the half-length figures from the choir-stalls now in East Berlin and Boston.

As a whole, however, the Augsburg Renaissance was mainly the work of young artists, who began to work a generation later than Muscat and were twenty or more years younger than Erhart. This generation of Erhart's pupils did its chief work in the post-Maximilian period. But they seem to have taken matters into their own hands very early and thus actually skipped the intermediate generation of sculpture at Augsburg which was so important in painting.

Of the three contemporaries who became masters at Augsburg in 1510, 1511, and 1514, Sebastian Loscher, Loy Hering, and Hans Daucher, Loscher (1482/3–1551) was the senior and the most important.[14] After his apprenticeship at Augsburg, his *Wander-jahre* seem to have taken him not only to the Upper Rhine but to northern Italy as well, and perhaps even to Tuscany. Returning to Augsburg shortly after 1510, he was able to enter Hans Burgkmair's circle with a store of Renaissance forms certainly drawn directly from their source. In 1513 he carved the life-size reclining figure of Alexius in Schloss Erbach, near Ulm; it is reminiscent of Burgkmair, but definitely surpasses Erhart in its animation.

Loscher's main work in these years, however, was devoted to the Fugger Chapel, for which he drew up an architectural plan. It was he, and apparently not Adolf Daucher, who supervised its ornament and furnishing. For two of the monuments there were designs by Dürer (1510); the rest were independent inventions of Loscher's. The most important were sixteen busts (Plate 25) and the putti, some playing, some holding coats of arms, some in repose, which once ornamented the choir-stalls. These child-figures, and another group of putti now in Vienna (Plate 17), are among the most important inventions of the century. They are certainly superior to the work of Peter Vischer the younger on the shrine of St Sebald in compactness of form, in scale, and in the part they play in the work. Compared with these boys, Erhart's Christ Child from Heggbach looks very Gothic. It is at this point that we become aware of the great acceleration in stylistic development which was then going on.

The children at rest, carved in stone, are particularly delicious; 'symbols of the slumber and awakening of the soul'. The half-length figures seem to represent Old Testament kings, heroes, and heroines, and prophetesses too, but it is possible that 'good heroes' of Antiquity may also have found their way in. There is also a very personal portrait of Jacob Fugger. Motifs of a retrospective approach to Antiquity, of late

medieval costume, of direct observation of the present, are entangled as they are in Muscat's circle, which seems to have had its influence on this work. A detail typical of Late Gothic busts of the Upper Rhine, the forward-reaching arm which gives the whole figure an alert, crosswise pose, has been transposed in most of the figures into a broader, quiet frontality. The dense fullness of the forms, a certain emptiness of communication, and the extreme precision with which many details are elaborated announce the near approach of Mannerism.

Many hands must have laboured in this enormous work. Older Augsburg artists – Muscat, Erhart too perhaps – played their part. It appears now that the idea that Adolf Daucher had no hand in it is not finally settled. It is possible that this craftsman, who came from Ulm in 1491 and died in 1523/4, may have worked as a sculptor too. But the work as a whole was, above all, the achievement of the second generation which came to the fore so early at Augsburg. It may be that very young men, birds of passage, contributed to it – Leonhard Magt could be considered as the author of single groups of playful putti.[15]

The altar of the chapel was made by Hans Daucher, Adolf's son. A pupil and nephew of Gregor Erhart, he was born about 1486 and died at Stuttgart in 1538. He probably worked in his father's shop from his early years at Augsburg till his father's death in 1522.[16] His altar figures in the Fugger Chapel, completed in 1518 at the latest, are entirely in the spirit of the younger generation and were an overwhelming innovation in the Augsburg of the age of Maximilian. On the altar, which is adorned with reliefs of the Passion, there is a free-standing group, the dead Christ supported by the Virgin and St John and the *angelus missae* (Plate 30). It is here, more than anywhere else, that Daucher is revealed as the pupil of a sculptor in the grand style standing on the threshold of classicity. He commanded, with comparative freedom, the whole formal repertory which lay to hand on both sides of the Alps, yet he must not be regarded as a mere eclectic. He had the capacity to fuse these various elements into a unity, and in this altar he was the creator of the first free-standing group in the north, just as his uncle was to have been the creator of the first equestrian statue.

The reliefs of this altar are certainly earlier than the relief of the Virgin of 1518 (Vienna). They show Daucher's gift for miniature; his small plaques, for the most part cut in the fine-grained Solnhofen stone, at first followed the contemporary art of Burgkmair, but later, partly under the influence of Dürer's graphic works and Upper Italian prototypes, developed into a style of subtle delicacy which enabled him to produce, in the twenties, outstanding work in small groups and portraits.

Loy Hering of Kaufbeuren (*c.* 1484–*c.* 1555) must come in here. Like his contemporary, he must have visited Italy (Lombardy) after his apprenticeship at Augsburg. His stone sculpture was made late in the age of Maximilian. The life-size Redeemer by the side of St Georg at Augsburg, and still more the enthroned St Willibald of 1514 (Plate 29) in the cathedral of Eichstätt, where Hering settled in 1513, are superb. Like Daucher's altar in the Fugger Chapel at Augsburg, they show how the monumental style enabled the younger generation to breathe a new spirit even into traditional Christian subjects. The figure of the Redeemer contains Late Gothic features. In the St

Willibald, the ornaments of his vestments are worked with the greatest precision into the fine-grained, marble-like material and are more impressive than the fall of the drapery. They give the surface a life of its own, and form a rigid casing to the flattened block of the seated figure. There is plenty of life in the face, but the head looks as if it were threatened by the flutings of the shell-topped niche, which draw the figure into a relationship exterior to its personality.[17]

Finally, Hans Schwarz[18] (b. c. 1492) must be mentioned. His work chiefly consists of small figures in wood. He left Augsburg for Nuremberg in 1519, and in the wanderings of the rest of his life, which took him as far as Poland (1527) and Paris (1532), he became the founder of the German portrait medallion. His Entombment of 1516 (Berlin), and the later, delightful tondi, still have some of the warmth of medieval carving, in spite of their small scale. The subjects are Christian or contemplative, though they are designed rather for the connoisseur than for the worshipper. The Judgement of Paris (private collection) and Death and the Maiden (Berlin; Plate 35) may have been part of a series. The sensuous beauty of the maiden in the embrace of the skeleton in its cloak of tattered skin is enchanting, and carved out of the wood with sensitiveness. The concave background gives space to the group and the light plays gently over it.

He was a poet among the wood-carvers and an expounder of character among the portraitists. The small, free-standing group of the Unjust Judge from the Nuremberg Council Hall (1519–20?, now Museum) may be ascribed to him. The judge is seated on a strange, fabulous monster, and, though a dubious representative of justice, holds the scales. A patrician throws money into the scales, and the poor man cannot restore the balance by his pleading. Here, the humour of Kraft's relief has turned into bitter paradigm, and his simplicity into perfected artistry. A note completely alien to Nuremberg has entered this work; it is a note which Schwarz shares with Hans Leinberger, the Bavarian. We may assume that, as young men, working in Bavarian or Austrian shops, they had some kind of connexion with each other.

SCULPTURE IN BAVARIA AND AUSTRIA

In the regions known as Bajuvarian, in Bavaria, Austria, and the Alps, Late Gothic luxuriated in the age of Maximilian just as it did in the free imperial cities of Swabia.

The period opens with Erasmus Grasser at Munich, who was probably born about 1450 at Schmidmühlen (Oberpfalz) and died in 1518. His greatest works were made about 1480.[1] His style, extremely animated and fired with an unprecedentedly realistic and grotesque power combined with an obvious feeling for mimic gesture, was a climax in later-fifteenth-century sculpture. From that climax, Grasser and the Bavarian wood-carvers of the time passed, though reluctantly, into a calmer style. The Bavarian temperament did not welcome the classic. Grasser's great Entombment at Freising Cathedral of 1490–2 is as silent as if its surging feelings had been stifled by grief. This effect is achieved by unobtrusive and simple symmetry, and his God the Father from a group of the Trinity (Munich) has a most impressively closed contour. Yet the wood is deeply undercut. In the Bötschner monument of 1505 in St Peter in Munich, which represents the Mass of St Gregory, we can feel the whole sculptural force of Grasser and his shop, once we compare this stone relief with Beierlein's tranquil and painterly relief at Augsburg.

Another revelation of Grasser's great store of striking faces is the busts of the prophets and saints on the choir-stalls in the Frauenkirche (1502), which are arranged in contrasting pairs, and often with a dancing turn about the narrow hips. The forms have hardened superbly; they are in harmony with the quality of the oak. The volume has been reduced and is denser. This consummate pithiness is an essential contribution to the style of about 1500 by the wood-carvers of Bavaria.

From Bavaria we may cast a look at the altar at Kefermarkt in Upper Austria.[2] It may have been made at Passau, the bishop's see. This geographical relationship is also indicated by an immediate predecessor of the altar, the St Martin from Zeillarn (Munich). The 'Master of Kefermarkt' was one of the great South German wood-carvers of the turn of the century. By 1498 the altar was probably nearing completion. Compositionally it may be related to Pacher's altar at St Wolfgang of 1471–81, but in style it certainly is not. Like the St Martin, it derives from Nicolaus Gerhaerts, though indirectly; for the derivation of its author from Stoss is just as obvious, and he may even have worked on the Cracow altar. Yet a comparison with contemporary work done by Seyfer at Heilbronn shows clearly the close connexion between the Kefermarkt altar and the Bavaro-Austrian region in which it stands; in the one case figures clearly outlined in definite and limited space, in the other a general flow of space subdivided, as it were, later by architectural elements in order to receive the three large figures. In its shadowy darkness the shrine has the indefinitely outlined, space-creating force of Late Gothic architecture. And the figures themselves are deeply undercut; the

effect is created by angular ridges, shadowy troughs in the drapery, and sharp, pointed forms against the darkness of the background. This effect has been enhanced by the loss of the colouring, but the difference from everything western is innate. It is born of the *genius loci*, of the swift-moving Bavaro-Austrian temperament with its predilection for the dynamic, which loves to combine hard forms in the figures with swirls of ornament. Thus the whole is a group of three different types of spiritual bearing: St Peter in dignified endurance, St Wolfgang attached to the world in his teaching and giving, and St Christopher, deeply moved and eager for all experience. It is he who sweeps the spectator off his feet.

A number of Grasser's pupils seem to have moved on immediately to a kind of proto-Baroque. But this strain in the most powerfully Bavarian sculpture of the early sixteenth century was introduced by a younger artist, Hans Leinberger. He made his first appearance about 1511 at Landshut, probably without any connexion with Grasser. Documentary evidence shows that he remained at Landshut, then the capital of Lower Bavaria, from 1513 to 1530. From 1516 on he had connexions with the court. He seems to have been born about 1480/5, and died about 1531/5.[3] The determining impulses in his art probably came from Austria, in the neighbourhood of the Danube school of painting, before 1510.

The high altar in the collegiate church of Moosburg was commissioned about 1511 and was more or less complete in 1514. It is high, but not really steep in structure. The upward movement is repeatedly checked by horizontals which once received further emphasis in the wings, now lost, by connecting arches and by canopies. But in spite of these checks the verticalism is recovered every time. The shrine shows the Virgin, taller and placed higher than St Castulus and St Henry (Plate 38). In the altar as we now see it the two St Johns, the flanking figures, are part of the arched movement formed by the heads. Except for the mouths and eyeballs, the figures do not seem to have been painted.

The figures also draw their life from the contrast between gesticulation and repose, between expansion and control. The ornamental swirl of the Virgin's drapery is held together in a single great movement by the Y-shaped form of a tangle of ridges, while the hems have taken on a life of their own and form a supporting line. The whole is developed in space, so that a balance is preserved between the surging forms and the inward structure. Many a realistic touch is scattered over the faces, the armour, and the modish clothing, yet the figures do not stand on their feet; instead the ornamental arrangement of the folds motivates the stance of the figures. They are not weightless, but they are so elastic that they seem to be on the point of floating away. The force that streams through the structure also governs their volume, yet they remain independent and preserve their radiant power. That is the source of the proto-Baroque impression of the whole.

The reliefs of the martyrdom of St Castulus again reveal Leinberger as a born sculptor. The space is partly reduced to crowning segmental and triangular pediments of Renaissance origin, and partly hinted at by wavering abbreviations and a few bits of landscape. It is here that we can feel a connexion with Altdorfer the landscapist, who was living near by at Regensburg. In this work Leinberger created the pictorial relief.

It was composed with painterly means, and shows some knowledge of Mantegna and of Pacher's architectural painting. But sculpture reigns supreme. The figure of the saint predominates, yet the huge soldiers surrounding him express in the simplest and most obvious language the power to which he must succumb. There is ornament too, to lift the group above the common rut of life. The Emperor Diocletian, with the features of Maximilian, is enthroned as if on a scroll.

This apparently happy and perfectly secure relationship to architecture and space, the same gamut of forms, vigorous and radiant, soft and yielding, foamy and fleeting, can be seen in the St Anne relief of 1513 in the Franciscan convent at Ingolstadt. Small reliefs of the Passion, executed about 1516, are inspired by work of the Danube school in the first decade. The Crucifixion, in particular, is as definite and clear as if it had been made on a grand scale (Plate 34). Christ is spread on the cross; the background is flat. His freedom is intact, though he is jostled by the two thieves, whose figures collapse, in exact profile, into the space from the edge of the relief. Below, the noisy throng gapes amid the riotous thicket of lances.

But large sculpture remained Leinberger's true field. A Renaissance Christ Child from Neumarkt on the Rott (Munich) stands kicking and tottering on the Virgin's lap. In this group, a true sculptor has created a small trough of space as a nest for the Child. The over-life-size Virgin of Landshut (Plate 31), once enframed in a rayed chaplet with Ave Maria beads and Paternoster medallions, once hung free in St Martin and was a contemporary of Veit Stoss's Annunciation. Its dynamic quality issues more from within the figure than at Moosburg, the multiple Y-ridge rises flexible, serpentine, and taut, from a rocaille-like form which represents the feet, yet the ornament does not at all outweigh the corporeality of the female figure, of the naked Child, asserting himself with a gesture all his own, or the moon-like austerity of the Virgin's face.

Some of Leinberger's later work was not devotional; the little bronze of a winged cherub with violin and bow (Paris), for instance, or the bronze statue of Count Albrecht von Habsburg which Leinberger made about 1514–18 for the funerary monument of Maximilian (Plate 32). In this figure, one of his greatest, Leinberger worked with unusual freedom. To keep in line with the backward-looking programme of the monument he had to represent an ancestor long since dead, and Dürer, though without great historical effort, had already tried to bring this figure of the past into his sketch of 1513–14 (w676–7). But Dürer had a statue of a quite different character in mind, and merely gave Leinberger the raw material for the costumes. It is only in the sculpture that we can feel the unbendingness in the lean body of the old warrior and crusader. It was Leinberger who first introduced, or reinforced, the count's stamping gait, the grotesque hangings round his legs, the armour, hung on the body like a bell, the deep pull-in round the waist, the trappings on the arms and back. And so the figure gives the impression of something adventurous and *altfränkisch*, almost as if an old family ghost had suddenly put in an appearance. That was certainly not in keeping with the idea of the monument. This touch of parody, in which the frontiers between unmitigated gravity and pure hilarity are not clear, announces the future Mannerist.[4]

Some of the wood-carvers of Leinberger's circle must have remained more faithful

to Altdorfer, as we can see in the figures of a virgin saint in Berlin and a St Barbara at Boston, both probably made under his influence.[5]

In the chief Austrian works of the end of the century, the over-life-size apostles and the Annunciation on the piers in the cathedral of Wiener Neustadt,[6] the style of the eighties was transformed, probably by way of fresh impressions of the Strassburg successors of Nicolaus Gerhaerts. These figures too are deeply undercut and ridged in their structure, but the weighty rustle of the massive drapery is more sonorous and more melodious than at Kefermarkt. In the course of time, such harmonious elements obviously developed in this workshop, which has been connected with the name of Lorenz Luchsperger. Inserted into the row of statues there is the figure of St Sebastian, with martyrdom in its stance and droop. For all the looseness of its Late Gothic outline, the body is beautiful, and the gestures return to the core of the statue. The feeling for wood, which comes out so strongly in all Austrian and Bavarian work of the time, has been discarded. A *verismo* appears which differs from Hagnower's by a greater warmth of humanity.

The greatest Viennese master of the age of Maximilian was Anton Pilgram.[7] He was probably born at Brünn (Brno) about 1450/60, and made his first appearance in Lower Swabia in 1481 in connexion with architectural commissions and more especially with architectural sculpture. Supporting figures (now destroyed) on the tabernacle at Heilbronn and the pulpit for Öhringen, now in East Berlin, works of Upper Rhine derivation executed in the eighties, are sharp-cut forms of immense sculptural force, the expression stern and endowed with a kind of energy which adds to the lines round the mouth a touch of defiance and sadness. It may be that Meit saw works of this kind when, as a young man, he carved the Entombment and the Falconer. From about 1502 Pilgram lived at Brünn; from 1511 to 1515 he was in Vienna as master mason of St Stephen's cathedral. This was the period of his finest sculpture – until 1513 the organ-bracket with his self-portrait, then the pulpit with the busts of the Fathers of the Church and another self-portrait. Both are still genuinely late medieval, and Pilgram was certainly responsible for their ornate Late Gothic forms. The Church Fathers are akin to the busts at Heilbronn, but they are less advanced in the expression of spiritual personality than Seyfer's work. The melancholy bent to suffering, or even to asceticism, comes out more noticeably in them, and though they are more than fifteen years later, they look far more Gothic than the Heilbronn busts, since they are set at an angle after the fashion of the Upper Rhine. The organ bust is still set at the foot of the organ, as Adam Kraft stood at the foot of his tabernacle; it is the right place for a mason. Yet it may be regarded as a genuine self-portrait. The bust is still a type as well, even here, but just for that reason the essential qualities of the particular individual come out – energy, passion, joyless bitterness, artistic spirit. Here is a sculptor of the Riemenschneider generation who had made his way from the formal abruptness of his early work to a melancholy introspection in his later days.

The Master of Mauer raised the standard of the Danube style in sculpture to that of its work in painting. He probably issued from the Nuremberg period of Veit Stoss and in all likelihood made his debut in the beautiful St Anne in St Anna in Vienna (*c.* 1505–

10), which does not belie its provenance. His chief work, the altar of the Virgin at Mauer near Melk, was made in the second decade of the century, or perhaps even after 1509 (Plate 36). The Madonna is enthroned on clouds, surrounded by God the Father, the dove, and the jubilant angels crowning her. Down below, fourteen saints intercede with her for supplicant children – human souls; this new subject, formulated for a pilgrimage church of the Virgin, fills the shrine. Unlike the altar of 1518 at Altmünster, which is crowded with form to the bursting-point, it is designed as a stage. Its round-arched case is far removed from the twilight of Kefermarkt and can be taken in at a glance. It is crowded with passionate, radiant saints and with women, rapt, gracious, or slightly silly in their piety. Children look up to pray for help. It is a group of supreme dramatic power. Even the simple-minded ecstasy, if properly observed, does not transgress the limits of honest credibility. The physiognomic and modish realities of the lower range, and the large heads, are set in sparse and emaciated forms. They offer their contrast to the rich, melodious folds of the Virgin's robes and the harmonious swirl of the angels and clouds above. It was this proto-Baroque which the Master of Zwettl carried on into early Mannerism in his chief work.

At Innsbruck, the emperor had the Goldene Dachl executed, probably by Niklas Türing, in 1500.[8] With its balcony it is like an imperial box. The reliefs on the parapet display the popular morris-dancers and the imperial audience in a clear style which gives rounded sculptural values even to the whirling, dramatically angular figures of the dancers.

But Maximilian, apart from the Goldene Dachl, initiated sculptural enterprises which raised problems both imperial and unprecedented. In 1514 he concluded an agreement with the Salzburg sculptor Hans Valkenauer (b. 1448, still alive in 1518) for a huge memorial monument in Speyer Cathedral to the emperors and kings buried there.[9] Twelve red marble pillars, round and polygonal, faced with figures of princes, were to stand free in the choir, supporting a huge royal circlet in stone. This majestic conception of the emperor's was, as a funerary monument, quite unheard of. It may be that an artist (Kölderer, the emperor's architect?) had made a first design for it, which has not been preserved. The sculptor knew his business. Parts of his sculpture have survived (Salzburg, Museum); figures of emperors, contemporary and unhistorical, are worked into the supports. The form is still in the early classic phase and is enclosed and compact. In the faces, now mutilated, there is unquestionable greatness. The scheme was never completed.

Maximilian entirely overshadowed this project by the work commissioned for his own monument. It was designed for a memorial church which he never had the funds to build. Finally it was set up in the Hofkirche at Innsbruck. It resembles the undertaking intended for Speyer in nothing but its over-sized dimensions. In fact, it is wholly novel in design. Forty over-life-size figures of ancestors and kinsmen were to glorify the House of Habsburg, thirty-four busts of Roman emperors were to testify to the glory of the Empire, and a hundred statuettes were to perpetuate the saints connected with the House of Habsburg. The ancestors, who included dubious claims such as Julius Caesar and King Arthur, a monumental pedigree, were arranged as a funeral

procession in a form which had long been familiar in Franco-Burgundian monuments. What was completely new was the scale and the introduction of ancestors into the procession. Reminiscences of Roman funerary pomp were more discernible than any western traditions. This may have been an invention of Maximilian's humanists. Yet the programme must have been largely conceived by himself. The whole was to have been cast in bronze, and gilded if possible.[10]

The emperor's plan was never completed. Yet his funerary monument has its due place at the end of this survey of the South German sculpture of his age. It provided German bronze-casting with a task which far exceeded the shrine of St Sebald. A number of the most prominent sculptors were engaged. Muscat, at Augsburg, contributed the best of the Roman emperors. Vischer, at Nuremberg, executed the statues of Arthur and Theodoric (Plate 12), and Leinberger, at Landshut, carried on from Dürer's design the figure of Albrecht von Habsburg (Plate 32). Most of the work, however, was done at and around Innsbruck. In 1508, Maximilian appointed Gilg Sesselschreiber from Munich, who had been working out the designs in drawings since 1502, to be superintendent of a foundry. About 1514 he also employed a second foundry, that of Stefan Godl, in order to speed up the work. This kind of team-work was a determining factor in Maximilian's funerary monument, as it had been in other works. A number of designers and painters, modellers and casters, worked so closely hand in hand that it is difficult to distinguish who did what. That served to make the tomb a single whole.

Sesselschreiber, born c. 1460/5, was 'the first beginner' of the work. It was he who translated into visual form the very various ideas which were submitted to him in word and picture. After great initial difficulties, his foundry produced eleven large figures, eight of which have been preserved (Plates 13 and 14). He was active at Innsbruck till 1516. It is uncertain whether he himself, or some artist unknown to us, created the models, which after all are the essential part of the work. In any case, by means of these statues the most sympathetic realization of the spirit of Maximilian is connected with Sesselschreiber's name. The primeval monumentality of his figures gave the tomb its special tone.

Mary, duchess of Burgundy, the emperor's wife, appears in the costume of her father's court. The raised pattern of the soft brocade, which falls in long waves, is uniquely rich; with all their fullness, these waves remain almost symmetrical. The forms of the body are only delicately hinted at, yet its structure and existence have become entirely credible in a dense unity of body and clothing. There is a sensuous enjoyment in the contrast between rough and smooth. The exposed part of the breast is set off by the brocade and the rich necklaces. The aristocratic calm of the figure reaches its climax in the upright head, where nobility and grace are united in the large, clear-cut features of the face. As a portrait it has no great resemblance, but in a general way it is true to life. In 1511–16, at a happy moment of dawning classicality, a Late Gothic artist portrayed the character of the dead princess. Elisabeth of Tyrol is a Gothic figure of enchanting nobility in a simple stance with a strong meditative face as idealized as is the whole figure (Plate 13). The intense charm of works which lack the final finish after

casting can be felt in the statue of Kunigunde of Bavaria (d. 1520), the emperor's sister. Her figure was carved in wood in 1515. It is the most enchanting of the standing figures, and the most refined both in the pattern and arrangement of the dress. The small bent head with the high forehead and the beaked nose hint at a personal admiration on the part of the sculptor. But he was most himself in the beautiful figure of Philip the Fair of 1511–16 (Plate 14). This was the emperor's son, who died young. One foot is advanced; thus the figure is quite remote from Peter Vischer's efforts to achieve contrapposto. Firm and broad, he stands there in his splendid surcoat and in the armour of the early sixteenth century, which was strengthened by a few flutings. The forms are as ornate as they are clearly outlined. They tell of pride, youthful beauty, and the brilliance of the man's appearance. The face is full, and seems to be raised by the gorget. The eyes, as always in the Sesselschreiber shop, are crescent-shaped under drooping lids, and in power too this head surpasses Muscat's small-eyed, Gothic head of Maximilian. The full light of the period is concentrated on the figure of Philip.

The statues from the Sesselschreiber shop are the most important feature of Maximilian's funerary monument. The sculptors from Nuremberg and Landshut contributed splendid and precious work, but more such intensely individual pieces would have exploded the programme, just as Vischer's figures were not really in keeping with the basic idea of the funeral cortège. It is the large statues of Sesselschreiber's shop which give the monument its note of nobility. They are fully mature formulations, purified form. We can sense a particularly felicitous identity between the design and the finished work. Both issued from the happy moment when the classic, just emerging from the Late Gothic, had not yet become Renaissance. Since work continued, in part at any rate, after Sesselschreiber's designs, the whole, in its final form, remained comparatively self-contained.

Stefan Godl, on the other hand, was merely the workman in charge of the second shop which made part of the tomb. His figures were designed by Jörg Kölderer; the drawings caught naïvely and soberly, and with successful detachment, the superficial and tangible aspect of the subject to be treated. The true artist was the wood-carver Leonhard Magt, who may, as a young man, have taken a hand in the putti in the Fugger Chapel at Augsburg, and was active at Innsbruck from 1514 to his death in 1532. His first works were twenty-three statuettes of Habsburg saints. In these statuettes the sculptor succeeded from the outset in pouring three-dimensional life into Kölderer's designs. While the statues from the first shop were for the most part mature formulations, the surprising thing in Magt's statuettes is their spontaneity, which is largely due to their smaller scale. In Kölderer's designs they were mostly members of different classes, wearing different costumes and bearing different attributes. But here they grew into creatures of real flesh and blood, in robes that either fall straight, or rise in huge swirls, but are always voluminous. The strong-featured faces are furrowed and sharp. Magt certainly belonged to a younger generation than Sesselschreiber's modeller. What he had to learn, Magt was endowed with at birth. He achieved that detachment in the work of art which makes it exist in its own right and independently of its environment, while Sesselschreiber's statues, though they have no architectural framework

and are fully three-dimensional, preserve in their hidden Gothicism a relationship to the world of the cathedrals.

That was roughly the state of affairs at Innsbruck when the emperor died. The aim he had in mind, and set down in detail in his will, was not yet attained. Magt was the great hope for the coming time when Maximilian's grandsons had to complete his plans.[11]

SCULPTURE IN UPPER SAXONY, THURINGIA, AND NORTH GERMANY

IT was in Upper Saxony that North German Late Gothic sculpture attained a perfection comparable to the best work of the Danube school. Hans Witten,[1] the monogrammist HW, was almost a contemporary of Riemenschneider, and the two actually have a character in common which may possibly be explained by their common origin in the Harz region. But while Riemenschneider does not seem to have been enriched very much there in his artistic growth, Witten's artistic origins are visibly in Lower Saxony, i.e. a part of the north of Germany, where his early work was discovered.

As a whole, in spite of his emotionalism, Witten's personality was more broadly based than Riemenschneider's; he was more resolute and decidedly more inventive. His originality already comes out in his early works, at Brunswick in the pulpit in St Egidius and the St John the Baptist in the cathedral, at Goslar in the *Kaiserleuchter* in the Council Hall. They probably date from the nineties. We may assume that Witten spent his *Wanderjahre* in South Germany, yet there is some trace of a distant connexion with a wood-carver's shop at Brunswick. He worked in stone from the beginning. He moved to Upper Saxony at the latest in 1501, which is the date of the St Helen on the town hall at Halle. At that time he had settled at Chemnitz, but had found a footing at Annaberg too in 1508, where his name appears for the last time in 1522. He probably died before 1525. His last work, the porch of the Schlosskirche at Chemnitz, was left unfinished. It was completed by Franz Maidburg in 1525.

But the idea and in part the execution of the porch are certainly Witten's. It was the last of the great ideas he set to work on soon after his arrival in Upper Saxony. In his early days there, a short classic phase can be distinguished in his St Helen and in the monument of Dietrich von Harras (d. 1499) at Ebersdorf, in which we can feel the full sculptural force of the smooth Maximilian armour, and the proud, chivalrous, and worldly temper of the age. These works were followed by the altar at Ehrenfriedersdorf (1507). Then came a series of unrivalled works in a grand kind of Baroque, the Pietà in St Jacob at Goslar (Plate 41), the Tulip Pulpit at Freiberg (Plate 40), the *Schöne Tür* at Annaberg (1512), the Scourging in the Schlosskirche at Chemnitz (Plate 39), probably executed in that order and concluded by the porch of the Schlosskirche.

The Pietà can certainly be regarded as the most splendid formulation of this ancient theme north of the Alps in the sixteenth century (Plate 41); seldom do the *rigor mortis* of Christ, the mourning of the heroic Virgin attain such harsh and dramatic heights. The Tulip Pulpit, however, has no forerunners (Plate 40); it is based on a miners' legend of the Prophet Daniel, who sought for ore on a tree and was helped by an angel. Daniel, the patron saint of miners, sits at the foot of the pulpit; a miner's lad, seeking for treasure, is climbing up under the steps. In this sense the pulpit is a treasure-tree. The

idea is combined with a fantastic upper structure which cannot be called architecture but rather a wonder-plant. Luxuriant vegetable growth with cherubs flying round it envelops the trunk. The body of the pulpit is shaped like the calyx of a tulip, running into scrolls on which the busts of the Fathers sway boldly. It may be that the idea was based on Veit Stoss's engraving of a capital (L10). It may also be that the miraculous flower is part of the symbolism of the Virgin, who appears on the sounding-board. It is a strangely original work. Holding-ropes and props for the stairs appear beside climbing vegetation and remains of abstract ornament; the one thing that does not seem to appear is the material out of which the whole is made: stone. The fairy-tale 'romanticism'[2] of the conception, the freshness and directness of its expression, are more closely related to the Danube style in the painting of the period than Pilgram's pulpit. There is no restraint, only a great wealth of forms in most skilfully worked filigree.

In the *Schöne Tür* also an iconographical programme has clearly been introduced into the picture quite independently by Witten: the vision of St Francis, on which the Portiuncula Indulgence is based. The vision is in keeping with the restless and fantastic architecture of the work; its forms are playfully transposed. Again we can sense the delight in the transposition of material into other significances; here too invention ranged freely, however strictly it remained faithful to its subject.

Even for so close-knit a theme as the Scourging of Christ, the sculptor, borrowing one detail from Schongauer, invented a triple-tiered tree growth, craggy yet supernatural; one might interpret it as a Crown-of-Thorns tree (Plate 39). In this way Witten gave monumentality to the subject and at the same time imprinted on it a new and sinister touch. The contemplative figure winding the Crown of Christ below is, more than the craftsmen of Kraft and Pilgram, a genuine creator of atmosphere.

Beings of this kind, creatures of sentiment and reflection who seem to have issued from folk-song, are also to be found in the tender and devout group of the Visitation which occupies the centre panel of the altar at Borna of 1511, in the tender faces of an angel and a deacon who support the lecterns at Ebersdorf, in the enchanting infants in christening robes at the foot of the font at Annaberg, which is like goldsmiths' work, and in several Virgins. Witten was a master who must have had music in him. His artistic being was of the true, unbounded kind.

In addition to his wood-carving, Witten was a notable sculptor in stone and even a mason, like Pilgram; his style in this kind of work still had a strain of the High Middle Ages. Two porches, two stone pulpits, a font, and two bosses have come down to us. We also know of his designs for vaults. He was able to impart his personality even to these almost architectural works. He made the gigantic wood-carving of the Chemnitz Scourging in forms which approximate very closely to those of the Freiberg pulpit just as unconcernedly as he echoed them in the organic forms of a sounding-board which recall goldsmiths' work on Late Gothic sceptre heads. Indeed, in his late work he still tended to use the new style of the twenties. The structure of the Chemnitz porch is based, at one remove, on Dürer's Life of the Virgin (B86), but it is created in quite different terms. Over-slender, remote from nature, with no sense of growth, it is a lightly-built piece of carpentry in stone, a scaffolding without the firm articulation

which true building would need. It might be some perishable triumphal arch set up for a festival.

In his Virgin from Calbitz (destroyed), which is probably his last work, Witten attained even in the statue the elongated proportions, the cylindrical shapes and those early Mannerist forms which look as though they had been turned on a lathe.

Without any influence from Witten, interesting Late Gothic work was produced in city workshops throughout this prosperous and flourishing region. Several competent wood-carvers were making sculpture of penetrating characterization at Freiberg from about 1490 on, the most outstanding being Philipp Koch,[3] for whom there is documentary evidence from 1498 to 1544. This bent to a slightly ironic self-contemplation, probably native to Upper Saxony, gave the spiritualized face of the aged St Wolfgang of c. 1520, now in Freiberg Museum, its note of passionate tenderness. The figures by Peter Breuer of Zwickau (c. 1470/5–1541), which remained Late Gothic till his death, are slender-limbed and mobile. He used engravings by Schongauer, possibly came under the influence of Erhart, and about 1492 worked with Riemenschneider. From that time on he employed Riemenschneider's compositional schemes, but transmuted his portrayal of the spiritually-minded into the charming emotionalism of the shallow-minded. His style retained this imprint throughout his production of altars, from 1497 till the Reformation reached Zwickau in 1522. Very occasionally, in moments of inspiration and with the natural gift for expression of his people, he created such sensitive versions of types formulated by others before him as the Christ in Distress (Freiberg Museum, 1500) and the Lamentation (Zwickau, Marienkirche).[4]

Silesian work about the turn of the century, for instance the two altars of the Death of the Virgin, one in the Catholic parish church at Swidnica (Schweidnitz) and the other in the church of Corpus Christi at Wrocław (Breslau), executed by various wood-carvers in 1492, owe most of their effect to the enormous influence of Veit Stoss in the east. That influence can also be traced in all kinds of variations at Cracow and in the Spíš (Zips) region at the foot of the Tatra Mountains.[5] Master Paul, who was probably a pupil of Stoss during his years at Cracow, was active at Leutschau (Levoča) and may have later renewed his connexion with his old master. There seems to be evidence of Paul's work from 1503 to 1520 in a large number of wood-carvings, for instance in the solemn high altar (from 1508) and in the fervent adoration group in the Czàky Altar in St James at Levoča. He was a warm-hearted, cheerful man, with a bias to bourgeois ostentation.

Besides Stoss's influence, however, there were also Silesian traditions of form which were mainly represented by Jacob Beynhart, who settled at Breslau in 1483 and died about 1525. One work stands out from his general stock-in-trade, namely a generously-conceived group of the Virgin with St John under the Cross (Museum of Arts and Crafts). Controlled feeling combined with large and powerful forms also characterizes the memorial tablets for Hans Schultz (d. 1505) and Sebald Saurman (d. 1507) in St Elizabeth. The carver of the St Luke altar in St Mary Magdalen transposed an engraving by Stoss into a relief; the forms are rounded, and the whole is reposeful. The relief of the beheading of St John in the gable of the sacristy porch of the cathedral (1517) is of

South German provenance: a terse, well-composed group above an astonishingly pure specimen of Renaissance architecture.

In Lower Saxony, at any rate in its southern part, the Master of St Epiphanius was the leading wood-carver after Witten's departure. He must have worked for the most part at Hildesheim.[6] His carvings date from *c*. 1490 to 1515. Whether there was any connexion between him and Witten is uncertain, but he was probably familiar with Riemenschneider's work. His real virtuosity comes out in his splendid men's faces, young and old; they are so acutely characterized that the intention of the typical persists in the individual. In the altar at Reinhausen (1507), the ages of life are character-ized by three temperaments which do not correspond to medieval tradition. The active, combative age – as was typical for the personal manner of the carver – is the old man, while the phlegmatic youth and the troubled, melancholy man in his maturity belong to the world of suffering and contemplation. But to the St Bernward in the church at Wienhausen he gave the genial, jovial countenance of the prelate who comes from the country gentry.

A younger, better wood-carver, the Master of St Benedict, was still more attracted by the appearance of old age and night. That can be well understood in a clerical city like Hildesheim, and at the time he was unrivalled except by the artists of Mainz. The Master of St Benedict seems to have been a pupil of Witten, and he certainly worked for a time under Riemenschneider, whose compositions he adopted twice. He appeared at Hildesheim about 1510; his work can be traced till about 1530. He was probably born about 1480.[7] In his peculiar predilection for foreshortening he had practically no predecessors. His bases, table-tops, seats of chairs – cabinet-makers' articles which he enjoyed bringing into his compositions even more than Riemenschneider – rise steeply backwards, books are distorted into lozenge shapes; even single figures are formulated in the same fashion, and they too were for him pictorial relief. Employed consistently, or even merely correctly, these foreshortenings would have produced nonsense, but as details here and there they are formulations of non-naturalistic expressiveness.

The lovely Education of the Virgin (Philadelphia; Plate 45) is one of his earliest works. Here too he displays his power of transposing Witten's emotionalism into his own more ascetic mood. His Pietà in the Museum at Hildesheim lacks the uncontrolled grief of its model, Witten's Goslar group (Plate 41), but his Virgin is more expressive in her sorrow. Yet she is at the same time held within so delicate a gamut of feeling that she can only live and be heard within very narrow limits of mood. The motif of the mouth opened to speak or sing often recurs in his saints. It imparts to the altar of St Benedict in St Godehard a terrifying vitality. In all these things we can feel an inward kinship with the thinker, with the spiritual seeker, with the haggard penitent and the visionary; we can imagine that this pre-Reformation master had an unusual command of theological erudition. His real relationship to Riemenschneider resides in this spiritual conception of his figures, in a not very vital conception of humanity. The strain of Mannerism which was its inevitable outcome was inborn in him, the master of a younger generation.[8]

The art of North-West Germany is overshadowed by the sculpture of Lübeck, where old Bernt Notke was working until 1509. He was the greatest sculptor in the Lübeck

region, the creator of the St George and the Dragon of 1489 in St Nicholas at Stockholm. His incised bronze tomb-slab of Hermen Hutterock in the Marienkirche of c. 1508–9 has the splendour of a style of old age and a powerful graphic effect. In the sharp angles of the cross-folds of the shrouds we can sense the worms of decay, yet in a gentler, supernatural fashion they score out, as it were, the steep, dried-out bodies resting beneath them. This was the contribution made by a very old man to the rich stylistic idiom of the age of Maximilian.

Its great master at Lübeck, however, was a younger man, Henning von der Heide.[9] His activity at Lübeck can be traced from 1487 to 1520. He died before 1536. His early works probably owe much to the influence of his great predecessor. He too began by cutting deep into the block, so that furrows of space entered into relationship with outer space, were painter-like zones of shade and served as foils to the contour. But his work lacks the abruptness of Notke's oak; although Henning usually worked in oak, he handled it as a softer and more malleable mass. That was how he was able to create the wonderful continuity of body and cassock in the St Jerome at Vadstena and the scene in relief composed mainly with figures in breadth in the Mass of St Gregory of 1496. Yet so macabre a work as the severed head of St John the Baptist from Norrby (Stockholm, Statens Historiska Museum) avoids Notke's *verismo*.

Henning's group of St George of 1504–5 (Lübeck; Plate 49) is the final answer of the classic moment to Notke's version of twenty-five years before, where the knightly saint appears and disappears in the tangled struggle which was forced upon him by the thorny forms of his adversary. The group, at that point, is crowded with naturalistic detail, out of which the knight and his sword arm advance rather like the ribs of a Gothic vault. Henning's St George is, in a way, a nude; although it is a group, it is actually felt as a simple, rounded shape wrought in a single substance, whether it represents the body, the clothing, the horse's body, or iron. It is a monumental sculptural whole. As a group, the work does not leave spatiality much to say; space is in the eliminated parts and has become negative in its confrontation with this dense sculpturality. The same power inspires the noble St John the Evangelist of the Marienkirche (now Museum). It is a statue in the spirit of the early sixteenth century, and at the same time, like Vischer's apostle statuettes, a kind of hark-back to the classic Gothic of Bamberg.

In the second decade of the century, Benedikt Dreyer's work appeared in Lübeck.[10] He was still alive in 1555 and is probably identical with a head journeyman mentioned at Lüneburg in 1505–7. He seems to have been born about 1485. With him, a new note was sounded at Lübeck, for he was a born story-teller. How steadfastly he stood with both feet on the earth can be seen in his first works in the Lüneburg district, especially the very individual bishop from Uelzen (Hannover). Henning's controlled spirituality was alien to him. Ridges and cutting are clearly visible in Dreyer's robust faces. A good deal of the individuality of his style resides in this visibility of the handiwork.

In the relief of the feast at the house of Simon (Providence, Rhode Island), the participants are clearly differentiated according to their spiritual status (Plate 37); the Magdalen is beautifully shaped with superb flowing hair; the bald skull of the

inquisitive Pharisee looks hideously small in comparison, while the head of Simon, busy with his toothpick, is enormously flat and broad. This intense characterization almost disrupts the proportions of the picture, but it is immediately comprehensible. In the Lendersdorf altar, to which this relief belonged, there is genuine humour in the nudes, damned and blessed, in hell or at the gate of Paradise, like the fools, gluttons and drunkards on the organ bracket (destroyed) of the Marienkirche. But it is not only the touch of low life in the types which produces the humorous undertone. The direct observation of life, the prosaic basis of this art, goes hand in hand with formal simplifications which arise from fluency in the carving. They have the deadly marksmanship of the satirist. Subject and form, blended in a rounded whole in Henning's mature years, are once more placed in contrast: realistic elements in Dreyer's work float in irrational relationships, and his broad, epic style is apt to be aimed at points outside the story.

That is also true of his free-standing figures, in which influences from his South German *Wanderjahre* blend with his North German training. In 1508 the rood screen in the Marienkirche at Lübeck was burnt. A new one was ready in 1520 (destroyed), and it is possible that Dreyer's seven saints were then already to be seen in its upper part. They bear witness to a superbly dramatic development. Starting out from statues with clear contours, quiet interior forms, and a sense of corporeality, for instance in the bishop from Uelzen, Dreyer seems at first to have followed the manner of Henning von der Heide. In the middle there stands the Virgin, with hardened forms, as the woman clothed with the sun in the Apocalypse (Plate 46). But then there are three extremely agitated, deeply undercut figures, St Michael, St John the Baptist, and St Roch, in which the figures retreat behind a superimposed network of form. It is the return to the Gothic ideal which took place so often about 1520. In his St Michael, Dreyer completely abandoned the classic interpretation of Heide's St George; the dragon, as is necessary in a figure which is not full round, is merely a fabulous attribute. The sword, slanting downward without any perceptible impetus, is not a weapon but a predominant feature of identity. The story does not tell itself. It is told by the ridges and sharp, dangerous-looking forms of the clothing and accessories. Even the blobs on the belt have the same function, and express something like the echo left in the nerves by a single moment of combat. In these figures, the stories of the saints are condensed into their own enjoyment of their saintliness. The forerunner of Christ is full of the pain and ecstasy of his asceticism; St Roch, the saint of the plague, is thankful and feeble in his convalescence.

The alms-box monk in the Marienkirche is, as a sculpture, characteristically related to something outside himself (Plate 229). His robust humour, his unsubdued worldliness, go far beyond Henning, but the treatment of the vestments is much more irrational. Dreyer wielded a tool which, in contrast to the mere virtuosi of the time, knew when to stop. Yet in spite of all that, there was a great deal in his work which set out on a path leading far beyond the style of the age of Maximilian.[11]

Hans Brüggemann's altar in Schleswig Cathedral (*c.* 1514–21) actually comes from Bordesholm.[12] With its nearly four hundred figures, it is the biggest scenic altar in North Germany. The oak of which it is made is practically unpainted, and the wings

52

are not made to fold. Opinions of the sculptor vary according to the valuation of craftsmanship. The labour lavished on this carving is incalculable. In comparison with Dreyer's manner of mastering reality, it leaves the spectator cold at first; *mutatis mutandis*, it has the coolness of Hans Daucher, and in the use of graphic art it anticipates Loy Hering's eclecticism. Brüggemann's style is of the north. He may have known Antwerp work. It is also possible that he had had a Lower German training. He was born at Walsrode, near Lüneburg, probably between 1485 and 1490. At Husum he seems to have done most of his work for the ducal family of Schleswig. He is mentioned for the last time in 1523. It may be that the Reformation reduced him, an altar-carver, to destitution. He is said to have died at Husum in the utmost poverty. The year of his death is unknown.

His figures are more temperate, and in a superficial sense more dignified than Dreyer's. He lacked Dreyer's profundity of mind and gift for fluent narrative. He followed Dürer's Small Passion woodcuts, but in doing so lost the dramatic tension of the scenes, replacing it by evenness of tone and a touch of melancholy. Yet he too was a creator. He carved the gigantic St Christopher in the cathedral of Schleswig, an early work, with the fringes of the mantle swinging out into space. In 1520 he made for the Husum tabernacle the fluent, yet compact Angel with the Lute (Berlin), and the Virgin in the royal palace at Copenhagen, both enclosed in severe patterns of linear folds.

Once the eye has been trained by works torn like these out of their context, a great deal of value can be distinguished even in the detail of the Bordesholm altar underneath all the virtuosity. It is a conscious narrative of how Christ, after his capture, is surrounded time after time by enemies. But anyone who expects fast action will be disappointed. The effect comes from the material. Brüggemann made use of sharp sidelights, and in that way made his foreground actors stand out against the dark, choir-like groups of his scene in deep relief. In St George and the Dragon from Husum (Copenhagen, Nationalmuseet) we see the carver capable of Renaissance form even on the grand scale (Plate 50). It may have been unpainted even in its original form. St George is rising in his stirrups and swinging his arm for the thrust. The face expresses weariness and something like fear. Whatever formal energy is left is gathered into the tail of the rearing horse; there is practically none in the dragon's threshing rat-tail. It is a characteristic work of the early Charles V period, with high breeding in its bearing.

It may be that Brüggemann did not receive his training in the Netherlands alone, but had also been at Osnabrück, a Westphalian cathedral city. The notable wood-carver known as the Master of Osnabrück[13] was obviously working there at the time. If we look at the great mass of works in his manner, they seem to find their place in the regular line of development of a single artistic personality in its full span from 1500 at the latest to the thirties. That period covers his earliest and his latest Virgins, the double figure at Alfhausen and the statue from Belm, now at Hannover.

Many typical forms of his Virgins and Pietàs were obviously repeated for many years and are as a whole of equal quality. The master was a particularly determined practitioner of first-class craftsmanship, which did not stand in the way of deep undercutting.

His relationship to Brüggemann, which is very difficult to define, lies in their virtuosity. But the Master of Osnabrück's work is not mere sober precision of form. The true character of his figures is an easy-going kind of imagination which verges on the worldly and the childish. His solid earthiness resides in the effect of the oak he used, the woodenness of which has not been entirely denied, rather than in the realism of the presentation, which is balanced from the outset by considerable and uniform stylization. Dreyer's swift characterization, which often neglects a number of elements, is alien to him.

Even the early Virgin in the Roseliushaus at Bremen is given an expression of sublime worldliness by the clear sphere of the head. These slightly stereoscopic forms offer a fully elaborated contrast to the modish robe, the lavish necklaces and jewellery, and, as a third component, the magnificent fall of the cloth in the heavy, untailored mantle. At a later stage, this contrast motif was gradually overcome by the delight in unrealistic, crumpled forms; at the same time the modishness increased. The St Ursula at Aachen with the ten maidens under her cloak is characteristic of this phase (Plate 47). She may have been some noble lady of the von Warendorf family who had had to take ten girls into her motherly care. The Virgin in the East Berlin relief of the Presentation is extremely worldly in the same way.

And yet towards the end the proportion was lengthened. In all probability the carving was left unpainted intentionally. The flickering play of the folds spread over the whole, and the rough provided the contrast to the smooth, which was reserved for the Child's body and the Virgin's face. In the Belm Virgin the face has become a tall oval and there is little realism left. These lathe forms, this echo of the wood in the work, this perfection of virtuosity are probably proof that the influence of the carver lasted long into the Mannerist age. As regards his antecedents, it is unimportant that he adopted in his Belm Virgin a form which Riemenschneider had often employed in many variations. His roots are to be sought in Westphalia and Holland.

Münster in Westphalia was the scene of activity for about eighty years of a group of artists who generally go by the traditional name of Brabender-Beldensnider, the latter word meaning a carver of images. Their relations among themselves are unknown. A Jorgen Beldensnyder is mentioned about 1480; from 1511 the name Hinrik Brabender-Beldensnider appears in the records. The date 1538 is given for the death of Hinrik *statuarius byldensnider*, i.e. a carver both in wood and stone. Johann Brabender was probably this Hinrik's son, and it was he who became the chief master at Münster in the middle of the sixteenth century.[14]

What has survived from the age of Maximilian is chiefly figures from the former rood screen of Osnabrück Cathedral, an Entry of Christ into Jerusalem from the west façade of Münster Cathedral of 1516, and the remains of the Calvary (probably 1508–22) later torn down by the Anabaptists to be used as barricades. It had the largest number of figures in Germany. The Brabender group had great influence, especially in the Münster region, and works were also exported, or artists perhaps removed, to Lübeck (four reliefs in the Marienkirche of 1498–1500) and Bremen (Cathedral).

The material, for the most part Münster sandstone, permitted craftsmanship of the

greatest delicacy. But any extreme of precision is generally avoided even in secondary works, whether they represent hearty scenes of low life or scenes of beautiful sentiment. Many groups achieved a true monumentality. The centre of the circle was at least one outstanding master, the so-called Hinrik Brabender the elder; he can be mentioned in the same breath as Adam Kraft. Christ's Entry into Jerusalem and the Lübeck reliefs are as firm in design, as simple in idiom, as uncomplicated in their effect. The really ravishing piece is the Calvary, which must have been made by a man of harsh, dramatic talent with a wide knowledge of men; perhaps it was the same master. The other works too show a controlled sensibility, a contemplative and grave high-mindedness.

In later creations of the Brabender group, for instance the St Peter from Iburg (Hannover) or the rood-screen figures at Marienfeld, some of the faces have exaggerated grimaces. In this phase the Master of Osnabrück could stand comparison with the stone-carvers of Münster.

SCULPTURE ON THE LOWER RHINE AND IN THE NETHERLANDS

The Lower Rhine

IN the Crucifixion in the Johanneskirche in Cologne, the fine, flowing folds of the Virgin's and St John's cloaks go back to a Dürer woodcut but the intensity of their gaze may be a specifically Cologne trait.[1] Sculpture in the actual geographical region of the Lower Rhine is more down to earth, more of the people, yet more inwardly agitated. In this part of the country, practically every city, and more particularly every small capital of a principality, had its own style in carving – Cleves, Emmerich, Rees, Kalkar, and Wesel, which was the real centre.

Master Dries Holthuys of Cleves[2] (Plate 48) was active about the turn of the century. In 1496 he carved the Virgin in Xanten Cathedral, and in 1502 the Diestelhuysen memorial tablet in the collegiate church of Cleves. His style was graphic, though graphic art was not always the foundation of his composition. Fine folds are delicately inscribed on to his figures. Inwardly they are as firm as a tree-trunk. Their expression is withdrawn and high-bred. The faces, a little forbidding with their large noses, small eyes, and fine-drawn mouths, tend towards the smooth forms of the new century. The Master of Oud-Zevenaar is closely connected with Holthuys, but he seems to be Dutch.

Other carvings from the Lower Rhine, for instance the Virgin from Sonsbeck[3] and a Christ as the Man of Sorrows (both Cologne), express the oak which is their medium so clearly that many a curve might be part of the tree's growth, and rough places here and there could be taken for its bark. A tendency, also native to the region, to give the imagination free play with the material, prepared the way for Mannerism, and it is not so much the substance of the oak (as at Osnabrück and in Holland) as its actual growth which echoes in the form.

The real centre of gravity in wood-carving on the Lower Rhine, however, lay in the great altarpieces. In 1498–1500 Master Loedewich made the high altar at Kalkar, a scene carved in wood with the main Stations of the Cross gathered round Calvary in the middle part, which, after the Netherlands fashion, rises above the rest. It is packed with a throng of human beings, animals, and plants, where the detail is excellent; there is power in the two busts of prophets flanking the scene. As a whole, however, it is a bewildering production. That was the reverse side of Late Gothic naturalism.

A more powerful creator of form was the Master of the Altarpiece of the Seven Joys of the Virgin at Kalkar, peopled for the most part by slender and graceful figures and in the style of a man who was probably still young about 1500. He could organize his work, but he only could co-ordinate it. This mastery of formal hierarchy, as can be seen, for instance, in Riemenschneider's Creglingen altar, was not attempted in this region.

On the predella there is a relief of St John on Patmos; a new feeling for nature breathes in the impassioned space of the relief.

The earliest altarpiece made by the future great master of the Lower Rhine, Heinrich Douvermann, is at Cleves. He carved the altar of the Virgin in the collegiate church (1510–13) in collaboration with Jacob Derichs. It is difficult to distinguish between the work of this collaborator and what the young master brought from his training in Brabant. This can be seen in the Tree of Jesse. The reliefs of the Virgin, deeply under-cut, already show the wayward, asymmetrical, and sometimes eccentric mode of composition of the Lower Rhine Mannerists.

The boundaries of this region towards the Netherlands were vague. The finest work done for Cologne Cathedral towards the end of the age of Maximilian, the memorial tablet of Jacques de Croy (d. 1516), most likely comes from the Southern Netherlands.

The Southern Netherlands

The artistic centre of sculpture in the Southern Netherlands was now Brabant, with Brussels, Malines, and Antwerp as the chief centres of production. It was, in fact, a kind of mass-production based on a very high standard of craftsmanship; there was a huge export trade, especially to the north-east as far as Scandinavia. All the same, the work of outstanding masters can still be recognized.

Brussels[4] led the way with Jan Borman the elder, who was entered in the guild register in 1479. It was he who made the St George altar for Louvain in 1493 (Brussels; Plate 44). Seven scenes of the martyrdom of St George are spread over the wings and centre panel of a plain rectangular retable. The chapel-like back walls with their traceried windows are, like the lavish ornament of the canopy above them, an allusion to the ecclesiastical context. But at the same time they are real space, and only a limited part of that space is allowed to the human figure. The whole work is executed in this firm, strong style. The saint, the victim of inhuman hangmen, of low-minded councillors and a brutal emperor, is broken on the wheel and burnt, scourged and hanged head down, sawn apart and finally beheaded. The martyr dominates the scene, not by his size, but because as a rule he occupies its centre and is the only nude figure, beautiful and slender, in the surge of violent movement and lavish costumes, and is almost eloquent as Florentine bronzes of the age of Verrocchio. This sculptural substantiality, though small in size, surpasses that of Riemenschneider's Adam. The dignity imparted to the human body, even though it is that of a saint, is unprecedented. It is still present when the saint is hanged head down. The head, the seat of personality in Gothic, appears at the bottom, upside down and rent asunder by light, yet still dominating the whole by its expressive power.

The choir-stalls in the church of St Sulpice at Diest (1491) may have been produced in this workshop,[5] like the scenes of St Adrian's martyrdom at Boendael. The style can be recognized in a number of single figures, for instance the fine Magdalen at Brussels. Jan Borman's uniqueness among his contemporaries was due to the fact that he could main-tain greatness throughout all this reality. He was a craftsman, but his mind was noble.

An excellent follower of the Borman style was the bronze-caster Renier van Thienen. In 1496–1502 he made the tomb of Mary of Burgundy in Notre-Dame at Bruges. The costume is ornate, and enchanting in the variety of its ornament. The fine-featured face is a far better likeness of the dead duchess than the statue on the tomb at Innsbruck. The large forms look still more Late Gothic than those at Innsbruck, yet, like everything produced in the circle of Borman the elder, they are on the point of achieving classical calm.

We do not know how long Borman was active. His successors were his sons Pasquier and Jan the younger, but his spirit did not survive in them. Mass production developed. Jan was entered master in 1499, and an inscription shows that he carved the altarpiece at Güstrow in 1522. He may also have made what is known as the Saluces altar (Brussels, Musée Communal), probably about 1500. Later stages of development in his workshop are represented by the Auderghem altar (Brussels, Musée Royal d'Art et d'Archéologie) and the altar of the Passion in Saint-Denis at Liège. Whatever luxuriance he allowed to detail, this son, up to the Güstrow altarpiece, maintained the tradition of Borman restraint. He made quite a number of altarpieces in Sweden in this manner.

The name of the most outstanding master after Borman the elder is not known. It was he who, probably about 1515, made the altar of the Virgin at Lombeek, where the confusions of the secular parts of the story play a lesser role. The main figures are simple and slender. The duties attending birth and death are natural and grave, and there is dignity and some idealism in the faces. This style was continued in the small altarpiece of the Adoration of the Magi (Bonn). The models for the bronze Croy memorial tablet of *c.* 1518 at Cologne, which has already been referred to, seem to have been produced in this carver's workshop, and probably cast at Louvain,[6] perhaps by Hieronymus Veldener (fl. 1501, d. 1539). The figures have the tranquillity of Gothic classicism. They are mostly designed for a frontal view, which is right in altarpieces, and thus present a certain contrast to the Renaissance forms of the shrine, which present them from different points of view and are much more of this world than of the world they – still – belong to. This style also found its way into stone sculpture, for instance in the tomb of Jacques Bogaerts (1520) in St Pieter at Louvain.[7]

Excellent single works executed in the region of Liège have been preserved, and are obviously local productions.[8] Among them there are eccentric, plebeian figures of St Christopher. On the other hand, a Christ in Distress (Brussels, Musée Royal d'Art et d'Archéologie)[9] stands out by the southern beauty of the body from the many examples of the subject which have been preserved, especially in the Netherlands. In this connexion it may be worthy of note that the Italian Nicolas Palardini was already working at Liège before 1518.

Antwerp went farthest in industrializing the art of the altarpiece.[10] Yet even there, there was a foundation of originality. The strength of Antwerp art is in characterization, not in ennoblement, in representation, not in exaltation. The Late Gothic was particularly powerful here. The many-figured altarpiece at Bocholt (Limburg)[11] is a typical and ordinary work of the second decade. A freakish delight in odd characters took charge of the characters from the Old Testament and all subsidiary figures, and it was

they that peopled the altarpieces – grotesquely clad women, bespectacled prophets, thick-lipped, braggart soldiers, and terrifying jailbirds. The effect is immediate in its impact. Work of high quality from a conservative workshop is an altarpiece in the Marienkirche at Lübeck of 1518.

The payment for the Lamentation altarpiece from Averbode (Antwerp, Museum Vleeshuis) was made to Jacob van Cothem in 1514.[12] The whole is centred on the deep, but controlled mourning over the body of the dead Christ. The subsidiary figures are noisier, fashion comes more to the fore, and the grandeur of the carving unites all the forms. The Lamentation from the former rood screen of Tervuren by Andreas Kelder-mans[13] (1517) is inspired with high dramatic feeling. We can see in both works the beginnings of exaggeration in the forms and of the emancipation of their elements. At Antwerp, Mannerism of this kind was supported by the local bias to humorous characterization, and was also, in all probability, the result of routine work and mass production by carvers.

Mannerism of this kind does not seem to have made its appearance until about the middle of the second decade of the century.[14] That is clear from the altar of the Sacrament from Averbode (Paris, Musée de Cluny), which was commissioned in 1513. The carver, Jan de Molder, had previously made the Ascension altarpiece for Lofta, now in Stockholm.

Since 1506, Michelangelo's marble Virgin had been in O.L. Vrouwen Kerk at Bruges. There is no immediate evidence of any influence it may have exercised on the sculptural repertory of the north, but there are artists in whom that influence comes out, for instance Benson, and Dürer speaks of it.[15] Within the Netherlands, Bruges now slipped into the second place, outstripped by the rising star of Antwerp. A pretty, aristocratic type of female figure was still the rule, as can be seen in the St Ursula of the Misericord (Berlin).[16]

These statues and statuettes were actually a speciality of Malines, and a large number of tranquil and aristocratic women saints, gilded and silvered with great care, passed out into the world from there. The St Dymphna altarpiece at Geel (Gheel) of 1515 is signed by Jan de Wavere (d. 1521/2), a master-carver of Malines. He too lacks the impulsive bluntness of the Antwerp style; his tone is more sustained and solemn.[17] Michiel Ywyns also worked at Malines; in 1514–18 he executed the statues of the Netherlands Counts and Countesses in the gable of the Council Hall at Middelburg.[18]

At Malines, the seat of the Burgundian court, the contrast between innovation and tradition must have been particularly glaring. The only thing that artists and craftsmen had in common was that they created sculpture. At that time Conrat Meit was also active at Malines, and Pietro Torrigiani was, for a short time, in the service of the Regent Margaret before he left for England. It was in this circle, about 1517, that the portrait of Charles V as a young man, a terracotta in the Musée Gruuthuse at Bruges, must have been made (Plate 28). It is captivating in its curious blend of high-breeding and momentariness. The broad base of the shoulders, the bristling relief of the Order of the Golden Fleece, the sweeping hat, are rich accessories. What is almost terrifying is the 'truth' of the work, the small head and waxy face of the young prince. The chin

F

juts out, and the look from the half-closed eyes is turned aside, as if in absent-minded-ness. What unites the whole is the long, clinging hair. This must be the work of a court artist, and an artist who could make it outstanding without resort to courtliness.[19]

The Northern Netherlands

In the Northern Netherlands too there must have been a great wealth of late medieval art. We may take it that Gelderland and Utrecht were among the main centres. But there are also some reliefs of the Passion, in a vigorous, quite unsentimental, and occa-sionally naïve style,[20] which point to Holland proper. Other works, such as the tranquil, self-contained Virgin from Culemborg (Utrecht),[21] may bear witness to influences from Brabant in this region. The fine elaboration of the serried forms of the head, of the nose, mouth, and eyes, in a large round face with a high, sloping forehead, seems to be characteristic. The feeling of the block has been preserved; the pleasure in the solidity of the material and the manner of working on it recalls the Westphalian manner. At no point is the ultimate expression wrung from the wood with artifice and violence, as at Antwerp. This restraint is not entirely a matter of material; it is also a restraint in the expression of feeling.

That certainly applies to the whole region of the Northern Netherlands. At Utrecht, the style of Adriaen van Wesel seems to have been continued in a Virgin now in the Van Straaten Collection there. Greater nobility, finer, more wavy folds of drapery than was the rule in Holland, predominate in this work. There is powerful sculptural density in it too. In the same way, the Virgin of the Flight into Egypt from Wijk-bij-Duurstede (Rijksmuseum), though she rides her ass like a countrywoman, is as isolated as a devotional image, and there is no homeliness about her. In this region, artists were able to strike the lovely note of the childlike without succumbing to prettiness or prattling.[22] The sculptural spirit of the turn of the century is also expressed in the small St Adrian from Soest near Utrecht (Rijksmuseum), a superbly rounded figure in smooth armour under the graceful fall of the cloak.[23] The Van Straaten Virgin has a counterpart in the stone fragment of a female saint (Utrecht), a most delicate and harmonious piece of work; other fragments from tombs dating from the beginning of the century have been preserved. The Utrecht Master of the Stone Female Head began work in the early classicist period, and in the twenties made wood-carvings in an odd kind of Mannerism.[24]

The largest stock of work has been preserved in the Gelderland region on both sides of the Rhine. The Master of Oud-Zevenaar, who has much in common with Dries Holthuys, and who was the author of a Virgin in the Stiftsdechanei at Cleves,[25] was a master of oak-carving in a manner which differed from the style of Utrecht and Holland. It was not the block, the solid core of the mass, that he delighted in, but the direction of the grain of the wood and the linearity imposed on his work by the material he was working in. It is possible that many of his works were never coloured owing to this personal bias. It is true that the colossal St Christopher from Oud-Zevenaar (Utrecht) was once painted, but the vitality of the carving is born of the joy in the hard

wood. St Christopher, his bearded mouth open as he groans, leans on his staff, swaying, but still upright under the growing burden of the Child. In the folds of the drapery there is a mysterious echo of the flow of the water which threatens to engulf him. With his craggy face, the saint might be a drowning man. This head, with its masses of hair, reappears in a bust on a reliquary. This carver's work also comprises two lovely Virgins, both inventions of their author and independent of each other. In the figure at Cleves, the harmony of the work with its material went so far that the Virgin's hand seems to be growing, like the branch of a tree, out of the fine ripples of her drapery. These Virgins are given an added beauty by the wonderful flow of their exaggeratedly long hair, a linear factor taking on a life of its own which, in the work at Cleves, already has Mannerist features. The Child, even in the St Christopher, might almost be a boy Pan with his tiny, earthly, and unspiritual profile.

Beautiful works at Utrecht, Amsterdam, and Haarlem issued from the Gelderland group; figures of St Anthony where the flames bursting up against the drapery show the same mastery of line as the falling, flowing beards, figures of St Roch, steadfast and patrician with only a fine line of pain rising from the nostrils, a wide-eyed Magdalen, whose modish costume is completely held in the enchanting flow of the line-work. It was probably executed towards the end of our period, like the group of the Virgin with the Child and St Anne (Arnhem), a symbol of warm family feeling, broad in structure, with undulating drapery falling over the full-fleshed bodies.[26]

The order issued in 1517–19 by the new bishop, Philip of Burgundy, and his chapter for a truly 'modern' bronze screen for the altar of the Maartenskerk at Utrecht must have come like a thunder-clap; it was to have trophies, *romsche Angesichte* (Roman heads), and pagan gods *geheelen antique* (in every sense antique).[27] The commission went to Malines, and Gregorius Wellemans of Antwerp made the models, with the help of craftsmen he brought from France. In the end the work was never cast; the models were destroyed.

CHAPTER 8

PAINTING IN NUREMBERG AND FRANCONIA

Veit Stoss

IN the painting of the age of Maximilian, the sculptor Veit Stoss must again be discussed first. A member of the very old generation, he worked in the flat three times, though always in connexion with sculpture. While at Cracow, Stoss seems to have been the painter of the sculpture on the high altar of St Mary. He also seems to have made his ten engravings at Cracow.[1] All are of ecclesiastical subjects, a sculptor's improvisations, not composed like framed pictures or graphic sheets by a painter. On the contrary, Stoss clarified in them a sculptor's attitude to space. The engravings were probably pattern-sheets; in any case, they were often used as such. For that reason the influence they exercised belongs to the age of Maximilian; for it seems that they first became more widely circulated as the result of the catastrophe which befell Stoss in 1503. It was the sculptors who gained by studying them. But their grand manner may also have affected Dürer while he was at work on the Apocalypse, for instance in the Lamentation (B2) with its passionate upward arc of St John's cloak, and possibly in his woodcut of the same subject (M186).

About 1503, Stoss added to Riemenschneider's carved altarpiece at Münnerstadt, which he was then colouring, painted wings with the legend of St Kilian.[2] They are the final proof that his work in painting, like that of Bernt Notke, occasionally went beyond what was customary for a late medieval sculptor. In any case, it is again the painting of a sculptor. The colours are earthy, dull, and verging on grey, with a powerful brick red bursting through it. The master who speaks here is the master of the Volckamer relief, with his uncomplicated, stratified arrangement of the figures, with his in-difference to true spatiality, and the whirling, swinging movement of his lean, compact figures broken at sharp angles. In the last picture the group attains its full and final splendour by deliberate distortion. It is a thrilling series which we owe to the experi-ment of a great artist.

Albrecht Dürer

There was nothing and nobody at Nuremberg who could stand comparison with Dürer, not even the work produced by his former master, Michael Wolgemut (d. 1519), who was still active with various assistants; nor the charming, but not very original Hans Traut the elder (citizen in 1491; d. 1516), who painted the high altars at Katzwang (1498) and Heilsbronn (1502), and was active till about 1508;[3] and least of all the delicate illuminator and *Konterfetter* Jakob Elsner (d. 1517), who later borrowed a great deal from Dürer.

It was probably in 1491 that Dürer,[4] sitting in front of a mirror, made a drawing, now at Erlangen (w26), which was a self-portrait, though only of the head and the hand supporting it (Plate 53). This unfinished web of pen-strokes, in spite of its prevailing calm, is one of the few genuine revolutions in the history of art. The features of his own face, rendered with great feeling, are certainly observed without passion, as if they did not belong to him; it may be true, as has been assumed, that it was physical pain that distorted the features and that the cloth round the head is a bandage. The hand is certainly shading an injured eye from the candlelight. But in that case it is this pain that enabled Dürer to make the unprecedented visible. There is an immense relish in the three-dimensional. The eye is substantial and glassy, and his observation of it is searching; it is the object of the pen-and-ink drawing, yet the eye is also grasped as Dürer's great theme of the picture. Dürer's own face, presented in its cramped material limits, is the face of a man who lives through his eyes. His art, to a greater degree than any other in the north up to that time, took the visual as its starting-point. Dürer was the first explorer, his medium being his art, and most of the results were indeed works of art. The innovation was still more marked than Peter Vischer's in his Bough-Breaker of 1490. In this drawing we can see the greatest artist of the age of Maximilian evolve.

Albrecht Dürer was by birth and training a mechanic. He was born at Nuremberg, the son of a goldsmith who had settled there in 1455 and had taken the name of his Hungarian birthplace Ajtas (Ajtó meaning Tür, i.e. door). He was competent, but not very successful. Albrecht was the third of the eighteen children of his mother, the daughter of a Nuremberg goldsmith. Dürer first learned that craft from his father. This was of double advantage to him: in his early youth he learned the use of the burin, the tool of the engraver; but not only that – his father had at one time learned from Netherlands masters. Thus even as a boy Dürer entered into the great tradition of European art. As a youth he felt drawn to painting, and therefore had a final training under Michael Wolgemut in one of the busy Nuremberg workshops which produced many altarpieces, portraits, and designs for woodcuts for the printers of Nuremberg. Anton Koberger, at that time the most important printer in Germany, was Dürer's godfather. Wolgemut was not a great artist himself, but he had a personal and astringent style.

Dürer completed his training in 1490, and moved to Colmar, *peragrata Germania*, in 1492. He had probably first visited Mainz and Frankfurt, and had met the Master of the Hausbuch; he may have passed through Holland too. When he reached Colmar, Martin Schongauer was already dead. It was easy for Koberger's godson to approach the publishers of Basel, another centre of European printing. The result was that the young man, within a year, had revolutionized the style of book illustration at Basel. He then moved to Strassburg and returned home in 1494 in order to conclude a marriage arranged with Agnes Frey, the daughter of a respected Nuremberg family. The marriage was childless and probably not very happy. It is in this connexion that we may regard Dürer as living on the fringes of society in an almost modern sense. Agnes acquired no social status as his wife; he seems to have shrunk from family life.

In the autumn of 1494, Dürer left his native city again. His next step was

extraordinary: he went to Italy, where classical antiquity had been reborn. This to the best of our knowledge is the first visit of an artist from Central Germany to Italy of which we know how fruitful the results were. At that time it was the custom for German artists to go to the Netherlands; they did not, as a rule, go south. Dürer went to Venice and most likely to Padua, Mantua, and Cremona. He was back in Nuremberg by the spring of 1495. Yet he had seen enough to translate into visible form what the Erlangen self-portrait had forecast in its spiritual independence. That was the beginning of ten years' relentless work and the analysis of the problems of art, and it was Dürer who initiated what is called the Renaissance in the north.

In 1505 Dürer set out on a second visit to Italy, which was to last for over two years. It brought him the finest commission that a German could hope for in Venice, and infused his work, which had taken on a slight bias towards rationalism, with fresh vitality. Given his love of knowledge, he hoped, at Bologna, to snatch something of the secret science of perspective. It has even been suggested that he visited Florence and Rome. He may just have passed through Milan. At any rate he seems to have known little of Leonardo. There is a connexion, however, which one can sense but not define.

Gregor Erhart grasped the ideas of form behind Leonardo's *Cavallo* at least as clearly as Dürer. It was very rare for Dürer to be bright, serene, and ingenious in his painting as Renaissance art was. In that respect Meit was happier, though we cannot tell how he managed. Lucas van Leiden, in his turn, acquired this lightness at second hand. Scorel was the first to see Raphael's art, although Dürer and Raphael had exchanged specimens of their work. Yet in his gravity, in his versatility as a child prodigy, Dürer was the man of destiny for the north. Socially, too, he attained the ideal of the *gentiluomo* which the Venetian painters had already achieved ('Here I am a gentleman; at home I am a beggar,' he wrote to his friend Pirckheimer).

Having returned to Nuremberg in 1507 he continued to paint in the Italian manner on which he had laboured so intensely at Venice, attained the summit of engraving, finished his woodcut series, and experimented in graphic technique. He began to study languages and mathematics, and embarked on his first version of the theory of art, which was to occupy him till his death. The craftsman's son raised himself to the level of the cultivated, scholarly artist in a sense unknown till then in the north, and took his share in the intellectual life of the humanists. From 1512 on, Maximilian engaged him on many commissions. He travelled little; visits to Frankfurt in 1508(?), to Bamberg in 1517, to Augsburg in 1518, and to Switzerland with Pirckheimer in 1519 interrupted this productive period.

After Maximilian's death, Dürer went to the Netherlands for a year in 1520 in order to have his salary confirmed by his successor. This time he was accompanied by his wife. The visit brought him a wealth of impressions and honours. He met Meit, Provost, Gossaert, Lucas van Leiden, Patinir, Orley, Vellert, and at Aachen possibly Grünewald. At Antwerp he came into contact with the early Reformers. He travelled right through the country. Insatiable in his appetite for everything the world had to offer to his eyes, he decided to see a stranded whale in Zeeland, and caught malaria. He returned home, his health ruined. Active till the last, he died at Nuremberg in 1528.

His last years were spent in passionate partisanship for Luther's attempts at reform, which he obviously carried at times to extremes. After the trial of the three 'godless artists' in 1525, who must have been friends of his, and after the Peasants' War, his Protestantism became more moderate.

He was a man who gave his all to his age. His life of action and study was probably without bombast, but it was exemplary. No artist had left such a host of witnesses to himself before Dürer; he was the first painter of self-portraits, and he classified and named his paintings and drawings with great care from first to last. He made notes of things seen and dream-visions; letters, diaries, and many kinds of chronicles give us an insight into his personality. He was the first to wring a terminology of art from the German language. His theoretical writings are the *Instruction in Measurement* (1525), *Theory of Fortification* (1527), four books on human proportions, which appeared in 1528, soon after his death, and a general work on painting which remained in manuscript. Nearly a thousand drawings have come down to us.

Dürer was a child prodigy. His greatest personal and artistic achievement was that he went on to become an adult prodigy. Development was the secret of his life. The sum of his intellectual and artistic life is not to be seen in the relative permanence of his being, but in its growth. In that respect too he ushered in the new age.

This metamorphosis was brought about, after his first visit to Italy at any rate, by degrees and by himself. Where others followed, he led. His path in life was often solitary. Dürer's influence was great, yet there is little similarity between his development and the style practised by his contemporaries at any time in his life.

It is difficult to define the legacy in Dürer's work of Wolgemut and the artists of Nuremberg. They may have introduced him in his early years to the designing of woodcuts; after all, it was Wolgemut who had emancipated the woodcut from the predominance of the publishers and made the artists fully responsible for it by founding an association of painters and capitalists. As a young man, Dürer may have made some contribution to Hartmann Schedel's *World Chronicle* of 1493, and he may have had other opportunities of trying his hand at illustration. But there is no echo in Dürer of Wolgemut's dramatic bitterness. On the other hand, we may assume some influence from the Nuremberg artist who, during Dürer's apprenticeship, produced the St Augustine altarpiece in 1487 and gave the topographical element an important part in it. Apparently it was this first step in coping with the factual which made the youthful Dürer already about 1489–90 venture on his water-colours of the Wire-drawing Mill (w61) (Plate 52), of St John's Cemetery (w62), and of the Three Lime-Trees (w64). In all probability the St John's Cemetery is as true to fact as some Bamberg water-colours of the time are.[5] In the Wire-drawing Mill, Dürer first set the high-roofed houses as scenic wings, then changed his standpoint and descended to the river-bed, so that the mountains rise high in the background. Having produced the first self-portrait, he took the first step to pure landscape (except for Leonardo's drawing of 1473).

In starting out as a journeyman, he not only had two periods of training to his credit; he had his own powers as a craftsman too. The self-portrait with his head

leaning on his hand is drawn on the back of a drawing which has on the obverse side a fine rendering of the Holy Family (w25). In this drawing, as in many of Dürer's early sheets, the deep but reverent humour of the Master of the Hausbuch can be felt. In the Holy Family with the sleeping Joseph (w30) an apparently Dutch element seems to have made its way in: the landscape is now spread out as a unified whole. It was probably Geertgen tot Sint Jans who stood sponsor to the sheet.

But Dürer struck no roots in this free, suggestive, and convincing world of wild growth. What he wanted was study, austerity, form. The influence of Schongauer, who was already dead, is shown in the drawing of the young couple on the way to a dance (w56). We can feel how Schongauer's precision, his well-bred idealism, has been transformed by the vehemence of the young explorer. It is in all respects a genre piece. The couple on the walk show what was being worn at Basel at the time; the lover has Dürer's features. The inequality of the couple's step is incomparable in the coincidence of the right feet, which brings a tender pause into the movement.

On the whole, the youthful Dürer, at work on the Upper Rhine, dependent on nobody but himself and already without a master, was looking to the future. The self-portrait of 1493 (w27) was a product of that feeling of triumph and is far more unfaltering than the self-portrait with the head leaning on the hand (Plate 53). The eyes look full at the spectator and there is suggestive modelling round the nose and mouth. Here is a master who can even draw the active right hand, the arm covered by a cushion. On the reverse of the sheet (w32) there are six more cushions piled up in various ways, but without any indication of what they lie on. Crumpled as they are, they are grimaces or masks.[6] Dürer was still exploring the world of chance. Even studies of his own limbs (w33–47) were for the time being useful.

It was the freshness of his observation which also gave the Basel woodcuts their unmistakable imprint. Dürer contributed to four series, in the editions of the moral tale of the *Ritter vom Turn* (1493) and of Sebastian Brant's *Ship of Fools*, printed in 1494, in a small unpublished book of devotions, and finally in an edition of Terence which never got beyond the drawings on the blocks. The amount of work he produced in these two years is greater than all his later woodcuts put together. The *Turn* is a work of bibliophile value. The folds of the drapery owe something to the sculpture but nothing whatever to the graphic art of the Upper Rhine. But Dürer's language very soon became bewilderingly direct. The subjects demanded creative imagination, and a wealth of realistic detail provided variety. The wit and the whimsical bent of the young artist tempered the slightly embittered manner of Sebastian Brant. There is a world of difference between his works and those of his collaborators. This was the moment when the modern woodcut was born. The details, black or white, began to lose their meaning as, say, black shoes, a black belt, and a white shirt, and became the means of artistic creation. Subsequently colouring was banned. The youthful graphic artist took the same way as the altar-carvers who, led by Riemenschneider, had just abandoned colouring. Both carvers and the graphic artist must have discovered a new delight in what was gained by mere cutting, a genuine artistic joy which worked hand in hand with the desire for elevation and spiritualization; after all, it had been the

colouring which had put life into the late medieval work of art. What Dürer had to say was soaked in reality, and remote from the controlled idealism of Schongauer, yet if his language became an artistic idiom, that was due to the restraint of Schongauer's burin. It was beginning to raise the woodcut to the status of the nobler engraving.

We are less clear about the painting, which Dürer seems to have taken up again at Strassburg. The impact of the self-portrait of 1493 (Louvre) is immediate. The white, bluish, and green tones of the clothing are delicately shaded off to grey with two tones of red providing a lovely contrast; the wild orchid is a dusty green. There is resolution in the small head with its softly curling hair, the look in the eyes is commanding and grave, the face is sensitive and firm.

In 1494 Dürer saw Italy for the first time. By the time he went, he had already developed an idiom of mythology which was largely his own invention. A poor North Italian engraving, the Death of Orpheus, provided him with the crude raw material for a drawing (w58). It is a miracle of fine detail and, in the trees, enormously rich in minutely observed, precisely outlined small forms. Such works were the foundations of Dürer's art of engraving. Other works were executed at Venice after Italian masters, Mantegna, Pollaiuolo, Credi, and Gentile Bellini. But the explorer also found himself faced with a host of things to which he clung with every fibre of his being. He now rendered Venetian women's faces and costumes with a far more fluent line, and depicted a Nuremberg woman side by side with a Venetian (w75) in such a way that these female figures and the style of their dresses look like an antithesis of north and south, of Late Gothic and Renaissance. The Adriatic provided him with the lobsters and crabs which he drew life-size with pen and brush (w91–2); they are terrifying creatures, one embattled with uncanny pincers, while the other creeps up upon us, head on, armoured, and heavy-moving in a repulsive sea. Dürer, a landsman, succumbed to their fascination and blended his sense of reality with a relic of demon fear, enlivened by humorous animation.

We know from Dürer himself that the Venetian painter Jacopo de' Barbari once showed him two figures, a male and a female, which were constructed on geometrical principles. Dürer met Barbari at Nuremberg in 1500; there may have been a previous meeting at Venice. In any case, however, Dürer became aware in Venice of this Barbari problem, which was to be so much in his mind throughout his life – the secret of proportion in the standing and moving human body. On a study sheet (w86) a nude youth stands in resilient contrapposto beside a knight in armour, a turbaned figure, and a child's body (after Credi), while a nude female back of 1495 (w85), balanced by a long staff, is rendered from life with a splendidly fluent brush (Plate 54). The master-draughtsman made almost unimaginable progress in a subject which had no special appeal for him, like the uncertain study of the woman bathing (w28), which he drew in pen and ink in 1493. Dürer's encounter with the Renaissance did not lead him straight to classical form, and he never worked from Antique models: the legacy of Antiquity came to him at second hand. And in making it his own, the first thing he did was to transform it. The value of that nude back can be grasped better in its fluency than in its structure.

Dürer crossed the Alps twice. In the bracing air of his travels he painted more than a dozen water-colours (w66–8, 94–105). First came views of Innsbruck, two from very near and one from a great distance. In these sheets, the jumbled forms of Late Gothic architecture in the cemetery of St John are spatially mastered with perfect ease. The sheets from the South Tyrol and Trento are still more convincing in their simplicity. More and more free nature found its way into water-colour, and it was indeed a gripping brush which was able to suggest the winding pass, the stratification in the great Adige loop, the curious hunch of the Dosso di Trento, and the earthy crust formed in the *Welschpirg* as if by some primeval upheaval, all with a lovely effortlessness. The crown belongs to the water-colour of Arco, done in 1495, in which Dürer combined the curve of the hillside, the growth of the trees, and the mighty motif of the mountain rock – in other words the recognizable physiognomy and the formlessness of nature – in the same way as the artists of the Danube school painted their sitters in a natural setting. The spring light is caught and painted in the olive trees.

While the early views of Bamberg[5] evidently had some utilitarian purpose, Dürer's Tyrolese works have no such purpose at all. Their meaning relates only to himself and his travels. True, he occasionally turned views of the kind to good use. They can hardly have been produced for sale; in fact, very few of his early drawings were. Yet they show a growing trend towards pure art and to art in a new sense which had gradually been clarified by Dürer himself. As purposeless landscapes these water-colours were a radical novelty. Back in his native city, he seems to have gone on with them. But now the motif often had nothing specifically personal. This is particularly clear in the views of a quarry near Nuremberg (w106–12). While in the Alps Dürer had employed the technique of water-colour in many degrees of intensity and on many subjects, what now appears is a variety of techniques applied to one unrewarding subject, in which stone-formations, quarrying strata, vegetable growth and rubble, delicate colour effects, and uncomplicated outlines seem to have fascinated him. He continued to make use of these studies even in his late graphic work.

Then come more important sheets, in which the eye is led over water to the cloudy sky of evening in water-colour, and in which the work of man's hand, a boat, a fisherman's hut, the *Weidenmühl*, are subordinated to processes of nature; what is probably the most outstanding of them sets a woodland pool in grandiose desolation (w113–15) (Plate 51); the surface of the water deepens in colour from leaden brown to blue, the sky is orange and red – a presage of *plein-air* painting. But he found a new way of painting familiar things – Nuremberg from the west with a low viewpoint (w116), where meadows, paths, walls, towers are no longer piled up from the countryside in the naivety of local topography, but recede in depth; there is delicacy and atmosphere in the colouring. On the other hand, the colours of the view of Kalchreuth (w118) are laid on side by side, bright and unmixed. In masterly order and without any individualization, the thatched roofs stand in the valley over which the eye travels to the opposite heights. Physiognomy and type – those were the poles of Dürer's art.

That is also true of the larger paintings of these years. Friedrich the Wise of Saxony sat to him for his portrait of *c.* 1496 (Berlin; Plate 58) and commissioned two altarpieces,

one of them the Dresden triptych with the Adoration of the Child by the Virgin, with St Anthony and St Sebastian on the wings. Both this altarpiece and the portrait are, to use Dürer's expression, *Tüchlein*, i.e. painted in tempera on canvas. This accentuates the rather dry, sharply modelled effect which Dürer must have aimed at and which delighted collectors. Motifs from the Netherlands are blended with others borrowed from Mantegna; a perspective plunge into depth makes the picture restless, and there can be no doubt that it is based on a composition by Bellini. The adoration of the sleeping Child passes into a worship of the Corpus Christi. In its absence of rejoicing the painting underlines this ambivalence.

In the portrait of Friedrich the Wise Dürer conveyed the dignity he had seen in Italy. Reddish flesh-tones, a muted green ground, and a black costume interspersed with gold all play their part in the somewhat sombre effect. There is something violent and a hint of almost unrestrained force in the structure of the figure; though the wide-open eyes are small, they dominate the sharp contrasts in the face.

In 1497 Dürer painted on *Tüchlein* two portraits of a daughter of the Fürleger family (Frankfurt and Paris, private collection): one is at prayer, her hair thick and flowing, in a simple dress on a dark background, of a very muted harmony of green and orange; the other has plaited hair, wears a ball-dress, and is holding love-flowers rather self-consciously, standing in front of a window looking out on to a garden and the distant landscape. In the first, the face is meditating in prayer with nearly closed eyes; in the other it appears at an angle, with narrowed eyes looking at the spectator with a play round the lips which is both sensual and mocking. Apparently the same person has been portrayed, as Castitas and as Voluptas, though both remain within the bounds of bourgeois temperance and respectability. It is characteristic that Dürer's Castitas turned out more Italian in her face and Bellinesque hands than the worldly child of Late Gothic Nuremberg. It may be that they were also formulations of the coming type of portrait *à la Madeleine*, enriched by the antithesis between them.

While the self-portrait of 1493 may have been a wedding-piece, the painting of 1498 (Prado; Plate 59) is definitely the first self-portrait in the history of painting not painted for a specific purpose. The head is proudly raised. Architectural verticals give steepness to the picture and add richness to the noble whitish grey and black of the clothing; within it the flesh tones and the finely curling hair are almost golden in their variety of brown and orange. The impressive greatness in the portrait of Friedrich the Wise has become, in the very similar pose of the artist, an almost stilted elegance. Dürer painted himself as a *gentiluomo*. He claimed social dignity for the artist of the north. The discrepancy from the reality of life at Nuremberg must have been immeasurable.

Then, in 1500, Dürer painted the most stylized of all his pictures, an exaggeration of all the ambiguities of the Fürleger portraits, namely his most famous self-portrait, that at Munich (frontispiece). No less off-hand a portrait could be imagined. The bust is strictly frontal and constructed round the vertical axis, i.e. it is perfectly in symmetry. The type is made to resemble the *imago Christi*. The inequality in the size of the eyes and the steeply sloping shoulders, noticeable in the other self-portraits, have been balanced out, and the face is ennobled and is probably founded on rules of measure. There is one

lack of conformity; the left hand, which we see as the right, naturally makes no Christ-like gesture of blessing; it relaxes the tension of the structure, and thus in its accuracy of detail and its hint of crampedness gives a last touch of Late Gothic to this classical self-enhancement. There was no lack of piety in the approach to the Holy of Holies in the *imitatio Christi*. At least as important in this self-portrait is that here we have the man as an artist and therefore as a figure of social standing, of spiritual dignity. This claim too is made quite seriously and is free of any arrogance; it is a confession of faith in the artist's creative imagination in a new – and as yet esoteric – sense, which still regarded that imagination as part of the great creative power. From the creative standpoint, however – and that is the thought proclaimed in the picture – the artist obviously no longer saw himself in his hours of happy invention, which were to return to him later, but at the point at which reason and insight into the structure of all things enabled him to recognize and apply to the work of art the rules governing the form of the body at rest and in movement and the principles of perspective.

The foundations which Dürer laid for a Renaissance in the north after his first visit to Venice are mainly to be seen in woodcuts and engravings. In these years of efflorescent genius the woodcut was practically confined to the sacred story. The only secular subject is the men's bathing-house (B128), the first woodcut to be issued by his publishing firm. The only mythological subject is Hercules and Cacus (B127).

During the same years Dürer produced at long intervals seven woodcuts of the Great Passion; these were supplemented by four more in 1510 and published in book form in 1511. The Lamentation is set in a wide Easter landscape; the gestures of the women wringing their hands die away in the saplings. A single woman rises, standing like a statue, into the upper half of the picture. The structure is symmetrical and self-contained. We can recognize in the traditional content of the picture an echo of Dürer's encounters in Venice. In the Bearing of the Cross, Christ is like a Hercules who, though his knees are buckling under him, is still able to bear the cross in contrapposto. Many diagonals lead up to the strong, grave face – the movement of the procession out of the city gate and up the hill to the right, the diagonals of the arms of the cross, the club which drives him on, the thrust of the lances, the rope that pulls him up. There is one moment of repose in this tumult of strident forms: the twisted half-supported body, the *vera icon* turned to St Veronica's kerchief, the masonry of the walls, and the upright lance of the fore-most soldier. Christ's followers are deeply moved, but they have self-control. Yet even Christ's executioners are not the scum of the earth, especially the foremost soldier with his beautiful, stalwart, upright body, his face turned outward and a little thoughtful, with hints of a self-portrait – I too might have been among Christ's adversaries. The horse and its rider under the cross are immediately credible. This pregnancy, however insubstantial the figures may be, was prepared for by the journey to the Upper Rhine. But the Great Passion cannot be imagined without Italy. Its forms have started on their way to classicism, a Late Gothic classicism. Yet the spirit that speaks from these sheets speaks from the mind of the Renaissance. God is a hero on earth; some justice is done even to his enemies.

Dürer spreads his web of black and white over large sheets, 'grosse Bogen'. He

approximated their size to that of his smaller paintings; technically these woodcuts are superior to his own painting. Dürer thought and saw in lines, and since his work at Basel he had spiritualized them, and, with the Renaissance eye for form, had given them uniformity and equality. Between the white of the paper and the black of the coloured block, there now remained for him nothing but a gradation of light and dark, and no conventional renderings of meaning. This linear art enabled him to express things that the variegated concreteness of colour had prevented him from expressing his life long.

At the same time it was to his advantage that his graphic art was not directed merely to a single patron, but to a large number of buyers. He was both inventor and draughts-man, must have been his own *Formschneider* (i.e. cutter of the blocks) at times, and thus had now fulfilled Wolgemut's plan of organization: he was his own publisher, and in particular his initials AD were now used as a publisher's signet. In this strong position, dependent on nobody but himself, he created a new type of illustrated book – the album.

The first to be published was the Apocalypse in 1498. It consists of fifteen woodcuts which have no direct relevance to the text and do not follow it closely. They say what they have to say, eliminate repetitions in the text, and seize upon dramatic moments in the confusion of the narrative. Dürer did not simply start out from the text, but made use of a wealth of pictorial raw material which he found in woodcuts of the late fifteenth century – predecessors of poor quality. No man has imagination enough entirely to invent such wealth of freshly seen detail and such composition. Recollections of engravings by Schongauer and Mantegna were absorbed in them.

The Apocalypse as a whole is not intended to be a simple narration in the late medieval sense, which Dürer had raised to a new, unprecedented level of dignity in the heroic realism of the Passion. The Apocalypse is intended to be miraculously natural, but supernaturally imagined at the same time. The new style in woodcuts with its spiritualized line, its emphasis on surfaces filled with line-work, is subject only to its own laws, and was supported by Late Gothic naturalism and the new sense of the movement and corporeality of the human body. Everything that happens on earth is animated, in movement, has its own reasons, and is so clearly distinguished from the imaginary that for the most part the spectator of the Apocalypse might be entirely eliminated. St John appears here and there as a participant in the action, but only twice as a great foreground figure, though even then he stands in complete contrast to the wonder of his vision, gazing on the seven candlesticks and the judge or devouring the book. In this sheet the space of earth and the heavenly symbols collide with a force which was not to be seen again till the Baroque. In the other sheets too, earthly reality occupies the foreground, once again a peaceful, wooded valley, a quiet sea, and then the most appalling scenes of destruction and doom, with the apocalyptic event seen in heaven; blessedly untouchable, fantastically terrible, it appears as the unique event without visible or comprehensible cause. The Four Horsemen burst out of the void, and the rhythm of their hoof-beats foretells slow and torturing destruction. Angels of heroic mould, gifts of the south, stop the winds, whose heads swell fantastically out of clouds. Above the flashing swords of the angelic hosts, the fresh storm rushes on apace.

The grotesqueness and absurdity of atrocious animal forms, absolutely concrete in the lower half of the picture, is elevated in the sky, as Michael's battle with the dragon in a superb immateriality of light and dark. Never was rhapsodic profusion of forms controlled in such a way, never had passion and dignity been united as in these sheets. We might speak of a 'latent pre-Reformation'[7] when we see how a great draughtsman turned back to the sources and created the most personal of work out of them.

Engraving had not been very widely used in Nuremberg up to that time. Dürer made it one of his chief media. True, there was no need to raise its status and make it respectable, as had been necessary for the woodcut; the process had had its practitioners long since. Yet even here Dürer was an innovator. He abandoned the traditional ambiguity and made the line the one and only element in the engravings. That meant a great future, since in the engraving the line is, after all, produced by direct effort and is not, as in the woodcut, the mere left-over, the part that has not been cut away. In Dürer's work the line very soon approximated to its geometrical function. It had a peculiar power of giving bodies a pure outline with full internal modelling; it corresponded to Dürer's feeling for the precise and the concrete, and also, for a long time, to his hope of constructing the human body with ruler and compass on a foundation of 'just measures' (aus der Mass machen). In this way, Dürer in his early years approached most closely to the Renaissance artist and to classical form.

Two Virgins, one with the Dragon-Fly (B44), probably dating from 1495, the other with the Monkey (B42), of about 1498, show how Dürer, within a few years, had mastered his technical element, the pure line. Neither Virgin can be imagined without Italy, but the Virgin with the Dragon-Fly contains in the foreshortened faces, in the lovely little profile of the Child, in the spreading landscape and in the representation of the Trinity a great deal of South German Late Gothic. The Virgin with the Monkey, although the landscape is splendid and in deeper recession, is simpler, more concrete in the modelling, and of greater dignity in the dominating motif of the Virgin's head. The monkey is the symbol of Eve, whose original sin was redeemed by the Virgin, the new Eve. Five years later, in 1503, Dürer retold the story in matchless simplicity. The Virgin suckling the Child on a grassy seat (B34) unites the most intimate of actions with the dignity of the Godhead on earth at the corner of a fence in a field.

Dürer owed this triumph of simple statement to his secular engravings, which are in the majority. They comprise completely objective scenes of life and customs – soldiers, a courier, peasants, a Turkish family. There are anecdotes, such as the profound and wonderful Walk (B94); the ill-matched couple in the Proposal of Love (B93) is rendered as a moral satire. The Prodigal Son (B28), kneeling on the ground, has indeed degraded himself to the condition of the swine of the farm, and his figure is engulfed in the forbidding backs of the human dwellings; he wrings his hands and looks up to heaven – a simple gesture which gains its artistic importance from the sloping roofs.

Above all, Dürer's humanist friends must have helped him to create the four moral themes which had never been prefigured, but in which the new beauty of the south could be confidently introduced. In the enigmatic Four Witches (B75) of 1497, the famous Three Graces of Antiquity are united – not very satisfyingly – with a fourth in

an infernal dance. In The Temptation of the Idler, generally known as The Dream of the Doctor (B76), a beautiful female nude appears, beckoning; it is Venus herself. In both sheets the devil in the background provides a Christian significance, or at any rate a moral pretext. In the Sea Monster (B71) the actual abduction, as a shocking event, is shown only by the secondary figures, while the victim herself, with hardly as much as a sign, lies relaxed on the fish-body of her seducer. The same nude also appears in the Hercules engraving (B73), which shows the hero in a pose which is only half-way to the actual attack, at the parting of the ways between vice and virtue. Never had such a muscular back been seen in the north. The face may possibly contain dramatized features of a self-portrait of Dürer. All four sheets are fruits of learned deliberation, yet as a whole they are not quite comprehensible. The human figures, echoes of the 'modern' feeling for form, are mainly there for their own sake.

From that time on the engraving took on a steadily increasing brilliance and approximated in size to the woodcut. In the St Eustace (B57), there is a wealth of keenly observed detail – the castle and the tree, the grass and the animals. The artist's intensity of vision of everything around him was so great that he could hardly bear any overlapping. Nearly all the animals stand in pure profile, as if they were in a herbal. This was the time of Dürer's large drawings of plants and animals; he loved to paint tufts of grass, the iris, the hare, the parrot, life-size wherever possible, with microscopic fidelity, deep seriousness, but without any prettification. Here and there the exactitude of the texture of the skin meant more to him than the credibility of the structure, and it is amazing how closely the engraving, in its refinement, rendered 'reality'. The animals are intentionally constructed on principles of 'right' proportion.

The Nemesis engraving too (B77), called 'The Great Fortune', owes its penetrating coolness to Dürer's double effort. The panoramic view of Klausen in the Tyrol is so accurate in detail that one's fingers itch to measure it. In static equilibrium, yet by no means weightless (while not long before St Michael had floated fantastically in the clouds), the goddess of fate moves on the sphere, holding the goblet as the prize, the bridle as fetters for man – Dürer's first symbolic representation. Her body and the paraphernalia are minutely described, but her proportions agree exactly with the Vitruvian canon: the length of the foot is one-seventh of the total height of the body, the head one-eighth, the face one-tenth, the forearm with the hand a quarter.

It was not until later that Dürer resolved the conflict between his imaginative feeling for nature and his desire to instruct. The Adam and Eve engraving (B1) contains the first sum of his studies in proportion. The Nativity (B2) is the first perfected fruit of his studies in perspective. The unity of space is convincing, the solid and the concave parts, the light and the dark, are beautifully balanced. The foreground figures of the Virgin and St Joseph occupy hardly a twentieth of the whole picture-space; this distance from the beholder enables him to grasp the whole as one noble unity.

The effect which this engraving owes to perspective was achieved in the Adam and Eve of 1504 by the new conception of bodily movement and proportion. What dominates this sheet is its sculptural values. The warm tone of the skin stands out beautifully from the dusk of the wood, the bark of the faintly lighted trunks, the

slippery snake, the crimped hair, the hides of the animals. Here too there is a wealth of symbols relating to the Fall, the Redemption, and above all to the division of humanity into the four guilt-laden temperaments it produced. Once more, Dürer was dealing in all seriousness with a theological subject. And yet what fascinated him himself was the perfect bodily beauty of man and woman. The sheet was preceded by drawings, some built up on various geometrical schemes, in which the man is denoted as Aesculapius, a warrior, the sun-god, Apollo, while the woman occasionally has lunar features. Reminiscences of Barbari's Apollo and Diana engraving probably found their way into these sketches. The outstanding fact is that the theme was 'beauty' in the modern sense, classicism not only in the subject but in the form too; the pure, clear outlines of our first parents, the exact proportions of their bodies, give a touch of coolness to the old theme.

In the two horses of 1505 (B96–7), Dürer, in characteristic fashion, made a double approach to the great exemplar Leonardo; the small horse, regular in build and in pure profile, the large horse, drawn from life, more massive by its pose in a slanting back view, and looking all the huger for being pressed into the picture area. Dürer seldom excelled the perfection of these engravings. Then there are drawings which are bathed in tenderness, such as the Virgins with the Animals of 1503 (W295–7) (Plate 62), irradiated by the northern love of animals and all the northern feeling for nature; never before or after has such a serene opulence been seen.

About 1502–5, Dürer made seventeen of the twenty woodcuts which were published as the Life of the Virgin in 1511. The storm of the Apocalypse had died down. There is hardly a more homely picture in the old German style than that in which the Virgin is spinning in the open air, rocking the Child in its cradle, surrounded by angels, while Joseph is busy with his carpentering, assisted by a troop of laughing putti; fowls, tools, and a running well fill the farmyard; snug, half-dilapidated houses, a doorway, and a distant castle form the background to the happy group. In many scenes there is the same wealth of ideas and delight. Dürer hardly ever appeared so warm-hearted and so tender. A note of humour is struck at times. The surroundings, the many buildings, add to the general gaiety; it is a rich variety of southern buildings, especially with Roman and Romanesque echoes, that passes before the eye of the spectator. Flamboyant ornament and Renaissance motifs are united with an exotic strain not without theological allusions. One superb creation is the great arcade enframing the scene of Joachim and Anne at the Golden Gate. But even the Birth of the Virgin with the women busying themselves in the young mother's bedroom, and the Betrothal of the Virgin have this ancient Netherlands motif of the enframing archway. The Presentation in the Temple has some of the fantastic light-effects of Islamic sacred architecture, owing to the separation of the columns and architrave from the twilit ceiling arches. The light is the operative factor; Dürer had never before created half-tones like these, and the delicacy of the cutting brings them out. In the Flight into Egypt the finely differentiated trees are far more active, far more saturated with the terror of the forest, heavenly light, and troops of joyful angels than in the Adam and Eve engraving.

In 1503 Dürer tried out a totally different technique. Charcoal drawing (W269–76) enabled him to work on a large scale, more quickly, more forcefully, and with a

splintered, astringent effect. He posed his friend Pirckheimer in profile, reproducing without idealization the broken nose under the heavy skull. At that time he made a series of drawings which were not only studies in the expression of feeling but, in a foreshortened head of Christ, were composed in such a way and so reduced to painterly values that the result approximates to Grünewald. An illness seems to have drawn his attention to his own body. There are traits of the self-portrait in the dreadful head of Christ. Also what is perhaps the most impressive nude with pen and brush (w267) was made at this time; it shows Dürer nude and wasted in a convulsive contrapposto.

The panel paintings of these five years, on the other hand, are dominated by the effort to achieve meticulous precision. There are not many pictures, if we leave out of account the large number he left unfinished when he again set out for Venice. Dürer's hand can be recognized in the Job wings at Frankfurt and Cologne, which probably belonged to the Adoration of the Magi of 1504 (Florence; Plate 65), and the Paumgartner altarpiece (Munich). This came first, and may have been painted as early as 1498. The central panel contains an Adoration of the Child. The figures are slender and light, as they are on the Job panels. The group of angels with the Child is a happy invention, like the donors to right and left. A thread of late medieval symbolism runs through the whole.[8] But the architecture, which has again become a field for experiment in perspective, is harder and more abrupt than in any of the graphic works. The type of altarpiece here used comes from the Netherlands; a scene in landscape is flanked by great figures of the two knightly saints, which are most likely portraits of the Paumgartner brothers. They are variations of the 'modern' motif of contrapposto and movement; the elegant Italian balance of St George is contrasted with the weighty, controlled stance of St Eustace, both set off against a dark background, like Adam and Eve. Thus the spatial unity of the triptych was sacrificed. It represents side by side, unconnected and almost without transition, the way Dürer had travelled in order to unite the old and the new, the north and the south.

In the panel of the Magi his cool mastery reaches its culmination. At all points the eye encounters indescribable miracles of artistry in the filling of surfaces, in balance, in sculpturality of form, with faces in profile balanced by frontal presentations; feats such as the enclosing of the Moor in two abruptly foreshortened arches create formal relations in what is really without relations; the rise of the ruins and the recession into depth are vehement; the arrangement of the colours is powerful, and the lavish enrichment with ornamental gold is without parallel. In these five years, Dürer, in contrast to the tenderness of his Life of the Virgin and the immediacy of his meticulous drawings, painted this Adoration without any casualness whatsoever. The result is not moving, but it is worthy of supreme respect.

Only a new enrichment of vision could after this take him farther on the *via moderna*. So Dürer started again in Italy. The scaffolding of his future was already erected. What Venice added to it was confirmation and truth to life, and an important commission for a painting, the Festival of the Rose-Garlands (1506, Prague). It was commissioned by the German colony. The theme is a festal one, and the fact that the painting is festive, too, shows how happy Dürer was in Venice. The Virgin and the Child, with St Dominic,

distribute the garlands; there is a gay throng of putti to keep things moving; the recipients, laymen and clerics, kneel on either side, while their supreme representatives, the emperor and the pope, the former with the features of Maximilian, receive their gifts directly from the hands of the Virgin and the Child. The whole is simple in its symmetry and reveals a considerable study of Giovanni Bellini's work. The isosceles triangle of the central group is supported by the angel with the lute at the Virgin's feet and stressed by the shining backcloth. But the main body of the brotherhood spreading out at the sides is a garland itself, as it were, to the monumental centre. On the extreme left there are bigger trees and bustling putti, on the extreme right Dürer and another man appear. The brilliance of the colouring is a novel feature. Yet details are carefully elaborated throughout the whole. The brush study for one subordinate figure, the builder (w382), made after life, has become something like an epitome of the Faustian conception of the Gothic artist.

Thus for a short time the painter in Dürer was relieved from the pressure of his graphic vision. The Virgin with the Siskin of 1506 (Berlin) is evidence of it if we compare it with the Adoration, which was painted only two years before. The same is true of the Berlin Portrait of a Young Woman (Plate 61). One of the basic elements of this portrait is its atmosphere, the other the simplicity of its modelling. Only a shadow unites the cheek and neck, entirely in terms of nuance. On the side which catches the light, the formal irregularities are traced with a delicate brush. Dürer had taken his first steps in this direction in a charming Portrait of a Girl (1505, Vienna), while on his way to Italy he had still drawn the rough face of a peasant woman with a vigorous hand (w375), but without any trace of light effects.

In the Christ among the Doctors, however (1506, Castagnola), very little Venetian influence can be seen. Unconventional in its iconography, it presents the psychological situation of a futile disputation. The beauty of the young Christ sets off the hideousness of the scribes; the assembly of busts, of quirkish heads and hands, practically without spatial relation to each other, seems to be quite disconnected against the black background; the proportions differ as widely as any on a study sheet. The wrangling group is an indication of Dürer's theoretical drudgery and at the same time of his familiarity with what are known as Leonardo's caricatures. The violent gestures are Italian, and the only centre in the picture is given by the knot of four hands, those of Christ summing up his arguments and those of the genuine caricature of the Pharisee bursting into the picture on the right, after the fashion of a Late Gothic ornamental knot.

Through his contact with the ideas of Leonardo and Alberti, Dürer now became for good and all a theoretician, having already previously attempted to explore proportion and perspective empirically. His irresistible drive forward now at last reached its adequate field, and his eyes were opened again to the indivisible unity of the human figure. The flowing outlines of the wonderful nude from the back of 1506 (w402) are no longer composed of strokes of the compass; they are accompanied in the interior by a line of deep shadow, and a blank area on the side away from the light makes the modelling of the body almost sculptural. That was the victory over all that had been Quattrocento in Dürer's early classicism. This clarification was carried out with the

76

help of a kind of Gothic, as can be seen in the panels of Adam and Eve (1507, Madrid; Plate 66). Unlike the figures in the engravings, Adam and Eve are supple and remarkably slender. Adam is not in full contrapposto, and his gesture is expressive and refined. Eve turns from the snake to the man with the movement of a dancer and points to the branch where the apple hangs before him. Her look is direct, and there is terror in her eyes; his look is grander, more ecstatic, and his expression is divided between desire and resistance. They are painted almost with preciosity – especially the Adam – in brunaille on a dark ground, which is enlivened only by a few green leaves, the red apple, and the red of the lips, together with the whitish pink of Eve's flesh and the scarlet head of the snake. This is Dürer's happiest picture.

After the altar of the Assumption of 1509, made for Jacob Heller (it was in the Dominikanerkirche at Frankfurt and was destroyed by fire), the centre panel of which he made entirely with his own hand, with great labour and the finest of fine painting, Dürer no longer attempted to compete with the craft of late medieval altar painting on a large scale. Thus the picture which goes by the name of All Saints (1508–11, Vienna), and is smaller in size, is an end (Plate 67). It represents the Adoration of the pre-Christian and Christian denizens of Heaven hovering round the Trinity in the upper range of the picture, while below the Christian congregation, temporal and spiritual, is permitted to gaze upon the Trinity itself, in so far as it belongs to the *civitas dei*. Right at the bottom, as in the two preceding altarpieces, Dürer appears, standing alone on the earth in a shining landscape. In its figuration of St Augustine's thought, this work is unprecedented; the Last Judgement, which could be expected as a companion piece, has been relegated to the carved wooden frame designed by Dürer himself; it is the first Renaissance frame in Germany and is of North Italian derivation. In the picture Dürer once more achieved without effort or drudgery what was innate in him as a painter, a wonderful kind of miniature-painting, which can stand comparison with that of the old Netherlands masters, and he sacrificed to it, to a large extent, his Venetian tonality. The vortex of the throng below is amazing; they look countless owing to the deep rift between temporal and spiritual figures, and because the frame cuts across them. The figures are more weighty and sculptural than in similar scenes in the Apocalypse, but they are credibly poised in space by the late medieval art of drapery.

At the end of the period, in 1512, Dürer received a commission he could hardly reject; the over-life-size figures of the Emperors Charlemagne and Sigismund were to be painted for the 'Heiltum', i.e. the treasury of the imperial regalia which had been kept at Nuremberg since Sigismund's time. The insignia and weapons are based on antiquarian studies: Sigismund's features are probably taken from an old picture. As regards Charlemagne, with his feeling for history, Dürer gave him the majestically patriarchal bearing of the first Holy Roman Emperor.

The succeeding period saw the culmination of his graphic art. A fresh increase in production had already begun in 1508–9. In their chiaroscuro effects, the woodcuts became still more akin to painting. Since his visit to Venice, Dürer had used for his drawings the medium tone of a coloured paper which he touched up with white. With shadows not indicative of form but tending to produce the effect of great homogeneity,

he won from his graphic art the greatest attainable tonality and light effects. There is some influence here from the light and comparatively decorative woodcuts of his pupil, Baldung. Visions or miracles such as the Resurrection (B15) or the Assumption (B94) take place in front of bright clouds in the middle tone. The Arrest (B7) has become a night piece rent with flickers of piercing light and deep shadow, and the interiors, for instance in the Last Supper (B5) and the Death of the Virgin (B93), are filled with flickering twilight. For this was the time when Dürer completed the final pages of the Great Passion and the Life of the Virgin, provided the three *Grosse Bücher* with title-pages, and published a first edition of them (in 1511) and the second of the Apocalypse, all through his own firm.

Further, he had been working since 1509 on a small-format woodcut album, entirely in the new style, and also published in 1511, namely the Little Passion. With its thirty-seven sheets, it is Dürer's most complete presentation of Christ's Passion; it begins with the seated Man of Sorrows, with the Fall as its motive, and enframed by the pictures of the Annunciation and the Nativity, the Descent of the Holy Ghost and the Last Judgement. In the actual scenes of the Passion, the bodily suffering and the degradation of Christ take the leading place; the beating under the eyes of Annas is terrible, the mocking of the defenceless Christ becomes despicable, the fall during the Bearing of the Cross is as unbearable as the Crucifixion and the Deposition, in which the slaughtered body falls on the shoulder of the man on the ladder. Yet there are, on the other hand, meditative and devotional woodcuts in between, especially those in which there radiates from Christ's head, which always appears without a halo, a cross-shaped light. There are four wonderful visions of the resurrected Christ; in one of them the light has become the dawn behind the mystical Gardener's back. Delicacy and terror constantly go hand in hand.

At the same time, starting in 1507, Dürer began a fifth series, the Passion in engravings (published in 1513). It is no work of edification, and has no text; with its sixteen sheets it was intended for connoisseurs who could appreciate the artistic opulence of the work. While in the woodcuts the deeper feelings were expressed in vigorous, yet simple scenes, while a more generally appealing tone had been won from the new kind of twilight scenes, in the engravings the artistic perfection is most pronounced in the night-pieces. The theme is the spiritual suffering of Christ; untouchable, he receives the kiss, he bears the Cross with perfect dignity, dies like a Hercules, and stands like Apollo on his coffin after the Resurrection. Even the inward feelings of his fellow-actors are recorded – the mourners, Pilate in his official isolation; Christ, praying on the Mount of Olives, raises his hands in a passionate gesture. At this point Dürer may have had Cranach's earlier woodcuts before him. As a whole, however, he seems to have approached Grünewald again. His mystical bent in woodcut and painting may be explained in the same way. We have no certain records of meetings between Dürer and Grünewald, but if any took place, they must have been far greater in importance than, say, Dürer's borrowings in the Little Passion of isolated motifs from Schäufelein's *Speculum Passionis* of 1507.

From that time on, Dürer achieved perfection by control. In 1513–14 he made the

three so-called 'master engravings'. Although they are of nearly the same size, they are not a series. Yet they form a spiritual unity; they reveal Dürer's work saturated by humanism to the last detail. Three ways of life are illustrated: those of the moralist, the theologian, and the intellectual artist.

The Knight, Death, and Devil of 1513 places the *miles christianus* (on whom Erasmus had written the *Enchiridion*) on earth, when he has to decide, regardless of all misgivings, to go his own way of action. In the figures of horseman and horse a drawing of armour of 1498 (w176) has been combined with the forms of a horse in movement suggested by Leonardo's Sforza Monument. Burgkmair's portrait woodcut of Maximilian on horseback of 1508 also entered into the theme. Quarry studies of his first years at Nuremberg were pressed into service too. In front of the steep, scaling rock face monsters appear before the rider, the absurd Devil, and the repulsive Death in the guise of a corpse with snakes coiled about on a jaded mare. The dog alone stands to its master and his horse in this repellent whole; tireless, tractable, intelligent, he embodies the fundamental virtues which the knight of Christ must have. Thus the three figures in the foreground form a unity; the strictness of their pure profile expresses their unfalteringness. There is no real place for Death and the Devil – they are phantasms of the marshy forests of the north, and the vehemence of this armed procession relegates them to the region of spectres. But, characteristically, it is the unwieldy, tortuous 'Gothic' forms which symbolize the thicket of temptation against which the knight stands out in his classical idealism.

The companion piece to this *vita activa* is Dürer's *vita contemplativa*, namely St Jerome in his Study of 1514. St Jerome was the saint most beloved of the humanists. Erasmus saw in him the prefiguration of his own endeavour to purify the ancient and venerable texts. Dürer's St Jerome inhabits the spiritual world of devout meditation, in which decisions must be taken which are not always philological in nature. Thus the saint is reduced to a small figure at the back of the room; his prime task is to listen attentively and understand well. We feel this in the peace of the study, in the tidiness with which the objects, nearly all set at angles against the perspective of gradually converging lines, are arranged round him with simple clarity. The room lies open before us, but it is shielded from any invasion by the amiable lion and the sleeping dog. It is cosy because it is a bit disorderly, and is made inviting by the sunshine pearling in through the bottle-end windows. In this middle region between light and dark, between diffused lighting and the small but shining halo, between the solid old walls and the muted tones of wood, St Jerome carries out his humble but absorbing work, like a gentle but bright little fire.

As a rule, when Dürer gave away this sheet, he did so along with the third master-engraving, the Melencholia I of 1514. The two works do not represent different ways to one goal but ideals innately hostile one to the other. In Melencholia I, the worldly spirit of the rational and imaginative domains of science and art stands out great among the heaped tools and emblems of architecture and geometry. But there is no attempt to reduce them to order. The genius has no roof over her head; she huddles beside an unfinished building near the sea. It is a moonlit night, while St Jerome's cell is flooded

with sunshine. Here again Dürer found the raw material for his sheet in popular late medieval illustrations and pictures of those afflicted by melancholy. The result in Dürer's hands was an incomparable creation, a *melancholia artificialis*, the melancholy of the artist. The traditional pose of the head supported by the hand reveals its old double meaning as an attitude of mourning and thoughtfulness. The face is shadowed, and gives the impression of a clouded mind, especially by the whites of the eyes. Melancholy is both in her blood and on her face. The putto at her side, twiddling at his work, personifies in her state of mind that mere mechanical skill which has no purpose but itself and acts senselessly, while art, sleepless and passive, has sunk into dull brooding and lost the power of action. The temptations offered by the whole host of objects cannot be simply swept away by the resolution of the *miles Christianus*, they are not blotted out by the kindly gravity of the learned saint, but tormentedly hold their ground and strike at a state both of mind and body. Dürer's art had once attained, through humanism, a new wealth of subject matter and the awareness of the south; this was now followed by the setting-up of an aesthetic and moral programme and the beginnings of a practical and theoretical investigation of beauty. But the Melencholia I owes its true essence to Dürer's humanism. In his *Occulta philosophia* of 1509–10, Agrippa von Nettesheim speaks of the inspiration which comes from the *furor melancholicus*, thanks to Saturn. As a first step, it creates imaginative insight within the bounds of space and volume. Can Melencholia I be simply this creative being faced with impassable barriers? Yet Dürer never made a Melencholia II of political prophecy and a Melencholia III of heavenly divination. In any case, this mysterious sheet of Melencholia I expresses the humanistic self-knowledge of Dürer the artist and geometrician, who received inspiration from above (*öbere Eingiessungen*), who went through the deepest depressions, and who confessed to himself about 1512: 'But what beauty truly is I do not know. God alone knows.'

Yet these engravings enriched the world with one realization – that artistic value is not identical with the mere size of what has been created. He knew that himself: 'And the conclusion is that many a man sketches something on half a sheet of paper in one day, or cuts something on a little bit of wood with his little iron, and there is more and better art in it than in some great work by another who has laboured on it for a whole year.'

In 1512 Maximilian began to employ Dürer on his projects. Here Dürer had to prove his worth in woodcuts in competition with the artists of Augsburg, particularly Burgkmair, who had been in the emperor's service for many years. Dürer collaborated in Maximilian's Gate of Honour, i.e. Triumphal Arch, and Triumphal Procession, which had been conceived by humanists according to the emperor's instructions and worked out in miniature pictorial form by Jörg Kölderer. Burgkmair was responsible for the Triumph. In the end Dürer contributed very little to it, except for the gay and youthful 'Burgundian Wedding', when it was published in 1526. He published Maximilian's Triumphal Chariot on his own account in 1522 as an allegorical variant of the original design.

The Triumphal Arch was a huge kind of placard, and it was Dürer's business to

determine its general lines. He was no courtier, and he replaced the noble restraint of the Augsburg artists by strong modelling and fiery exuberance. If Dürer had been able to stand his ground against his fellow-artists it would have been another shrine of St Sebald. The result was a mammoth woodcut (B138), eleven feet high, printed from 192 blocks which were cut between 1515 and 1517, and are for the most part based on designs by other artists, namely Wolf Traut and Hans Springinklee of Nuremberg and Albrecht Altdorfer. Dürer himself designed a few figures and some vigorous ornamental and architectural details. The whole is remote from the Roman triumphal arch, the more so as there are no horizontals in it. The purpose of the strangely fantastic front view is to glorify Maximilian's *Honour and Power* in every direction by a summary of his other publications. It is as instructive as it is strange, and has to be decoded like some kind of secret writing. Thus it takes on the character of a Mannerist marvel. It is one of the few ideas of Maximilian's that he ever saw carried out to completion. Dürer contributed only five illustrations to *Freydal*, Maximilian's account of himself (1517). For the rest, there were a large number of occasional commissions, some of which are only known to us from precious drawings. The two posthumous portraits of the emperor (Nuremberg and Vienna) were not painted on commission.

The most beautiful products of this connexion, however, are the drawings in the margins of the printed prayer-book which was probably put together for the Order of St George and was designed in part on Maximilian's instructions and printed at Augsburg in 1513 (Plate 63). Dürer did the beginning and ornamented forty-five pages in coloured ink so that they would balance the black mass of the text; the remaining pages, once Dürer had created the pattern, were distributed to Cranach, Burgkmair, Baldung, Breu, Altdorfer, and others. The work remained unfinished as a whole. In any case, the intention was not to make an illustrated special copy for the emperor, but to provide models for the finest kind of woodcut illustration. The text, in an archaic, animated black-letter type, is an attempt to reproduce liturgical manuscripts of the fifteenth century. It would have been a Book of Hours for the connoisseur of the printing press.

What we possess is splendid enough. Dürer took it as an incidental and amusing *hors d'œuvre*, free of all the official allegory of humanistic programmes. He improvised with his pen, picking up a sentence, or even a word in the text, with a freedom which at times makes it impossible to discover the connexion. Christian texts, liturgical texts, moral interpretations, figures of Hercules with mythological allusions – this illustrative material is blended in a weightless but abundant flow of ornament traced by the vigorous pen of an inexhaustible story-teller. Once again the forms of south and north are blended – free, animated Late Gothic with grotesques – yet in such a way that Dürer's characteristic sense of modelling remains unchallenged. In this work Dürer spoke his own language, with spontaneity and humour, and also with an abundance of creative imagination.

The classic side of Dürer, the German classic, comes to an end in this free efflorescence of ornament. In 1521 he made some more ornamental designs (W921), probably for the Nuremberg Council Hall. But his classic phase is actually bounded by the years 1505 to 1515, between the Rose-Garland Festival and Maximilian's prayer-book. It is the

closest possible approach of the German of that century to the spirit of the south and to the classic as a whole. Yet even in the nude seen from the back of 1506, in the portrait of the Venetian woman, in the Fall, and in the master engravings, he never achieved the noonday repose of a true classic moment at rest within itself, i.e. anything like the harmony of a Raphael. Even during these years there was tension and curiosity, and a burden of unresolved conflicts. The probing preliminary studies for the Heller altarpiece (w448–65), the additive and finicky procedure of his large paintings, the horrors of the Little Passion, the Gothic and demonic elements in the master engravings would have no place in the conception of an enchanted summer garden of the classic kind. The Germans never had, nor could they have had, a serene classic.

In addition, we possess portraits by Dürer dating from this period which stand witness to his absolute fidelity to reality, and even to its bitterness. In 1514, shortly before her death, he made a splintery charcoal portrait of his mother (w559; Plate 55); it is the bony face of an old woman exhausted by the birth of eighteen children, with squinting eyes, bigotry in her gaze, and a withered neck in lines which are coarse and pitilessly describe ugliness, and yet combine to form a reverent and moving picture.

That was the starting-point of a grandiose series of large portrait drawings, mostly in chalk or charcoal, which Dürer raised to the standard of an independent genre. All were of an unprecedented fire, of a realism transcending anything that could be achieved – within classical bounds – unmistakably individual physiognomies of robust personalities rendered in a forceful modelling. Two enchanting girls' heads (w561, 562) were drawn in 1515. At the imperial diet at Augsburg in 1518, Dürer made a swift but majestic sketch of the emperor, and drew Cardinal Albrecht of Brandenburg and Jacob Fugger in heavy semi-profile, the Graf zu Solms in full profile, and Hans Burgkmair with an intuitive objectivity which was his not contemptible rival's due (w567–71). The same bearing characterizes the painted portraits, for instance the broad, amiable Unknown Man of 1516 (Washington) and the bird-like, headstrong Wolgemut of 1516 (Nuremberg). These were the years when Dürer also produced the gnarled and wrinkled heads of the apostles of 1516 (Florence) and the Virgin and Child with St Anne, almost glassily transparent in its colouring and substantially rounded in the modelling (1519, New York).

All this was accompanied by further theoretical studies and more work on construction. What he aimed at was to build up the human body by volumes and not by planes. The Dresden sketch-book of 1519 contains drawings of heads split up into facets. Later, Dürer endeavoured to apply these cubic constructions to the human body in movement by means of orthostatic projection. But even in engravings of 1519, such as the 'Little' Cardinal Albrecht (B102) and the Virgin nursing (B36), the important element is the volume of the figures, which is, however, made to appear clear and measurable. And in the engraving of St Anthony (B58) of 1519, not only the figure of the saint but the citadel too – after a view taken on his first journey to Venice – is piled up in the landscape in overwhelming volumes. Dürer's post-classic style was supersculptural.

So the visit to the Netherlands – was it perhaps also a second visit? – gave him little

that was quite new and strange; but it brought him confirmation, freedom, and elation. We can see it in the sketch-books of this journey, one in a narrow, upright format with pen-and-ink sketches, mainly of human faces (w744–60), the other in oblong format, with sketches in silverpoint of a large number of things he saw, tools, works of art, human beings, lions, dogs, views of towns, buildings, which he interpreted strictly sculpturally – a large collection of material observed as though they were still-lifes (w761–87).

Dürer's homage to Antwerp is recorded in the pen-and-ink drawing of the harbour of 1520 (w821; Plate 64), which is probably unfinished. The first thing he grasped was the spatial whole, not the details. The transparent lines of the masts and ropes of the boats set off the picturesque but cubically effective buildings, because they are brilliantly lined up in a space-creating diagonal, and this effect is heightened by the diffused light of the overcast sky of a town not far from the sea.

Only a few portraits have come down to us from the nearly 150 which Dürer made in the Netherlands. More than a dozen drawings, for the most part in chalk or charcoal, were finished works of art intended for presentation or sale, and formed a magnificent continuation of the series begun in 1514. The men – but Dürer's wife also figures in the series – are generally bust-length, and the brim of a huge cap acts as counterpoint to the features. There is a preference for a dark background, and the energy of the whole is enhanced by white lettering added above. An attractive portrait of Erasmus (w805), not quite finished, is among them, and another of Bernart van Orley, the painter (w810), also; there are rather smaller sheets in silverpoint of Sebastian Brant(?), the satirist (w817), of Lucas van Leiden, the painter (w816; Plate 57), and a young Negress, Catharina (w818), whose alien features are enchantingly human. Some painted portraits of 1521 have also been preserved, for instance the exquisitely executed Bernhart von Resten (Dresden) and Lorenz Sterck (Boston, Isabella Stewart Gardner Museum); this is almost a brunaille, with some blue tones and carmine to breathe life into it. It is up to Dürer's supreme achievements.

One sacred picture has come down to us from this period at Antwerp, namely St Jerome in Meditation (1521, Lisbon; Plate 60). Dürer took as his starting-point the head of an old man of ninety-three, drawn by him twice (w788–9); he sits with sad, downcast eyes, in the harmonious waves of his hair and beard, in the play of light over his wrinkled skin, the narrow slit of the mouth, and the prying, sensitive oriel of the nose, drawn down to the last detail. The painting, in vermilion and bluish-grey on a warm green background, shows the corner of the study and the desk with a book; the right hand has the head leaning on it, and the left, pointing down to a skull, adds a *memento mori* to the picture. The crucifix and the inkwell bear witness to the work the saint has laid aside and the service in which he stands. What the picture really has to say is in the meditative absent-mindedness of the eyes, which only seem to look at us. While the master engraving gave us a learned St Jerome in the spirit of Erasmus, this picture of the saint, as the artist probably intended, is Lutheran, of that early phase when the Reformation seemed to be reopening the whole world of the spirit, and the spiritual minds of Antwerp were drawn to it. From the stylistic standpoint it offers many a tribute to the country in which Dürer was staying; above all, in the space-creating play of the light,

which is atmospheric and dusky in quite a different way from that of the Virgin with the Child and St Anne. There seem to have existed Flemish half-length pictures of St Jerome, and Quentin Massys may have painted a St Jerome in his Study. In any case, Dürer's approximation to the artistic spirit of the Netherlands was epoch-making at Antwerp.[9]

Back at Nuremberg, Dürer set about preparing his writings for the press. They were set up in a black-letter type designed by the Nuremberg writing-master Johann Neudörffer. It was the first black-letter type to be used generally. Dürer furnished the illustrations, among others a draughtsman drawing the portrait of a man, a reclining female nude, and a lute and a tankard in perspective with the help of a squared pane of glass. The still life and the nude itself, the latter for the first time in the north, were treated as artistic problems with the simple purpose of showing how to do it right.

The portraits of the last seven years are splendid. There are a number of profiles among them. The huge woodcut of Ulrich Varnbühler (B155) was made in 1522, the 'great' Cardinal Albrecht, an engraving (B130), in 1523, both with full-blooded faces under ornate headgear, with inscriptions and an escutcheon filling the background, Varnbühler turning his head dramatically, Albrecht bloated and oddly rigid. Yet both are treated in such a way that the spiritual quality of the sitters also comes out in the outline. The Melanchthon engraving (B105) of 1526 is simpler, more human, with deepset eyes under the mighty roof of the forehead. The starting-point of all these portraits is the sculptural quality of the sitter. The Erasmus engraving (B107) of 1526 was the first three-quarter-length portrait to be produced in Germany. The most splendid of all are the portraits of Friedrich the Wise (B104) and Willibald Pirckheimer (B106). In the Friedrich particularly the manner of representation which describes every single form is balanced by the supreme and intense linearity of the hair and the fur.

The culmination came with the portraits of Hieronymus Holzschuher and Jacob Muffel (1526, Berlin; Plates 69 and 70). They were dignitaries of Nuremberg, and the paintings were probably intended as companion pieces from the outset; in any case, they are so closely related to each other that they look like epigrams with a touch of humour, and once again sum up the polarity in Dürer's genius for portraiture. The forms in the Holzschuher portrait, dominated by the nose arching from the middle of the face and the eyeballs turned towards us, are veiled by the waves of the comparatively smooth hair and a beard which has been groomed with a touch of vanity. Muffel's magnificent, clearly outlined skull, modelled with a sculptor's hand on the cheekbones and temples by strongly marked shadows, stands as naked as a building, imposing order on all the rest, the slightly veiled, quiet look, the small nose, the thin lips, the almost metallic forms of the ears. In this painting there is hardly a form which is not sculpturally stimulating. In the Holzschuher portrait, however, there is the calligraphy of the hair; its incredibly delicate execution is perfectly characteristic, but there is a touch of Mannerism in it too. In this portrait Dürer clearly started out from these details and built out of them the figure of a stubborn old craftsman-citizen in his tamelessly fiery spirit and all the limitations of his wrongheadedness. In the conception of Muffel, on the other hand, his starting-point was the whole, determined by the fine forehead, and

we are given some inkling of the self-discipline and autodidacticism of a cool, conscientious, but not really great man.

At Nuremberg, Dürer started on a number of sacred subjects which all remained unfinished. Drawings for a woodcut Passion broader than high had been made since 1520 (w793–9, 803, 889). As a narrative with many figures it would have been a serious summons to meditation; the figures in the Bearing of the Cross and the Entombment move parallel to the picture-plane and are remote from the spectator, the space is conceived in strata, like a relief. There is an objectivity in these narrations which the earlier Passions did not have. Dürer was replanning in them what he had executed for the Little Passion (B54) but rejected: Christ on the Mount of Olives (after Mantegna), lying on the ground, his arms outstretched in a gesture of utter submission. The only drawing that Dürer gave to a cutter was the Last Supper of 1523 (B53). In this sheet we feel a definite adherence to one of the fundamental requirements of the Reformation, namely that the Eucharist should be, not a sacrifice, but a 'Testament and Sacrament'; there is emphasis on the bread and wine, but the dish that traditionally contains the Lamb stands empty in the foreground and presents a striking contrast to the window at Christ's head.

Another important scheme, however, had to be abandoned on account of the Nuremberg Reformation of 1525: a painting of the *Sacra Conversazione*. From this plan there have come down to us six compositional studies, one sheet with angels making music, and more than a dozen wonderful heads, hands, and drapery (w836–57), the earliest dated 1521. This Adoration of the Holy Family by saints and angels, combined with a picture of the Betrothal of St Catherine, would probably have represented the sum of all the endeavours to blend north and south. St Barbara and St Apollonia (Plate 56), two basic female types of piety and devotion, in the simplest and clearest sculptural form, yet with all the freshness of direct observation, without finickiness and in an enchanting play of light, would have found their place in the great composition.

The only parts to be executed, though with decisive alterations, were the so-called Four Apostles of about 1525, presumably begun as wings (Munich; Plate 68). St Philip (B46) on the right wing was turned into a St Paul when it became an independent picture. A reminiscence of Giovanni Bellini's pairs of standing figures on the wings of the Frari altar came in too. St John and St Peter, St Paul and St Mark (in reality an evangelist) are represented. They are Dürer's artistic last will and testament, and were presented by him to the City Council in 1526 as a memorial. Built like stone statues, motionless in the huge drama of their drapery, the foreground heads in almost pure profile, these monumental figures show that Dürer was occupied with a final clarification, a grand manner of his own. He may have been thinking something of the kind when he said to Melanchthon: 'When I was young I sought for variety and novelty; now, in my old age, I have begun to see the native countenance of nature and to understand that this simplicity is the ultimate goal of art.'[10]

Thus Dürer, according to the evolution of the whole, worked on the parts to unequal degrees. St Paul is drawn with great precision, St John modelled more broadly, while the others are added in a more painterly fashion. As Neudörffer says, he had shaped the

heads to represent the four temperaments, to the left the sanguine and phlegmatic, to the right the choleric, with St Paul as the melancholy. Thus they are not merely characterized as saints, but as four fundamental kinds of religious experience. The theory Dürer so often followed assigns to St John the happiest temperament, that of innocence, but to St Paul the most dangerous and sublime. This is Dürer's last word on Melancholia in its ultimate form.

Dürer presented the pictures to his native city entirely in the sense of an exhortation. Long quotations from the writings of the four saints, drawn up by Neudörffer after Luther's September Bible, are placed at their feet, to give warning of false prophets and abominable heresy, and are launched just as much against the Protestant sects and radicals as against the adherents of the old faith.

Dürer's Earliest Successors in Franconia

When the *artis praeceptor Germaniae*, whose influence spread far beyond the domain of German art, died in 1528, none of his more important pupils was still active at Nuremberg. In the first ten years of the century, Baldung, Schäufelein, and Kulmbach had passed through his workshop, while Pencz and the two Behams belonged to a younger generation.

Hans Suess, known as Hans von Kulmbach because he was probably born in that Franconian town between 1475 and 1480, lived at Nuremberg until 1522.[11] In his youth he had come under the influence of Barbari, who was at Nuremberg from 1500 to 1503. What distinguishes Kulmbach from Dürer is that his figures are more slightly built and slender, yet his work as a whole reveals him as Dürer's pupil. At times Kulmbach worked in close collaboration with him and was obviously one of his intimates. In 1501 and 1502 he delivered woodcuts in collaboration with Dürer for two books by Conrad Celtis; among his other book illustrations there must be mentioned thirty woodcuts in Ulrich Pinder's *Beschlossen Gart*, published at Nuremberg in 1505. His stained-glass work, which starts about 1508, was the beginning of a new efflorescence of the art at Nuremberg: the windows of Maximilian and the Margrave in St Sebald which were made in Veit Hirschvogel's workshop, were designed by him in 1514. His considerable work as a draughtsman never attained the importance of Dürer's.

Kulmbach was a born painter, and his work is entirely original. In the roughly fifteen years of his independent, fruitful career, he – side by side of course with Dürer – gave Nuremberg painting its own peculiar mark. About twelve altarpieces with wings by him have been preserved, some of them with carved centre panels. Dürer's retirement from this kind of work in 1510 left the field open to Kulmbach. The following pictures are worthy of mention. First, the scenes with St Peter and St Paul taken from an altarpiece in eight parts (before 1510, Florence) and the altarpiece of St Anne in St Lorenz (1510). Then between 1511 and 1516 he delivered at least three altarpieces to Cracow (Krakau): the central panel of the altar of the Virgin, an Epiphany, is now in Berlin; an altar of St Catherine survives in St Mary's; and of the St John altar, at least the predella remains (Warsaw). In 1520 he painted an altar for Schwabach.

In the first of these altarpieces individual motifs of Dürer's stand out clearly; in 1513 he painted the Tucher votive picture in the church of St Sebald after Dürer's design of 1511 (w508), but from the beginning these pictures lived by their colour, and were youthful, calm, and personal all at once. The wings are not movable and are too big to cover the centre panel. The later Cracow altars are a deeply felt narration of the lives of the saints; there is a romantic strain in the landscape which recalls the manner of the artists of the Lower Rhine and Northern Netherlands, with whom Kulmbach may have become familiar in his *Wanderjahre*. The Tucher triptych, a Virgin under a huge round-arched aedicule, differs from Dürer's drawing in the greater freedom and charm of its composition. As a rule, the colouring is held in soft tones of the primary colours with the addition of a warm green. The feeling is never fiery, and hell, in the Rosary picture on the Plassenburg at Kulmbach, is not even infernal.

Yet the range of expression in his few portraits is not narrow. Beside the robuster portrait of his later years, now at Nuremberg, and the thoughtful, tender youth of 1520 (Berlin) there is the Margrave Casimir of Hohenzollern (1511, Munich; Plate 72), in a pale yellow cloak embroidered with the phases of the moon and a white and gold costume which is both imaginative and true to life. Even in his portraits the colour has more to tell us than the line. He is a painter of the beautiful, and in his work there breathes a tender and appealing humanity.

Hans Schäufelein was born about 1480/5, perhaps at Nuremberg, and died between 1537 and 1540 at Nördlingen, where he had settled in 1515.[12] His early work in painting, which began soon after 1500, is full of reminiscences of Dürer, which he took over with a kind of fumbling audacity. This comes out especially clearly in the altarpiece of Ober St Veit (*c.* 1505–6, Vienna, Diözesan Museum), which Dürer had apparently asked him to execute and which he had to paint, for the most part, after his master's drawings (w319–26); this brought him for a time under the full severity of Dürer's influence. But in addition to cool splendour he dashed off virile male portraits (1507, Warsaw and Washington). One of his natural gifts was poured into his extensive work in woodcut; he delivered 170 woodcuts for the *Beschlossen Gart* of 1505, 29 for Ulrich Pinder's *Speculum Passionis* of 1507, and from 1511 on he was kept hard at work by Augsburg publishers, collaborating also in Maximilian's *Theuerdank*, *Weisskunig*, and *Triumphzug*. At Nördlingen he continued designing for woodcuts. A born, extraordinarily fertile story-teller, he was more warm-hearted, intelligible, and melodious than Dürer.

The Crucifix with King David and St John the Baptist is his earliest dated altarpiece (1508, Nuremberg); it was in this work that he became free of Dürer, and, more than that, discovered his own style in the gentle emotionalism of the two heralds of Christ and the brown-green harmony of the colouring. For a time he worked in Hans Holbein the elder's workshop at Augsburg. He may have seen early works by Cranach and Breu in Austria. About 1509 he painted proto-Baroque pictures for the wings of the huge carved altarpiece by Hans Schnatterpeck at Niederlana (Lana) near Merano.

From 1510 on he was active in Swabia; panel pictures gradually came to the forefront of his work. The series of four heads of 1511 (Vienna and Kreuzlingen, private collection; Plates 75 and 76) are something like psychological studies of the four

temperaments or the ages of life. The Auhausen altar of 1513 shows Schäufelein's mature style, though tempered by Augsburg influences. The votive tablet of Anna Prigel (d.1517, Nördlingen, Museum), is a tall, lavishly coloured work and, especially in the elongation of the figures, a presage of Mannerism. For his later years, the Ziegler altarpiece (1521, Nördlingen, St Georg) and the St Peter paintings from *Christgarten im Ries* (Munich), from the end of the decade, are characteristic; graceful, rich in tone, based on a balance of red and blue, the patches of colour rather loosely strewn over the green of the landscape. Unlike Kulmbach, Schäufelein often had weak passages side by side with moments of deep feeling. Towards the end, as his freshness faded, the general quality of his work declined with it.

What Schäufelein retained till late in life was a marked sense of characterization; his portraits are more dreamy, more vulgar than those of the more delicate Kulmbach. Abbot Hummel of Deggingen (1531, Schleissheim) is rendered in a very personal and quite Mannerist style: he looks as flat as a shadow on a monochrome background, and is spatially rather cramped than released by the Renaissance porch and crowded in by escutcheons, crests, and inscriptions.

Among the lesser followers of Dürer ranks Paul Lautensack the elder, who was born at Bamberg in 1478 and died at Nuremberg in 1558. His Farewell of Christ (Nuremberg) borrowed from the master its timidly iridescent colouring. There was also Wolf Traut, who was born and died at Nuremberg (c. 1480–1520), the son of Hans the younger, whose Holy Family altarpiece of 1514 from the Clothmakers' Chapel near St Lorenz (Munich, Bayerisches Nationalmuseum) was based on Dürer with a certain naivety, while single works, like the St John the Evangelist (Nuremberg), have a touch of the Danube style in their chiaroscuro. Dürer engaged him as a designer for the Arch of Honour.

For this, he also engaged Hans Springinklee,[13] who worked as a miniaturist at Konstanz in 1510–11, lived at Nuremberg in 1512–22, and seems to have died about 1540; he worked on Maximilian's Triumphal Procession too. He seems to have been Dürer's closest associate and was thoroughly conversant with his woodcut style. There are a considerable number of works by him extant, mostly made for the Nuremberg printers. The manner of his activity as a painter is not quite clear.

PAINTING ON THE MIDDLE AND UPPER RHINE AND IN SWITZERLAND

Mathis 'Grünewald'

IN 1510, or not long after, a master had to be found to paint the wings to the altar-shrine carved by Niclas Hagnower of Strassburg for Isenheim. But no painter existed on the Upper Rhine who could stand comparison with him, and Hans Baldung had probably not been recognized as such. Therefore the commission went to the Middle Rhine.

At Frankfurt, Martin Caldenbach, surnamed Hess (*c.* 1470–1518), was active at the time. He had been a friend of Dürer's, and had made a certain name for himself.[1] In 1506 Caldenbach painted a lifelike portrait of Jacob Stralenberger (Frankfurt). He worked as a designer for woodcuts in a few books printed at Mainz and Strassburg.

The Isenheim commission, however, did not fall to him, but to Grünewald.[2] With him the second contribution of supreme genius entered the development of German painting, the first having been Dürer. The name Grünewald is incorrect: it is based on a historical error of the seventeenth century. His name in fact was Mathis Gothardt Neithardt, and he was probably born at Würzburg. He was either the painter and wood-carver who was living at Seligenstadt near Aschaffenburg from 1500, or the painter who was working at Aschaffenburg about that time. Either artist may also be the 'Mathis' mentioned at Aschaffenburg from 1480 to 1490, who seems to have left no independent work behind him. Should the latter be the case, he must have been born about 1455/60; if it is not, he was probably ten or fifteen years younger. This Gothardt Neithardt was soon taken into the service of the Archbishop of Mainz, superintended the rebuilding of the castle of Aschaffenburg for Uriel von Gemmingen about 1511, entered the service of Uriel's successor Cardinal Albrecht of Brandenburg, and was employed probably about 1521–3 in his other capital, at Halle an der Saale, as artistic adviser and clerk of the works. Thus for years Mathis was connected with the most highly cultivated court and the most worldly prelate in Germany.

Pre-Reformation trends probably influenced him, as they did the humanist cardinal himself; it is certain that he adopted Lutheran ideas about this time, yet his work corresponds in no way with the artistic ideas of the Reformation, which were in any case not yet fully mature. He was probably involved on the peasants' side in 1525; it may be for that reason that he escaped to Frankfurt in 1526–7, and subsequently to Halle, where he died in 1528 as a 'Wasserkunstmacher', i.e. probably as an employee in the salt-works.

There must have been an engineering streak in him. He appears as an expert on wells in 1510 and in 1517. In 1527 he received at Frankfurt permission to draw for the city of

Magdeburg the *Mainmühlen*, an industrial power station. He also seems to have dabbled in chemistry as a 'soap-boiler'. He obviously knew something about medicine, partly, maybe, from its magic side. This contemporary of Dürer's was a versatile personality. He is not mentioned by the humanists, except by Melanchthon in 1531, but he was probably acquainted with some scholars of the Middle Rhine, and he had at least three Italianate patrons, the two archbishops and the preceptor of Isenheim; his own store of knowledge was great, even if it was not specifically humanistic.

In such work of his as has come down to us there are no juvenilia. Thus we have no idea of where he was trained. He must have met the Hausbuch Master and Holbein the elder. What he had seen before he made his appearance on the Middle Rhine and in Franconia about 1500 is unknown. He may have visited Italy in the second decade of the century, but it is doubtful whether he had been there before.

His drawings are nearly all studies, partly from life. Water-colour landscapes painted for their own sake, and still lifes, so important with Dürer, do not figure in Grünewald's work. Among studies from sitters there is at Stockholm one drawing which is certainly a portrait, and resembles Rudolf von Scherenberg, bishop of Würzburg (B35), who appears in Riemenschneider's tomb. The head of Margaret Prellwitz of Halle (B37; Louvre), also gives the impression of a portrait; it is the only picture of an old woman that can stand comparison with Dürer's drawing of his mother of 1514 (Plate 55), and is just as relentless in its portrayal of the ugliness of old age. But whereas Dürer's charcoal follows inflexibly, yet precisely, the contours of the form, expresses everything in line, and uses shadows only to emphasize the modelling, in Grünewald's work the outline of the over-elongated nose and the cheekbones is of secondary importance, the even folds of a neckerchief kindly conceal the scraggy neck, the modelling is carried out much more by light and shade, while the strokes of the soft chalk fuse to form surfaces which can easily be imagined as patches of colour. It was a full-blooded painter who made this drawing. Probably it was intended for some devotional purpose, for a Death of the Virgin or a Pietà.

The other more than thirty sheets of Grünewald that we possess are also studies for paintings. Most of them are executed in a mixed technique with chalk.[3] One Virgin with the Child St John (B24) derives from Leonardo. Even the ambiguous *Trias Romana* (B38) might have found a place in altarpieces which are familiar to us from Bosch, whether the haloed *Triciput* represents science, dialectics, and moral philosophy, or an infernal trinity of lust, voluptuousness, and pride, or – following Ulrich von Hutten's scathing anti-Roman satire of 1520, *Vadiscus sive trias romana*, translated into German in 1521 – 'haughtiness, unchastity, and avarice', personified in a citizen of Gomorrha, Simon Magus, and Judas Iscariot.

Beside these bitter and extremely painful drawings with their incomparable surface bloom, there are others with a sensuous feeling for skin, down, and hair, regardless of structure and muscles, yet with an incredible power of observation (Plate 73); ardent holy women, drapery of the finest material, often most delicately pleated, yelling boys with vigorous, expressive faces which are removed from the common run of every day – this draughtsman was sensuous in his apprehension of the world, but the native nobility

of his mind did not admit trivialities. These sheets are the important ancillary work of a great painter; while he was versatile as a personality, as an artist he was wholly committed to the plane, the chalk, and the brush: he was a painter and nothing but a painter. If he was indeed a carver as well,[4] there is certainly no trace of it in his drawings.

We know of a number of lost paintings, the importance of which can be guessed in part from the preliminary drawings, for instance, three altarpieces for Mainz Cathedral, one dated 1520, a Transfiguration for the Dominican church at Frankfurt mentioned in 1511–12, an altar for Oberissigheim near Hanau (if it was ever painted), and an altar of the Magdalen for the cathedral at Halle. Other works have come down to us in a fragmentary condition, for instance the wings from Bindlach of 1503 with the Fourteen Saints of Intercession in the church at Lindenhardt, to the north-east of Nuremberg.[5]

The first of Grünewald's pictures to have been preserved seems to be datable 1503; whether earlier drawings exist is uncertain. The Mocking of Christ from the collegiate church of Aschaffenburg (Munich; Plate 77) is still like a Gothic ornament in the way the two tormentors dominate one diagonal of the picture, the other being occupied by the blindfolded victim and the leader of his adversaries, while a pitying man seems to plead for mercy for him. Though they are in the foreground, these figures belong to a row of men's heads in the background; it is a composition of masterly simplicity which renders its theme most impressively, but without any attempt to fill space. The tormentor above Christ is literally superior to him; in the exaltation of his reckless and mechanical flogging, his arms flail like the sails of a windmill. It is suggestive how the musician, with his spidery fingers, brings sound into the scene and makes the clatter of blows almost audible. For the ringleader, the cook in Dürer's engraving (B84) has been pressed into service. The way in which the movement twists the close-fitting left trouser-leg of the tormentor in the foreground reveals the painter of the skin. Never had the mocking of the blindfolded victim been painted more impressively in Germany.

From that time on, Grünewald's works remained essentially uncomplicated and wholly concentrated. They are first of all two altar wings in grisaille for the Dominican church at Frankfurt with the deacons St Laurence and St Cyriacus (Plate 78) above and noble women saints beneath (Plate 79), St Elizabeth of Thuringia and probably St Lucy (Frankfurt and Donaueschingen). These served for a long time as fixed wings to Dürer's Heller altarpiece, yet they may originally have belonged to another centre panel, perhaps the Transfiguration. They are all healing saints; the profusion of plants at the feet of the princess and at the heads of the deacons are the healing herbs of medieval tradition; the fig-tree[6] which accompanies St Cyriacus, with its freely rendered foliage, is the tree of knowledge and redemption and also yields a soothing remedy for plague and epilepsy, of which the saint is healing the king's daughter Artemia, jerking her neck back in a single movement, while her arms, still cramped, seem to be dancing. The doctor's eye of the saint blends austerity with knowledge, severity with pity, while beside him there stand St Laurence, light-footed and angelic, the nurse with her housewife's face, and the martyr with wide-open eyes.

In the Crucifixion at Basel, the landscape contributes to the general effect in a way till then unknown, not because Christ praying on the Mount of Olives and the soldiers

marching off after the execution can be divined rather than seen in the distance but because, with its few touches of green and brown and the darkness of the sky, it seems to render some idea of the state of mind of the four mourners, of the good centurion, and even of the broken body on the Cross. These imponderables have always been felt. They are part of the secret of Isenheim.

The paintings for the wings of the high altar of St Anthony's Monastery at Isenheim (Issenheim), now at Colmar, must have occupied Grünewald from about 1513 to 1515. The date 1515 can be made out on the Magdalen's ointment jar. Several small last touches may have been added when the work was already at Isenheim, and the whole had to be brought into harmony with the carvings. All of them reinforced the expressive features.

The place where the paintings went at Isenheim was a hospital chapel. Thus the weekday side of the altarpiece is devoted to the sick in the care of the Anthonites. St Anthony and St Sebastian on the fixed wings were helpers in erysipelas and syphilis, the two St Johns in the centre panel in epilepsy, but all of them, especially Christ on the Cross, the Virgin, and the Magdalen, were helpers in plague. On weekdays it was a plague altar.

It was dedicated to the Virgin, and the Sunday side belongs to her. It tells how Christ entered the world and how he left it at his resurrection, his second birth. The four pictures form pairs: the Annunciation and the Virgin awaiting the birth belong to the age *sub lege*, the Birth and the Resurrection (Plate 85) to that *sub gratia*. The centre panel is clearly divided into two parts, and near the vertical line where the altarpiece would be opened to reveal the next transformation, namely the Crucifixion (Plate 80), the symbolic fig-tree reappears.[6]

When the altarpiece was opened for the last transformation, there were to be seen, beside Hagnower's radiant and lifelike carvings, two companion pictures, one of St Anthony's temptation and the other of his discourse with St Paul, whose very aged face may be that of the master, while St Anthony's is pretty certainly a portrait of Guido Guersi, the Preceptor of Isenheim, whose escutcheon can be seen beside him. The programme of the whole, in particular the Crucifixion and the Feast Day side, contains visions from the Revelations of St Bridget and theological ideas from Italian sources that would be due to the instructions given him. There is a wealth of mystic symbolism scattered through the whole altarpiece.[7]

The Virgin of the Annunciation, in a blue robe, all but retreats before the apparition of the unearthly, prophetic, almost menacing angel storming upon her, clad in a robe like red flames. In front of the illuminated choir of the church, with the dove of the Holy Ghost floating almost invisible in it, she represents the pre-existence of the Virgin as a vestal. Beside her there is a shrine in the very latest Gothic representing Solomon's temple; she is surrounded by a choir of singing angels, and probably with people of the Old Testament. The Virgin kneels in the colours of dawn and awaits the Nativity in the shape of the miraculous picture of the kneeling Virgin in a robe of ears which was worshipped at Milan; she is lost in thoughts of the Advent and the Incarnation as she sees them in the right-hand half of the central panel, from which she is still separated by

the curtain of the temple. What is meant is the Immaculate Conception, and the symbolism of the rosary is interwoven in it. The angelic music, which is probably the artist's own invention, is conceived as a pure and uncontaminated natural force, the instruments, in the form given to them, are unplayable, but the viola-player is transported in his own ecstasy, behind him the feathered gamba-player is enraptured, and the angel with the viola da gamba in the foreground is possessed by childlike inspiration. His music is also addressed to the Virgin in the right-hand half of the picture, holding her well-grown Child in ragged swaddling-bands, prophetic of the loincloth. She is surrounded by symbols of the Virgin and Christ, among them the Rose without Thorn as the Rose of Jericho, the symbol of martyrdom, while the heavens above her open upon their hosts. At the top, God the Father is little more than an apparition of light.

The Resurrection (Plate 85) is the artist's own invention. Before a starlit sky, the halo of the resurrected Christ, yellow, orange, red from within outwards and surrounded by a ring of greenish blue, is the only source of light. Within it, Christ is robed in a long, trailing cloak, which is carmine in front, bathed in yellow light outside, and blue and violet inside. The panel reminds one of a medieval initial, and all the violence of the upward movement and the guards collapsing beneath it is contained in a firm pattern. The immense impact comes from supreme moderation and economy. Christ's hands are raised in the gesture of the Last Judgement. The Resurrection is the only work by Grünewald where we meet the gaze of Christ.

The Lamentation in the predella belongs to the series of Sunday pictures in which the Virgin prefigures the event, but it is just as much part of the weekday picture of the Crucified (Plate 80). All the horror is in the latter, but the painting is exquisite. To the left there is the agonized triad of those nearest to Christ. The Magdalen is in a pleated dress, her hair unbound and fluttering, her hands clasped with fingers that seem to be quivering with grief; the Virgin is fainting and livid in robes which look like marble. St John supports her, accompanying her every gesture as if it were actually a sculptural group (even at the risk of the right arm being drawn incorrectly), feeling with her, indeed only feeling pain through her, since he does not look at Christ. To the right the picture is bounded by the Baptist, a thick-set figure with an almost exaggerated gesture which expresses his whole work, since it points to the centre of the picture. Christ, gigantic in proportions, is nailed to a rough-hewn cross with a twisted upright and the crossbeam bending under the burden. The whole horror of the Passion is over; a dead body covered with the scars of torture, racked and stretched in agony, hangs on the cross, with wounds and thorns in the shimmering flesh, the face horribly distorted, the shoulders out of joint or perhaps intentionally torn from their setting to increase the pain. Grünewald toned nothing down, yielded to no generalization, painted everything right down to the upward convulsion of the hands, yet he did not lose himself in details. It is a Hercules on the Cross, not Riemenschneider's tender God, nor even the *beau Dieu* of Dürer the classicist. The ragged loincloth points back to the Infant's swaddling clothes. Can the open hands also be the praying hands of *Christus Mediator*? Can there be in the bent cross-beam an allusion to the cross-bow speeding the martyred body like an arrow upwards to pray for mercy? Probably a great deal of all this has

several meanings, yet no literary analogy is known. In any case, Grünewald gave an exacerbated version of the motif in the Small Crucifix (Washington), and continued it late in life in the unrelieved gloom of the great picture now at Karlsruhe.

The Temptation of St Anthony harks back to a tradition of Tuscan painting. In the Meeting with St Paul, the latter wears a robe of palm-leaves which otherwise only occurs in Italy and is based on the text of the Golden Legend. The conversation between the two is carried on in a peaceful, if fantastic landscape, under moss-hung trees opening on to a valley-meadow and bluish-white alps. They are two old men, and there is understanding between them; the noble abbot and the ascetic hermit represent the whole range of monastic life. Nearly all the beautiful plants are medicinal. The deer is like a bond between the two saints, and seems to be listening; the creature is at ease, it is the naïve, primitive element between the wise men, placed with genius like the animal-angel making music at the Nativity and the piper in the Mocking of Christ.

The Temptation of St Anthony, on the other hand, depicts the dangers attendant on spiritual and clerical life. Cast from his spiritual heights, the saint sees himself overpowered by a mighty host of demons. Sunk in meditation, he first sees the unchained dogs lowering below; a man afflicted with 'St Anthony's Fire' has laid hands on the breviary – even the duty of tending the sick may distract the religious from his spiritual life. What we have in this picture is the experiences of an exaggerated spiritualism, and there may be an allusion to attempts at achieving contemplation by intoxicants. This pandemonium is quite a different thing from Dürer's real, comically menacing creatures from the Adriatic, but it is more corporeal and direct, and less allegorical in tone than the hell depicted by the other contemporary painter of the inferno, Hieronymus Bosch, who was probably unknown to Grünewald. Even the landscape, with its bare trees and its ruin illuminated by fire, enters into the whole, splintering and baffling; the moment of annihilation seems to have come. We, however – though not the saint – can become aware of the intervention of the Godhead from heaven, and the mountain peaks in the morning light, wonderfully observed and symbolically consoling. A natural phenomenon which seems to have been actually seen by the artist, the eclipse of the sun in 1502, is rendered with the same force in the Small Crucifix.

The fixed wings of the Isenheim altarpiece may have originally been planned in grisaille. St Anthony and St Sebastian stand on pedestals covered with Late Gothic foliage, half-way to animated sculpture; St Sebastian in a sophisticated red cloak with black stripes is almost a classical figure, and is placed with an audacious virtuosity. He is probably a final addition which does not quite harmonize with the Crucifixion; he also bears witness to a turning-point in Grünewald's art. There is among the drawings a tuba player (B33) who is based on the same conception of the nude as a single whole.

The Snow Miracle (Freiburg), the wing of an altar of the Virgin of 1519 from the collegiate church at Aschaffenburg, and the Virgin in the Garden at Stuppach near Mergentheim, which may have been the central panel, are delicate in colouring, but do not harmonize so sweetly as once Grünewald's works did. And finally the Karlsruhe pictures have descended into dull earthiness. There is an increase of Italian motifs and Renaissance elements; the Miracle of the Snow takes place in front of a Roman city, not

unlike the Lateran palace and church seen from S. Maria Maggiore, and the Karlsruhe Carrying of the Cross has a background of buildings with classical entablatures and heavy round arches.

In the Meeting of St Erasmus and St Maurice, painted between 1521 and 1525 for Halle and now in Munich, the trend to self-conscious artistry is complete (Plate 84). Gold and many shades of red lie side by side with silver-blue and Moorish brown. It is possible that the two are engaged in a disputation, which may turn on warlike deeds or spiritual tolerance, or it is perhaps a discussion on Reformation questions. And the saints have different degrees of reality. St Maurice is a little comic in his armour, and in this figure Grünewald followed a (lost) statuette, possibly designed by himself, then in the Treasury at Halle. But St Erasmus is a portrait of Cardinal Albrecht, who greatly revered the saint, partly for the sake of Erasmus of Rotterdam; he had also at that time adopted a humanistically tolerant attitude towards the Reformation. Thus this altar has a wealth of ideas and a good deal of reality; it was actually a topical picture, though on an elevated plane. It is the most beautiful, most effulgent German picture of the epoch.

Yet Grünewald comprehended the Middle Ages entirely until his death. The Stuppach Virgin in the Garden is described as 'the rainbow of hope', for it is the rainbow, an atmospheric phenomenon, and not a halo, which encircles the heads of the Virgin and the Child. The picture is packed with Marian symbolism. The Virgin's strikingly voluminous veil is in line with the fact that a relic consisting of a veil was venerated at Tauberbischofsheim not far away. In the Karlsruhe Carrying of the Cross, the Lord looks upward in utter helplessness, surrounded only by his enemies. There is no radiance in the colouring, and mixed tones predominate. This, and the Crucifixion, may be Grünewald's last works; in any case, they are the gloomiest.

Yet in another picture which he painted in the last years of his life there is an un-expected emphasis on medieval traits; in a predella at Aschaffenburg the dead body, intentionally cut off by the frame, is given in a crushed and bent pose, as if it were still writhing in agony. The wrung hands of the Virgin can be seen protruding from her robe, but not her figure. Grünewald had always given the gesture a peculiar significance; here it stands alone, a fragment – a motif apparently elaborated by Baldung. In the Christian context this is the exact antithesis of the independent, that is still life or land-scape significance of all things in Dürer. But it is in keeping with the whole process of disintegration of late medieval iconography. It is true that Grünewald had no hand in its secularization, but simply assumed that the spectator was familiar with the traditional types of picture and would therefore be able to read his picture aright.

Grünewald's whole being offers the extreme antithesis to Dürer's. For that reason, historians have been all the more fascinated by the question whether the two ever met and whether either had an influence on the other.[8] About 1503, when Grünewald was delivering altarpieces in the neighbourhood of Nuremberg, something like an approach to Grünewald can be felt in Dürer's drawings. About 1509, when Dürer was working on the Frankfurt altarpiece, there are moments of ecstasy and light effects in his graphic work which seem to justify the assumption. In 1520 Dürer made a present of some prints 'dem Mathes'. Was that Grünewald?

Grünewald, on the other hand, like nearly everybody else, made use of Dürer's graphic work, especially in the Mocking of Christ and in the Isenheim altarpiece. The Isenheim Virgin may go back to Dürer's Virgin with the Many Animals (Plate 62); at this point we may conceive that some personal contact had taken place. It is only if we place Grünewald's birth very late that he might have been a pupil of Dürer, yet there are more elements in his art which, in a general way, are more antiquated than anything in Dürer and seem to make Grünewald considerably older.

However that may be, Grünewald and Dürer must have been something like the poles of German art in their day. Apart from his paintings and drawings, Grünewald left no personal documents behind him, no letters, diaries, or other writings, and no early works. He did no graphic art. Thus he could not influence artists at a distance like Dürer, nor can we speak of any Grünewald pupils. His influence on German painting and sculpture must have come from his work alone.

He made few portraits, yet, though his portraits, landscapes, still lifes, plants, and animals cannot be detached from his altarpieces, they have an enchanting immediacy of observation and are as modern as Dürer's. Grünewald was certainly the better painter of women, and one of the lost altarpieces of Mainz contained a winter landscape such as does not exist in Dürer.

Grünewald's media were light and colour; his space is created more by painted atmosphere than by linear perspective. He was the artist of two dimensions, and even in his drawings he is a painter through and through, remote from Dürer's interest in form, from his sober love of sculpturality, his eloquent line. If Grünewald had visited Italy, he would not have been called the *Praeceptor Germaniae* of drawing, but the 'German Correggio', as Sandrart wrote.

Grünewald, the painter, mystic, and poet, was certainly not less versatile than Dürer, and devoted his gifts in painting and drawing almost exclusively to the altarpiece. While Dürer, the humanist, had scarcely any interests beyond art, Grünewald allowed most of his gifts to develop side by side. Though Grünewald, unlike Dürer, was for many years in court service, he was anything but a court artist. His Passion is a martyrdom of the common people, though on the other hand he never excluded the nobles. Dürer's bourgeoisie did not appeal to him.

Above all, it was Dürer's golden mean, his temperate zone, that was everything that Grünewald was not. Dürer elevated man to his true status of dignity, but not beyond it. Christ was human, like a pagan god, with something of Hercules in the Passion, but at other times more than a touch of Apollo. Horrible and violent, transfigured and simple, secret and most spiritual – that is man, that is, above all, Grünewald's godhead. In spite of the great vision of the Apocalypse, Dürer never attained to Grünewald's range or depth. The tragic and the mystic, the not quite strict dualism in which traces of pantheism appear from time to time – in such things Grünewald was greater than Dürer.

The visionary and the unstable were certainly elements of Dürer's artistic being as well, but they seldom formed the content of his work, as they did with Grünewald; perhaps Dürer had to hold them in check as a measure of self-preservation. Grünewald, with his religious spirit, was far better equipped for sublime insights, but he was less

endangered and exposed. For all Dürer's splendid concentration, which commands respect both in his work and in his character, Grünewald was more of a piece. He is certainly the only German painter whose work seems to be inspired from on high.

Hans Baldung Grien

In Alsace, after Dürer's departure from Strassburg in 1494, the gap left by Schongauer's death in 1491 does not seem to have been satisfactorily filled. The long-drawn-out history of the Isenheim altarpiece, which was humiliating for the free city, seems to show that for a long time there was no painter available of Niclas Hagnower's calibre.

Hans Baldung, surnamed Grien, was born at Schwäbisch Gmünd in 1484 or 1485 as the son of a family of bourgeois men of letters who had many connexions with the Upper Rhine. He seems to have spent his early years at Strassburg. Throughout his life he sought the society of men as cultivated as himself. There was in him something of the dilettante in the best sense of the word, but he had an excellent training. About 1503 he was associated with Dürer at Nuremberg, where, with Schäufelein, he contributed, on his own account, a large number of woodcuts for books by Ulrich Pinder, the *Beschlossen Gart* and the *Speculum Passionis*, published in 1505 and 1507. Yet he probably left the town when Dürer went to Italy in 1505, and turned to the north. At that time he painted two altarpieces for Halle. In 1509 he settled at Strassburg, where he delivered illustrations for books to be printed there almost every year until 1523. He only left the city once (about 1512, for a visit to Freiburg which lasted till 1517), was held in great respect there and made a member of the City Council, and worked as a court painter and as a designer for stained glass, and even for textiles; later in his life he also designed woodcuts. He died in 1545.[9]

At Nuremberg, when he was about twenty, his work began with the two wings of an altarpiece for the church of Schwabach and with woodcuts probably made to a commission from Dürer in which he strove to use the master's idiom, yet managed to make his own personality felt. From 1503 he made drawings of figures which were entirely of his own invention, with an assured sense of the organic unity of every figure not cramped by Dürer's teaching, but as yet completely naïve; there is no trace of Kulmbach's and Schäufelein's struggle with Dürer's problems. In comparison with the uncouthness of Schäufelein, the illustrations for Pinder are subtly and delicately drawn; there is imagination in the formal idiom and at times an enchanting fluency. Foreground figures are already boldly cut off by the edge of the sheet. The altarpieces from Halle Cathedral (Berlin and Nuremberg, the latter of 1507) are astonishing revelations of an independent artistic mind and a painter of the highest rank. The paintings start out from the colour; the general impression is determined by rare hues, sometimes combined in an unprecedented fashion, with vigorous and even daring effects. Though Baldung was a man of intellect, in art he was a 'natural'. It may have been a meeting with Cranach which helped to liberate Baldung's talent from the austerity of Dürer's studio style. The picture of the Magi, a little clumsy in structure, is poles apart from Dürer's Epiphany of 1504, which Baldung certainly knew.

At Strassburg, and later at Freiburg, his gift of spontaneous and vivid sensuousness came into its own. His imagination seems inexhaustible, his command of form is absolutely free. He is spellbinding in his absolute sureness, in his unemphatic, yet always significant formal expression. In woodcuts he continued Dürer's technical problems unproblematically and achieved effects of light with splendid contrasts of shade, the whole conceived decoratively. The careful, yet easy suppleness of his line may have even contributed to the luminosity of Dürer's style about 1510.

Baldung was very much occupied with altar pictures. The Crucifixion of 1512 (Berlin) is bright in its colouring, though muted and fiery here and there, with grey-black clouds. The figures are sculptural enough, but those of the Virgin and Christ are enormously elongated. The bodies of the thieves writhe in torment round their crosses; the one on the right looks more anguished because a thigh is consciously distorted, while the circulation in the hands and feet of the one on the left has been cut off by the ropes and they are leaden grey in colour. The self-conscious pose of an onlooker provides an artistic contrast. A devotional diptych (1513, Innsbruck) shows the Holy Family with angels in their chamber; and the Virgin in a warm red robe with a carmine cloak is placed facing the dead Christ on Calvary under the rough-hewn posts of the crosses, on which, with grisly humour, the calves of the dead thieves' legs can be seen; there is a view of mountains in the distance, partly concealed by a cloud (Plate 81). The homely grey-brown room with its green curtain stands in contrast to the world outside, the lovely family picture to the fury of pain; the women's eyes are red and disfigured with weeping. Another Lamentation (Berlin) has the full, mighty tone of Grünewald, and some drawings (K37, 40, 110) show the influence of the great master of the Middle Rhine. But in Vienna and at Nuremberg there are joyous Holy Families in the open air under a tree, whose lichened boughs, alive with birds, convey the touch of fairy-tale which pictures of the kind had at that time in the Danube region. It makes itself heard again in the wings which Baldung made for Hans Wydyz's Schnewlin altarpiece in Freiburg Minster; yet the powerful twists in the upward thrust of the trunks are actually very firm in design. In Baldung's work the human figure outweighs any pre-romantic nature feeling.

Baldung's chief occupation during these years was his greatest work, the high altar of Freiburg Minster (1513-16) with the Coronation of the Virgin in the centre panel – a radiant and glorious picture. The Nativity has become an impressive night-piece. On the wings, the Apostles, still in ecstasy from the descent of the Holy Ghost, look huge, and might be a troop of soldiers. This is the proto-Baroque of a Mannerist in the making. On the reverse there is a Crucifixion in a manner all its own. In addition to portraits, which include a self-portrait, it contains strange fragments of an almost sinister reality, a hideous face on the stem of the Cross, a gigantic riderless white horse driven into the scene under the darkened sun. This is the point at which the element of panic in Baldung enters his altar-work.

Baldung's woodcuts of the Fall (B1-3) are saturated with sexuality. The passion of Dürer's Adam (Madrid) looks spiritual beside it. Baldung's humanity is propelled by urges in a way no artist had ever dared to show before. In the drawing of 1503 (K1) and

the woodcut of 1513 (B48) Aristotle is enslaved by woman. There is a peculiar emphasis on Potiphar's wife in his contribution to Maximilian's prayer-book (K54). The fighting horses are grand in their savagery (K51), like the gaping jaws of the lion and walrus ridden by boys (K57–8). The Fates are demonic witches in the woodcut of 1513 (B44). Baldung had already depicted an infernal witches' sabbath in a chiaroscuro woodcut of 1510 (B55), and in the chiaroscuro drawings of 1514 (K63, 64) the beautiful young witches are the dominant factor. Obscene allegories followed (K62, 65), but the artist never degraded his figures; his native candour raised him above that.

This feeling for life gave a special tone to the four small tablets made about 1509 and later, and now in Vienna, Florence, and Basel, on the subject of Death and the Woman. At first he blended in them the old Dance of Death theme with the idea of *vanitas*. But about 1517 he boldly took as his subject a woman receiving the kiss and embrace of a skeleton (Plate 82). The Deluge (1516, Bamberg), a picture of the end of the world partly based on Italian motifs, is in the same line. Saturn himself – perhaps Baldung's most splendid drawing, of 1516 (K48) – is a demon-ridden human being (Plate 74).

This insight into the nature of humanity could not but make Baldung a master of the portrait. His Count Löwenstein (1513, Berlin), in his yellow and black costume, dominated by green and red, is as noble as it is vivid (Plate 71). There is something ominous in the way the young Count Palatine Philip (1517, Munich) appears in two shades of red against blue, in his jaunty fragility and in an adventurousness which had no foundation in life. The reddish-haired young man of twenty-five (1515, Vienna), thoughtful and rugged, is delicately painted in all the primary colours. The Margrave Christoph I of Baden (1515, Munich) appears with a terracotta-brown face on a deep turquoise blue background and shows every sign of approaching psychic disintegration. Baldung had already painted him in 1511 in an uncannily bald woodcut, which, contemporary with Burgkmair, was probably one of the first portrait woodcuts to be made in Germany. He was a portrait artist who neither worked to pattern nor indulged in formal experiments.

Baldung's real achievement lay in what had never been seen and never said before. He saturated his pictures with it and won from it new themes, demoniac, libertine, romantic. The response from the humanists and cultivated clerics may have allowed him to pursue his way consistently for twenty-five years to come.[10]

Minor Painters, the younger Holbein Generation, and Manuel

Hans Wechtlin, born about 1480/5 at Strassburg, where he died after 1526, was an original draughtsman and maker of woodcuts. He was one of the first, after Dürer, to make single prints with Renaissance material.[11]

What happened at Basel after Dürer left we only know in the field of graphic art. Between 1502/5 and 1511, the monogrammist DS made his appearance in woodcuts; all trace of him was lost later, perhaps in 1517.[12] He seems to have worked on impressions he gained not only at Augsburg, in particular from Ulrich Apt, but from the Middle Rhine too, yet in the end he discovered his own idiom which, in its turn, had

an influence on Augsburg. His figures are gnarled but forceful and his manner of narration reveals deep feeling for his theme, yet he succeeded in some rather light-hearted *genre* pieces.

Urs Graf owed nearly everything to him, and often copied him. Born at Solothurn about 1485, he was a goldsmith, engraver, and designer for woodcuts and stained glass. He lived at Basel from 1509 till his death in 1527/8.[13] But he was caught up in the vortex of the life of his time more than any other artist. In his own mind he was a free soldier rather than a plebeian craftsman, and was happiest in the lowest strata of society from which the *Reisläufer* (soldiers of fortune) were mainly recruited. In 1511 he went to Rome as a simple trooper, in 1513 to fight Dijon; he was in the battle of Marignano in 1515 and also took part in campaigns in North Italy in 1521 and 1522. He became the ruthless chronicler of this self-seeking, plebeian kind of fortune-hunting. He recorded the horrors of battle, camp life and the gravity of its war councils, the braggadocio of men and the profligacy of women – indeed anything that can happen under the heading *carpe diem*. He condensed his Alpine travels into great lake and mountain landscapes. Though in his own country he was an ungovernable brawler, he elevated many natural instincts to the status of art and expressed them without restraint, whether in the mythology of antiquity or in Basel street scenes. His technique was masterly; in 1513 he made the first dated etching in history – before Dürer. What he described – the swagger of the great, frivolity, lust, and drunkenness – also applies to the way he drew. After the Late Gothic of the first ten years of the century, Mannerism makes an early appearance in his work. He never seems to have been touched by humanism, and very little by the Renaissance. In the sheet with the nude youth by a tree (MG11) of 1521 the boy's limbs and the trunk of the tree seem to be wrought out of the same material. In the drawing in white of the ensign, intoxicated with his huge banner (MG15), of 1514 the figure is elongated and there are overlappings and convolutions. The line glides impetuously over details. The masterly stroke of his pen was subjective and autocratic, and without any love for the subject. Often he transgressed the boundary where mockery and gravity meet and ended in parody. As early as 1514 he was making caricatures of love, for instance in the couple (MG29) and in the strolling husband and wife (MG30). St George's fight with the dragon (MG55) of 1519, with the hero in fourteenth-century armour, turned into a mock fight, even more than Leinberger's statue for the tomb of Maximilian.

In the Flagellation (MG57) of 1520, the blood-lust of the tormentors exceeds anything that had ever been seen before, while the beheading of St Barbara (MG56) of 1519, with the gruesome, almost tender outline of head and neck, seems quiet in comparison. Graf succeeded in exaggeration, where we feel his keenest challenge; often in the drawings of his blowsy girls of 1518 and 1525 (MG1, 3), with their shaved forehead as bare as a bladder and their smile a grimace (Plate 90). Lust for life and weariness of life stand side by side; what sprang from a genuine source was coupled with repulsiveness. In the third decade there appeared the lascivious Venus on clouds (MG65), the grotesque figure of the *Reisläufer* with his waving plumes (MG13), and the raving women committing suicide, all affected as well as Mannerist. Graf was gripping, insolent, and witty; he had not an iota of Baldung's precise perception of form.

What painters filled the gap left by Dürer's departure from Basel is quite unknown. Hans Herbster, born in 1468, had become master there in 1492 and died as late as 1550. A Carrying of the Cross, signed HH (1515, Karlsruhe), formerly assigned to the Holbeins, is probably his work.[14] It is a piece of bold and vivid colouring, dominated by violet, and it is painted fluently, with a fresh landscape, the bodies a little blurred and the figures bent sharply at the knees.

Ambrosius Holbein was a journeyman in Herbster's workshop about 1516, presumably together with his younger brother Hans Holbein the younger. Ambrosius had left the workshop of his father, Hans Holbein the elder, at Augsburg in 1514, had painted female figures from Antiquity at Stein am Rhein in 1515–16 for the decoration of the abbot's banqueting hall, and then joined his brother at Basel. There he was registered in the guild and became a citizen in 1518, worked on the illustration of Basel books till 1519, and presumably died there at the age of about twenty-five.[15]

In woodcuts he was a gay and entertaining narrator. In 1516 he painted a signboard advertising the writing-lessons of Myconius the humanist. He made a few marginal drawings in Myconius's copy of Erasmus's Praise of Folly. The best work left to us by this sensitive artist is his portraits: the two boys at Basel (Plate 86) and the twenty-year-old youth of 1518 at Leningrad. The brothers are set in aedicules of different shape on a soft blue background; both the fair and the dark one wear orange-yellow doublets, underlined by the brown and yellow of the architecture. The dominating feature of the thoroughly childish faces, which really makes them adult, is the unusually small, keen eyes.

The older Holbein generation, Hans and his brother Sigmund, also seems to have left Augsburg at that time and to have been active on the Upper Rhine, and fairly certainly in Switzerland too. Sigmund, who was a taxpayer at Augsburg for many years but died at Bern in 1540, was an artist in a thoroughly Augsburg style, assuming that three panels of the Virgin (Schweinfurt, Schäfer Collection, and Mauritshuis) can be attributed to him.[16] The portrait of Zimmermann (Xilotectus), the humanist of Lucerne (1520, Nuremberg), is by the same hand (Plate 87); a gently austere man of thirty with a harp, touched by the skeleton hand of death – Baldung's theme transposed into a portrait.

It was in these surroundings that Hans Holbein the younger, the youngest and greatest of the family, made his debut about 1516 as a youth of eighteen.[17] At that time he painted the other side of Myconius's signboard, which was more startling in space and lighting, and dashed off in ten days in 1515–16 the greater part of the marginal drawings to Erasmus's Praise of Folly, which delighted the author. From 1516 on the lion's paw can be traced at Basel in woodcuts for books. In the same year Burgomaster Meyer of Basel commissioned a double portrait of himself and his wife in a Renaissance arch which spans both panels; this was the first bourgeois burgomaster of Basel to be painted by the foreign youth. In this work Holbein freely transposed Burgkmair's chiaroscuro woodcut of Baumgartner into a diptych dominated by red and blue. In 1517 he painted on paper Adam's temptation by Eve, busts with portrait features, both deeply grave with narrowed intense eyes, Eve rapt and purposeful, Adam gazing

vaguely upward, a delicious study in apple colours. In the same year he painted the portrait of Benedikt von Hertenstein (New York), an enchanting picture in black, grey, and carmine, which makes the very small, and actually grey eyes look grey-blue. Hans shattered Ambrosius's epic breadth with vehement suddenness. He will be one of the main figures of the second part of this volume.[18]

Hans Leu the younger, the son of the Zürich painter Hans Leu the elder, was born about 1490.[19] He seems to have entered Dürer's workshop quite young. He probably met Altdorfer. In any case he may have worked for a time in Baldung's workshop at Freiburg and have been in touch with him later. By 1514 at the latest he was back in Zürich and fought at Marignano in 1515. The only Italian influence in his work comes from Lombard ornament. In 1531, reduced to financial straits by the Reformation, he fell fighting at the Gubel. His earliest dated drawing, The Virgin at the Loom in the Temple (1510, London, British Museum), shows Dürer's influence. Dürer training can also be recognized in the incredulity of St Thomas of 1514 (Copenhagen), in the internal modelling and in the vigour of the outlines, while in the monumental Pietà drawing of 1519 (Cambridge, Mass.), Baldung's influence has produced similar results. On the other hand, Leu's sheets, which are mostly in black on paper primed with colour and touched up with white, make the landscape more like scenic wings and render more of its atmosphere and native mood than was usual with Baldung. In Leu's work the human figure is bathed in this continuum, and this is true also of the trees, even when, standing in the foreground, they look like limbs bulging over the biceps. Behind it, the background, overgrown with vegetation, forms a back-drop which is often fantastic in its intense and saturated colouring.

Leu's share in Baldung's Schnewlin altarpiece at Freiburg, the landscape which is the background to the sculpture of Hans Wydyz the elder, is calm and flatly decorative. While the woods in Baldung's wings always seem to be cracking, and nature is rendered in all its wild growth, Leu gives a dreamy, windless landscape in a mute state of maturity. It is often a landscape of late summer or autumn. Accumulations of white blur the outlines of the Swiss snow peaks, and bear into the woods from countless unreal sources of light a mass of sparkling life, yet also create the feeling of decay. Will o' the wisps seem to be flitting through the fantastic landscape of lakes and mountains which is now at Basel; the forms are disintegrated. Christ on the Mount of Olives (1520, Basel) is seen from the point of view of the soldiers, one of whom, creeping through the hedge, presents us with his buttocks. The Orpheus Idyll (1519, Basel) has a touch of humour (Plate 89); it is a brown tempera picture with the singer making the animals and the whole of nature bow to him and imposing peace on them with his music. He is a touching child of nature among the animals, painted with some naivety in white, black, and brown – Leu must have been gentle and emotional by temperament.

Hans Fries, born at Freiburg im Uechtland about 1460, probably died at Bern about 1523; he was a forceful artist who belonged to the south of German-speaking Switzerland.[20] Such works of his as have come down to us were painted between 1500 and 1514. His masterpiece, St Anthony of Padua's sermon on the death of the usurer (1506, Freiburg, Franciscan church) is an almost revolutionary record of the social trends of

the pre-Reformation decades. Fries was a passionate artist painting fanatical themes, but his landscape details are tender and poetic.

The most outstanding Bernese painter was Nikolaus Manuel Deutsch. He was born at Bern in 1484 and died there in 1530. Highly gifted as he was, his life raised him far above his situation as a craftsman painter to be a free artist on his own account and, moreover, to become the aristocratic amateur. He probably began his training with a stained-glass worker, then went on to Fries, and he was probably also a pupil of Burgkmair's at Augsburg. The part played by Sigmund Holbein is unknown to us. Dürer's graphic work was known to Manuel. After his *Wanderjahre* in the south of Germany he settled in his native city in 1509; he was connected with leading families and almost uninterruptedly a member of the Great Council, until he was elected to the Little Council in 1528 for his work for the Reformation. He went on two Italian campaigns in 1516 and 1522. Then he was summoned to play his part in politics. All the same, he found time to write some satirical and humorous poems. They are practically all directed against the Roman Church, and, though written in homely language, are artfully constructed.[21]

The earliest of his extant works are drawings and designs for stained glass, made about 1510. The wings of the altar of the Virgin (1515, Bern, and Winterthur, Reinhart Collection), with St Luke painting the Virgin and St Eligius as a goldsmith, show that Manuel was familiar with the medieval artists' workshops. His work began at the early classical stage. Later the Mannerist element makes its unexpected appearance. In the remains of a Martyrdom of St Ursula and the two Beheadings of St John (Bern and Basel) action becomes, as it were, too powerful for the actors. In the Basel picture more especially (Plate 88), the executioner casts the head into the salver with a gesture which leaves any naturalism far behind. The picture is a night-piece; greenish-yellow beams of light fall through the air from the clouded moon, making palace and prison dim and even darkening the rainbow.

In his tempera brunaille of Death Embracing a Young Woman (1517, Basel), Manuel almost excels Baldung's work in boldness and power; in any case his manner was similar, and his most daring sheets are never, like many by Urs Graf, ugly and insolent, but express the vitality and belief in life of a son of nature, who was a man of breeding and had seen war. There is a similar faith, tempered by sorrow, in a canvas at Basel in which the artist, kneeling with his family, prays the Virgin, the Child, and St Anne to intercede with God for plague-ridden humanity. It is a devotional picture which is already something of an occasional piece by the future Bernese statesman. There is a hint of Grünewald in the remains of the Legend of St Anthony (1520, Bern); Manuel may have visited Isenheim. He never achieved Grünewald's depth and mastery but in the Temptation showed himself to be Grünewald's equal in the intensity of the atmosphere and in the sense of space in the landscape painted *alla prima* with a fluent brush.

From that time on the amateur appears in him occasionally. The charm of the country gentleman, the naïve freshness, even his types, rustic from the outset, his freedom from any touch of humanism, came out more clearly. He managed with only a few faces,

especially his own, which appears in the goldsmith's and painter's workshop, and returns in the picture of the Judgement of Paris (Plate 83), up to the late self-portrait (Bern), with the bold nose, the small, sensitive mouth, and the warm-hearted look.

The two canvases at Basel may have served as tapestries; we can see in them the designer of lost murals. The Judgement of Paris and Pyramus and Thisbe – also treated with serenity and both lacking in depth – are rendered on a pure tempera background of blue, red, and even yellow, while the landscape is in various mixed tones of green and greenish-brown. There is practically no orange or violet. The feeling for nature is relaxed, elegiac, and not passionate, as it is in the Murder of St John. The most statuesque details are the wonderful beech-trunks. The antique personages are dainty and puppet-like, with lively, eloquent profiles and a touch of histrionics in the turn of the head. There is some humour in the modish, even eccentric costumes, and there is an echo of carnival when the king's son, in the likeness of a Bernese district governor, judges the three so similar goddesses. The composition is very flat. Even the enchanting vistas into the landscape reveal no conscious effort to produce spatial depth. Thus what we see on these canvases is a strangely unreal world, which seems to be filled with dread, with thunderous menaces, just as much as with fairies and wondrous marvels.

PAINTING IN SWABIA AND AT AUGSBURG

SWABIA

IN Swabia, something of the innate vigour of the old, small towns still survived in painting. At Memmingen there lived Bernhard Strigel,[1] the son of Hans the painter and nephew of Ivo the wood-carver or *vice versa*; he was born in 1460/1 and died in 1528. Trained in the workshop of his father and uncle, he probably worked first on their altars for Disentis (1489) and Obersaxen, and he himself never lost touch with the Grisons. In the early nineties there is influence from the Netherlands traceable to Bouts and a connexion with Zeitblom, the Ulm painter, which found expression in the painted wings of Erhart's high altar at Blaubeuren of 1493–4. Strigel's placid manner comes out in the Holy Family altarpiece from Mindelheim (*c.* 1505, Nuremberg and Schloss Donzdorf). He clung to everything which he could animate by violent changes of direction. Soon afterwards there came four pictures of Christ's childhood (Schloss Salem), among them a night-piece which went back to Dürer's graphic work and to the Netherlands for the delightful light effect. In 1507 he made an official portrait of the emperor, and afterwards painted him often. Having been summoned to Vienna on the occasion of the double betrothal between the Habsburg and Jagiello (1515), he painted speaking portraits and one group of the imperial family. There is great intimacy in the approach to the sitters. In spite of his predilection for landscape vistas seen through windows, the arrangement is in the nature of a relief; brocaded walls also play an important part in the two sculpturally composed portrait wings of Conrad Rehlinger with eight children (1517, Munich). The sleeping grave-guards of 1521–2 (Munich), with their unemphatic, quite uncontorted faces, are painted broadly with sonorous, finely graded colouring. Strigel was a born portrait-painter, but for all his observation he was cautious and made no effort to achieve psychological intimacy. There is a certain immobility in the mood of his pictures.

At Ulm, beside Bartholomäus Zeitblom[2] and Jörg Stocker,[3] yet another painter deserves mention, namely Martin Schaffner. His signature first appears beside that of Stocker on the wings of the Ennetach altarpiece (1496, Sigmaringen).[4] Schaffner was born at Ulm in 1477/8 and died there in 1546/8. About the turn of the century he appears to have spent some time under Holbein the elder at Augsburg; unlike Gregor Erhart, however, he did not stay there, but not long after settled in his native city, where he collaborated in his altarpieces with a wood-carver's workshop, which was obviously under his management, and conceivably under his artistic direction.[5] His Virgin with Angels (Béziers) followed that of Holbein the elder of 1499 (Nuremberg), but replaced the gold ground and canopy with actual architecture. In the portrait of Wolfgang von Oettingen (1508, Munich) there is a landscape with hunting scenes outlined in gold on a bluish-green ground.[6] As yet without marked individuality, he followed the tradition

of the Zeitblom group. The influence of Dürer's graphic art can be clearly felt when he painted scenes with figures, for instance the Descent of the Holy Ghost (1510, Stuttgart), or the delightful Adoration of the Magi (Nuremberg) and the two altarpieces for Wettenhausen Abbey near Günzburg, the first of 1515 (Augsburg), the second of 1523–4 (Munich). In the colouring, however, Schaffner often followed the Augsburg manner with great success, using Holbein's and Burgkmair's light effects and differentiation of materials. He employed Renaissance forms, but with a strong Swabian accent. He had a tendency to breadth in the narration. The general tonality of the first Wettenhausen altar is dark; the space is created by the figures. From that time on, local colour became more important in his work; the Hutz altar in Ulm Minster (1521), where the figures are at least convincingly related to the space, is light in tone, tending towards whitish-grey, while the second Wettenhausen altar is really bright with its red and warm grey tones.

Schaffner's strength lay in the single figure, such as the Apostles St Philip and St James the Less (Nuremberg) with their delicately toned faces and exquisitely painted white beards and hair, and with solid haloes of shiny coloured circles standing out against the Renaissance buildings in the background. The Crucifixion of about 1530 (Stuttgart) is important in itself and noble in feeling. Schaffner was a gifted portraitist and far superior to Strigel in spiritual insight: Eitel Besserer (1516, Ulm) is a supremely individualized portrait, Raymond Fugger (c. 1527, Schloss Oberkirchberg) an important bust portrait, firm in structure and with strong internal modelling. Schaffner's development went on almost to the end of his life. We can see that in a table he painted in 1533 (Kassel) with astrological, tellurian, and moral allegories, an unprecedented commission for a man who had remained loyal to the old faith.

Jörg Ratgeb, born about 1480, perhaps at Schwäbisch Gmünd, and known by documentary evidence to have been active at Heilbronn, Frankfurt, and Herrenberg, was executed at Pforzheim in 1526 for having taken part in the Peasants' Revolt. It is difficult to place him among the even-tempered Swabians.[7] Apparently he began work at Frankfurt; he may have spent his journeyman years in the country of Bosch and Patinir, perhaps at Antwerp.

The double full-length portrait of Claus and Margaret Stalburg (1504, Frankfurt) has been both claimed and disputed for Ratgeb. Tall and slender, secular figures, connected with the lost centre panel of a Crucifixion, they are more relaxed than Dürer's Paumgartner brothers, since they are not concealed under the appearance of saints. It is a very pictorial painting, with little internal contour, and the woman's face, in the light flow of the colouring and the white and gold of the cap, tiny as it is, resembles Ratgeb's certain work more than anyone else's.

Such works of his as have come down to us belong to about a single decade: the altar at Schwaigern with the martyrdom of St Barbara, dated 1510 – a remarkably early date for such beginnings of Mannerism; two altar wings (Stuttgart) with the Ecce Homo and the Carrying of the Cross, after Dürer; and murals in the Carmelite house at Frankfurt, now for the most part destroyed. The latter are not only impressive in size but important in subject-matter, as they represent the story of salvation from the Creation

to the Last Judgement, and the history of the Carmelite Order – very skilful illusionist painting with figured architecture, executed between 1514 and 1518. Then come the larger altarpiece from Herrenberg (Stuttgart), done in 1519 at fresco pace, and finally two drawings for an altarpiece of the Virgin (formerly Dresden).

In its lighting, the Resurrection in the Herrenberg altarpiece follows Isenheim. There is not a single restful figure in the whole work; every participator in the scene is in violent movement, whether acting or suffering. There is nothing in between. Every torturing or tortured figure is passionately or hatefully involved in the cause of Christ, who has obviously been taken as a symbol of the humiliated and rejected. There is something agitated and agitating in all the pictures, the stench of prisons, moustachioed criminals, rooms filled with conspirators, and the quiet places of the death of the poor. There is not a gesture of reconciliation. The people living in this atmosphere are tense and driven. Movement sweeps down on them like an untamable force; it does not come from within. Thus in the Flagellation (Plate 91) the left leg of the flogger bursts gigantically out and deprives the body of its natural proportions. The exaggeratedly elongated body of Christ swings round the pillar. A soldier rises like a giant to hammer down the Crown of Thorns; among the rest there are short undersized figures – even here the normal is exceeded in both directions. Late Gothic *verismo* and the truth of the humbly human, where we feel that the artist is putting his whole self into the work, stand beside perspective passages and medieval symbolic proportions such as rendering Christ larger in size than the others. In the Flagellation, the trellis-like tower from which Christ descends through a number of scenes to the torture cellar seems to belong to the ear-splitting clatter of feet on the flagstones, the iron tools, the crack of the whips, and the shouts of the soldiers, whose bustle with their instruments is almost audible. There are tatters of space which seem to come to rest nowhere, but to whirl in circles. The whole is assembled in large passages, not very rich in detail and painted in such a way that it shows that the painter was trained in fresco. The general effect of the colouring is sallow, enlivened by iridescent contrasts of warm colour and white. Ratgeb has left far behind him the intense colouring of the Old Swabian school, if ever he used it at all.

AUGSBURG

The other principal Renaissance city beside Nuremberg was Augsburg.[8] The position of Augsburg was based on the assimilation of Renaissance ideas by a whole generation. Ulrich Apt the elder was one of the seniors.[9] The son of a painter, he was born about 1460 and died at Augsburg in 1532. In 1481 he was an independent master. It was he who painted the fresco of St Christopher of 1491 in the cathedral, a huge, broad, Late Gothic figure. His most important work consisted in the two wings of an altarpiece for Heiligkreuz at Augsburg (1510, Karlsruhe and Paris) with the Adoration of the Child by the Shepherds (Plate 96) and the Magi; if one counts the fair-haired, spiritual head of Joseph, it contains the portraits of the twelve office-holders of the weavers' guild. In

Apt's enchanting work the Renaissance meant little more than a great plenitude of life; it was a joyous enhancement, not a toning down. The restless background may contain reminiscences of *Wanderjahre* in the Netherlands. The figure of an old man (Vaduz) is somewhat slenderer in the Late Gothic fashion, with the eyes devoutly upturned. The double portrait of an elderly couple (New York) is dated 1512. Its warm colouring is set off by cool flesh tints; the modelling of the forms is sculptural and effective.

Apt's style was probably carried on in his workshop, where three sons may have worked not long after the beginning of the century. They passed master in 1510, 1512, and 1520. One of them may have been the Master of the Rehlingen altarpiece (1517, Augsburg), a Crucifixion surrounded by a mob of rough, rather puppet-like figures, carefully painted, which spread over all three wings. Another son may have been the author of the University altarpiece (1512/13, Munich), which also unites the wings by the grouping of four saints in a garden painted with great truth to nature; the figures rise above the hip-high wall, so that the eye roves over a wide, soft green landscape – a composition more usual in Netherlandish altarpieces. In the outstanding Lamentation in Munich, there are echoes of Engelbrechtsz., Oostsanen, and probably Mostaert. This descendant of the Apts, however, seems to have been the author of a Rehlingen portrait of 1540 (Berlin); it is a young man's face, still vacant, the eyes still insecure above a splendid Augsburg coat of armour with the monogram LS – whether of the painter or the armourer is uncertain.

Hans Holbein the Elder

A more decisive impetus to the new age at Augsburg than that of Apt was given by Hans Holbein the elder.[10] He was born at Augsburg about 1460/5 and seems, in his long *Wanderjahre*, to have visited not only Ulm, where he met Michel Erhart, and the Upper Rhine (the Schongauers), but probably also the Netherlands. Influences from the Columba altarpiece and other works by Rogier, and perhaps Memling and Hugo van der Goes, appear in his early work; his style bears the mark of impressions received from sculpture. In 1493 he did the paintings for Michel Erhart's Weingarten altarpiece (now in Augsburg Cathedral); this was when he was a citizen of Ulm, where he is mentioned in 1499. Yet apart from a stay at Frankfurt about 1500-1 he was at Augsburg from 1494 (when he probably married a sister of the elder Burgkmair) to 1515, among other things as a designer of stained glass and the head of a large workshop, where his younger brother Sigmund also worked for a considerable time.[11] Then he turned south-west, worked at Isenheim and presumably at Lucerne and Basel, and probably made the very vivid portraits of donors for his son Hans's Oberried altarpiece in Freiburg Cathedral. He probably died in 1524 – it is not known where.

This Late Gothic realist painted the pictures of the Virgin in the Weingarten altarpiece; all the objects and household implements in St Anne's bedroom and the truth to nature of the girls' faces in the Presentation testify to an intense power of observation. He was, of course, not so novel and revolutionary as Dürer was in those years. Holbein made more than two hundred drawings, mostly in silver-point, a technique native to

the Netherlands. They are not actually studies for pictures, but primarily scenes from the world about him, above all, portrait heads of unaffected simplicity, without pose, as if they were strangers to the draughtsman and unconscious of sitting. Thus they are more alive and objective than any carefully elaborated piece. A unique work is the transfigured head of an old man with half-closed eyes (Copenhagen), which does not exist in virtue of its outline, but in purely pictorial fashion in its light and shade, arching forward by means of the white hair and beard. This is certainly a late work, for Holbein steadily grew nearer to this pictorial manner, which is so remote from Dürer's vehement drawing. It is to this gift of observation that many of the figures in Holbein's altar-pieces owe their truth to life.

The twelve pictures of the so-called Grey Passion at Donaueschingen, painted about 1498, mark a very great advance in the creation of form; probably in consideration of the carving in the shrine the inner sides of the wings are almost uncoloured grisaille (the outer are more greenish), and by that very fact what Holbein has to say becomes remote from reality, like unpainted sculpture. The very consciously constructed scenes are for the most part organized like reliefs in two strata. Christ in Distress, on the other hand, is given some space. The bare ground, though there is no grass painted, is as green as a meadow, the background is bluish dark green. It is a moment of rest in restlessness, with enemies lurking on the watch, but the pointing, questioning, nudging brings out the last pause before the decision.

Just before the turn of the century, Holbein's ten years of great commissions began. In 1499 and about 1504 he painted the basilicas of S. Maria Maggiore and S. Paolo (Plate 92) for the Dominican convent of St Catherine at Augsburg which formed part of a cycle for the blind arcading of the chapter house. The given outline was a pointed arch, and with its framework of painted tracery, Holbein set his picture of S. Maria Maggiore in a relation to the Church spiritual. On the other hand, in S. Paolo he gave more feeling to the fourteen scenes from the life of the apostle, and enriched the spiritual with a very actual space, so that St Thecla, seen in the centre of the whole, seated, and from the back, might be a detail from a Dutch genre piece. The Late Gothic manner of presentation was so forceful that the old ecclesiastical elements faded into the background. Holbein may have paid another visit to the Netherlands before he painted this picture, but after his stay at Frankfurt, where, in 1500-1, with the aid of Sigmund and Leonhard Beck, he had made the huge, double-winged high altar for the Dominican church; it had a carved group – now lost – in the shrine, while most of the paintings have been preserved at Frankfurt, and some fragments at Hamburg, Basel, and Toledo, Ohio. The outer sides, with the Tree of Jesse and the 'genealogy' of the Dominicans, continued the architectural constructions of the pictures of the basilicas, but with different means. The paintings of the Virgin and the passion are so unprecedented in the brilliance of their colouring that they give the impression of enamel, which is enhanced by the refinement of the various greenish-blue and violet tones.

Holbein may have made the general design for the high altar from Kaisheim (1502, Munich); in any case, the pictures of the Virgin in the interior are obviously related to Gregor Erhart's Virgin, and in all the scenes the movement goes towards her. Even on

the outer sides the colours are composed in a mysterious and spiritual fashion, which is, at the same time, musical; the mid-blue which appears four times in Christ's cloak; the King of the Jews and the Resurrected Christ appearing three times in carmine; and then the more patchy-looking white of St Peter, with blue in the shadows, shine clear and pure against the more variegated but duller colours of the figures of the world, and the same is still more true of the shades of blue in the Virgin's robe.

Ulrich Schwarz's votive tablet (Augsburg, Museum), probably of 1508, shows Holbein, in many family portraits, and even in the sacred figures such as Maria Mediatrix, the Man of Sorrows, and God the Father, as a portraitist of crude and not at all sublime human figures. He also painted portraits for their own sake, about 1512, for instance, a woman of thirty-four (Basel), entirely in very warm flesh-tones, with an ochre-brownish dress on a blue ground, the eyes looking straight ahead and very small, the face modelled by colour alone, with highlights here and there on the curves (Plate 98). A gem of ruthless realism, only partly veiled by humour, is in the portrait of a couple now at Castagnola, the man full of life and somewhat fattish, his pointed nose supercilious, the woman in profile with a red nose, rather stupid, and both as tempera-mentally unmistakable as if they were on a stage. The portraits are possibly companion pieces, though they were not painted at the same time; the man is to be dated about 1515, the woman ten years earlier. Holbein, the painter of humanity, attained as great a psychological depth of insight as his contemporary Quentin Massys.

About 1515, Holbein, with his precision of observation and his apparently objective perception of people, things, and actions, had approached so close to pure detachment that the use of Renaissance forms was to be expected. They appear only as decoration, in the architectural background of the Man with the Fur Cap of 1513 (private collection), and especially on the wings of the St Sebastian altar (1515/16, Munich). The Virgin in the Böhler Collection in Munich brings to a close a series of Virgins which began in Late Gothic and grew more and more worldly; here a green curtain borne by angels in front of a blue sky and an architectural motif of a threefold, empty balustrade in grey brings in a new touch of earthly dignity. The last known work is the Fountain of Life (probably 1519, Lisbon; Plate 95). Once more, the elements of Holbein's absolutely personal manner appear side by side; the saints in the foreground have a touch of Gerard David and Hugo van der Goes,[12] the triumphal arch in the Venetian style had had its predecessor in Hans Daucher's work of 1518[13] in Solnhofen stone (obviously the picture was also overpainted by a member of the circle of Herry met de Bles), yet Holbein created a superb unity with the delicately coloured, mildly ceremonious saints and the new architectural forms.

Hans Burgkmair the Elder

The only Augsburg painter who could to some extent stand comparison with Dürer was Hans Burgkmair the elder.[14] He was born at Augsburg, the son of Thomann the painter (d. 1523). He was probably associated with Schongauer on the Upper Rhine from about 1488 to 1490 and possibly followed that up with a visit to Upper Italy. In the

years around 1505 he was again in Lombardy, and in particular visited Venice. Thus his life, as far as the centres of his training are concerned, was very like Dürer's. In 1498 he was registered master at Augsburg, where he died in 1531.

Burgkmair's work as a painter begins with a panel of the Virgin with five female saints (private collection), painted in the nineties, in which his artistic descent from his father and Schongauer come out clearly; it emerged further with two portraits of 1490, one of the famous Strassburg preacher Gailer von Kaysersberg, the other of his friend Bishop Friedrich, Graf von Zollern (both Augsburg). Both are remarkable works by a young artist who strained every nerve to reproduce the deeply lined face of Gailer and the massive features of the bishop with superb individuality. Even later, kindliness was not an outstanding feature of Burgkmair's portraiture. In any case, the spare portrait of 1501 of a young man, set convincingly into its frame, who may be identified as Manuel Deutsch,[15] represents a haughty, sarcastic young being with strongly marked features. Anna Laminit (Nuremberg; Plate 97), famous for long fasts and later executed for religious fraud, has, under the brim of her grey fur cap, the pale, bony face of a hairless woman with a bent for the lunary, mediumistic, and ascetic, a special case for the portraitist and a great success of powerful monumental simplicity.

After his first visit to Italy, Burgkmair's women became more finely drawn, but more homely, his men nobler, more ideal, more youthful; for instance, the fair-haired Hans Schellenberger (1505, Cologne), the dark-haired elegiac youth of 1506 (Vienna), who so closely resembles him, the thoughtful man of 1506 (Florence), and finally the Sebastian Brant (c.1508, Karlsruhe; Plate 99), his dress blackish-grey with touches of warm red and a fur hat against a cool green ground, the first pure profile in the north for a long time past, with a large, prominent, inquisitive nose. The background is nearly always in monochrome. The triumph over an early astringency, the new conception of colour as a means of artistic expression, a touch of Renaissance freedom in the personality, all these are due to Giovanni Bellini.

The moving death-portrait of Conrad Celtis, a woodcut of 1507 (P118), is probably the first portrait print in the manner of Roman funerary monuments; in the woodcut portraits of Pope Julius II (1511) and of Jacob Fugger (P33 and 119), with which, at the same time as with Baldung,[16] the woodcut portrait began in Germany, Burgkmair remained faithful to the Renaissance gravity of the profile which had developed out of the principle of the portrait medallion; he even applied it to Christ (B21).[17] He achieved the absolute perfection of what a portrait sheet could give in 1512 with a portrait of Hans Paumgartner in Renaissance architecture (B34) printed in three different shades of mauve plates without any black-line work. His portrait of a young man (Oxford) and another of his father in illness (1520, Dresden)[18] show that he nevertheless possessed the power of creating out of the less domesticated forms of life, heroic figures and the hieroglyphics of old age.

And yet this brilliant portraitist remained first and foremost a painter of altarpieces. He contributed three basilicas to the series of churches of the convent of St Catherine: St Peter's (1501), with the remodelled portal for the jubilee of 1500, the first adoption of purely Renaissance forms in German painting, S. Giovanni in Laterano (1502), and

S. Croce (1504, all Augsburg). The structure is adapted to the place which Holbein had given Late Gothic ornamental architecture. At the beginning, Burgkmair emphasized the horizontal in order to give a clear separation between the individual parts of the complex iconography, but later he returned to decoratively applied tracery.

Venice seems to have played a part in releasing him as a painter of altarpieces from the double authority of Late Gothic basic forms and partial adoptions from the south. In the triptych of 1505, made to the commission of Friedrich the Wise for Wittenberg and now at Nuremberg, St Sigismund and St Sebastian appear in the centre panel; this is no longer the usual group of three. An empty space between them in the middle of the picture is barely occupied by one of the angels who spread out the brocade. In the wings, St Eustace and St Valentine are oddly placed on a gold ground under a sketchy tabernacle. There are bunched clusters of form, for instance on the right wing the head of St Christopher as he looks up to Jesus; they may owe something to Breu. On the outer sides of the wings St Roch and St Cyprian stand against a marbled architectural background, with a somewhat distorted expression on their faces.

The woodcut of the Virgin with the Child of 1508 (P84) is Byzantine in its origins, like the drawing in Paris.[18] The Virgin of 1509 (Nuremberg) is unique, because the Child, standing on the ground, tells unmistakably of Italy (Plate 94). A segmental pediment gives dignity to the Virgin; the Child is almost bow-legged. Building and natural growth stand side by side, life and world dominion stand side by side too, and both are in nature. This attitude is eminently characteristic of Augsburg. Burgkmair had become polyglot, and when he had achieved full maturity he placed words of the most varied derivation just where he considered them to be most appropriate. The composition of the Virgin and Child of 1510 at Nuremberg was based on the school of Leonardo, the Holy Family of 1511 (Berlin) is made restless by the ruins, the destruction of the old world, the landscape, and the appearance of the star; the mystic marriage of St Catherine (1520, Hannover) has calmed down into a classical group of three figures, and the landscape and the distance are mere glimpses behind the splendid tapestry of the Virgin.

In Burgkmair's later altarpieces this multifariousness was reduced to unity. They are conceived as a whole, like Grünewald's. In the St John altarpiece of 1518 (Munich; Plate 93), one scene is spread over the whole inner side, beautifully set in a green and detailed landscape with tones of red, particularly in the robes of the saints; in the St John on Patmos elemental nature came out with greater force than ever before in Burgkmair; a pen-and-ink drawing (Stockholm) seems to have been the preliminary study for this central panel. St John's face is awry, and there is torment in his look. In 1522, in collaboration with Loscher, though Gregor Erhart was his natural contemporary, Burgkmair made the wings for Loscher's Rosary altarpiece for the Chapel of St Roch of the Imhoff family at Nuremberg; it is beautifully painted in the same way as Holbein the younger painted his Passion wings at the same time.

In 1529 Burgkmair painted the Battle of Cannae (Munich) for Wilhelm IV of Bavaria; he followed Livy in detail, grouping the battle-scenes clearly on three planes behind each other, but not in a single view. In 1528 he also painted Esther in the presence of Ahasuerus (Munich), an oriental subject which gave him great imaginative scope.

Painted from a near, but deep viewpoint, showy and disturbing in flickering, wilted colouring, assured, with many facts and reliefs of the Quattrocento, the picture is a piece of bravura with a genuine feeling for a moment of critical decision.

All these qualities are also Burgkmair's strength in his woodcuts. From the beginning of the century at the latest, Burgkmair was the centre of the Augsburg woodcut. His art was not that of Dürer, which delved into the depths and at times became scientific. Gaiety and freedom, inexhaustible imagination in narration, delight in decorative splendour, the firmest command of Renaissance forms then to be found in Germany, and a natural dignity gave the tone to Burgkmair's woodcuts. From 1510 he was assisted by an excellent cutter, Jost de Negker of Antwerp, who was born about 1485 and died about 1544; he was a master of the chiaroscuro woodcut. Burgkmair had made a beginning with this technique as far back as 1508 with the noble equestrian figures of St George and the Emperor (B32, 33). They had in fact been preceded in 1507 by Cranach's chiaroscuro print of the same saint. Burgkmair and Negker[19] continued it in 1510 with the terrifying woodcut of Death murdering Lovers in a Venetian setting (B40), for which Lucas van Leiden's David and Goliath was pressed into service.[20] Then followed the Virtues, the Vices, and the Constellations in magnificent frames. What is admirable is the staying power which made it possible to tell such stories in all their breadth, yet characteristically throughout.

Burgkmair seems to have boldly taken a line of his own with Maximilian I's Genealogy of 1509–12. For the ninety-two mythological and Habsburg ancestors, he always found some characteristic point, thanks to his sense of humour and his feeling for the past. It was in the same way that Burgkmair also mastered, from 1512, the *Theuerdank*, to which he contributed fourteen illustrations along with Beck, Breu, and others, and the *Weisskunig*, to which he contributed a hundred and eighteen out of two hundred and fifty-one, all proof of his historical volubility and power of fantastic allegory. These volumes were finished in 1517/18. Finally he was commissioned to provide designs for Maximilian's *Triumph*, in collaboration with Dürer, Beck, Schäufelein, and Altdorfer. He finished his part – the lion's share: sixty-seven woodcuts – by 1516. Among them there were some designed by Kölderer's workshop, but there was no friction between the two. Burgkmair mastered all this work with facility, liveliness, rhythmic power, thunderous rhetoric, fiery pace, abounding fantasy in the decoration, and pungency in the subject matter. No wonder he is the finest animal draughtsman in the group and the most versatile delineator of characters, in their respective environments. In all these things Burgkmair was far superior to Dürer for the work in hand, thanks not only to his Swabian equanimity, his delight in work well done, and in a formal but uncomplicated idiom, but also to an agreeable shallowness and a dislike of probing too far. In Maximilian's prayer-book on the other hand he fell far short of Dürer's gay manner of narration, his whimsical invention and creative ornamental power, especially as he aimed at unity of ornament on each separate sheet. Then came a few series of woodcuts, made with the assistance of Negker, of Christian, Jewish, and pagan heroes and heroines (1519) (B64–9). The figures are encrusted with linework after the Mannerist fashion, like the delicious Follies of Love of 1519 (B4–6, 73). In 1523 he illustrated a New Testament

of Luther's, with an Apocalypse quite independent of Dürer's. Of 1524–7 are great wood-cuts, such as the Mount of Olives (B17) and the Seven Sorrows of the Virgin, their linearity stressed by white internal lines. Even in the last ten years of his life Burgkmair's wealth of invention and productivity did not fail him.

Other Augsburg Masters

Daniel Hopfer the elder, who was born about 1470 at Kaufbeuren and, having settled at Augsburg in 1493, died there in 1536, was a graphic artist in a more technical sense.[21] As an oustanding etcher of reproductions, he made an important contribution to the dissemination of Italian ornament. He may have been the first German to etch on iron plates. Having cast in his lot with the Reformation in 1522–3, he etched the Creed and the Lord's Prayer, and a religious satire against the priests based on the Gospel of St Matthew 23:13 ff. (B33, 28, 31), only the first of which goes back to medieval models, while the Paternoster is partially based on Holbein's metal cuts of 1523. As a whole, the medieval pictures are replaced by more modern designs, which give Reformation im-petus to traditional social and religious satires by combining them with Gospel texts. All these series consist of eight or twelve small pictures, and these in turn were printed together on one sheet; here, for the first time, we encounter the work of a man who was a typical Kleinmeister, but also truly a master on the small scale, without pretensions of any kind. It is notable that it seems to have been Zwingli who, at the same time, intro-duced the large, hanging or wall catechism of tall, placard shape. The old medium size and the old function of the altarpiece were both vanishing.

Leonhard Beck[22] was born about 1480, the son of Georg Beck, who had had his share in the ultimate and supreme glories of Augsburg illumination with two psalters of 1494 and 1495. In 1495 he was apprenticed to Hans Holbein the elder, and was his assistant at Frankfurt in 1501, where he seems to have collaborated on the Passion panels of the Dominican altarpiece, with the exception of the Resurrection, and later on the Walther memorial tablet of 1502 (Augsburg) and on the small Crucifixion altar from Kaisheim (Augsburg): both were obviously painted in Holbein's workshop. In 1503 he was made master. He took a share in the illustration of *Theuerdank* and *Weisskunig*, and, in 1516–18, without any assistance, made a hundred and twenty-three woodcuts of saints in the *Sipp-Mag- und Schwägerschaften* of Emperor Maximilian; they were a very free adaptation of Kölderer's lost designs for the statuettes of the tomb. He died at Augsburg in 1542.

If he was really the author of the series of chalk portraits of Augsburg artists ranging from 1502 to 1515, and of a few other portraits belonging to it, he was a notable draughtsman and delineator of character.[23] Though rather weak in invention, he poured fresh dramatic energy into the elder Holbein's palette during the time he worked for him. He may have continued to work more or less in the manner of Holbein. The St George and the Dragon (Vienna) with its fine colour scheme is connected with the Danube school of painting. Later, about 1520, Beck vacillated between Burgkmair and Breu in an Epiphany and in votive tablets of the Weiss couple (Augsburg). By him also there are fluently painted single portraits, such as that of a young man of twenty-one

(1515, San Francisco, California Palace of the Legion of Honour). Beck's later portraits are not easy to distinguish from those of Christoph Amberger, his pupil and son-in-law.

In his early years, Jörg Breu played his part in the development of the Danube style.[24] Indeed, in its early phase, he and Cranach were obviously its most outstanding representatives. Born about 1475/6, apprenticed to Ulrich Apt in 1493, he set out on his *Wanderjahre* in 1496, and was certainly in Austria from 1500 to 1502 obviously as a wandering painter, not a member of a guild. From 1502 till his death in 1537 he was active at Augsburg as a painter and designer for stained glass and woodcuts.

We possess one work by Breu dating from before he set out on his great wanderings, the marriage portrait of the Augsburg armourer Coloman Helmschmid and Agnes Breu (Castagnola). The work lacks unity. Beside the bright figure of the woman rendered in a light, warm red and green, the colouring of the man in his reddish-brown fur collar looks dull, or even dirty. We can see by his pronounced features, defiant mouth, and cleft chin that Breu had to copy a portrait by Burgkmair.

There are three Austrian altarpieces: one of St Bernard of 1500 at Zwettl, and two of the Virgin and the Passion, the first from Aggsbach (1501, Herzogenburg, collegiate buildings, and Nuremberg), and the second the former high altar of Melk, of about 1501–2. They are works of a youthful pioneer of genius. Breu may well have found some confirmation of his manner in the work of Rueland Frueauf the younger, the Passau painter, and may have exchanged ideas with Cranach, also a stranger to the region, though there is no evidence of him in Austria till 1502–3. Breu was the first to fuse into a single world-picture the direct observation of, and feeling for, nature – which Dürer had restricted to his water-colours – with human figures which are moving in both senses of the term. This was a historical moment in the history of Christian altar painting. Among the monks reaping the corn, St Bernard kneels in a harvest landscape saturated with summer. A road winds through the gently rolling hills and disappears behind the waving corn, to reappear on the height beside the wayside crucifix. There is distance in the lake and its mountains. The inviting, almost romantic landscape is supported by the castle and the hill monastery. From that time on, landscape was a sonorous attribute of the Passion, intensifying the atmosphere of the Nativity and the fear and danger on the Flight into Egypt (Plate 101), both from Aggsbach. In the latter picture there is a view of the little town where the massacre of the Innocents is going on and pursuit has started from the height to which the blessed and careworn fugitives are moving between rocks and woods. These Aggsbach pictures, oblong in shape and full of tension, form a truly terrible Passion; the savage soldiers fall on the victim of the Flagellation in two diagonals. He does not stand there like the dark, glittering column; his knees seem to be breaking beneath him in a fragile diagonal. All the figures in the picture bend over Christ, who is not Herculean, as he usually is in Grünewald. Their staves bend as they force the Crown of Thorns on to his head. This is a scene which is repeated at Melk in simpler forms, with the central figure with the footstool terrifyingly enlarged (Plate 100).

Unlike the natural surroundings, the figures are felt rather than observed; they have preserved a touch of the German past, of Jan Polack's altarpieces in the Bayerisches

Nationalmuseum at Munich of 1490–2. There is a sense of conflagration in the scene of Christ taken prisoner, and there is feverish madness in the Passion. Yet one figure nearly always remained free of distortion – that of Christ. St Bernard too, for the most part, stands like a statue, as he heals the possessed who are held at a distance from him by two men; they form a kind of relief which is seen from a different viewpoint within the picture. For the most part, the relief consists of many single heads, thrown back, turned aside, or prone; each pose has its own special significance. Breu drew them in most careful perspective, yet without creating a unified spatial effect. The details of the harsh faces, which are often conceived as horrible grimaces, are almost entirely flattened out after the manner of masks. True, the masks are convex and there is a hint of supporting bones, but heads are seen frontally, and not built up out of their true roundness. These masks for the most part appear in a sideways perspective, bent or thrown back, and are then, in their turn, subjected – not always with success – to the specific perspective of the picture. The transition from the 'face mask' to the unavoidable rounding of the head often remained tangible. That is how the oddly flattened, broad heads of Breu came into being, with their mongoloid expression often reinforced by the narrow, flaming slit of the eyes. In this form Breu produced a whole generation of the enemies of Christ. In a general way, however, this perspective, applied to faces twice in succession, was not unique in its time. Statues of the Late Middle Ages, with base, books, or tools seen in perspective – as at Hildesheim or later in work by Claus Berg – can be seen by us from quite different points of view, and so effects come about similar to those of Breu.

The more formalized Breu became later, the more his naturalistic narrative was strewn with traits of conscious artfulness. Of the period after his return to Augsburg, the charming Virgin with Saints and Angels of 1512 (formerly Berlin; destroyed) and the Virgin of 1509 in the church at Aufhausen,[25] presumably after a design by Dürer (w466), are the first works preserved. They show that he developed the Augsburg bent for the idyllic. After the first turbulent flowering of his genius, in which he made use of engravings by Schongauer for the Melk altarpiece, Breu became a virtuoso in the adoption of Renaissance forms from Augsburg artists (Burgkmair), from Italian Quattrocento-Gothic masters, and perhaps even from Gossaert. Breu's attitude to Dürer's classic spirit is characteristic. Although the entablatures in the room in which the Virgin sits recede rather more abruptly than in Dürer's drawing, they largely prevent any space-creating effect. The Virgin sits almost in front of the room, or at any rate not perceptibly in it. Irregular patterns of fragmentary ribs are spread under the tunnel-vault, in contrast to Dürer, whose network of ribs almost creates a Renaissance coffered vault.

There are Antique buildings in the pictures on the small organ of about 1522 in St Anna at Augsburg, yet for all their perspective they create no space; they are brimful instead with over-deeply modelled form. The cramped stage of the design for a votive tablet (Stockholm) hardly leaves room for the Fourteen Saints of Intercession to whom it is dedicated. A rolling sea of human bodies opens the picture of St Ursula which spreads even across the wings of an altarpiece of 1525 (Dresden).

Thus Breu's Battle of Zama (Munich) is, with its confused throng of figures, more

Mannerist than Burgkmair's carefully constructed Battle of Cannae. Breu, with his native energy and delight in movement, deprived corporeality and space of their force by an untrammelled riot of movement; nothing freezes under his hand; all is white hot. That already holds good of the agitated, conventional gestures of the Ascension pictures on the great organ in St Anna at Augsburg (after Botticelli and Filippino Lippi).[26] The Lucretia (1528, Munich), in its warm, brownish colouring, has similar things to show. The figures gesticulate like puppets, surrounded by the civilized forms of correctly constructed Renaissance architecture. There are details which recall cassoni and Botticelli's Lucretia in the Isabella Stewart Gardner Museum in Boston.[27] In the picture at Basel the foreshortening is exaggerated. Samson slays the Philistines, but, as with the sleepers in Ratgeb's Resurrection, no vista of space results. The eye, as it were, plunges at a blow into the main picture plane, and is held spellbound by the tumult.

This is the reverse side of the fine human dignity of classicism, which Burgkmair still possessed, but Breu only achieved at times. From the outset Breu's strength lay in drive and violence, the domination of the mob, the horrible. He had his idyllic moments. Burgkmair was master of both elements; for he too responded to the terrible, as a comparison of Breu's drawing of a severed head (Vienna, private collection)[28] with Burgkmair's head of St John (1522, London, British Museum) proves. But what both Breu and Burgkmair lacked was Dürer's golden mean. Thus Breu painted many Virgins, but he had too little sense of personality to become a portraitist. The only kind of portrait he succeeded in was the type of the patrician bully, as for instance in the portrait of a young man at Hannover.

Every once in a while he returned to the woodcut. Thus he was a contributor to Maximilian's *Theuerdank*, and made eighteen woodcuts of the Investiture of Ferdinand I with the hereditary possessions of the Habsburgs in 1530 (in Austria and South-West Germany). He contributed to Maximilian's prayer-book the drawings subsequently signed with the initials MA. He also made the designs for Loy Hering's Salm monument.[29]

PAINTING IN BAVARIA AND AUSTRIA

Bavaria

TOWARDS the end of the fifteenth century, Breu must have passed through Bavaria on his way to Austria. If we try to imagine what painters he met or could have met there, it will give us a starting-point for the present chapter.

He probably encountered the vehement style of Jan Polack in Munich.[1] Polack, who seems to have come from the east, bringing Bohemian influences with him, must have struck Munich like a tornado when he appeared there in the middle of the seventies – much as Grasser, the sculptor, did. He died in 1519. His main works belong to the nineties; about 1490 he painted two pairs of wings for the great altarpiece in St Peter (Munich, Bayerisches Nationalmuseum). They are incomparably passionate. Along with them, the splendid Trinity of 1491 in the chapel at Blutenburg and the dramatic altarpiece from the Franciscan church (1492, Munich, Bayerisches Nationalmuseum) must have impressed Breu. The eight portraits by Polack which have come down to us were painted before about 1495; they are caustic likenesses, wayward but telling, and often dashed off with a roughly-handled brush.

A much more attractive figure was the engraver and goldsmith MZ, who is probably to be identified with Matthäus Zasinger, who was born in Munich about 1477 and died after 1555.[2] He may have been one of Dürer's first pupils, and learned from him his light, clear manner in engraving. His talent was original, especially in his genre pieces and stories. His engravings are dated between 1500 and 1503.

Breu may also have met Mair of Landshut.[3] As a painter, who produced twenty-two engravings and three woodcuts, he probably began work at Freising, which we may take to have been his native town. He was born about 1450 and is mentioned in Munich in 1490. He then assisted Polack in his great altarpiece in St Peter, especially in two scenes of St Peter's life, and was later active at Landshut. He last dated a drawing in 1504; among the twelve others the dates 1495 and 1496 occur.

His paintings, on the other hand, obviously extend over a period of thirty years. The Crucifixion (Cologne) may well have been painted in the workshop of Pacher's St Wolfgang altar[4] about 1485. In the early nineties, when he was obviously already independent, he came into touch with Augsburg, in particular with Holbein, whose uncle he probably was. There is some similarity in colouring between the two. Mair used the innkeeper in Holbein's Weingarten altarpiece (1493) for his Freising panel (1495). He made other borrowings from the Master ES, in the lovely St George and the Dragon (Munich). There are echoes of the north-west in his pictures. A contemporary of Jeroen Bosch – though lacking his unerring vigour – and a somewhat crabbed exponent of Late Gothic, Mair made his figures look like weightless puppets; there is imaginative

playfulness in his architecture, but his panel for the sacristy of Freising Cathedral of 1495 is totally different from Holbein's; it is self-contained, and not developed out of the frame. Mair applied the grotesquerie and fine brushwork of the small format even to this large painting. It is in two superimposed stages: in the lower there is the washing of St Peter's feet; above, smaller and in perspective – though Christ retains his traditionally significant height – there is the Last Supper with the architecture crowned by the Pillar of the Flagellation. On the right, Christ on the Mount of Olives, on the left, Judas moving towards the soldiers and, in the distance, Judas hanging from the tree. But to enlarge on the iconography is not all that is needed to characterize Mair: we must also admire his charming trifles, the ducks in the canal, the partridge, the crawling snail, the squirrel cracking nuts behind the kneeling donor, and the manifold play of the delicately articulated architecture. He was a master of small talk, almost insatiable in detail. The multiplicity of motifs gave the whole a touch of surrealism.

His later works are more intimate, warm-hearted, and profound. Less emphasis is laid on mere artfulness. In the picture of St Oswald (Munich, Bayerisches National-museum), the great talker has kept himself in hand. The Ecce Homo (1502, Trento) is clear and comprehensible. This is Mair's classic moment, and it was easy for two Renaissance medallions to find a way into the architecture. But Mair was never jejune. In the picture in Vienna, St Matthew stands poetically in his tabernacle with delicate lights playing about him; the room of the Virgin's birth in the Berlin picture remains mysterious. Both the grotesque and the decorative are overcome.

As for Mair's engravings, he sometimes parted with them in coloured form; antici-pating future developments, he had them printed on paper tinted with water-colour. In some cases he gave deeper modelling by means of hand-colouring, enriching, and altering the print. Thus he created a transition from the old-fashioned hand-tinted graphic art to the chiaroscuro print, which did not yet exist. His subtleties of drawing and painting in the intimacy of his interiors, and his rendering of persons and things, had their influence on Altdorfer, even though Mair had no feeling at all for landscape. Wertinger's Sigismund tablet of 1498 in Freising Cathedral derives from Mair's classic moment. It may even have been painted in Mair's workshop by the younger man.[5]

Hans Wertinger, surnamed Schwabmaler, was born at Landshut or Wertingen about 1465/70; he was probably trained at Augsburg, and later became a pupil of Mair at Landshut, where he was a citizen in 1491 and died in 1533. He was active in painting, and in drawing for woodcuts, and stained glass; later he worked for the Landshut branch of the Wittelsbach dynasty. A distinguished portraitist with Late Gothic begin-nings, he often painted landscapes behind his sitters which had a considerable value of their own. A landscape of the kind is the background to the portrait of Duke Ludwig X (1516, Munich, Bayerisches Nationalmuseum), a broad figure set in the depth of the picture space under a stone arch with a garland and tassels. A balustrade separates the figure from the vista, yet the details of the architecture create a palpable relationship to the free space. Ten years later, the same forms reappear, but the effect is totally different. Duke Wilhelm IV and his consort, in their double portrait (1526, Munich), are not placed in an intelligible relationship to the landscape by foreground structures. In this case, the

frame interferes with the figures from the sides. What remains is a golden fruit garland which helps to hold the busts in the picture plane firmly, in spite of their slanting posture; the lonely figures are almost rent asunder by the stripes of their costume, which is covered with a close-knit pattern of gold, umber, and bluish-brown. The foreground and the hangings are still very deeply modelled. Almost too much value is given to very delicate landscapes with warm colouring under a blue sky. The series of the Months (Nuremberg), fresh, but equally full of Manneristic abbreviations of form, stands mid-way between the Danube feeling for colour and the narrative power of Hans Weiditz the younger.

Breu cannot have met Altdorfer at Regensburg, but he certainly met the two Frueaufs at Passau, Rueland the elder, who had returned from Salzburg to Passau in 1497, where he died in 1507, and more particularly Rueland the younger, probably the son of Rueland the elder, who was born about 1465/70, became a citizen of Passau at the same time as Rueland the elder, and is mentioned there for the last time in 1545.[6] As a journey-man he was probably the collaborator on the wings of the St Augustine altar of 1487 (Nuremberg) who signed himself RF.[7]

The elder Rueland was actually a man of the Quattrocento, but in the four panels of a St Leopold altar at Klosterneuburg, probably dating from 1505, the younger shows himself one of the founders of the Danube style, and one of the most serene revolu-tionaries that can be imagined. In Margrave Leopold's Departure for the Hunt under the Castle Rock, we can feel the new sense of unspoilt nature, to such an extent that even the margrave is small. In the Boar Hunt the figures are actually very small and as nimble as they are in engravings (Plate 102). The boar, with the three huntsmen closing in on it, is hemmed in by the hounds near its wallowing-place. Surrounding it is the delicate springtime wood with the mighty, fertile hills with their ploughed fields above. It is probably the first spring scene in German painting to have been truly observed from nature; the figures may be antiquated, but it is closer to reality than Breu ever came.

Austria

Breu probably never visited Salzburg, where the Tyrolese style in painting prevailed at that time. Marx Reichlich (Plate 103), who was influenced by Michael Pacher and probably employed by him on his great commission of 1484, the high altar of the Franciscan church, was registered as a citizen of Salzburg in 1494, and made it his home. Until Pacher's death in 1498 he still occasionally collaborated on this altar. At the same time he kept up his connexions with the Tyrol, where he may have been born in the neighbourhood of Brixen (Bressanone) about 1460, and delivered altarpieces from there in 1489 to Wilten Abbey at Innsbruck, in 1499 to Brixen (now Museum), in 1501-5 to Hall (now Museum), in 1506 and 1511 to Neustift (Novacella) near Brixen, and in 1515-20 to Heiligenblut in Carinthia. A number of portraits are dated 1519 and 1520; they were ascribed to the group known as the Angerer Master's, but have meanwhile been recognized as late works by Reichlich. The date of his death is unknown.[8]

Even in his contribution to Pacher's altarpiece he replaced his teacher's realistic local

colours by his own soft modelling of flesh and his own tonal colouring, which is made up of strata of fine brushwork. As an early representative of the classic style he overcame Pacher's foreshortened plunges into space; his backgrounds became spacious, and in the new century, whether in architecture or in landscape, they were so wide that the figures seem to be embedded in them. At this point Reichlich seems to approach the Danube school, and as a master of colour he may have influenced Cranach and Altdorfer. In a general way he kept himself to himself. In his St James and St Stephen altarpiece from Neustift (1506, Munich), the human figures, saints or hangmen, are not entirely part of their environment; their faces, modelled by light even to the pupils of the eyes, and by brown areas of shadow with a little gold in the haloes, are clear, firm, and block-like under the intense red, with a great deal of violet and lilac, of the architecture. Reichlich neither took man as the measure of all things, like the Augsburg school, nor did he see him governed by nature. The dignity of his martyrs comes from their saintliness; that is why their tormentors' faces are hideous and mask-like – he could not do justice to them. But his martyrdoms are rather gloomy in mood than bloodthirsty in narrative. Serious-minded men, living their quiet lives at home, were simply chronicled, without any idyllic overtones. His portraits, even in the votive tablets, have something of Roman tomb sculpture, which is enhanced by the neutral ground, by their gaze into the distance, and by their defiant, square-set bearing, although the modelling is soft even there. In the Life of the Virgin from Neustift (1511, Munich) there is brightness even in the architecture, with its pink, pale blue, orange, and grey colouring, and a staircase of greenish sandstone, and there is something earthy in all the tones, which are slightly tinged with grey. In that ambience his women, even his girls, look matronly; charm yields to heart-warming grace. The swelling body can be felt under the block of the outline. Reichlich must have visited Venice and seen works by Bellini and Carpaccio.

That is also the case with Urban Görtschacher of Villach in Carinthia, the painter of the Ecce Homo of 1508 and of the Susanna, now in the Österreichische Galerie in Vienna. He knew how to temper scenes of violence with brutal mobs by lovely details.[9]

Jörg Kölderer[10] offers a more definite pointer to the Danube school. A painter who is also mentioned as an architect, he came from the upper Inn valley and was first commissioned by the court at Innsbruck in 1497. In 1498 he became court painter to Maximilian, in 1518 court architect, and he remained this under Charles V and Ferdinand till his death in 1540. Large frescoes by him have disappeared, except, perhaps, for remains in the Goldene Dachl at Innsbruck.[11] He illuminated books on weapons, hunting, and fishing, and he made pen-and-ink drawings of the 'Fortified Places and Keeps in the Tyrol' about 1507/8. One factor in his appeal was the freshness of his vision and rendering of recognizable places, in which the painters of Franconia had preceded him.

Later he was the director and organizer of Maximilian's artistic projects. We know what part he played in Maximilian's Triumphal Chariot and Triumphal Arch, in the plan for the monument at Speyer, and for the emperor's tomb; his designs served as a basis for the bronze statuettes and for Beck's series of woodcuts. The style of his workshop can be recognized in the illustrations to *Freydal*. It is the fate of designs to be lost

after use. Thus of Kölderer's work for the tomb of Maximilian, nothing remains but an illuminated manuscript[12] in Vienna, with drawings after Sesselschreiber's finished work and plans and of his own designs for what was still lacking. From the little that has come down to us of work by his own hand we can see that he was a provincial master who never quite shed his Late Gothicism. He was versatile, and interested in new developments. His historical importance derives from the fact that he attracted draughtsmen of the younger generation to his workshop and made it, so to speak, the clearing-house of the Danube style. There was more dash to their brushwork than to Kölderer's. Thus the workshop gradually passed from the technique of illumination to the coloured pen drawing. Altdorfer was probably a member of the team. He must have had some hand in Maximilian's Triumphal Chariot; the splendid battle-scenes as pictures carried in the Triumphal Chariot in the miniature 'fair copy', destined for the emperor, begun about 1507 and finished in 1512, are the summit of the work done by Kölderer's group. The designs which preceded them may have been still more important. As regards Kölderer himself, however, at that time, the drawing, as mere news communication or even instruction, was not much appreciated among the great artists. Thus his practical and organizing activity made more mark than his actual artistic production.

Albrecht Altdorfer

Albrecht Altdorfer[13] was probably born at Regensburg about 1480. He is believed to have been the son of Ulrich Altdorfer, who was apparently an illuminator. Albrecht became a citizen of Regensburg in 1505. He was elected a member of the Outer Council in 1519 and of the Inner Council in 1526, and thus attained public status. In 1526 he became superintendent of municipal buildings. Whether that implied the designing of buildings, we do not know. Altdorfer was a member of the City Council when it called in a Protestant preacher in 1533. He travelled to Vienna in 1535 to present his city's apologies for its political and religious doings, and died at Regensburg in 1538. Two journeys for artistic purposes must be mentioned in this brief account of material success and moral courage: in about 1503–5, and again in 1511, he travelled down the Danube to Mondsee and probably to the neighbourhood of Vienna.

If one leaves Huber out of account, Altdorfer was the youngest of the great exponents of the Danube style; Breu furnishes the first certain date, Frueauf followed suit, in 1505 at the latest, and Cranach was in Vienna in 1502–3, but had, so it seems, begun work in the Danube style earlier. These three must have known each other. Some part of their influence may have been already active in Kölderer's workshop; minor masters certainly worked there from time to time. Altdorfer may have begun his career there. In the older parts of the 'fair copy' of the *Triumph*, namely the chariot of the emperor, his mother, and his female ancestors, which show some timidity in the execution, a good deal recalls the early engravings by Altdorfer. He may have set about the new and unwonted themes with youthful zest. The fact that the later pictures carried in the *Triumph*, with their bold spatial vision, were able to introduce the Danube style into Kölderer's workshop probably goes back to Altdorfer's designs.

The earliest date we have for Altdorfer is 1506. It is on two drawings. One is of two dancing muses in Mantegna's Parnassus (or Zoan Andrea's engraving of it) and shows in free adaptation two maidens, one with a shield, one with a lute, personifying war and music; they bear a dish of fruit which crowns the picture (w1). The other is a witches' sabbath (w2) in ghostly and vertiginous black dashed off on a dun ground, the lighting made restless by highlights. It reveals, before Baldung, something of Altdorfer's knowledge of white and black magic in nature. In this drawing, the draughtsman fully mastered his medium. Previously, probably soon after 1500, he made thirteen tiny woodcuts (H62–74) which, stuck into a manuscript prayer-book in the monastery of Mondsee, were probably made there. If Altdorfer began to work with Kölderer so early in life, he was the only great exponent of the rising Danube style who was actually still a youth.

There are small pictures dated 1507: the Stigmatization of St Francis and the Penance of St Jerome (Berlin), the landscape with the Satyr Family (also Berlin), and the Holy Family (Bremen). As an illuminator and engraver in small format, he only ventured on a larger scale very tentatively. There is a touch of Mair's lightness and facility in these pictures. We may take it that Altdorfer thoroughly disliked Polack's barbarism. In his early engravings he tended towards the bright clarity of Barbari. He was certainly acquainted by that time with Cranach's Vienna work, though he never adopted Cranach's savage scenes of torture, and indeed remained entirely aloof from Breu's and Cranach's heroic style.

But through his improvised borrowings from Italy, Altdorfer created a serene, unmedieval, and more ideal view of the world than the harsher Danube artists. There is a fairy-tale grace in his Lovers in the Cornfield (Plate 111) and Under the Tree (w11–12) of 1508, and the ravishing female standard-bearer (w39) of 1512. He was a master of suggestion in his gloomy forest combats (w4, 40, 41) and in the St Christophers (w22, 38) of about 1510–12 in their ghastly light. There is a vein of the fantastic in The Man of the Woods of 1508 and in his Satyr Family (w6, 24). Altdorfer was an explosive creator of nature in nearly all his early drawings; a number of them were already made for their own sake and intended for collectors.

Celtis gave an approximate description of his subjects: 'What delights me are the springs and green hills, the cool banks of the murmuring brook, the dense foliage of the shady woods and the rich vegetation of the fields.' But that is not the whole story, and Celtis, the humanist, probably never had any kind of influence on the form of a work of art.[14] The enchantment of the forest, the feelings of Celtis, and still more of Paracelsus, born in 1493, dreaming of the religion of the ancient Germans, are rather a reflection of Altdorfer's and Cranach's landscapes. Altdorfer stands at the turning-point in history at which art prevailed over science, unless, as in the case of Dürer, the artist was a scientist too.

But Altdorfer's faculty was not Dürer's. He was quite unmoved by new problems of form, by perspective and proportion. The Satyr Family (Berlin) was ready to hand in Riccio's figures and reliefs, or in Venetian paintings,[15] waiting for transport to northern forests. Other borrowings from the south at the time remained without lasting consequences. Altdorfer made his debut as an independent artist with drawings and

paintings in which the calligraphy of grass, bushes, and trees was faultless, and he coined his own formulas. They are rooted in Late Gothic ornament and also in Late Gothic naturalism, but they remain his own. Thus Pacher's altarpiece at St Wolfgang may have meant a great deal to him by its formulae of representing space and the terse forms which the illuminator, accustomed to improvisation, stood in urgent need of. The Nativity at Bremen has such an avenue of trees leading the eye into the depths; even in the St Florian altar Pacher's influence can be felt. Pacher's low horizon also allowed greater size to Altdorfer's figures. Reichlich, at Salzburg, had continued this tradition and the connexion with Italy. But Altdorfer never really mastered perspective; St Francis's face, as he renders it, is as distorted as it is in Breu, and his St Jerome is copied from Cranach's picture of 1502.

Yet all this is of no great importance when we come to consider Altdorfer's innovations. Even in the first decade of the century he outstripped not only the merely naturalistic possibilities in Late Gothic foliage ornament but also the thrusting growth of the trees in Cranach's early work, and was able to grasp the specific habitus of every tree he painted. His favourites were larches. He did not merely attain, as Cranach had done, a convention of foliage, but the essential nature of the particular species of each tree. As early as the little Berlin pictures of 1507, natural growth has achieved almost equal rights with the saints. For him, no natural form stood isolated; it was embedded in the rhythm of the elemental forces of nature. A kind of frenzy may be sensed in his drawings of the first ten years of the century. What Dürer was concerned with was the proportions and shape of his lime-trees (w63, 64), and the peculiarities of their separate forms in the cut of the leaf, in the bark, in the ramification of the boughs. This static realism was alien to Altdorfer. There was no hair-splitting about him, whether in the conception or in the execution, nor did he seek for fundamental laws. Till 1513, when he practically abandoned this technique, there is not in his chiaroscuro drawings a single leaf, or group of leaves, or piece of grass which stands by itself as an independent fact. He gave the tree as a whole, nor was the tree a self-contained unit, but a part of something greater, of the forest, and ultimately of the general luxuriance of nature. Thus to anybody who has a feeling for them, his trees are more credible than Dürer's, but to anybody who checks their proportions and tries to understand their growth in detail, they look wrong and confused.

The great pictures painted about 1510, the Crucifixion (Kassel), which has a trace of Dürer in its composition (Plate 109), the two St Johns from Stadtamhof (Munich; Plate 110), the Rest on the Flight of 1510 by the Renaissance fountain with a lake landscape behind (Berlin; Plate 104), are set in a living natural space. They now have something of Cranach's astringent greatness, which Altdorfer obviously attempted to rival by increasing the size of his pictures. In the St Johns, the Evangelist is in blue and is probably a portrait of Altdorfer's brother Erhard, while the Baptist, in brownish-mauve and brownish-violet, may be Albrecht himself; they are seated in a landscape of trees and mountains rendered solely in brown and warm green. But the trees thrust upward; there is personality in them, just as there is a hint of vegetation in the figures. The mossy ground is crowded with small animal and vegetable life. The breath of fields and

forests rises, and man, himself almost a rooted growth, is woven into the totality of this life. The primeval forces join in the chorus of the sacred stories. Even in the pen-and-ink drawing of the Danube at Sarmingstein of 1511 (w28; Plate 114), which takes in the river, the rock, and the mountain, there can still be felt in the rocks the primeval forces which once went to make them. Altdorfer is a painter of perpetually breeding life, with all its gloom and all the ghostly forests of the north, yet with all the delight in the cross-pattern created in the alpine landscape by the pollard willows (w29). From the topographical point of view, however, the whole lacks precision and the view over the Danube as from above is actually impossible. Altdorfer did not observe the rule of Franconian water-colour landscapes, where everything had to be 'right'. But his drawings are inspired, light-footed wholes, dream wanderings along paths of a rich store of observation; his figures are weightless creatures without joints or articulation, floating heroes of miracle and legend, never quite distinct, but with an immediate impact of unmistakable spiritual truth.

All this can be regarded as a fundamental bent to Mannerism. And that was the way Altdorfer took in his figures. The draped figure of the Virgin in the Nativity of 1507 is structureless, like the bare stake and the twisted trees which surround the St Jerome of 1507. There is, in the figure of Christ in the Crucifixion of about 1510 (Plate 109), a sense of the body as a unity which the Satyr Family of 1507 still lacked. There is a touch of the classic in the splendid composition of this Crucifixion. Yet the expressive figures of the Virgin turning forward and St John backward make the space look as if it were turning on its own axis. The Virgin of the Rest on the Flight into Egypt of 1510 is exaggeratedly slender (Plate 104); the Renaissance fountain in the foreground is not very steady on its base, and its basin seems to be tilted towards the Child, who is splashing in the water. The St Johns (Plate 110) still have something like a life of their own; their seclusion is no longer solitude, for they obviously regain something from the growth of things which is itself hardly subordinated to them. These are the main works of Altdorfer's first efflorescence, inspired pictures with nature and figures suffused with passion. Their ardour – including the chiaroscuro drawings of the years up to 1513 – shows the proto-Baroque of most of the great artists of this generation.

In 1515, the faces of the Holy Family with an Angel (Vienna) become more formally generalized and flattened: they lose their sculpturality. In the Resurrection of 1517 in the altarpiece in the museum at Regensburg (Plate 106), Christ is over-slender; Gabriel is simply an ecstatic rush through the air, the Virgin of the Annunciation is as disembodied as an elf. Who would venture to follow the structure of the figures of the altarpiece at St Florian? The limbs, seemingly lost, of Malchus, who lies where he was thrown down in the Arrest, the body of St Peter striving to regain command of himself after his outburst of rage, whatever is enclosed in the grotesque armour of the *Landsknecht* who is scanning St Peter's face with scorn, the limbs of the disciples on the Mount of Olives, as they succumb to the overpowering need for sleep, the raving torturer in the Flagellation, the Virgin as she writhes in agony for her son, who is being laid in the grave. Altdorfer's unrestraint in his figures and his lack of knowledge of their structure furthered the development of his Mannerism.

Yet the beginning of his Mannerism was delayed and complicated by the influence of the Augsburg Renaissance about 1514. Even about 1512, more of Italy could be seen in his drawings; Mantegna, Marcantonio Raimondi, Florentine engravings were pressed into service, with the result that his figures, at times, became somewhat clearer and more corporeal. There is also rather more Renaissance detail in the St Florian altarpiece. Moreover, from 1511 on Altdorfer devoted himself more and more to the woodcut in splendid single works, and, in 1513, in a series of forty small woodcuts – the Fall and Redemption (H1–40) – a kind of *biblia pauperum* without text. It was by this series, and, in a general way by the illuminations he did in his youth, that he became the first master of the small scale in Germany.

About that time Maximilian engaged him for work on the big woodcuts. He worked on the corner towers of the Triumphal Arch. As 'Master of the Baggage-Train' he made part of the Triumphal Chariot woodcuts, and he found a rich reward for his earlier collaboration in the designs for the miniature 'fair copy'. He made twenty-eight marginal drawings for the Prayer Book (later most of them were erroneously signed with the initials AD). It was here that he found himself mainly in rivalry with Dürer, Baldung, and the Augsburg artists. Dürer was the model for all the others. Altdorfer gave way to his style just a little. But he never introduced actual space on the bottom band, as Dürer did. More weighty figures, often in the drapery style of Leinberger, the sculptor, generally appear in the margin. Bristling with ideas, Altdorfer placed harmless scenes at the bottom of the sheet, surrounded by the scrolls of his foliage, which forms a gay contrast to the psalm of lamentation they accompany. Twice he surrounded the text with the most fragile tendrils of runner beans or convolvulus, often inhabited by a crane snapping at a mosquito, while the weightiest details, two putti, are at the top in a most un-Düreresque fashion, though they too are as light as a feather.

This was the time when he painted the small Nativity (Berlin), with the enchanting ornamental winding of the scroll from which the angels read their message of peace (Plate 105); the architecture is a little stouter than that of the old German town rising behind the Renaissance fountain in the Rest on the Flight of 1510 (Plate 104). And Altdorfer retained something of this encounter with the great brothers-in-arms of art in his day, which probably came to an end in 1516, and with the idiom of the south – a little more clarification, and above all, in his graphic art, greater vigour in the modelling. This can also be seen in his chiaroscuro drawings, which he took up for the last time about 1517 in a series of apostles and saintly women, though they have none of the impetuous vehemence of 1512.

The space in which all these have their being has become the content of the picture as it had never done before. Within that space the twigs and leaves sprout from the trees, the grass grows, the surface of the lakes glides away, and the mountains swell. Dürer's landscapes are all built in recession; every form is spatially suggestive, every distance looks measurable. Any spectator, confronted by Altdorfer's deep vistas, who tried to make a plan of the visible spaces in the picture would come to grief. It is true that Altdorfer created great distances, but they are felt, rather than seen, by the spectator. The eye is not led; it is often thrust into the depths, or it glides over the figures enclosed

in the vista. The actual depth of the space can hardly be even felt, except when, for instance, the eye can measure constructed forms by comparing them with each other; an instance is the homely nook in the Last Supper (Regensburg), in its relation to the foreground forms. The intention is not clear depths, but strange and wonderful distances.

What comes first in Altdorfer is spatial unity, as the product of untrammelled fantasy, in contrast for example with Leu, who filled his planes decoratively and created moods. Just as the vibration of nature passes through every figure of Altdorfer's, it also passes through his buildings. The foreground is often confused and fantastic – already in the bald gorge of a ruin in the Nativity of 1507, the tottering nook of the Rest on the Flight into Egypt of 1510 (Plate 104), the chaos of stones in the small Nativity in Berlin (Plate 105). True, the vigorous figure of Judas in the Regensburg Last Supper has some spatial force (Plate 106), but no clear spatiality was created by the abrupt foreshortening of the table under the waves of the truncated webs of the groin-vault. The same holds good of the consciously false foreshortenings in the Death of St Sebastian in the altarpiece at St Florian (Plate 108) or the insane perspective in the Entombment, also there. Even the elements of terror bring a sudden breath of naturalism into the fairy-tale mood; in the former they serve to heighten the effect of the cudgel which rises menacing from the deepest depths, in the latter they elevate the mourners above the condition of the corpse.

And finally it is light that carries the meaning of Altdorfer's pictures; it really is an actor in his stories. He discovered things about light which are otherwise to be seen only in Baldung. It is the light which gives Altdorfer's woods and clearings their hints of secret life, of spectral menace, of smiling candour. The early drawings live, in particular, by their white heightening. Light, often coming from several sources, trickles over the lichen-hung, ruined walls of his Nativities. The view on to the courtyard behind the Last Supper (1517, Regensburg; Plate 106) anticipates the Impressionists in its joy over the yellowish-grey walls. The times of day and the seasons are rendered at St Florian in radiance and twilight, in the livid colours of autumn and the blazing splendour of midsummer, even if they do not correspond to the actual historical event. In the St Florian altar, more particularly, a new element has been added to the traditional medley of contrasting colours – a very fine grading of the tones, which very often do not lie in the same range, within the separate areas of contrasting colours. In the Martyrdom of St Sebastian (Plate 108) there are three different shades of yellow in the clothing of the lansquenets – lemon, golden yellow, and dirty ochre – which stand beside the martyr's white loincloth, his rosy flesh tint, the blue and white cap of the foremost archer. The Resurrection really takes place in light (Plate 107); the sun, which is here, one might say, the halo of the rosy figure of Christ, is surrounded by red, orange, violet, and mauve clouds, with various shades of blue in the sky. The angel pointing upward is orange and vermilion, the two others whitish, with yellow wings. In the armour of the watchmen there are contrasts of mouse-grey, bronze-brown, and steel blue. On the St Florian panels at Nuremberg the yellow orb of the sun is fused with the onset of twilight, and the reflection of a sunset can be seen in the water. At that particular time,

about 1519, if we observe the steady development of Altdorfer's art, we can realize that the Christian story was still intact, and was practically the only one that was ever told. It drew little strength from the Renaissance of the south. But Altdorfer, in an almost panentheistic sense, infused it with the symbolic power of the *anima mundi*, a power which was destined to increase.[16]

Minor Painters

Meanwhile a large circle of disciples, and later of pupils, gathered round Altdorfer. Recent scholarship has split off, for example, the draughtsman of the Paris Lansquenets, active from about 1512,[17] a cruder, jollier personality, and the Master of the Battle in the museum at Würzburg, a picture, dated 1514, representing a fight between mercenaries in which the tumult is mastered by a free and easy line and fairly dark shades of brown.[18] A third disciple, Georg Lemberger, soon went to live in Saxony.[19]

The Historia Master has some kind of identity too.[20] In his first pictures, from about 1508 on, Altdorfer's early style can be felt. In one of them, the Nativity (*c.* 1511–12, Chicago), the Virgin is rustic and thick-set, with a snub nose and a mouth distorted in breadth; she also approaches from the distance, great with child, by the side of Joseph; they are uncouth yokel types. The head of the ox breathing on the Child and the re-calcitrant ass are exaggerated. The whole is painted tonally. The wings of the angels surrounding the Child bring a touch of fairy-tale into this almost commonplace rustic scene, which is linked to the upper world by the golden halo passing into the golden sky and by the verticals of the blue-striped rocks and hanging lichen. We can follow this painter up to the Pulkau altarpiece, about 1518–22; hence he used to be called the Master of Pulkau.[21] His squat figures spread luxuriantly. In his early works his dramatic, high-falutin idiom is proto-Baroque. It was not until he illustrated Grünpeck's text of the *Historia Friderici et Maximiliani* about 1514–15 (Vienna, Staatsarchiv) that, under the influence of Altdorfer, he conceived his subject in more restrained form. The beautiful scenery is always Austrian; the inconspicuous, commonplace aspect of the emperor's life outweighs its extraordinariness. Nowhere else does Maximilian appear in the same guise as here, as a country gentleman, a local Austrian ruler. This subtle, cultivated, quite unprovincial draughtsman, like all the Danube artists, always found room for the simple, stout-hearted life of the people, probably in conscious contrast to Burgkmair's courtly elegance and Dürer's forceful precision. He was less interested in structure than in calli-graphy. This was the only painter of the Danube school who seems to have lived in Vienna for many years, and he was probably identical with Niclas Breu, Jörg Breu's younger brother and pupil at Augsburg, who can be traced in Austria from 1524 to 1533.

Erhard Altdorfer, Albrecht's pupil, began his career under the spell of his slightly elder brother.[22] About 1510 he was working for the abbey of St Florian, and also probably for Lambach, and it is from there that his picture of St John on Patmos, now at Kansas City, comes. His first engravings, three of which are dated 1506, are prentice work, and they lack Albrecht's impetus and daring. The first drawings of the same period

are somewhat dry and conventional. However, it was not long before Erhard was in a position to communicate Albrecht's new style to Austria, with its jungle luxuriance of all vegetation and the rounded forms of his graphic idiom; he, for his part, having cast off the constraint of book illumination, may have gained, by way of the Historia Master, some inkling of the great painters active in Vienna about 1500, Lucas Cranach and Jörg Breu. His work took on vigour; indeed, his forms became monumental in a not entirely spiritual fashion. While the landscape surrounding St John on Patmos lacks Albrecht's freshness, there is greatness in it. Erhard's landscape drawings, though not very clear in the detail, are held together in mighty, almost epic rhythms. He continued working in this way until, in 1512, he went to Schwerin as court artist and master mason to the dukes of Mecklenburg, where there is documentary evidence of him till 1561. He sometimes exaggerated his giant trees, though from without and not from within, yet the Old Fir Tree (Copenhagen), dating from the artist's later years, is a dramatic figure of saga even in the mutilations of its outgrown strength. For the so-called Lower German Bible of 1533, printed at Lübeck, he made eighty-five woodcuts, a kind of forced labour which suited his temperament. There are reminiscences of his brother side by side with others of Cranach, whom he resembled closely as early as 1513 in the woodcut of a tournament. The drawings, with their formulae of massed light, sometimes rival those of Leu the younger. In several of his restless Bible woodcuts he comes near to Lemberger.

The Master of the Portraits of the Thenn Children belonged to Salzburg; he was a portraitist such as might be expected at Salzburg, considering relief sculpture there. In 1516 he painted the busts of two boys and a girl (Frankfurt), with their childish paraphernalia and ornaments (Plate 112).[23] The local colours of their clothing, which is rendered for the most part in mauve or coral-red, are, like the bluish-green mountain landscape, painted with a generous, or at times crude brush. Above the snowy peaks the sky is greyish-blue. A good deal seems to point to Huber's style.

Wolfgang Huber

As Frueauf had long since faded into the background, Wolfgang Huber, court painter to the bishop of Passau, and hence never a member of the guild, soon had ample scope. Huber,[24] born at Feldkirch, the capital of the Habsburg territory of Vorarlberg, must be reckoned with the Swabians. Apparently he was born there about 1485, the son or nephew of the painter Hans Huber.[25] The rich and varied scenery of his home must have made a lasting impression on Wolfgang. During his *Wanderjahre*, on which he set out about 1505, he most likely reached the Salzach district by way of Innsbruck and Salzburg. A drawing of the Mondsee is dated 1510 (Plate 113). He may also have become acquainted with Kölderer's workshop, have seen a great deal at Salzburg (Pacher, Reichlich), may have had his attention drawn to Mantegna, and probably paid a visit to Augsburg. However he came by the knowledge, he knew better than Altdorfer who Dürer was. Soon after 1510, in 1515 at the latest, he settled at Passau, fascinated by the scenery along the Danube, which he travelled up and down in 1513-14. Between 1515

and 1521 he painted a St Anne altar for his native city (Feldkirch church and private collection; Plate 115) and delivered it complete with carved parts made by some carver of the Passau–Salzburg group. In 1529–31 he went to Austria, where he drew a view of Vienna in 1530 after the retreat of the Turks. There may also be evidence in drawings of later visits to his native place. His headquarters remained at Passau, where he had a large workshop. Till his death in 1553 the bishops supported him, and, like Altdorfer, he also carried out architectural commissions in their service. It was not until about 1539 that he acquired the citizenship of Passau.

If Altdorfer was a youth when the Danube style developed, Huber was a boy, or perhaps an apprentice in a distant city. But with the first drawing that is certainly by his hand, the Mondsee landscape of 1510 (H32) (Plate 113), he entered the group of Danube artists as an independent personality and not as a pupil of Altdorfer's, though they exchanged ideas. His feeling for reclining forms enriches the Mondsee sheet with a few horizontals as compositional elements. There are no sprouting grasses here, no flicker of light and uncertain shade; there are very few chiaroscuro drawings by young Huber. His language is economical, simple, and penetratingly clear. Perhaps that might be called Swabian. In any case there is talent in the drawing, but no overwhelming genius. Unlike Altdorfer's measureless depths, plunging at first from the foreground, later from a near middle distance, Huber's space is a unity in a new and unimagined sense, and its extent can be easily followed by the lightly sketched 'spatial echo' of the willows. True, he has not yet quite mastered his foreground. The light too is the clear, form-preserving light of a classic. This early drawing was certainly intended for a collector as an independent work of art.

A view of Urfahr near Linz (HIII) at Budapest has the same power of suggestion; a few simple and solid house-roofs in the foreground provide a scale, proportions, and relief for the river and bridge, the village and the mountain background. This is far remote from Altdorfer's drawing of Sarmingstein of 1511 (Plate 114), which is strangely confused, fermenting and boiling with creative energy. Huber retained this clarity when he penetrated farther into the growth of nature and the life of man in it; we can see it in the robust individuality of the trees in the Pasture with the Mill of 1514 (H13), and in the upward thrust of tree and tower, and the quiet outline of the mountain ridge in the view of Traunkirchen on Lake Gmunden of 1519 (H21). A master of pen-and-ink drawing, he was able to subordinate the detail to the general effect, for instance in the Landscape with the Bridge of 1515 (H29). Like Dürer, he worked from a profound insight into form; his trees and figures have taken on personality more than Altdorfer's, but he had nothing of Dürer's finickiness. His outline and impetuosity were greater than Dürer's more coolly fashioned, more durable forms. A few bold woodcuts – three lansquenets, the Holy Family, a Crucifixion with a very personal conception of Christ, Pyramus and Thisbe – follow the same line. They show clearly a beginning of Mannerism.

But the classic moment of the first decade of the century also comes out in such a landscape of Huber's as that with the bridge of 1505 (H88). Moreover, a short pre-Baroque phase, in which a meeting with Altdorfer may have taken place, gave rise to chiaroscuro drawings and other similar work (H4, 20, 35). This phase was soon over, and

was followed by Mannerism. The sources from which Huber came to know Antique subjects and the formal idiom of Italy remain unidentified.

Huber's beginnings as a painter become clear somewhat later, but probably before the Feldkirch altarpiece. The Visitation in Munich (Bayerisches Nationalmuseum) and the Flight into Egypt in Berlin (Plate 116) come from an altarpiece of the Life of the Virgin. Both recall Breu's compositions, though the style is much freer. There is emphasis on Elizabeth's status as housewife, while the Virgin is followed by a kind of retinue almost forecasting future genre pieces. In the open air, the fugitives are also monumentalized to a certain extent; the figures on a slab of rock look great against the vista of valley, woods, and mountains; Joseph's eyes are raised to the Virgin with a protective look, the Child merely intimated at her breast. In comparison with Altdorfer's ideal of 'the tall woman with a small head',[26] the figures look thick-set and broad. Here too, as in a genre piece, everyday life appears. A cow has joined the train, and in its anxious scanning of its surroundings there can be felt the recollection of distant pursuers, of the slaughter of the Innocents at Bethlehem, which had been the subject of pictures by Breu and others. As in the early drawings, the foreground is not quite mastered; the colouring is variegated in medieval fashion.

The Farewell of Christ (1519, Vienna) and the nine pictures from the St Anne altarpiece with the Lamentation (Plate 115) of 1515/21 give a clear idea of Huber's position at the end of the age of Maximilian. He had obviously consulted Dürer's Life of the Virgin many times, but transformed it considerably. The buildings, some of which are based on Passau Cathedral and others on an architectural drawing of Bramante's, are higher, the landscapes more spreading. In such spaces the figures of the Holy Family look smaller, but some of them are isolated like statues on small pedestals and thus present a sharp contrast to both formlessness and architecture. The light in the buildings flickers, and its source is the Child; delightful effects of luminosity appear in the details. The colouring has become mild and is often delicately tinted. Altdorfer's agitation has vanished. The youthful romanticism which was present in Altdorfer's early work and in Huber's Life of the Virgin has retreated. The feeling is gentle, and in the Lamentation, a picture crowded with painted spectators, is of elegiac greatness.[27]

PAINTING IN UPPER SAXONY, THURINGIA, AND NORTH GERMANY

Lucas Cranach the Elder

IN Lucas Cranach the elder we encounter the last of the great artists of the Danube school, again not an Austrian, but a painter whose heart may have learned to respond to landscape when he was in Vienna. But in placing Cranach at the beginning of this chapter, three other aspects of his work claim our attention: firstly, he was born in a region where Franconians and Thuringians mingled; secondly, since the beginning of his work for the electors of Saxony he belonged to Central Germany; and thirdly, in his later years his influence mainly spread in Protestant North Germany.

Lucas Cranach, actually Lucas Maler, born at Kronach in Upper Franconia in 1472, was probably a pupil of his father, Hans Maler. He is found in Austria about 1500, and there is documentary evidence of him in Vienna in 1502–3. From 1505 he was court painter at Wittenberg and remained in this post for the rest of his life, first under Friedrich the Wise and afterwards under his two successors. He died at Weimar in 1553. In 1508–9 he visited the Southern Netherlands. At the beginning he signed his works with his monogram; from 1509 his pictures, and the work issuing from his work-shop, usually bear the signet of the snake with upright wings.[1]

We know no more of his early work than of Grünewald's, whose debut was con-temporary with his. We have no idea of his father's work. Lucas's connexion with the Upper Franconian artist who signed LCz is not clear.[2] It is uncertain whether he had met Dürer when he appeared on the Danube; he seems to have known the Apocalypse. We may assume some influence from Marx Reichlich. He must have met Breu when they were both in Austria, obviously as itinerant artists not registered in any guild.[3] Lucas was the elder and more gifted of the two. From about 1500 on his pictures are not only the brilliant prelude to his artistic career, but also the efflorescence in European painting of an imaginative and dramatic feeling for nature which could later be con-tinued by Altdorfer and Huber.

Probably the earliest picture which has come down to us is the Crucifixion from the Schotten Abbey in Vienna (now Kunsthistorisches Museum). It gives us his point of de-parture. Many shades of red are juxtaposed with blue and slate-colour on the greenish-brown place of execution; the thieves are rosy-brown, and behind the one on the right there is a birch-tree. Christ's body, dull yellow and bathed in blood, with a loincloth in flower-like tender pink, stands out against the sky. The whole is set in nature with a mighty wind sweeping through the sparse vegetation. That was Cranach's style about 1500, an-ticipating Grünewald's. Two wings of an altarpiece in the Vienna Akademie contain very vivid pictures of St Valentine, the patron saint of epileptics, and of the Stigmatization of

St Francis, the latter beautifully painted in grey and green (Plate 117); both saints are in yellowish-brown colouring, with faces full of character and life, and are broadly painted and heightened with white. The Franciscan monk is curled up on the hillside, fast asleep; the movement of the tree takes part in the supernatural event, which is given miraculously visible form by this feeling for nature. In the Penance of St Jerome (1502, Vienna), there is no trace of the asceticism of hermit life. It is the first dated picture by Cranach. The Crucifix too stands in the midst of the forest, not as an image for worship, but as if Christ had just died.

The Crucifixion of 1503 (Munich; Plate 118) shows Christ from the side, like St Jerome. Forerunners from the previous century are now taken seriously and dealt with boldly; the heroic group of the Virgin and St John stands opposite Christ. All nature chimes in, with its leafless trees, its dense clouds, and the rush of the wind which sweeps Christ's loincloth up in a huge swirl. Yet in spite of all, if we compare this Crucifixion with Grünewald's, we can feel a tempering hand at work; Cranach's is a work which belongs to the classic moment of the early sixteenth century. But it is in idylls that Cranach could be entirely himself. The Rest on the Flight of 1504 (Berlin; Plate 121) shows the Virgin in red sitting on the ground, Joseph in blue with a red mantle, the great angel in gold; with these exceptions, the dominant colours are those of the forest and the meadow, the bubbling spring, the old familiar fir-tree and the gay birch, the distant vista of the wooded valley under a light sky. All the busy angels who make music, bring water, and offer the Child birds to play with could be either child nymphs or elves – both dear to the humanist circle in Vienna, which worshipped equally Old German and Old Roman subjects. The fairy-tale has reached perfection.

Cranach actually worked for this circle. He painted the portrait of Johann Stephan Reuss, the rector of the university, in 1503 (Nuremberg), that of his wife (Berlin), and the double portrait of Johannes Cuspinian, the historian, and his wife (Winterthur, Reinhart Collection; Plates 119 and 120). And in the latter double portrait the 'temperaments' are accompanied and identified by the 'melancholy' and 'sanguine' birds, the owl and the parrot, with the same pregnancy as in the St Jerome. In portraiture, which did not at first appeal to this type of artist, Cranach made a further advance towards the new feeling for nature. He set the four sitters, who varied widely in temperament and age, in an open landscape. Cuspinian, with his dreamy head raised, seems to be listening to the twittering of the birds and the rustling of the trees, while his wife, a child of Sol, seems to have found a haven in the freedom of nature, and with the whole gladness and freshness of her eighteen years enters into a serene harmony with the landscape around her, which is the picture of her spiritual self. In the same pithy and vigorous manner, which is distinguished from Altdorfer's excitement by greater calm and restraint, Cranach made drawings with the new feeling for nature and excellent woodcuts which, until the twenties, combined Dürer's motifs with his own in highly original fashion. Cranach seems to have made the first real chiaroscuro woodcut, his St George of 1507.

Cranach was a genius as a youth, and his talent remained with him throughout his long life. At Wittenberg, perhaps even on the way there, new impressions crowded in upon him. There he could, for a time, compete with Barbari and Meit. There, if not

before, he could see work by Dürer; his Adoration of the Magi (Florence), painted at this time for Friedrich the Wise, was poles apart from the Rest on the Flight.

For a time, Cranach adopted Dürer's light, transparent colouring. That is true especially of the Martyrdom of St Catherine (1506, Dresden; Plate 124). In that picture, and in the little movable altar at Kassel, there is an assemblage of figures all elongated to the same degree. In comparison with his work in Vienna, the wavy fall of the clothes gives the figures relaxation and repose. It is possible that they are an echo of Cranach's early style, which is unknown to us.

But then different, proto-Baroque elements came out. The altar of the Holy Kinship (1509, Frankfurt) was made under Antwerp influences, particularly from Massys and probably from Gossaert too. Figures appear in a kind of Renaissance interior, with the main groups held together by whirling folds of drapery. The two figures on the outer side of the wings vaguely recall proto-Baroque Bavarian sculpture. The wide, pointed sleeves have a life of their own, and spectral faces with mouselike eyes might be gnomes. It has been suggested that the head of St Anne was painted from a death-mask. Cranach hardly ever attempted anything like this spatial structure again. The Holy Kinship in the Vienna Akademie only has the coolness of bizarre stone structures.

The rounded modelling of Cranach's Venus of 1509 (Leningrad) had no successors. There too a note of the classic moment can be heard, this time coming from Dürer. Yet the difference from Dürer's Adam and Eve of 1507 is immeasurable; Cranach's Venus is born of the flow of the line and the melting softness of the surface, but not of structure. There appears in this picture, for the first time, the monochrome ground which is earlier found in Dürer's circle (Barbari) and which from that time on gave increasing clarity to Cranach's nudes, though in an almost Quattrocentist sense. And that is also true where the Giorgionesque Nymph of the Fountain (1518, Leipzig; Plate 125) lies in landscape, enclosed in a contour knotted, so to speak, by her crossed legs.

In the Virgin in Wrocław (Breslau) Cathedral, the roundness of the body is once more contained in the old feeling for nature. As a whole, Cranach's sense of proportion was not quite secure in the second decade of the century. Hunched and elongated figures rub shoulders, though there are more of the latter. St Catherine and St Barbara (Dresden) are towering in their disproportion. An average in height was seldom maintained. The parallel folds of the drapery often reinforce this effect. Waved hangings often seem to carry off with them draperies varying in meaning and texture; parallel folds of wide, turned-up sleeves which have fallen into hanging ovals are a dominant feature in the effect of the Karlsruhe Virgin, and became a favourite motif. Cranach also evolved a multiplicity of other formulae. The little chubby bodies in the Massacre of the Innocents (Dresden) form a whirling mass of consonant, un-childlike forms. Human figures in general are deprived of proportion and shape by the line-work of their clothes and by towering plumes, the horses by pieces of armour or heavily patterned trappings. From the middle of the second decade, Cranach caught up with Early Mannerism.

Then his inborn gift for portraiture began to bloom. Most of the altarpieces mentioned are full of recognizable or concealed portraits. The Salome (Lisbon) is one of his best female portraits. As a whole his men are forthright, honest, occasionally a shade

fogeyish, and in a good sense 'altfränkisch';[4] on one occasion he seems to have been fascinated by a peculiarity in the setting of the eyes. Expression is only conveyed by the face and hands. The body often seems to be crushed by the monochrome ground, the frame, and a frequently exaggerated decoration by patterned textiles, slashes, chains, and jewels, beneath which, for example, the princely children now in Washington can hardly breathe. A faithful rendering of costume, where it occurred, enhanced the general convexity of the form, but not the personal stature of the sitter.

This personal stature comes out in the life-size, full-length portraits of Duke Heinrich the Pious and Duchess Catherine of 1514 (Dresden; Plates 122 and 123). It is probably due to Cranach that this type of portrait was released from the sacred connotation in which it still appeared in the Frankfurt wings, attributed to Ratgeb. The herculean presentation of a man who was not even very strong, combined with Cranach's new sense of proportion, produced a most impressive picture. This impressiveness comes from the fact that the figures are built up like towers by the countless yellow slashes in the duke's light red costume, and an extravagant number of ornamental gold details in the duchess's red dress have been inserted with great accuracy. These are sculptural, generalized forms with no touch of the classic in them. The light colour of the duke's dog gives the animal a spectral, meaningful aspect. In the companion piece, the little dog's face presents a contrast to that of the duchess which is probably intentional. Even this trick of later portraitists is not without a touch of the grotesque in Cranach. These are the first markedly Mannerist paintings, not only in Cranach's work, but probably in the whole of German art. They may have taken their imprint from the court painter's duty of keeping in mind the dignity of the sitter's appearance and the faithful rendering of the splendours of dress.

Cranach worked with the greatest facility in his drawings, especially in the playful animal drawings for Maximilian's prayer-book, which can easily stand comparison with Altdorfer's, Baldung's, or even Dürer's. It was there that he retained most of the 'Romanticism of 1500'.[5]

Other Painters

In Saxony, the most important artist next to Cranach was the master of the altarpiece at Ehrenfriedersdorf of 1507, traditionally known as Hans von Cöln, who may be the same person as the carver of the altar, Hans Witten.[6] He was a very peculiar man who, with a dash of the Danube style after Breu's manner, peopled the Passion with tall, agitated figures. At the same time, as in later still lifes and genre pieces, he placed apparently subsidiary motifs in exaggerated size in perspective, using them as a call to meditation: the wine-cooler in the foreground of the Last Supper, or Malchus with the lantern in the front of the steps on which Judas is betraying Christ.

In 1510–17 Master Michel, a Swabian from Augsburg, delivered to Danzig (Gdańsk) the gigantic high altar for St Mary.[7] He made use of Dürer's graphic sheets for the Passion and the Life of the Virgin, adding constellations and virtues after Burgkmair's woodcuts. He too may have absorbed some influence from the Danube school. His faces

are at times distorted in a way similar to Breu's. His strength lay in the colouring; it is glowing and full, but there are also already half-tones. Master Michel took an active part in the religious and social troubles of the twenties, wasting his talent. The pictures on the back of the altar, sketchy but drawn with perfect sureness, may have been added by him after 1527.

At Lübeck, the aged Bernt Notke was still active about 1500, also as a painter.[8] At that time he had painted for the Marienkirche the great Mass of St Gregory (destroyed in 1942), a panel with the fully eucharistic connotations of its subject, and substantiated by a number of turbulent and realistic faces of onlookers and a violent townscape through the window; all the same, there is moderation in its powerful colouring.

PAINTING ON THE LOWER RHINE AND IN THE NETHERLANDS: 1: THE LOWER RHINE

AT Wesel on the Lower Rhine, Derick Baegert was still alive in 1515, but his chief work had been done long before. His last great series of paintings, the Passion altar from St Laurenz, Cologne (Munich and Brussels), a work of the nineties, was finished with a good deal of help from his workshop, in which possibly his son, Jan Baegert, and certainly his nephew Jan Joest, were already active.

This is the important Jan Joest, surnamed von Kalkar or van Haarlem. He was born at Wesel, probably about 1455/60. In 1505–8 he painted the wings of the high altar of the Nikolaikirche at Kalkar (Plate 131), and his work is far superior to that of the carver, Loedewich; he may have settled at Kalkar for the purpose. In 1509 he went to Haarlem, where he died in 1519. He may have spent his journeyman years there; there are traces of Baegert's teaching, but his point of departure seems to have been Ouwater and Gerard David. Thus he may have crossed the Netherlands more than once. In 1505 he received at Brussels a commission to paint a Seven Sorrows altarpiece for Palencia Cathedral[1] (Plate 130). Such works of his as are known are nearly all late, for a second altarpiece in Spain, four panels of which, representing the Legend of St Bartholomew, have been preserved in S. Lesmes at Burgos, was probably painted between 1514 and 1519, and therefore sent from Haarlem.

Joest's style transports the original Late Gothic feeling for nature into the new century's manner of vision. With his outstanding gift for physiognomics he filled his altars with figures that look like portraits, and a number of independent and psychologically perceptive portraits have come down to us. The planning of compositions and the conquest of new forms were not his forte. Responsive to things as they appear in light, he painted Jesus, in the Palencia altarpiece, in the temple under a high chapel wall, in shadow, light, and reflections from the windows (Plate 130), and gave a glimpse of the fugitive parents under the palm-tree, and of Christ bearing the Cross in an inexorable advance. Tribute is paid to the corporeality of things; his composition tended towards symmetry and stratification. But what actually roused his feeling was the transitory. Agitation of movement and the flow of light made of the Arrest of Christ a spectral picture of terror (Kalkar; Plate 131); the night of the Nativity becomes a wonderful fairy-tale because it can be comprehended as an event happening in night and light.

That could almost be described as Danube painting on the Lower Rhine evolving out of its own – though related – principles. A reckless urge to observe can be felt in Joest, though he was no longer young, and though in his painting there is always a certain objectivity and clarity, something grave and aristocratic. The simple dignity of Christ at the well, with his fragile, sensitive forehead, is compelling in its appeal. Joest's joy in the actual object is restrained; the Council Hall of Kalkar is given no pre-eminence in the

Raising of Lazarus, or the five portraits in the confrontation of Christ with Pilate. The Renaissance forms in the Burgos altar, which are richer than those at Kalkar, are mere decoration of an accessory in the scene. Joest was a master of Late Gothic classicism without set patterns and without repetition. He seldom had room for the instinctive movements of passion and mostly retained its lyrical undertone. We watch him at his best in the play of the light, in the varied fall of the drapery, and in the incredible variety of his treatment of hair. His influence spread to Antwerp through Joos van Cleve and to Cologne through Barthel Bruyn, a relative of his.

At Wesel, Jan Baegert continued to work in his own and his father's style. He must have been born about 1475/80, and goes by the name of the Master of Kappenberg.[2] He had no original mind and made extensive use of existing graphic work, particularly that of Jacob Cornelisz. of Amsterdam. In 1520 he painted the wings of the high altar at Liesborn, fragments of which are probably extant at Münster, in London, and elsewhere. He freed himself, very gradually, from his father's style at the beginning of the century, and later gave his pictures a characteristic harmony in the brightness of fairly equivalent colours in a warm and attractive earthy tone. The picture of a huntsman praying (Nuremberg) is particularly noble. His paintings of the Passion have the dignified manner of the new century.

At Cologne, the artistic idiom renewed itself yet again, and, with considerable influence from the Netherlands, unfolded in a last efflorescence.

The St Bartholomew Master was very closely connected with Utrecht and the Northern Netherlands; indeed, he may have come from there.[3] His early work of 1475, the Bylant Book of Hours (Cologne), was illuminated in that region for a Gelderland family; the Baptism of Christ with the Fourteen Saints of Intercession (Washington) was probably painted for Arnhem Cathedral, and the Deposition (Louvre), a late work, was also painted for Arnhem. But his main works were made for Cologne churches and certainly at Cologne itself; among them are the altars of St Thomas (Plate 128) and of the Crucifixion (both Museum), painted in 1501 or a little later for the Carthusians, whose mystical piety he may have shared. Further, small devotional pictures and altars have been preserved, one of them painted for a member of the Frankfurt family of Holzhausen (also Cologne). He seems to have been active at Cologne up to about 1520.

He was from the outset a Late Gothic artist of a singular kind. In his very decorative pictures, the miraculous element overcame the new kind of sensuous representation in a most original fashion. Sometimes the result is bizarre, but it is always cultivated. The Late Gothic manner of narration was quite alien to him. He had the whole formal repertory of Late Gothic ornament to choose from, with subtleties of secular decoration too. Gold is applied ingeniously; the layers of shadow on it resemble the delicate hatchings of contemporary engravings and create, up to a point, a feeling of space. There is a rare radiance in the colours – they resemble enamel, for the intermediate tones have been largely suppressed. Then again they recall the delicate bloom of flower-petals. The Crucifixion altar and the Deposition (Louvre) – the latter descended from Rogier – though they are not spatially interesting, look like carved golden shrines, but without the shrine's weightiness. They are examples of a supreme art of cryptic allusion; at times

they are really witty in what is meant to look like quotations, while as a matter of fact there are actually few borrowings from the traditional formal heritage. Neither the refined nor the grotesque was alien to him. On the other hand, the broad-faced Virgins and hosts of angels are quite naïve. In the Assumption, the angels are swept up tumultuously; most of them are serene, and they are of a spiritual loveliness when they mourn for Christ.

The planes of reality are subtly interwoven. Thus the Saints of Intercession hover round the Baptism in an ingenious abbreviation, as the saints do in the St Thomas group. The latter, however, achieves its effect from stone pedestals, which make the figures look as if sculpture had come to life; behind it, the gold ground makes way for a glimmering aura of turquoise, sulphur-yellow, and rosy orange. These radiant colours are more lofty, more joyously abstract than the traditional gold ground. The extremely sensitive colour-sense of a painter who was happy to stand alone overcame the old supremacy of gold without rejecting it entirely. And there is no doubt that this highly personal technique, executed with virtuosity at all points, made it possible for profound spiritual insights to take on visible form. As a representative work of the early classic phase of about 1510, the St Bartholomew altar for St Columba (Munich) is composed of peaceful, yet wonderfully holy figures of saints and a central panel in a lapis lazuli hue. The magnificent Deposition was painted at the turning-point to the proto-Baroque.

The Master of the Holy Kinship seems to have been his contemporary; he was probably a native of Cologne. He too began his activity about 1475, and his latest work, the delicate, transparent triptych with St Barbara and St Dorothy at Cologne, cannot have been painted before 1514.[4]

The group of Cologne paintings which has given the Master of St Severin his name, though the larger and more gifted part of the group was split off and ascribed to a Master of the Legend of St Ursula, was more important.[5] Differences in quality may be explained by the collaboration of a very large workshop. This master was an outstanding colourist, but where the St Bartholomew Master designed in colour and placed its highlights like a goldsmith, the Master of the Legend of St Ursula was a painterly painter whose brushwork is free and even thick; in that respect he was one of the supremely gifted artists of the time in North-West Germany. He was a painter of light. The St Ursula cycle (mostly Cologne), a series of nineteen pictures on canvas, probably painted about 1495–1505, is actually rather dark; olive tones, delicate grey, muted violet, with some touches of red and blue dominate the surface. It was in this way that the Annunciation to St Ursula was turned into a miracle of light, and became one of the great artistic conceptions of the time. The Stigmatization of St Francis (Cologne; Plate 126) is built up on the beautiful grey of the habits against the olive-green of the landscape, which cools down into two shades of bluish-green in the distance, with secondary scenes to lead the eye into it. With means which an admirer of the St Bartholomew Master could only regard as modest, St Francis, like St Ursula in the series on canvas, has become a true hero of the spiritual life. Grey is the colour of his face; it speaks of the sleepless nights of the ascetic and of the overwhelming force of the miracle that has come upon him, which have become visible merely by means of a few white

lights gliding over his features and which, in drawings on tinted paper, would be called white highlights.

The portrait of a young woman at Cologne is brought to life by the same 'spectral and fairy-tale' colouring;[6] its very restraint in the colouring makes it all the more spiritual. The Calvary (formerly Berlin, destroyed, and Cologne, Diocesan Museum) came at the end of the master's *œuvre*, and probably about 1510; it is a splendid example of proto-Baroque.

A somewhat younger Cologne painter, who goes by the name of the Master of the Aachen Altarpiece, managed to reach the proto-Baroque as well, but also an early kind of Mannerism.[7] Yet the work of all these masters seems to have come to an end about 1520 or, in a number of cases, much earlier. And now, for the first time, an artist who, though he was a native of the country, was an alien in his art, made his way at Cologne. This was Barthel Bruyn the elder, and though he was not of the same calibre as the St Bartholomew Master and the St Ursula Master, he was a man of destiny at a time and in a place which, by its deep-rooted conservatism, made the breach (which was to come everywhere) particularly abrupt. To a large extent his work belongs to the age of Charles V.

PAINTING ON THE LOWER RHINE AND IN THE NETHERLANDS: 2: THE SOUTHERN NETHERLANDS

BRUGES AND GHENT

IN the fifteenth century the centre of gravity of Netherlands painting had been Bruges. Gerard David, the Dutchman who had been active there since 1484, carried on the tradition as Memling's successor, and with even greater vigour than he. Through his pupils, especially perhaps Joos van Cleve and Patinir, David's influence extended to Antwerp. He died at Bruges in 1523, after having entered the Antwerp guild in 1515.[1]

In the Southern Netherlands, he was able, first and foremost, to achieve a new relationship with the *patres* of Netherlandish painting, Eyck and Campin, and the creative archaism[2] which he shared with many of his generation was the foundation of the important influence he still exercised in 1500–10. What he brought with him from Holland was a peculiar feeling for landscape, obviously inspired by Geertgen, which lasted throughout his life; for him it was a calm and natural form of life. Even in one of the chief works of his later years, the Deposition in the Frick Collection in New York (Plate 133), the light bursting out of the dark clouds on the horizon is the one bright element in the picture, except for the parchment-coloured body of Christ, the mute partner of the dark-clothed figures; every other colour is there to set off this parchment colour, even the noble grey of the ground, since there is no yellow or orange apart from the flesh-tints of the living figures. A bitter, but not hopeless evening mood; the by-standers are true mourners, but there is no outburst of grief.

The tenor of his pictures is this gravity of feeling. As a painter of figures, Gerard heralded the new age. The scenes of Justice (1498, Bruges) manifest this bent of his, not so much in the Italian decoration and the obviously Antique gems which have been pressed into service, nor yet in the not quite successful perspective of the courtyards, but in the clarity of bodily existence, the firmness in the stance of the figures. Judgement is pronounced with composure and seriousness, the flaying is performed impersonally and with skill, as if it were not horrible. David made Dutch sobriety his forte. There is a strain of monumentality in the strongly marked shadows, and the line flows rather than articulates. Even his small works, like his Rest on the Flight (Prado), with its dominating Virgin, possess grandeur.

Thus David entered the new century as an early representative of the classic trend. The panel of the Virgin with Female Saints which he presented to Sion Abbey in 1509 is entirely built up on the sculpturality of the figures; some liveliness enters into the space in the pattern of the tiles, but otherwise there is neither architecture nor ornament. It is a grave, almost silent throng, with simple and faithful portraits among them, standing without any formal discord beside faces with an unindividualized truth to life. At that

time David was able to make the three-dimensional solidity of appearances more credible than any other Netherlands artist, as can be seen particularly when the figure of Christ asserts itself in a diagonal across the corner of a room, as in the Dublin panel, or when the background opens in multiple grilles, as in the Betrothal of St Catherine (London), or, in more complex diagonals, in the Feast at Cana (Louvre). Towards the end the sky becomes still brighter than in the Deposition, sets off the outlines sharply, as in the altarpiece now at Washington, and crowds the figures forward in a positively terrifying sculpturality, as in the Crucifixion in the Palazzo Bianco in Genoa, where a low horizon makes of the wide sky in the picture a mute actor in the drama.

We have no really clear idea of David's late style. The London panels of the Magi and the Deposition seem to show that after 1515 his palette lightened under the influence of Massys. On the whole he had as much to give to Antwerp as he could receive there. With the stiffening forms, for instance, in the Washington altarpiece and in the Berlin Crucifixion he seems to have tended towards Mannerism. There, as in the wonderful blue wing-paintings of the Annunciation (New York), iridescent colours appear, and the repetitions in the London Deposition must not be regarded as a weakness in characterization, but as a Mannerist *unisono*, i.e. the enhancement of a motif by repetition.

Two painters, apparently mostly active in Spain, came from Bruges and Ghent: Michel Sittow, who was born at Reval (Tallinn) probably in 1469 and died there in 1525,[3] and Juan de Flandes, who was probably not much younger and died at Palencia about 1519.[4] What both of them did was obviously to take the minute, small-scale technique of Flemish painting to the south. With his miniature-like, delicate, and rather variegated panels, among others those in the Palazzo Real in Madrid, Juan was very much a disciple of Gerard David and Simon Bening. In such works as the uncannily lifelike portrait of Princess Juana (Castagnola), he showed remarkable powers of innovation. The sonorous colour harmonies of his later work, for instance the panels from S. Lazaro at Palencia (Washington), reflect the feelings aroused by the vitality of the south, and perhaps South French worldliness too. In Sittow we can find a trace of old Memling. Like Juan, he was in the service of Isabella of Castile. After her death he seems to have returned to the Netherlands and to have worked for Philip the Fair and the Regent Margaret. He spent some time on a visit home to Reval and on visits to Copenhagen and then back to Spain. Till he returned to Reval about 1518, he led the life of a successful court painter. He painted gorgeously-coloured, deeply-modelled half-length figures of saints and portraits of Spanish grandees with breeding in the style and delicacy in the brushwork, for instance the knight of the order of Calatrava (Washington; Plate 137). Soon, however, he adopted a half-way form, namely the portrait in the guise of a saint which was coming into use at the time. Thus he portrayed Catherine of Aragon as Mary Magdalen (Detroit). In 1515 he painted Christian II of Denmark (Copenhagen) in the choicest blend of golden-brown and silvery-grey tones, with the sitter presented all the same as a frank picture of savage splendour. This is proof of Sittow's imaginative grasp and love of truth.

At Bruges, another painter working at the same time as David infused some vitality into developments. Jan Provost was born at Mons, married, in 1491, the widow of

Simon Marmion, the painter, and may have started work at Valenciennes. However, after a short stay at Antwerp he settled at Bruges in the year of Memling's death, 1494, and died there in 1529. Our knowledge of his work is uncertain, for it is only his late style that can be safely identified. The only dates we have lie between 1521 and 1526.[5] What emerges is an alert mind with a wealth of often surprising ideas, quite different from David, the Dutchman; a little unbalanced and very suggestible. Late influences from Marmion, David, Massys, Bosch, Joos van Cleve, Patinir, and Bening are adopted with intelligence.

A Lamentation at Zürich (private collection) is constructed in diagonals rising to the right and with features that are essentially Late Gothic. In the hospital at Genoa is a head of St Peter, almost crass in its realism, but great in the pose of the figure and in the lines corresponding to it in the background walls. The halo, a thin, transparent circle of the same kind as David's, in no way interferes with the romantic piling-up of the trees. There is also the Virgin in London with the drapery in vigorous thrusts, the flower-pot asserting its volume, the tree opening up space, and a landscape described in detail in the background.

These are all motifs of the future Mannerist. In the slim panel with the stable at Bethlehem at night (London, Viscount Bearsted), the ox in the foreground is not merely a repoussoir figure; it breathes, snorting, on the little child in front of it, which is the only source of light. The proportions vary. Very large, but compact figures appear in the Rotterdam Disputation of St Catherine (Plate 142); a childlike saint between great uncouth figures, fanatical faces and heated disputes. The picture is introduced, after the fashion of a caricature, by a dwarf. Hardly any figure has normal proportions, just as Provost often omitted one of the chief colours – blue, for instance – and bathed the whole in a slatish violet. All these deviations from tradition actually serve in a wayward manner to deepen the subject-matter, however fanciful they may look. In the Christ carrying the Cross of 1522 (Bruges, Musée des Hospices), the Cross, as it were, lies over the faces, not only of the executioners but also of the Virgin and St John. It is a deeply serious work.

It is known that Provost was often commissioned to do temporary decorations, for instance those for the state entry of Charles V into Bruges in 1520. He had a great facility for giving every theme its due. The Virgin in Clouds with Prophets and Sibyls (probably 1524, Leningrad) is as serene as its theme. The composition terminates ingeniously in a clover-leaf with flaming fish-bladder-shaped forms making the link between the world of heaven and the world of earth, the cloud regions in the skies and the landscape vista. This, in its turn, is the main feature of the last Bruges work, the Last Judgement of 1524–6. A few of the resurrected arranged in deep foreshortening represent with their swirling movements the multitude which has come to judgement and the helplessness of this world; the calm, creative power of the other world is brought out. Provost is talkative, but his talk is witty and refined. He starts out from a silvery clear, happy whole; the details are placed with a lively sense of narrative.

BRUSSELS AND MALINES

In the nineties there seems to have been no painter in Brussels who could rival Jan Borman the elder. Of those who continued into our period the tradition established by Rogier, the most important were the Master of the Joseph Cycle and Colijn de Coter.[6] The latter was also active at Antwerp in 1493 and must have had a great name about 1500. His many pictures of the Entombment of Christ are cramped into the picture space, a manner derived from Hugo van der Goes. All the figures, including that of Christ, crowd and sharply overlap each other, and stand out with terrifying realism and a threatening gravity about them. In this assemblage of expressive fragments there is practically no space. His Last Judgement for St Alban at Cologne (parts are now in the Wallraf-Richartz Museum) is also based on the sculpturality of black-shadowed bodies; there are daring foreshortenings in the faces too.

The Master of the Joseph Cycle, who takes his name from tondi in East Berlin and New York, succeeded in finding a formula for unusual themes. The Interpretation of the Dream is dramatic and telling, and recalls the heavy fatefulness in Goes's subject matter. There are also panels by him from an altarpiece from the abbey of Afflighem (Brussels). He may possibly be identified with Jacob van Lathem, who was active as a master at Antwerp in 1493.

Another painter whose starting-point was this Brussels tradition was the Master of the Legend of Mary Magdalen.[7] His portraits of Philip the Fair and the Regent Margaret as children (Philadelphia and Versailles) are dated 1483, and there is documentary evidence of his activity till 1527. His portraits point to a lasting connexion with the Netherlands court; he may have worked at Malines for a time. The portraits of princes, which were often reproduced in several copies, are decorative rather than subtle; they are pretty, yet painted with care and detachment. In the wing of an altar now in Melbourne, he inserted a group-portrait of the house of Habsburg-Burgundy in the Feeding of the Ten Thousand. The rest of his portraits are less constrained and rather stolid, but they are faithful likenesses. His altarpieces are serious, but uninspired. The faces, most of them rather puppet-like, broaden out in his later work. In the now scat-tered work from which he received his name, probably of about 1520, the Magdalen is squat and large-headed; her small eyes are wide-set and look as if they were floating in the rather flat face; the head, which might have been turned on a lathe, is shaped by the clean-cut outlines. This master may possibly be identified with Pieter van Coninxloo, who worked for the Netherlands court from 1481 to 1513.

It is amazing that this master was able to retain the favour of a court which had in its service such outstanding artists as Mostaert, Sittow, Gossaert, and Barbari, even though they were not permanently employed. Further, from 1515, Bernart van Orley, though still quite young, was in the regent's service, though the most important part of his work belongs to the reign of Charles V. It may be that there was really a lack of out-standing artists in Brussels and Malines at the time, and foreigners were employed to supply the deficiency. We cannot so far gain any idea of the work of Valentijn van

Orley (d. 1532), Bernart's father and in all probability his teacher. Nor are we sure about Jan van Roome, also called Jan van Brussel, mentioned from 1498/9 to 1521, a much-employed designer for sculpture and applied art.[8] His name is connected with murals in the Busleyden Palace at Malines of about 1507/8, which are a typical humanistic commission. They represent mythological scenes in essentially Late Gothic clothing, yet with a lavish use of Renaissance architectural details.

Bernart van Orley (c. 1492–1542) did most of his work in Brussels.[9] His altar of St Thomas and St Mathias (Brussels), commissioned by the masons and carpenters of Brussels, was painted about 1512. As a compliment to his patrons, he introduced a large number of buildings, all cut open, as it were, an architectural phantasmagoria composed of southern, Romanesque, and Late Gothic forms. The emphasis is on these forms and on the scenes in movement rather than on the bright landscape. The figures in the grisailles on the outer sides of the wings are quieter and more effective.

The diptych with the Betrothal of the Virgin and Christ in the Temple (Washington) is more compact. The composition takes the form of a relief; the figures move in front of buildings which, like the flats on a stage, come to an end parallel to the picture-plane. It is characteristic of Orley that already here he removed the real action to the middle distance. This distance gave his work dignity and a kind of detachment, but it was a sacrifice of the immediacy and power of contemporary close-up painting. The fact that Orley, at a time when all contemporary art was turning back to the founders of old Netherlandish art, should have repeated Campin's Madonna in the Apse shows his desire to provide the sacred figures with a dignified background.

Very far removed from this is the garden background in the Virgin and Child with Angels now in New York (Plate 141). It is a painting in wonderful reddish-brown, blue, and green combined with delicate slate-grey, pale yellowish-red, dull violet, with mauve, yellow, and orange only appearing in finely tempered modulations. This was the efflorescence of Orley's art. In the Oslo Annunciation, we can feel even in this disciplined artist some touch of proto-Baroque passion, which is emphasized by the beautifully executed double architectural enframement.

After 1515, the court painter did portraits such as that of the Regent Margaret and the successor to the throne, and that of Dr Zelle (1519, Brussels), rendered with care and restraint in classic repose and in muted, or even leaden colouring. Once, however, Orley ventured to paint Charles in an unexpected pose, youthful and princely at one and the same time (Budapest; Plate 138). The Order of the Golden Fleece and all the swinging curves of the costume and the cap-brim temper the wedge-shaped form of the face with the projecting chin seen from below. In the power of its characterization the portrait can stand comparison with the terracotta bust of the Meit circle.[10]

ANTWERP

When Quentin Massys, coming from Louvain, settled in Antwerp in 1491, he soon became the leading artist of the rising and prosperous city. He met few older artists

at work; the only one to emerge as a personality is the Master of Frankfurt. Jan Provost seems to have made only a short stay at Antwerp in 1493. Contemporaries of Massys – Gooswijn van der Weyden and the Master of the Morrison Triptych – remained faithful to an older style.

The unknown artist who goes by the name of the Master of Frankfurt, taken from the two altarpieces he painted for that city (now in the Städelsches Kunstinstitut and the Historisches Museum), was born in 1460,[11] as we know from his self-portrait with his wife (formerly Vienna, private collection). About 1493 he did his great panel of the meeting of the Archers' Guild (Antwerp), a scene of worldly festivity painted with Late Gothic delicacy. In the pictures of the Magi the features of the Emperor Friedrich III (Stuttgart) can be recognized several times, and once those of Maximilian, whose portrait he also painted. In the Antwerp panel Maximilian and his son Philip can be seen in the background. These details confirm the master's early connexion with the Habsburgs. There are borrowings from Campin, Eyck, and Goes. He was a Late Gothic naturalist. His animals, especially the dogs, are true to life. A tangled growth of many plants covers the ground. The faces are joyless, which is also true of the self-portraits which he often used in altarpieces. Even his saints lack vitality. In the two Frankfurt altarpieces, the first of which was probably painted in 1504, he adopted the current calming-down. The broader figures with the quieter folds of their drapery have a touch of the classic which is associated at Antwerp with the name of Massys. The Master of Frankfurt had paved the way for this development with a Virgin with Angels, now at Ghent. He was certainly still alive in the twenties, as can be seen in many Mannerist details: women saints, slender, languid, strangely and lavishly dressed like their sisters in carved Antwerp altarpieces, clamped into the picture space by the swinging hems of their robes, pursuing their own thoughts with the dull eyes of the sleepless.

Gooswijn van der Weyden apparently came to Antwerp from Brussels in 1496[12] and died there soon after 1538. He trained a large number of assistants, yet how he trained them is a matter of surmise, since hardly a single work of his own can be identified with certainty. If it was he who painted the St Dymphna altarpiece from Tongerlo (Vienna, private collection), he was continuing the Brussels trend of the Master of the Joseph Legend of about 1505. And in the panel of the Virgin with Donors delivered in 1511/15 (East Berlin) – the only work that can be ascribed to him with certainty – he owed a great deal to his great predecessor, Rogier van der Weyden. Traces of Massys' influence are very slight. Gooswijn may have been a teacher of Antwerp Mannerists, and conveyed the Late Gothic manner to them.

The artist who bears the name of the Morrison Triptych[13] cannot really be grasped in the work from which he took his name (it is now at Toledo, Ohio), for it is not independent work. He is to be seen at his best in the London Virgin with Saints. The figures are loosely assembled, and a forest clearing surrounds them like a *hortus conclusus*. The woods are as artificial as the fantastic chapel in the background. From the distance, evening light streams in diagonal rays through the wood and the building. What the artist really loved was that light; it holds the picture together, it conveys the mysterious and changing mood of night – this romantic painter of light may well have been a

Dutchman. The saints are elevated above any crass realism; they seem to live in a land of faery. No emphasis is given to the figures, and it is only in them that traces of Massys can be seen. It is possible that the Morrison Master may be identified with Simon van Herlam, a Dutch artist who settled at Antwerp in 1502 and according to the documentary evidence lived there till 1524. He probably came from Haarlem. In that case he was not a pupil but a contemporary of Massys, which is borne out by his work. He also worked for export, especially to Spain.

All these Bruges, Brussels, and Antwerp painters were, with the one exception of Orley, *au fond* Late Gothic and remained so at heart, yet they already reflect Massys' influence, in part at any rate.

Quentin Massys

Quentin Massys[14] introduced a new trend to Antwerp, or rather he developed it there. He was born at Louvain in 1465/6, and had seen Dirk Bouts's work there. It is said that he was originally a blacksmith, and he kept a strain of the elemental in him, which gradually grew into delicacy. Thus, though allegedly self-taught, he did not burst like a gale upon an old-fashioned practice of art at Antwerp in the nineties. Besides, he was obviously not the naturally expansive type which would have suited the citizens in this time of soaring prosperity. What he brought with him, and kept till his death in 1530, was probably appreciated by the up-and-coming citizenry of Antwerp as a counter-weight: a gift of quiet observation, of polished statement, of wisdom in his form. He raised an accomplished handicraft to the level of virtuosity, and that was obviously the way in which the art of this 'masterless master' appealed to the new society in its growing concern with humanism and the intellect.

The St Christopher (Antwerp) links up with the pattern of Bouts and his pupils, yet stands witness to Massys' originality. What is new is, in particular, his observation of the action of light; the orb of the sun rests on the horizon of a river scene; the banks of the river are partly seen in a bird's-eye view, and the water, brown in the foreground, flows over olive tones and yellowish-green to blue in the distance – a spontaneous, naïve, yet convincing understanding of the Netherlands landscape. The foreground is already dusky; the surface of the water casts the rays of the sun back to the faces. But in the midst of the whole the mighty figure of the saint is seen from the hips upward as a self-contained, dark mass of red and blue drapery against the sky. He looks defenceless and alone. His features show strain. Menaced by the waves, St Christopher gropes his way through the waters in the dangers of twilight.

There are Virgins of the nineties, two of them at Brussels, which may owe something to memories of Louvain; here Massys seems to be on the way to a chiaroscuro which was, in the last resort, Dutch. Yet it reinforces the sculptural reality of the figures and gives emphasis to the large and simple forms. A revival of works by the founders of Netherlands painting, especially Campin, also influenced the development of Massys' new style; it was with the help of these founders that both the pointed forms and the sweet expressions of the intervening decades were overcome. Massys banished the prolixity

of Late Gothic. His pictures are dominated by finely rounded heads of Virgins, and the only naturalistic touch is in the mouse-like face of the Child Christ. He was an early classic master from the start.

The Betrothal of St Catherine (London), painted on canvas, must be mentioned here (Plate 127).[15] The composition is very free, symmetrical but not strictly so, harmonious but not smooth. The work of Massys introduced into the Netherlands tradition a touch of the North Italian Quattrocento. There is something of Leonardo in it. Renaissance forms, like the Late Gothic forms which preceded them, give support to the composition and stress its dignity. Massys always limited the function of architecture in this way; in the south he found a welcome formal repertory for the classicity he had by now attained. Within these limits the name given him by Thomas More is true: the re-creator of ancient art.

In a diptych at Antwerp he had already painted Christ in the gesture of blessing, in an archaic style and frontally, as Bouts did. Later he painted the Saviour in half-profile, his face above his right arm; the figure, however, is sharply cut by the frame, as Gerard David's is not. It is all very dignified, with great feeling for the scraggy forms of the neck, the line of the profile, the lean cheeks – a noble, purified presentation, fed from a feeling with a strongly aesthetic bent.

The chief works of the first decade, the Lamentation altarpiece of 1507–9 (Antwerp) and the altar of St Anne from St Pieter at Louvain of 1508–11 (Brussels), follow Massys' great aim (Plate 129): quiet forms, harmonious composition, and a structure based, far more than David's, on the sculptural aspects of the human body. Yet there is none of the compact effect of the relief; the figures are separated by the delicate colouring. The Antwerp altar tells of consummated martyrdoms. The St John wings, with the martyr-dom in its smouldering tones and Salome's dance in sultry combinations of red, violet, scarlet, orange, pink, and gold, superbly frame the solemn centre panel. The mourning of the women and the gravity of the helpers are underlined by the sustained emotion of three thick-lipped figures, illuminated by the candle in the dusky sepulchre – a sublimely poetic interior (Plate 132). In the Brussels altar the Holy Families are shown with dignity in front of an airy and symmetrical hall, the real function of which is to act as a frame dividing into three parts a delicate landscape in the background. Men, gentle and mild, women, august and tender, are held together in harmonious swirls of drapery. There is something here like Holbein the elder's approach to events. Even the child, who probably died young, and who is seen in the picture busying himself with sacred books and devotional pictures, is serious beyond his age, but there is just a hint of humour here, because the child is reading upside down, yet seems to understand with the intuition of the naïve. Other subsidiary details are full of quiet life, and there is great sensitiveness in landscape vistas. Yet Massys never allowed himself much landscape, and in his interiors the figures dominate too. From that point of view he is strictly a painter of sacred personages. But his attitude to colour has changed since the 1490s. He now lightens the shadows and pours a diffuse light over the figures in which the fairly equivalent colours flash up like enamel. That is why there is, even in this great altarpiece, a hint of miniature.

That also applies to the main panel of the altar of the Seven Sorrows of the Virgin (Lisbon), in which blue is the dominating colour. It was painted about the same time. The smaller panels, now scattered, show the same trend; but feeling plays a greater part in the solemnity of the actions. The homeless Virgin on the Flight weeps as she rests; led from Christ's tomb, she wrings her hands as if in prayer, and there is real majesty in her self-control. The landscape plays its part in this harmony of feeling. Half of it is towering mountains, but part opens on a distant view and stretches from an olive-brown foreground to a cool distance under a sunset sky with the first, thin night clouds.

Massys in his later years painted many Virgins too, and there are many replicas by assistants. Yet the pictures by his own hand are always his own invention. The almost life-size Virgin now in Berlin shows the change in Massys' style about 1520 (Plate 134). Its smooth contour, triangular composition, and the architecture of the throne preserve unity in the profusion of keenly observed details, which are delightful in themselves and would be the joy of any connoisseur. The arms of the Mother and Child are entwined in an idiom of their own. The kiss is exchanged, as it were, in two symmetrical gestures. The power of the artist's early years has been tamed. Emotion seems to have been banished, and sentiment comes to the fore. The picture is dominated by pure local colours, the forms are smooth, but are not sufficiently rounded to give any impression of fullness: classic roundness has been sacrificed to an impeccable clarity in the relation between the planes. The Louvre Virgin of 1529 is of this kind; the still-life element has increased, the forms swell a little. As always, the Virgin's narrowed eyes look out of her flatly modelled face under heavy upper lids. All these Virgins are church or devotional images, but would meet the taste of the connoisseur as well.

Two works are notable for the broad spread of landscape. One is the great Temptation of St Anthony (Prado), where this trend reaches a point at which Massys the figure-painter seems to have lost himself (Plate 136). He placed his figures in the dramatic setting by Joachim Patinir, who signed the picture, in particular the three small-eyed and delectable maidens who lavish their wiles on the saint as if he were a second Paris, and tease him. The girl on the left draws her yellowish-green dress behind her like the clawed tail of a salamander, a sign of her infernal origin; an old crone with withered breasts figures the end of earthly things. The other picture, St Elizabeth with St John (Poznań), was inspired by Leonardo's Virgin with St Anne and the Child. There were many elements in Massys' personality which helped him to understand Leonardo better than any other Italian. It is possible that this landscape, brightening as it recedes into the distance, was painted by his son Cornelis.[16]

But the farther Massys moved from traditions of form, the more he allowed the rough and tumble of low life to pierce the refined smoothness of his work. Even his late works are sometimes overcrowded with figures. The Ecce Homo (Prado) and the panel of the Magi (1526, New York) are characteristic of this Mannerist development. The former is actually a brunaille interspersed with delicate olive-grey; red and bluish-green appear, especially where the howling crowd surges towards Christ with wide and rolling eyes. In the latter, the gentle Joachim type of the St Anne altarpiece appears in the guise of a king. The other faces are merely stupid and nasty. The prevailing tones between red and

blue are velvety and mild; an orange-yellow sleeve hardly provides a counterpoise to this intentional one-sidedness, which is still more sublimed by the gold and silver tones of the immense profusion of ornament. Massys is a painter of delicate things and also a delicate painter of crude things.

In his altarpieces his aim was nobility of expression and refinement of feeling, a blend of flavour and mood. He painted solemn idylls in which aesthetic calculation occasionally makes itself felt; his bodies are substantial, yet the interest is not in their structure, but more and more in their sensitive surface. Yet the accessories of Massys' compositions reveal how powerful his vision of the world could be when his longing to create monumentality out of miniature-like painting allowed.

Massys was a great portraitist. All his portraits have a touch of real occasion; here, more than anywhere else, he was contemptuous of any preconceived pattern. Increasingly his presentation of his sitters came to look as if that particular character had evoked, or created by force, the special structure of the picture. The portraits of men in Chicago and New York probably date from the beginning of the century. The latter's delicate palette consists of violet, orange, and green, so that the three primary colours are much less apparent. A generalized modelling is given by the strong shadows of the nose and cheeks. The Man with the Carnation (Chicago) is bolder. All the colours are mixed with various shades of brown, even the nut-brown of the flesh, and contrasted brilliantly with a green background: the very warm, earthy colour of the large hat and the turquoise of the background. Thus the blue carnation is, like the dot on the i, the clue to the picture.

The Pilgrim to Jerusalem (1509 or later, Winterthur, Reinhart Collection) is a magnificent and faithful portrait caught on the wing, as it were (Plate 139). The head is raised from the monochrome grass-green ground by a shadow: painted shadows from the frame (an effect probably introduced by De Coter) enclose the sitter in a narrow space. In it, the dark figure seems to present itself almost against its will, and the whole body seems to be shifting as if in pain. The fingers almost wring the papers they hold. The brownish skin is furrowed and strewn with warts, the head evasively slanted. The fugitive look from the grey, unmatching eyes is sceptical and sidelong. The nose sticks out like a club: a vacillating character evidently, hardly able to remain upright. The nerve-ridden face of the man in the Frankfurt portrait is given still more striking presence by the projecting, and probably overdrawn nose; the movement of the right hand adds a touch of momentariness which appealed to Massys' successors. The wealth of significant gestures may already be called Mannerist. The figure is made to look taller by the low viewpoint. Massys never looked down on his sitters.

In 1517 he painted the 'Friendship Diptych' of Erasmus and Petrus Aegidius (the former now Rome, Palazzo Barberini, the latter at Longford Castle). The scholar, collected, sensitive, and courageous, has his eyes bent on his writing; Aegidius is lively and interested, a disciple whose submissiveness elevates his master. A few books, papers, and pens are introduced to give the theme a context, but there is nothing superfluous. Muted tones of brown prevail. The silence of the study and the unspoken communication between the two becomes palpable. Thus the picture keeps us outside; yet even

here Massys did not carry the psychological exploration of character as far as he had done in the Pilgrim to Jerusalem.

There is a very mature portrait in New York of a woman looking out from between the columns of a church porch. In spite of the monochrome ground we can feel her freedom of movement; for the brown, enframing architecture is cut into to such an extent that it loses a great deal of its three-dimensional value. The soft light sets one of the columns in warm shadow.

There was another field of portraiture which greatly attracted Massys; that of eccentrics. It was he who, following the Flemish *patres*, actually made this field bear fruit. In Massys' work such figures often have a note of bitterness. He was fascinated by the dark side of character and the physiognomic oddity. Here again he could look to Leonardo. It is difficult to interpret the portrait of an old woman (London; Plate 140), with a minute nose and a gigantic upper lip in an over-ornate and very old-fashioned dress: it may be an anonymous study in the grotesque, a social satire, or the portrait of a court dwarf and fool with a taste for finery;[17] in any case, she is a relative of the hag in the Temptation of St Anthony. In the profile portrait of a cynical old man (1513, Paris, Musée Jacquemart André), a 'caricature' by Leonardo may have been blended with a medal of Cosimo de' Medici; it is possible, on the other hand, that the deeply-lined head is a genuine portrait. If these portraits are inventions, their peculiar effect comes from partial distortions with details added straight from life. Massys did not attempt, as Dürer did, to work on a plan of the whole which could be modified from case to case. He was obviously an empiricist, and established something like recipes, especially for the sacred panels. In spite of this, however, one never has the feeling of poverty.

These caricaturing pictures were probably moralizing in their function. Unlike Bosch, Massys did not paint the depths of devilry, and even the Temptation of St Anthony is not deadly serious. What the detached humour of these pictures seems to say is: these things exist, though they should not. Massys obviously created the formula of the ill-matched lovers as a subject for painting. These couples stand at the turning-point to the mere genre piece. Their humour resides in the disproportion between the two. Each wants something from the other, but it is not the same thing. The distorted grin of the amorous and infatuated old man has its antithesis in the cool self-possession and slightly mocking coquetry of the courtesan, who is handing over the old man's purse to a delighted third party, the fool. Here again there is strong emphasis on the entwined arms; they symbolize the central knot of the tangle.[18] The picture of the Gold-Weigher and his Wife (1514, Louvre) is an elegant satire on the greed which vanquishes book-piety. It brings out the fussy worriedness of the husband; the clinking of the coins seems audible in the silence. In this psychological study (which may go back to Van Eyck), Massys gave a model to his century.[19]

Other pictures of abnormality, in the sense of bodily, moral, or spiritual deformity, must be mentioned in this connexion; drunkards, bagpipe players, usurers, fools, male and female, have been discovered, most of them small in size with thin priming and sometimes painted on vellum. Some are dashed off with great fluency and a palette of choice, clear colours. They are sisters and brothers of the low-life types in such scenes as

the Ecce Homo and the Magi; it may be that the best of them were his own creation, at any rate the lost prototypes. His *trouvailles* in the field of genre, together with his portraits, provide a counterweight to the aestheticism and sentiment of his sacred pictures.

Joos van Cleve

Joos van Cleve[20] was a master-craftsman like Massys and probably his competitor, for he seems to have produced and reproduced with a bigger workshop, and therefore in unequal quality. His work lacks the immediate impact of personality and has neither the greatness of Massys' religious nor the quasi-privacy of his physiognomic discoveries. Thus although Joos was fifteen or twenty years younger than Massys, he is far more medieval. He was a gifted colourist; his taste was bourgeois and obviously had a wide appeal to many classes of society. All the same, he always kept a certain elegance.

He was probably born at or near Cleves, and may be assumed to have been identical with an assistant whom Simon van Herlam entered at Antwerp under the name of Joos van Wesel in 1510; he maintained his connexions with the rulers of Cleves. In 1511, Joos van der Beke – apparently his real name – was registered master at Antwerp, where he died in 1540/1.

The earliest date we have is on the wings with Adam and Eve (1507, Louvre). This work is based on impressions from Memling and David; indeed, David's influence can be seen in all Joos's early work. We do not know for certain whether he stayed at Bruges till 1510. If he had been at Genoa before,[21] as there is slight evidence to assume, how far remote is his Adam and Eve from Dürer's, also painted in 1507 after a visit to Italy. But Joos's point of departure was certainly Jan Joest van Kalkar, and his lasting connexion with Barthel Bruyn the elder may date from then. However, once settled at Antwerp, he adapted his work to Massys' manner.

In opening up space he was superior to Massys. His *forte* was scenes with many figures. The two pictures of the Death of the Virgin, one of 1515 (Cologne; Plate 146), the other of 1523 at the latest (Munich), show his mastery of interiors. The apostles, in a spacious stone hall, are assembled round the Virgin at the moment of her death; they are animated, busy, gravely presenting the candle, in loud or mute lamentation. In both pictures the face of one young disciple is illuminated with wonderful warmth from below, as he lights the censer. The apostle holding it in the Munich picture throws open the depths of the hall. The Cologne picture is constructed parallel to the picture plane and is interspersed with staccato figures of disciples. In part, the master's aim may have been to give the two panels a totally different composition, since they were painted for the same Cologne family. And in all the theatrical bustle the delicate dignity of the Virgin's body, seen small in perspective, is preserved.

Joos came closest to the heart of his bourgeois clientèle with a large number of pictures of the Virgin and Child which follow with great stylistic sureness types by Van Eyck, and later by Campin; it was his usual practice to add a bespectacled Joseph, reading, in a straw hat or a hood. A parapet in the foreground bears a kind of still life

of fruit and adds a note of sweetness and delightful homeliness. The culmination of these three-figured pictures is the Adoration of the Virgin by St Bernard (Louvre), probably painted in the first decade of the century (Plate 135). In a general way, Joos, even in smaller devotional images, was the painter of the Virgin in her happiness. The Child Jesus in the flower of his childhood meant more to him than the suffering Saviour.

Joos also painted many versions of the Adoration of the Magi, the homage to Christ of the great alien, exotic world. In the Berlin triptych, the creation of space as a technical achievement is made as obvious as it is in the panels of the Death of the Virgin. It is in these works that the master came nearest to the group known as the Antwerp Mannerists; indeed, he may have been their leader. And in the smaller of the two Epiphanies now in Dresden, he achieved by 1520 that bloom of flowering colour and formal intensity which only these 'Mannerists' were capable of. That determined his future. Space became subsidiary. Yet nature makes itself felt through the crevices of the ruins at Bethlehem. At this point we can feel the influence of Patinir, which could have begun in the years they may have spent together at Bruges. It can even be felt in works where Patinir did not collaborate personally by painting the landscapes for altarpieces by Joos and other artists. Joos's Patmos landscape (University of Michigan), which he painted himself, surpasses many Patinirs, because the figure of St John is so superbly set in the forms of the terrain.[22]

Joachim Patinir

Joachim Patinir came at the right time; the world around him was ready to adopt his way of expressing feeling for nature, and imitated him lavishly. In 1515 Patinir, who originally came from Bouvignes or Dinant, was registered master at Antwerp; he died at the latest in 1524.[23] His whole *œuvre* can hardly have been created in this short period. His quieter, more harmonious landscapes, especially in markedly religious works, such as the altarpiece at Philadelphia, may have been painted before 1515, and probably at Bruges.

In any case, his period of activity was short, yet in that short time he must have exercised an extraordinarily strong influence. In 1521 Dürer spoke of him as 'the good landscape painter', which is interesting, since it was the first time this term was used in the languages of Germany and the Netherlands. In the division of labour in the craft of painting, the term became almost a professional title, since, as we have seen, Patinir painted the landscape passages in other artists' pictures. But it is not the collaboration which is the peculiar feature of Patinir's work; works produced by many hands, with the joints concealed as far as possible, were common in late medieval times. What is new is that in a successful collaboration, for instance in Massys' Temptation of St Anthony (Plate 136), the joint can be felt, the duet enjoyed for its own sake, and both masters identified. The first condition for this continuance of old methods in a new sense was that all the collaborators should be equally accomplished, yet ready to work as a team, a condition that was not always fulfilled.

In most of the pictures, however, Patinir is alone, and it was in these pictures that he

really responded to the feeling for nature of his time and his people and created the Netherlands scheme of the devotional picture, in which small-scale saints move in wide spaces and thus sacrifice a good deal of their old autonomy. It was he who discovered the panoramic landscape. Thus most of his panels must have been in what is called in English 'landscape format', and he spread a continuous landscape over all parts of his triptychs, for instance the one in New York (Plate 145). The inanimate element which was later meant by the word 'nature' formed, in his case, the chief content of a Christian altarpiece.

This joy in the countryside is akin to the longing for freedom which moves a man to climb up a church steeple in a flat landscape for the sole purpose of experiencing distance. Patinir rendered flat country in a sweeping bird's-eye view, but the mountains as seen from below. They are always invention. The part shown is made to look like a whole, as in old maps. And so Patinir's painting did not further the exploration of space in depth, as Huber's did; his horizons are rather high, unlike those of his more 'modern' precursors, such as David. What makes the distance distant in Patinir's work is atmosphere and the logical, yet soft gradation of colour. Yet Patinir avoided both the excessive emotions of the Danube school and the infinity of Altdorfer's space.

The landscape recedes in fluent transitions from warm green to cool blue; as a Netherlander, Patinir often painted sheets of water, mostly gleaming in a turquoise tone. He was specially fond of allowing them to stretch to the horizon. But whereas later coast-dwellers were fond of embracing and painting unbroken expanses, Patinir always kept the clear line of the horizon. He obviously welcomed these horizontals as the one static element in his pictures. They set off the steep, rocky mountains and precipices, which are, as it were, the real actors in his pictures; he seems to have given them ever greater value in his later works. But he had a predilection for setting their fantastic shapes in contrast to the conscientiously painted, warm-toned, darker land lying at their feet. The hermits' huts cling to their sides, and towns nestle in their declivities. But Patinir also introduced another shape of rock, with a horizontal top. They usually occur in the middle of a picture; they have something of the unpredictability and dangerousness of volcanoes (Zürich).

In the so-called Underworld (Prado), that strange union of an Elysian Paradise with the Charon of Hades and the Inferno of the devil, the Tower of Hell has a touch of this abruptness. Yet Patinir was thrifty in his use of Boschian devilries. The destruction of Sodom and Gomorrha (Oxford) gave him the opportunity of reversing the sequence of his colours; this is probably characteristic of the first stage of his Mannerism. The landscape starts off in the foreground in deep blue-green, grows warmer in the middle distance, and behind blue rocks the background is red with fire.

For the most part Patinir's red is restricted to the fringes of the evening clouds and the figures, which he did not always invent himself, and which are not always impressive. In 1521 Dürer presented him with four versions of St Christopher.[24] Quite often the figures are painted by another hand. Yet there are pictures where no joints can be detected, and which are certainly entirely by his own hand. In them the Virgin resting on the Flight, St Jerome, or St Christopher wading through the water fit credibly, neces-

sarily, and even harmoniously into the landscape. In the Vienna Baptism of Christ, God the Father is seen against an airy sky, and not, as before, on a gold ground. After all, God made heaven and earth. The paradox of introducing him like a particle in the midst of his own visible creation is probably first noticeable in Patinir, but it is compensated by his serene naïvety.

The First 'Antwerp Mannerists'

Just as Patinir exaggerated the height of his rocks, other Antwerp artists of the time exaggerated the size of their buildings and figures, things which are easily checked by the beholder. Nor were they all able to compensate this trend by that conscientiousness which was Patinir's personal gift, or by the love of the born classic for the horizontal of the horizon.

The 'Antwerp Mannerists' were not inspired by any sense of balance. This large group was not an isolated phenomenon. The earliest date on record is 1513; in that year Adriaen van Overbeke was commissioned to do the great high altar for Kempen. The style is at the same point of emerging Mannerism as that of Joos van Cleve's contemporary Death of the Virgin. From the outset all kinds of decorative motifs were available from the southern repertory of form, and they were often freely blended with Late Gothic in delightful compositions. Slender, active figures appear in high rooms. It is this Gothic strain which, in particular, distinguishes these works from those of Gossaert, who was at that time aiming at a much cooler, post-classical Mannerism. Dutch influence probably came in through Engelbrechtsz. It is difficult to say who originated this exaltation in Antwerp itself. Among the older artists, Joos van Cleve in particular produced works of the same kind. Gooswijn van der Weyden may have contributed to it too. Yet the style now being developed may have been already practised by some group without a leader at the same time. After all, the coming style was in the northern air at the time, especially among the young painters who became masters at Antwerp in the first decade of the century, though it did not emerge before 1513-15. There are later dates for similar, but increasingly Mannerist pictures; in 1516 the high altar at Västerås, in 1516 the Nativity (Cologne), in 1518 the altar of the Briefkapelle in the Marienkirche at Lübeck, in 1519 the Adoration of the Magi at Karlsruhe. But most of them must date from the twenties and later.[25] It is small wonder, in view of the vast number of carved altars of that style exported from Antwerp, that the painters of the wings participated in it. Sometimes mere virtuosity was combined with facility and shallowness, but there were the strong and the weak, as everywhere else.

Jan Gossaert

Jan Gossaert, also known as Mabuse, at once gives the impression of something out of the common run after we have seen Joos, Joachim, and the Mannerists. Gossaert appears as a gentleman painter; there is almost nothing bourgeois and vernacular about him. He was, like Massys, a seeker, but, quite unlike Massys, he was not a fortunate

explorer; he was an experimenter and inventor. He soon fell entirely under the spell of Italy, which gave him formulae of his own, largely without Leonardo, and in any case, primarily formulae. His was a powerful, and at the same time complex nature.[26]

He was probably born about 1478 near or at Maubeuge. He seems to have been as much at home in the north as in the south of the Netherlands. In 1503–7 there is documentary evidence of him as master at Antwerp: he may have been trained at Bruges. He learned from David, but his colouring comes more from Provost. At the beginning of the second decade he probably took part in the mass-production which was one of the roots of Antwerp Mannerism; but he was not so successful in collaboration with other artists as Massys was with Patinir. As a whole Gossaert was the born court artist, though a difficult one. About 1508–9 Philip of Burgundy, the patron of the classic trend in the Netherlands, that is for instance of Meit and Barbari, took him to Rome. Later he was active in Philip's service at Souburg and Middelburg, and in 1517–24, when Philip became bishop of Utrecht, probably moved to Utrecht with him. After Philip's death he took service with Philip's grand-nephew, Adolphe of Burgundy. He died in 1532, probably at Middelburg. In his activity for the courts of collateral lines of the House of Habsburg, he undertook, after 1515, occasional commissions at the court of the Regent Margaret at Malines.

The works of Gossaert's early years as a master are the Agony in the Garden (Berlin), and the two grisaille wings with St Jerome in the Wilderness (Washington) which probably belonged to the Agony. After the wonderfully shaded grisailles, the inner panel stood revealed as a night-piece. The Gossaert hallmark of artistry is there from the outset – also in the coolly calculated composition. Joest's feeling for nature was more delicate and complex. Gossaert's rocks, with their slate-coloured shadows, find their contrast in a sharp moonlight which has become the bearer of the sinister message of the fateful night.

The Adoration of the Magi (London) is also a masterpiece (Plate 144). It was painted in the manner of Van der Goes, and with forms borrowed from Dürer's Nativity (B2), yet it is basically an original and majestic work. Violet and slate-colours in the shadows are interspersed with the shades of grey the artist loved. The colouring is chromatic; Gossaert threw a cloak of scarlet merging into violet over brown fur and composed the Moorish costume in various shades of red and gold. Yet all the primary colours are also duly represented. There is considerable sculpturality in the figures. The many spatial indications, based on Dürer, may have cost Gossaert some effort. They are not what he was talented at, and so the foreshortening of some of the faces is not quite credible. The picture belongs to the early classic situation, and was obviously painted before Gossaert had seen Italy.

He had begun in the field of landscape painting which was then developing in the Netherlands and on the Lower Rhine. Yet he was obviously not often inspired by inanimate nature. In Rome he laid the foundations of his sculptural figure style. From that time on landscape meant very little to him. He brought drawings back from Italy, some probably by other hands, along with specimens of graphic art. His own sheets, which include a nude, show that he had studied the solid forms of Antique remains.

He grasped things bit by bit; he laid no foundation for a total new artistic outlook. The interpreter of southern form, which became so vitally important to him and to his patron, was, before his visit to Italy, Dürer, and Dürer still remained so afterwards.[27] Later, Barbari's influence set in and grew.

The large Virgin with St Luke from Malines (Prague) reflects the immediate effect of his Italian journey. A coldly solemn, echoing architecture, consisting mainly of Renaissance forms, recedes into the background and is skilfully foreshortened. The group of the Boy with the Goose is inserted as a reminiscence of Rome. At this point the detail rivals the main theme. Seated at a great distance, St Luke is drawing the Virgin, observing her, with a touch of preciosity, from above. Gossaert's artistic disposition was always cool, but here it seems to have become frosty, in spite of the delicate colouring. The recorded but uncertain date of 1515 probably places the picture too late. In itself, it looks as if it had been painted soon after the visit to Italy.

In the Palermo triptych the Virgin, surrounded by very statuesque angels and women saints, is seated at the foremost edge of the picture-space, under a forward-thrusting canopy of the Latest Gothic style. It is definitely a transmutation of the diaphragm arch of old Netherlands painting.[28] A landscape, as irrelevant as a back-drop, is spread out behind, and also, as the Garden of Paradise, on the outer sides of the wings, where Adam and Eve appear with the tree and the serpent, though in the reverse position to Dürer's Small Passion. The action, however, is crowded on to one of the wings, while the other – an anticipation of Mannerism – is void of figures.

In Rome, Gossaert had overcome his native vernacular. With two sources to draw on, the north and the south, he felt himself much more free to create a style of his own than David and Massys had been about 1500. His dashing pen-and-ink drawings of histrionic soldiers are based on Roman studies and gain from them something of the fantastic quality of the statues of the tomb of Maximilian of the second decade. The sheet with the betrothal of St Catherine (Copenhagen) also dates from that proto-Baroque period; the ornamental forms are similar to those of the monuments at Brou.

The finest work of this period of transition, probably dating from about 1515, is the St Luke with the Virgin, now in Vienna (Plate 143). The stage has a blind wall with Renaissance articulation and reliefs after Filippino Lippi: for the architecture in his works, Gossaert maintained for a long time a free choice between his two repertories of style. In front of this architecture the Virgin appears miraculously to the artist-saint, who kneels at his prie-dieu and whose hand is guided by an angel. The moving quality of the event and the emotion of the artist can be felt. The Virgin could no longer appear on earth in the naïve manner of the Late Middle Ages, but only as a vision.

On the other hand, the mythological couples which Gossaert painted in 1516–17 – Neptune and Amphitrite (East Berlin; Plate 166), Hercules and Dejanira (Birmingham, Barber Institute), and probably the Metamorphosis of Salmacis and Hermaphroditus (Rotterdam) – were entirely earthly. Neptune was the patron god of Philip of Burgundy, the admiral and later bishop. In a pillared hall of Doric austerity and glassy coolness of colour, the marine deities stand like giants; the outlines of the bodies are perfectly clear-cut. They are probably based on Barbari's Mars and Venus, with some influence from

Dürer's Adam. But Gossaert exceeds both in the sculpturality of his forms, and in that respect his work can stand comparison with Meit's Mars and Venus. A meeting with Meit may have contributed a great deal to Gossaert's post-classic Mannerism, which was just setting in. From that time on he often quoted sculpture. His heads, like those of animated marble statues, approach each other as they do in double portraits. The frostiness of the execution may be a courtly manner of concealing personal allusions. The picture of Hercules and Dejanira, in which an intricate entwinement of the limbs both suggests and conceals an erotic intention, is another witness to this stage of Gossaert's style. This is the 'Renaissance' which appealed to the humanist dilettante of the north. From 1516 Gossaert used the signature Joannes Malbodius.

His portraits are of the same kind. The desiccated couple now in London resemble each other as married couples tend to do in old age; they are domineering and maybe evil. The centres of energy are the chins and the roots of the noses. In its struggle for reality, his picture, which was painted soon after the artist's return from Italy, recalls Dürer. It is also a conquest in the field of chiaroscuro; the shadows are colourless, and generally black. On the other hand, the portrait of Jean Carondelet, the patron of Erasmus, in adoration before the Virgin (1517, Louvre) is just as credible, though it is very much idealized. Carondelet is very imposing in his physical presence, and is grasped, in one vital way at least, as a spiritual personality. The Virgin is smaller and remote; her face has the smooth finish of the turner's work. Her eyes, like those of the Child, are of a glassy, unreal greyish-blue. Carondelet worships a piece of sculpture rather than a living being. On the outer side of this diptych a bleached skull lies beside the coat of arms, the old *memento mori* motif, but rendered here with strict *verismo*. The niches project with explosive force. Simplification of forms in the portrait reappears in that of Eleanor of Austria (?) (Portland, Oregon, August Berg), a panel which possibly also dates from 1517, and in which, by a most skilful turn, the outer corner of the eye meets precisely the delicate outer curve of the cheek.

Gossaert's great talent, probably akin to that of Dürer in its alertness, left Massys' troubles over space and depth far behind. What meant most to Gossaert is the sculptural rigidity of his figures. They are devoid of expansiveness. Baldung was much freer. Gossaert's clear-cut outline, his glassy colours meeting abruptly, the reflected lights in the shadows – all these factors worked together to achieve the sculpturality in his paintings. Further, by the lack of spirituality of his types and the daring of his nudes he overcame Massys' sentimentality, but at the same time cut himself off from Massys' psychological depth. Throughout his life, Massys had worked in terms of the native preliminary stage of the classic, whereas to Gossaert the nature of the classic had been revealed in the treasury of southern forms. But just for that reason it could only serve to enslave him to Mannerism. The portrait now at Manchester, New Hampshire, with its huge, antiquated 'artist's cap' and eloquent left hand, is exceptionally free. Probably it is a self-portrait of this most gifted Fleming of the first Mannerist generation. The best of his work of that kind was yet to come.[29]

CHAPTER 15

PAINTING ON THE LOWER RHINE AND IN THE NETHERLANDS: 3: THE NORTHERN NETHERLANDS

Hieronymus Bosch

In the Northern Netherlands the most important painter of the old generation was still active: Jeroen van Aken, surnamed Bosch after 's Hertogenbosch, where he worked. He was born about 1450 and died in 1516.[1] One could say that he was predisposed towards the Mannerist style; in particular, the Antwerp school very often borrowed from him. But he remained remote from it. He hardly ever approached the classic, nor did he make any advance towards post-classic. Thus his 'Mannerist' strain is actually a special case, splendid, but entirely late medieval.

In Bosch's work, as in that of others, the development of naturalism took place before the nineties. A world of figures in furious movement, which look not unlike puppets, fills his early panels and is rendered with a bright, delicate palette of his own devising. It is true that the realism in Bosch's work increased later, but that only applies to the details. The Carrying of the Cross (Escorial), probably dating from the early nineties, is lucidly organized by the main lines of the Cross. The crowd, till that time swarming masses, has been assembled in relief-like blocks. New colouring appears too; the colours are more intense than before – indeed, at times they glow. They tell more of the surface of things.

It took time, however, for Bosch to develop his specific character. His dualistic vision of this earth made him dwell on the power of the devil in freely invented allegories and in creatures like *fleurs du mal*, in strangely evil diabolical figures which are far remote from the secularizing, humorous tone in which Dürer, in his early years, pictured weird creatures of the sea.

Bosch's path led to form on the grand scale. That is evident in his half-lengths of the Crowning with Thorns (Plate 150) and the Carrying of the Cross. They are based on what was originally a North Italian type of picture. In the same way as in Colijn de Coter's work, closely enframed compositions made it possible to neglect problems of space. Great movements dominate the picture-plane; weights are distributed by a deliberate choice of colours. In the Crowning with Thorns (London) three colours – orange, yellow, and violet – hardly appear: the picture is based on supremely delicate variations of green, blue, and red. Everything is seen at close quarters, but there are all the same notable pictorial effects and relics of aerial perspective. By this concentration Bosch was able to represent in the four executioners surrounding Christ the four temperaments, the four ages of life, and four variations of human cruelty. And yet these panels give the impression of experiments with readily available material; at the same time each achieves a surprising profundity. Bosch may have painted such pictures till

159

the end of his life, but for the most part they bear the stamp of the time about 1500. The Carrying of the Cross at Ghent, with its almost isolated, fully modelled heads and exaggerated physiognomies, may be his last word in this line, and it is far remote from Dürer's Christ among the Doctors, though Dürer's figures are isolated in a similar way, and the link between them is not a link in space.

But that is not the whole of Bosch in his later years. The so-called Tramp (Rotterdam) is a roundel with almost radiating lines playing about its centre (Plate 148), and harks back to the half-lengths. But it shows everyday people in their everyday setting, embeds them in the finely differentiated earthy tones of the landscape, and invests the dubious house with firmness of structure and full credibility. It is not known whether the picture represents the Prodigal Son or Saturnine Man as part of a series of the Children of the Planets. The most striking thing about it is the naturalness of its execution and its proverbial wisdom.

Most of Bosch's works are packed with symbolism. Only initiates could decipher them, and it was to the initiates that they were addressed, like many humanistic writings of the time. Even in the late triptych of the Adoration of the Magi (Prado), beside the narrative which governs the foreground, the figure of the Anti-Christ can be seen. Through all the details there runs a strain of mystification, and there is many a cryptic allusion in the graded tones of the landscape. St Anthony (Prado) is besieged by a host of devils mysteriously made up of insects and a funnel, a human arm and a milk-can, an animal's tail and a helmet. The diabolical has become artificial, and, as it were, synthetic, and presents itself in the guise of the absurd. The allusion in these grotesqueries is, for the most part, envenomed. In the Lisbon altar of St Anthony many of the devilries could, up to a point, still be taken humorously, but now double meanings and ambiguities can nearly always be felt, and it is often questionable – indeed, that question lies in the nature of his art – what allusion is really meant.

The triptych of the Last Judgement, probably painted before 1508 (Vienna, Akademie), reveals Bosch's utter lack of confidence in the kindliness of the visible world and the rationality of human nature. This applies still more to the triptych of the Garden of Earthly Delights (Prado; Plate 147). In the wealth of inventions of senseless sensuality, in which the only remaining hope is the Judge of the World, Bosch seems to have abandoned any organization. But only at first sight. In this triptych, which is unprecedented even in Bosch, a clear, calm vision of Paradise is placed in contrast to the earthly confusion of sensual fantasies and the crowded horrors of hell. There is virtually no continuous space; only small fragments, for instance a delicious apple orchard, remain. Everywhere the detail is of extreme precision. Even the pictorial structure, in its alternation of clarity and confusion, reflects the moral allegory of the enigmatic whole. It is in all probability a didactic presentation of the vanity of the world made to look like an altarpiece, but hardly fulfilling the function of an altarpiece. Even if it were possible to unravel all its meanings, its real artistic quality would not come out – the effect of childishness fused with mystery, the power of uniting, in one whole, crude and quite unrelated details, the gaiety of localized colouring spread out like a carpet without any real connexion by light and shade, where the central panel, in sensuous

fruity colours, stands between the soft, spring-like tones of the left wing and the greenish-grey, livid colours and the transitions to violet in the right wing. Nor is there any passage which makes us feel that a decorative intention had dictated the placing of the forms. The triptych keeps its own unique greatness, a greatness that is extraordinarily timeless.

In both its aspects, the purified and the confused, the work is purely Late Gothic. Yet the mastery of so many forms of expression may stand witness to a freedom in the choice of style which had gradually become possible at that time. Bosch was now an old man living in a remote place. He knew that works of his were in the possession of the rulers of his country, Philip the Fair and the Regent Margaret, but he was likely to be detached from his time and world. The fantastic nature of his creative work and his abolition of the laws of reality may have pointed the way to many a Mannerist. As a colourist he was far in advance of his time. The airy landscape of his middle period was re-translated into carefulness by Patinir, though Patinir worked more fluently and from a different point of view.

Jan Mostaert and Other Haarlem Painters

Jan Joest, who was active in painting on the Lower Rhine, may have been trained at Haarlem; in any case, he finally settled and worked there from 1509 to his death in 1519 – his Burgos altarpiece was probably sent from Haarlem. Perhaps Joest was able to settle at Haarlem because Mostaert spent many years away from it.

For the leading figure in painting at Haarlem after Geertgen's death was Jan Mostaert, who was born there about 1475 and died there in 1555/6. In 1500 he is mentioned at Haarlem as master. He is said to have been court painter to the Regent Margaret for eighteen years and to have been in her retinue wherever her court went. Thus, if he entered her service about 1490/5, he must have seen France, Brussels, Spain, Geneva, and Savoy before Margaret settled at Malines in 1507.[2] He may have kept his citizenship of Haarlem during this time. His work is so versatile, his subject-matter so manifold, his brushwork so striking in its delicacy that he can easily be imagined as a court artist.

Mostaert's earliest work, a densely populated Tree of Jesse (Amsterdam), with lively figures which are still very much in the style of the eighties, shows the influence of Geertgen or his successors. The colouring of the small panel of the Holy Family at Table (Cologne) is imaginative and refined; the homely atmosphere of a good, jolly meal harmonizes well with the gravity of the quiet parents.

A good deal later, about 1520, came the great altar of the Passion (Brussels). In this work, or at any rate in its central panel, Mostaert remained more or less indebted to Rogier's Deposition. This archaism is blended with a peculiar strain of Early Mannerism; the figures are painted as if they were statues standing in an altar shrine. In this work Mostaert, even more than Rogier and the St Bartholomew Master, was playing with the allusion to the other medium. Yet the sculptural was not really his bent; he abode by his choice of generally cool areas of flat colour with very few shadows. In this he was akin to Massys, and probably tried to rival him.

He displayed more power in devotional images, usually small, such as the bust of Christ Crowned with Thorns, familiar in many versions, the beautiful Holy Family under the Apple Tree (Rome, Palazzo Venezia; Plate 154), or the Adoration of the Magi (Amsterdam). Whether the action is grave or gay, movement can hardly be felt. On the contrary, Mostaert's strength lay in the idyllic timelessness and lingering repose he could express in his figures. The Magi, like the resting Virgin, are three-quarter length. Features of the Dutch landscape – an apple-tree, thatched cottages, northern mountains – give the scene a touch of affectionate homeliness. Woodcuts by Cranach have been used for the Holy Family.

This pedant of the idyll, who partook in the new feeling for nature, had, like Altdorfer, a sense of the primeval. In the Expulsion of Hagar (1525, Castagnola), Abraham might be the autocratic master of a Dutch farm. The picture at Williamstown, Mass., of Mother Eve with her Children in front of a cave in the rocks is bathed in beautiful evening light, while on the distant mountain ridge the sacrifice of Cain and Abel and the first murder take place. It is a blend of peaceful, unspoilt life with rivalry and hatred. There is a magnificent portrait of a Moor by Mostaert (London, Sir Thomas Barlow), the first to be painted in the Netherlands. In the end, this gift led him to the painting of contemporary events. His West Indian landscape is full of Mexican landscape elements – a canyon and Indian dwellings resembling the pueblos of Arizona – probably after drawings (Haarlem; Plate 153). They show real knowledge, and express something like a fellow-feeling for the bewildered inhabitants, naked savages overwhelmed by an expedition of Spanish *conquistadores*. This picture dates from 1542 or soon after; Haarlem and Mexico belonged to Charles V's empire.

Mostaert probably served the Regent Margaret mainly as a portraitist, although no portraits of the imperial house by his hand have come down to us. A number of replicas of portraits of the early fifteenth century have been ascribed to him. If they are his, he had, in his own way, taken his part in the revival of the *patres* of old Netherlands painting. In any case, he was an outstanding portraitist in his own right. The impressive figure of a bearded man (Berlin) is rendered in scarlet on a green ground. The bald-headed man (Copenhagen) is powerful; the flesh tone is finely modulated with Mostaert's favourite colour, a warm, brownish violet. As a rule he emphasized the outline of his slender half-length figures, and gave his portraits a natural background, often with the high, airy sky of the Netherlands. He frequently animated the recessed planes of his pictures with scenes with small figures. In this way there appear the story of St Hubert, and several versions of Augustus with the Sibyl and Alexander with the wife of Darius. There are occasional echoes of Antiquity in the architectural detail which emphasize the dignity of his sitter, as, for instance, in the portrait of Adriaen van Wienoxbergen (Brussels). The surroundings, as a rule, are local, and although we cannot speak of a literal truth to nature in the landscape, we may assume in castle and house many an allusion to the life of the sitters. The whole of his nature, composed of many elements, has credibility, even when it appears in portraits as an accessory. Mostaert had a supreme sense of colour. In his later works there appear beside the fine colours of the portraits intensely warm tones and strong shadows. Thus the man in the portrait

now at Worcester, Mass., wears, with his black cap and coat, a fur collar flecked with light and dark brown and an undergarment in various tones of reddish-mauve. The violet and bluish-grey of the distant rock gives superb support to the whole composition. Mostaert was a masterly portraitist, who was certainly feeling his way towards personality, less, perhaps, in the painting of the hands, but certainly in the understanding of faces. In any case, he explored character.

The Master of Alkmaar,[3] in his largely shadowless paintings, especially the Egmont portraits (New York), had much in common with Mostaert, and probably went through the same training at Haarlem. If he is not – in spite of some evidence – identical with Cornelis Buys the elder, active about 1490–1524 at Alkmaar, a brother of Jacob Cornelisz., but with Pieter Gerritsz., who had been active at Alkmaar and Haarlem since 1502 and died at Haarlem in 1540, he belonged to the Haarlem school before Mostaert developed it. The Virgin with the Child and St Anne (Brussels) is both animated and austere; this was a work in which he competed with the versatile Mostaert. His name originates from the panels with the Seven Works of Charity of 1504, painted for Alkmaar (Amsterdam). The representation of the duties of the Christian is unadorned, but moving. Christ is tranquil, and is almost always one of the crowd in need of charity: it is only to prisoners that he appears as the Redeemer, and, at the funeral scene, as the Last Judge. The Master of Alkmaar's pictures are remarkable for their light rooms in brick colour and green gardens which stretch before the eye, and for their bright and springlike colouring. His Holy Kinship is lovely in its harmonious colouring; his saints look like princesses. The eyes are small, the faces of the men are boldly modelled with strong cheek-bones, the heads are egg-shaped. That is also true of Christ on the road to Emmaus. All this shows clearly that the master was a contemporary of Frueauf and the early Danube school.

Amsterdam

The Master of the Death of the Virgin in the Rijksmuseum[4] was probably active at Amsterdam (or Utrecht?); an animated group of apostles, one of them an expressive figure seen entirely from behind, is toned down by the precision with which the room with its bright tiles is rendered. Light and shade are worked out object by object, as they are in a still life. The men have the hard-worked faces of elderly craftsmen. The portraits also keep to a style of bourgeois simplicity.

Jacob Cornelisz. van Oostsanen, also known as Jacob van Amsterdam, took time to advance beyond this stage.[5] Born before 1477, and probably c. 1470, a brother of Buys the elder, he was the dominating figure of the first third of the century in Amsterdam, where he owned a house in 1500 and died in 1533. It is not certain whether his work can be identified with that which has been grouped under the name of the Master of the Deposition from the Figdor Collection; in that case Jacob too would have issued from the Haarlem school under Geertgen's influence.

The unsigned panel of Christ the Gardener (Kassel; Plate 151) and a monogrammed woodcut are dated 1507. Jacob left a wealth of woodcuts behind him, as well as extensive

work in book illustration and designs for stained glass and embroidery. In a city which till then could boast of no great artistic tradition, he plundered Dürer for his popular woodcuts as no other artist in Holland did. At the same time, however, he gradually advanced to deeper understanding and more personal adaptation of Dürer's models. About 1523 his production of woodcuts was sacrificed to a trend towards greater sculpturality which had been visible in his painting for some time.

The Kassel panel of 1507 is densely painted, with thick-set figures and angular faces. Though the general impression is light, the picture is studded with green details in a kind of *horror vacui*. The patterns of textiles and of vegetable growth appear side by side and are practically equivalent in value, as they are in a carpet. From that point Jacob came gradually to give up localized for general colouring dominated in some cases by dull or cindery tones. In the Adoration of the Magi of 1512 (Naples), cool colours prevail, and a great deal of black in the costumes helps to produce strong spatial contrasts. At this time too Jacob began to give his pictures greater depth by means of definite perspective; in the present case the eye is led to the sea, rendered faithfully to nature, probably for the first time in Dutch painting. He found some of his models in South German graphic art. Obviously a journey to Jerusalem which he made in 1525 had little to give to his painting. It appears, however, that in the twenties Jan van Scorel, who had been Jacob's pupil in 1512, when he returned from Italy, had some influence on the work of his old master and of his son and successor, Dirk Jacobsz. In a general way, Oostsanen's painting became more fluent, his line easier, while the immobility it had shared with the woodcuts was abandoned. An example is the sensitive, dark-coloured Adoration of the Magi (Chicago). But there are Mannerist traits too, as they had been latent in Jacob's work for many years, for instance in the Mary Magdalen of 1519 (St Louis), and especially in the Salome (Rijksmuseum). Salome's face is flattened, distorted, and egg-shaped; the head of St John, foreshortened in a kind of exaggerated perspective, lies with bleeding throat in a shimmering blue dish which subtly contrasts with the pale blue of the dress and its red and green sash. On the whole, however, the psychologism of Early Mannerism was alien to Jacob. Just as his saints seldom expand into enthusiasm or ecstasy, but remain, for the most part, confined in the flesh, the Witch of Endor (1526, Rijksmuseum) has little of the brilliant revelation of the night side of life made by his South German contemporaries.

What is really Dutch in Jacob is the keenness of his observation, which was his from the outset. The double portrait of the Van Teylingens (1511, Rotterdam), with its darkish flesh-tones and brownish-violet shadows, has grasped what we can recognize as likeness both in man and wife. And what looks at us from the self-portrait of his last year (Rijksmuseum; Plate 152) is a bird-eyed craftsman with a bent for the humour of things in their earthiness; this is no great and cultivated mind, nor an artist in the new sense of the word, but a master of his trade, a man of the people, living through his eyes. The violet shadow of his nose, though executed with less sparing and dignified means, still shows something of Gossaert's sculptural effects. In a royal countenance such as that of Isabella of Denmark (Castagnola), a member of the house of Habsburg, Jacob, by his very nature, could not dig so deep.

Delft and Leiden

At Delft, an unknown master was active who goes by the name of the Master of Delft, probably a follower of the Master of the Virgo inter Virgines.[6] His *œuvre* belongs for the most part to about 1510 or even later. A Crucifixion (London) is swarming with agitated figures. He loved to paint Holy Kinships with women saints, often looking like grotesquely overdressed girls with piously pale, silly, or pert faces. On the whole his are a gay, inventive style, a select palette of generally light colours, and an agreeable facility of execution. The pace and excitement of many of the pictures are in line with the proto-Baroque of the second decade.

At that time Leiden was at the beginning of its eventful history in Dutch painting. Hugo Jacobsz., who died about 1534/8 and was the father of the greatest of the Leiden painters, Lucas Hugosz., has been identified with the Master of the Panels of St John, so called after the remains of a large St John altarpiece now in Rotterdam and Philadelphia.[7] The colours are intense, and warm red often stands beside violet brocade and green. The figures are powerfully modelled, and they are moderate in movement and clearly outlined even in the loosely assembled groups. There are open architectural backgrounds, fanciful in the Late Gothic manner, yet compactly sculptural rather than architectural (Plate 149). The meeting of Christ with St John shows the feeling of the coast-dweller for the life of low-lying land. Impressive trees rise with their masses of foliage against the bright distance of the flat scenery and a sky with clouds floating in it. These effects can be compared to those of Dürer's water-colours. Hugo Jacobsz. was a master of the classic possibilities of the Late Gothic. He was Lucas's first teacher, and it is clear that he had great gifts to pass on to those coming after him.

Cornelis Engelbrechtsz., the most outstanding Leiden master, was Lucas's second teacher. He is believed to have been born at Leiden in 1468, is mentioned there between 1499 and 1522, and died in 1533.[8] We cannot tell with certainty what his work looked like before he was forty. The altarpiece from the Marienpoel monastery (Leiden) was painted about 1508; in the central panel the Lamentation in clear colours stands out on the brown background, a towering composition with many figures, yet satisfyingly composed with unpretentious artistry and easily legible. A painted framework of Late Gothic architecture encloses six more pictures of the Sorrows of the Virgin. On the wings, the donors and their patrons appear in tabernacle-like structures, while outside there are four women saints in the unexaggerated sculpturality of a quiet Late Gothic.

Among the works known to be by Cornelis there are undoubtedly some which were painted earlier, for instance a lovely, many-figured picture of the Betrothal of the Virgin (formerly Dresden, Graf Medem), where the modelling is still more pronounced and is combined with more realistic detail. Cornelis's artistic origins are uncertain; he may have started from Colijn de Coter's Brussels style. Yet the proto-Baroque and Mannerist development of his later work seems to have come about independently of the Antwerp school.

The great Crucifixion altarpiece, also from Marienpoel (Leiden), was probably

painted about 1520. A crowd, skilfully assembled in the main scene, daring fore-shortenings, for instance in the head of the thief, and cleverly arranged repoussoir figures betray a growing versatility. The many iridescent colours show it too. These changes of style, which are still more marked in the Crucifixion now in New York, are Early Mannerism with a relatively small importation of southern form. Van Mander calls Cornelis's painting 'artistry without art'.

Classical ornament occurs in the panels of the Farewell of Christ and of Christ with Mary and Martha in the Rijksmuseum. The bustle in the background emphasizes the quietude which surrounds Christ as he speaks. The whole looks like the snugness around a teller of tales. The pictures have not Massys' force, but they have his intimacy. Even in the Farewell there is not a loud note; the feeling is tempered, and the whole statement is conveyed in intertwined hands and arms. The iridescent colours appear again, and a number of clashing colours are set in patches like jewellery or precious stones, on the more ornate costumes. Yet one tone predominates. The landscape, painted with feeling and greatness, recedes in stages from yellowish green to pale blue; there is also a sudden transition from greenish light-brown to the bluish-grey in the depths, with the pale violet and pale mauve of the rocks and architecture as inter-mediary. Cornelis's talent found particularly happy expression in smaller pictures, for instance in the later panels with the slender figures of the Emperor Constantine and St Helena (Munich), in their mature, Late Gothic Mannerism (Plate 156).

The portraits of the Ottens couple (1518, Brussels) are remarkable (Plate 157); these are the only portraits by Engelbrechtsz. that have come down to us. The sitters, whose dignity becomes excessive by the diagonally placed Renaissance niches – like those in Massys' Virgins – are outlined with the utmost conscientiousness. And the view through the window on to the husband's brewery by a Leiden canal has, for all its literalness, the magic of a town vista actually seen.

In the late works we may assume that Cornelis's three sons collaborated, especially Cornelis Cornelisz., called Kunst, and Lucas Cornelisz., called de Kock. It is not always possible to distinguish where the father's work left off and another hand took it up. Not only Aert Claesz., known as Aertgen van Leiden, came from Englebrechtsz.' workshop, but Lucas Hugosz. too, the glory of Leiden.

An important part of Lucas van Leiden's activity falls into the years before 1519.[9] He is believed to have been born in 1494, though the date may be as early as 1489, and was a child prodigy. In 1533 he died after a life apparently mainly spent at Leiden. His pre-cociousness seems to have gone hand in hand with poor health. His father was his first teacher and was followed by Engelbrechtsz., but he soon outdid them both. He is said to have published engravings of his own invention at the age of nine, or at most fourteen. His earliest dated engraving, the sheet with Mahomet and the murdered monk, is of 1508, and a number of others must be earlier still.

The earliest picture to have come down to us, the small panel of the Chess-Players (Berlin), must have been painted before 1508. White moves and wins; the girl has played a good game, the onlookers take a lively interest, the loser is desperate. It is as if high tragic actors were playing comedy – the gestures are overdone. Youth seldom

writes comedies. Yet we may say that the subject of the picture is not merely a game of chess; something greater may be at stake. Like the early engravings, the picture is audacious. It is packed full of form, yet what the young artist had at heart was the human figure and the individuality of countenance. No trace of influence from Engelbrechtsz. can be seen. Lucas went back to the subject of chess in the second decade, varying the players with greater experience of life. In any case, it is important that a life-work could begin in the new century with a genre piece. The lion's paw is there, though it still gropes.

It was perhaps Engelbrechtsz. who weaned Lucas from this hesitating manner. Half-length figures, like Susanna before the Judges (Bremen), are far less compact in their grouping. The general tone of the Epiphany altarpiece (Merion, Penn., Barnes Foundation) is a muted greenish-brown which gives coherence to the delicate brightness of the clothing. The Virgin has a pale blue cloak over a dark blue robe in front of a bright green meadow. There is ease in the grouping, and nothing of the stage in the space; it is homogeneous as if by nature, an effect which is, for the most part, achieved by atmosphere. The relation of the tree-top to the sky is like that in his father's picture, but his sense of modelling, even at this stage, is already greater than that of both his teachers.

Lucas continued these small pictures with half-length figures in the Epiphany now at Chicago. The figures are smaller than before; between them a vista opens on to the cool colours of the background landscape, where Herod's horsemen are searching for the Magi. The colour of the little picture is held in perfect balance by the gold brocade and red in the foreground, with skilful touches of pure blue. The whole is a miracle of delicate painting, executed with effortless sureness.

In view of this picture a third source of inspiration has to be mentioned: Dürer, whose graphic art was certainly one of the factors in Lucas's early training. After the middle of the second decade Lucas's own graphic art was soaked in it. And even his painting owes much to the other child prodigy of the age. Like Dürer, Lucas had a predilection for small-sized pictures because of the freedom they give. A feeling of buoyancy radiates from his work. As a painter he had a happier hand than Dürer and was less formalistic than Gossaert, whom he knew. He attached greater value to effects of light and to what just happened to be there.

This manner is clearly illustrated by his self-portrait at Brunswick (Plate 155). It is a study with an appraising look in the eyes, set against a radiant, warm red. This background is really antiquated, but all the same strikes a note of youth and daring. This was the first self-portrait to be painted in the Northern Netherlands, and from then on self-portraits were a fairly frequent feature of Lucas's graphic work and his painting. The Brunswick picture is convincing in its candour, not to say bluntness. Lucas was a born observer. We are informed of all the ups and downs of the face, though it is not explored, as Dürer's was, by lines, nor is it rendered in lines. Considering that this is a painting by so brilliant an engraver, it is astounding; it is one of the incunabula of European Baroque painting, a piece of proto-Baroque in the early sixteenth century.

The Beheading of St John the Baptist (Philadelphia) shows an early Mannerist trend in Lucas's work of the second decade. Nearly all the primary colours are assembled

round the livid head of the Baptist, but yellow and violet are very much reduced. Salome, in a light blue and light grass-green dress, though without iridescent colours, is not interpreted as a pathological case. An early date for the rise of Mannerism in Lucas's work is given by the Pyramus and Thisbe engraving (B135) of 1514. It was followed by two drawings, one of Judith and Holofernes and one of Jael and Sisera.[10]

Lucas's meeting with Dürer in 1521 opened up new possibilities to him, but it was not the only factor at work on him. The turning-point seems to have come before. The splendid Virgin in Berlin (Plate 161) was probably painted about 1520. With works of this kind behind him, Lucas van Leiden set out on his journey to Antwerp to meet Dürer in person.

PART TWO

THE EARLY YEARS OF CHARLES V: LATE GOTHIC AND POST-CLASSIC MANNERISM

THE REIGN OF CHARLES V: THE FIRST
TWENTY-FIVE YEARS, 1519-1545

MAXIMILIAN's successor was not a German. Charles, his grandson, had been brought up at the still-existing Burgundian court and in an atmosphere of French–Netherlandish culture. His mother-tongue was French, and even in Germany he had to manage at first with the smattering of Flemish he had learned during his early years at Ghent.[1] Thus his first introduction to his dignities took place in the north-western, almost independent, borderlands between the Empire and France; in the meantime (1506–16) he had entered on his heritage of the Spanish kingdoms and Naples. While Maximilian was comprehensible to his contemporaries mainly in a 'German', or what might be termed a national, role, the imperial duties Charles was called upon to fulfil from the very outset were supra-national, and those duties were made more onerous and complex by the unprecedented aggregate of hereditary territories beyond the imperial frontiers, not to speak of those in the New World. Although Maximilian had only been able to govern his empire from the saddle, as it were, in his perpetual riding through it, he was never too remote from his own castles and country seats and his own chancery. But Charles, throughout his life, was like a medieval emperor, a travelling ruler without a permanent capital. When he abdicated, he was able to say that he had been to Germany nine times, to Spain six, to Italy seven, that he had visited the Netherlands ten times and France four, and that he had crossed the sea to England twice and to Africa twice.

Though this Burgundian ruler had spent years in courtly unintellectualism, he by no means lacked the will to work and to gain precise knowledge of affairs. Yet, as he saw it, Germany and even the Netherlands must have seemed far remote for many years. He was felt to be a stranger in the Empire. He combined great breadth of vision with remarkable coolness of judgement.

From the start it was realized that regents must be appointed. From then on, Margaret, and later the emperor's sister Mary, ruled the rich central lands of Charles's domain from Malines and Brussels, and took care to expand them and round off their frontiers. What the princes of the Empire first did was to enforce the institution of a Council of Regency to govern Germany during the emperor's absences. Charles took the edge off this restriction of his power by placing his brother Ferdinand in the German positions and making over to him, not long after, the hereditary Habsburg group of countries. Indeed he went further: he had Ferdinand elected King of the Romans in 1531, which made him heir apparent to the Empire.

In spite of the agreement between the brothers on matters of principle and the undisputed supremacy of Charles as ruler, the multitude of Maximilian's endeavours seems to have come to be concentrated more and more in the hands of two persons. Ferdinand, who soon became heir to Hungary and Bohemia, took charge of policy in

the south-east. Throughout his life he had to keep an eye on the Turks, who in 1529 even besieged Vienna. But by that very fact he equipped himself for his national task as a German king. In view of the unsolved constitutional questions, his tolerant attitude towards the Estates was proper to his royal standing. In Germany he was soon more popular than the emperor. That gave the emperor still greater freedom for politics on the greatest scale that could possibly have been carried on in Europe. But it meant that Charles became more and more involved in the opposition to the papacy and France, both of which were driven by the huge aggregation of his resources into an unfortunate policy of defence.

A humanist by education, but always a faithful son of the Church, his relations with the pope were nearly always critical to the point of danger. In spite of the conviction implanted in him by Adriaen of Utrecht, the later Pope Hadrian VI, that the Church was in urgent need of reform, he was deeply alien to Lutheranism; yet he found himself only too often dependent on German opposition to Rome. Brought up as a Frenchman, and belonging, up to a point, to a collateral line of the French royal house, he was marked out to be a world ruler, and found himself nearly all his life hostile to the ruling house of France. In the course of these hostilities he won Milan and also kept the Franche-Comté, from which his most important statesmen, the Granvellas, came. He also succeeded in relieving his possessions in Flanders from French suzerainty, and in joining them with the Holy Roman Empire. On the other hand, in the end he had to abandon his dynastic dream of regaining Burgundy for his own house.

Yet could the old imperial role be revived, and given validity for his time by the un-precedented power in the hands of this ruler, who took his stand first and foremost on his dynastic connexions? Could he create a united Christian Europe? If anyone was to build a new structure out of ancient elements it could only be this prince, who com-bined an Erasmian intellectual bent with feudal chivalry, and who was, in spite of his moderate physical strength, invulnerable in his ease and grace. Or did everything he did merely serve – in the end utterly against his will – to exacerbate the nationalism of the western world? In Germany, in any case, and in the Netherlands he was confronted with explosive forces whose elemental power even a ruler as mighty as he could hardly quell.

In the first ten years of his reign the rumblings in the depths which had been heard even in Maximilian's last years broke surface. What happened can actually be called the first stirring of the German nation, and Luther arose like an elemental force. He found himself forced to go beyond what he had intended in 1517, and in purely logical fashion to contest the authority of the Church and its hierarchy, which in the end led to an attack on the distinction between the priest and the layman.

At the Diet of Worms in 1521, Charles followed up the Papal Bull of Excommunica-tion by an imperial proscription which, however, he was prevented from putting into force by opposition in the Diet. Minds began to divide. Luther's Reformation pamphlets appeared, and the Reformation began its activity. The repercussions were immense. A religious force of supreme importance had entered the epoch. The Germans, who had long been embittered by papal dominion and financial oppression, heard their ancient

complaints against Rome given a mighty voice by an inspiring personality. The people, the humanists, and even large sections of the clergy saw the overdue reform of the Church approaching. Luther seemed to confirm what had long been in people's minds about the levelling of the social hierarchy. Hussite and other anti-ecclesiastical trends took heart from him. Riots, atrocities, and terrible disappointment followed. In 1525 the Peasants' Revolt (partly a bourgeois revolution), spreading in South-West and Central Germany, was suppressed – even though many territorial princes, including Friedrich the Wise, had been ready to yield, under the first shock, to the social demands – and more horror was the outcome. Luther had abandoned the peasants in disgust, and by that had proved himself a Christian reformer, but not a German revolutionary.

Anabaptism, a related movement, which tended to iconoclasm and a reform of life, swept through the Netherlands and Germany, and was persecuted in spite of its principle of non-violence. Anabaptism too went far beyond Luther's and even Zwingli's intentions. At Nuremberg in 1525, the humanist Denck, along with the 'three godless artists', was condemned for the repudiation of secular and ecclesiastical authority on mystical grounds. The leaders of a quiet, undemonstrative Christian practice such as Sebastian Franck and Kaspar Schwenckfeld spent their lives as fugitives. A very small number of groups survived, for instance the Bohemian Brethren and the followers of Menno Simons, who finally abandoned the Church for his Mennonites (1536). Anyone who attempted to establish the Kingdom of God on earth by violent means, like Thomas Müntzer at Mühlhausen in 1525 or the anabaptist fanatics at Münster in 1534–5, was suppressed by the princes and drowned in blood. Meanwhile the emperor's German troops stormed and sacked Rome in 1527 and murdered loose-living priests and their courtesans.

Thus in the end the German princes, whether they were loyal to the old faith or were drawn to Luther or Zwingli, were masters of the situation. Among them were Renaissance personalities such as Cardinal Albrecht of Mainz and Magdeburg (d. 1545), who had triggered off Luther's opposition by the sale of indulgences, and vacillated for many years between Rome and Reform; and Philipp the Generous of Hessen (1504–67), in whom a crushing, and actually extremely Lutheran sense of sin and brutal self-reproach was coupled strangely with cold political calculation. There were also faithful adherents of Luther, such as the Elector Johann of Saxony, Catholics like Duke Georg of Saxony, and the anti-Habsburg Duke Wilhelm IV of Bavaria. After the first twelve years of Charles's reign the political scene looked as if German disunion had simply seized on the Reform movement as a new apple of discord. It would have been impossible, and at times not even desirable, for either Charles or Ferdinand to crush the adherents of the new faith. Both Catholic and Protestant princes inevitably played into each other's hands whenever the interests of their own principalities were at stake. As far as religion was concerned, the Estates at the Diet of Speyer in 1526 were actually left free until a general Council should be formed. Charles, however, could not get the pope to summon a Council, and one after another of the princes used the delay to form 'state churches' which were to strengthen their position step by step. The reformed camp itself was disunited, since Philip had not been able to reconcile Luther and Zwingli at the Disputation of Marburg in 1529.

For in Zwingli, who was actually more spiritually akin to Erasmus than Luther was, a second Reformer had appeared at Zürich about 1518. He placed his faith in the natural goodness of man, who, reborn in Christ, is empowered thereby to take his part in the reshaping of the world. With supreme confidence in himself, Zwingli strove to combine an almost demythologized Christianity with political action. Thus in spite of his early death in 1531, he had created an enduring Reformed 'Church'. True, it could never quite take its place in the endeavours to reunite Western Christendom, which at times seemed to promise success. But to that end Zwingli's reform would only have been acceptable if it had never intended to overthrow the Church and the Empire. Luther never attacked the Empire and never meant to abandon the one and only Church; for him, the Church simply stood in need of reform. Zwinglianism, on the other hand, was so full of new ideas, that, however confused they might be at the moment, and however ready the movement was to make tactical concessions after Zwingli's death, it was so bound up with Swiss anti-Habsburg feelings that it rendered any religious and political union on a common basis impossible for the time to come. A large number of humanists had, in the long run, not stood by Luther. His common man's dislike of intellectualism, his orthodox creed of the *sola fides et sola gratia* were directly opposed to the humanist *via moderna*. As early as 1528 Erasmus noted that many a university had decayed under Luther's influence.

Thus the great storm had led to no final result. Critical observers could find no point which they could entirely approve. Nevertheless, to the outside world conditions in Germany were more or less stabilized after the Confession of Augsburg of 1530 and after the formation of the Schmalkalden League in 1531. Charles had to take refuge in negotiations. He carried them on till 1545, hampered again and again by his opposition to Rome, his wars with France, and his anti-Turkish enterprises in North Africa. Thus in the thirties a certain equilibrium in religious tendencies had been achieved. The 'superior minds' (Ranke) still seemed to determine the epoch. In religious disputations the relief of tension failed more often than it succeeded, and the effort was postponed from one Diet to the next. Urgent challenges of the day had to be met, particularly the question of imperial aid against the Turks, in which the loyal Lutherans, still faithful to the Empire, took their part. Luther was deeply disappointed by the turn affairs took. 'If I had known from the beginning what I have now heard and seen, namely that men bear this enmity to the Word of God, I would certainly have kept silence.'

In 1541, however, the religious disputations at the Regensburg Diet were carried on with a superior sense of the reality of the situation, so that a union of the faiths seemed within reach. Charles himself had summoned the participants, with Bucer and Melanchthon on the Reformed side. The Papal Legate, Contarini, a man of humanistic bent, sent to Rome a statement of the doctrine of justification which would probably have been acceptable by both sides. The emperor, in spite of all influences to the contrary, urged the cause of union and was successful in achieving a useful text. Politician and humanist as he was, he may have attached too much value to formulae. Calvin, on the Zwinglian wing, having fled from France and become the leader of Reform at Geneva, stiffened the Protestant side; the pope rejected the text of Regens-

burg, and both parties in the imperial Estates refused support. This was probably the most dramatic moment in the history of the Reformation, when the emperor, a sterner adherent of the old faith than anyone else, was more far-sighted than the theologians. They were quarrelling over intricate differences which few of their contemporaries understood. While the Church had shown an open mind on earlier occasions, the parties now sat in its ruins, rigid and unyielding.

By that time Charles's patience seems to have been exhausted. He had been the commander in a large number of campaigns, though none of them in Germany, where he was in any case forbidden to keep Spanish troops. As early as 1540 he had acted with great severity at Ghent after a tumult in 1537 in which the mob had refused to make the customary contribution to the national defence. In 1543 he undertood a rapid campaign and defeated the duke of Jülich, who, with Anglo-French assistance, had contested his hereditary right to the dukedom of Gelderland. It seems that Charles's policy, from that time on, became more and more Machiavellian. He now dreamed of power, since twenty years of peaceful activity had proved vain.

In questions of art, Charles was never as important as Maximilian. The mere fact that his imperial duties went far beyond Maximilian's made it difficult for him to become a patron of art in the Netherlands and in Germany. He had most of his building done in Spain, where his unfinished palace at Granada, standing in majestic frigidity among Moorish and a few Late Gothic buildings, proclaimed his bias to the classical world, yet rather to its Italian than to its Flemish or German form. The huge demands made on him, and the lack of a permanent residence, prevented him from promoting artistic enterprises, let alone planning them himself, as his grandfather had done. But his taste in finished works of art was sure, and among the international great artists in his territories he was able to grant his commissions to the best. Flemings, Germans, and Italians painted his portrait; Titian was awarded outstanding honours by him. He made no art collections, but left behind him at his death choice articles of practical use, and even certain things commissioned for his posthumous glory.

When Margaret died in 1530, patronage at the regent's court practically came to an end. Yet her successor, Charles's sister Mary, was a friend of Erasmus. She tolerated Protestants at her court, which she soon removed from Malines to Brussels. Thus, as there was no centre of active patronage of the arts, the princes, with Ferdinand at their head, divided the imperial role among them, a tendency which was to last throughout the century. Ferdinand continued what the old emperor had begun at Innsbruck. As a personal enterprise he began the Belvedere at Prague in 1535. He made collections. A small group of artists was in his service. In the Netherlands, however, no notable church was built between 1520 and 1560, and the same may be said of the rest of the Empire. Buildings were, of course, continued and finished, but few of them were Renaissance enterprises such as that of Cardinal Albrecht at Halle, who was the most outstanding patron of the age.[2]

In a general way the capitals of the several principalities slowly became centres of art. It is true that an artist at Antwerp, Leiden, Haarlem, or at Bruges, Strassburg, Augsburg, Nuremberg, and even Regensburg and Danzig (Gdańsk) could count on plenty

of commissions. But it was also worth while to settle at Brussels and Malines and enter the service of the court, or at Innsbruck, Munich, Landshut, Stuttgart, or even Celle, Wismar, and Neuburg. Protestant cities such as Bern, Basel, Lübeck, or Brunswick, which had lately been the centres of considerable activity in the arts, forfeited their standing. Places which had remained Catholic, like Mainz, or smaller centres like Freiburg, Münster, Osnabrück, often enclaves in Protestant territory, continued the art of the altarpiece. For the rest, princely castles were built, and a few fortresses, such as Hartenfels at Torgau, which Luther's last elector, Johann Friedrich (1503–54), had begun in 1532. Otherwise all that was left were town halls and the individual patronage of rich citizens, above all the Fuggers.[3] Private patronage on a smaller scale must also already have had a certain standing.

The great revolution of the epoch must, of course, have harassed the artists too. They were sometimes caught in the wheels of executions. Even if events did not upset the artists' convictions, they often led to inactivity, impoverishment,[4] a change of residence, or a total alteration of the commissions received. Holbein's life is the most obvious example, but it is not the only one. Yet there can be no question of a 'widespread death of the German artists'[5] after Dürer and Grünewald had died. What the time lacked was not great artists, but great commissions, whether in the old or the new sense; there was no community. Luther did not at all approve of the image-breaking by the fanatics and the Zwinglians, but he was indifferent to visual art.[6]

The individual enjoyed comparatively great freedom; the time was rich in unusual and original minds. At the end of this breathing-space, in 1543, the chief works of Copernicus and Vesalius appeared in print. Charles V saved Vesalius from the Inquisition. The foundation of the new, scientific vision of the universe was practically laid.

CHAPTER 17

PAINTING IN THE NETHERLANDS AND ON THE LOWER RHINE: 1: THE NORTHERN NETHERLANDS

Lucas van Leiden

IN 1522 Lucas van Leiden was registered member of the Lucas Guild of Antwerp, while still remaining a guildsman at Leiden.[1] But at that time he was no longer a mere artisan. Yet he was lucky enough not to become a court painter. He was spared a premature decline of the fire within him, and a wise adaptation to circumstances kept his art from petrifying. He remained the child prodigy. He can thus be called the first true artist in the Northern Netherlands. As a painter and engraver with a personal vision, he was also the first Dutchman in whose work drawing played a considerable part. He was a virtuoso fascinated by what was difficult, and he was versatile enough to adopt many ideas and to elaborate them on a higher plane. In particular, he owed a great deal to Dürer's graphic work.

In the summer of 1521 he met Dürer at Antwerp. The impact of this meeting is immediately recognizable in Lucas's portrait drawings of that year, especially in those at Leiden, Stockholm, and Weimar. They begin with the great portrait sheets which Dürer had raised to the status of independent works of art. Lucas's are, however, square or broad in shape; the head does not appear above a high pedestal, as it does in Dürer; hence it seems diminished, and more immediate, while the shoulders look stronger. The drawing seems to be clutching at the form with its outline. Yet even in these sheets there is a hint of the flooding light which Lucas, as a Dutchman, loved so much; it is not merely there to give greater distinctness to the object. The drawings are perfect and have all the virtues of the Brunswick self-portrait, enhanced, no doubt, by the meeting with Dürer. At the same time there is a touch of light-heartedness in the drawings. There is no feeling of being introduced into the sitter's personality, as there is in Dürer.

The mark of pictorial genius is on the portrait of a man of thirty-eight (London); the poise of the head is superb. The Virgin with Mary Magdalen and the Annunciation, remains of a diptych of 1522 (Munich), still show Dürer's influence. What had been gained in the portrait in London has turned, in these meticulously drawn paintings, into an almost cool detachment, satisfied with increased articulation. In Mary Magdalen's small head there is a continuation of the Early Mannerist proportions of the second decade of the century.

In this comparative vacuum of impersonality, Lucas's ultimate adoption of the new repertory of form and a partial redirection of his aims seem to have come to pass; in the new sense, his aims can now be called aesthetic. The new style can be seen in the Leiden triptych with the Last Judgement, commissioned in 1526 (Plate 158), and the Boston

canvas of 1527 of Moses striking the Rock (Plate 159). It is a post-classic Mannerism which, thanks to Dürer, Lucas could master without going to Italy himself; he drew mainly on Marcantonio Raimondi, while his graphic work took on fresh life from ideas suggested by Pierino del Vaga's and Rosso's Loves of the Gods; he was probably also stimulated by Gossaert. The Christ Child of the Virgin at Amsterdam is in Gossaert's manner; in its daring yet sensitive variations of blue it is an astonishing performance. But Lucas was able to enhance the theme still more in the splendid, almost pagan goddess at Oslo (Plate 160).

The picture of Moses does not narrate the event; the moment it shows is when the miracle is accomplished. The prophet cannot be identified at first glance. Very little running water can be seen. There are many people carrying jugs and jars, but there is little sign of the agonizing thirst that has to be quenched. It is a grandly composed group – a number of human beings among rocks, loosely assembled and gesticulating – which gives a credible representation of a tribe in its natural community and is set as naturally in the circumstances of its life as those in the genre pieces with which Lucas began. He is himself present in a self-portrait, a bit dwarfish in size but with an eloquent profile. The sonorous tempera surpasses Dürer's small pictures on canvas. There are a few choice intermediate colours; very delicate grey, violet, and olive tones side by side in Moses' robe bear witness to the new sense of colour, and in the general sculpturality of the groups there are flattened faces, stilted gestures, and elongated figures.

The great triptych with the Last Judgement (Leiden) seems to have been installed in 1527 after only a good year's work (Plate 158). At the top, the panels are cut into a bell shape for more than a third of their height. This was a masterly stroke by which Lucas achieved greater airiness. Here too he is more concerned with the results of the action than with the action itself. The figure of Christ appears at the top, reduced in perspective, whereas Provost, just before, had rendered it over-life-size, in medieval fashion. At this point Lucas was in agreement with Orley's altarpiece of 1525. The comparison, however, reveals the true master. A single landscape extends over all three panels, as Patinir sometimes did; in the centre the field of judgement is expanded by a few sickle-like lines into a blue-green wilderness, with the fires of hell to the right giving a splendid colour contrast. The resurrected stand in front in the most varied tones of soft orange, with angels and devils fighting for their bodies. Lucas worked economically, based everything on the effect of a few, mostly nude bodies painted with a master hand – the possibility of displaying a whole studio is exploited with gusto, but without playfulness. In his later years, his graphic art, for instance a Venus, Cupid, and Mars of 1530, presents the nude in eloquent pose, executed with virtuosity, but often in a very serious mood. In the triptych the forms are roundish, spherical, the gestures full of meaning, the figures thin and elongated, and treated summarily; they have none of Dürer's details to check the eye. This great work does not move the spectator by the terrors of the *Dies Irae*, nor does it carry him away by the power of its composition: it enchants him above all by the fluency of the painting, which is so thin that here and there the preliminary drawing shimmers through the top glazes. It is the work of a man who hardly knew what metaphysical needs were.

The altarpieces of the Dance round the Golden Calf (Amsterdam) and of the Healing of the Blind Man of Jericho (Leningrad) continue on the same lines. The latter is said to have been dated 1531, the former may have been painted before the Leiden triptych, but more probably later. In these works too the central scene is spread over the wings. The Dance round the Golden Calf, a bright country dance backed by dark woods and mountains, occupies the middle distance. In the foreground, large in size and in great detail, there is the daily bustle of the people's life. In both altarpieces more landscape appears than in the tempera canvas and the chiaroscuro is more marked; it is composed of bands of light, it places the accents and creates the mood of the picture. Occasionally the intense colours are iridescent. The splendid groups of trees are a late reversion to his father's style. The supporters of the armorial bearings on the outer sides of the Leningrad wings, with their fluttering cloaks, sleeves, and plumes and all the splendour of their heraldic costume, echo Lucas's Mannerism of the second decade, but are far more powerful in their physical presence.

Other Leiden Painters

Two of Lucas's teachers were also active at Leiden, his father, Hugo, who survived him, and Cornelis Engelbrechtsz., who died in 1533, the same year as Lucas. Hugo's late work has not yet been discovered. Cornelis's later work often flows almost indistinguishably into that of his collaborators.

These collaborators were for the most part his three sons.[2] The eldest, Pieter Cornelisz., known as Kunst, may be left out of account here; he was principally, or even exclusively, a draughtsman. Of the youngest, Lucas Cornelisz., born in 1495 and surnamed Kock, we know that he made water-colours on canvas, but they are lost. He may possibly be the painter of a group of pictures which were collected under the name of Jan Wellensz. de Cocq, who was registered master at Antwerp from 1503. They undoubtedly belong to the immediate successors of Cornelis Engelbrechtsz., and they fully correspond in style to the age of his sons. Their author, however, was more probably Cornelis Cornelisz., the brother who was born in 1493 and died in 1544, and was also surnamed Kunst.

With Cornelis Cornelisz. Kunst, to call him by that name, the Leiden style of the Engelbrechtsz. circle reached a curious climax. Though not so protean as Lucas (from whom many of his subjects were taken), not so sure in his first conception of the theme or so penetrating in the development of his versatile gifts, Cornelis Kunst had at times a greater wealth of ideas than Lucas, was more differentiated in his painting, often easier and more imaginative in his narrative, and actually more involved in the action he presented.

Never before, as in the picture at Körtlinghausen (Von Fürstenberg Collection), had St Christopher been shown so pitted against the water he wades through or in such tragic travail, nor had the Christ Child, sitting as a dead weight on his trailing cloak, with the glassy globe in his hands, ever seemed so unearthly. Cornelis painted the life and temptation of St Anthony several times, creating the demons out of his own

imagination and probably without reference to Bosch (e.g. Geneva, Musée d'Ariana). In the convincing manner of the South German landscapists he placed St Paul and St Anthony as hermits in a woodland wilderness (Vaduz). The fern and the tree, the bird bringing food and the owl, come home to us almost as much as the disputing saints. It is a warm-hearted idyll, delicate in its humour, comparable in that respect to a good deal of Hans Leu the younger's work, but more spirited as a whole. Another St Christopher landscape (formerly Munich, von Bissing Collection), seen more from a bird's-eye view, has less of Patinir's topographical precision; it was probably painted soon after 1520. Cornelis, unlike Patinir, filled the depths of his picture-space with alternating light and shade; he may have known Patinir's work. Cornelis always had something fresh to say. The usually small size of the pictures tells of the aesthetic delight of patron and artist.

The landscapes with Lot (Plate 164) and the Carrying of the Cross (Detroit and New Haven) are probably later works. In both, the eye is attuned to the theme by large figures on a height in the foreground; the wine-pouring daughter of Lot and the incestuous couple prepare the febrile mood of the blazing landscape, while in the Carrying of the Cross, where Christ can be seen in the midst of a throng in the middle distance, there are women and children looking over the embankment of the road to Calvary, where the Crucifixion seems to be already accomplished. One of the women, either one great with child or another with a baby at her breast, is probably the Virgin too; thus Christ's path through life moves into the depths of the landscape in three stages of recession. In any case these 'repoussoir' figures are set in meaningful relations. The wine-pouring daughter of Lot has a blue cap and ribbons and pink sleeves to her violet dress. In the clothing of the onlookers at Christ's Carrying of the Cross, iridescent tones are mingled in the choice shades of carmine with light green and blue with vermilion; in the middle distance slate-grey almost entirely subdues the local colouring, yet at the town gate, on the place beneath the Cross, pale vermilion and yellow reappear, and it is only in the vistas opening on the farthest landscape that bluish-green and light blue come in. It may have been this delicate colourist who painted the equestrian portrait of Charles V as St James of Compostela in 1535 (Worcester, Mass.), soon after the campaign in Tunisia.[3]

Another artist of this group, who may have also been a son of Engelbrechtsz., remains a shadowy figure. This is the painter of the Temptation of St Anthony of 1511 (Brussels). It reveals a fluent style based on bluish-green and light grey with beautiful nuances of light. The demons resemble those of Bosch's middle period, though the old artist at 's Hertogenbosch had by then ceased to paint them. It shows the extent to which imaginative spontaneity had been tamed that a classical male portrait, now at Castagnola, was probably part of this devotional image. This painter must have been important at Leiden beside Lucas, to whom his pictures were at one time ascribed.[4] He followed the lead of the Master of the St John altarpiece rather than Engelbrechtsz.; what could in addition be credibly ascribed to him on account of its colouring is the Sermon in a Church in the Rijksmuseum.

Aert Claesz., surnamed Aertgen van Leiden, was Engelbrechtsz.' youngest pupil. He

was born at Leiden in 1498 and died in 1564.[5] In all the uncertainty of Leiden production, his *œuvre* is the least clearly defined. The bonds between his work and Engelbrechtsz.' and Lucas's, and even to the Sermon in a Church, are vague. In the large study for an Esther triptych (Brunswick) there are traits of Scorel. The core of his early work is the several versions of the Nativity, two of them in Paris and Cologne (Plate 165). The scene is introduced by Joseph in a red cloak, seen from the back and half in shadow. For the source of all light is the Child, adored by angels and shepherds, and casting his light upon the blue robe and rounded face of the Madonna. A play of shadows rises up into the ruined Romanesque vault. The place where the Child lies seems enframed and sheltered by the curves of the vault and the main figures, who stand like posts. In their harmony and beauty these Nativities are not far removed from Lucas's manner.

The combination of the human figure and high, generally round-arched architecture is a fundamental motif of Aertgen's style. The Death of the Virgin (Düsseldorf) is seen in front of the rood-screen of a cathedral; the light plays through many openings with angels hovering in shadow and glory. The choir is painted in aerial perspective as if clouded in incense. The Apostles' robes flutter wildly. In many figures, and in the ideal architecture, there seems to be an echo of Altdorfer; indeed, it has been suggested that the panel was painted by a South German, Abraham Schöpfer. However, Aertgen's loveliest works are also inspired by a joy in flooding light which seems almost to devour the forms. That is the reason why he used so much white in his paintings. It occurs even in an open-air piece like the Raising of Lazarus (Amsterdam).

In 1558 he repeated this subject in very different form. The triptych now in the museum at La Fère is in his late style. He was never entirely original and now leans on Heemskerck. The spectacular gesture of the man restored to life, the dramatic movement of the onlookers, are contrasted with a repoussoir figure and the quiet, almost columnar figures of the saints.

Jan van Scorel

There is something majestic in Jan van Scorel's life and work.[6] He was born at Schoorl in 1495, and was the son of a priest. After his years of schooling at the grammar school at Alkmaar, he became a pupil of Cornelis Buys the elder and Jacob Cornelisz. at Amsterdam. In 1517 he visited Gossaert at Utrecht. In 1519 he set out on a six years' journey which took him to Strassburg, Basel, and to Dürer at Nuremberg, and then for a time to Carinthia and in 1520 to the Holy Land by way of Venice. He returned to Venice in 1521 and in the following year was summoned to Rome by Pope Hadrian VI, a fellow-citizen of Utrecht, who made him Conservator of the entire Belvedere in succession to Raphael. After his patron's death he returned to Utrecht in 1524 and not long after became a canon. Apart from a stay at Haarlem in 1527–8, he remained at Utrecht. Travels took him to Breda and Malines in 1532, and in 1540 to France, where he may have seen Fontainebleau. A good many of his enterprises did not serve the cause of art, but were undertaken for his Chapter, since he had ceased to regard himself as a professional artist, though he certainly took art very seriously. He already

signed himself as *pictorie artis amator* on the altarpiece in Carinthia. World-wide travels, antiquarian culture, connexions with princes and clerical rank – all these things combined to give him a new and superior status. It was unique at a time when artists began to choose between their duties as guildsmen and their obligations to the court. Thus in Scorel's later work there appears a streak of humanistic dilettantism; in 1543 he designed a rood-screen for O.L. Vrouwekerk at Utrecht; about the middle of the century he was engaged on dyke-building schemes. He died at Utrecht in 1562.

The altarpiece at Obervellach in Carinthia of 1520, commissioned by the Frangipani, reflects all the experiences of Netherlands art that the young artist had gathered, his training, possibly by the Master of Alkmaar and certainly by Oostsanen, and obviously his meeting with Dürer, reflected in the isolation of figures in groups against a background painted with the precision of Dürer's travel sketches. Then Scorel saw Venice. His picture with figures in a wide landscape, Tobias with the Angel of 1521 (private collection), recalls, like the picture of the Stigmatization of St Francis in the Pitti Palace, the work of Dosso Dossi, and shows the influence of Giorgione and his successors on the future landscapist. Portraits with interesting modelling and remarkable dignity have also been attributed to Basaiti and to an artist named 'Zuan Fiammengo' in Venice about 1516–24 (Stuttgart, Paris, Oldenburg, and Vaduz). They bear witness indeed to his response to Venetian portraiture, and particularly to Palma Vecchio. The impressions of the totally alien, of the Orient, may have taxed the Dutch painter beyond his powers. In any case, no pictures of that phase have come down to us. Yet a travel sketch of Bethlehem, obviously owing much to Dürer's feeling for *choses vues*, has been preserved, and later, certainly with the use of sketches made on the spot, topographically faithful views of the Holy Land often form part of the backgrounds to his pictures, for instance in the Entry of Christ into Jerusalem, which belongs to the Lochorst triptych (*c.* 1525–7, Utrecht; Plate 162).

Before that, however, he had spent about two years in Rome. For an artist whose studio was in the Vatican, and who had the chief works of Raphael and Michelangelo to hand, little direct echo of them can be felt. He was in no way submerged by them. It is perhaps only in the portrait of his pope (Louvain University) that he seems to have attempted to vie with Raphael's Roman successors. Individual motifs which he may have kept in mind – for instance the central motif of the great Lion Hunt woodcut,[7] taken from an Antique fragment – return later. A bright figure, sharply outlined on a dark ground, the Virgin as a Mediterranean peasant type, and in a general way a freer sense of style seem to have been the harvest of his Roman years.

In spite of this richer equipment, which Gossaert never had, Scorel remained on the whole an artist with a Netherlands view of things, possibly because he was the greater man. In the Lochorst triptych, Jesus and his disciples, a brightly coloured group in the foreground, see Jerusalem in the distance in a haze of light and air (Plate 162). Scorel intentionally made the diagonal of the hill in the foreground cover up the middle distance; he had a special feeling for Jerusalem and, as a pilgrim to Jerusalem, he could tell about it. It is quite legitimate for the bright-toned landscape almost to take priority over the figures. This is also the basic pattern of later pictures. Bathsheba in her Bath

(Amsterdam), in a pose as ingenious as if she were a piece of sculpture on a fountain, forms the foreground triangle against a wooded, dark green and brown middle distance, while the mountains, hatched in the distance, are covered with a cooler, light glaze. In the Presentation in the Temple (Vienna) the human figures look small against the classical architecture.

Virgins at rest, often in robes with the broad stripes familiar in Italy, appear in front of landscape vistas, sometimes with roses and flowers, in the early work done at Utrecht and Haarlem (Plate 163). They might almost be animated sculpture. The Child is long-limbed, and in his face there are features both of the infant and of Pan, just as the Virgins are Dutchwomen, yet at home under a southern, radiant sky. A fantastic boulder often serves as an exotic backdrop. It appears too in the Portrait of a Lady as Mary Magdalen (Rijksmuseum), of which there are several replicas; in the depths of the landscape the saint is elevated into the air, perhaps providing the gorgeous sitter with her justification and her hope. The figures alternate abruptly between light and dark, while the landscapes pass almost imperceptibly from green into cooler tones.

Then there are group-portraits: rows of pilgrims to Jerusalem from Utrecht and Haarlem, four panels painted between 1525 and c. 1535 (Utrecht and Haarlem Museums). They are probably intended as processions, yet after the leisurely fashion of the Dutchman, they lack vigorous movement, but are all the more pronounced as portraits. The canon of Utrecht far excelled his Amsterdam competitors, Dirk Jacobsz., the son of Oostsanen, his former fellow-pupil, and Cornelis Antonisz., whose activity extended from the first 'Doelenstukken' in 1529 and 1533 till after the middle of the century. This was the origin of the bourgeois portrait group.[8]

Scorel's portraits of individuals are probably the most precious of his works. He entered into the character of his sitter, and was independent in spirit himself and there-fore free of obsequiousness or breezy familiarity. Yet, conservative as he was, he retained till 1529 the round-topped panel which Gossaert had long since abandoned. The portrait which goes by the name of Simon Saenen (Rijksmuseum) is painted with the simplest of means, in a black cloak with brown fur on a wonderfully warm red-brown ground, with the cheek outlined upon it. In the same year Scorel painted his companion, Agatha van Schoonhoven (Rome, Doria Gallery), with all the freshness of affection and understanding. Another enchanting portrait is the warm-hearted effort to catch the being of the Schoolboy (1531, Rotterdam; Plate 168). On his fair hair he has a gleaming red cap. Scorel's portraits convey a feeling of unity between painter and sitter, especially when, as in this case, he is shown in semi-profile with the eyes looking frankly towards us.

Later, after the beginning of the thirties, his sitters keep more at a distance. A broader format makes room for the development of shoulders and elbows. The Carondelet (Brussels) seems, in his black suit, to be in armour; yet even here the equal spiritual status of the artist can be felt. On the other hand, immediacy may have increased under the influence of Vermeyen. From that time on Scorel often released his sitters from the established profile and gave them in the turn of the body a touch of transient movement

and spiritual freedom. The superb Portrait of a Man in Berlin is dappled with light and shade like the fur which the sitter wears.

Unlike Gossaert, Scorel came to take a long-sighted view of his figures, and in later years even of his portrait heads. He gave less prominence to localized colouring. Light, the portrait, and landscape were his all. Venice had given him more than Rome. Landscape makes a dramatic appearance in the greatness and terror of distance in his Baptism of Christ (Haarlem), in his Crucifixion (Detroit), and as late as 1542 in his St Sebastian (Rotterdam), a nut-brown Michelangelesque slave who stands in front of a landscape void of anything but ruins (Plate 167). In these pictures, as already in the Utrecht Lamentation, the movement and colouring of the figures are beautifully accompanied by the terrain behind them. By this time Scorel had abandoned any intentional contrast between figure and space which had formed part of his reminiscences of Rome.

Scorel's Mannerism, till then mainly developed out of his knowledge of classical art, was now enriched by a post-classical style in the figures. That can be seen in the St Sebastian. The Breda Holy Cross altarpiece of c. 1541 is based on the plunge into the depths formed by the almost over-modelled bodies of men bending over their work. He may actually have seen works by Rosso at Fontainebleau.

Scorel's late style can be seen in portraits such as that of Cornelis Aertsz. van der Dussen (Enschede), where the figure towers almost to the top of the picture-space, and in the triptych of Van der Stijpen van Duivelandt (c. 1550, Birmingham). In the triptych, the space left for the meeting of Christ the Gardener with Mary Magdalen is reduced to a small area in a delicately coloured landscape. Scorel, with the exception of Lucas the greatest painter in Holland in the first half of the sixteenth century, paved the way for the Mannerism of the mid century by his style and by his influence on his pupils. His most important successor was Heemskerck.

Marten van Heemskerck

Marten van Heemskerck, named after the village where he was born in 1498, came to Scorel as a journeyman at Haarlem in 1527–8,[9] after having passed through the hands of two Haarlem and Delft masters whose quality is unknown to us. Scorel, who was only a little his senior, may have passed on to him his impressions of Italy, which by then were clarified. Marten subsequently himself spent the years 1532 to 1535 in Rome. For the rest of his life he lived at Haarlem, where Mostaert was still active. He died in 1574.

Heemskerck's work begins at his prime, and his portraits of the Bicker couple (1529, Rijksmuseum) are not *juvenilia*. The prevailing colouring is not variegated, but splendidly coherent: the wife is in a green dress with reddish-brown sleeves and a black bodice, and appears before an orange-brown wall with a bright red stripe in her distaff (Plate 169), the husband in a suit of different shades of slate-grey, and there is added the greenish tone of oak and the dull yellow of some bone accessories. The wife's spinning-wheel, rendered with evident technical interest, and the husband's table are set diagonally. Behind the man there hangs a picture or a mirror with a profile portrait, and although

the perspective is impossible, these things create spatial relations and a psychological duplication. The same knack can be seen in the Family Group at Kassel. The space-creating table is full of dishes and crockery; this kind of still life gives gaiety to the parents and their jolly children. Both parents are grasped in a transient moment of action. Beside these pictures, Scorel's contemporary works, such as Agatha van Schoon-hoven, look like the products of some worthy old master.

Heemskerck's portrait of his father (1532, New York) is more conservative. Yet even this furrowed face aims, in its linearity, at an immediate sculptural impact. It was a fruitful year. With the subject of Judah and Tamar (Berlin, Schloss Grunewald), he boldly invaded the field of genre painting. The Dead Christ supported by Angels (Ghent) has strong contrasts of light and shade created by artificial lighting. Christ is dead, but lives on in the humiliation of the Man of Sorrows. The angels are super-natural beings who care for him, and they cast huge shadows. The sacrifice has long been accomplished, yet it continues to do its work and is fulfilled in the everyday present.

Finally, the picture of St Luke and the Virgin (Haarlem; Plate 170), was dedicated by Heemskerck to his Haarlem guild on his departure for Rome. The unusual quality of the work, the skilful choice of a low viewpoint, and the illusionism of the palette, which seems to stick out of the picture, have been greatly admired. Gossaert's pictures on the same subject derive from classical works only in form, but in Heemskerck this old Netherlands subject is brilliantly reanimated and saturated with humanistic ideas. The Virgin stands like a statue – thanks to Scorel. But her face is alive, isolated and lifted to another plane of reality, partly by the angel with the burning torch. There is self-conscious artistry in her counterfeit on the easel. The painter is less St Luke than a bespectacled expert inspired by the *furor poeticus* personified behind him,[10] while the saint rendered in relief on the painter's chair seems to be borne aloft by his ox. This intrinsically sculptural blend of several worlds is bathed in earthly, though strange, reality by the crass chiaroscuro of the artificial lighting.

Heemskerck's rather dry and conscientious antiquarianism in his Rome sketch-book, which served him for so long, cannot compare with the objective vehemence of Scorel's few travel-sketches. Heemskerck did not absorb immediately what he saw. In the long run, Michelangelo in particular must have moved him deeply, but his style seems to have been formed by Salviati, and Roman and Florentine post-classic painters such as Giulio Romano and Pontormo; this comes out very clearly in his voluminous graphic work. Venus and Cupid in Vulcan's Smithy (1536, Prague, Nostiz Collection) is rather stiff and marmoreal. Later his mythological pictures, for instance the enchant-ing Procession of Silenus (Vienna), are bursting with impulsive movement, freshly seen, adopted with facility and fulfilled in gaiety.

The huge altarpiece for Alkmaar of 1538–41, now in Linköping Cathedral, is exciting in its movement. Yet as a whole there is no loss of control; all is kept temperate. The distorted figure of the helpless victim is bound to the column of the Flagellation. The mocking adoration of Christ crowned with thorns is pictured by figures moving into the distance, then skipping back towards him. A stifling crowd of over-sculptured

bodies surrounds Christ, who is falling under the weight of the Cross. In the Crucifixion and Resurrection the surging mob and the stillness round Christ become the chief bearers of the statement. The Adoration of the Child by Angels and Shepherds is a true popular miracle.

Later, Heemskerck's style became simpler. It was his own spiritual development that seems to have led him to join in the Mannerism of the middle of the century. While the Baptism of Christ (Berlin), possibly dating from before 1532, shows the Baptist in an extremely complex pose, in the Brunswick picture of 1563 the gesture is Roman. In both pictures the forerunner of Christ stresses his obeisance, and in both the main figures are large and placed in the foreground in front of the crowd undressing or bathing. In his Mannerism, Heemskerck seldom made use of vicarious foreground figures. The Lamentations at Rotterdam and Delft, the latter dated 1566, illustrate the same trend away from strong modelling and crowding to greater freedom, which in this case meant more richness. If we are to believe Van Mander, he said at this time: 'If a painter is to flourish, he must avoid embellishment and architecture.'

In all this development the effects of recession, which had been achieved by Scorel, were not Heemskerck's most urgent challenge. For him, landscape was simply a medium of delicate, light backgrounds, later in beautiful harmony with the fine leathery colours of the figures, which by this time had abandoned their powerful modelling. Thus the Erythraean Sibyl of 1564 (Rijksmuseum; Plate 173) is enchantingly coloured in tones of pale yellow, gold, and blue and sits in front of a vista which recedes into the unreality of light grey and white.

Portraits of men, in their Renaissance dignity, look more aloof, or at any rate more proudly distant, than the Bicker couple were. Unlike Scorel, Heemskerck makes no attempt to be as worldly as his sitters, but serves them with works which his knowledge of the world makes possible. His choice colouring was a help in this undertaking. The Man holding a Globe (Rotterdam) is a very commanding presence against the slate-grey of the architectural background. Joannes Colmannus (1538, Rijksmuseum) is almost a grisaille, except for touches of red and the flesh tints.

The self-portrait of 1553 (Cambridge; Plate 171), is unparalleled in its force of portraiture. The sudden turn of the bearded head makes for spontaneity. There is a vitality here which holds nothing back. The ruins of the Colosseum, with the small figure of the artist himself in front of them, painted in a sonorous brown, is at the same time a grandiose *memento mori*. While St Luke paints the Virgin (Rennes), surrounded by statues which might be in the courtyard of a museum, we feel in the self-portrait the warm touch of life. Unlike Gossaert, both Scorel and Heemskerck, as Dutchmen, had a genuine feeling for the fragmentariness of classical ruins, for their picturesque values and their iconographical content. And a fantastic play between then and now, between the torso and the living body, fills Heemskerck's Bull Fight in the Amphitheatre (1552, Lille).

Marinus van Roymerswaele

With Marinus Claesz. van Roymerswaele we almost feel as if we were in the presence of an older generation, yet he was barely five years older than Scorel. A native of Zeeland, he was in 1509 apprenticed to Symon van Daele, an Antwerp stained-glass worker. His paintings are dated from 1521 to 1552. They do not seem to have been done at Antwerp, but in the provincial narrow-mindedness of the northern countryside. In 1567 Marinus took part in the image-breaking at Middelburg on Zeeland, and was punished and exiled. He seems to have died soon after. His chief impressions at Antwerp seem to have come from Massys' works, especially those of the second decade, and an echo of Dürer's St Jerome of 1521 also reached him.[11]

Marinus painted four variants of this saint in his study as a half-length figure, each existing in several versions. One of them (East Berlin) closely follows Dürer; the others depend on Marinus's own invention or on lost originals by Massys. The version in the Prado is dated 1521 (Plate 172). These pictures, probably intended for the studies of learned men, retain little of the Lutheran Christian humanist, as Dürer had envisaged St Jerome. For the most part they are broad in format, with quantities of writing materials and manuscripts, and show St Jerome brooding over a skull by an open illuminated Bible. The saint's robe is red against wainscoting in shaded tones of brown; the table cover is green. The peculiarity of the picture is in its composition and drawing. As early as 1521, Marinus showed the Father of the Church as a cramped, ascetic type with tense features, who seemed to be listening, indeed to be waiting for voices from within. Later the signs of bigotry, and also of derangement, increase. An outburst of fanaticism seems to be on the way.

Marinus's double portrait of the Money-Changer and his Wife (1538, Prado) certainly derives from Massys, but it is not a balanced contrast of greed and piety. The condemnation of worldly life seems to be on the point of becoming social criticism. In the Calling of St Matthew (Castagnola), it appears in Christian guise. In the two Tax-Collectors (London), however, the hatred of the greed of the agents of the tax-farmers and the government comes out as clearly as the fellow-feeling in the lawyers' chambers for the humiliated and offended, who will never get their rights from the arrogant pettifogger. The Munich Tax-Gatherer is obviously a portrait. There are several variants of most of these pictures, several of them by Marinus's own hand. In those revolutionary times they must have had considerable influence. They were certainly intended for government offices and lawyers' chambers as a warning, but whether they ever found their way there, considering their bitterness, is not known. To fall into an anachronism, there is actually something of the political poster in them. The topical criticism which portrayed wickedness as ugly had not cooled off into genre.

Marinus was a crotchety but a competent man. He was able to adopt Dürer's forms with some understanding. His paintings have something of the popular appeal of Dürer's woodcuts. They seem to have settled into formulae about 1520 – there is little else by him except Virgins and portraits – and developed towards linearity. His Tax-

O

Collectors wear fantastic wigs, which may be a caricature of the red tape of official costume. In their odd garb and their cramped, almost obsessed faces the artist's graphic sense runs riot. Strong colours, various shades of red, violet, and green, dominate the pictures. Marinus, when all is said and done, did not advance beyond the Late Gothic Mannerism which had been his starting-point.

CHAPTER 18

PAINTING IN THE NETHERLANDS AND ON THE LOWER RHINE: 2: THE SOUTHERN NETHERLANDS

AT the beginning of the century, when painters still changed their headquarters after having registered as masters, they moved from town to town, from guild to guild, and generally settled according to their own free will. In court service, however, artists were quite often unsettled, freer than the others, yet bound to their patrons, and they appear, as far as the general tone of their work can show, to have become less acclimatized to their new surroundings. What they had to say was more generalized and more detached; they had been torn up by the roots and had struck no new ones. That was not the immediate cause of the style they developed, but it was a contributing factor to it, that is, to post-classic Mannerism. Such is the position of Meit, Daucher, Sittow, Vermeyen, Holbein the younger, and the South German *conterfetters*.

Jan Gossaert

This also applies to Gossaert, now known as Mabuse, who had gone to the north.[1] Scorel is believed to have visited him at Utrecht and Lucas van Leiden at Middelburg in 1526. Dürer was there in 1520, but did not meet him; he saw the (now lost) high altar of the abbey, and does not appear to have appreciated it. But it is doubtful whether Dürer would have approved of Baldung's work about 1520. For Gossaert had become a Mannerist. He had continued his mythologies. Venus and Cupid (1521, Brussels) is a delicious piece of work (Plate 174). It is packed to the core with relations to the directions of the frame; the full-fleshed figure of Venus is set off by a soft play of asymmetrical motifs. One is reminded of small-scale sculpture after the manner of Meit. The Vanitas at Rovigo (Accademia dei Concordi) is unsurpassed in its revelation of slender, yet full contours; it has echoes of the Medici Venus and the long lines of Botticelli's profiles. The empty helmet is as macabre as the skull, the medieval symbol of Vanitas on the Carondelet diptych. Gossaert sums up in himself all the potentialities of the epoch, Humanism and Christianity, the Middle Ages and the Renaissance; his post-classic Mannerism is so imbued with Late Gothic elements that his works still appear northern and Netherlandish.

Biblical themes dominate, but their choice is characteristic. After 1520 Gossaert depicted the Fall seven times; of the four drawings, the one now at Providence has the dimensions and finish of a picture. He showed every attitude of temptation, hesitation, surrender, in gestures which are often laboured. We can feel that these works draw their vitality from personal feeling. There clings to the memory of Gossaert an odour of loose, maybe of dissipated living; that may have affected his work, but not the care

189

in its execution. And yet it is hardly possible that all these nudes were drawn from life; their intricate gestures go back in part to Raphael, Marcantonio, Michelangelo, the Antique figure of the youth with the Thorn in his Foot which Gossaert had drawn long before, and then again and yet again to Dürer and Baldung. That is true of every one of his works. In his pictures of the Fall the feeling of impulsive energy is that which Baldung had given to his woodcuts in 1511 and 1519.

In Gossaert's later style there is obviously renewed consideration of Dürer. His relationship at this time to the artist to whom he owed so much in his youth may be compared to Baldung's – a bond between two men who were almost of the same age, which also made it possible for Baldung at one time to take something from Mabuse.

While Gossaert was, almost from the outset, superior to Dürer in the sculptural intensity of his bodies, the individual borrowings, from the middle of the second decade at any rate, are made to become part of a thoroughly personal style. The crossing of the legs, the arm bent inward, the complicated pose of the recumbent Adam – such motifs made his own formulations unconventional and invested them with a strain of fresh vitality, while raising them to the level of mastery in imitation by the obviousness of their origins. These works spoke a very varied language with allusions and even quotation marks. The question of mannerist eclecticism in Gossaert is not one of poverty, but of brilliance and self-conscious artistry. There is genuine quotation, but there are also features which only appear to be such.

That also holds good of the Christian pictures. The wings of the altarpiece of 1521 (Toledo, Ohio), of which the Deposition in the Hermitage is the centre panel, show Gossaert in a renewed attempt to come to terms with architecture. It seems that he wished to support the open landscape of the centre by massive corner chapels into which perspective leads the eye. Orley did the same thing at the same time.

In the Virgins, the modelling of the Carondelet Virgin was increased. Here too, architectural details, whether round-topped blind niches or angular-moulded stone panels, reinforce the modelling to the point of exaggeration. It is stereoscopic painting. In the great Prado Virgin, probably painted at this time, the architectural motif is splendid (Plate 175). At the height of the faces of Mother and Child, an angular cornice curves away like an apse and gives a hint of a – secularized – halo round the sacred heads. Every form has its own eminently sculptural meaning, for example the bare breast of the Virgin against the full-fleshed body of the Child. A Virgin which was the portrait of the wife of Gossaert's last patron was often repeated.

For the most part his portraits are of sitters of rank. Count Floris of Egmond, probably dating from 1519 (Mauritshuis), is sensitively painted. White brocade opens on a mauve material with gold-lined slashes, and the head in its powerful, not strongly individualized form stands out from the cool violet ground; the roving gaze of the intense blue eyes gives the portrait all the vitality that a gentleman's self-command allows him. Increasing in delicacy and in richness, this series of portraits continues up to the late portrait of Baudouin of Burgundy (Berlin), and recalls the magnificent ornateness lavished on the portraits painted by the followers of Raphael and Sebastiano.

Very often in Virgins and in portraits, the moulded stone panel acts as a foil to the

sitter. In front of it the sitter, overlapping the frame, stands out boldly, a sculptural, actually unspatial object. Gossaert seldom made use of features of interiors, like Massys' shadows which include even those cast by the frame. Even the charming portrait of a Princess (London), which is mainly based on brownish red and green with metallic tones, has this generalizing character. The portrait of the children of Christian II (Hampton Court; Plate 176) was probably painted in the year of mourning after their mother's death in 1526. The clothes are black and white, the faces almost grisaille; the only colour is in the accessories. Childish liveliness is combined with precocious princeliness before the cold marble tablet in muted reddish-violet. This note of melancholy is remarkable in an artist who, unlike the congenial Baldung, always evaded expressions of feeling.

Joos van Cleve

In the twenties, the aged Massys was still active at Antwerp. So was Patinir, who died only about 1524. The Master of the Mansi Magdalen moved in the wake of Massys, with influences from engravings by Dürer and Marcantonio Raimondi. He had a predilection for outlining and accompanying his figures with the forms of the landscape, and, so to speak, enumerating the weights which make up the formal balance of his pictures. His late works – he was probably active in the twenties and thirties – are reminiscent of Baldung's generalized nudes of the twenties.

It was, however, Joos van Cleve who steadily moved into the position of Antwerp's leading painter.[2] He had the habit of repeating the compositions of his popular Virgins several times. His own inventive faculty, on the other hand, he applied for example to his Adorations of the Magi. The great Dresden Epiphany with St Luke and St Dominic, painted for Genoa, is a more skilful arrangement of the forward and backward movement of the figures. Yet even in this picture, with all its manifold forms – two patrons, the donor, the self-portrait of the artist in the middle distance, a phantasmagoria of ruined buildings, Jews in disputation – the essential theme is not swamped; the Virgin appears exactly in the middle of a round platform, and no harm is done if she appears exaggeratedly small beside Joseph; on the contrary, this admittedly groping application of the means of perspective sets her at a palpable remove from the bustle about her.

Joos profited more from Dürer's stay in the Netherlands than Massys had done; his St Jerome in his Study (Milan, private collection) harks back to Dürer's picture of 1521, painted at Antwerp. Yet Joos's painting lacks the density of observation of Dürer's and therefore does not give the same feeling of an achievement won by effort. He did not possess Dürer's profundity and universal validity. A good deal of feeling is lavished on small accessories. Joos's St Jerome is bald, small-headed, and naked. This sensitive type of saint is, in the last resort, akin to Massys'. He suffers, but his capacity for suffering does not go very deep. The sentimentality of this late composition goes far beyond anything that has come down to us from Massys.

But Dürer may have contributed to clarification in other ways. The Boston Crucifixion, one of the finest works of the time, shows restraint. It is the old group of three –

the Virgin, robed in many shades of blue, withdrawn in the stillness of grief; St John in blue and yellow in a melodramatically contorted pose, his red mantle fluttering like a long-held note; Christ, whom they mourn, hanging dead on the Cross, which stands behind them. The body is brown, the face and limbs are greenish, and deadness is emphasized still more by the loincloth, which is not grey, but of a warm violet tone in the shadows. In the absence of stress on the essential theme which was characteristic of Joos, he is smaller; some allusion to a bronze crucifix is consciously sought. The landscape is admittedly in the tone of Patinir, but it harmonizes wonderfully with the figures.

Yet Joos's prevailing manner is Mannerist. A Lucretia (Zürich) is dressed with a sophisticated elegance which both clothes her and leaves her naked. The centre is filled with a dreadful motionlessness. Her eyes narrowed, her lips parted, she drives the dagger beneath her breast in a luxurious abandonment to pain; she is a kind of counterpart to the penitent St Jerome. The real action lies in her feeling, not in the brutality of her suicide. The veil and the tassels of her sleeves swing as decoratively as the coifs of Urs Graf's courtesans, the skirt is gathered in a huge knot over her hips. Another type of Lucretia (Vienna and San Francisco) already bears the subtle marks of French court painting; the shadows of the pale blue sleeves shimmer in red. This picture must have been painted about 1535.

From about 1520 Joos seems to have approached the followers of Leonardo. He may even have gone south himself (for the second time?). There is no mention of him at Antwerp from 1528 to 1535. The great Lamentation altarpiece (Louvre) comes from S. Maria della Pace at Genoa; there is a Last Supper in the predella, freely inspired by Leonardo's; the lunette, quite unusual in the north, but already used by Joos for a Genoa altarpiece, has the Stigmatization of St Francis. He now renewed his first encounter with the south, whatever form that may have taken, by studying the works of Leonardo's successors, among others Luini. Yet he obviously came closest to the influence of the great Italian when he was at the court of François I, probably after 1530. Unlike Massys, his selection from Leonardo's multitudinousness was modest. The smile on the faces of his Virgins more than anything else tells of Milan influences.

The Virgin with the Carnation (Kansas City) is the most Italian of all his pictures. The various tones of blue in the Virgin's robe and the red surrounding the Child stand abruptly side by side, but there are intermediary tones of pale violet, light blue, and dull yellow. The Child appears in bold contrapposto. This is an important picture, yet, like the Genoa altarpiece, it hardly belongs to the north. But already earlier, in the Virgin now at Cambridge, Joos had made some part of Leonardo truly his own (Plate 177). The youthful features of the Virgin are, up to a point, painted with light. No other Northerner had been able to express in the half-closed eyes of the quietly smiling face – which is all the same on the brink of tears – the radiance of blessed and agonizing presentiment which pours over the Child sleeping on her bosom.

It seems that Joos was summoned to the French court as a portraitist. His portrait style, for which we have a definite, early date of 1508/9 in the portrait of the Emperor Maximilian, probably only attained a degree of personality which could stand com-

parison with the profound, high-bred, and pregnant style of Massys towards the end of the second decade. Joos often used strong shadows and shadows of the frame against his grounds, which are nearly always in monochrome. He was no psychologist, but a worthy portraitist of serious-minded bourgeois, men and women, or of the lesser nobility, in sharply outlined forms and in the early stages with a strain of the Gothic. Though he lacked the serenity of the true observer, he might be considered the successor to the Master of Frankfurt. The sensitive self-portrait of about 1520 (Castagnola) is also reserved in its expression of personality. The double portrait at Kassel is dated 1525 and 1526; for the first time there appear here broader figures pressed, as it were, into the picture-space, with headgear touching the upper edge; the volume of the bodies can be felt, and the clenched hands are quite exceptionally telling. There is a prevailing expression of tension and restraint in the pictures; they are far removed from the serenity of Massys' portraits and the noble bearing of Gossaert's.

It was only after a renewed contact with Italy that Joos was able to satisfy the taste of the court. François I (Philadelphia) is presented in a frontal pose which is emphasized by his costume (Plate 178); between the red table in front and the green ground, his small eyes look sidelong. The modelling of the face by shadows is very scanty, the hands are slightly swollen, as if they were independent objects. The cap is rather an ornamental curve than a spatial element. Thus the general effect is dominated by the greyish yellow of the doublet with its alternating silver and gold rings and whitish-pink and reddish-white lacings. Joos, who was hardly the actual designer of such lovely things, as Holbein might have been, had the painter's eye and the courage to give the king's ugly face its touch of demonic force. He was also by that time enough of a Mannerist to enjoy such a rigidly ornate front.

The portraits of Eleanor, the king's Habsburg–Netherlands wife (Hampton Court and Vienna), can hardly be regarded as companion pieces to the king's, yet they were also painted after 1530. There is the same contrast between the decorative plane of the breast with bushy, lavish sleeves bursting out of it and the closed contours of the hands and the delicate oval face. The movement, oval in its course, yet with frequent and capricious breaks, is played off against her aristocratic reserve. The flesh-tints are of shining enamel. Joos's Henry VIII (probably 1536, Hampton Court) is of the same kind. A comparison with more important portraits of this often-painted king shows Joos's fidelity to this subject, but it also shows how weak he was in psychological insight.

Some portraits of burghers have been ascribed to Joos's last years at Antwerp. The Old Man with the Bulbous Nose (Prado) is deeply expressive and felt with great sympathy; lights glide over his face, a new feature compared with Joos's simpler lighting in earlier portraits. Although the meaning of the gesture of the hands is not easy to grasp, they are speaking. There is an almost angry eloquence in the self-portrait(?) now at Windsor Castle, with its roving eyes and gesticulating hands, again probably without any deeper meaning. Those may simply have been studies in expression. For in the end, Joos, who had never indulged in experiment, experimented with his own face. This portrait can hardly have been painted before 1540/1, the year of his death. There still remains some doubt as to whether we are here not faced with a younger Antwerp painter.

The 'Antwerp Mannerists'

The main body of the so-called 'Antwerp Mannerists' flourished along with Joos, and perhaps not without his influence; from about 1515 on they worked for as long as he did.[3] In this group, which was very probably active at Antwerp itself, a plethora of hands have been distinguished and mostly styled 'master of so-and-so'. Adriaen van Overbeke's name is mentioned; a few works have been ascribed to Henneken de Beer; it is doubtful whether Gooswijn van der Weyden, who was alive in 1538, was still active that late. A 'pseudo-Bles' group and a Master of the Groote Adoration have been postulated; the Master of the Lübeck altarpiece of 1518 is also named the Master of the Abbey of Dilighem, after an altarpiece (Brussels) which was apparently commissioned by an abbot ruling there from 1537. The Master of the Antwerp Adoration who signed with the letter G, the Master of the Martyrdoms of St John, and the Master of the Solomon Triptych (The Hague) – all these names cover groups of paintings which cannot always be clearly distinguished from each other. There are, however, characteristic single works, among them one at Oberlin College, Ohio; it is dated 1525, and dates are rare in these paintings.

Like the contemporary wood-carvers, these painters represent the meeting of a waning, yet vital Late Gothic which was to endure for a long time with individual encounters with the southern world of form. Joos van Cleve's situation often recurs. There was plenty of recourse to Dürer, but details of Italian provenance were welcomed, and often set like precious stones in these Late Gothic altarpieces. Thus a huge baluster, which is is quite out of place, but is a significant allusion to the Flagellation, is the pillar of the ruined stable at Bethlehem, and is the detail which lends greatness to an Adoration of the Magi attributed to De Beer, now in the Musée de Cluny in Paris. The point here is not the breach of the architectural canon, but the force of the new combination.

The same applies to the elongated figures of the executioners in the 'pseudo-Bles's' St John the Baptist (Berlin), and still more to the scenes by the Master of the Martyrdoms of St John, works which are comparable to the strangely fantastic South German pictures of the time. The idiom is very often flickering and febrile, and cannot be measured by classical standards. The Late Gothic hankering after topicality in Christian history threatened to degenerate into something like foppishness.

Colouring, too, lost its balance. The Master of the Groote Adoration took his stand on Dürer in painting his Carrying of the Cross (Philadelphia), but his crowd is garbed in clashing colours which are quite unlike Dürer's; the man dragging Christ forward wears sulphur yellow, turquoise is set by the side of red, and the nobles stand out in choice, leathery tones; and these extremes often stand excitingly side by side, for instance, orange olive and lilac grey. 'Jan de Beer' loved chromatic gradations, as in the Cologne Adoration of the Child. In his Banquet in the House of Simon (Brussels), the Master of 1518 employed the old triad of the primary colours, yet he was able, by a subtle admixture of grey, to mitigate the formal incoherence of his architecture and the plunge into the background, so that the prevailing feeling is cool and noble. While in

this picture he was first and foremost a follower of Gossaert, he was already on the way to Orley's first, and not yet smoky colouring.

In Christian subjects these masters were preoccupied with a playful variability of the forms. The later works of the Master of 1518 certainly contain the large pointing figures in the foreground which Scorel employed. With all that, the old iconographical content was preserved and transformed; thus in a Mannerist Mount of Olives (Philadelphia), Death appears holding a great golden vessel containing the sponge with the vinegar for Christ Crucified.

Beside grandiose architectural fantasies, landscape in Patinir's manner was added poetically, and spread out peacefully, especially in scenes of happy content. Herry met de Bles was a successor of Patinir and was probably the same person as the Herry de Patinir who was registered master at Antwerp in 1535 and may have been a relative of Joachim's.[4] In his small figures he certainly owed less to the slowly transformed Late Gothic of the Mannerists than to Massys, whose figures were probably familiar to him in Hemessen's versions; he also interspersed these with Italianate forms. Herry was the most successful landscapist of the time, and certainly remained so to the middle of the century. He saw the world as high and mountainous, he gathered his observations indiscriminately and piled them up with virtuosity. Given the distances in his landscapes, the colours were not rich, like those of his forerunner, but often faded and occasionally tinged with grey. His pictures are often small in size, occasionally round and very crowded. They are rarely pure landscapes. Herry often set biblical events in the open air, but with no intention of making altarpieces out of them; they also lacked the intimacy and vigour of Cornelis Cornelisz.' sacred landscapes. He painted mythologies too, among them the enigmatic picture of the sleeping pedlar with the monkeys. Landscapes with mines, iron-forges, and forge-hammers told strange tales to the curious in a detached kind of way. The artist himself, who made no use of Joachim's basic horizontals, was himself a creator of a fantastic world, fascinated by the earthy diggings of the human ant-heap.

In 1531, immediately after Massys' death, his sons Jan and Cornelis were registered masters; the latter was a landscapist, but what work of theirs has come down to us belongs for the most part to the middle of the century.

In connexion with the Late Gothic Mannerist style in figure and landscape, the name of Dirk Vellert must be mentioned; he was registered master at Antwerp in 1511.[5] His engravings are dated between 1522 and 1544; his drawings are mostly designs for stained glass, since he was a stained-glass worker by trade. But at a time when painters were beginning to specialize in designs for stained glass, he did panel-paintings as well. His altarpiece of the Adoration of the Magi (Rotterdam) is traditional in its colouring and an extremely skilful and imaginative composition. In contrast to the vertical tendency of most Mannerists, his departures from perfect proportion tend to the horizontal. His stage is peopled with short, thick-set figures in lively movement, the profile of a king is broadened with the longing in his eyes, his Virgin's faces are flattened or, as Breu liked to see them, might have been turned on a lathe. In heads looking upward Vellert often displayed his skill in bold foreshortening.

Pieter Coecke van Aelst

Peter Coecke, born at Aelst in 1502, may have come under Vellert's influence while he was still quite young, yet he is believed to have actually been Orley's pupil.[6] In 1527 he is recorded as master in Antwerp. He seems to have visited Italy at the beginning of the thirties. In 1533 he went to Constantinople in connexion with the tapestry industry, and the visit is recorded in a series of vivid woodcuts. He may have taken part in the Tunis campaign of 1535 in the retinue of Charles V – even before that he bore the title of *pictor imperatoris*. In 1550 he died at Brussels, where he must have settled late in life, for in 1544 he was still living at Antwerp, and in 1549 he delivered or directed the decorations of that city for the state entry of Prince Philip; his illustrated book of the entry was published in 1550.

In a general way there is a close connexion between his art and printing. It was with the help of printing that Coecke became the tutor of his northern contemporaries. In 1539 he published a summary of Vitruvius's *Die Inventie der Colommen*, followed by Serlio's writings on architecture in Dutch, German, and French. His teaching was certainly directed against the Late Gothic strain which was very marked in what is known as 'Antwerp Mannerism' and laid the foundation for the academic Mannerism of the middle of the century. He seems to have been the first Flemish artist to have taken up strapwork and grotesques, which paved the way for the first Floris style. We may add that he worked as a designer for tapestries and stained glass, sometimes with Orley but generally as his rival, and that he exercised an influence on Antwerp sculpture of his time. Here then was an artist who was not spontaneously productive, but designed, directed, stimulated, and taught. In him – which was of great importance for the rest of the century – a new type split off from the painter pure and simple; a twig from Dürer's tree took on independent life in him, who lacked practically everything that Dürer had, above all, originality of thought and personality in execution.

For Coecke's own work, unlike Orley's, has no great weight. A good deal that he delivered was made by his assistants in his obviously large workshop – his wife Mayken Verhulst was an artist, and Willem Key, Pieter Bruegel, and Neufchatel passed through his hands. No picture by his own hand can be identified with certainty. Even the most famous, his Last Supper, a composition which goes back to 1527 at least, seems to be known only in a large number of replicas, which he had his workshop repeat till the end of his life.

This steadiness was probably not merely that of an entrepreneur; it betrays the teacher. What has once been pronounced good cannot be improved. This restraint set him apart from the delight in variety which was characteristic of most of the Late Gothic Mannerists then working at Antwerp. It actually looks as if a native of Brussels had invaded Antwerp, but Coecke was first and foremost an artist trained in Italy and was certainly rather younger than the other Mannerists.

The composition of the Last Supper shows that he had come to know Leonardo. In his search for distance, he pushed the table, which is set crosswise, into the middle dis-

tance and paved the way for his theme by still lifes of food in the foreground. The architecture is, as it were, built up step by step with some artifice. It has considerable sculpturality. Together with the group of the disciples it helps to concentrate the emphasis on the figure of Christ. An accent in volume, front right, finds its response, back left, in an open space leading into a back room. The figures perform a fluent action with intelligible and harmonious gestures. There is a hint of the mask in the broad-browed faces and their strongly rooted noses. We do not feel that we are present at an isolated event. Coecke was not attempting here to be a reporter, as he was in his Turkish woodcuts. The religious significance of the meal is expressed clearly in the stained-glass windows and the tondi on the wall, representing the Fall, Cain and Abel, David and Goliath. The comparison in Joseph and Potiphar's Wife goes back to Raphael's Loggie. Even the self-portrait of the artist with his wife (Zürich) shows something of the same trend to generalized form.

Jan Sanders van Hemessen

The real force of Antwerp painting in this generation is Jan Sanders van Hemessen.[7] He was the true heir to the Lombard type of picture elaborated in Massys' circle, especially to the genre pieces which received their imprint from Massys himself and were followed up by Roymerswaele in the north. Jan was already master in 1524. Until 1550 he seems to have lived at Antwerp, but later moved to Haarlem, probably on religious grounds. He is said to have died in 1566. His pictures are dated between 1531 and 1557. Jan probably visited Italy as a young man; there are traces in his work of influences of Michelangelo, of the Florentine High Renaissance, of Lodovico Mazzolino and Cosimo Tura. Hemessen's figures are far remote from the academic gauntness of Coecke's; in part he may owe the vigorous fullness of his figures to his study of Gossaert's work. But mainly his figures just tell of the vitality of the common Netherlands people which from that time on became hard to control. It found its first outburst in Hemessen's work.

True, early works, such as the Young Lady (almost a child) at the Clavichord (Worcester, Mass.), seem to have been painted under the spell of a desire for gentility. The dull sheen of the instrument and the general feeling of the room are caught in delicately muted orange and violet tones. The Child Money-Changer (Berlin) is given wholesome, full-fleshed forms. The dreamy but vigorous head in both pictures is distinguished from the many daintily refined imitations of busily-idle ladies or gaily bedizened Magdalens, which were popular at the time, especially as painted by the so-called Master of the Half-Length Female Figures.[8]

Hemessen's Virgins suckling the Child, for instance that of 1544 (Stockholm), are self-contained in a living and impregnable repose. Even his St Jeromes are not representations of emotional ascetics like those of Joos van Cleve, nor gaunt eccentrics like those of Roymerswaele, nor do they have the nocturnal face of the old man with the makings of a humanist in Dürer's Lisbon painting; they just show a vigorous type of human being, reflective but capable of outbursts of feeling.

Nil humanum is also the undertone of the genre pieces. The action often takes place in halls of a southern type, yet there is nothing to be seen but pedestals and the bases of columns in front of which merry companies or the adventures of the Prodigal Son are shown. It is as if the half-length genre piece of happy feasting had developed into a true scene, yet was unable to expand into full-length figures. Conceived at close quarters in the keen light of a small room, the bodies at the foreground edge of the Madrid Quack Doctor are crowded together in front of a free space; the figures do not seem to belong in the palatial hall which has just been placed at their disposal. Emphasized effects of light and shade give deep modelling to distinctly localized colours. The sweep of the gesture of the man pulling the woman and the tankard towards him in the picture of 1536 (Brussels), and the clumsy, reeling movements of the carousers, are magnificent. The figures look equal in age, and Massys' besotted old men only appear in subsidiary roles: in the cynicism of an old bawd, or in a dilapidated old drunkard. What really occupies the centre is the desire of the man for the robust Flemish woman. In all figures, the hands are the most expressive bearers of the narration. The painting of 1543 at Hartford (Plate 182) is crowded with counting, speaking, pointing, touching movements, with hands that grasp each other, with the greedy paws of dogs and cats; the man is gaunt, a creature of instinct, and is harassed by the fingers and faces of the girls bending backwards and forwards.

In the Karlsruhe picture, the *Temptatio* has been invested with spirituality and shorn of inessentials in its cool colours. It contains more danger and dignity than many a harassed St Anthony of contemporary painting. It is as if the man had become aware of an inward call; the great tone of Dürer's Declaration of Love (B93) first bore fruit here. We can understand why this picture was called The Prodigal Son. The same dramatic fullness is to be seen in Hemessen's Call of St Matthew.

In this way Hemessen was able to achieve a beautiful, popular heroine in his Judith (Chicago; Plate 183), as she re-enacts her deed in a final swing of the sword – but the blade is practically outside the picture. The general effect is fair, the light-skinned, red shimmer of the body beside the nut-brown head of Holofernes. This young woman, who only finds room in the picture-space by a complicated twist of her body, is warm-blooded and cool at the same time, her soft brown gaze entranced and unerring.

Towards the middle of the century, the influence of Michelangelo on Hemessen became particularly noticeable. The Christ in the Mocking scene (1544, Munich) is a three-quarter-length figure in a sea of raging and hideous masks of powerful sculptural effect. This sculpturality was already present in the Man of Sorrows of 1540 (Linz). In the same years he also painted versions of Raphael's Virgins. But that did not require a further visit to Italy. Like that of his more academic contemporaries, Hemessen's Mannerism at this time increased. His Italian experiences became more effective.

In his late years Hemessen also painted large, full-length figures. His style grew more agitated; the sculpturality remained, but the simple, full-fleshed forms were sacrificed. In its fluttering waves the drapery became more palpable. Christ bursts in upon the money-changers' benches like a tornado in the picture of 1556 (Nancy); the bodies and wares of the traders are scattered like jetsam. The hand of Tobias (1555, Louvre; Plate

181) is knowledgeable and visibly miracle-working, and the surrender of the blind father is a wonderful expression of faith. A humanistic idea – the new age gives sight to the old – is presented in this Old Testament story; the high classic repertory of form appears in Netherlands guise; could this possibly be an allusion to the Reformation too?

Hemessen was certainly responsible for the small-figured and often unedifying scenes in the backgrounds of his genre pieces; he 'maeckte groote beelden, en was in sommighe deelen seer net en curioos', as Van Mander says. Probably his daughter Katharina van Hemessen (b. 1527/8) lent a hand in them. This is the point of union between him and the so-called Brunswick Monogrammist who has been identified with Jan van Hemessen and who is more likely to have been Katharina than Jan Aertsz. van Amstel, the elder brother of Pieter Aertsen. There are some portraits signed by Katharina, for instance the pairs of portraits of men and women of 1549 (Brussels) and 1551 and 1552 (London) – gaunt figures, the head almost touching the top of the picture-space, with not much personal expression. Her chief work would be the Brunswick picture with the almost indecipherable monogram, the Parable of the Banquet, after St Luke, chapter 14. Like the Sacrifice of Abraham in the Louvre, the picture is painted in greater detail than many backgrounds of her father's. Sonorous colours dominate the foreground, and a huge block of architecture is in the middle distance, its brick walls tinged with slate grey. The background is worked out with care. It is full of rustic bustle and dominated by a cool green which looks more grave than light. This was followed by many-figured pictures, with the Entry into Jerusalem (Stuttgart), the Carrying of the Cross (Louvre) and the Crucifixion (Basel), all sensitively painted without any leaning to the miniature. A couple of lovers in the open air who have left the Kermesse (Brunswick), as Altdorfer once sketched it, parties in brothels, referring probably to the Sixth Commandment, are set down with the same unselfconscious delight in the natural and the crude as they are in old Hemessen's tavern and brothel scenes in the backgrounds of his large-figured riotous companies. He may have started out with these small-sized pictures, and his daughter specialized in them later.

Bernart van Orley

Until 1542 Bernart van Orley was active at Brussels and in the entourage of the court.[9] His Job altarpiece (1521, Brussels; Plate 180) displays the peculiar progress of the artist by way of proto-Baroque to a Mannerism based on a more intense appropriation of southern classical motifs. Signorelli's frescoes at Orvieto seem to have been known to him, though it is not certain whether he had actually seen them. He made use of engravings by Zoan Andrea, and Raphael's Ananias in the Sistine Tapestries has been turned into the dramatic figure of the Rich Man in Hell. Raphael's cartoons for the tapestries could be seen in a tapestry-workshop at Brussels from 1514 to 1519. Orley's meeting with Dürer in 1520/1,[10] to which he owed many a motif, can, however, hardly be brought together with the passionate idiom of the Job altarpiece. With inspired sureness, one figure is placed in the foreground of each of its panels, so that the significance

of the fundamental mood of the scene becomes clear at a glance. The events are not told like quiet stories.

In the Adoration, the Magi literally plunge forward, both in the painting and in the tapestry (Philadelphia and New York). The vigour of Orley's Mannerism lies in the grasp of a single viewpoint, which need not by any means be identical with the chief figure in the story. Yet in his Last Judgement (1518/19-25, Antwerp), Orley, unlike Provost and Lucas van Leiden, presents the multitude of those awaiting judgement without resting satisfied with the significant and representational figures in the foreground. The Holy Families of 1521 and 1522 (Louvre and Prado) are self-contained; there is knowledge of Raphael in them. The composition seems to hover on one grandiose movement; the figures look like fragments of garlands. The colouring is dominated by a smoky tone.

At that time Orley was more occupied with designing than with painting; a large number of tapestries, the best that the Brussels workshops produced in the twenties, must be ascribed to him. He was given commissions mainly for biblical subjects, but also for historical and contemporary events, the majority probably by the court; they were executed in splendid, richly allusive form, often with a border such as had been evolved by that time. These borders contained ornament, still life, and genre scenes. Orley also designed stained-glass windows for Sainte-Gudule in Brussels, to a commission from the regent. With all these jobs going on, a separation between invention and execution began to make itself felt. The same may be true already of Jan van Roome, who was probably, however, exclusively a designer and not an executant. Hence works based on his designs show little of a personal style. But Orley had become an artist in the new sense; he worked creatively in different media which he could hardly have mastered as a craftsman. There may have been a streak of the entrepreneur in him.

Yet it was not until the succeeding generation that the real breach came between conception and execution. About 1530 Orley painted the magnificent prophets in the triptych for Granvella (Besançon), and from about 1531 he worked on the gigantic Passion altarpiece in Notre Dame at Bruges, for Margaret's memorial chapel; he had, of course, assistants. Some of the panels are mighty in gesture, and the whole work effective in its light and shade and the intensity of its colouring. He left it unfinished when he died in 1542. But the antiquated method of production lingered on in Brussels. In 1522 the Güstrow altarpiece by Jan Borman the younger was installed; the paintings, in Orley's manner, were superior to the common run of export goods.

Malines and Bruges

Jan Vermeyen was born near Haarlem in 1500 and was probably an apprentice at Leiden and later Gossaert's pupil at Utrecht.[11] He was a friend of Scorel and seems to have owed a great deal to Scorel's style. About 1525 he was taken into the service of the Regent Margaret. He remained in Habsburg service after her death as court painter and art adviser. In 1534-5, when he was in Spain, he took part in Charles V's

campaign in Tunis and in 1545–8, commissioned by the Regent Mary of Austria, made cartoons with scenes of the campaign (Vienna). He died in 1559 in Brussels.

Vermeyen was the true master of the speaking likeness. He painted the prominent figures of the age of Charles, among them the emperor and his brother Ferdinand. The great men of the Malines court, Spaniards among them, look heavy, or almost coarse, with broad shoulders, great heads set for the most part on hardly visible necks, and generally in a frontal pose. The strong modelling of these busts and three-quarter-length figures was achieved by Scorel's chiaroscuro. Vermeyen went beyond Scorel in achieving a blood-warm, almost shocking presence of his sitters; the light often falls on the hands, which are always eloquent, and even in the portraits of the princes contribute to the dramatic effect. That may be Vermeyen's personal invention; Massys, as an old man, had tried his hand at it once, others, like Dirk Jacobsz., imitated it. The personalities so brilliantly revealed from a single point of characterization are at the same time elevated, so to speak, by being presented from a low viewpoint. They have more self-confidence than Scorel gave his sitters. Yet Vermeyen was able to make the spiritual quality of Carondelet and others, and the noblesse of the Habsburgs, stand out from the crowd of his eloquent sitters.

His devotional panels are generally crowded with figures in rather cramping frames, some of them illuminated in masterly fashion from below. They and his graphic work occasionally owe a great deal to Scorel. Judging from his wanderings in courtly circles, Vermeyen may be regarded as a master of Southern Netherlands painting, but hardly as belonging to a school of Malines.

The problem of Italy was approached from a very different angle by Vincent Sellaer of Gelderland. He worked from about 1522 to 1524 at Brescia as the assistant of Moretto, and later there is documentary evidence of his activity at Malines till 1544.[12] Although his style was saturated with North Italian art and was influenced by the Leonardo circle, his own art was not only personal, but retained a certain atmosphere of the north. The Holy Family, Jesus and the Children, Judith, Leda, Caritas, and Antiope – all these works have, in spite of their Italianate strain, a fresh naïvety, a northern lack of grace, and a feeling for children.

Finally the artistic requirements of the capital were served by two artists whom we only know by their graphic work. Firstly, Franz Crabbe van Espleghem, active at Malines from 1497 till his death in 1552; his early engravings show the dominating influence of Gossaert. Secondly, Nicolas Hogenberg of Munich, who was in court service at Malines from 1527/8 till his death in 1539.[13] He was probably the more gifted of the two, and it was he who was mainly responsible for the introduction of the South German etching technique in the north. He illustrated Apuleius in woodcut, and made a great series of etchings of the state entry of Charles V and Clement VII into Bologna and a remarkable cycle (after Orley) on the occasion of the death of the Regent Margaret.

Bruges still had its artists too. Besides Ysenbrant and Benson, both of whom are said to have been pupils of David,[14] there was Lancelot Blondeel, born in 1498, probably at Poperinghe, and registered master at Bruges in 1519, where he died in 1561. He seems to have incorporated the lively artistic spirit of Provost in the new generation.[15] His

relation to the fine arts was that of Orley and Coecke, though he was not so thorough as Orley and not so didactic as Coecke. He had greater facility. He introduced the southern repertory into Bruges. He collaborated with architects and sculptors, and provided them with sketches and designs. He was often commissioned for public decorations, and there is therefore in his Bruges altarpieces a touch of the generous manner of ephemeral creations; even in altarpieces he preferred painting on canvas. The Virgin with St Luke and St Egidius (1545, St Salvator), was made to serve as a church banner (Plate 179). The triptych with St Cosmas and St Damian (1523, St Jacob) shows the legends of the saints as small scenes set into, and as feigned reliefs applied to, an architecture which is a fantastic blend of Late Gothic and southern forms: it occupies most of the available space, but is so light and free that it is in no way oppressive. It was certainly Blondeel who inspired whatever is brilliant in Ysenbrant's architectures. Later, for instance in the banner and the scenes from the Life of the Virgin in Tournai (Doornik) Cathedral, the dominating feature is Renaissance architecture, though by that time it was already mixed with the beginnings of strapwork. In the same way as in a triumphal arch, the sacred stories are loosely attached to the powerful structure; the effect is sure and the decoration extremely adroit.

CHAPTER 19

PAINTING IN THE NETHERLANDS AND ON THE LOWER RHINE: 3: COLOGNE AND THE LOWER RHINE

WITH Bartel Bruyn the elder the protracted Middle Ages of Cologne painting came to an end. Bruyn, who was born in 1493, was a relative and presumably the heir of Jan Joest; he may have been his apprentice at Wesel or a journeyman at Haarlem. From 1512 to his death in 1555 he worked at Cologne.[1]

One of his earliest dated works is the Nativity of 1516 (Frankfurt), an appealing picture executed in tones of blue and red in a resonant combination. The Virgin and the angels are illuminated from below; as a night piece it is obviously the work of a pupil of Jan Joest. Borrowings from Joest can also be seen in the wings of the high altar of 1522–5 in Essen Minster. But here the outstanding element of his work comes to the fore, the dependence on Joos van Cleve, which continued until, at the time of the Xanten high altar of 1529–34, he succumbed to the Michelangelesque style of the Scorel group. In later works, such as the Crowning with Thorns (1538?) and the Carrying of the Cross (c. 1550–5) (both altarpieces at Nuremberg), his debt to Heemskerck becomes obvious. They are intricate, but very skilful arrangements of figures. The painting consists of areas of localized colour. The muscular male nudes are in a reddish-brown tone, with the landscape contrasting in improbable greens as in many of Joos van Cleve's later works. In Bruyn's Last Supper from the triptych belonging to the church of St Severin at Cologne (now Eastern Zone), Late Gothic drapery renders this second-hand connoisseur of Italian art great service; it bears the spiritual part of the action and gives Judas his character.

In the second quarter of the sixteenth century, the word painter (*Meelre*) died out on the Lower Rhine, and was replaced by the word *Conterfeiter*, i.e. maker of likenesses.[2] Bruyn too did his best work in portraits, and it is just at this point that Joos van Cleve's influence makes itself felt. Bruyn was actually the first to found an important school of portraiture at Cologne, where before there had only been sporadic beginnings. A number of excellent portraits of men and women, and occasionally also of children, issued from his workshop between the twenties and the fifties along with family groups, some of which found a place in the altarpieces. His observation was keen, his execution charming and unexaggerated, as befitted his bourgeois sitters. For the most part the figures are set against a blue or a green ground; a landscape vista, such as appears in the fine portrait of the black-and-red-garbed Burgomaster Arnold von Brauweiler (1535, Cologne; Plate 184), is rare. A male portrait of 1533 (Nuremberg) is exquisite in the colouring of the blue cloak with the orange-brown fur trimming. Once his subject led him into an extravaganza, in the portrait of a young woman (Nuremberg) with her breast bared; this is an Upper Italian type probably communicated through Joos. The

pinkish flesh tint, blended with fox fur, and a copper-coloured chair-back stand between the blue and green tones of the setting and the landscape vista. This portrait too is so gentle in its execution that the whole appears in the end neither courtly nor courtesan-like, and without any hint of daring.

Anton Woensam of Worms,[3] who died at Cologne in 1541, and Pierre des Mares[4] could not compete with Bruyn as painters. Woensam, however, deserves mention as a skilful designer for book illustration at Cologne. He left a large number of woodcuts, among them a view of the city, dated 1531. Jacob Binck, born about 1500 at Cologne,[5] did not remain there, but led a roving life in court service in the northern countries and in Prussia, where he died at Königsberg (Kaliningrad) about 1579. He left behind him portraits and a large *œuvre* of graphic art – sacred, mythological, and secular – mostly engravings which he made under the influence of the Beham brothers and also after Rosso Fiorentino. He was a notable sculptor too.

Jan Baegert was still working at Wesel. The apparently most highly gifted painter on the Lower Rhine, Jan Stephan van Kalkar, born in 1499, probably had his first training in the Northern Netherlands. From the middle of the thirties on he was working in Venice under the influence of Titian, and later at Naples until his death in 1546/50. That much of his life is known. It also seems certain that between 1538 and 1543 Jan Stephan illustrated Vesalius's Anatomy; thanks to his illustrations, too, Vesalius's great work became a worthy successor to Leonardo's. In particular, the woodcuts of the skeletons, though they are intended for teaching purposes, reproduce in large, even dramatic gestures, the movements of living beings. The deepest impression is not macabre, but a feeling for life which is as melancholy as it is rapturous. What Titian contributed to the work is not known.[6]

In the later sixteenth century, Jan Stephan was looked upon as a second Titian, and his work and Titian's were often confused. A clue may be seen in the portrait of Vesalius in the Anatomy. The best documented portrait is that of the Cologne Alderman Melchior von Brauweiler (1540, Louvre), a figure in choice and varied shades of black and grey, with very warm flesh-tints, picturesquely blended with its surroundings in the Venetian manner. A related group of Titianesque northern portraits, with the figures rather more isolated in space, must be ascribed to the Austrian Jakob Seisenegger, who worked partly in similar circumstances.

PAINTING IN NORTH GERMANY, UPPER SAXONY, AND THURINGIA

IT was still the rule in North-West Germany for artists to settle where they were born. Ludger tom Ring the elder was probably born in 1496 and died at Münster, which was presumably his native city, in 1547.[1] There has come down to us a memorial tablet by him of 1538 with the *Intercessio Christi et Mariae* and a reconstruction of a cycle of sibyls and Antique sages based on Southern Netherlands prototypes (both Münster Cathedral). The brushwork approximates to that of Jacob Cornelisz. Several family portraits are, with all their restraint of expression, his best work.

Heinrich Aldegrever, born at Paderborn, settled about 1527 at Soest, where he died about 1555/61.[2] As a painter he produced only a few portraits, which were very faithful in likeness, almost to the point of caricature. In engraving he was, apart from the school of Nuremberg, the most outstanding figure of the time. We can see ideas borrowed from Dürer, as well as from Rosso, Pollaiuolo, and Robetta; there was a give and take between him and Binck, and indirectly Aldegrever followed in the footsteps of Bartel Beham. His Old Testament genre pieces, his Antique heroes and heroines, his great portraits of Wilhelm of Cleves and of the two leaders of the Anabaptist movement at Münster, his solemn wedding-dancers, and his Antique ornament are, in their fluency and precision, among the best engravers' work in existence. His modishly costumed figures are long and slender, with small heads.

Lucas Cranach the Elder

In the interior of northern Germany, Lucas Cranach the elder[3] dominated the whole period. He was essentially an isolated figure, comparable to nobody. He was granted the privilege of armorial bearings early in life and later he attained wealth and civic dignities; from 1519 on he was several times member of the Municipal Council of Wittenberg, and between 1537 and 1545 was alternately burgomaster and alderman. From his contacts with Wittenberg professors he gained a certain erudition. He was an early adherent of Luther – in 1521 he secretly painted a portrait of the Reformer under the name of Junker Jörg – and became the real artist of the Reformation. In 1550–2 he followed his third ruler, Johann Friedrich the Magnanimous, into captivity at Augsburg, where he developed a voluminous activity, and to Innsbruck. In 1553 he died at an advanced age at Weimar.

Cranach lacked the persistent personal approach otherwise characteristic of his generation. He became a court artist at an early age and remained the head of a large workshop of the late medieval type. His output shows little change in quality; his workshop became an industrial enterprise delivering branded products, recognizable

by the signet of the snake with raised wings. In 1537 the wings were folded when Lucas's eldest son Hans, who occasionally signed with his monogram HC, died at Bologna. From that time on Lucas the elder seems to have directed and partly carried out the production with Lucas the younger, although it is difficult to distinguish his personal share. It is characteristic, however, that in this mass-production there are few copies, though large numbers of variants. Cranach had something new to say even for a twelfth Lucretia and a thirtieth Virgin. We must add the peculiar pregnancy and propagandist effect of the Cranach manner, which to a certain extent emulates the Lutheran pamphlet. He collaborated with eight woodcuts[4] in Melanchthon's Commentary on the Lord's Prayer of 1527, and finally produced certain formulae for Reformation altars, though his formulae failed for some time to find acceptance by others. As regards the portraits of the Reformers, Cranach had a kind of monopoly; even the much copied portrait of Luther on his death-bed was his work (Hannover; Plate 185), although the actual study for the portrait must have been made by some other artist who can hardly have been a member of the Cranach studio. As for portraits of princes, he made sketches, i.e. brush studies in gouache on tinted paper – some are preserved at Reims – and kept them with a view to replicas, and it is at times difficult to say which of them is the original painting. His own princes sat to him as a matter of course several times.

Thus the factory was not lacking a foundation in immediate observation. Cranach's portraits retained their immediacy to the end, and there are no studies of animals[5] as penetrating as his; after all, he accompanied many a princely hunt. Animals in Dürer have greater objectivity, but less feeling, while in Baldung there is rather a subjective enhancement of their animal urges.

From the end of the second decade, Cranach's formal repertory hardly changed, except in colour, which became more cool and glazed and lost its gaiety. Drawings such as the Judgement of Paris (R46) give insight into Cranach's later conception of the nude. In the male nude seen from behind (R45), an earlier work, the individual forms were certainly modelled with greater care, though without any artificiality in the construction; that was now given up. In that sketch, where, after all, what really mattered was the general grouping, the partial forms of the body outlines were drawn with verve, though the pen followed the main limbs into the interior contours. It is a loose assemblage of sculptural units.

This was the basis on which the sharp outlines of Cranach's paintings of Venus, Eve, and Lucretia were made. The result is a characteristic flow on the surface, but not structure and growth swelling from within; they are skin set into speaking contours, not truly articulated structure. The contours are filled with ivory, or even shimmering bluish white like enamel; a few modelling shadows are cast by one, or as a rule by several lights issuing from indefinite sources. The colour too seems to glide, without resting on details. It does not give the breath of the body nor the warmth and mass of the flesh; that is all hidden behind the glassy, miniature-like surface and treated with sensuous delight in, and an over-acute awareness of, the outlines of the subjects depicted. Often Cranach introduces fine, transparent veils in trickling folds. There is a dainty restraint in the gestures; they do not create a spatial field for the body, but often look

like calligraphic signs, for instance in the Three Graces (1535, Kansas City; Plate 189). Samson's Lion (Weimar) and St George's Dragon (Dessau) are almost heraldic. Cranach never attempted to paint a well-poised being at rest within itself, nor the springlike natural growth he had represented in his early years.

Figures are often placed against a dark, monochrome background. Nudes shown in the open air nearly always have a tree behind them, so that the outline and light colour of the body can stand out sharply against its dark foliage. Draped figures are also accompanied now and then by dark foils of some kind. These artifices disturb the sense of space. Where architecture appears, as it occasionally does, for instance in the portraits of Cardinal Albrecht as St Jerome of 1525 and 1526 (Darmstadt and Sarasota) – made after Dürer's engraving – it is confused by the way the frame cuts the scene and by the abrupt plunges of the perspective. Thus even his favourite woodland scenes, in spite of a number of gorge-like vistas into depth, are not rationalized, but for the most part merely the securing of a mood for a scene entirely enacted on a narrow stage in the foreground. Even the garden of the Golden Age (Oslo) and the Paradise (1530, Vienna) are shallow, though they are crowded with figures.

In many-figured scenes Cranach seldom found so clear a language as Baldung. Judith at the Table of Holofernes (1531, Gotha; Plate 188) needs the menacing figure at the left and the lance at the right to make it intelligible at all; the companion picture, The Death of Holofernes, is at once made intelligible by the same means. In the Banquet of Herod (1531, Uccle, Van Gelder Collection), Salome's dancing pose with the salver is duplicated by the page with the dish of fruit. There may in this even be an ironical allusion to the contrast within the story between the two characters. Cranach also mastered mass-scenes with similar means. The Overthrow of Pharaoh (1530, Munich), in spite of its miniature-like painting, is dominated by only a few types of forms: the whirling swarm of the drowning, the surge of the breakers, the grainy boulders on the shore, the rugged rocks. Occasionally Cranach found a special charm in reducing his narrative to a minimum. Bathsheba in her Bath (1526, Berlin) derives its appeal from concealment and silence, not from prying observation.

Some of these scenes approximate to genre. The theme of amorous intrigue, perhaps borrowed from Massys, generally sacrifices its tragic note to prettiness; there are, beside differences in age, differences in social standing, as for instance in the workshop picture of the Peasant in the Town (Darmstadt). With a dose of humorous charm, and without any attempt to inculcate a philosophy of life, the spectator is given an example of how not to behave. True, the contrast between the chubby youth and the eleventh-hour lust of the old man was very welcome to Mannerism. The repertory of physiognomics had not changed very much since the vigorous first decade. Cranach may have known Dürer's Christ among the Doctors of 1506, as appears from a caricature in the picture Christ and the Woman Taken in Adultery in the town hall at Kronach. The face of the dupe in the Mouth of Truth (1534, Nuremberg) is very personal; it is reminiscent of the atmosphere of the genre scenes of the Hemessen group. The Woman Taken in Adultery, like the Hercules in Women's Garb spinning beside Omphale (1532-7, in many versions), are play-acting, just as the courtesans with the amorous

old men are false in several strata of their being. The charm of the pictures resides in their allusiveness and indirectness, the play between grossness and daintiness. A small size was particularly suited to these subjects. Large size, however, somewhat after the fashion of pictorial maps, was chosen by Cranach for the Stag Hunts of 1529, 1544, and 1545 (Vienna and Madrid), which are narratives of important and, in part, past events in the history of court life.

Till the end of his working life Cranach painted religious scenes and devotional images. The old theme of the Man of Sorrows, for example, was also acceptable to the early Lutherans, and Cranach treated it frequently and significantly.[6] Further, there are new themes of Protestant theology, some of them very didactic,[7] such as the Way of Life (1529, Gotha and Prague), Christ with the Children in St Wenzel at Naumburg, with a version of 1538 at Hamburg, and finally the allegory of the Redemption (1555, Weimar, Stadtkirche) by Lucas the younger.

One of the most moving portraits Cranach ever painted is that of the Margrave Casimir (1522, Vienna). The careful etiquette of beard and costume is directly connected with the pathological melancholy of the face. In 1526 Cranach painted the portrait of the sons of Heinrich the Pious (Wolfsgarten Palace near Darmstadt), companion pieces in which the precocious face of Moritz (Plate 187) and the childish simplicity of Severin stand in striking contrast. In 1537 Cranach again painted Duke Heinrich, again life-size and full-length (Dresden). The immense, antiquated sword is both a weapon and an emblem, as well as a compositional means of steadying the somewhat insecure stance. Behind this great diagonal, crossed by the hilt, there stands the mighty cylinder of the figure, a Mannerist creation in the grand style. We can judge how far justice was done to this personality if we compare the portrait with the frigid colouring of Elector Johann Friedrich (Berlin; Plate 186; the picture was cut down later). The imperial sword again has this insignia quality, the diagonal is given again, but the man portrayed is utterly different. With all the etiquette, with all the effort to maintain distance that speaks from the picture, the elector's face with its dull, shrouded gaze is held in the picture-space as if he were afflicted with vertigo, and this reappears in all his portraits by Cranach.

Cranach's later Luther type is oddly wavering, as if 'assailed by temptation'. The gloved hands of Friedrich the Wise (1522, Gotha) lead a life of their own 'akin to the forms of entrails or deep-sea creatures'.[8] In the Portrait of a Girl (Louvre), the dark tone of the dress and ground almost merge, so that the strands of unbound hair stand out proudly and almost with a vegetable linearity. The figure of Cardinal Albrecht kneeling before the Crucifix (Munich) is almost ornamental in the swirl of its red drapery and white borders.

There is a number of portraits of young women, painted about 1530, in which the individuality of the features has been so submerged in the type that they have sometimes been believed to be ideal portraits. But they are not ideal in the classic sense; they are phantoms of personalities frozen into masks. Two portraits of women of 1534 (Lyon and Dresden) must come in here,[9] with their ornate and sophisticated dress, their slanting slits of eyes, their roguish features, the feline grace of their heads. And finally there is

the almost grotesque portrait of Caspar von Minckwitz (1543, Stuttgart), in which the soft parts are swollen up into almost misshapen convexities.

This work may have been executed by Lucas the younger. Just as Hans Cranach, the son, obviously adapted his style to his father's 'to the point of self-immolation',[10] the portraits and Protestant allegories of the studio of Cranach the elder passed steadily into the work of Lucas the younger, so that the transitions are hardly perceptible.

Georg Lemberger

The most gifted counterpart to Cranach in Central Germany at this time was probably Georg Lemberger.[11] Like Erhard Altdorfer, who was also active in the north then, he was a descendant of the Danube school by right of birth. He came from Landshut – possibly he was a relative of the sculptor Hans Leinberger – was active at Naumburg about 1520, and from 1522/3 at Leipzig, until he was banished as a Protestant in 1532. Later he probably worked till about 1540 at Magdeburg, especially in the illustration of Lutheran literature. His earliest known work is the pen-and-ink drawing of a Magdalen (1513, once at Rotterdam); and there is a woodcut of 1515 of three stiff, stumbling lansquenets. A Conversion of St Paul (Naumburg Cathedral) and a Battle with the Turks (Merseburg Cathedral), both in landscapes of the forelands of the Alps, are the work of a self-confident artist and are based on a few dominating colours, especially various shades of red. To the very end of his life Georg Lemberger's graphic talent remained firmly wedded to a feeling for ornamental effects and an irresistible freshness in the handling of the tools.

PAINTING IN AUSTRIA AND BAVARIA

Albrecht Altdorfer

AT the time of Charles V's coronation, Altdorfer,[1] then active at Regensburg, was about forty and had eighteen years to live. While the effervescence of his inventive faculties had settled, a certain coolness had supervened, due perhaps to the work for Maximilian. What remained with him till the end was his intuition, which was pre-rational in kind. What was still before him was a great new impetus.

The altarpiece at St Florian was followed by a St Florian cycle, now at Florence, Nuremberg, and in private ownership, and a Nativity of the Virgin (Munich). At the same time he produced, about 1520–3, nine landscape etchings, light to the point of transparency, and much more real and peaceful than the chiaroscuro drawings of his early years. Altdorfer painted two pure landscapes (Munich and London), and since Dürer's water-colours had not yet become public, he thus brought his own harvest home. The magic of maturity and the tempestuousness of growth were now united in Altdorfer. The tree in the Landscape with the Footbridge luxuriates in its own growth, the willow in the Rescue of St Florian's Body is huge in its spread. It is more difficult to decide what is the 'natural size' of a tree than that of a human being. Yet the fact that we concede to the tree, and approve of, an excess of growth which we would not allow human beings, may be a privilege due to northern landscape, but it is also, and no less, Altdorfer's wholly successful premise. Even in his later work the trees are springlike in their youthful exuberance. The foliage is a cloud of coloured flecks. In many cases mosses and hanging lichens stress the verticals of the gaunt larches. This kind of over-growth produces an effect of old age, of the autumnal, of the kind that Leu, in particular, had created at an earlier time. Altdorfer's love was given entirely to the sapling and the old tree, but not to the vigorous manhood of Dürer's trees.

He also painted ruins, probably in the thirties, for the Adoration of the Magi at Frankfurt, and his last Nativity, the great version in Berlin. Mosses, grasses, and bushes inhabit the Epiphany. But the Late Gothic Mannerist taste for ruins was past; what appealed to Altdorfer at this time was the sane architecture of the Augsburg school, which harmonizes better with the glittering gifts of the Magi. The purely painterly formation of the ruins in his early years was now abandoned in favour of a more linear style. Among these precipitous walls the people appear minute. It was the context of the picture that determined them. They could even be reduced to torsoes; this comes out very clearly in the Joachim in the Nativity of the Virgin (Munich), whose figure is cut sharply off by the lower edge of the picture. The face of Lot's daughter (1537, Vienna) is impersonally smooth, while that of Lot is exaggerated in its aged amorous-ness (Plate 194). The bodies are entwined, but they are built on the same pattern. There

is a similar crowding of forms in the entirely worldly and joyous murals (oil tempera on plaster) of the imperial bath at Regensburg (w112); they belong to the thirties.

Altdorfer often borrowed single figures; about 1518 he imitated a Byzantine *Hodegetria* in his Fair Virgin (Regensburg, St Johann), which Dürer had condemned as a *Gespenst wider die Heilig Geschrift*,[2] a spectre against the Holy Scriptures. The almost puppet-like Virgin at Budapest recalls works of the early fifteenth century. The Crucifixion surrounded by a mob, also at Budapest, rings like a quotation from a medieval pattern, while the ambience of the Crucifixion of 1526 (Nuremberg) echoes Wolf Huber's Crucifixion woodcut (B5). These things can hardly be attributed to a lack of formal power; they must be dictated by the need for a confirmation of the old forms at a moment when they had just become doubtful. The Virgin in the Angelic Glory, hovering above a landscape (Munich), is unique and entirely personal in its technique; its glowing power is a presage of the Battle of Alexander.

One of the small number of portraits by Altdorfer that is known to us is set off by a flowing curtain behind it; it is a slanting, spatially uninterpreted female figure (Castagnola) placed before a gradation of countless shades from green to black.

The Mannerist's relation to space was always weird. A completely unbuildable church houses the romantic Nativity of the Virgin at Munich (Plate 195); a dancing ring of angels combines this fragmentary and disparate architecture into an unreal whole. The crouching Magdalen of the Crucifixion in Berlin is a *repoussoir* figure, but she plunges us into the confused vortex of the crosses, which are placed without any architectonic intention. The Renaissance castle in the Susanna of 1526 (Munich) is as set and surrealistic as a fairy-tale.

Owing to the dissonance of the colour values, the architecture of the Frankfurt Epiphany almost fails to achieve unity. Within the area of a single theme, the colours diverge widely and approximate to those of other areas of meaning to which they are in any case dangerously close. That is a fundamental device of post-classic Mannerism, which Altdorfer mastered superbly.

We can see in the Battle of Alexander at Issus (1529, Munich; Plate 192)[3] how Altdorfer differed by temperament from the other artists, Burgkmair and Breu – not to speak of minor talents – who were commissioned by Wilhelm IV of Bavaria for the same series. Altdorfer alone had a sense of space, light, and form which enabled him to shape this almost unpaintable historical scene, in which men stake their all and the universe joins in. There is order in Altdorfer's picture, but it is not the classical order in three stages, which Burgkmair used for his Cannae, nor a teeming confusion like Breu's Zama. The pictures carried in Maximilian's Triumphal Chariot have here become the most superb battle-pieces that can be conceived. Altdorfer's battle rolls back and forth, but it is always intelligible. The high viewpoint removes the horror to a distance, the tassel of the pompous panel with the inscription of victory points straight to Alexander; it imposes order on the battle, as it were, parts the seething clouds, and separates Alexander's sun-realm from Darius's lunary region in the cool, darkening sky. For victory will fall to the army irradiated by the setting sun, and it is to the glory of that army that the shafts of the sun pierce the rolling clouds and make mountains and castles

flash. There can be no doubt of the ultimate victory in the close-knit wedges of the fighting groups; the generals can be recognized at the first glance by their tactical positions. Moreover, the cosmos seems to be taking part in the battle. Grünewald's stars and light had poured forth their eloquence on the death of Christ. The Battle of Alexander is entirely of this world, but in a sentimental, almost childlike fashion. Yet there is here a vision of the grandeur of history which even the almost humorous details cannot blur. The single figure is a mere drop in this ocean.

Wolf Huber

Of Wolf Huber's art[4] more has probably been lost than of other painters'; he lived till 1553. After the Life of the Virgin panels and the Feldkirch altarpiece, the conception of which belongs to the second decade, he produced at least two more altarpieces, two Passions, one a tall oblong and one broad, in and about 1525 (St Florian and Munich). The Elevation of the Cross (Vienna), painted on a pointed-arched panel, probably precedes both series. The goggle-eyed character studies of 1522 are a kind of preparation for the savage bustle of the executioners. The slant of the rising Cross gives the perspective opportunities for expressive distortions of form. Light blue, grey, and violet dominate the picture, with pale ochre and even salmon red here and there. There is a fiery gaudiness about the colouring against its twilit background. After 1550 Huber painted an Allegory of the Redemption (Vienna), a subject characteristic of its date. A study (H31) exists for a battle-piece perhaps designed for the Wilhelm IV series.

Huber had more talent and sureness in his portraits than Altdorfer. A chalk drawing of a man (1522, Basel, private collection) has all the more feeling for its subject because it is devoid of passion; it is a broad, ungainly head on a thick neck, with oddly flaring nostrils. Huber's painted portraits have architectural backgrounds after the Augsburg manner. Yet, in a fashion done more clearly by Cranach, he allowed landscape entry into the portrait of an architect (Strasbourg, destroyed), and introduced ruinous walls and the sky into pictures of two members of the Hundertpfundt family (1526, Dublin and Philadelphia). The brown of the walls, choicely composed of violet and umber, the stones jointed with powerful graphic effect, are contrasted with the lightly modelled faces.

Huber's portraits give the impression of occasional pieces in the best sense of the word. The two last, those of Jakob Ziegler (c. 1544–9, Vienna) and of Count Palatine Ottheinrich (?) (c. 1552–3, Merion, Penn., Barnes Foundation; Plate 196) can take their place among the most outstanding portraits of the middle of the century. Both are half-length figures, almost filling the width of the picture-space, high above a wide, open Danube landscape, so that the heads, and in the portrait of Ottheinrich the strong line of the nape of the neck, stand out in the upper half of the picture against the sky, which appears as moving air, as blue distance. In the Ziegler portrait it bears a huge inscription in Roman capitals, in that of Ottheinrich an astrological sign. These two portraits of a man of mind and a man of action are of unusual psychological penetration.

The most important part of Huber's mature work, however, consists of drawings. There are first of all three landscapes in water-colour and gouache of about 1522 (H6, 17, 22), and there is the wonderful pen-and-ink view of Feldkirch of 1523 (H25) (Plate 198). It is like an ode to the place, or even an ode to the tree in the foreground, which leads the spectator into the picture above the river, away over the town, and even up the mountainside into the radiant air – a feathered tree of fantasy, the heaviest thing in the drawing, and yet very light. In these works, and in the Danube Valley at Krems of 1529 (H8), and above all in the Old Willow of 1529 (H18), Huber's work is more melodious than Altdorfer's. The Old Willow is treated as ornament, but unlike Late Gothic ornament it presumes exact knowledge of the species of tree and beyond that conveys a good deal of the elemental power of a hollow giant of a tree. Thus Huber is far distant from Dürer. Later there came landscapes with a high viewpoint, looking down: the View of the Valley of about 1536 (H9) and the View from a Ravine of about 1552 (H26), the former with the homely spectacle of farmhouses and castles, the latter faithful in its rendering and yet, in a strange manner, almost geological; the rocks look doughy, as if they were still in a state of growth.

While Huber always remained definite in the location of his forms in space, towards the end he approached Altdorfer's kind of statements. Just as the Flagellation at St Florian takes place in the nave of a church which seems almost to curve owing to the perspective, just as the late portraits are enriched by the communication of distance which is difficult to estimate, the distance becomes reality in Huber's jagged mountain ridge in the great Alpine landscape of 1541 (H103 – copy?). The View of a Town with a Great Bridge of 1542 (H10) (Plate 193) is embedded in the limitless rolling of wind and water. This dramatic drawing is one of the earliest purely atmospheric creations, and if it is indeed by Huber, would represent his ultimate step in the art of landscape.

Other Painters

Huber had a retinue of followers along the Danube whose work it is difficult to distinguish. Augustin Hirschvogel (1503–53) and Hans Sebald Lautensack (1524–61/6), both actually natives of Nuremberg, probably based many of their etchings on Huber's drawings. In Bavaria too, many artists whose names are known, though they are not in the first rank, came under Huber's influence at one time or another.

Hans Muelich, who was born in Munich in 1516 and died there in 1573,[5] on the other hand, was certainly trained under the influence of his father Wolfgang, who is recorded at Munich from 1509 to 1541, and of Bartel Beham, but was probably a collaborator of Altdorfer's for a time before he went to Rome in 1541; on his return he settled in Munich. About 1536 he began with sacred pictures in the manner of Altdorfer and was often commissioned later for portraits by the House of Wittelsbach, but there is also a drawing of a cottage garden, an uncommissioned occasional piece, and there are book illuminations for the court.

The warm green, billowing curtains in the portraits of a couple of the Ligsalz family (1540 and 1542, Munich) are reminiscent of Altdorfer. The way in which this

dominating green melts into the ochre and sky-blue of the landscape vista behind the woman is great art; in the husband's portrait it plays into the warm brown of the fur. The figures are three-quarter length, the heads are placed higher in the picture-space than Huber used to do, the costumes are blackish, and it is only in her pink flesh-tones and the narrow red strip showing under his coat that the complementary colour makes a brief appearance. Another time, in the portrait of a Woman of Twenty-Seven (1541, Detroit), a choice violet-brown dress is fluently painted in front of a cool green curtain. Albrecht V of Bavaria (1545, Munich) is given a brown and black costume with reddish fur on a background of chequered olive-brown brocade, a morbid colour which makes its own contribution to the sickly, yet energetic face. But there is humour too in the portrait of a court jester (1545, Munich), which is rendered in various tones of red and brown. Finally, in the portrait of Wilhelm IV on his death-bed (1550, Munich, Bayerisches Nationalmuseum) the features are contorted in the death-agony; the left eye is peacefully closed, but the right eye open and revulsed. Muelich was unquestionably a very sincere and unerringly humane portraitist.

Similar work was done by Jakob Seisenegger[6] in Austria for Ferdinand I, whose court painter he became in 1531. He was born in 1505 and died at Linz in 1567. Apart from his journeys to the Diets, to Bologna, Madrid, and the Netherlands, he was mainly active in Vienna, where he had settled. In spite of some narrowness of his own sphere he was actually ennobled in 1558.

He may have started from the Kölderer workshop at Innsbruck, and from the style of the Swabian Hans Maler of Schwaz. He may also have become familiar with Amberger's style at Augsburg and Beham's portraiture at Munich. The portraits of a husband and wife of the Kleplat family (1536 and 1537, Innsbruck) give a general idea of the stylistic position of his bourgeois portraits.

While Muelich had naturalized forms of the Roman and Florentine portrait with an Upper Italian nuance in Munich, Seisenegger's court portraits have more of the air of the great world, not only because of the urbanity of his sitters, but also because the full-length figure, which had developed in Germany and had found its definitive expression in Cranach,[7] had become the official type of the Habsburg portrait. The supreme example of this type is the portrait on canvas of Charles V with his dog (Vienna), which is remarkably faithful in all its accessories. It served Titian for his picture in the Prado. Seisenegger had been prepared for this development by his early connexion with Pontormo, which comes out clearly in the extraordinary modelling of the Habsburg Princes of 1530 (The Hague), and by the resemblance of his colouring to Moretto and Titian, which occasionally causes difficulty in distinguishing his work from that of the Titianesque northerner Jan Stephan van Kalkar.[8] Seisenegger was outstanding in his characterization, i.e. in rendering the unapproachable regal dignity of his sitter; his attitude was one of devotion to his princes and to the pride of their nobles.

PAINTING AT AUGSBURG AND IN SWABIA

IN Swabia, Schaffner was still at work at Ulm, Strigel at Memmingen, Schäufelein at Nördlingen, and Ratgeb was also still alive. At Augsburg, now entirely the centre of artistic activity, Burgkmair, Breu, and Beck were still working. A few new figures appeared, although they did not oust their elders, as the younger generation of sculptors did.

Hans Weiditz the younger gave a new turn to book illustration. He was probably active in Burgkmair's workshop when Maximilian's epic deeds were illustrated.[1] Born before or about 1500, probably at Freiburg im Breisgau, presumably the son of the sculptor Hans Wydyz, he may have had his training at Strassburg, was active at Augsburg from 1518 to 1522, and later became master at Strassburg, where books illustrated by him appeared until 1536. He was probably identical with the Augsburg master who has been surnamed the Petrarch Master.

Paintings by him have come down to us. Pyrrho the Philosopher on a stormy sea, painted on parchment (Munich), shows his sense of colour; the ship delicately coloured grey in grey water, with the sailors finely rendered in variegated costumes. Three panels at Augsburg also show the cheerfully secular style of his narrative. But Weiditz's principal achievement is his diligent, yet grand work in book illustration. The series which goes under the name of the Petrarch Master amounts in itself to roughly seven hundred and forty woodcuts. His main work was a German edition of Petrarch's *De remediis utriusque fortunae*, published at Augsburg in 1532, one of the most widely read and studied books for a century. With Sebastian Brant as his adviser, Weiditz had finished his two hundred and fifty-one illustrations by about 1520. Soon afterwards he illustrated a translation of Cicero's *De officiis* which had only appeared in 1531, with sixty-four woodcuts. In the Petrarch illustrations we see Weiditz as an acute observer of the life of his time, which he satirized both in its urban and rustic forms. He was the first to render peasants as neither comical nor curious; he had instead a feeling for their simplicity and crudeness. He also possessed a genuine appreciation of craftsmen, artists, teachers, and men of learning, while he abhorred not only the nobility and the clergy, but their agents, the bailiffs and mercenaries. Thus he loosely attached many a sharp touch of satire to some casual expression in the text. It is in keeping with all this that Weiditz sympathized with the Anabaptist iconoclasts in 1529.

He was a born illustrator, and devoted himself to illustration much more than any of his contemporaries. Trained by Burgkmair in the never-ending varieties of composition, yet sober and faithful, he was an open-eyed reporter of the many, and even the smallest, things of this multifarious world. Though he had more suitable and exciting material than Maximilian's novels could provide, he had no bias to over-dramatization or any intention of professions of faith. He seldom made use of the work

of his predecessors, and his training was not Düreresque: his perspective is often faulty and he seldom managed a uniform lighting. But as a whole he had a great deal of Burgkmair's virtues, without sharing the Augsburg delight in ostentation; instead one detects a pinch of Upper Rhine acrimony.

Jörg Breu the younger, the son and pupil of Jörg the elder, born soon after 1510, died at Augsburg in 1547, registered master in 1534 after *Wanderjahre* which took him, among other places, to Venice, was not an outstanding artist.[2] Yet it has once been suggested that the Lucretia of 1528 (Munich) was his work and not his father's. His large canvas, The Widow in the Presence of the Emperor Trajan (New York), gives some idea of the pompous decoration of the Renaissance and perhaps of the murals, now vanished, of the South German cities.

Christoph Amberger, born about 1505, was probably trained under his father-in-law, Beck. In 1530 he was registered master. In 1548 he made the acquaintance of Titian, then at Augsburg. Amberger died at Augsburg in 1562.[3] In the portraits of 1539 of a woman and a man (Vienna), in those of a husband and wife of the Dettigkhofer family (1533, Stuttgart), and in the portrait of an unknown man (Birmingham, Barber Institute), Italian influences, probably imported by way of Palma Vecchio, can be seen side by side with the Augsburg manner. It is in a Mannerist portrait style of the German Renaissance. This comes out very clearly in the portrait of Charles V (*c*. 1532, Berlin; Plate 199), but it lies less in the composition than in the superb interpretation of the pale but masterful face, with the glassy shimmer of the eyeballs in the line of the profile. The grey-blue, cold background has a touch of the painterly airiness of other Amberger backgrounds; a soft shadow of the sitter falls on it.

The Christoph Fugger of 1541 (Munich) is a vigorous picture executed with novel means. Fugger, an active youth of twenty, stands in front of a grey wall and a silk curtain of intense, almost venomous turquoise blue which throws up the pink in the flesh-tints. Venice had exercised its influence yet again, obviously in the person of Paris Bordone. In the superb portrait of Christopher Baumgartner (1543, Vienna) and the Wittich portrait (1544, Brunswick), the form is harder and more expressive. The portrait of Sebastian Münzer (1552, Berlin) is in the last resort Augsburg Renaissance again. Amberger was on the way to abandoning European High Mannerism.

He showed the same conservatism when he followed Holbein the elder's example in his altar for Augsburg Cathedral of 1554, though he replaced Late Gothic by Renaissance architecture. Thus his preliminary studies for the bronze figures for the tomb of Maximilian of about 1548–50, in spite of their remoteness from its earlier phases, fitted perfectly into the whole.

Perhaps the most gifted portraitist of the time at Augsburg was Laux (Lucas) Furtenagel.[4] He was born at Augsburg in 1505, was apprenticed in 1515, joined Burgkmair, is documented at Halle from 1542 to 1546, and then returned to Augsburg. However, we know too little about him to give him his due place beside Amberger. His name is connected with two representations of Luther on his death-bed, of 1546: one is a pencil drawing (Berlin); the other may be the death-mask in the Marienkirche at Halle. His only well-known picture (1529(?), Vienna) is a portrait of Hans Burgkmair

and his wife. It is an unusually bold and suggestive picture; it shows an ailing man and his ageing wife after thirty years of marriage. Her hair is unbound and her dress reveals a little more than customary. Burgkmair's left hand is strangely eloquent; after the fashion of Late Gothic decorative accent, the fingers hold a hand-mirror like a piece of architecture, where – a rare form of the Vanitas motif at the time – both faces appear as death's heads. Within the uncharacteristic outline colour is set beside colour in an open weave. Both sitters look at the spectator aggressively with a hint of squint in the eyes.

There is yet another artist to be mentioned, Hans Maler of Ulm, who was active at Schwaz in the Tyrol.[5] It seems that only a brief span of his activity can be surveyed, from 1517 to about 1529; before that he had possibly been no more than an artisan, in the following of Strigel. The two portraits of Sebastian Andorffer (1517, New York and a private collection) are classically reposeful and painted in delicate brushwork. Though there is a distinct resemblance between them, they portray Andorffer both with and without a beard, once in a black and once in a red coat. This was the kind of superficial effect Hans Maler enjoyed. All the same, the juxtaposition of two sides of the man's nature can be seen in the antiquated yesterday and the stylish today. A somewhat flat type of Mannerism can be seen in the ornate Weltzer portraits of 1524 (Vienna, Akademie), in the exquisitely dressed Queen Anna (1525, Berlin), and in the Portrait of a Girl of the same date (Graz, private collection). The observation of the individual features now took second place. The faces, not very alive and occasionally a little morose, are rendered in a few sharply outlined forms. The small heads rise above the busts as smooth and glassy as enamel, and the patterns of the dress material and the jewellery swell the chorus. The decorative arrangement of the script on the monochrome background ties all the modelling down into the picture plane. The backgrounds are as a rule greenish, but some are cool blue; the colours of the clothing are strong, the costumes often black, with here and there a red cap.

The most gifted of non-Augsburg Swabians was probably the Master of Messkirch, surnamed after the altarpieces of about 1530–8 in the Stadtkirche at Messkirch (parts at Munich, Donaueschingen, and in private collections) which, by a rare privilege, he was able to provide with a uniform set of nine altarpieces, each with a scene from the Gospel in the middle and single saints on the wings. About 1532 he painted a series of frescoes in the choir of the Cistercian nunnery at Heiligkreuztal. He was one of the most brilliant and scintillating colourists of his time, as can be seen in the Falkenstein and Wildenstein altarpieces, the latter of 1536, both at Donaueschingen, and both more serene and more intimate than the Messkirch paintings. The Wildenstein Virgin, with the sun behind her, is enchanting, radiant with gold, reddish lilac, and yellow, the clouds in many tones of grey with a touch of Baldung's colouring. The master was probably born about 1500 in Franconia; he was a painter and also a designer for stained glass. He may have been trained in the Kulmbach circle and later with Schäufelein at Nördlingen; he was considerably influenced by Dürer and Baldung and was active at Messkirch from about 1530 on.[6]

Although he was a landscapist, his figures were often more vigorously modelled than Schäufelein's. Yet their proportions are Mannerist. A huge torso is surmounted by a

short bust and a small head. This type, which he had developed by the time of his first commissions, and on his own lines, remained his own throughout, in his sheltered life at a small, conservative court, except that iridescent colours increased in the course of time and that the beautiful panel of St Benedict, painted in 1538 or later (Stuttgart; Plate 207), is cooler in its colouring and shows a trend to the more muted late works. St Benedict is probably a likeness of the donor. Any influence from the great world outside may have come through graphic work alone. With the magnificent design for the framework of the Messkirch altar (Basel), the master turned back partly to Daniel Hopfer. Burgkmair's sheets also played their part. For the Renaissance architecture on the wings of the Wildenstein altar he plagiarized Sebald Beham's series of the Planets.

PAINTING IN SWITZERLAND AND ON THE UPPER AND MIDDLE RHINE

Hans Baldung Grien

BESIDE Cranach, Altdorfer, and Huber, Baldung carried from the age of Maximilian into the age of Charles V an art that was personal, significant, and self-contained. He was fully active for twenty-five years of the period and survived Holbein the younger.[1] A friend of humanists, appreciated by the high clergy, a member of the municipal council of the now Protestant city of Strassburg, he may have shown some indifference to religious questions.

Yet in several works he took his own personal part in the theme of the Eucharist, which was then preoccupying Protestant minds: a Virgin (Berlin) is accompanied by a boy carrying a bunch of grapes; another is in a vine-arbour (Strasbourg). In both the Child is asleep – the ancient allusion to the Corpus Christi. There is further a graceful Virgin with a standing Child holding bread in his hands (Vercelli). All these pictures have sacramental significance. Indeed the Nativity of 1539 (Karlsruhe) in which the livid body of Christ is supported by angels contains an allusion to the eucharistic allegory of the Pietà with Angels, a subject which Baldung had executed as a woodcut as a young man. It is part of the new transmutation of the Virgin theme that the Berlin Virgin, in Antique draperies, to a large extent nude and even without a halo, is not far removed from a representation of Caritas, a motif which made its first appearance in Baldung's free adaptation of a Gossaert Virgin with bared breast of 1530 (Nuremberg).

Back at Strassburg, Baldung had opened the period with two powerful altarpieces. One is the fairy-tale Nativity of 1520 (Munich), in which the monumental Romanesque ruins, however hollow they may be, bear heavily on the group and make anything like Altdorfer's folksong tone impossible. The other is an impressive Baptism of Christ (Frankfurt) which is entirely concentrated on the main group, while on both sides small angels hold up the draperies of Christ with folds which have something of the distortions of adults' clothing. On the threshold of Mannerism, Dürer's pupil was preoccupied with something like Dürer's problems of the interplay of forms. In woodcut, there is a huge St John the Baptist (B31) and a proto-Baroque series of apostles of 1519 (B7–18), almost Baldung's last sacred works. But quite late he created another spiritual subject in the Magdalen panel of 1539 (Darmstadt), where the saint's robe is entirely in the style of Grünewald. The Nativity of the same year (Karlsruhe) has been cut down all round, yet it seems that from the outset no figure was represented full-length, except for the Child. The large forms of the parents' heads and the upper parts of the angels' bodies advance from the velvet dusk and look like gestures stretching out into the picture-space. This too was taken from Grünewald.

On the whole, however, spiritual themes lose their pre-eminence. The mood of latent pre-Reformation[2] and the still unexhausted modernism of Baldung's early art came to the fore, even in the more occasional portraits which now appeared, for instance the masterful Morsperg of 1525 (Stuttgart), compelling in the abnormal direction of its gaze, and also the portrait of Adelberg III von Bärenfels, with the dark contorted face (1526, Basel), the portrait of a narrow-eyed lady or courtesan of 1530 (Castagnola), with her clear, enamelled skin, probably related to a Judith by Cranach, the black-costumed Georg I zu Erbach of 1533, with the roving yet uncertain look in the eyeballs, or that of Canon Ambrosius Volmar Keller of 1538 (Strasbourg), with his earthy, mixed colours and his melancholy features placed in front of a gloomy landscape. Portrait woodcuts appeared every now and again in books, among them, in 1521, a mighty Luther in the guise of a monk, with a halo, and blessed by the Dove. Baldung's real strength came out in the portrayal of conflicting characters. The painting of a twenty-nine-year-old man (1526, Nuremberg; Plate 197) has light-brown flesh tones and warm grey clothing on a turquoise-blue ground. The portraitist kept in balance the betrayals and the concealments of a shifty but powerful temperament. The form, which is grasped in its general convexity, lies like a mask round the dissembling eyes. The left hand looks self-conscious, as if its secrets had become audible.

But other works could claim precedence over the altarpieces and the portraits. From c. 1524/5 dates a series of nudes which bear the imprint of the Renaissance: Adam and Eve (Budapest), Venus (Otterlo), Judith with the Head of Holofernes (Nuremberg). Apparently they were originally companion pieces. The contours stand out clear against a black ground, but the centre of interest is not, as in Dürer, the clear structure, the articulation, but the organic unity of the bodies, in the breathing skin, in the fluent lines of powerful, yet steeply proportioned bodies with small heads. Baldung's nudes now became not only life-size, but also monumental. The general tonality of the Judith panel is nut-colour, with Holofernes' head red-brown; her hair is the colour of brass, the knife bluish, like the cloth. The Old Testament heroine, her face a mask, plotting cruelty, her thighs demonstratively decorously crossed, Venus displaying herself generously, Adam coppery with tousled hair growing into Pan's horns, Eve with unchastely veiled look. It is a theme which is as full of joy in life as Gossaert's mythological lovers of 1516 and 1517. If this represents a reaction to Dürer,[3] it was a reaction in terms of Early Mannerism, and if we look at Dürer's Lucrece of 1518, Baldung was the better painter. It is, however, uncertain whether a recent meeting had actually taken place. We can see no trace of anything Baldung could not have known before Dürer's second visit to Italy. The proportions of the bodies do not keep to the rules of Dürer's book. Yet ideas in the book could have been communicated to Baldung in advance and may have had an influence on the way in which he constructed his figures. If so, Dürer's detached way of explaining may have appealed to Baldung's coolness.

Two allegorical female figures of 1529 (Munich) probably belonged to a series of temperaments: a melancholy Prudence and a phlegmatic Music.[4] The almost black ground on which the figures stand out in the self-sufficing idiom of their outlines, with Prudence pale and a little bluish, is characterized as the interior of a wood with

occasional, sudden vistas on to a clear white landscape. Melancholy has as her attributes a silver-grey slow-worm[5] and a greenish mirror, while Phlegma has a yellowish, sleeping cat and a viola.

The fact that the Three Graces and the Ages of Life (Prado) are companion panels has not yet found a fully satisfying interpretation. In the latter may be represented earthly life, with its need of redemption; in the former heavenly life, merely menaced by the serpent in the tree and the goose being strangled by the innocent boy (symbols of temptation and death). The former shows Elysian, muse-like figures, and for that reason wrongly bears the name Harmony. The bodies are silver-grey with grey shadows, the fine draperies ochreish-white or reddish-black, and even in the trees and the dark shoots of the bushes there are no medium tones. In the deep blue sky, there is a whitish-yellow disc edged with orange-red – the sun. The companion panel is also in this spiritualized late style, and there the meaning of the allegory is clear. From the child sleeping on the ground a line of age rises past the weeping young woman to the grim-faced old crone who seems to be exposing the young woman and is, in her turn, being led away by death. Yet death's power is limited; for the child is sleeping trustfully on the point of his breaking lance. The landscape has died away into the icy grey and olive tones of winter, though a flower is blooming by the boy's side: a dead tree-trunk stands rigid in olive and grey, covered with hanging mosses and repulsive fungi. Baldung was still the greatest German colourist. In the distance a diminutive army can be seen on the march, then come scenes of hell countered from the height of the pale grey winter sky by the Crucifix and the dove in the mandorla. In this picture Baldung has rounded out and matured the significance of the death-scenes of his early years, and a particular sympathy can be felt both in the humanistic allegory of innocence and in the way in which Christianity as well as vitalism take part in the rendering of earthly life in original sin. In 1544 Baldung once again painted the Seven Ages of Woman (Leipzig) in nudes with warm flesh tones accompanied by primary colours (Plate 202). The procession of women winds up to the vine which offers a higher life.

Five pictures of Antique legend and history of 1530–1 have come down to us: Marcus Curtius (Weimar), Lucretia (Poznań), Hercules and Antaeus (Wrocław; Breslau), Mucius Scaevola (Dresden), and Pyramus and Thisbe (Berlin; Plate 190) – obviously parts of a series painted for a patron with humanistic tastes. An engraving of Robetta's has evidently been used for the Mucius Scaevola. The hero stands turning his blackening hand aside; he faces the seated, lifeless body with the wounded neck – the epitome of death. It is a scene of life in a battle camp in extraordinarily bright colours. The other panels are equally intense in their colouring, though they are more self-contained. Pyramus and Thisbe is a night-piece, deep blue, like a jewel flashing in the moonlight.

In 1531 Baldung painted a more vivid version of Hercules and Antaeus (Kassel; Plate 191). Abandoning all the accessories, he rendered the mortal struggle of two bodies against a black ground on red-brown earth. The murderous tension of Hercules' muscles, which mounts to his wrinkled nose and his concentrated eyes, is doubly underlined by the projecting paw of the lion's hide and the empty eye-sockets of the lion's head. With his red-brown body he raises the pale ochre-grey Antaeus from his

mother earth. Antaeus is nearly dead, his eyes are revulsed, his muscles slack, his foot cramped in pain, his veins swollen, his ears bleeding, his tongue violet-red. It is a tragedy entirely of this world and without godliness.

In the same way the woodcut of the drunken, sleeping Bacchus with putti (B45), made in the twenties, shows a most earthly and grossly mocked figure of a god. The most important woodcuts of Baldung's later life are the three sheets of 1534, with horses running wild in the wood (B56–8). Baldung went farther than Dürer's studies and constructions by allowing animal scenes full independence. He must have been most deeply attracted by horses. He had already rendered them in paintings and drawings (K51, 131) in all their sensitiveness, their spectral entrance on the scene, their raging, elemental power. But at this time they became the sole subjects of a series of woodcuts in their fights and the lusts of their matings; the theme was probably 'the passion and bitterness of creaturely love'.[6] Yet in the startled and dazed scattering of the herd, in the inevitable struggle between the instinct-driven stallions, there is an inkling of animal psychology. The same questioning, the same inexplicably unsolved mystery is present in the woodcut of the spellbound stable lad of 1544 (P76). Baldung had placed the unbridled horse – it is uncertain whether it will shy in panic from some fire or danger, or has already done so – in an uncanny relationship to a witch swinging a torch and a man lying fainting on the stable pitchfork – which might also be used for the journey to the witches' sabbath. His face is seen crassly from below, so that the eyeballs enter into the outline like balls of glass. It is possible that this is an allegory of untamed lust, but the coherence is not quite logical, and its effect is as compelling as a dream; it is something which concerned the master himself, whose escutcheon with the leaping unicorn also appears. These are unpainted animal pictures of genuine genius.

There are also pictures of human beings under the goad of instinct – a painting of Lot (Berlin) and ill-matched couples of 1527 and 1528 (Liverpool and Karlsruhe) – and the witch theme has been transferred from the engraving for some amateurs to a painting of 1523 at Frankfurt, the most dazzling performance Baldung ever achieved (Plate 201). The background is a blazing hoarding in a gamut of colour beginning with pale yellow and passing by way of sulphur-colour to orange, with red-brown and smoky-brown intermediate tones. In front there are two witches, one slender and standing, the other stout and seated on a grey goat, holding up a blackish glass vessel with a red seal. A brownish boy has a huge, flaming torch in his hand. The ground is covered with deep green growth. The vehemence of the elements is reflected in the pale, yet very substantial bodies; the women are under the spell of the enchantment, yet they are its owners and masters. This is quite a different thing from Oostsanen's Witch of Endor of 1526. The colouring is incomparable. There is no blue or violet at all; the other colours are graded chromatically, since at that time Baldung had, for the most part, abandoned complementary for contrasting colours, and graded shades for iridescent tones which offer no possibility of *vergleichen*, i.e. of resulting in balance, as Dürer required; for Dürer would not have painted even shot silk iridescently. Dürer, who sold 'Grün-hansen's', i.e. Hans Baldung Grien's, prints along with his own at Antwerp, would certainly not have approved of his master-pupil's Mannerist colouring, and he might

have disliked his elongated or thick-set figures, the glassy clarity of his rendering, and the coolness coupled with heat in Baldung's climate. Yet Baldung surpassed his teacher both in his painting and in the organic unity of his forms.

He was also able to extend the territory which Dürer had conquered for art. In spite of losses due to the Reformation, he continued to create new versions of the Crucifixion and the Virgin with fading colours, and once made a free variation of Gossaert's great Prado Virgin. Yet, unlike the aged Cranach, he seldom produced new variants of old formulae, whether his own or others'. Further, in his later years he seems to have worked without a studio. A number of pictures seem private ventures. Most of them must have been purely personal inventions. Few borrowings from other artists' work can be traced, and there are none from Italian Mannerism, from which he always stood apart.

He was fascinated by all that was unforeseen, unforeseeable. From 1512 on he painted more and more realistic details based on a pre-scientific knowledge of the pathology of the human body. He also devised abbreviations of traditional pictorial forms. Thus as early as 1513, long before Grünewald's Aschaffenburg Lamentation, in his own version (Innsbruck) he gave the legs of the two thieves, and only the legs, as independent gestures, and the Karlsruhe Nativity of 1539 consists of similar expressive, torso-like elements.

Baldung's manner of observation was cool and bold at the same time. The position of the motionless stableman is striking, but it is truly observed and not just ingeniously devised. Baldung's pictures are always saturated with panic. For all his vitality, he was aware of the supernatural, which had often enabled him to express the mystic symbolism of the Corpus Christi and the Sacred Blood. Yet he secularized the numinous in para-psychological fashion just as much; ruttishness and panic are the fate of his animals. He presented witches as if initiated in magic; even in his late years he seems to have painted dream visions, and imaginative symbols of life on earth conclude his work in painting.

It may be that this highly intelligent genius of a painter, this man with the artist's eye and the deep insights, was indifferent to the religious conflicts of his age. He survived the period of the great upheaval with a kind of reverence for life, which was by no means mere neo-paganism, and he continued his work uninterrupted until his death in 1545.

Hans Holbein the Younger

At Basel, Holbein had already made his dazzling appearance in the last years of Maximilian's reign. But he really belongs to Charles V's age, and was its most prominent figure, since the other great painters in Germany – Cranach, Baldung, Altdorfer, and Huber – were considerably older. It is of importance for the course of events that he did not enter the service either of Charles or of François I, a possibility which seems to have offered itself in 1524; in the end he became court artist to Henry VIII and in that way entered the history of English art.[7]

Holbein was born at Augsburg in 1497/8, the son of Hans Holbein the elder, whose

pupil he must have been.[8] In about 1516 he was at Basel, in 1517–18 at Lucerne; in 1519 he was registered in the Basel guild and was active in many fields; he painted a number of altarpieces. The monumental commission of the municipality to paint frescoes for the Rathaus occupied the young citizen in 1521–2. He painted house façades, made designs for stained glass, remained faithful to portraiture, and created in particular nearly twelve hundred designs for woodcuts and metal-cuts, among them the famous Dance of Death, the work of a Kleinmeister with an inborn sense of monumentality, for which he found excellent cutters, especially Hans Lützelburger (d. 1526). There are reasons for believing that Holbein visited Italy as a young man; he is known to have been in France (Bourges and Blois) in 1524.

In 1526 he went to England, recommended by Erasmus to Thomas More and other friends, and confined himself to portraiture. Back at Basel in 1528, he was a witness of the iconoclasm of the following year. Although the new municipal authorities engaged him for the final work in the Rathaus, he finally settled in London in 1532, practically abandoning religious painting from that time on. He seems to have found the patronage of the German Merchants of the Steelyard. He painted their portraits, decorated their hall in 1533 with triumphal processions of Poverty and Wealth, and designed for them the decorations for the state entry of Anne Boleyn.

Yet as early as 1533 he was at work on portraits of court personalities. In 1537 he entered the service of Henry VIII, and was soon in demand for all kinds of commissions. In addition to portraits of the royal family, he painted large murals and ceilings in palaces, which have been lost, and made designs for the state robes of the king and his queens, which were obviously his own work down to the smallest details, to the very ornamental buttons and shoe-buckles, the necklaces and jewellery, and as a whole represented his taste in fashion. More than two hundred and fifty designs for craftsmen and decorators, especially for goldsmiths, show how Holbein left his mark on the silver plate, the pageant weapons, the boots and bookbindings of the royal household. Thus the spectator can see Holbein in these royal portraits in a twofold sense – as the portraitist and as the dress-designer – and the only thing that had to be interpreted afresh was the figure of the king who wore it all and with whom the artist seems to have borne the vicissitudes of these years. Indeed, Henry VIII's confidence in him was so great that he sent him to the Continent with his ambassador to seek a bride, so that he might have an idea through objective portraits of what his future queen would look like. If we add Holbein's death in the London plague of 1543, all the facts of his life are covered. No letter and no notes by his own hand have come down to us. We know nothing whatever about his personality. He twice abandoned his family for long periods, but even that is not easily interpreted in an age when the arts were 'freezing' at Basel.

Holbein's detachment was by no means always coldness. That is evident in his superb early works. The gentle, yet eloquent portrait of the jurist Boniface Amerbach (1519, Basel) was certainly not painted without some personal attachment. At that time Holbein seems to have seen Grünewald's and Baldung's chief works at Isenheim and Freiburg. Then came the splendidly gloomy pen-and-ink drawing on an olive-brown ground of a Christ in Distress (1519, Berlin) and the brunaille diptych in tempera

(Basel) of the seated Christ of Sorrows with the Virgin in the pose of the Annunciation, in her future role of Mater Dolorosa (Plate 205). Both are touched up with white, the diptych with superbly conceived Renaissance building giving a hint of its incrustation colours against a light blue sky.

While Italian elements were here blended for the first time with northern feeling, there can be felt in the wings of the Oberried altarpiece in the cathedral of Freiburg im Breisgau – the portraits of the donors were painted by Hans Holbein the elder – in addition to the use of Dürer's engravings in the lighting effects, the influence of Baldung; in the Passion in eight scenes (Basel), with its enamel-like colouring and effect of preciousness, a touch of the virtuosity of southern art; and in the Last Supper (Basel) a transmutation of Leonardo's fresco. Many forms, mostly decorative, may have reached Holbein by way of Nicoletto da Modena, Zoan Andrea, and Jacopo de' Barbari. But the Virgin painted for Johann Gerster (1522, Solothurn) could hardly have been created, with its lighting, its glorious ultramarine, and the flashing banner of the knight, without some knowledge of Venice. In Holbein's painting in the twenties there is a quite unmistakable strain of Leonardo. But all these elements are completely absorbed in Holbein's work. Thus he was no child prodigy, like Dürer, however precocious he may have been. It was rather that he possessed the incomparable advantage of his way having been paved by an outstanding father, and of having at first kept in touch with him. This enabled him in the end far to surpass his father. Holbein painted practically no landscapes; he was a townsman.

In the Dead Christ (1521/2, Basel; Plate 209), the union of northern and southern lines of tradition can be recognized. It may be a painting which replaced one of the stone Sepulchres which were especially venerated on the Upper Rhine, where the viewpoint must be imagined to the left, in a church choir. The disfigurement is horrible: the lips are not red, but as livid as the body, and the bruised flesh is greenish-grey round the red wounds. *Verismo* is blended with abstraction and expresses, from a totally different standpoint, everything that Grünewald painted and was to paint of the mortality and death of mankind, whose predecessor and redeemer is Christ. It is an unemotional, indeed a merciless description, but it is not the work of an atheist; it is a summons to the *compassio Christi*.

At that time Holbein also created the eight metal-cuts for the Paternoster which were published in 1523 with a commentary by Erasmus under the title of *Praecatio dominica*; a new idea, both in form and conception, for in pre-Reformation times the words of the Paternoster were never illustrated. Of the same amazing novelty is the so-called Dance of Death, a series of fifty-one small woodcuts, mainly designed in 1523–6 and first published in 1538, a kind of humanistic *Biblia pauperum*, conceived from the outset without words. Initials with death-scenes had preceded it. (From 1520 on, Holbein had created in his book illustration a series of magnificent initials.) These were the beginnings of the art of the Little Masters in Holbein's work, yet it was against that background that the great portraitist must be seen.

Holbein's feeling for death[9] was only part of a wide and vigorous feeling for life. The humour in the Oberried altarpiece cannot be overlooked. Happiness in this world

appears in his book illustrations, and even in the Dance of Death; his façade frescoes at Lucerne and Basel overflow with festive spirit and joy in life. He painted Magdalena Offenburg of Basel as Venus with Cupid and as Lais Corinthiaca, the latter of 1526, both at Basel and both light-hearted homage to the delights of love. This innate gaiety may have been reinforced by his visit to France, where he acquired the pastel technique *à trois crayons*, which he often used later. Even the picture of a mysteriously beautiful woman, now at The Hague, has traces of France and Leonardo in the fluency of its composition. It must have come easy to him, in his first years in England, which he spent in the circle round Thomas More, to paint a lady in a white fur cap with a squirrel and a magpie (Houghton Hall, Norfolk) in all the grace of her feeling for animals. In this picture a tree such as had spread so naturally behind the figure of Amerbach (1519) appears as ornamentalized as in a tapestry. The portrait of Niklaus Kratzer, the astronomer (1528, Louvre; Plate 200), stresses his wit. Thomas Godsalve and his son John (1528, Dresden) are portrayed, though with discretion, as healthy country folk, a little limited in outlook.

At this point there should be mentioned the designs that Holbein made for wall-paintings now lost, especially on the Haus zum Tanz[10] (Plate 206). This is monumental painting of a quite peculiar kind. What the spectator feels first is the irregularity and the lack of construction in a picture which is yet not meant to be seen as flat. Holbein depicted peasants dancing, a stone statue, a balustrade with figures, indeed he rendered the whole of the upper walls and roofs of a town with a great deal of paraphernalia. He laid no stress on the construction of the Late Gothic houses, nor did he impose on them the regularity of Renaissance building. He consistently avoided any contrast of the kind. The whole flat surface becomes Mannerist by its implied spatiality, the hovering architecture forfeits its solidity, and all that is three-dimensional is confused and latticed. With playful sureness a gay half-illusion is created.

But this gaiety went hand in hand with austerity. Holbein's portrait drawings[11] show that he was not a man to set pencil to paper before he had mastered his subject. He did no trial work. Thus there is rarely a difference between the study and the painting. That he was not particularly concerned to reveal the psychology of his sitters can best be seen in the small eyes of most of his portraits. That makes them dominating, cool, and reserved. For Holbein, psychology was mainly accidental. Exposure was not his line.

The Virgin of Burgomaster Meyer (Basel), for which Magdalena Offenburg sat as model, is not a pure realization of the Renaissance, though its architectural forms give dignity to the Virgin of the Misericord (Plate 210). The shell niche on its improbable imposts presses the figures, including those of the worshippers, into a narrow space and imparts to them a startling sculptural power. The expression of perfectly free human beings has not been fully achieved; a strain of pose, even of petrifaction, has remained. At the same time the preciousness of every detail comes into play. The altarpiece, designed in 1526, was certainly completed in 1528–30 after the death of the two sons. The changes were made by Holbein with consummate skill, and the picture was by these changes transformed into a votive offering. Holbein's sense of the three-dimensional, which was sometimes inspired by works of sculpture, is revealed in the

mighty organ wings of Basel Minster. His austerity reaches the verge of terror in the wall-paintings for the hall of the Rathaus after an Old Testament and classical scheme drawn up by Beatus Rhenanus. In high eloquence they demand from the Councillors justice and the fulfilment of duty.

And finally Holbein's feeling for types of humanity and the dignity of personality transcends everything else. His father's observant eye was enriched in him by an un-erring rapport with every sitter. Thus he could surpass Massys' portrait of Erasmus by greater truth to life, just as he later surpassed Joos van Cleve's royal portraits. The artist who knew no Latin yet became the portraitist of the humanists. He painted the gentle, sensitive Amerbach (1519, Basel) with the same sureness as he painted Erasmus, three times about 1523 and on other occasions until 1532, just as he painted Thomas More, the humanist statesman (1527, New York, Frick Collection; Plate 203), and the humanist archbishop Warham (1527, Lambeth Palace, London). Massys' medal of 1519 may have helped him to find a formula for Erasmus. The simplest portrait (Basel) was probably the first: he stands at his desk in profile, writing, with his eyes on the paper. Holbein may have kept this portrait as a pattern. The version in the Louvre is much richer, the outline of the nose more venturesome, the former plain green ground is replaced by a curtain with coloured ornaments and panelling which make the room more intimate, the silence more audible, and the whole more precious. In the larger portrait at Longford Castle (Plate 204), Erasmus stands behind a table, as if entrenched in a corner of a room which is enframed by Renaissance pillars, a green curtain, a warm grey wall with a shelf, and various accessories – a delicious piece of painting created, probably, with some knowledge of how Massys had painted scholars' rooms. Yet for all this richness, Holbein was economical in his grasp of the essentials; the head is in three-quarter view, and although the eyes are half veiled, so that the delicate strength of the sitter seems largely obscured and the features faded, the critical force, the capacity for annihilating irony is present.[12] The figures of Warham and Thomas More seem to be placed in a narrow niche, the former as a prince of the Church, kneeling at a prie-dieu in a harmony of white, gold, and red, in front of a yellow-brown damask curtain, the latter in chestnut-brown fur, a velvet cloak touched up with iron-blue and flaming red sleeves with blackish shadows in front of a green, swelling curtain. Follow-ing the example of Baldung, Holbein had no hesitation in accompanying rosy faces with nut-brown hands; the hands are of the nature of still lifes and seem to be irradiated from behind. The lighting is not yet uniform, the colouring is restless and flickering – a truly dramatic picture.

After his return from London Holbein painted, probably in 1528, the most personal of his portraits, that of his wife and two elder children (Basel; Plate 208). The com-positional foundation of the theme may be Leonardo's Virgin and Child with St Anne, though Charity, symbolizing the love of one's neighbours, has also entered into it. It may be that the picture conveys something of the misery of the abandoned family. The mother is very much aged – her eyes are affected, and look sad and reddened with weeping – and the faces of the children are joyless. The picture, which has been cut down a little on the right-hand side, exercises a good deal of its moving effect by the

fact that the composition is open on the right (as is also the case with the restrained vehemence of More). It is possible, though not necessary, that it might have been completed as a diptych with a self-portrait or St Luke painting the Virgin.

Back in England, Holbein occasionally filled the background of his portraits with meaningful accessories. In 1528 the astronomer Kratzer is surrounded by his instruments (Plate 200), the corner of the counting-house of Georg Giese (1532, Berlin) both signifies his manner of business and stretches the portrait to indicate the picture-plane, above all, the blue velvet damask behind the bench where his coarse Cromwell (1534, New York, Frick Collection) is seated, and the airy curtain behind the Man with the Lute (Berlin), are means of revealing personality. So are balustrades or tables with sumptuous covers, where the hands lie at rest. The lighting has become more uniform, but the movement of the figures in space has been restrained rather than liberated by the beautifully painted and very significant accessories. From the spatial point of view, these pictures are reminiscent of reliefs.

That is also true of the group portraits, for which we have to rely mainly on studies, cartoons, and copies. The family of Thomas More, of 1527-8 (drawing at Basel), was the first portrait group of more than two persons to be painted in the north in which the members of the group were not shown kneeling. In the full-length mural painting of Henry VII and Henry VIII with their consorts of 1537, once in the Privy Chamber in Whitehall, the marble monument in the middle with its Latin verses extolling the virtues of the kings almost assumes that prominence in the picture which the inscription had already possessed in Dürer's engraving of Erasmus. The only picture of this type to have come down to us shows the French Ambassadors (1533, London; Plate 216). They are imposing by the mere fact that they are life-size: this is true monumentality. Cranach's almost life-size, but separated standing couple of Heinrich the Pious and his consort of 1514 (Plates 122-3) has become a spatially united group in the Ambassadors. They are two young noblemen, twenty-nine and twenty-four years old, the former in the robes of the Order of St Michael, the latter in the vestments of a bishop. They stand in front of a green curtain and at both sides of a stand with astronomical and musical instruments and books, among them a Wittenberg hymn-book, which express their bent to the liberal arts and create at the same time a gigantic Vanitas still life; for while the grisaille Crucifix by the left-hand edge is partly cut off by the curtain, there appears on the faithfully rendered *opus alexandrinum* pavement copied from Westminster Abbey a huge distorted figure in an unrealistic diagonal, which looks rather like the bone of a cuttle-fish, and can only be seen as the skull it is if looked at from below the bottom left corner. It is possible that Holbein added to this painting, which is radiant with all the arts of the new *verismo*, by means of a lately discovered skill, a discovery of Erhard Schoen, known as anamorphic design.[13] It is certainly a *memento mori*, and perhaps, too, an allusion to the artist's name – Holbein = hohl Bein, hollow bone (or skull). Once again the Mannerist centre without figures is also the centre of the intellectual and spiritual meaning.

But Holbein's true field remained the less than life-size portrait panel with a highly polished ground contributing to the noble brilliance of the colouring. The court

artist, even in his most official works, resorted more and more to a cool blue, or to a bluish or dun-green background. It is seldom rendered as a curtain; generally it is an abstract surface, neither wall nor air. It is laid on densely, while the preliminary drawing often shimmers through in the figures, where the paint is generally rather thin. This background often bears an inscription in Roman lettering, arranged with a supreme feeling for the distribution of planes, and in its turn it contributes to a feeling of abstractness just on the level of the head. In accordance with this attitude the foreground balustrades vanished.

And yet the figures in the work of Holbein's last ten years did not achieve real freedom. The pose is more and more often frontal. The look, and the head with it, which had once been turned aside, sometimes as if by chance, now confront the spectator, but they seldom have the ease and light-heartedness of the young Derich Born (1533, Windsor Castle). As a rule the eyes seem to be seeking something in the distance behind us, an effect which is heightened by their being less than life-size.

In the companion portraits of the Wedighs (1532/3, New York and Berlin), the anomaly of eyes of different size is stressed as an element of alienation, and only finds its formal compensation in the brim of the cap. Summits of perfection, though they are only drawings, are the portrait sketches of Henry Howard, noble and distant, and the sphinx-like Lady Parker, both thoroughly Mannerist beings.[11] From that time on, the head was seldom given enough freedom to turn away from the direction of the body, and in that respect too appeared strangely motionless. The outline of the shoulders, the side contours of the head, the brim of the hat became more and more a precisely drawn, often dark line. It is eloquent, but it is bodiless and lacks vigorous modelling. Of course, even in these late years Holbein produced portraits in profile and semi-profile, but even these have been deprived of space and freedom of movement. The source of light is in front, and disturbing side-effects are excluded. That too helped to impair the sculpturality. Individualization reached incredible heights, and yet there is about these portraits something spectral which even applies to their spiritual qualities.

At the same time the body in the picture was less and less seen as connected with supports on which it rested and which, though cut off by the frame, can be sensed in normal portraiture. Without them, the figure tends to lose all structural conviction. In the Erasmus woodcut of 1535, the lower part of the body is covered by a herm. The lovely Christine of Denmark (1538, London), which is unique as a single whole-length figure, is all the same not a figure of the Renaissance. In her dark dress and silk cloak on a (now) dark blue background, she seems to glide or float over the ground. Living colours appear only in the lips and at the corners of the eyes, in the precious stone in her ring and in the sealing-wax which, as a *trompe l'œil*, holds in place the inscription in the background. Of the French Ambassadors (Plate 216), the layman's stance is not credible; the lower part of the bishop's body seems to be walled in by folds and ornaments. Holbein chiefly confined himself to half-length figures, which became in their turn steeper in proportion. The frame comes to dominate the picture. It comes closer to the figures, and is the source of the line-work which holds the body itself in the subtle ordering of the picture plane. A number of these traits unite as one group the

mostly life-size, half-length figures of the Sieur de Morette (1535, Dresden), of the Falconer (1542, The Hague), and of Lady Lee (New York). They reach a climax in 1539/40 in the portraits of Anne of Cleves (Louvre; Plate 213) and of Henry VIII (Rome, Palazzo Barberini, a copy of the lost marriage portrait), both in the noble splendour of gold and red. In the portrait of the king in the great velvet cloak, of 1542 (Castle Howard), the substance of the body almost seems to dissolve under the rigour of the ornament.

At the same time the spiritual statement becomes stronger. Holbein's later portraits describe the massive force and versatility of the Merchants of the Steelyard, the spreading vitality of the London court and its ruler; they contain strength of character, noble calm, coarse brutality and cold intrigue, joy in life and lust of pleasure, as they characterized that society. But more and more also, anguished dullness, submission to force, foppish over-refinement, and pallor in the presence of death make themselves felt. The sickness and weariness of old families is not concealed in the portrait of Anthony of Lorraine(?) (Berlin; Plate 212), nor is the extreme delicacy of Edward, Prince of Wales (1539, Washington), nor even the bloated decay of the once brilliant king (1542, Castle Howard). Holbein was a court painter with an incorruptible eye, representing the full height of mid-century international Mannerism, which he did not live to see: yet there is no actual connexion between this child of Augsburg, who signed himself in 1543 as 'Basileensis', and the mature Mannerism of the south.

The Middle Rhine

In the twenties, Grünewald was still active on the Middle Rhine; in 1531, Sebald Beham, the engraver of Nuremberg, settled at Frankfurt. At the same time Conrad Faber von Kreuznach, who signed with the monogram CVC,[14] was active at Frankfurt from 1525 till his death in 1552/3, with an interval about 1530. He did a long series of portraits, mostly of Frankfurt sitters, and as a rule busts or hip-lengths.

PAINTING AT NUREMBERG AND IN FRANCONIA

D ÜRER died in 1528. His older pupils no longer lived in the city. The three most brilliant of his younger successors, the two Behams and Pencz, were the three 'godless artists' who were expelled in 1525. Sebald Beham had declared at their trial: 'What a god is I know not.' All three had refused to acknowledge Christ, the Gospel, the sacraments, and their rulers. There was a touch of youthful radicalism about the affair. The sentence was soon revoked, but only Pencz returned to Nuremberg to settle permanently.

The chief figure is Bartel Beham.[1] He was born at Nuremberg in 1502, and was Dürer's follower in the engravings and woodcuts which he began in 1520. In 1527 he gained a footing in Munich, where he can be traced in Wolfgang Muelich's workshop till 1532. From 1530 on he was Bavarian court artist at Munich and Landshut. He died on a visit to Italy in 1540.

Beham probably gave more to Muelich than he received from him. He was already equipped with an outstanding skill in portraiture; the bust of a youth (formerly Bremen), which dates from his Nuremberg time, is Düreresque, but it is his own. The earliest dated portrait, that of Chancellor Leonhard von Eck of 1527 (New York; Plate 215), is freer in its rendering and presents the figure down to the elbows of the folded arms. Above the very solid plinth of the pale greyish-violet costume, a small, but very interesting head moves freely in the upper quarter of the picture; it is set against a black background like a block of marble. Dürer had just made an engraving of Erasmus in the Italian half-length style; this composition exercised a direct influence on Beham's engraving of Eck, but the influence went farther. In 1528 Beham painted the two portraits of the Stüpfs, husband and wife (Castagnola), the first hip-length figures in German painting: a couple of self-possessed burghers. The rendering is enlivened by a band of restlessness in the middle, with the husband's flecked fur collar and a pale red streak on the red and yellow dress of the wife.

In three weighty portraits of 1529 there is a sense of momentariness. The portraits of a married couple now in Vienna present the husband as umpire in a game or an archery match. He is seen at the moment when he is recording the results with chalk on a table (Plate 214); a parrot has just settled on the wife's forearm. A bourgeois woman, formerly in the Chillingworth Collection, is busy at her spinning-wheel. This way of conveying greater vitality was represented about this time particularly by Vermeyen; the motif of the woman at the spinning-wheel appears in the same year in Heemskerck, but it is unlikely that there was any connexion. As a whole, Dürer's late work was consistently followed; real objects observed without any emotion are grouped in a magnificently sculptural way. As in Dürer's Jakob Muffel (Plate 70), the whole was there before the details. Beham added many small objects, as Dürer did in his Erasmus engraving. They

all look unused; they give no impression of mass and might be hollow. The fine, clear head of the woman at the spinning-wheel is painted exactly by rule. There is so little that is fortuitous in the portraits, and everything is so closely dependent on the preconceived whole, that an air of artificiality is always present.

In these stone-cold organisms one detail generally bears all the weight: the look in Eck's eyes, gripping but not appealing, which seems to elude the spectator on purpose, or, as in the umpire, actually pierces him with a force full of inward life. In the portraits of Charles V and Ferdinand I of 1531, only preserved in engravings (B60–1), the Habsburg underlip is unnaturally exaggerated, though the faces are otherwise flattered in their presentation.

On the whole, the powerfully modelled bodies hardly went beyond a generalized form. The Renaissance sense of dignity comes out in the breadth of the shoulders. The backgrounds are monochrome, or filled up with curtains and hints of buildings. The pale sky-blue behind Ruprecht Stüpf gives no impression of space. In the portrait of Maximilian II of 1529 (Vaduz) the view from below into the building turns the figure of the two-year-old prince into that of a courtly puppet. The picture of the Testing of the Holy Cross (1530, Munich), painted for the Wilhelm IV series, is also both flat and yet has a perspective racing into depth – like Breu's music pictures.

In the more courtly Wittelsbach portraits (1531, Vaduz and Ottawa, 1533 and 1535, Munich), the connexion with North Italian Mannerism comes out clearly. The gold and carmine tones of Ottheinrich von der Pfalz are both choice and splendid. It is open to question whether the official commission was responsible in itself for the difference from the unadorned portraits of burghers, which are considerably more direct and personal. Beham's visit to Italy of 1540 may not have been his first. On the other hand, as early as the thirties he was handling general Mannerist ideas in the vigorous and realistic fashion of an older generation. The widely distributed print *Mors omnia aequat* – a child asleep beside an hour-glass with four skulls (B28, *c.* 1530) – is in its direct, hardly even allegorical symbolism, a serious declaration of faith in this world in the spirit of Baldung. In the same way, even in the thirties, he may still have painted portraits in an earlier German manner, similar to that of the Baldermann engraving of 1533 (B63). The definitely southern Vanitas (Hamburg) is dated as late as 1540.

Sebald Beham, born at Nuremberg in 1500, died at Frankfurt in 1550. He seems to have been his brother Bartel's first teacher.[2] A few works by him for Cardinal Albrecht are still extant – miniatures and a painted table-top (Louvre) – but there are no panel pictures. He was the leader of the Nuremberg 'Kleinmeister', including Pencz. His work consists of engravings, etchings, and woodcuts. He was one of the most productive virtuosi in the graphic art of his age. In the restless years after 1525 he worked for publishers at Ingolstadt and Augsburg. He had his Planet woodcuts printed at Nuremberg in 1531, but then settled at Frankfurt, where he had a steady connexion with book production, especially that of Egenolff. It was only then that he worked himself free of Dürer's powerful influence.

His work began in 1518 in Dürer's sculptural style, which he exaggerated. Artificiality is strangely combined with popularity. Masterly, and perfect in technique, the 'Klein-

meister', Sebald at their head, became widely known by huge editions of their graphic pieces, often on a tiny scale, which prevented damage and made for an easy passing from hand to hand. Also graphic work took on the function of broadsheets. The narratives were topical and simple. Dürer had given graphic art its freedom and praised the aesthetic merits of the smallest size.[3] Since Sebald Beham could do anything technically, the choice of his subjects brought him into dependence on the cultural level of his customers such as Dürer had hardly experienced. These graphic artists are also called Kleinmeister, because their subject-matter was often small, intimate, and humble.

The Passion hardly appears in Sebald's work; indeed, there is little of the New Testament in it. He seems to have been unmoved by the spirit of the Reformers, but to have been deeply affected by the social movements of his time. Genre motifs occasionally introduced by Dürer, especially motifs from peasant life, were now narrated in breadth and without the condescension of the townsman, though at times very crudely; markets, dancing, kermesses, and lansquenets came to the fore. As late as 1544 there are intentional reminiscences of the Peasants' War. The trend to genre was furthered by the Old Testament, which Dürer had neglected. Further, the classical legends and allegories, that great educational force of the age, were liberally laid under contribution. Sometimes Sebald's renderings are not very clear. He himself excused his crude erotica by the taste of the time. These, the first genre pieces in the history of German art, were produced in very small format. They are related to Altdorfer in their intimate humour: the etching of the Annunciation to Joachim (P54) was certainly inspired by him, and it is possible that he was also responsible for the choice of small formats. The ornamental engravings are also important, since they helped to spread Renaissance forms, in particular the grotesques. A good deal was taken from Aldegrever, but full advantage was taken of Italian graphic work – Mantegna, Pollaiuolo, Marcantonio Raimondi. There are also purely ephemeral themes, pictures of sieges and state entries. Thus the vast range of subject-matter to which Dürer had merely pointed the way was exploited by Sebald Beham for the first time and given the status of art, although the small formats and in some cases the subjects made it impossible for him to give free rein to his high abilities. In Bartel Beham's smaller graphic œuvre there appear, in addition, battles between Antique nude warriors, and Pencz provided a Roman triumph, proverbs, and didactic themes.

It is known that Georg Pencz[4] was active in Dürer's workshop for a time; he painted murals in the hall of the Nuremberg Rathaus after his master's designs. He was born at Nuremberg about 1500. He matriculated in the guild in 1530. As a young man he signed with his monogram JB (Jörg Bencz) and later with GP. About 1530, or perhaps even earlier, he went to North Italy, and in 1539 he was evidently in Florence and Rome. After Bartel Beham's death he was summoned to Landshut by the Wittelsbach, and later, in 1550, became court painter to the duke of Prussia. He died in the same year at Leipzig or Breslau (Wrocław).

The bust of an old man (Vienna), probably painted in the early twenties, is Düreresque in its absence of emotion and in the unerring clarity of its outlines. Yet there is a personal note in it which presages the future hardness of Pencz's form. The delightful,

delicately painted altar wings at Cologne, with three saints and the Angel Gabriel, however close they may be to Dürer, are personal in the firmly outlined, almost metallic drapery. The colouring is glossily variegated.

The Judith of 1531 (Munich) shows a first preoccupation with North Italian painting, which had already entered on its post-classical period. But the metallic sheen and simple stereometric forms of the heroine were nothing new for a follower of Dürer. Thus Venetian elements, such as we can see in the Portrait of a young Man of 1534 (East Berlin), stand beside borrowings from Dürer, for instance in the paintings of the Silver Altar of the Jagiellon Chapel at Cracow, finished in 1538; they even appear in the Portrait of a Man of 1543 (Vienna) or are partnered by 'Primitive' German features, as in the woodcuts for Hans Sachs' Triumphal Arch and Wedding Procession. There is a peculiar hardness about them all; the forms are tightened up, selected bits of reality are stressed, and spatiality is neglected.

In the forties the influence of Tuscan and Roman Mannerism is almost always apparent. In engravings, the figures are over-deeply modelled and stand out in high relief. The portraits are usually hip-lengths. The figures are often placed in the corner of a building, which all the same hardly conveys a sense of space. The St Jerome of 1548 (Stuttgart) is crowded in by several small tables; he is a learned man of the world, and not a brooder in the former German (or Netherlandish) tradition. The distance from the sitters remains great, however comfortably they may appear in their seated pose. Flecked fur often introduces an added motif of restlessness into pictures which are crowded with wooden furniture and strike one as uncomfortable. The eyes of the sitter look far into the distance, or, in the Sebald Schirmer (1545, Nuremberg), pass through the spectator, piercing, but not inquiring, as though the sitter were a Roman emperor. The colouring is not variegated; Schirmer's prevailing tone is warm brown, black, and metallic in the tones of his armour, while in Jörg Hertz, the Master of the Mint (1545, Karlsruhe), yellow and black prevail, as also in the Unknown Man of 1544 (Darmstadt; Plate 211), where the goat-like profile is repeated in a mirror.

Pencz enjoyed working on a large scale; in this and in the cold, bright colouring reminiscences of Giulio Romano are felt, for instance in the ceiling paintings of the Fall of Phaeton in the Hirschvogel House at Nuremberg and in the Diana Room of the Landshut Palace of 1543. The same year saw the production of an exaggeratedly large oblong picture which recalls Bronzino. It shows a peaceful, sleeping woman,[5] a nude without any dominant mythological or allegorical significance or undertone, and is the first nude of its kind in German painting. The nude in Dürer's woodcut of the Draughtsman with the Reclining Woman (B149) has here been, in a way, removed from its didactic purpose to become an end in itself. The unemotional introduction of slightly exaggerated proportions, the sense of accuracy in measurements, come from Dürer, though it is out of keeping with Dürer's intentions. This High Mannerism has an affinity with the classicism of 1800.

The aim was the grand manner, attitudes of dignity in the Renaissance sense. The tendency to extremely large dimensions fits in with this; it is remarkable that tiny engravings of the Kleinmeister Pencz appear side by side with them.

Erhard Schoen was a little older than the Kleinmeister. He was born in 1491 or a bit later at Nuremberg, and died there in 1542.[6] His main activity was designing for wood-cuts, and he worked for the most part for Nuremberg publishers. He was influenced by Springinklee. He contributed to Maximilian's *Theuerdank* in 1517 and also to the Triumphal Arch. After 1520 he only treated religious subjects if poets suggested them to him. His range of subject-matter, apart from the rarity of themes from the Antique world, is rather like that of the Kleinmeister, but his idiom is artless, which is not only due to the woodcut technique. In his broadsheets he was an excellent reporter. About 1531–4 he seems to have discovered the principle of anamorphic design. In a puzzle picture,[7] which at first sight seems to consist of four allegorical scenes and landscapes in a bird's-eye view, the portraits of Charles V, Ferdinand I, Pope Clement VII, and François I have been smuggled in in such a way that the viewpoint is placed far outside the picture plane to the side, while the vanishing point is in the picture. Holbein may have found in this woodcut a suggestion for the distorted skull in the Ambassadors of 1533 (Plate 216), and the distorted likenesses of Charles V and his consort in S. Miguel at Valladolid and the portrait – possibly Netherlandish – of Edward VI (1546, London, National Portrait Gallery) also go back to Schoen's woodcut (though the authorship of the London painting has been disputed between Guillim Scrots and Cornelis Antonisz.). Seen from this angle, Schoen appears as something like a disciple of Dürer, though he expended his ingenuity on a very small corner of Dürer's vast domain.

CHAPTER 25

SCULPTURE IN THE NETHERLANDS AND ON THE LOWER RHINE

The Northern Netherlands

AT Utrecht, the efforts made by Bishop Philip of Burgundy about 1517–19 to introduce forms *all'antica* and 'modern' forms had come to grief. Later, it was the Reformation that was chiefly responsible for taking the chisel out of the sculptor's hand. The Utrecht sculptors changed over to the joiners' guild.[1] Obviously the painters had greater freedom to earn a living. But that is a proof of how much more ecclesiastical, and, for the time being, how much more medieval, the average sculpture of the early sixteenth century was than any painting. The self-sufficient image in the sense of the new era was the painting. The portrait reliefs of the van Vladerackens, husband and wife (Vorden, private collection), executed in the style of Heemskerck,[2] are unique. They almost equal South German work. But as a whole, sculpture was still in the service of religion.

The leading sculptor of the twenties, and perhaps of the thirties too, at Utrecht, the Master of the Female Stone Head,[3] continued to ignore Italy. In his delight in the contemporary fashions with which he so richly robed his female saints, he may have picked up ideas at Antwerp. Yet he was thoroughly original; this Utrecht master might well be called a second Master of Osnabrück. In his work too the wealth of secularity is not vulgarization; it brings the saints nearer to us. The large, convex faces with their small, segment-shaped eyes, tiny mouths, and prominent noses all show a kind of thoughtfulness which is not really spiritual, but expresses a mood of rare psychological appeal. The same can be seen in the somewhat vulgar Woman of Samaria busying herself at the well (Zyfflich, church). The picture is full of *choses vues*. The woman is pouring the water into her pitchers with great care, yet her bent head and her narrowed eyes give the feeling that she is meditating over some casually offered maxim. The St Ursula may be a late work (Rijksmuseum; Plate 42); the mantle has dwindled to a narrow strip of cloth, which she holds over her maidens in a graceful gesture – a spiritual event requires a mere allusion, no massive proof. The costume she wears has fantastically antiquated features; the ideal of beauty is far removed from anything classical. The basic conception is so much that of a relief that in late work by this master, as so often at Hildesheim, perspective foreshortenings also occur. There was a large export from this workshop as far as Norway.

At the same time an equally moving St John under the Cross (Rijksmuseum), with a dramatic turn to his delicate, spiritualized head, was made by another hand.[4] In this figure Mannerist rigidity and agility are carried unusually far. The heaviness of the body, which originated in the Northern Netherlands, comes out in the huge Christ in

236

Distress (Rijksmuseum); here, if anywhere, something of the Renaissance can be felt. His herculean form may have developed in Dutch carving of this period out of the formal feeling of the Arnhem Virgin and Child with St Anne.

A more conservative wood-carver was active in Upper Gelderland; he is known as the Master of Elsloo, probably in connexion with the carver of the Crucifixion at Beek.[5] A work by him, the Virgin in Saint-Jacques in Brussels, is dated 1523. Four groups of the Virgin with the Child and St Anne are by his hand also or come from his workshop (churches of Elsloo, Montfort, and Maaseik, and Rijksmuseum). Unruly Boy Christs link the pairs of mothers, who lack the old homeliness. The women are more showy than they used to be; they turn over the pages of books with slender, slim-fingered hands. The style of the drapery with its multiple folds is somewhat repellent and metallic. This Mannerism, derived almost entirely from Late Gothic, reaches its climax in the magnificent group of the Virgin and St John in the church at Ellicum;[6] they are two radically different beings in their reaction to the horrors of the Cross.

The Master of the Piercing Eyes, who carved a Christ with three apostles (Utrecht), a St Andrew (Cleveland; Plate 43), and a series of apostles in the church at Neeroeteren, was of a different kind.[7] His figures are naturally passionate, the heavy woollen stuff of the drapery is in lively movement, the small, coarse, haggard countenances of the apostles are of a peasant kind.

The Southern Netherlands

The production of altarpieces in the Southern Netherlands continued in the age of Charles V. At Malines there was obviously no interruption in devotional art, the calligraphy growing more fluent and quite often more expressive. Even the Antwerp altarpieces now show some classical influence, which was before a domain of the court painters of Malines and was heralded in the work of Borman the elder. The altarpiece from Pailhe (Brussels, Musées Royaux d'Art et d'Histoire) definitely reached Mannerism, towards which many a work had moved since 1515. In the middle of the altarpiece at Opitter there is a fiercely agitated Crucifixion with torturers. Below, the Virgin is fainting in the midst of a chorus of similar-looking women. Thus the theme of lamentation is made to sound *unisono*.[8] The events of the other scenes of the Passion are simply hinted at and dashed off with almost ghostly haste. The foreground is given over to passionate feeling. This altarpiece has been connected with the name of Master Robert Moreau, who came from Paris and was registered a citizen in 1532/3. His name is especially known for the gradual introduction of Renaissance figures into altarpieces, for instance, Oplinter about 1530 (now Brussels, Musées Royaux d'Art et d'Histoire), Enghien (Edingen; Chapelle du Parc), La Flamengrie about 1539, Bouvignes-sur-Meuse about 1540. The structure remained complex, but the many subdivisions of the case are noticeably more closely united. In the small altarpiece of 1535 (Brussels, Musées Royaux d'Art et d'Histoire), the Renaissance aedicule finally triumphed.

As late as 1539 a Brabant altarpiece went to Telde on the Canary Islands, just as Madeira provided a good market for exports from the Southern Netherlands, mostly

of a tall format.[9] But the Reformation in the north had, in the meantime, reduced the territories which would import.

The majority of the immigrants no longer took up the art of the altarpiece, which was in decline. Nor did they, like Mauch, come for religious reasons: most of them arrived before any such partisanship was necessary or possible. What attracted them was the other great phenomenon of the century, humanism, as it had been developed by the refined culture of the court of Malines. Humanism provided quite different commissions, and for these commissions, immigrants such as Meit from Worms (on the Middle Rhine) and Mone and Beaugrant from Lorraine were the right men. They brought with them something new – the formal repertory of the south.

Conrat Meit leads the van. He had stood the test in this new environment soon after 1510 and was probably the most outstanding artist in it.[10] The sculptural density, the convex compactness coupled with the polished elegance of his mature Malines style, continue in the bronze Lucretia in Brunswick, which is related to an engraving of 1514 by Lucas van Leiden (B134). It is probably the work of a successor of Meit's, but is certainly executed in the master's manner. The pose of the suicide is far more complex than anything that had gone before. The upper part of the body is bent towards the free leg. The head, with its closing eyes, is averted from the region where death is striking; it dominates, but already suffers. The left outline of the neck turns in the opposite direction from the curve of the right hip. It is clear that the point at issue here is the statement as a whole; the limbs are not carefully articulated, they flow into each other. The psychological tension between will and passivity, fear and self-destruction, becomes palpable in the twisted forms and the quiet splendours of the lower part of the body. At the same time the small figure presents five main aspects corresponding to the five sides of the base, and in their different ways all have something to say. From the back, the body actually writhes in physical pain; in the frontal aspect there is a dancer's balance between the powers of life and death.

The *Fortitudo* in the Musée de Cluny is later. The column which the girl is breaking is definitely not the support and aid of the figure, as it would be in Late Gothic; all sculptural power issues from her body. The art of sculpture only attained the power of making such a posture intelligible at the stage reached by Meit.

A multiplicity of small figures continued Meit's style without the radiant sculptural vitality of Meit's own work. Portraits too may have continued. Meit may have delivered the design for the statue of Margaret in the Innsbruck tomb, which is distinguished from Magt's manner of attack by an undertone of superior and more reflective mastery.

Meit's chief works in the succeeding period, as far as we know them, are monumental in size. They are the half-length figure of the Virgin in Sainte-Gudule in Brussels (Plate 219), the marble and alabaster tombs at Brou near Bourg-en-Bresse, commissioned in 1526 and finished in 1532, and the unfinished alabaster Pietà in Besançon Cathedral.

The Virgin of Brussels is the first life-size marble Madonna in the history of northern art, and as such the first echo of Michelangelo's work at Bruges, though it is certainly

independent of it. The skin of the Child is lovely, though there is no indulgence in detail. The Virgin's long hair falls round her delicate but vivid face with marvellous substantiality. The marked parallels of the flowing drapery are a last echo of Late Gothic. They were probably suggested by Gossaert, who himself borrowed a good deal from Meit.

At Brou, Margaret had splendid tombs set up for her mother-in-law, Margaret of Bourbon, her husband Philibert the Fair of Savoy, who died young, and herself. She died in 1530 before the work was completed. The memorial to Margaret of Bourbon is in a wall-niche of Burgundian tradition with *pleurants* at the side of the tomb. The other two monuments are both in two tiers. Above, there appear the figures of the rulers in all their dignity and princely robes, yet with the aged features stamped by their hour of death. Below, arcades open on to representations of them dead, but not with any of the horrors of decomposition. They have the peaceful beauty of those who sleep; they are not void, decaying husks, but living souls. The idea is entirely un-medieval: it may be questioned whether it was already contained in the grisaille designs made by the painter-designer Jan van Roome in 1513–14.[11] What Meit had to deliver by his own hand were 'les mains, les visages et les vifs' (the pictures of the living). He had assistants with Italian and French names. Needless to say, Meit, pioneer of the new sculpturality, had his troubles with the leading architect of this Latest Gothic church of Margaret's. He is undoubtedly responsible for the expression of enchanted repose in the Regent Margaret's death portrait, which resembles that of the Brussels Madonna, and also for the touching trait of submission to fate in the countenance of the dead Philibert, the radiant, yet human yieldingness of the living Philibert, the spirituality in the portrait of Margaret, the loveliness of the best among the putti. The perfect finish, the extreme lavishness in the ornament, and the precise rendering of the clothing and jewellery expressed Meit's convictions, but were for the most part the work of his assistants. In this international work, executed to the commission of a supra-national regent, we have the rare case of a German achieving smoothness without shallowness. In this sense Meit can only be compared with Holbein, the court painter of England.

There is something of Michelangelo in the perfection of the Pietà at Besançon. It also approximates to Italian form. It is probably based on the lost Pietà supported by Angels by Andrea del Sarto, which had become widely known in Agostino Veneto's engraving. In its lack of symmetry Meit's Pietà is extremely expressive, yet abrupt.

Meit died in 1550/1; he had left court service after Margaret's death and probably settled in Antwerp in 1534. The works that he delivered to Tongerlo between 1536 and 1542 are lost. One of the enigmas of the history of sculpture is what Meit's late small figures looked like.

In any case, a number of small wood-carvings was produced in the second quarter of the century in the Southern Netherlands, among them a stubby group of the Fall (Berlin), a Samson with the lion's head (Munich), a so-called homage to the Emperor (New York), and the statuette of a warrior (Cambridge, Mass.). The greatest economy in the design and a delicate treatment of the skin go hand in hand with high relief, a free-flowing beard, a powerful lion's mane, and lovely ornamental fantasy; the warrior is a

highly romantic descendant of the heroes on Maximilian's tomb. Meit's style is here developed into a predilection for oddity, a playfulness, which is stylistically polyglot and retrospective. Several hands must have been at work.[12]

Jean Mone (also Monet) was probably not much younger than Meit, as he is mentioned in Barcelona in 1497. He must have been born about 1480, at Metz in Lorraine, but had Italian and French training before he came to the Netherlands. In 1512–13 he was at Aix-en-Provence, and in 1516 back at Barcelona, where he appears with the surname Aleman. In 1517 he was assistant to Bartolomé Ordóñez in the decoration and furnishing of the cathedral *coro*, and he may have paid a visit to Naples at that time. Dürer drew a portrait of him at Antwerp in 1521. From 1524/5 until his death, probably in 1550, he was active at Malines. In 1522, Charles V conferred on him at Brussels the title of 'artiste de l'empereur'.[13]

He is the representative of a somewhat younger generation in the Netherlands which was more closely associated with the emperor than Meit, who had been in the service of Charles's aunt. We owe to Mone the fine alabaster portrait of the emperor with his young consort (1526, château of Gaesbeek). The couple is shown in high relief in front of a portal covered with shallow ornament; they are both regal and personal. The features, standing out from the greater concreteness of the surrounding forms, have been caught with a rapid hand. Although they have no great depth, there is real life in them. Mone was no innovator. His achievement was to bring the south to the north. Meit was above any such intermediary role. What Mone added was the grace of his rendering. His distinction certainly originates in his power of omission, whereas Meit's figures are bursting with form. Yet this kind of vacant pallor was the style of the time.

Mone's chief works were alabaster altarpieces, one at Halle (Hal) of 1533 (Plate 220), another in Sainte-Gudule in Brussels of 1538–41. These were the first genuine Renaissance altarpieces in the Netherlands, built up with classical architectural forms, their lavish ornament drawn from the formal repertory of the Quattrocento. The wooden altar thus found a rival in its traditional location. Yet the altarpiece at Halle was absolutely devoid of true classical feeling. Tondi are enframed in orders of pilasters and make the whole work seem to float. Pilasters stand precariously above panels, not pilasters, and convey to the entire altar a touch of irrationality. But reliefs of the Seven Sacraments are noble in their beauty. The peculiar semi-transparency of the material, which concentrates all the light on the ridges, is put to ingenious use. Some works, for instance the tomb of Cardinal Guillaume de Croy of about 1528–9 at Enghien (Edingen), have been attributed to Mone, but many Italianate artists, masters of carved decoration, worked beside him in many places in the Southern Netherlands. Mone's position as intermediary between north and south should therefore not be overrated. One thing is certain, namely that he was employed between 1534–5 and 1544 on designs for architecture and applied art.

Guyot de Beaugrant, of Lorraine, who settled at Bilbao about 1533–5 and died there in 1551, was commissioned by the Regent Margaret to do the (lost) tomb of her brother, Franz of Austria, in the Caudenberg Church at Brussels in 1526.[14] It was a child's tomb, and was executed forty-five years after Franz's death. In the chimneypiece in the Franc at

Bruges, completed in 1531 (Plate 222), which the Regent Margaret had definitely commissioned in memory of the 'Ladies' Peace' of Cambray of 1529, Guyot, who was living at Malines at the time, was the real sculptor. The chimneypiece as a whole was the work of a team, and it is typical for the coming age that invention and execution parted company. The preparations went back to 1528. The design was made by the painter Lancelot Blondeel. Many experts were consulted. The structure is extremely top-heavy owing to the lavish ornament of the overmantel, which is broader than the fireplace. Hermann Glosenkamp, Adrien Rasch, and Roger de Smet collaborated in the work, probably on the decorative parts. Beaugrant is believed to have carved the four alabaster reliefs of the story of Susanna, which clearly show his connexion with Mone, together with the winged putti. But the five oak statuettes of Charles V and his male and female ancestors, which are clearly inspired by Blondeel's design, are obviously by Beaugrant himself. The upper part is filled with portrait medallions, splendid putti, and lavish ornament. The *horror vacui* can be felt in the most delicate detail work. The whole is a Triumph of the House of Habsburg under new aspects connected with the young prince. Maximilian's Arch Triumphal was no less ingenious and artful, but, although it was in print, it was less public. The present work is dominated by an aristocratic coolness. The robust, smooth oak stands in a truly Mannerist contrast to the sheen of the alabaster; there can surely have been no thought of painting it. The faces are thoroughly individual, the statuettes, with their excellent proportions, are weighty. This Mannerism of abundance is remarkable in contrast with Mone's Mannerism of the void.

Other painters were also at work on sculpture. It is usual to connect Pieter Coecke's name with the reliefs on two overmantels and a loggia from the De Moelenere House at Antwerp (built in 1549).[15] A small, free-standing group of the Sacrifice of Isaac in the Rijksmuseum (Plate 233) has the theatrical pose of Coecke's late style; the patriarch, clad in a Renaissance tunic, moves with 'Gothic' verve. At Antwerp, Filip Lammekens (1493–c. 1550), obviously an architect by profession, also made designs for altarpieces and tabernacles.

But even in cases where not only the carving but the design too were made by one artist, in the more routine work of choir-stalls, altar reliefs, and single figures for churches the concentration of power in the new style seems to have been reached to a large extent about 1530. This is not a Renaissance Italianism prevailing on a higher level, but a Mannerism in which traditional forms were blended. Moreau has already been mentioned. Single works in oak, like the beautiful relief of the Visitation in the Rijksmuseum and the splendid, but over-dramatized Magdalen in Berlin,[16] show this just as clearly as the choir-stalls in St Gertrude at Louvain, which were completed in 1543.[17] The disproportionately long bodies and the spirituality of the robes of the huge Apostles in the south porch of O.L. Vrouwekerk at Tongeren of 1532, on the other hand, look more Gothic in the upward flaming of their robes.[18] Finally, the St Margaret in Notre-Dame-la-Chapelle in Brussels[19] is very free in the execution and worked almost in the round. In the refinement of her clothing and the self-consciousness of her movement she is a noble sister of the women saints by the Utrecht Master of the Female Stone Figure; she shares the complex emotional situation of Joos van Cleve's Lucretias.

Thus the crass stylistic break between Jan Borman the younger's Güstrow altarpiece and the work by Mone had been bridged somewhere about 1540, to a large extent by native artists and in a kind of Early Mannerism.

The Lower Rhine

Cologne does not seem to have had a sculptor as advanced as Mone. Imports from Brabant showed some Renaissance ornament. Jacob Binck worked mainly in the north-east;[20] he introduced Cornelis Floris to Königsberg (Kaliningrad). His name is associated with a mourning Virgin (Cologne) and a St Barbara (Berlin), statuettes in rich, voluminous drapery with a dash of medievalism in their display of emotion. Thus Binck must have started out from the small-scale sculptors of the Southern Netherlands. At Cologne, however, and especially on the Lower Rhine, the art of the second quarter of the century sprang mainly from Late Gothic roots.

Heinrich Douvermann came from the neighbourhood of Dinslaken.[21] After his training in Brabant, he had worked at Cleves and later at Kalkar. He is mentioned until 1544. The wildness of his life seems to have made difficulties for him, as it did for Gossaert. It can be felt, up to a point, in his work, in occasional crudeness and marked fluctuations in quality. He seems to have retained the predellas of his great altarpieces for execution by his own hand – they were, after all, the most easily seen. The predella in the collegiate church at Cleves of 1510–13 shows the Tree of Jesse in the stage of a clarified Late Gothic naturalism; formally, it is still Brabant, and it is to a large extent unoriginal.

Douvermann introduced the Tree of Jesse twice more into the predellas of his altar-pieces: in 1522 into that of the Sorrows of the Virgin in St Nicolai at Kalkar, and about 1536 into that of the Virgin in St Victor at Xanten (Plate 224). Even at Kalkar, Late Gothic prevails; Douvermann transposed a foliate ornament of the type of Israhel van Meckenem into carving, and the result is a marvel of its kind. The whole weight of the narration is borne by this foliate scrollwork, it is the tree which grows out of Jesse's body. A masterly and extremely original work, it corresponds to Hans Witten's fantastic trees, which, however, are more compact in shape. Fifteen years later Douvermann carried the same subject far beyond the range of Late Gothic. The scrolls are still more tree-like, the boughs and twigs are clearly subjected to an order of precedence, and the wavy, flying roots of the Kalkar predella have disappeared. While in that predella the figures of the ancestors of Christ looked out through gaps in the ornamental arbour, at Xanten they seem overgrown by lattice-work, and have forfeited all their vitality. The root, treated here as independent ornament, smothers the figure subject of the predella and rises from it, twining about the complex outlines of a shrine in the Netherlandish tradition.

The altar at Kalkar, which is very slightly coloured, depends on the effect of the oak. It shows Douvermann at his best. By shifting his accents he obtained fresh formulations of old themes; the groping and eavesdropping of the nocturnal pursuers is eerie, the cautious glide of St Joseph is effective, but the central figure of the story, the Virgin

with the Child on the Flight into Egypt, is made practically invisible by the shattered idol, which, in the composition, erects a barrier before the bailiffs. Douvermann often stressed such secondary elements in his stories.

In the Altar of the Passion (c. 1530, Cologne), the body of Christ, after the Deposition, is very definitely relegated to a subordinate place behind the expressive group surrounding the Virgin. In the Lamentation, it is outweighed by the solemn mourning of the Maries, which is magnificently enhanced by the duplication of the figures. And in the Resurrection, the carver's whole intensity of feeling is poured out on the watchers by the tomb. In masterly fashion the larger figures are worked almost in the round; what lies behind is embedded in landscape and is on a smaller scale, though it is important in the story.

The execution of the Xanten altarpiece seems to have been largely left to assistants. We can see Douvermann's later style in the Annunciation on the St Matthias altarpiece at Xanten of 1531, where a psychological effect is won from the complex turn of the Virgin's body; it is also to be seen in the rigid, over-ornamented busts in the Xanten high altar of 1529–44. The climax of this late style is reached in the Magdalen in St Nicolai at Kalkar (Plate 223). She is the sister of the Brussels St Margaret, yet the Kalkar saint is quite different; the forms are round and full, yet she is not at all substantial under the weight of her ornament; with its strange smile the face looks like a mask. At this stage in his peculiar development Douvermann rejoins the cool and tasteful style of international Mannerism in its essentially Netherlands form.

Arnt van Tricht the younger was Douvermann's best assistant in the altar of the Virgin at Xanten. His reliefs of the Annunciation and the Visitation can stand comparison with the work of his master. Even though the scenes take place in the open air, they are surrounded by the decorated panelling of a bourgeois Renaissance interior. The bulk of Arnt's work belongs to the middle of the century.

The many stone carvings on the Lower Rhine, for example the Calvary of Canon Berendonck by St Victor at Xanten, completed in 1525, and the four Stations of the Cross, completed there in 1536, are quite different in spirit.[22] Uncomplicated in outline, powerful in form, with simple planes and a wavy fall of the woollen drapery the Calvary conveys a deep sense of inward sympathy. The four Stations, above all the figure of Christ, are composed with conscious art, and though agitated by their very nature and packed with action, are similar in tone. The grimaces of the lurking soldiers, of the mocking crowd, of the sleeping or bewildered guards by the tomb, are gathered together in closed, compact forms in the manner of the elder Brabender; even fashionable clothes have this compactness. The master may have known Antwerp; the early classic phase of about 1500 here continues into the second third of the century. Above all, the substance of the stone is given a voice in the Westphalian manner. These works may belong to the school of Westphalia: there are grounds for identifying their author with Master Thonis of Coesfeld.

SCULPTURE IN NORTH GERMANY, UPPER SAXONY, AND THURINGIA

IN the second quarter of the century, the outstanding centre of production was Münster, and it is connected with the name of Heinrich Brabender. After 1536, following the vast destruction caused by the Anabaptists, the cathedral stood in need of repair.

First came an episode; for the figure on the central pillar of the galilee, St Paul, is unlike Brabender's manner.[1] He is in the spirit of the Apostles at Tongeren, though the structure is clearer and the organization firmer. The toga is Roman in character; movement is imparted to it by the waves of the lower hem, while the rest approximates rather to the quieter flow of the thirteenth-century statues which form part of the same galilee. This tells of a fine feeling for history guiding the sixteenth-century sculptor. The modelling of the face is delicately graduated, the eyeballs can be felt under the lids, the beard and halo invite the touch, and though there is no overloading, the relief of the figure catches the eye at all points.

If the *Beldensnider* (carver of images) Johann Brabender, of whom there is documentary evidence at Münster from 1539 until his death in 1562, was the author of this work, this was indeed a great beginning. In any case, he worked for the cathedral. The tabernacle is dated 1536, and is an outstanding work by a mason rather than a sculptor. Renaissance balusters characteristically united with essentially Late Gothic architecture result in a work bristling with form. The angels in the Angel Choir of 1554–5 recall, in their stocky build and the melancholy of their features, works by Heinrich Brabender the elder. They were made by Franz, Johann's brother.

Johann's chief work was the two-sided rood-screen in the cathedral, which, except for details, was made between 1542 and 1547 and is now mostly destroyed. There were great rows of seated apostles and saints; Christ appeared in majesty.[2] Towards the middle, forms of obvious Renaissance derivation penetrated the canopy, and were clearly intended as a culmination of the whole composition. It is very possible that Gothic architecture at Münster was a kind of confession of the old faith. Yet the figures are massive and substantial in a quite un-Gothic way. This earthy weight, however, is balanced by the sensitiveness of their expression. That Johann Brabender was anything but a posthumous Gothic artist came out clearly in the Renaissance rood-screen of 1546 in Hildesheim Cathedral (destroyed in 1945), and still more in the font in St Mary at Osnabrück, dated 1560.

At Hildesheim, the Master of St Benedict continued to work, as the Master of Osnabrück obviously did too.[3] The work of his hand can possibly be identified till about 1530, and his followers continued. The spirituality of his style in limewood carving could still be intensified. The series of Evangelists and Fathers of the Church (Hannover) were originally, after Riemenschneider's manner, unpainted. A grand St

Nicholas standing in profile and a St Catherine with a long, oval face give us an impression of the maturity of the art of this master of psychology; both are in private ownership at Hildesheim, as is a St James the Less, still composed on the scheme of Riemenschneider's stone Apostles, but piled on high, and far superior to Riemenschneider in the ascetic expression of the face. These later works were dominated more and more by the urge to interpret the feelings of the elect. There are no subsidiary forms which are not in the service of the main form. This unclassical absence of contrast strengthens the feeling in the figures, though it deprives them of the breadth of life. It is Mannerism mainly drawn from Late Gothic sources.

Levin Storch, the Master of Rethen, began with the altar of the Passion in Hildesheim Cathedral.[4] It is another example of the North German manner of narrating the Passion which can be seen in the Berendonck Stations of the Cross or in Brüggemann's Schleswig altar. Storch is mentioned at Brunswick in 1524–5. Sentiment of the Hildesheim type was not in his line. He described the wealth of things in this world and organized them by an unerring choice of the location of the centre of interest and by the space-creating means of reducing the size of figures in the background. He was an outstanding portrayer of human beings; his physiognomic repertory was far greater than Brüggemann's. There are representations of the four temperaments, sensual, spiritual, and ecstatic heads, others terrified and bewildered, malicious and cunning, honest and stolid, simple lansquenets, uncouth criminals, fat and squabbling monks, fervent apostles, robust captains, prudent councillors; there are noble and serious faces side by side with strange grotesques, children and old men, Negroes, Jews, and Arabs – all pouring forth from the rich imagination of the artist. Many details go back to graphic art, in particular to Cranach's Passion woodcuts.

The Crucifixion from Rethen (Hannover) has left this over-abundance behind. The statues are now formed with a vigorous feeling for the full rotundity of the body. A strong sense of order has grouped all the multifariousness in a few, economical, ruling forms which are superbly related to each other. Given this power of organization, Storch was a dramatist of the spiritual world. Above the two ways of showing grief expressed in the figures of the Virgin and St John there rises the huge, almost Herculean body of the dead Christ. The whole is sublime without being refined. In North Germany only Hans Witten can have been his teacher. It is possible too that he was familiar with the art of the Middle Rhine. The traces of this Late Gothic carver of altarpieces can be followed for another ten years in quite a different direction; after the Reformation at Brunswick in 1528 he went over to secular stone sculpture, and from 1531 on he adorned the castles at Celle, Gifhorn, and Medingen (1541) in the service of the Lutheran Duke Ernst the Confessor. He died in 1546/7. In these sculptures we find a characteristic transformation of the altar-carver's types. Voluminous programmes for architectural sculpture have come down to us, worked in limestone and, as it seems, originally coloured: medallions with grotesque male heads; portraits of princely couples and heads of Antique poets or philosophers; busts of Old Testament tyrants and kings; and figures of the Virtues (Plate 221). In part, they are based on graphic series by Pencz and Erhard Schoen. The grotesque heads derive from the same bestial world as the torturers of

Christ on the Passion altar. The figure of Justice recalls the wooden Virgin under the Cross. The fine stone required no great change in calligraphy. Storch was active throughout the great rift in his age, apparently without spiritual crises and without being forced into silence by the new faith.

Benedikt Dreyer was less lucky.[5] He was probably twelve or twenty years older than Storch. After his Late Gothic style had flamed up in the St Michael hurling the thunder-bolt in the (lost) screen of the Marienkirche at Lübeck, his pre-Baroque trend faded in the twenties. The St Anthony altar (1522, Lübeck, Museum; Plate 230) again introduces single figures swathed in drapery which is generally rendered in linear form. Transparent Late Gothic scrollwork represents Renaissance balusters like filigree. As weight, as space-occupying sculpture, they don't exist. In the same way substantiality is banished from the figures; space is kept at bay. St Roch and his angels only find some equilibrium in their relation to each other. Stylishness appears in this saint and in St George, but the hermit is a very quiet, unworldly successor to Hagnower's worldlier saints. Dreyer appears to keep well within the framework of Christian iconography. But what really engaged his attention is the spiritual events in the people he represents. The way he interprets his subject matter psychologically is the outstanding quality of his work. Yet his manner of narration remains perfectly clear. The robe of the Virgin in the Annunciation seems to be whirled against her body by the gale of the event.

Works from Dreyer's workshop can be found as far as Norway and Esthonia. For his late period – he was still alive in 1555 – we have few dates. In 1540 he delivered models for candelabra to the Marienkirche at Lübeck. He also made similar designs for silversmiths; in his hands, the foot of a pear-shaped chalice became a pear-tree, with putti romping in it (Lübeck, Museum). The pipe of the Danzig Seafarers – his last known invention – is covered with a superb richness of figures, both droll and serious (Gdańsk; Danzig). Even here we find magnificent figures on a scale which was, willy-nilly, small.

The other Lübeck sculptor of the time was Claus Berg.[6] Though none of his works seems to be known at Lübeck itself, he was born there before 1485. From 1504 he appears to have been in Danish service. For a long time his workshop was at Odense. In 1532 he left the country on account of the Reformation. Where he went and when he died are not known. Works by him first appear in the second decade, and a master-piece only towards the end of his life. The style is so individual that it is impossible to detect whether there is a derivation from Notke, or whether or not he was appren-ticed to Stoss in South Germany.

The altarpiece at Odense, of about 1517–22, is a unique blend of three themes of late medieval art: All Saints, the Passion, and the Tree of Jesse, all united in a general presentation of the edifice of faith (Plate 228). The immanence of Christianity is of far greater power than in Brüggemann's contemporary work. The spiritual association of the three themes was certainly not only Berg's work; the learning of some cleric must have been behind it. The huge altarpiece is unified in subject, but not universally in-telligible; it is instead highly specialized in the direction of a personal symbolism. It is the kind of thing that appears roughly at the same time at Mauer, Zwettl, and Breisach, and in Dürer's All Saints. The saints are ranged in three rows, one above the other;

women and angels, in contrapposto, or moving calmly forwards, are in the lowest rank; above them men, mostly clerics, turn hither and thither in greater animation, and at the top prophets and apostles come raging along in the wildest agitation. These three tiers are reduced in height and foreshortened towards the top. The topmost, fourth tier, on the other hand, is the highest; the joyous festival of the Coronation of the Virgin is surrounded by the rejoicing hosts of heaven. The result is a naturalism in perspective which is nevertheless subjected to a medieval hierarchy of significance, the figure of the Crucified appearing the largest. The whole altarpiece vibrates with a supreme vitality. But the degree of truth to nature varies. The most concrete figures are the royal family on the predella, but the thick-set female figures in the lowest storey and the nudes are also unquestionably earthly beings. The figures in the higher tiers become more and more spiritualized. The whole turns into a gigantic, floating, and spaceless picture terminated, as if by chance, by a frame. The Late Gothic scrollwork is reduced to spiky trails in which, in order to distinguish the storeys more architecturally than Douvermann did, little brackets are inserted. The few balusters become trellised sheaths without a palpable core. At the same time a certain equality of values between animated and not animated has been achieved. In each tier a head has sometimes no more significance than a bunch of drapery or a shoe.

It is this Mannerism which distinguishes Berg's Crucifix groups at Sorö (1527) and the Crucifix at Vindinge (the Virgin and St John once belonging to it are now at Copenhagen) from Veit Stoss's last Crucifix. The latter, by the contrast of the symmetrical and weighty torso with the tortured and contorted limbs, achieves a formal contrapposto. The Vindinge Crucifix is incomparably more uniform; there is no contrapposto to underline the great manifestation of the suffering on the Cross. The same is true of the mourners probably from Vindinge. There is nothing audible except the expression of earthly anguish; in this Berg went beyond Storch. By the exaggerated expression of the unusual and very individualized features, the God the Father in the church at Tirstrup (1522) became a troll, a primeval earth spirit. The trend to the gigantic becomes more and more pronounced; the movements become almost overpowering in their force.

Eleven apostles at Güstrow are probably the last work by Berg that has come down to us. It is a wild company that the aged artist carved, character sketches of incredibly vigorous men who are, at the same time, victims of a secret fear, creatures of the same kind as King Christian in the Odense predella (Plate 226). These figures were created by an unbalanced temperament; the tension between self-control and sudden outbursts of emotion is almost palpable. In this ugliness, Berg transcended the work of the Master of the Piercing Look. The apostles might be warriors in Reformation battles. A crude kind of psychology is also there. The forms reach the verge of the alienated, the comical, the absurd, akin to the coarseness of contemporary writing. But this expressive power does not issue from the body, organically or dynamically; it is 'put on'. Simon's face is worked out like a mask in a plane which is at an angle to the frontal plane – presumably in consideration of the front view of the altarpiece for which the figures – now separated – were probably intended. Both his legs are too short in the calf. In the other apostles also accuracy is neglected. The bodies are wizened and only held together by the

crystalline forms of the unruly folds of the drapery and their comprehensive sweep. Berg was a monster of a master, bent on abstraction and Mannerism. The term Baroque, on the other hand, can only be applied to him to characterize his personal vitality.

Except for Berg's Apostles, the strangest work in Mecklenburg is the altar of St Roch in the Marienkirche at Rostock.[7] It rather harks back to Dreyer. Its wings cannot be closed; it is made for a single view. The compression and contortion of the figures has been carried so far, Dreyer's urbanity has become so sophisticated, that a comparison with Douvermann's late Magdalen comes to mind. There is great delight in wood, and this indeed all the artists of this group felt. The carver of the St Roch altar rated aesthetic value higher than narrative. Compared with his elegance, Berg's apostles seem passionate confessions of faith uttered by a lonely old man.

Master Paul made his début at Danzig (Gdańsk) in 1517, and work of his can be traced until 1546. His origins in South German sculpture are obvious. There are echoes of Stoss in his work, but what seems to have been most important was a connexion with the Landshut–Regensburg group of the second decade.[8] He was obviously still a young man when he made the gigantic rood in St Mary in 1517. He had a feeling for the grand manner. The body of Christ has angular forms, the head is that of a dead man. This, owing to the distance of the view, can however only be divined. Mountainous folds, huge strata in the material, give significance to the gestures of the mourners. The Crucifixion from Rethen looks more abstract and more northern in comparison. Paul's sensuous manner can also be seen in the Salvator and in the Virgin beside the astronomical clock in St Mary. The clumsy arrangement of the superb draperies goes back to the manner of movement of the second decade. The Virgin's face is wonderfully tender in the slightly roughened forms of her closely pleated cap. We see here too the strong stress on the cheekbones which makes Paul's later work, particularly the altar of the Joiners' and Carvers' Guild, immediately recognizable. Convex forms like these in uncoloured wood almost make it look like bronze. The forms of the hair are as regular as the decorative edging of the clothing. Delight in accomplished detail can be clearly felt.

The year 1534 saw the creation of the eloquent and very individual portrait heads of the wall panels and frames of the so-called *Rundeele* of the Christofferbank in the Artushof. In 1542 came the huge St Christopher, lean, narrow-chested, wedged into a breast-plate decorated in a pseudo-Roman style (Plate 225). On it there falls a very long, ornamental beard which covers the saint's neck. The painfully ascetic face is like a mask; each roll of flesh in it is clearly delimited from its neighbour. The curved eyebrows meet like a pair of tongs. The eyes glare hugely; they almost goggle. There is a distortion in the stance of the saint, whose weight-bearing foot is concealed by the water; the resting part of the body is tense. The arms project just as abruptly and in the same angular fashion as the face from the torso, which is stiff with ornament. One arm is propped, though laxly, against the body; the other carries the enormous staff and the Child, who looks weightless and whose figure is as highly finished as if it had been turned on a lathe; in a playful movement he holds the globe above St Christopher's head. The sharp ridges of the fluttering cloaks make up for the lack of balance in the

whole. All expression is concentrated in the spiritual anguish in the saint's face. Both in abstraction and in expression, Master Paul is just as far removed from Berg's late outbursts as from the temperate St Paul of the Münster galilee.

The sculptors' workshop which provided Cardinal Albrecht's Late Gothic cathedral at Halle with sculpture must also be derived from South Germany; it had been transformed with Renaissance elements between 1518 and 1526.[9] On this humanistic foundation, about 1525, a series of over-life-size statues fronting the piers was once more created – Christ, thirteen Apostles, and saints of the cathedral. They are hardly developed as bodies. The strong faces of the apostles, which are developed by means of studies from life, stand on broader shoulders than Late Gothic figures usually have (Plate 227). The systems of folds are disproportionately long and almost submerge the bodies. They are dominated by creases and angular crests of cloth in a marvellously rich arrangement which does not come out at first sight. Between the ridges are flat, frozen surfaces, as if a tidal wave had stopped in its tracks. There are still echoes of the pre-Baroque. Thus these figures are not truly statuesque; there is a touch of the dancer about them, they burst forth, withdraw, seem to swing their shoulders, are in agitated movement, yet are, in a way, spiritually fettered. This is perhaps the most appealing cycle of sculpture of the time, and it gains in richness just because the statues do not seem to have been worked in mutual relationship.

The master responsible for them appears to have been Ludwig Binder. A late influence from Backoffen, an echo of Leinberger can be noted. Binder was still at work in 1560. His memorial tablet of Johannes of Anhalt in St Nicolai at Zerbst shows the prince with his raised head bent slightly to the side, with sensitive hands, in visionary movement. This is a worthy descendant of German cathedral sculpture, and yet characteristic of the new spirit in art and religion. But a greater artist may have been behind the work at Halle: Grünewald, who was Clerk of the Works for the cardinal, may have had more than a merely organizing influence on the creation of the figures.

South German art can also be seen farther to the east, at Cracow, where Stoss's influence was still to be felt. The export routes of Nuremberg led there. But the chief work of the time, of about 1520, the St John altar in the church of St Florian influenced by Stoss, has another connexion with eastern Germany.[10] Two scenes from the Baptist's life, with a landscape of great feeling, two with Salome's dance and the beheading, in which the flat, but precisely carved, high interiors seem to take a mysterious part in the events, important fragments of a Baptism of Christ, all show the influence of Leinberger, though with a difference which one might define as greater resolution. The greatest affinity is with the Danube style. The only country in which similar things can be found is Austria, especially in the work of the Master of Zwettl.

CHAPTER 27

SCULPTURE IN AUSTRIA AND BAVARIA

THE altarpiece from Zwettl, now in the church at Adamov (Adamsthal) near Brno,[1] is the chief manifestation of Austrian art in the early years of Charles V's reign (Plate 231). Traditionally, it was made in 1516–25. The time it took is adequate to the proportions of the work, of which only a fragment – the gigantic shrine – has been preserved. Andreas Morgenstern of Budweis (České Budějovice) was the joiner. The names of the six wood-carvers are not known to us.

In this work, as in the altars of St Wolfgang and Kefermarkt, the top canopy-work seems to force its way upward through the box-shrine, so that the trunk of oak out of which the whole grows unites in the end to become the bearer of the Cross. The subject goes back to the foundation legend of the monastery, but it also expresses the contemporary feeling for nature that we have found in Douvermann and Witten. In the subject matter of the shrine – the Death, Assumption, and Coronation of the Virgin – a good deal of local legend and allusion seems to have been woven in, and apocalyptic allusions too. St John, the visionary of the Book of Revelation, stands out clearly as a man of action among his duller companions, and it is he who sees what is happening in the shrine, a feature familiar from Italian painting. Unlike the Odense altar, the Zwettl altar has no clear demarcation between the storeys. The higher we look, the more do the figures lose their substantiality. The apostles, in all their grief, have the power of a primitive world; their draperies swirl vigorously as they do in Stoss; their beards are like bushes. But towards the top the swirls of the draperies grow more indistinct, as if they were on the point of merging with the pasty clouds. The warped ogee arches flutter upward.

This grand relief is uncoloured. A great deal in it has remained unexplained. The rioting angels of the Assumption actually are joyless, many gnomelike faces of the accompanying choir look oddly tormented, and in the host of innocent children's faces in the topmost range there are enigmatic grotesques. There were already similar forms of strange weariness at Mauer; in the twenties they are used to excess. But it seems beyond question that at Zwettl the apparently free flight of formal imagination was bound down to set tasks, even though we do not know what they were. The soft swell of the forms, the reduction of things to ornament, the independence of movements in an enchanted life of their own – all this can be called Altdorfer in three dimensions. Especially in the oak tree, the forest feeling of the Danube painters awakes to fresh life. In the course of his work the carver grew more and more Mannerist. His style has been found again at Melk in a large Mount of Olives, and in Vienna in the Resurrected Christ with the Virgin above the portal of the Salvator Church. A particularly delightful, graceful, and gay work of Viennese sculpture in stone is the St George altar in St George near Bratislava (Pressburg).

A Danube master of great power about 1520 was the carver of the Pulkau altarpiece.[2] The forms are more rounded than at Zwettl, the expression less refined. It is true that all this, like the altarpieces of Mauer and Zwettl, goes back, in the last resort, to Stoss. But the Austrian tone is unmistakable even here; the festal elegance which is a transmutation of Stoss's choleric manner, the decorative deftness in accessories, the spatial flow, the human relations between the characters in the scenes, are also characteristic of Danube sculpture. Thus this carver also worked at times with the Master of the *Historia Friderici et Maximiliani*.

Andreas Lackner probably descended from Stoss or his pupil, the Viennese Master of Mauer. He was living at Hallein in 1518; he was active in Styria and perhaps later in Vienna, but in any case he was in Styria in the forties and was the owner of a busy workshop for gravestones in the district of Leoben. He died in 1545.[3] In 1518 the St Blaise altarpiece at Abtenau was made, and the same year brought the deeply moving crucifix from Admont (Graz). There are unmistakable echoes of Leinberger, yet Lackner replaced Leinberger's springy, pithy figures by a broad and bulky feeling for the body, a pasty substantiality. The parallelism of the three Abtenau bishops is strange; with all the wealth of motifs in the drapery, there is little variety in the standing figures, but what they have to impart is all the more definite. We are faced here with the Mannerist motif of duplication. The excellent boxwood relief of St Benedict from St Peter at Salzburg (Vienna, private collection; Plate 234) and the two women saints at Leoben (Museum) are more fluent in line, and at the same time more relaxed in expression and also more vital. A small relief, signed EL 1522, of the meeting between St Peter and St Paul also shows Lackner's capacity for creating atmosphere in terms of space, uniting in a convincing whole architectural features not entirely credible in themselves.

Works of this kind, several of which are by a group of carvers obviously from Salzburg and Passau,[4] have come down to us and show the influence of Altdorfer's and Huber's painting; in addition, the graphic work of Dürer and Cranach, and even traits of Baldung play their part. Yet these carvers of pictorial reliefs succeeded not only in the use of painterly means, but also in the development of specific qualities of sculptural relief. This is obviously due to Leinberger's Moosburg altar. But the relationship between the Master of Irrsdorf, the Master JP of 1521, the Master Adam D., the Master of Tiedemann Giese(?), and the Master of Wolfgang von Thenn remains in doubt. Some of them may even be identical with each other.

The earliest works of this group are probably the Irrsdorf reliefs (Salzburg). They are scenes from the life of the Virgin with thick-set figures after the manner of Huber and may date from about 1515–20. High ruined church halls are composed by an intuitive perspective like the rich landscape spaces in JP's reliefs of the Fall. While Leinberger's pictorial reliefs were completely locked to the eye trying to explore depth, these small-scale carvers gave some hint of spatial depth which put life into the distance. This, the basic motif of Salzburg painting since Pacher, was now re-mirrored through Altdorfer and also Huber, who engaged one of these workshops for the sculpture of his Feldkirch altar. Just as nature does, the carvers interwove the elements of their

carvings, man, house, and tree. It is true that the human figure is firmly established in spite of its flowing moods. But masterly precision and deep undercutting are also applied to tree and leaf. These are 'fairy tales constructed with dogged German diligence'.[5] The individual forms are puckered, and the delight in their roughness is certainly drained to the dregs. But the small size entailed reduction to a pattern, for instance in the foliage. The reliefs of the Fall are packed with this concreteness, and just because of that they are impetuous and grave. The Eve of the Temptation (Gotha) is cool in her lunar beauty. The Family of Adam (Frankfurt, Liebieghaus) approximates to Altdorfer's satyr families. The reliefs signed Adam D., one of them dating from the thirties, follow closely those of JP, though in form they are perhaps harder and less fluent. Adam D. need not necessarily be a signature. JP may be interpreted as J. Pocksberger. These were the first German artists to give a full development in relief to architecture and landscape.

The portrait relief, however, in which the human figure is embedded in architecture and landscape, was also practised in this circle, probably under the inspiration of Cranach's early portraits. The portrait which bears the name of Tiedemann Giese (Berlin, Schloss Grunewald), a painted relief, is one of the best. A sweeping stage-set composed of ruins is related to the hat and dress of the figure, which occupies only the lower half of the relief. Human beings in a landscape of intense mood can be seen also in the portraits of a Young Man (Vienna), of Wolfgang Thenn (1531, London, British Museum; Plate 239), and of an Unknown Man with Skull and Hourglass (Berlin). In the portrait of Thenn an impetuous directness is conveyed by means of the jutting knee of the seated figure. Brocade ornament and chopped draperies luxuriate over the figure. This directness has become an important feature in the Berlin relief. The sculptural force is concentrated in the face and the significant play of the hands; the costume and the coat collar are as plain as a plinth, though a few delicate details are introduced into the background with its river port. The result is a portrait such as Huber painted in his last years.

Hans Leinberger's Landshut work is obviously, in its turn, also an early and very personal branch of Danube sculpture. Leinberger died at the beginning of the thirties; his work in the twenties was an intensification of what had gone before.[6] It was at that time that he made the splendid figure of St James the Greater (Munich; Plate 235), probably suggested by Baldung's woodcut of the seated St John the Baptist. This figure is not built up as body, but primarily as a wonderful star-shape; above the left knee radiate the folds of the drapery and the pages of the book which the saint's slender fingers are turning. Yet at the same time the block has gained inward firmness. The St George of the Frauenkirche in Munich may date from the beginning of the twenties; it possibly represents Leinberger's closest approach to the sculptural compactness of the south. Yet in spite of that his bent to ornament never weakened; the outline of St George and the Dragon remained a graphic flourish. The Rorer memorial tablet of 1524 in St Martin at Landshut gives us a date for Leinberger's coming to terms with Renaissance ornament; pilasters and piers are so woven over that the structure is almost obliterated.

The Christ in St Nikola at Landshut is close to the St George of Munich in its sculptural structure. The tortured head rests on the hand, and it is the weight of the head that one feels rather than the gesture of sorrow. That gesture is intensified in Leinberger's other Christ in Distress (Berlin; Plate 236). The modelling of the skin is flat and melting, and is conceived less as the covering of the body, which is built up from within, than as surface. In the *Tödlein* (Little Death) in Ambras Castle the main effect comes from these same tatters of skin and flesh, which move over the skeleton like leather. Death approaches dance, almost like the Count of Habsburg of the Innsbruck tomb, demonic and overwhelming.

The later the work, the more all form seems to be drawn into a single flow of line. This can be seen in the Virgin in the church at Polling, of 1526-7, with the enchantingly gay flow of her modish dress. The Man of Sorrows in the museum at Weilheim comes from the same altarpiece, but the chopped drapery has withered and lost its substance, and the figure is farther removed from organic growth than the *Tödlein*; it is disproportionately long and intentionally distorted. This is also true of the Crucified Christ at Pinkofen (private collection), a horribly elongated figure, purely emotional and probably the most frightful that Leinberger ever created. Compared with the St James, there is in these late works a drying up of the radiant form which still flowed in that figure. In comparison with the *Tödlein* and the St George, the dancing motif and the still statuesque conception of the body have been abandoned. Uniformity increased; the living quality of the forms and the natural contrasts they presented decreased.

In 1529 Leinberger received for the first time a salary from the ducal chamberlain which was not payment for a single work. This was the beginning of a regular connexion with the house of Wittelsbach. Leinberger died, however, between 1531 and 1535.

The memorial tablet of Aventinus the humanist (d. 1534) in St Emmeram at Regensburg[7] goes back to Burgkmair's woodcut portrait of the dead Celtis. But the difference between the two is immense. The Bavarian historian looks terrifyingly huge as a half-length figure framed by a window, behind which he cannot really find room. Many details resemble the relief portraits of Salzburg-Passau. The even folds of the gown, the perfectly groomed curly beard are intentionally contrasted with the sharp-featured face with the sidelong look that aims, but does not strike, and with the tense, yet already rigid features. It might be a portrait-bust standing in a window, the effect of something artificial rendered in terms of art is so strong.

At Innsbruck in 1518, after Sesselschreiber's disappearance, Stefan Godl undertook the casting of the great bronzes for Maximilian's tomb. After the twenty-three statuettes, seventeen full-sized statues were produced by his foundry. Leonhard Magt remained the carver of the Godl workshop; he worked after Kölderer's designs.[8] Now, for the first time, it is possible to speak of statues. Magt's statues were the first to liberate themselves from space and surroundings. Sometimes they look more thick-set than the earlier works and more broad in the build, like the statuettes. From time to time, it must be admitted, the sense of what over-life-size demands is lacking. The pasty fall of the cloth and the Renaissance unity of figure and costume are responsible for that.

Friedrich III might almost be a statuette. Yet this figure is of supreme quality. With a sublime bend of the head the father approaches his son's grave. Astute and unbending traditionalist that Friedrich was, he appears so great of soul, is so transfigured and spiritualized, that the statue may have been created after a model of the Sesselschreiber age. The same is believed of Philip the Good, whose magnificent face bears perfect comparison with the lavish heraldic ornament of his bell-shaped armour. It is difficult to know what part in these great portraits was played by Conrat Meit, who is known to have made posthumous portraits of people unknown to him and has been proved to have worked for Maximilian too. That is true above all of the statue of the Regent Margaret (Plate 237). Here all the formulae which play an obvious part in Magt's faces, for instance in that of Bianca Maria, Maximilian's second wife, have been avoided. Margaret is a unique and unrepeatable natural shape, supremely aristocratic even in the noble fall of her brocade dress. Yet Magt's personal touch certainly entered into his models as well: the great immediacy and profound feeling for materials are his.

Later, towards the end of the twenties, the forms stiffened. That does not mean that imagination failed to create so many ancient heroes. It would certainly have been possible to obtain portraits for some of the seven last statues, for instance that of Joan the Mad, in order to endow them with life. But we must ask whether that living quality lay in the line of Magt's development. Certainly it did, in the sense of the Renaissance statue. There is no question that the last of the series, Geoffroy de Bouillon, cast after Magt's death, has a credible and firm stance, perhaps the best of all the Innsbruck statues. But the complications of all this tomb work which had to be executed by the collaboration of so many artists and models in order to fulfil the romantically historical feeling of a man who was already dead, became onerous; indeed, the reverse side of this majestic, imperial conception must have made itself felt more and more. These complications come out in the greater artificiality of the forms. The stiffening that can be seen in the robes and in the consistently applied mass of ornament, and even in the knees of the men in armour, was really a development of Mannerism. It had little to offer to a man like Magt, who was concentrated on immediate impact, but in the end it produced the expressive old crusader Geoffroy de Bouillon.

How well the patron, who was by that time the emperor's grandson Ferdinand, thought of his Innsbruck foundry was shown in 1525 by the incident of the *Ehrenpild*. The Archduke had taken on a bet at Augsburg that Godl was the most skilful bronze-caster in Germany. The result was the bronze statuette of a warrior (Graz; Plate 238). What was required was a standing nude in a clever pose, but no actual subject was proposed. All that was asked was diligence, artistic skill, and daintiness (*Artlichkait*). What was produced – we do not know if it was considered successful – fulfilled the demands of the order; by introducing a gesture à la Pollaiuolo the sculptor did little to redeem the lack of clarity in his terms of reference, though he may well have felt a sense of relief with this new freedom. This is the story of one of the first works of art in Germany without a stipulated subject, a work humanistic in kind but without humanist collaboration – indeed, art for art's sake. The legs of the statuette still have a touch of Late Gothic thinness, but the contrapposto is tremendously developed. The figure is

stocky, the face serious and no longer young. The whole is masculine, powerful, without grace, and far removed from anything that Meit created at the time. The spatial sculpturality of Vischer's forceful Bough-Breaker is here perfected. Yet the *Ehrenpild* differs from it in its uselessness.

SCULPTURE AT AUGSBURG AND IN SWABIA

THE Fugger Chapel was Sebastian Loscher's principal work.[1] At the beginning of the twenties he had made ponderous altarpieces in deep layers of relief, at times in collaboration with Burgkmair. For the succeeding years until his death in 1551 only small-scale works can be attributed to him with certainty, but they are particularly delightful and spirited in execution. The magnificent statuette of the Virgin (Augsburg) is conceived fully in the round. Loscher built up his figures simply and developed them from the body. A certain stiffness in the stances enhances the vigour of their unadorned being. All this being so, Germans could probably only create Christian art for a short, favourable period, the period which also produced the beautiful relief of the Virgin at Munich (Plate 240). Here, motifs from the Lombardi are effectively exploited. The simple, box-like, stepped supports are characteristic of Loscher's feeling for architecture. He was not a friend of Hans Daucher's ornate style of relief.

The relief of the Homage to Jacob Fugger (Berlin) belongs to the early twenties. In this work, Loscher created, with the aid of Renaissance forms, a space which was felt rather than constructed, in the manner of the Salzburg–Passau wood-carvers. In the Justice relief (1536, Berlin), depth in space is created only by architectural and landscape elements. The air seems literally to flow around the magnificent figure. Yet Loscher too is an heir of the Middle Ages. He could make Justice's stance credible only by some outward whirls of drapery.

In the years after Maximilian, Hans Daucher[2] used the small size still more consistently than Loscher; he was specially suited to it, thanks to an extraordinary feeling for delicate work in fine stone. Such large-size work as he was commissioned to do or as was created under his influence is not without importance and is realistically credible, but does not possess a firm foundation in a basically cubic conception, like Loscher's.

The patrons must have shared the liking for work that was delicate and small. We can assume that many of Hans Daucher's reliefs were commissioned by the younger members of the house of Habsburg, for instance a Virgin with Angels of 1520 (Augsburg), a revised version of the relief of 1518 (Vienna) after Dürer and Marcantonio Raimondi. Daucher was a compiler, yet he produced very personal works. The very detailed, yet symmetrical architecture invests the graceful subjects with a rich harmony. Such architecture recurs in the memorial tablet to Wolfgang Peisser (d. 1526) in the Liebfrauenkirche at Ingolstadt. The sensitive filling of a plane, the use of subtle asymmetries – this kind of thing was intended for the humanist amateur.

The portrait roundels of the brothers Philipp and Ottheinrich of Pfalz–Neuburg (1522; private collection) are delightfully immediate in their impact. Full-length portraits with symbolic allusions and allegorical undertones are, however, more frequent in Daucher's œuvre. About 1522 there was an increase in the commissions for Habsburg

portraits of this kind. Maximilian is portrayed posthumously as St George (Vienna). The horse's body vanishes under its heavy trappings, but the horseman, in his powerful profile, represents convincingly both personality and rank. The bare ground is not scooped out, as Hans Schwarz did, it does not encompass; it is mere abstract depth, as Holbein's blue backgrounds were soon to be. This small-scale finesse would have meant nothing to the old emperor; his bent to the monumental died with him.

All the same, it was a misfortune that Mone, and not Daucher, became court sculptor to Charles V; for Daucher's equestrian portraits of the young emperor of 1522 show the superiority of his work (private collection and Innsbruck). The horse is seen rearing against a landscape. There is something fantastic, something strange in the whole. Daucher's ability to render the elegant play of Burgundian courtliness comes out in the relief of the two Habsburg brothers, executed some time after 1526 (New York, Morgan Library; Plate 241). The younger, then already a king, stands back a little and greets the emperor with a noble reverence. The most subtle variations of a stone-cold, vacant background make both stand out for what they are – rulers. There is no doubt that the relief stands for the unity of the Habsburg. It is doubtful whether, given the prevailing coolness, any feeling of brotherhood could have been conveyed. The horses are again masked and the bodies of the horsemen are rendered in a generalized sculptural form, but petrified in their armour and concealed by the parallel folds of their coats. The only echo of Dürer's verve is in the bold sweep of the hats. It gives the faces an expression of the momentary, a dash of youthfulness. In the Allegory of the Friendship of the Wittelsbachs of c. 1534 (Schloss Neuenstein), the centralized architectural motif reappears. In 1536 Daucher entered the service of Württemberg, but he died soon after, in 1538.

In 1516 Viktor Kayser appears as a pupil of Loscher's occasional collaborator Jacob Murmann the elder. He was registered master in 1525 and died at Augsburg in 1552.[3] He too worked in Solnhofen stone; there have come down to us a Holy Family (Louvre) after Dürer's Life of the Virgin, a Farewell of Christ (Munich), a Lamentation (private collection), and a Susanna in her Bath (Berlin), probably all dating from the twenties. In the last-named relief the swaying outlines of the fruit-trees, and even the garden as a whole, seem to be taking part in the action. The result is, as in Schwarz, the introduction of a strain of Danube nature-feeling into the art of Augsburg. In Daucher's Judgement of Paris and his portraits of the emperors there are landscapes too, but they are reposeful background accompaniments. In Kayser's work the landscape is active; it has as much life of its own as the fluttering draperies and the hair flaming round the gaunt, Late Gothic faces. The determining factor in his work is two-dimensionality. For the most part the figures are crowded on to two planes; thus his reliefs vaguely recall blocks for woodcuts, and so have the charm of abstractions.

Loy Hering, too, who lived at Eichstätt from 1513 till his death about 1555, must be counted among the Augsburg artists.[4] Like them, after large-scale works of the second decade, and after two richly ornamental tombs with stony bishops of c. 1520 at Eichstätt and Bamberg, he turned to small-scale sculpture, and from that time did outstanding work as a Kleinmeister.

The Garden of Love (Berlin) probably belongs to the twenties; a number of Dürer's engravings were skilfully combined in it. Although it is a relief done after the manner of painting, it possesses sculptural reality, and a highly relished convexity of the bodily forms. The Fall (London) is a relief half-way to free-standing sculpture, but it is not a fragment; it was made after Baldung's woodcut of 1511, but with characteristic changes which relieve stone-carving from the compulsion to fill a rectangular space (Plate 242). Hering retained the slight stiffness and constraint in Adam's pose; in her relief, Eve is enchanting and even more sensuous; there is special emphasis on the fluttering hair. The truly Baldung-like expression of covetousness is transposed into three dimensions and stands out – the endurance of a fiery experience. The relief of the Exposure of Romulus and Remus (London) belongs to the same period. There is great feeling in Rhea's writhing arms. The man with the determined profile carrying off the sleeping children has a strain of Quattrocento vehemence. In later works Hering develops a bent for the flatness of Daucher, for instance in the portrait relief of Charles V of 1532, where the emperor is portrayed as *pacis conservator*. The splendid Venus (Moscow), Hering's only bronze statuette, shows that his feeling for the rotundity of form could leave behind the dictatorship of the relief and achieve free-standing sculpture.

Seen from the point of view of Hering as an entrepreneur, all these things were more or less by-products. The bulk of his more than a hundred extant works consists of Christian art, especially funerary sculpture. He succeeded in getting much out of the most usual type, the donor kneeling under the Cross; he rendered it in peaceful moods. Dürer's graphic art was his main source. The most delicate work in stone is combined with ornament which changed gradually with changing fashions. Hering was the creator of a formula of humanistic utilitarian art of a very high standard. He exported works as far as Vienna and Carinthia; the most northerly points of his expansion were Boppard on the Rhine and Münden on the Weser.

At Augsburg, as against Nuremberg, the production of works in bronze was obviously sporadic.[5] One of them is the powerful, compact Neptune of the Jacobsplatz Fountain, cast about 1530. Further, there are a King David, a Prudence(?), and a Shield-Bearer (Munich) by the so-called Master of 1561, and probably cast before 1540. They have the Antique precision of Loscher. A magnificent specimen is a Lucretia on a door-handle (Vienna) by Joachim Forster, a superb figure standing on a skull and thus suggesting vanity, with a sideways turn of the head which is not motivated psychologically, but has an immediate appeal to the feelings; the hair is flaming, as in Kayser's agitated figures.[6] In 1516, Forster was a fellow-pupil of Kayser's under Murmann; later he became a goldsmith at Bern, was active at courts even in Italy and France, and finally worked at Augsburg, where he died in 1579. His brother-in-law was Christoph Weiditz the elder, a native of the Upper Rhine, who also settled at Augsburg in his later years.

But beyond enthusiastic workers in Solnhofen stone and skilful bronze-casters, there were certainly at Augsburg in the years after Maximilian master-carvers in wood, a material beloved by Loscher too. There is an unidentifiable portraitist of standing, known as the Master of the Heads on Boxes, who carved powerful and convincing portraits in genuine succession to the busts in the Fugger Chapel, but smaller, and

intended for collectors. For a connoisseur also, no doubt, was the wonderful Fortune on the Globe (Berlin),[7] the work of another unknown artist. The grace of the Augsburg school, freedom from any rules in spite of classicity, a strain of Late Gothic transposed into Mannerism, all this is contained in the dancing pose of the creature in her cap and floating sash.

But beside all this Augsburg art, a metamorphosed Late Gothic continued to flourish in Swabia, which still produced remarkable work in the smaller towns. Daniel Mauch continued, at first at Ulm, where Schaffner was also at work, and Jörg Lederer at Kaufbeuren.

But a new generation of wood-carvers also made their appearance. They are called the Masters of the Parallel Folds;[8] they appeared towards the end of the second decade, when the trend to the vertical came in both in dress and in the fluted armour named after Maximilian. Yet the style of the parallel folds is not a reproduction of these real forms, but a style which may have developed alongside the fashion. The wood-carvers' work is excellent; the carver of reliefs from Wangen on the Rhine (Rottweil, Lorenzkapelle),[9] who may have been a native of Konstanz, executed noble works in the tempered style of Swabia. Two others have been given names, the Master of the Mindelheim Holy Kinship and the Master of Ottobeuren, both probably active on the Swabian boundaries of Bavaria, to the east of the Iller. The former made his appearance earlier. The only date available is that of the death of Apollonia von Montfort in 1517, whose tomb at Neufra he executed. The work from which his name is taken was probably earlier than that. Early classic portraiture is blended with the presentation of a contented patrician family. There are still many pre-classic traits in the graceful little head of his Virgin and the worthies among the older men. The work is held together by the enchanting swing of parallel and fish-bladder-shaped runs of folds which die away like a melody at the edge in every direction, where the cloth is softly turned up. The general course of the line, emphasized by parallels, is softened by dents and dimples which bring out the corporeality of the bodies and invite the eye to linger. In the Montfort tomb, in the reliefs of saints at Nuremberg, and in the Adoration of the Magi formerly in Berlin, however, the entire form is inundated with parallel lines; clothing, utensils, and hair seem to be overgrown by moss. Forms are twins of other forms, not exactly as in Claus Berg, but on the same principle. Cloth is as vegetable as hair; yet, as in the Danube painters, what results is not only an impression of greater naturalism, but above all a feeling of wonder.

The Master of Ottobeuren was probably a successor of the Master of Mindelheim; no details about him are known. His reliefs with St Maurice and St Martin from Feldkirch (Bregenz) are not yet entirely stylized, not yet kneaded in all their parts; they allow the natural individual form, the repose of corporeality, to be seen. But in the Ottobeuren reliefs of the Annunciation and the Nativity this is all reduced to uniformity, as it is in the St Christopher from Babenhausen, now at Düsseldorf (Plate 246). Draperies and flags pour out of hidden sources; a mysterious light trickles over the figures and the landscape which is often included. In the Nativity in the church at Oberkammlach, drapery, hands, and hills seem like a single gesture, the revelation of a

single power gestating in them. That power does not expand, as in the Baroque; instead, it subordinates everything in the Mannerist way or, which is more characteristic of the Ottobeuren Master, pours life through everything. Small reliefs with Old Testament or secular subject matter, partly belonging to a series of Women's Wiles (Munich, Nuremberg, and private collections), which once obviously decorated pieces of furniture, show the progress of this style in the age of religious turmoil. The style of the parallel folds, the Swabian version of Early Mannerism, was most widespread between 1515 and 1530.

Christoph von Urach,[10] who was mainly active in the Neckar region, and later in Baden, obviously developed out of pure Late Gothic after 1500. He was active into the forties and ended in a robust kind of Mannerism.

SCULPTURE IN SWITZERLAND AND ON THE UPPER AND MIDDLE RHINE

ON the Upper Rhine, the Master HL was active as a maker of altarpieces even in the period after Maximilian.[1] His main altarpieces are the one at Niederrotweil, made probably about 1514/18, and the Breisach altarpiece, which bears the date 1526 (Plate 232). He lived till about 1533. Both altarpieces are partly coloured without undercoating, but are not polychrome throughout.

HL was the wood-carver who most resembled the Master of Zwettl. His Mannerism reached its full development in the Niederrotweil shrine. The figures in the Coronation of the Virgin are flattened, the draperies laid in ornamental folds; there seems to be no air to breathe. A few compositional features come from Baldung. St John the Baptist, a sentimentally self-complacent figure with intricate gestures which are quite unlike Grünewald's, yet has the pointing index-finger of the Isenheim St John. The shell-shaped folds of the Virgin's robe come from Grünewald too. The same motif, in ingenious transmutation, reappears in the splendid Nuremberg figures of the St Johns and in the Breisach Virgin.

In the Breisach shrine the same story is told as at Niederrotweil, but in more abstract form. The veil of ornament across the whole shrine prevents any idea of earthly space arising; it enframes the picture of an event remote from earth. This raising into the realm of air and clouds, which Baldung had created at Freiburg, is executed sculpturally here; the figures are borne aloft by clouds, but their undulating form passes into the draperies and the little bodies of the putti that bear them and are almost submerged by them: in this shrine the cloud is a fundamental gesture of sculptural representation altogether. Yet the subject remains intelligible, though it is transformed in highly personal fashion. Unlike Berg, HL made considerable differences between the individual subsidiary forms; they are rich and not completely subjected. The figure of the son is majestically mild. The flower-like and delicate figure of the Virgin Mother is both aloof and suffering. God the Father seems to be rooted in the folds of his draperies, to raise himself on them and radiate from them. The flames of his beard play round him, and his features are tense. This is no troll giant, as he is at Tirstrup: he incorporates something of the creative power in all growth. And he pours power into everything he does with the bend of his head, the ardour of his eyes, the strength of his shoulders; he commands the Coronation, which the son carries out jointly. The Evangelists on the predella are similarly significant in their being. They are the four humours incorporated in four ages of life.

However, this master of the grand style and the welling fantasy of forms also occasionally worked on a small scale. A delicious group of Adam and Eve (Freiburg im Breisgau) has come down to us.[2] Woodcuts by Cranach and the engraving of Dürer are

skilfully transposed in it. As in the Breisach Christ, interest centres less on the structure of the nude human body than on the sheen of the surfaces. There is no touch of the urgency of Gossaert, or of the fatefulness with which Baldung and Hering invested the subject. It is a serene Paradise in the silence of late summer, enriched by animals and many kinds of fruit.

Hans Sixt von Staufen is documented at Freiburg from 1515 to 1530.[3] His chief works, the Locherer altar in the minster, dated 1524, and four Habsburg statues on the Kaufhaus, dated 1530, are connected neither with HL nor with Wydyz. We may assume that their style derives from Hagnower. Hans Sixt was a man of simple mind of the type of Christoph von Urach. If the relief of the Intercession (Lyon) was carved by him, he began in a tempered Late Gothic style, and remained faithful to it in the unpainted Locherer altar, which is distinguished from the spirituality and fantastic ornament of the Breisach altar by its robust objectivity and harmonious balance. The best in Sixt's work are the quasi-portraits of quiet old men. As a sober realist, he may be said to have worked out everything to the last detail, while Dreyer, the humorous realist, appeals so strongly just by his allusiveness.

Not only Swabian but Upper Rhine workshops also made exports to Switzerland. HL had no small following there.[4] The Basel workshops with the peculiar pedantry of their beauty kept their influence for a time. A late specimen of this direction is the altar-piece of about 1534 from Schloss Wartensee (Zürich).

Hans Gieng, active from about 1525 to 1562/3 at Freiburg im Uechtland and at Bern, was the most powerful sculptor in the south of German-speaking Switzerland.[5] From his early years there is a salver with the beautifully masculine head of the Baptist (Freiburg). A stone group, Wrath (also Freiburg), made about 1549–50 for a fountain, consists of a warrior gazing wildly about him with a naked sword, accompanied by a roaring lion; it is executed after a Burgkmair woodcut.

Two names of famous sculptors on the Upper Rhine remain. Friedrich Hagenauer, in all probability the son of Niclas Hagnower, and in any case a native of Strassburg, led a wandering life as a sculptor of small portraits; he was mainly active in South Germany and Cologne (1536–44).[6] With Hans Schwarz and Christoph Weiditz he was among the most important portraitists. He had a predilection for the eloquent profile, but there are also heads by him in frontal view and with half-turned faces. There is vivacity in his grasp of his sitters. He invested them all with a Cinquecento directness which comes from a pregnant conception of his subject and a precise idiom of form, and is often executed in strong relief. His relation between background and figure is unerring. It is still present in the large relief bust of Philip, bishop of Freising (Berlin); the background is plain and lacks the landscape which the Salzburg school loved so much, but owing to the wood it is warmer than Daucher's backgrounds.

Christoph Weiditz the elder, in all probability the son of Hans Wydyz the elder, the brother of the painter Hans Weiditz the younger, produced between 1523 and about 1544 a hundred and fifty of the most beautiful German medals, which most magnificently represent the main protagonists in the history of Charles V. He had travelled through Europe for a time in the emperor's suite, and settled at Augsburg in 1532, where

he died in 1559.[7] In the development of his style he owed a great deal to his brother Hans, probably a good deal to the Netherlands, and later to his rivalry with Hagenauer. His portraiture is so rich in form that it too could be turned into large scale, as can be seen in the terracotta bust of an unknown man (self-portrait?; London). Compared with the terracotta of the young emperor (Bruges, Musée Gruuthuuse), it is without tension and concentrated on the representation of what was visible and dignified, and is remote from interpretation of character. Weiditz also made silver, bronze, and fine wood statuettes, for the most part very slender, extremely rhythmic figures of suave coolness. Here too we can only assume derivation from South Netherlandish statuettes. The later Weiditz's figures were executed, the greater the appeal he gives to eloquent contour, the tapering of the extremities, and a certain suppression of details. The Lucretia (Florence, Bargello), which is somewhere between Antwerp and Augsburg in style, is full of the psychological insight of High Mannerism. At that time Weiditz was collaborating with his brother-in-law Forster at Augsburg.

On the Middle Rhine, sculpture developed under the aegis of two great masters, Grünewald and Backoffen. At Mainz, the memorial tablet of Canon Hatstein (d. 1518) in the cloisters of the cathedral is in the manner of Michelangelo's Pietà in St Peter's; it had no successors.

We must believe that Grünewald was capable of undertaking the designing and superintendence of buildings and sculptural work in the same way as Gossaert, Coecke, and Blondeel. In 1511 he was employed by the elector as Chief Clerk of the Works for the alterations to Schloss Aschaffenburg and delivered designs and models for architectural members decorated with sculpture. His influence at Halle too may have consisted in such work. But there is more 'Grünewald sculpture' than 'Altdorfer sculpture',[8] and the former does not merely represent the movement of the primacy in the arts to painting which took place in the later years of Maximilian: the personality of the painter himself can be felt in these works, not merely the adoption and transposition of his individual forms of painting, as in HL's work.

'Altdorfer sculpture' began in the age of Maximilian; what it brought was the inclusion of the environment, the communication of atmosphere – in short, painterly sculpture. But in Grünewald's work the essential factor was the transformation of the figures. It tended to Mannerism; it was created later. It is not clear, moreover, how much the Grünewald group owed to Leinberger, which would mean that a branch from the tree of painting had been grafted on to a sapling which had, in any case, grown out of a coming to terms between sculpture and painting.

The Crucifixion from Mosbach near Aschaffenburg (Darmstadt) (Plate 22) is fully in the manner of Grünewald and most nearly related to his style; the gale blows the Virgin's robe against her body, imprisoning her in its metallic forms; in the frontal view – and the group was practically made for that – her face is almost hidden. St John embodies the more active attitude of mourning; his large face is sensitive and flat in the modelling, and is beautifully moved. Christ soars gigantically above, a crucified Hercules, dead. The most beautiful figure is the Bishop (Frankfurt, Liebieghaus), which is probably connected with Backoffen (Plate 245). There is something of the pre-Baroque in the

almost dancing twist of his body, in the wonderful swing of his draperies. A rich volute, already present in the St John, has become a dominant motif. The knife has cut deep into the wood, and thus the wrinkled old man's face in its unadorned almuth surmounts, as the clearest sculptural form, the fluttering swell of the drapery. Only a comparison with Lackner's St Benedict (Plate 234) can show how much Middle Rhine moderation is preserved in the figure. This bishop is lighter, more fragile, and more graceful than anything made by Leinberger, and soars without effort.

The two bishops at Düsseldorf,[9] the St John the Evangelist in the church at Bossweiler (Pfalz), and the altarpiece from Burgschwalbach (Wiesbaden)[10] belong to the Middle Rhine. As in Witten's late Virgin, and as in the later works of the Master of St Benedict, the Virgin's proportions are expressively elongated, and one can feel that she is made of wood.

At Mainz, the St Thomas group in the cathedral of 1521 continued the stone-carving style of Backoffen.[11] The high relief is half-way to free-standing sculpture. The carving is choice and fine. Christ is of earthly corporeality, yet the Late Gothic idiom of folds is beautifully combined with it. The subject of Doubting Thomas is rendered rather as a spiritual insight than as palpable proof. Putti, one bunching up his robe and another making music, are not mere externals.

This line was continued by the Master EA, who made the Greiffenklau memorial in Trier Cathedral (1525–7) in a clear dispassionate realism, like the sculptor of the Ottenstein tomb at Oberwesel, where the woman (d. 1520) appears in a closely pleated robe with a free-hanging cloak beside the man in smooth shadowless armour. Finally, the wall-tomb of Archbishop Johann von Metzenhausen in Trier Cathedral of 1542. This is extremely Renaissance in its structure, even though there are some left-overs of Late Gothic forms. Just as nobility can be revealed in silence, there is in this monument a patrician emptiness, and only the accessory forms are in rich, though delicate relief. This is one of the outstanding works of post-classical Mannerism, and one of the few in Germany that can stand comparison with similar works in Italy.[12] But if one looks at the Middle Rhine bishop (Cologne, Schnütgen Museum), or at the Halle Cathedral sculpture, which goes far to negate the body, the parting of the ways at which Backoffen's workshop must have stood becomes clear. When the master's death obviously dispersed his assistants, both post-classic and Late Gothic Mannerism were within their reach.

Finally there is a group of Middle Rhine tombs of members of the nobility, especially in the neighbourhood of Heidelberg, where the connexion with Mainz and Backoffen is not clear. Hans Seyfer's influence may have still been directly operative. The monogram ML would fit the Heidelberg sculptor Moritz Lacher (or Lechler) mentioned from 1519 to 1538.[13] Some of the monuments are unusual. In the Ingelheim tomb of 1519 at Handschuhsheim, a strain of Early Classicism seems to linger. Escutcheons and crests sway in front of the magnificently undercut, Late Gothic branch-work ornament of the fluttering helmet covers. The upper termination is formed by an undulating inscription, not by an arch. The woman seems to be breathing under the loose flow of her pleated dress; the freely moving knight in armour stands in Antique contrapposto. In her monument at Oppenheim, Katharina von Bach (d. 1525) seems

to lack breath in her narrow Renaissance aedicula. Although it is only a torso, this tomb is perhaps the most monumental funerary figure of the period. It is bursting with form. In its union of classical corporeality with the rustling language of the robes it resembles the late Parthenon style.[14] The flow of movement is becoming autocratic; the figure is imperceptibly outgrowing its natural measure and is becoming excessively steep. A fellow-spirit of Levin Storch was at work here.

SCULPTURE IN FRANCONIA AND AT NUREMBERG

At Würzburg, Riemenschneider was still active in the period after Maximilian. His late Virgin from Tauberbischofsheim (Berlin) also gives proof of the Mannerist transmutation of the Late Gothic.

Riemenschneider's pupil Peter Dell the elder was a native of Würzburg and died there in 1552.[1] He was a wood-carver on a small scale, and occasionally worked in bronze. When he was registered master in his native city in 1534, he had been an assistant to Leinberger, and he owes to the great artist of Landshut the style of the few large-scale works that have come down to us, for instance, the Virgin and Child with St Anne in the Wilgefortiskapelle at Hörstein. Apart from graphic ideas, the main compositional features of his Crucifixion reliefs also derive from Leinberger. But in his small works he transposed this into the Franconian style; the contours are hard, the profiles with their receding chins are often thrust forward, the line is sharp and decided. His most powerful works are his portrait reliefs, made in the twenties and thirties; in them he united something of the atmosphere of Salzburg and Passau with a clear observation of mankind and a tempered vitality. The six statuettes of the deadly sins (Nuremberg) are late works. It is chiefly in their faces that these slender, fashionably dressed women manifest their vices. There is no violence in the playfulness of their gestures; the whole remains allusive. Dell's art was made for men of culture.

Veit Stoss was also still working at Nuremberg, like Peter Vischer the younger, whose father was still alive too. The monument in the Schlosskirche at Wittenberg, made by the son in 1527, established the type of tomb produced in the Vischer workshop for a long time after the death of both masters: a slightly projecting Renaissance aedicula, precisely set, surmounted by an area of floating escutcheons without constructive intention.

Sculptors trained by Peter the younger and Hermann Vischer may have continued to work in Nuremberg.[2] The bronzes of pacing youths in Munich and Vienna are probably transmutations of Italian forms into the idiom of this group. The flowing contours, the sloping shoulders, the curious unsteadiness in the long paces of their advance are as German as they are Mannerist, and perhaps even show a retrospective influence by Flötner on Nuremberg. This would be the place to refer to the figure known as the Nuremberg Virgin, a wood-carving of fine and restrained tonality.[3] It was probably made as a model in the Vischer workshop and once more shows that alloy of German Late Gothic with the spirit of the Quattrocento which is to be seen in the Apostles on the Shrine of St Sebald; it is a late echo and probably dates from the twenties. The classic element had not increased since the days of Peter the elder and his two great sons, the Late Gothic is undiminished. Yet nowhere in Germany had there been a Late Gothic as flaccid as this, and with so little regional atmosphere.

At Nuremberg, as at Augsburg, small-scale sculpture now took the lead; this development had been prepared long before by the Vischers. The first artist to work exclusively on a small scale was the versatile Ludwig Krug,[4] born about 1488/90, the son and brother of two Nuremberg goldsmiths both named Hans; he died in 1532. As a goldsmith he was, with Jamnitzer, the greatest in sixteenth-century Germany. He obviously worked in part after Dürer's designs.

For the relief of the Fall of 1514 (Berlin) there was no graphic original; the whole is dominated by the smooth front view of Eve, the muscular back of Adam; the outlines are clarified, the heads rendered in pure profile, and there is practically no subsidiary detail. The whole is stone-cool and almost without action. The first parents are self-conscious. The same subject at the moment of the serpent's temptation is to be seen in a relief of 1515, extant only in bronze casts, which is more narrative, but formally closer-knit. The spell was not broken till a later red marble relief (Munich; Plate 243); here the action is almost cheerful; it is accompanied by drastic gestures – a waving tree with an almost comic serpent, and fluttering hair. Krug executed his last version of the subject (Berlin) in alabaster on grey slate, so that the outlines recover their former elegance. Adam's cramped attitude goes back to Michelangelo; the intricate movements show Krug's post-classic Mannerism. And finally there is the wonderful relief of Orpheus and Euridice (Hamburg), a transfigured, more serried reduction of Peter the younger's plaque to a closed form. In this work Krug found a more direct expression of tragedy which was perhaps beyond Peter Vischer's lighter, more playful manner. After Dürer's death sculpture became more important than painting at Nuremberg.

The Berlin relief of Cleopatra is dated in the year Krug died, and its monogram PE probably points to the gem-cutter Peter Ehemann, who is documented at Nuremberg from 1510 till his death in 1558.[5] The high relief, mounted on slate, is one of the most outstanding works of post-classic Mannerism at Nuremberg; it goes back to a Euridice by Mosca, and an engraving by Beham provided the model for the pilaster ornament. All the same – and just after Krug – it has a tone of its own in its flowing outline, in the sleekness of its forms. Cleopatra has the same yearning look as two ivory statuettes (Munich), probably by the same master, which again represent beautiful women suicides: they show some sentimentality and impoverishment of feeling.

At this time Nuremberg also produced portraits without the display of outer dignities which Christoph Weiditz had given to his London terracotta. Matthes Gebel, *Konterfetter* and *Statuarius*, registered citizen of Nuremberg in 1523, where he died in 1574, carved two nearly life-size busts of counts palatine (Munich), in which the unadorned head actually looks bare, so much was he concerned with the sculptural form. Their profound insight makes them true successors of Meit's small portraits, but in the grasp of a passing moment they are works of a later time, probably of the thirties. So here is another medal-cutter who mastered the large scale.[6]

The greatest Nuremberg artist of these years, however, was Peter Flötner.[7] He was born in the nineties, probably in the Thurgau in Switzerland. In 1522 he came from Ansbach to Nuremberg, and died there in 1546. Two visits to Italy – the first about 1520, another soon after 1530 – matured and clarified his style, although his beginnings

betray something like a basic gift for the classic form, which was certainly reinforced in the city of Dürer and the Vischers. But his way took him farther. Two works of the twenties show the vitality and creative power of his sculpture. The bronze horse at Stuttgart (Landesmuseum; Plate 248) is as unruly as a foal, and is far removed from the monumentality of Erhart's horse for Maximilian; this sculptor, who was too young for the Early Classicism of Erhart and Sesselschreiber, had not the makings of classicism in him. The boxwood David (?) (Vienna), perhaps inspired by Michelangelo's marble figure, presages in the drawn-out tension of its long limbs, and in its intricate bends, the coming master of Mannerism. These two pieces are not built up by the articulation of single links; Flötner as a Cinquecentist started out from the anticipation of the organic whole. The sharp double folds on the youth's left hip are characterizing accents, not joints as in a work of building; in that there is a last echo of Gothic.

A further visit to Italy disposed of Gothicism for good. The great work which followed, the Apollo Fountain of 1532, the most splendid piece in Nuremberg since the time of Dürer, has no vestige of it (Plate 244). It is based on Barbari's engraving of Apollo and Diana, but everything has changed. Here, in a later generation, Dürer's striving for formal clarity and purity is fulfilled; any clinging to characteristic detail has been stripped away. It lacks the force of Dürer's Apollo; there are none of the characterizing tensions which Flötner had had before. Flowing contours, slender proportions, light, almost elegant movements, a fully achieved volume, and a perfect calm in the front of the body make this Apollo stand comparison with its Italian contemporaries. It may be that Flötner had only seen classic and no Mannerist work in Italy, so that he could, of himself, take the step to post-classical Mannerism for which Nuremberg had long been prepared. With ingenuity he placed the figure, with its demonstrative beauty and economy of detail, in contrast to the very agitated form of a pedestal with putti riding on sea-creatures; even animals cast from nature are introduced. These extreme curlicues set off the smooth and rather vacant main form; the artistry of the whole becomes palpable. All this corresponds to an early phase of Mannerism; 'natural' balance between the whole and the details is not aimed at directly but achieved by contrasts, yet all the forms are not made to resemble each other so closely that a uniform impression of over-fullness or emptiness could arise.

This proportion of extremes is also responsible for the harmony of the chimneypiece of 1534 in the Hirschvogelsaal in Nuremberg. The construction as a whole is definitely southern – in comparison say to the Bruges chimneypiece, which is not much older. It is true German Renaissance in its most joyous, freest form that enlivens the frieze of the playing putti. But however much man may be grasped in his corporeality, he is not the measure of all things; that can be seen by the way the frame compresses the putti and by the overcrowding of the relief. But above all, this fullness is set in contrast to emptiness, the purity of the outlines is related to the overlying network of ornament, and it is this determined apportioning which is entirely Flötner.

Flötner kept up a versatile activity in sculpture and architecture at Nuremberg; it was not only in his finished works but even more as a designer that he was a true *praeceptor Germaniae*. By the woodcuts and the drawings for memorial tablets, furniture and

marquetry, goldsmiths' work, bronzes, and stove tiles he exercised an influence in his time as great as Cornelis Floris did soon after. But Flötner was in the happy position of always being able to execute his designs himself, and he did it with great precision. His small works in Solnhofen stone, and above all the wealth of his plaques, most of them in lead, are proof that his inexhaustible imagination was not content with designing. Christian, mythological, and didactic human subjects are all equally represented. These are the works in which he was most free of the formal austerity of Nuremberg. Krug's sculpture can be related to Dürer, but not Flötner's. In a design for a memorial tablet he seems to have been inspired by Grünewald's Transfiguration. His figures are sensitively elaborated, growing from their background with wonderful suavity, all slender in their proportions, often seeming to float in long-drawn draperies with melodiously falling folds. The background is often a natural space, and its figures play their part in the whole, in the breathing of the vegetation and the brilliance of the light. Flötner was a sculptor-poet just as Altdorfer was a painter-poet; it is the living feeling, the lack of anything dogmatic in his enthusiasms which make his genius so joyous.

THE END OF THE AGE OF CHARLES V AND FERDINAND I AND THE EARLY YEARS OF PHILIP II: ACADEMIC MANNERISM

CHAPTER 31

THE END OF THE AGE OF CHARLES V AND FERDINAND I AND THE EARLY YEARS OF PHILIP II, 1546–1564/7

IN 1544, Charles had brought his fourth war against François I to a successful close. In the Peace of Crépy, François had not been able to keep Milan, and he had renounced his hopes of Naples and his supremacy in Flanders, while Charles had ceded Burgundy. Charles had obtained the maximum of what was available to him. In 1545 the Council General, till which all religious questions had been postponed, opened at Trent. One of the emperor's most urgent aims began to be fulfilled.

Luther died in 1546. Charles took the path of power in order to achieve the inner unity of Germany. However, with Duke Moritz of Saxony (1521–53), a shrewd and perhaps unscrupulous politician appeared on the scene. He was first Charles's most important co-operator and then his most avid antagonist. Himself a Protestant, he played for high stakes and for the time being saw his main chance of gain on the emperor's side. His much disliked cousin, the Elector Johann Friedrich, lost the war for the Schmalkaldic League at the battle of Mühlberg in 1547, and became a prisoner of the emperor. Moritz was awarded the status of elector of Saxony.

Lutheranism was not stamped out. Yet from then on only Calvinism, but not Protestantism as a whole, was able to gain ground. The dead point of the pendulum had been reached. The emperor was now in a position to abolish the existing supremacy of the German princes. Many ideas of Maximilian's played a part in his own, though in a new form. In particular, he considered the establishment of a standing army to be subsidized by specific regions of the Reich in order to guarantee the defence of the Reich frontiers and peace throughout the country. That would also have strengthened the emperor's position. The succession was to have been secured for – in this order – King Ferdinand, the emperor's son Philip, and Ferdinand's son Maximilian. In that way the cohesion of the House of Habsburg and its territories would have been secured.

But the Diet of Augsburg of 1547–8 frustrated every plan, even those of the victor; even Ferdinand turned against the proposed order of succession. Fresh solutions had to be found. In 1548 Charles began to effect a legal and political dissociation of his Burgundian territories from the Reich, and in 1559 the old spiritual unity of the Netherlands with Cologne was terminated by the establishment of three new archiepiscopal sees.

At Trent too Pope Paul III thwarted the emperor's expectations of settling the controversial religious questions by postponing the settlement until the defeated Schmalkaldic League would participate and agree to enter on negotiations. In a second phase of the Council in 1551, in which, among others, Melanchthon took part as the representative

of Moritz of Saxony, religious peace seemed to be coming to grief on the obduracy of the Curia.

Finally there appeared a decisive weakening of the emperor himself, the only power which really aimed at union. By a crafty policy of subterfuge, Moritz of Saxony had practically become the head of the same Protestants he had fought at Mühlberg. He suddenly advanced on the unarmed emperor, who escaped the attack by the skin of his teeth. In this attack Moritz was in league with Henri II of France, who had, by an obscure agreement with the plotting princes, obtained a kind of right to lay hands on the Lorraine bishoprics, which he promptly proceeded to do. In the Treaty of Passau in 1552 the imperial party was forced into granting religious peace according to the *status quo ante* even without a Council. The Pacification of Augsburg of 1555 was thus implemented, though the Calvinists were not actually included in it.

Moritz did not live to see the Diet of Augsburg. This, the most gifted of the German princes of his generation, who had largely determined the history of the century, fell in battle in 1553. Augustus, his more circumspect brother (d. 1586), carried on the important role of Saxony as the second power in the Reich, taking the middle way as a Lutheran and maintaining peace for many years.

But even the emperor did not appear at the Augsburg Diet of 1555; he eluded the consequences of his failures. He began the series of his abdications. By 1556 he had laid all his crowns in other hands: Ferdinand I (d. 1564) had become emperor, his son Philip the successor to the hereditary territories in Burgundy and the Netherlands, in Italy and in Spain. Charles died in retirement at the monastery of Yuste in 1558.

Yet however powerful both Habsburgs, and especially Philip (d. 1598), were at that moment, they were on the defensive all the same. The religious reorganization of Germany had failed. Neither the Catholics nor the Lutherans nor the Calvinists had won the day; now there were three creeds, although the third had no assured legal status in the Empire. The way to a national state, which France and England were to take successfully, though with terrible religious wars and conspiracies against the Crown, was practically cut off. Part of the reason may have been that Ferdinand, though firmly rooted in Germany, could not liberate himself from Charles's conception of politics on the grand scale when the time came for him to rule alone. That conception had been a unified Christian western world.

And even the other heritage, the Netherlands, which could have become a mainstay of any future world rule such as envisaged by Charles, detached itself more and more from the Empire. It is true that Philip received the Netherlands practically free of any imperial suzerainty, but he found himself faced with a new and vigorous root of national statehood which, fostered by Charles for other reasons, was soon to put forth lively shoots. It was not granted to Philip to guide matters in Europe from so lofty an outlook as his father's.

Peace still reigned: indeed the successors to rule in Germany were able to maintain peace for many years to come. Thus the ten or twelve years which followed Charles's abdication were more or less under the same auspices as his own later years. This period about the middle of the century is a culmination of the conflicting concepts of the age

which had been created at the time of Maximilian's freedom of thought, and developed side by side with enormous force in Charles's early decades. Later Charles and Moritz had striven to fuse them or to reduce them to a relation of polarity.

There still lingered something of the spirit of Erasmus, in whose name two of his disciples had come to grief, Zwingli and Charles, when they endeavoured to decide spiritual matters by force. Was it within the potentialities of the third power, the Lutheran, which with Erasmus had remained more aloof from than all the rest, but which was now led by the clear-minded, sensitive Melanchthon (1497-1560), to establish something like order in Germany? The makings of it appeared in the Elector August's time.

But the sky ahead soon darkened. In 1555 Pope Paul IV began to apply the Inquisition, founded in 1542, to Christian humanists in Italy. At its last session the Council of Trent, in 1562-3, confirmed the functions of the censorship and the index, established in 1559. What had been foretold at Regensburg in 1541 now became actual fact; the Church codified its dogmas and hence broke all the bridges to the other creeds which its tradition would have enabled it to build. The decision gave the Church internal power, and it immediately gained in secular and spiritual power. As a result, the new creeds – while Luther had always aimed at reform and not at separation – of necessity became 'churches', and as many churches, to be exact, as there were Protestant sovereigns. Intolerance, once based rather on local and temporary phenomena, began to flood the whole of Europe. It is not by chance that Charles, at his abdication, spoke with regret of the failure of eleven edicts of growing severity issued from 1520 on against heresy in the Netherlands, which threatened the death penalty in nearly all cases. It was only now that the practice became truly serious. But there was burning at the stake also in Geneva. All that was left to the more liberal-minded were small islands clustered round greater powers, in the circle of the emperor, who in the end had represented the old faith at Trent, struggling alone and with all his power for inner reform, and even round Philip II and his half-sister Margaret of Parma, who was Regent of the Netherlands from 1558. There were also members of the high nobility, especially of the Netherlands, who did not share the inferiority of most of their equals in rank inside Germany.

It is true that in 1566 the noblemen of the Netherlands, harried in their struggle for their rights as nobles against the reforming younger Granvella, allowed the Calvinistic preachers to incite the people to a burst of image-breaking in the churches. These misdeeds led to dangerous reactions. In 1567 the duke of Alba appeared in the Netherlands with a Spanish army and replaced Margaret as regent. The dispute between the sovereign and the nobles set in there too. In the end it was only successful in the south. In 1568 Counts Egmont and Hoorn, who were anything but extremist, were executed in open violation of the law. Other nobles, in particular William and Louis of Orange-Nassau, escaped Alba's clutches. The Burgundian period of far-reaching internal peace in the Netherlands, which had once been re-established by Maximilian, was over. Persecution of the heretics was the order of the day.

The way of living of the German high aristocracy of all creeds was often astounding. 'Judging by their manners, there are hardly coarser-grained Christians to be found anywhere' Erasmus had said as far back as 1518. Drunkenness and gluttony, whoring and

hunting seemed to fill their days even up to the reigning princes. The vitality of this generation, applied to material pleasure, was often undermined by remorse which was as vague as it was demoralizing. All this being so, matters in the territories took what course they would. It is all the same notable that this only apparently vital generation went about pompously in dark Spanish costume, that the Burgundo-Spanish etiquette invaded even small courts, while in the lower classes there still remained a touch of the gay clothing of the age of Maximilian and also of the early years of Charles V.

The result was that the culture of Germany became still more split up. The few centres of the past certainly remained, and as long as matters were unsettled, Augsburg and Nuremberg were even in a position to expand their influence. But the number of smaller, territorial centres of culture definitely increased. Great building schemes were embarked upon at Dresden and Heidelberg and in other places. The first genuine art collections were begun at Neuburg and Heidelberg by Elector Ottheinrich of the Palatinate,[1] and at Munich by Duke Albrecht V.[2] Ferdinand I himself was something of an art lover, but even his work, like that of all the others, was provincial and not imperial in scope. Moreover, a new factor came into play to intensify the late medieval dispersal of the Empire into separate centres of art so that the significance of even medium and small capitals increased, be they Jever or Gottorp or Brieg.

SCULPTURE IN THE NETHERLANDS

THE invasion of Netherlands sculpture by the Renaissance[1] has something in common with the way in which the 'Roman' ponderousness of the High Renaissance in Italy itself followed the daintier, more ornamental style of the late fifteenth and the early sixteenth century. Yet the Italian manner, which was at first only used by progressive-minded newcomers, and was appreciated by the temporal and spiritual nobility and praised by the humanists, collided with a deep-rooted, popular Gothic tradition, and it was not until the thirties that the mere quotation of figures and ornaments all'antica in their old connexions was transformed into a truly new style. Both sculptors and architects found their way to a freshly organized form of classical harmony. Conrat Meit's figures at Brou, or Lancelot Blondeel's and Guyot de Beaugrant's light-footed, highly decorative figures, which seemed to be nearly merging with the overmantel in the Bruges Palace of Justice (Plate 222) and already then looked modern in comparison with the Late Gothic overmantels which were still being made – for instance that in the Council Hall of Courtrai (Kortrijk) of 1527 – were followed by more self-confident, voluminous figures in truly classical poses. Their faces express sublime gravity; the ornament, which consists of purely Renaissance forms, is restrained and soon spreads to the whole of church furniture, stalls, pulpits, fonts, stoups, and even to structures for which Italy had no models – rood-screens or tabernacles, whose Gothic structure appears strangely interspersed with these Antique motifs. The human form takes precedence; the knowledge of the body and its functions gives birth to a higher realism. The understanding of the modern style becomes deeper and replaces the first stormy, often gothically uneconomic adoption of innovations. There is greater artistic wisdom, less impulsiveness and less play of hybrid forms.

Beside Jean Mone and Guyot de Beaugrant (cf. Chapter 25), Jacques Dubroeucq (c. 1505–84)[2] was the third and the most determined modernist. After about five years in Italy, especially in Rome – a sojourn then already de rigueur for artists – he returned in 1535 to Mons (Bergen), where he finished for the church of Sainte-Waudru a huge rood-screen by 1548 and two altars about 1550. He also designed the choir-stalls and the choir-screen. Besides tombs, altarpieces, and choir-screens, rood-screens of French types remained favourite commissions. They were incomparably splendid; the Gothic love of luxuriant decoration continued to dominate, as in the overmantels, which are the opposite numbers in secular art to the rood-screens in the churches. Dubroeucq's rood-screen at Sainte-Waudru, like all the rest of the decoration and furnishing of the church, was destroyed in 1797, but was rated as high as those of Reims, Amiens, and Beauvais in the seventeenth century. The sculpture, most of which has been re-united in the church and assembled, since 1926, to form various altarpieces – statues of Virtues, etc. (Plate 251), reliefs with biblical scenes in the traditional alabaster –

bears eloquent witness to Dubroeucq's impressions of Italy. The statues show a more classical contrapposto than the figures in the reliefs, which are linear in their movement and recede in many subtle gradations after the manner of the *rilievo schiacciato* of such Italians as Sansovino, Francesco di Giorgio, Donatello, and Ghiberti; but they are composed with fewer figures boxed in tightly. This, Dubroeucq's most important creation, must have seemed doubly revolutionary in the Gothic interior and beside Gothic screens such as they were still executed, for example in St Gommarus at Lier (1530–40) and St Nicholas at Diksmuide (Dixmude) (1535–44, destroyed in 1914). When the artists of the north first appeared in Italy seeking for the style *all'antica*, they did not follow Michelangelo but the calmer, more classic bent of northern Italy, which was chiefly represented by Antonio and Tullio Lombardo (d. 1515 (?) and 1532), and above all by Jacopo Sansovino (1486–1570),[3] who had to a certain extent transposed Raphael's Roman figure style into terms of sculpture. Sansovino's workshop was as large as his following, which included Danese Cattaneo and Alessandro Vittoria. The North Italian style responded far more to the Antique statuary then being unearthed than did Michelangelo's and hence it entered more easily into the way of feeling of the first Italianist northerners. In this connexion we may think of the importance of the Lombards, the Leonardeschi, and the Venetians for contemporary northern painting. Thus in the work of Mone, Dubroeucq, and their contemporaries of the thirties and forties there is no *terribilità*; along with Sansovino's classical style and controlled movement there is grace and powerful but temperate modelling, but it is simpler, tending more to robustness, and is at times of a latent Gothic like its models, whose moderate proportions and movements contained a certain element of Mannerism, transposed into the anti-classic style. The harmonious forms and the stylized beauty of Sansovino's manner also passed into the later years of the century by way of Floris.

In Dubroeucq's workshop, from about 1544 onwards, Giovanni Bologna of Douai (1529–1608) was employed.[4] He did not, however, return from the visit to Italy on which he set out about 1550 and became an Italian, even in his art, although he never denied his Flemish origin. However great his influence was in Italy, and, through his pupils, in South Germany, there are far fewer traces of his work in his native country than might be expected. As regards his pre-Italian years, only the figures of Faith, David, and Moses on Dubroeucq's rood-screen have been tentatively attributed to him, merely on the basis of not very convincing conclusions from his later development. He settled in Florence in 1558/9, soon became famous there and at Bologna (with the Neptune Fountain, completed in 1566, his first major work), and forms the historical link between Michelangelo and Bernini. He parted company for good with the history of art in the Netherlands.

If Giovanni had returned, he would most likely have become the rival of the master who, about 1550, made Antwerp the centre of sculpture over the heads of Malines, Bruges, Liège, Brussels, and other towns: Cornelis de Vriendt, alias Floris, who was born in 1514(?) and died in 1575.[5] Within a few years he rose above all the local schools of the Netherlands, which, of course, also kept busy and in fact soon took to the Renaissance style themselves, though they did not command the sculptural form, the

monumentality, and the wealth of invention by which Floris set a standard that obtained him commissions and apprentices from far and wide.

Beside Floris, Dubroeucq, and Mone, a typical master of this kind was Michel Scerrier of Bruges, who in 1545 executed the tomb of Jean Carondelet, Chancellor of Flanders, in St Donatian at Bruges (the effigy is now in St Salvator). The dead chancellor does not lie stiffly recumbent in prayer, after the Gothic manner, but is supported on his elbow as if in meditation, after the Italian manner. Another typical figure working at Utrecht was Colijn de Nole of Cambrai,[6] who died between 1554 and 1558, and in 1543–5 executed the great chimneypiece of the Council Hall of Kampen. In addition to free-standing tombs and tablets in the old tradition, wall-tombs were now introduced into the Netherlands, inspired by Italian models.

A particularly delicate sculptor of low reliefs and statuettes for private collectors was Willem van den Broecke (1530–80).[7] After his training at his native city of Malines and in Italy, he was registered master at Antwerp in 1557, and was already praised by Guicciardini in 1566. From Antwerp he also exported works in marble and alabaster: to Augsburg he sent in 1560 an altarpiece for the Dominican church, the five reliefs of which remain in the Maximilianmuseum there (Plate 252); to Schwerin about 1563 the reliefs for the newly built chapel in the palace of the duke of Mecklenburg; and to Spain three choir-screens, now lost.

Cornelis Floris's teacher was probably an Italianist of the type of Mone; it may have been Pieter Coecke (d. 1550), although we can form no idea of his work in sculpture. In any case, Floris took from Coecke his way of making designs for other crafts and arts, and was thus instrumental in definitely separating execution from creation. This process had already set in with the Late Gothic engravers of ornamental motifs. During his studies in Italy – he was in Rome in 1538 – Floris must also have been impressed by Raphael and his school, by Antiquity, and by the grave manner of Andrea and Jacopo Sansovino. In 1539 he was registered master at Antwerp. As an honourable, if peripheral, commission, he illuminated the members' list of the painters' guild of Antwerp, the Liggeren (Antwerp, Koninklijke Academie voor Schone Kunsten), with initials in the grottesche manner. Like Cornelis Bos at the same time, he published series of engraved ornamental designs. They came out from 1548 to 1557, and helped to spread the taste for grotesques, which no import from Italy had made so widely known before. The fantastic, luxuriant microcosm of his vases, cartouches, masks, etc., and the strap-work originating from Fontainebleau and imitating metal straps cut out and curled, was to enrich the work of sculptors and woodcarvers right down to the seventeenth century, even in remote places.[8] As early as 1566 Guicciardini wrote that Floris had introduced the grotesque into Flanders, but in fact Coecke preceded him.

As a sculptor and designer of church furnishings and tombs, however, Floris was surprisingly restrained – like his French contemporary Jean Goujon. The articulation of his work is architectonic and intelligible. He was able to draw the line of demarcation between structure and ornament, as his Italian models did and his over-zealous successors generally did not. No single part is more valuable than the whole; the gamut of decoration from free-standing statues down to the simplest ornament fits much more

freely, and without any luxuriance, into the architectural members than in his own pattern books. In that way he always achieved the decoratively satisfying, restrained monumentality of the Italians. The commissions he received were by no means all secular; in fact they were primarily for churches. A flood of monuments, memorial tablets, and church furnishings of all kinds followed his first known work of sculpture, the memorial to Duchess Dorothea in Königsberg (now Kaliningrad) Cathedral (1549). The most important of the works certainly his own are the tabernacle of 1550-2 in St Leonard at Zoutleeuw (Léau), a Gothic structure nearly 55 feet high but composed of classical elements (Plate 249). From before 1550 until after 1553 he executed the tomb of King Frederick I of Denmark in Schleswig Cathedral. The lid is conceived as a couch, in the Gothic fashion, but the king is praying with open eyes; in fact he is meditating in the same way as Carondelet on his tomb of 1545. The superstructure is borne by six caryatid-like Virtues on a base, a modern transmutation of the Burgundian pleurants which had such a wide influence. In 1554 Floris completed the tomb of Jan III van Merode in St Dymphna at Geel (Gheel). Here there are six warriors as bearers, who recall the four kneeling knights of the Engelbert tomb of 1526-38 at Breda. Floris's most important late works may strike us as neo-classical in their austerity. Architecture dominates; the style of the figures is remote from all the contemporary Mannerist flux of movement. A foremost example is the tomb of Duke Albrecht I of Prussia in Königsberg Cathedral of 1568-74, Floris's one remaining wall-tomb, with a triumphal-arch motif which recalls Andrea Sansovino's tomb of Cardinal Ascanio Sforza in S. Maria del Popolo in Rome. From 1568 till after 1576 Floris was engaged on the free-standing tomb of King Christian III of Denmark in Roskilde Cathedral (Plate 250), which shows French influence in its structure, for instance from the tomb of Louis XII in Saint-Denis. About 1570-3 Floris made the rood-screen in Tournai (Doornik) Cathedral; its architecture is more significant than its friezes, figures, and low reliefs. Its model was Jacopo Sansovino's Loggetta of 1537-40 in Venice; like the Loggetta, the rood-screen is a classic work of the High Renaissance, and is harmonious to a degree never again achieved in the Netherlands.

The materials used by Floris's workshop and followers were traditional: black and red marble for the architectural members, and alabaster – often imported from England – for the figures. Wood was no longer used. Unimportant commissions, it is true, were executed in sandstone, tufa, or wood, but they were often painted or grained to make them look more precious – a presage of Baroque make-believe. Like his brother Frans, who founded a painters' workshop of equal influence and with just as much division of labour, Cornelis managed the large number of commissions in such a way that, as in carved Gothic altarpieces, it is very difficult to determine where he set his hand to the work. But like the Middle Ages, though for different reasons, his age did not take that matter very seriously. What mattered was invention, especially where work on a large scale was concerned. On occasion he was commissioned only for designs, and they were then executed wherever the client lived (e.g. in Brussels and Oudenaarde). Floris's determination to abandon excessive individuality in the execution and complication of motifs (except in ornament) made it very easy to copy his designs. His figures are with-

out passion and less delicately executed than many 'local' works, and in spite of the quality of the workmanship, to which he attributed great value, come out best in decorative settings. Nowhere in Floris can we find Dubroeucq's or Willem van den Broecke's delicate execution, for instance. What is characteristic of him is the predominance of stone over bronze, which was just then at the height of its popularity in Paris and Italy. Giambologna on the other hand avoided marble because, overworked as he was, he could only guarantee flawless treatment in bronze. It is also characteristic that the small bronzes which spread Giambologna's style all over Europe were not taken up by Floris; he did not work for the connoisseur.

Floris's style preponderated not only in the Netherlands: journeymen and pupils went out from Antwerp along with his works.[9] Gradually ornament won the upper hand in their work till ornament, escutcheons, reliefs, and figures encrusted the whole of architecture. The effigies on the tombs were realistically dressed up and the result tended to be petty. It was especially in North Germany and Scandinavia that the churches were full to overflowing with works of Floris's kind. In those districts the Protestant territorial rulers found no native tradition conformable to their wishes; on the contrary, tradition had completely broken down and could only be treated on the artisan level. The Reformation had, to a large extent, eliminated the old patrons, and connexions between the artists and the new patrons and the south did not exist.

We can here only mention two or three notable successors of Floris. Anton van Zerroen of Antwerp worked on the tomb of the Elector Moritz of Saxony in Freiberg Cathedral, although after a design of the Italian painter De Thola. Master HH (Hendrik Hagart?) executed in 1561–4 the tomb of Edo Wiemken (d. 1511) in the parish church at Jever.[10] Elias Godefroy, a sculptor and architect, worked for Landgrave Philip of Hessen and shortly before his death (1568) began his wall-tomb in St Martin at Kassel. Alexander Colijns of Malines (1527/9–1612),[11] more prominent than the others, worked in 1558–9 at Heidelberg for the Elector Ottheinrich on the cycle of allegorical sculptures on the castle façade; in 1562–6 he executed for the tomb of Emperor Maximilian at Innsbruck twenty-one reliefs from the life of the emperor. They were commissioned by Emperor Ferdinand after designs by Florian Abel, a painter working in Prague. In Prague Cathedral in 1564–89 Colijns worked on the tomb of Emperor Ferdinand I, his consort, and Emperor Maximilian II. After that, in 1584–7, at Innsbruck, he made the tomb of Hans Fugger from a wax model by Hubert Gerhard. This is now in St Ulrich at Augsburg. In 1594–6 Robert Coppens of Antwerp, then working at Lübeck, was paid for the tomb of Duke Christoph of Mecklenburg (d. 1592) and his consort Elizabeth (d. 1597) in Schwerin Cathedral. The reliefs bear witness to familiarity with the Tournai rood-screen. Floris's influence can be traced even after 1600, especially on the Spanish and Portuguese peninsula, in England, and in France.

Hans Vredeman de Vries (1527–1604?) of Leeuwarden,[12] who was only half a generation younger than Floris, appeared as his equal as early as the fifties, and was a still more versatile man. He was architect, architectural theorist, painter, engineer, and designer of furniture and gardens. He attached even more weight to theoretical activity than Floris. His influence was not spread through sculpture but, as far as we know, entirely

through engravings and pattern books. The extent of his influence on decorative sculpture and the decorative arts is all the more astounding; it radiated from more than five hundred prints and countless drawings, and through re-impressions and copies over the whole of Northern Europe into the latter half of the seventeenth century. His ornamental prints and pattern books came out in Antwerp from 1555 onwards, following up Bos, Floris, Ducerceau, and the school of Fontainebleau, but with novel, still more luxuriant strapwork, grotesques, etc. These were meant for sculptors and carvers, but he also did many patterns for other crafts. His influence was personal too, being exerted on his many journeys; in addition to the Northern and Southern Netherlands he worked, for instance, at Aachen, Wolfenbüttel, Hamburg, Danzig (Gdańsk), and Prague

SCULPTURE IN GERMANY

IN Germany[1] a monumental enterprise such as the new façade of Heidelberg Castle was an exception in the middle of the century. It is to be explained by Ottheinrich's humanistic ambitions. The political and religious troubles of those years were unfavourable to bigger projects, to the founding of workshops and local schools. Practically no altarpieces were set up, nor were buildings decorated in monumental fashion. The political restlessness often resulted, as far as the artists were concerned, in unemployment, impoverishment, new kinds of commissions, in short, a lack of time and means to form new traditions. Religious persecutions, whichever side they were on, hounded the artists from one place to another. During the Middle Ages they had been free to go where commissions took them; now they were mainly driven by motives of conscience. The Netherlands suffered most, and for that reason her artists were to be found everywhere, in Germany, England, and France, though in Italy only if their artistic inclinations took them there. On the other hand, they streamed into Germany because, until the abdication of Charles V, the Netherlands had formed part of the Empire and still represented an artistic entity in the artists' minds. Van Mander and Sandrart published their lives of the artists of the Netherlands and of Germany in a single work, distinguishing them merely as Low German and High German. After the religious settlement by the Confession of Augsburg there were, in Germany at any rate, no persecutions as there were in France and Flanders. Thus art in the Empire was extremely confused in style and had no definite points of reference or standard set up by the individual artists, who were always on the move. Every political fragmentation was followed by its artistic counterpart. Thus art can be grouped according to the place of its execution or its patron more logically than to the origin of the artists. Even where the new creeds – Lutheran, Reformed, and Anabaptist – led to no image-breaking, at the same time they left, for the moment, no permanent great tasks for art. As in the Netherlands, the sculptors received plenty of commissions for tombs, memorial tablets, chimneypieces, porches, gables, pulpits, fonts, domestic altars, and so on, yet the results seldom achieved more than good craftsmanship. A very unevangelical splendour even invaded Protestant tombs. Extravagance was now fully under way; single motifs and decoration outweighed the whole: the figure lost its value, and in relation to the decoration the architectural structure became unmonumental and insignificant. The massive display of forms showed neither Renaissance discipline nor even the consciousness of effects which contemporary Italian Mannerism possessed. What actually persisted was Late Gothic feeling. The only common denominator was a new idiom of form derived by all artists from all kinds of models; but there was an absolute lack of that economy or comprehension of form which characterize great artistic personalities. Important commissions were constantly entrusted to artists from the Netherlands and Italy; where

masterful personalities were at work was a matter of general knowledge, and envoys were often sent to engage masters at such places. For the sculptors, patrons were on the one hand fewer in number, on the other more specialized in taste. Humanistic scholarship and love of display, the adornment of personal life, and last but not least the collector's instinct played a determining part among the aristocratic, ecclesiastical, and patrician patrons. The works of art were as often as not cabinet pieces – it was at this time that the term came into being – which had their purpose in themselves: they were to be handled with admiration by the connoisseur and to serve to decorate private apartments, courtyards, and gardens. In the North, copies after Antique and contemporary Italian artists appeared in steadily increasing numbers beside plaster casts and engravings, and the effect of the collections on the taste and style of the artists should not be underrated.

In North West Germany,[2] beside the competent elder German masters with Flemish–Netherlands connexions such as Johann Brabender, and native Netherlands masters such as Aert van Tricht, who endeavoured more or less successfully to work in the new style, more modern sculptors were active, and can be recognized here and there, but they neither left an *œuvre* behind them nor promoted developments; such were Benignus Campus of Cologne, mentioned from 1555 to 1573,[3] and those masters who in 1558–78 lavishly adorned with sculpture the interior and exterior of the castle of Horst near Recklinghausen.[4]

In South Germany[5] the so-called German Renaissance continued to exist; it was more closely connected with Italy than the Netherlands. In this part of the country the predilection for small scale prevailed with the majority of sculptors, including the best, such as Meit and Daucher. The very finest pieces came from the goldsmiths and carvers in boxwood, soapstone, ivory, semi-precious stones, and might be table bells, épergnes, fountains, door-handles, statuettes, inkwells, or portrait busts, medals, plaques, chessmen, tankards, boxes, and caskets. In such small pieces South Germany was abreast of Italy, but in Italy such jobs – we have only to think of Cellini – were mere occasional pieces and what really counted was monumental commissions.

Nuremberg and Augsburg remained the two most active centres, not only of bronze-casting, but of small-scale wood- and stone-carving too. At Nuremberg, Pankraz Labenwolf's workshop continued till 1563, the year of his death, the tradition of bronze-casting after the break-up of the Vischer workshop, and that of Georg Labenwolf, the son, until 1585, the year of Georg's death. The Goose-Bearer fountain at Nuremberg (Plate 253; at present in the courtyard of the town hall), made about 1550–60 by an unknown master of the Labenwolf workshop, is treated in a genre way, characteristic of the time, whereas such a commission might elsewhere have become truly monumental. Many a small bronze peasant, lansquenet, and huntsman issuing from the Labenwolf group bears witness to the delight which the burghers took in figures of the common people. (It should be noted that this delight is manifested as early as about 1500 in wooden statuettes of poor people; examples are at Nuremberg.) The bronze statuette of the Blessing Christ Child, probably made between 1550 and 1560 (London), has the tender charm of the Quattrocento. The $6\frac{1}{2}$-inch alabaster bust of

Ottheinrich of 1555 (Louvre)[6] is a typical cabinet piece, a piece of decoration rather than a monumental form; but the vitality of its expression makes it one of the chief works of these years. It may be by Joachim Deschler (active at Nuremberg and in Vienna from 1532 till 1571) or by Dietrich Schro (active at Mainz from 1545 till 1568); among the latter's funerary monuments is the tomb of Archbishop Albrecht of Branden-burg in Mainz Cathedral, of 1545–54, in fairly pure Italian forms – which, considering this particular client, is hardly surprising. Peter Ehemann, the gem-cutter, continued to work at Nuremberg till about 1558, Matthias Gebel produced medals and figures in the old tradition for a large public till 1574, and many other names and anonymous works could be mentioned.[7]

The only international Nuremberg artist after the forties was Wenzel Jamnitzer from Vienna (1508–85),[8] who was registered master in 1534. He was the first of this most famous family of goldsmiths in Germany. He brought the goldsmiths' art at Nuremberg to a level of excellence at which it remained for more than a hundred years. His standing as a goldsmith in Germany was comparable to Cellini's in Italy and France; he worked for emperors, kings, and princes spiritual and temporal and for the wealthy of his city, and through his children, grandchildren, brothers, nephews, and collaborators his in-fluence was lasting and spread far and wide. His intellectual power also came out in mathematical treatises which he published in good Nuremberg humanist tradition in 1557 and 1568. He constructed and decorated mathematical and astronomical apparatus and already made ornament by machine. His works of sculpture, so far as we know them, are nearly all small figures or reliefs on caskets (Berlin; Munich, Residenz; Dresden, Grünes Gewölbe), goblets (Berlin), épergnes, tankards (Munich, Residenz), looking-glass frames (New York, Morgan Library), ornamental fountains, and similar things. But the figurework rises far above mere applied decoration. It is sculpture in its own right which satisfies the closest examination. The aristocratic figure style of Flötner's plaques deriving from Italian Mannerism was continued by Jamnitzer, who also adopted his arabesques. A specimen of artistry for its own sake, with the purposelessness which suited the age, and one which might indeed be called its classic example, if it were not so unclassic, is the 33-inch-high Merkel épergne in the Rijksmuseum, which was made before 1549. It was not executed to a commission, nor as an object of utility, and was bought by the Nuremberg Council for its own treasury. The foot is covered with a riot of foliage and animals; above, on the bowl, are scrolls, grotesques, a bunch of flowers, and other things. The silver figure of Earth which bears the épergne itself has not its like in Germany for its full, rounded forms and the Indian swing to its hips. Jamnitzer's knowledge of contemporary sculpture in northern Italy, in its Sansovino form, is clear. Later works such as the 2 feet 5 inch gilt bronze figures of the Four Seasons, made before 1578 and now in Vienna (Plate 254), the caryatids of a silver fountain in the form of the German imperial crown which was made for the emperor at Prague, reveal that Jamnitzer remained at the height of the development of Italian Mannerism. He could stand comparison with Danese Cattaneo, Cellini, and Ammanati, no matter how northern the grace and bony the limbs of his over-slender figures. In comparison with him, the rest of Nuremberg small-scale sculpture shows less

internationalism, rather squatter proportions, and a bourgeois, earthy realism; it remained more under the influence of the Renaissance of the first generation.

One of Jamnitzer's specialities was the use of casts of small animals. It was already known to the Italian potters of the Quattrocento, then became familiar to the bronze-casters at Padua, Florence, and Venice, and in 1532 to Flötner in the Apollo Fountain in Nuremberg (now Peller Haus). Palissy did similar work in France. But Jamnitzer displayed supreme virtuosity in his technique, and by the third quarter of the century it was practised by all German goldsmiths' workshops. The feeling behind this kind of scientific naturalism also found expression in the use of nautilus shells, ostrich eggs, animals' horns, coconuts, corals, and things of the sort in small sculpture, and of course in the way in which private collectors displayed works of art side by side with rarities of nature. Nature and art were not opposites; the boundary between reality and appearance no longer existed. In this connexion it is worth remembering that this was the time when still lifes and landscapes came into being. But in Germany casts of natural objects were not used to create independent works, as in Italy.

The most important sculptor on the grand scale who was still active at Nuremberg did not issue from the native tradition. This was Johann Gregor van der Schardt of Nijmegen (c. 1530–after 1581).[9] He had worked in Italy in the sixties, and Guicciardini praised his work in 1567. In 1570 he was at Nuremberg, and can first be recognized in works for that city, although he had travelled far and been employed by Emperor Maximilian II and King Frederick II of Denmark. He made the life-size, coloured terracotta bust of Willibald Imhof, the collector, now in Berlin (Plate 247); a smaller bust of Imhof's wife was made later, after Imhof's death in 1580, as often happened with double portraits. Imhof is characterized as a collector by examining a ring; the bust is, in a way, a 'genre' portrait of an absent-minded art lover. In 1580 Van der Schardt made painted faïence medallions of Paul von Praun (now at Nuremberg and in the Landesmuseum at Stuttgart), another important Nuremberg collector who owned, in addition to bronze statues, dozens of terracottas by Van der Schardt. Yet only a few busts and plaques of the kind can be ascribed to him, and still fewer bronzes (Vienna, Stockholm, and Amsterdam). He seems to have worked for the most part after Antique and Italian models, which, however, can hardly be identified now. The grave realism of his portraits was blended in a characteristic Netherlandish fashion with grandeur in the presentation, quite different from the more idealistic Italian bronze busts (for example, those by Alessandro Vittoria) or from the *verismo* of the southern terracottas. That was unusual in South Germany, and so Van der Schardt was given preference over native talent, a parallel to Nicolas Neufchatel's painted portraits of the sixties.

By its constant connexion with the imperial house, with sovereigns and their intel-lectual and artistic retinue at the Diets, and with the quasi-royal commercial houses of the Welsers and the Fuggers, the art of Augsburg[10] took on a still more cosmopolitan, especially Italian, character. But the sixties and seventies not only brought the death of a number of outstanding patrons; the tradition of the medallists and sculptors of the age of Dürer also died out: Christoph Weiditz the elder died in 1559, Hans Kels the younger in 1565 or 1566. Travelling masters from the Netherlands gained increasing standing,

especially for monumental commissions. As early as 1568/9–73 Hans Fugger had gathered round him Friedrich Sustris and a small colony of Italian artists who fitted out his palace. When Duke Ludwig of Württemberg inquired for a sculptor at Augsburg in 1576, an employee of the Fugger company, who was an expert in the matter, told him that there was no 'outstanding sculptor' resident in the city at the time.

Another example of the rapid decadence of good tradition after 1550–60 is the situation at Würzburg,[11] where Peter Dell the elder continued the style of his teachers Riemenschneider and Leinberger in tombs and small wood-carvings to the middle of the century (memorial tablet to Konrad von Bibra, d. 1544, in Würzburg Cathedral). His son, Peter Dell the younger (tomb of Bishop Melchior Zobel, d. 1558, also in Würzburg Cathedral), degenerated into mere mechanical routine. It is sadly revealing to compare the monuments of the third quarter of the century in Würzburg Cathedral with Riemenschneider's Bishop Lorenz von Bibra (d. 1519). The commission for the tomb of Sebastian Echter (d. 1575) was given to Peter Osten of Ypres (documentary evidence of him from 1571 to 1589, at Mainz, Würzburg, and Speyer), who executed the commission in 1577/8 in the style of Floris. Osten's most typical work is the rich and graceful alabaster memorial altarpiece of Landgrave Georg I of Hessen-Darmstadt and his consort in the choir of the Protestant parish church of Darmstadt, dated 1589.

PAINTING IN THE NETHERLANDS

THE development of painting after the forties and fifties[1] was determined by a pheno-
menon which turned out to be more important than all the changes in style. It was the
division of painting into different genres, the specialization of painters in distinct sub-
ject matters, which was soon followed by a hierarchy of the subject matter. This pro-
cess, which set in most visibly in the Netherlands and there led most quickly – in only
two or three generations – to definite specialization, has affected European painting down
to our own times, particularly in the academies, and is still the standard for both the art-
lover and the art-historian today. It may be objected that the hazards of survival give
us a one-sided picture of certain painters of the middle of the sixteenth century, and it
must be recalled that the idea that painting in the Gothic age was almost exclusively
religious has of late been corrected from literary sources as an accident of preservation.
However, not only are the works of the sixteenth century preserved in greater quantities
than those of any preceding age, so that a greater fairness of judgement is possible, but
also the contemporary sources speak quite clearly in this matter, for instance the early
historians and connoisseurs who regarded certain painters as specially good in special
fields. Then there are the entries in the guild registers, and the captions under the en-
graved portraits of painters which praise them in some direction or other (for instance
Dominicus Lampsonius's *Pictorum aliquot celebrium . . . effigies*; first edition Antwerp,
1572[2]). For this reason in the following pages the various subjects are treated separately.
This is also justified by the fact that they take on strikingly different aspects in the same
painters' work; to give an example, very tempestuous compositions may stand side by
side with quite natural portraits. It is another instance of the constant vacillation of
northern painters between *ars* and *natura*.

The predominance of a particular type of subject in the work of a painter was rare,
and this was known at the time too. Aertsen, for instance, also painted biblical scenes,
and the elder Pourbus did not only paint portraits. But Mor painted portraits practically
exclusively, and Bruegel none at all, while Lombard painted neither droleries nor land-
scapes. So actually we are not far wrong if the names of artists after the middle of the
sixteenth century involuntarily call up before our eyes definite subjects, and generally
only one or two kinds of subject.

There are other phenomena which increase steadily from about the middle of the
sixteenth century. True, the painters' workshops continued in the multiple working
traditions of the Middle Ages, but they were more and more subject to the new, specu-
lative convictions which came from Central Italy and found their literary expression in
Vasari.[3] In particular, design and execution were more widely separated than ever be-
fore; the new division of labour, which had begun in the school of Raphael, became the
practice in the north too. The 'invention', i.e. the act of imagination, the solution of

formal problems, was regarded as more and more the main achievement among artists and patrons. Michelangelo said 'si pinge col cervello, non colla mano'; at the same time Vasari formed his collection of drawings. The manual part of painting was no longer *ipso facto* a matter for the master himself; it was appreciated only secondarily and could without serious detriment be left to others. The same is true of cartoons and designs for murals and stained glass, tapestries, decorations, buildings, monuments, chimneypieces, sculpture, etc.; never before had it been so difficult to identify the designer with the executant. In any case, according to the new taste, the appeal of colouring was less than that of *disegno*. These changes were operative specially in history painting, from which the greatest efforts were demanded. They resulted in a check on the individuality of the artist, a possibility of imitation which, side by side with the power of creative imagination in certain masters, laid the foundation for the spread of the 'Roman' figure style. With the exception of the wood-carving workshops in the Gothic age, earlier generations had never seen so active a painting business as that of Frans Floris, the direct predecessor of the Rubens workshop. Neither Jan van Eyck nor Dürer had created anything which was so ubiquitous yet so diffuse. If the old sensitiveness of execution often suffered under these conditions, technical care remained, just as wood was still generally used for panels, though painting on canvas as practised in Venice could have replaced painting on wood in the second half of the century. There was more demand for delicacy of execution in subjects other than 'histories', for instance in portraits; yet we must wonder whether Bruegel's friends comprehended his technical genius as much as the whimsicality of his inventions. If they had, they would not have employed the swarm of copiers and imitators till far into the seventeenth century; for these could only satisfy the need for possessing his motifs.

The main branches of painting evolved in these decades are these: the *Ordonnantie*, the religious or secular historical or allegorical picture, which was the most distinguished kind; the portrait, often painted by the same figure-painters; the rustic genre scene, in which comic accents predominated; the bourgeois genre, which as a whole took itself seriously, started later, and gained ground more slowly; the still life, which at the same time developed into the large-scale genre piece, for instance in Aertsen; and the landscape, either with biblical or mythological figures, as it had been from the beginning of the century, or, as an innovation, without narrative. In addition, about 1560 the architectural picture came up as a new genre of painting.

Finally, from the middle of the century, there were artists who drew for the engravers, modelling themselves on the pattern of such Italians as Marcantonio Raimondi and the Raphael workshop. However, they seldom took the graver or the needle into their own hands, so they have only a subordinate place in the history of graphic art.[4] It is characteristic of the impersonal and austere taste of the time that there was a great preference for engraving, as against the freer etching by the artist's own hand, or the coarser woodcut, which was only used for popular prints. Thus those who drew for the engravers were farther removed from the possibility of obtaining true facsimiles of their drawings than, for instance, the Germans of the fifteenth and early sixteenth centuries and the Kleinmeister who had made their drawings direct on the wooden block and

then had it cut. The designers for reproduction now could count on growing numbers of reproducers and publishing-houses, for instance that of Hieronymus Cock, who were not creative, but who were eager to do justice to designs presented to them, and indeed to the art of all European schools and trends, especially that of Antiquity. This rising tide of engraving about 1550 by the side of all the imports from Italy is another significant pointer to the precedence of invention, of 'the idea' of design, even in the north. Moreover, the engravings bear witness to the growth of the dualistic conception that division of labour in artistic production is possible. Yet another reason for the rising wave of reproduction in graphic art was, of course, the insatiable interest in illustration which spread to steadily growing circles. In its turn the mass of graphic art had its influence on painting and sculpture, and it was primarily the engravings which did for the interested public in the later sixteenth century what art books, journals, and television do now. The greatest of all the designers for engraving in the Netherlands, Hendrik Goltzius, began his career as early as about 1580. It would be easy to pass him over in a history of painting; but as a *peintre-graveur* he was formidable, and by means of his more than 550 designs reproduced by others he became the greatest power in art between Floris and Rubens.

History Painting

In the forties, a deepened, almost antiquarian love of the Antique began to make its mark on history painting. A generation had grown up which was no longer astonished or swept off its feet by Antiquity, and absorbed it in more objective study. After Gossaert and Scorel this was the third wave of travellers to Italy, or 'Romanists', as they called themselves. But there was a steadily growing precision in the demands made on Antiquity and theory. After the fashion of the Jerusalem pilgrims, special guilds of artists who had been to Rome were established and lasted till the seventeenth century. The emancipation from the workshop tradition was now complete. Painting was ruled less and less by craftsmanship and custom than by art – *Brauch* and *Kunst* were Dürer's terms – and also by scholarship. The spell of the old iconography was broken, there were new subjects to describe; the *pictor doctus* felt himself under a perpetual summons to personal invention. Familiar subjects were often represented in novel forms.

The first of these more intellectual and more archaeologically inclined painters was Lambert Lombard (1505–66),[5] who deserves more attention as a type and a stimulant than as an artist. The protégé of Prince Bishop Erard de la Marck and his successors in the newly erected palace at Liège was recognized not only as a painter and architect, but also as an antiquarian, a numismatist, and a polyhistorian, and was one of the first art-historians north of the Alps – not counting the tentative beginnings in South Germany. He admired and himself copied even the artists of his native past. In 1565 he furnished Vasari with details about northern artists for the second edition of the *Lives* (1568), and in return asked for reproductions of Margaritone, Gaddi, and Giotto for comparison with native medieval stained glass. Lombard is said to have visited Germany and France as early as the thirties and studied monuments of provincial Roman art. In any case he

stayed in Italy, including Rome, from 1537 to 1538 or 1539 for the purpose of buying antiques. By diligent copying after the Antique and his Italian contemporaries he became fully conversant with the *maniera antica*, and after his return, as Van Mander says, 'like Cheiron, a master and educator of heroes' and 'a father of our art of drawing and painting'. Lombard's scholarly knowledge of Antiquity and Italy, such as no former explorer had ever brought back with him, met with general response and brought him many eager disciples, among others Floris, Key, and Hubert Goltzius. But not all his 'pupils' can have been beginners; fully qualified masters seem to have come to him for higher education and discussion.

Anyone looking at Lombard's work under the impression of his literary fame will be bewildered by his lack of natural artistic temperament. True, only a few (not very attractive) pictures can be more or less credibly attributed to him or his workshop, for instance scattered panels of a St Dionysius altar from Saint-Denis at Liège, and none of his frescoes have been preserved; but he left behind him considerable numbers of drawings, and the publishing house of Hieronymus Cock and many other engravers engraved nearly seventy compositions by him (Plate 256). Among them was, for example, Lambert Zutman (Suavius; *c.* 1510–74/6),[6] who built on Lombard's work in his own Parmigiano manner. It is Lombard's drawings from which we can gain a clear idea of his style. Whatever their subject-matter, the compositions consist of stonily lifeless figures, dignified in their pose. They are often quoted from, or variants of, Antique statues, generally look like them, and are placed side by side neither with any grading according to their importance from the point of view of the narrative nor with any linear compositional communication. One is automatically reminded of the way in which contemporary courtyards and gardens displayed Antique sculpture. There are hardly any studies from life in Lombard's *œuvre*. Single figures in all kinds of poses do occur, but are not taken from life, but variations of sculptural motifs of Antiquity or the Cinquecento, probably executed with the help of lay figures and engravings.

In 1540, Frans Floris (*c.* 1518–70),[7] Lombard's most important pupil, was registered master at Antwerp. His conception of the style *all'antica* was the same as Lombard's, but his imagination, his sense of colour, and the sureness of his draughtsmanship were far greater. As the head of the third 'Romanist' generation he fulfilled what Lombard had heralded. He went to Italy only after 1541, and saw Michelangelo's Last Judgement, which Lombard had not yet seen. For him, as for many of his successors, it was a momentous experience. In two sketch-books, now at Basel and in private ownership, we can feel how young Floris did not, like his teacher, cling to Antiquity and even more to the High Renaissance, but how he was impressed by contemporaries of the forties, the successors of Michelangelo and Raphael, such as Vasari, Salviati, Bronzino, and Zuccari. At the same time his pictures show that, in addition to the Florentine and Roman gamut of colour, the tone and soft technique of the later Venetians and North Italians were familiar to him. It is not only the slenderness of his female bodies that recalls Tintoretto. In this connexion it must be remembered that Maerten de Vos had come back from Venice in 1558. There are also many points of contact between Floris and the Fontainebleau school. Thus after the late forties – we encounter him first as a painter

in 1547 in his Venus and Mars (Berlin) – every decisive innovation of the time appeared in Floris's work at Antwerp: he seems to have drawn the sum of all previous efforts to discover the south; he was the first who appears to have made the 'Antique' style entirely his own.

Floris's chief work and an instructive example of the 'Romanist' history picture is the monumental Fall of the Angels (1554, Antwerp), once the central panel of an altarpiece in the cathedral (Plate 255). Here Floris shows his complete mastery of the Italian idiom. He gave movement to the figures with daring foreshortenings and overlappings and filled the whole available surface, although even he, in Gothic fashion, neglected spatial clarity. The vitality of the figures is made visible in violent action and muscular tensions. The modelling of the bodies is trenchant and reveals, to the point of exaggeration and monotony, a diligent study of the nude. There is tonality in the colouring; the old, piebald local colouring has been overcome. But compositional unity is destroyed by calculated details; it is difficult to make out any unity of composition – the panel is conceived as a fragment of a boundless whole. Floris's picture exemplifies the lofty aims of this kind of subject: play of forces, movement to the point of motion for its own sake, pathos, the nude as a heroic form, and a maximum of differentiation of moods to the point of a mere adding of effect to effect. The picture exemplifies, too, all the Mannerist aspects of the efforts in the Netherlands to come to terms with the south. The foreshortening of the classic bodies is done with great skill, but the motifs are not very functional. The actions come to no end, passions in a tangle like this lose all their effect, gestures cancel each other out. Fantastic motifs – quite in keeping with the taste of the time – are now more repulsive than any in Late Gothic art, because they stand side by side with the most matter-of-fact realism.

Floris shows an entirely different side of himself in a series of less ambitious compositions, for instance the Adoration of the Shepherds of 1558–60 (Dresden) and of 1568 (Antwerp), the St Luke of 1556 (Antwerp; Plate 257), or the Holy Family at Munich (inv. no. 1945). These are rather pictures whose lasting artistic importance we can understand. In the manner of all the Romanists of his generation, Floris revealed that he could compose with monumental simplicity, and could place realistic and fully modelled figures in clear space as no age had ever done before. Moods are expressed without affectation, with freedom and many contrasts. In these pictures the High Renaissance seems to survive, but styles always run parallel in Floris and sometimes merge; it is difficult to trace any organic chronological development. Floris's age was eclectic by conviction, dependent on occasion, subject, and size, but basically without organic motivation.

Floris's smaller works are, as usual, more reliably his, even though, considering the organization of his workshop, they still give no unmistakable testimony to his powers as a painter. Their pale, thinly glazed colours and blackish flesh tints are excellent anyway. For that matter the portraits too dispel any doubt as to whether he and his colleagues were good painters; they nearly always showed themselves as such when they wanted to, i.e. when the commission seemed to require it. There are times when the sallow, narrowly limited colouring recalls the grisailles of Gothic altarpieces. The brush-

work is swift and open, and better adapted to large-size painting than it had been before in the north. This casual handling was soon recognized as something unusual, and there was applause for the rapidity of the production, just as the quick and spirited painting of Vasari and Tintoretto was praised in Italy.

Floris's achievement in painting can actually be estimated, apart from the portraits, only by a number of heads and busts in oil on wood, which were yet another innovation of his workshop. These heads often reappear in his compositions; in the Feast of the Tritons (1561, Stockholm) there are two heads with which such studies can still be connected. The wooden panels may be regarded as a more durable variant of the usual cartoons and drawings on paper. Floris had a large number of these heads (tronien) in his workshop and told his journeymen which to use and where to place them in pictures. The panels were not actually studies from life; they may have been made from models, but were transformed into types for the sole purpose of being used in imaginative work. The primary impulse may have been less their immediate use than the interest in physiognomic types and heroic countenances. If so, they belong close to the popular series of emperors, apostles, and other such subjects. Rubens, Van Dyck, and others continued the tradition.

From the beginning of the fifties, Floris's workshop was, with that of his brother Cornelis, the sculptor, the artistic focus of the city, and created a style to an extent which no other workshop did till Rubens. Its influence spread far beyond Antwerp, and it executed commissions from all kinds of places, for instance in 1554 an altarpiece for the church of Arnstadt in Thuringia. According to Van Mander, Floris had a hundred and twenty pupils. That may be an exaggeration, but hardly a famous name in the next generation is missing from the list.

Floris probably did less to train painters than to employ young painters already trained, who gave him competent help, for instance in painting altarpieces and history pictures after his drawings – a fact which hardly encourages the attempt to discuss his personal share in his œuvre. This kind of collaboration, which is visible in his art and underlined in contemporary literature, became general and remained so. Rubens carried it on.

Floris bestowed as little a uniform style on the art of the Southern Netherlands as his brother, yet he may be regarded as a pattern of the aims of most history painters. They present facets of his style, even though they cannot be directly connected with him. His contemporary Lambert van Noort (c. 1520–71) was a master of this kind at Antwerp. Another was Willem Key (c. 1515–68),[8] who, like Floris, had been trained by Lombard. The extremely indistinct œuvre that can be grouped round a Lamentation of 1553 in the Henkel Collection at Düsseldorf, and a Susanna with the Elders of 1546 at Pommersfelden, bears the mark of a self-controlled, cultivated mind in which Gothic traditions still survived: the calmness of the composition, the smoothness of the brushwork, and the clear colouring recall Massys; only a few forms are 'modern'.

Pieter Pourbus (c. 1510–84)[9] was registered master at Bruges in 1543 after an apprenticeship with Blondeel, and remained there practically as the painter to the municipality, competent and conservative. Apparently he did not go to Italy, and even a Last

Judgement of 1551 painted for the Council Hall (now in the Museum at Bruges), a subject which might have tempted any painter into competing with Michelangelo, remained predominantly traditional in motifs and composition. Pourbus's two Last Suppers of 1559 in St Salvator at Bruges, and of 1562 in Onze Lieve Vrouwekerk, also at Bruges, are still variants of Coecke's famous composition of the thirties. The brilliant Feast of Love in the Wallace Collection in London (Plate 259) and the Annunciation in the Museum at Gouda give a particularly fine idea of Pourbus's traditional, bright colouring and of his brushwork, which was as distinguished and precise as Key's. Such works show that, where figure types and compositional schemes were taken over from Italy, the tonality and broad manner of the Italians did not by any means spread at the same time, nor indeed to all parts of the north. Pourbus's son Frans (1545–81)[10] joined Floris as a journeyman in 1562 and in 1569 was registered master at Antwerp, where he devoted himself largely to portraits. He did these with greater success than he achieved with simple history paintings in the manner of Floris. Lucas de Heere (1534–84), another of Floris's pupils, took his style with him to Ghent and in 1568–77 to England, though nothing certain is known about those years. He deserves recognition as an antiquary more than as a painter of history pictures,[11] such as Solomon and the Queen of Sheba (1559, Ghent, St Baafs), cartoons for tapestries, among them the Festival at the Court of the Valois (Florence), and decorative work. About 1560 he wrote an ode to Van Eyck's Ghent altarpiece which Michiel Coxie had copied in 1557–9 for Philip II. His lost poem on famous painters was probably the most important forerunner of his pupil Van Mander's Lives. Like Lombard, he also bears witness to a new historical sense and a national pride which did not exclude admiration for the south. In those years it was possible not only to prevent the sale of the Ghent altarpiece, one of the recognized glories of the town, but also to preserve many other works for the sake of their artistic value during the image-breaking of 1566.

At the same time there were still representatives of older times who continued to work and exercise an influence, notably Scorel, who died in 1565, and Heemskerck, who lived till 1574. Beside the followers of the Floris trend there were figure painters of quite different leanings who were not without importance, in spite of a touch of archaism. Such were Jan Sanders van Hemessen, Roymerswaele, Swart, and Blondeel, all of whom continued to paint in styles they had evolved earlier.

The most important was probably Jan Massys (c. 1510–75),[12] who was registered master at Antwerp in 1531, but was banished as a Protestant from 1544 to 1558, when he was active, it seems, in France and Italy. A large number of works testify to his popularity, but most of them are dated after 1558. He added to the smooth, Leonard-esque tradition of his father Quinten the raciness of Fontainebleau, especially in female nudes. In the Flora Meretrix (?) (1561, Stockholm; Plate 258) or the Susanna with the Elders (1567, Brussels), for instance, this contrast to the predominantly unerotic Romanism is clearly seen. Cranach in Saxony offers a parallel. Pieter de Kempener (1503–80)[13] came home to Brussels from a long stay (from 1537 to 1562) at Seville, and remained there until his death as the leading tapestry designer, succeeding Michiel Coxie. Cornelis van Cleve (1520–67),[14] Joos van Cleve's renowned son, who may have been registered

master in 1541, was only active till 1554, when he became insane. He must have been a prolific worker, but his *œuvre* remains hypothetical. Of the Master of the Prodigal Son, who was active till about 1560, the contrary is true. Here we have an extensive and distinct *œuvre* which has so far remained anonymous. It is grouped round a picture in Vienna (no. 986), reminiscent of Aertsen, and a Return of Tobias at Ghent, and it is characterized by graceful gestures, soft modelling, and broken colours.

About the middle of the century Italy began to retain increasing numbers of artists from the Netherlands who were either capable of mastering the Italian style or were specialists, landscape painters for instance. After 1546 the Medici tapestry factory at Florence was a particular focus of attraction. The most important personality in the Florentine foreign colony was Jan van der Straet (Stradanus; 1523–1605),[15] who was registered master at Antwerp in 1545, came to Italy before 1550, and, like his contemporary Giambologna, was completely absorbed by Central Italian Mannerism. His influence spread back to the Netherlands through a host of engravings after his vigorous narrative drawings, the most unusual of which represent new discoveries and inventions, *Nova Reperta*, and hunting scenes, *Venationes*. Lambert Sustris of Amsterdam (1515/20– after 1568)[16] had probably settled at Venice before 1545 and absorbed Titian's figure and landscape style and colouring to an astonishing degree, yet without abandoning a certain northern paleness.

Dutch variants of Antwerp art appear in the style of the brothers Dirck and Wouter Crabeth of Gouda (d. 1574 and 1589),[17] who did the lion's share of the work on the new windows in St Jan (1555–71), a commission which they obviously deserved. Stained glass, incidentally, in spite of political troubles, continued to flourish in the north, while in the south no great achievements can be recorded in the second half of the century. Anthonis Blocklandt of Montfoort (1533/4–83)[18] was yet one more pupil of Floris's. He spread the Floris style in the north in 1552, was still in Italy in 1572, and with the new experiences he gathered there became a link between South Netherlands Romanism and the more intense Dutch Mannerism of the last quarter of the century at Delft, Utrecht, and Haarlem. He was also the teacher of Mierevelt and Ketel and influenced Goltzius.

Portrait Painting

Among the 'Romanists' portraiture sank to the level of a mere bread-and-butter trade, and has, as is known, been called that by artists down to our own day, whatever success their portraits may have achieved. As soon as there was enough demand for history pictures, the portrait tended to become neglected. We might well think today that the northern portraits of that time were for the most part more successful efforts than the over-ambitious – and stylistically astonishingly variable – history pictures by the same artists. In the portraits they had their reliable craftsmanship to depend on, their famed gift of characterization, and now in addition a new freedom, dignity, and ease. However, this estimate of ours places artistic significance above historical. It remains a historical irony, an unrequited love, not to say a mistaken appreciation of its own

possibilities, that the sixteenth century repeatedly produced the most important and effortless achievements in fields which the artists themselves regarded as inferior. This is true not only of the portrait but also of landscape, genre, and still life, i.e. the reposeful things which responded best to the Netherlandish temperament.

The competent portraitists who were active all over the Northern and Southern Netherlands cannot even be enumerated here.[19] Over and above them there is a considerable number of single, anonymous pieces, for instance the Thecla Occo (Amsterdam, Het Gebouw van Barmhartigheid Foundation), which can stand comparison with the best works of known masters and, like many an anonymous small bronze, bear witness to the high standing of this particular art.

The portraits by the modernists of the Floris generation are distinguished from those by traditional native contemporaries, e.g. the Master of the 1540s, by a large-minded noblesse of Italian origin; and at the same time from the older Romanists such as Scorel and Heemskerck by richer colouring and greater sculptural definition. The only portraits that can be ascribed to Floris himself with certainty, the Falconer (Brunswick; Plate 261) and his wife (1558, Caen), are sufficient proof of his mastery as a portraitist and the supreme self-confidence of the age. The open brushwork is striking.

In a general way, the three-quarter-length portrait now came to the fore; the forms grow heavier, the outlines sparer. The classical taste of the time comes out characteristically in the tangles of hair and beard. Unfortunately we can gain no clear idea of Willem Key's portraits, although he was much admired as a portraitist by Guicciardini in 1567 and by Lampsonius in 1572. His life-size portraits of the Antwerp city council, burnt in 1576, must have been among the earliest instances of South Netherlandish portrait groups, a rare category. At Bruges, Pieter Pourbus, from 1551 on, made portraits of the respectable citizens, for example the Fernaguut couple (Bruges, Groeninge Museum), in a rather old-fashioned but distinguished style. From 1569 his son Frans was active at Antwerp in a rather more flexible style, as witness the Joris Hoefnagel Family (1571, Brussels), a combination of a portrait group and a genre piece. The 'family tradition' of the Pourbuses was only to reach its culmination in the grandson Frans Pourbus the younger (1569–1622), the court painter whose astringent but solid style much impressed the young Rubens.

Travelling masters spread the South Netherlandish conception of the portrait at the courts and in the more important cities of Europe. They could not stand comparison with the best, who had remained in their own country, and may at times have gone away not only to evade religious and political trouble, but also competition. Their absence, however, deprived them of the enriching experience of greater masters. Most of the important English portraitists of the second half of the century were immigrants from the Netherlands, for instance Hans Ewouts of Antwerp (active in England in 1545/9–74), Guillim Scrots (active in England in 1545/6–53), and Marcus Gheeraerts of Bruges (mentioned in England in 1568–77).[20]

The portraitist who, as the painter of the Habsburgs, reached European standing above all other artists from the Netherlands was Anthonis Mor (1517/20–1576/7).[21] He was a native of Utrecht, and the earliest portrait that can be ascribed to him with cer-

tainty, namely two Canons of Utrecht as Pilgrims to Jerusalem (1544, Berlin), confirms Van Mander's assertion that he was Scorel's pupil. In 1547 he joined the Antwerp guild. In 1549 he was taken up by Cardinal Granvella, and became court painter at Brussels; the Regent Mary of Hungary, the later King Philip II, and the duke of Alba were his patrons, and thus, more than any of his compatriots, he came to the centre, not only of the political world, but also of decisive artistic influences from the south. His noble patrons, like Holbein's, sent him on portrait commissions round western Europe. In 1549–50 he travelled to Lisbon, where he painted in 1552 the portrait of Queen Catherine of Portugal (Prado). He had gone by way of Rome, where he probably painted the two full-length portraits of the Emperor Maximilian II and his consort Mary, dated 1550 and 1551, and also in the Prado. In 1552–3 he was in Madrid, and in 1554 in London on the occasion of the marriage of Queen Mary Tudor to Philip II of Spain (the queen's portrait is now in the Prado (Plate 264), King Philip's at Althorp). In 1555 he was back in the Netherlands, and painted Prince William of Orange (Kassel, Gemäldegalerie, perhaps a copy), returned to Spain in 1559–60, was back in Utrecht in 1560 (Jan van Scorel, London, Society of Antiquaries), and in 1568 presumably back in London (Sir Henry Lee, London, National Portrait Gallery). Between his journeys he worked at Brussels, Utrecht, and Antwerp.

Mor's development as an artist was as rapid as his rise in society. His portraits of Granvella (Vienna) and of the duke of Alba (1549, New York, Hispanic Society; Plate 262) have already shed the Scorel tradition, and reveal a complete and sensitive reaction to Titian, Moroni, and other North Italian masters, whose works he could get to know more quickly than anybody else. What is specifically Italian is the economy of the gestures and accessories, the tonality, and the elegant simplicity of the composition, which can be felt down to the calm, almost slack hands. In this way Mor's portraits were a perfect reflection of the ruling courtly ideal: silence, self-control, the abandonment of rhetoric and incalculabilities. It is hardly possible to describe his development. His portraits show no great variation. Like Holbein, Mor found some simple formulae early in life in which he was able to place his sitters, due to the uniformity of their high rank – half-, three-quarter-, or full-length, always life-size or rather more than life-size, with a turn to the side, while the head or the eyes are turned forward, to lend the pictures some spontaneity. The impression of unemotional, but only seemingly imperturbable, dignity, inhibited by mistrust, often verges on the menacing, as it does neither in Mor's bourgeois contemporaries nor in the Italians. The implicit challenge to the spectator to fathom the characters of these self-enclosed sitters gives Mor's portraits some excitement. The brooding hauteur of Central Italian Mannerism and the spirit of Spanish ceremony seem to cross in them. Within the narrow confines of his composition, Mor proved himself a master in the revelation of the individual behind all his modishly rich disguise. This blend of realism and stiffness, of diligent description and dignified gesture was achieved by none of his contemporaries, not even by Titian. On the other hand, in his bourgeois portraits, for instance in the so-called Goldsmith (1564, The Hague), in his self-portrait of 1558 (Plate 263), and in his female portraits, Mor blended sociability and eloquent naturalness with austere nobility of appearance.

Mor's portraits are set apart from those of all the 'Romanists' not only by the profundity of their psychology but also by the refinement of their painting. No other painter was able to combine the ancient Netherlandish density and fluency of brushwork with Venetian differentiation in colouring and tonality. His painting is of the greatest finesse of detail, yet the general effect is never sacrificed to pedantry or the delight in accurately rendered surfaces. His modelling is powerful, full of delicate transitions, yet unobtrusive. His flesh tones are more lifelike than the predominantly brownish tones of his contemporaries. Mor's influence on Spanish portraitists such as Sanchez Coëllo and Pantoja de la Cruz causes as little surprise as his fame in the north. It is more important to look back on him from Van Dyck and Velázquez. He was undoubtedly one of their ancestors.

There is literary evidence for a few history pictures by him, but the only certain example we possess is a Crucifixion of 1573 in the Santa Cruz Museum at Toledo. It is a weak piece of work which shows the typical Netherlandish conflict of capabilities, and awakens no interest for any more of his history pieces. We can only be grateful that fate led him into the field in which his true genius could fully unfold.

Genre Painting

The third task to which painters now devoted themselves was genre, especially peasant pictures.[22] In the many-figured, small variety which was taken up by Bruegel, there is practically no hint of the Renaissance. It stood in intentionally radical contrast to the serious norms of history painting: it was slapstick acted on the stage of art, as once the droleries of the manuscripts or the misericords of the choir-stalls had been. A large-figured variety of genre which made claims as high as those of the monumental history painters is represented by Jan Sanders and Aertsen. Here the contrast between the native subject matter and the Romanist form is even more striking than on the small scale. Genre, in all its forms, was of course regarded as a minor form of art, but was appreciated by all classes of the population, not only in painting but in every kind of graphic technique.

If there is a certain historical irony in the success of the Netherlands in portraiture, there is even more irony in the fact that the greatest artistic genius of the age was a genre-painter: Pieter Bruegel. His very high standing in the present century, however, must not blind us to the fact that his position in his own time was comparatively low. Neither he nor his art was regarded as a paragon of painting. He did not direct the course of developments, but, with conscious archaism, terminated the old tradition of the Netherlands. Part of his queer fascination lay in that very fact. The main stream of development was carried on by Floris and all the serious figure painters who shared Floris's convictions, who responded to the passion for Italy, and assimilated, with varying insight, the Roman, Florentine, and Venetian contributions, which Bruegel refused to do, although he had been in Italy.

Bruegel joined an undercurrent which had flowed steadily since the time of Bosch (d. 1516). As a young man he had seen the efflorescence of the 'Boschiads',[23] as they

were called later, those fantastic cabinet pieces, mostly spread out in landscapes, which, even when they treated religious themes, also contained among their countless motifs a number of genre elements, but which never reveal knowledge of the new compositional rules and of the nude in the 'modern' manner. Before and alongside Bruegel, famous painters of such pictures were, for instance, Jan Mandijn of Haarlem (1500–c. 60), who, from 1530 on, registered pupils at Antwerp, the last of them being Spranger in 1557; Herri met de Bles, who became master at Antwerp in 1535(?); and Pieter Huys, master at Antwerp in 1545 and still active in 1577. Given the lack of any certainty in the attributions, painters like these remain extremely diffuse, but the innumerable pictures of their type point to their popularity. Our ideas of the varieties of early genre are sadly fragmentary, since for every panel that has been preserved there were dozens of tempera paintings on canvas – more than in any other field – which have vanished, because they were cheaper, more elementary in the painting, ephemeral in function, and executed by lesser masters. A hint of this loss, though no compensation for it, is given by literary sources as well as by graphic reproductions down to the satirical broadsheets, small, decorative gouache paintings on parchment or paper, drawings, etc.

Among the genre painters, the Brunswick Monogrammist was an important figure in the second quarter of the century. Whether he was Jan van Amstel of Amsterdam, who was better known as a landscape painter and was registered master at Antwerp in 1528, or Jan Sanders van Hemessen, who was registered master at Antwerp in 1524 and was principally a painter of large-figured pictures, or a third person, his parable of the Last Supper according to St Luke 14: 15–24 (Brunswick), his Ecce Homo (Amsterdam), his brothel scenes, etc., were, as they must date from about 1540, predecessors of Bruegel's many-figured scenes. Pieter Aertsen too painted similar things about 1550, and there is in addition the probability of Bruegel's deriving some inspiration from German Renaissance art.

We know little more of Pieter Bruegel's life than what Van Mander tells in his *Schilder-Boeck* in 1604, and what can be deduced from dated works.[24] He was probably born between 1525 and 1530. The place of his birth (Breda?) and his social background are uncertain. Van Mander's assertion that he was of peasant origin cannot be confirmed. In 1551 he entered the Antwerp guild as a master. It is uncertain who his teacher was. Van Mander names Pieter Coecke, but there exists neither documentary nor stylistic proof. Between 1551 and 1555 Bruegel went to Italy by way of France. In 1552 he was as far south as Reggio Calabria and Sicily; in 1553 we find him in Rome, but probably in the same year he travelled home over the Alps. After 1555 he was definitely back at Antwerp, working as designer for Hieronymus Cock, the publisher of engravings. Before Italy he does not seem to have been active in that field, although Van Mander says so; afterwards, however, he continued in it till his death, besides painting. In 1563 he moved to Brussels, where he died in 1569.

It is obvious from all this that there are few great post-medieval painters about whose personality we know so little. Yet Bruegel was fully recognized during his lifetime. As a painter he had important patrons: one of them was the rich Niclaes Jonghelinck of

Antwerp, a brother of the sculptor Jacob, who possessed, besides twenty-two pictures by Floris, sixteen by Bruegel and who commissioned the series of the Months from him in 1565. About 1563 Bruegel came into favour with Cardinal Granvella, who bought several of his pictures. Abraham Ortelius, the Antwerp geographer, was a friend of Bruegel. After his death his work was in still greater demand. Between 1593 and 1595 Archduke Ernst, and after him the Emperor Rudolf II, acquired the present collection at Vienna. Collectors in the Netherlands and Italy vied with them in the acquisition of Bruegel's works. Giulio Clovio, the miniaturist, whom Bruegel had met in Rome as far back as 1553, left several of his pictures, apparently landscapes, in his estate in 1578. The very names of these patrons bear witness to Bruegel's intellectual calibre, over and above his appeal as a painter and anecdotist; for although, as late as 1900, Bruegel's compositional and figure style led many to believe he was a jester or a simpleton, a 'Peasant Bruegel', he was never a *peintre naïf*. It has only become obvious recently that his connexion with the religious thought of his time was very profound, especially with Coornhert's kind of free thought. There are close parallels in Coornhert's writings with Bruegel's pictorial moral philosophy and his fight against human folly and greed in all its forms.

It is possible to obtain a picture of Bruegel's artistic career after his return from Italy from a series of works dated from year to year, but his beginnings still remain obscure. His early works are already quite distinct from those of Coecke, if Coecke was really his teacher, though Bruegel's grisailles may recall Coecke's. Coecke's wife painted water-colours on canvas, a method widely used in her native city of Malines; it may be that she introduced Bruegel to this technique, which was later to play such a part in his life. Illuminated manuscripts, illustrations, decorative pictures in water-colour, and tapestries that have been lost are more likely sources of Bruegel's subject matter than paintings on wood. Yet observations of this kind are not very secure bridges between Bruegel and tradition. What is more important is that figure subjects, and large-scale work altogether, do not appear in his early years, which means that he was not attracted by the grand manner of the south.

His first datable works are drawings of 1552. They reveal a landscape artist after the manner of Matthijs Cock. It was as a landscapist that Bruegel went to Italy, not as an academician in search of learning, and he remained there unimpressed by contemporary Italian figure painting, but not unimpressed by the heroically ideal landscapes of the Italians and the sight of the Alps. In drawings of 1553 we can discern the long, wiry lines of Campagnola and Titian. The earliest dated picture, a landscape with Christ by the Lake of Tiberias (1553, private collection), with small figures which may be by Bruegel's travelling companion(?) Maerten de Vos, on the other hand shows a bird's-eye view of a panorama in conservative Netherlandish taste. The years 1554 and 1555 only offer us drawings or engravings after drawings. They are mainly views of the Alps, made on his return journey or immediately afterwards, and are quite different in character from the sheets of 1552–3. They are not views of nature, but composite views in deliberate 'artistic' arrangements. They recall only distantly the fantastic Byzantinism of Patinir's successors, but are observed with geological intuition, with

an eye for the life of the earth and the tumultuous past of the rocks. This seriousness has made of them grandiose 'character studies' of the mountains – true, even if not strictly realistic. Bruegel enriched many a design after his return with the dramatic impressions of his journey.

In 1556 he took up for the first time compositions with figures, obviously stimulated by Cock, who wished to publish them. But what came out was not the history picture *all'antica* but popular scenes, satires, moralities after the manner of Bosch, as they were still practised by Mandijn and Huys. In the engraving 'The Big Fish eat the Little Fish', for which Bruegel's drawing of 1556 is preserved in Vienna (Albertina), Cock actually named Bosch as the inventor. But after 1557 Bruegel's name appeared, and after the Seven Deadly Sins of 1558 (Plate 270), done from drawings of 1556–7, his reputation in this genre was established. By means of these engravings, which have dates down to 1565, he has remained known to the public.

We must always keep in mind that Bruegel, as far as we know, obtained no public commissions, but worked always for private collectors. (According to Van Mander, he was, however, commissioned shortly before his death by the Municipal Council of Brussels to paint a few scenes of the building of the Brussels–Antwerp canal.) Thus the general public only knew him by engravings. In the literature he also was still reckoned, e.g. by Guicciardini, after 1567, as another Bosch, and that cliché, which was taken more and more to mean mere buffoonery, afflicted his name till the present century.

Bruegel himself was only active in graphic work on one occasion, in the Rabbit Hunt of 1566. It is not possible to discuss in detail here the engravings after Bruegel. They form an immense realm beside the great realm of his paintings and his landscape drawings. Often the attempt to interpret an engraving leads into a wide field of contemporary philosophy, theology, literature, proverbs, allegory, and superstition, all fields in which the experts are uncertain or of contradictory opinions. Today the engravings frequently interest the scholar more than they appeal to the art-lover, who may be doubtful about their intrinsic artistic significance. The paintings, though hardly less difficult to interpret, never present the same puzzles as the engravings – which were at all times more attuned to speculative thinking – and in any case every painting of Bruegel's is a joy to the eye. It is unfortunately useless to praise Bruegel's colouring without having it before one; but it was in his time a unique phenomenon of delicacy and plenitude. Often the colours too had their symbolical significance. Thus their interpretation is as important as that of the subject matter, with which critics have been occupied for many years, and of the way in which Bruegel's composition unfailingly serves the expression of his theme.

Along with figure compositions there are also drawings of single figures – again no nudes or draped figures after the Italian taste, but peasants, beggars, and cripples. They are presented realistically, without affectation, and often in unusual poses, on occasion even turning their backs to us. All the studies bear colour notes, and many the additional note 'naer het leven'. But they are not merely that. So far as we can see they have not been used in pictures or engravings, but were done for their own sake. They do not show individuals in fancy dress: they are character studies of anonymous types. The

bodies, often deeply marked by life, are moralities, as it were, whereas the academic bodies of the 'Romanists' are aesthetic manifestoes.

The first paintings Bruegel made after his return from Italy (for instance the Adoration of the Magi of c. 1556 at Brusssels) also show the style of Bosch which was so much appreciated in Bruegel's engravings. The picture at Brussels is a densely populated composition, giving the effect of a tapestry. It is, like the cheap products of Malines, executed in tempera on canvas. But in comparison with Bosch it is painted less graphically and with greater benevolence in the expressions. The year 1557 brought a pure landscape: a cartographic panorama in which the Parable of the Sower is enacted (Washington, on loan from the Putnam Foundation). Apart from this picture, Bruegel's history paintings till 1562 were crowded with figures. These figures, the symbolic monsters which appear, the high viewpoint, and the strewing of the motifs after the manner of the broadsheet, recall not only Bosch and the Gothic style, but also younger painters such as the Brunswick Monogrammist, popular canvases, and graphic art. Rabelaisian and bursting with life for instance are the Netherlandish Proverbs of 1559 – a hundred in number – in Berlin (Plate 260), and the Fight between Carnival and Lent (Vienna), in which an apparently realistic market bustle becomes an allegory culminating in the foreground in a group which can yet be regarded as a mere mummery too. In 1560 there followed the Children's Games (Vienna), a cornucopia such as no painter since that time has poured forth. At this point we may also recall Flemish illumination of the early sixteenth century. The intention of the Children's Games and Proverbs is not only illustration; they are allegories of a sinful and foolish world. The bustle is moralized and becomes transcendental after the Late Gothic manner of thought.

After 1560, the all-over patterns disappear, but the borrowing from Bosch remains. It is revealed in another fashion by the apocalyptic and comfortless Triumph of Death (Madrid), the volcanic Dulle Griet (1562?, Antwerp, Museum Mayer van den Bergh; Plate 266), and the Fall of the Angels (1562, Brussels; Plate 265). This last picture should be compared with Floris's Fall of the Angels of 1554 (Plate 255) in order to measure the distance between Italian progressiveness and pseudo-Gothic archaism which was possible in the middle of the century. Compositions with real protagonists appear at the end of the fifties. Their figures usually appear archaically large in size, and take no part in the Lilliputian throng of the more commonplace figures: for example, as allegorical statues among everyday scenes in the engravings of the Seven Virtues of 1559–60. The only exception is the Dulle Griet – an outstanding protagonist and at the same time a fully alive, determined virago.

In 1562 the characteristics begin to appear which dominate Bruegel's late figure paintings. The composition becomes more concentrated, the action more unified, and a profounder harmony is created between figures and landscape. The first picture that makes the new aims clear is the Suicide of Saul (1562, Vienna), in which the bristling masses of the marching army are set in contrast to the lonely Saul and his esquire (Plate 268). In the late years, and not by chance, figures and compositional ideas appear from Raphael, Michelangelo, and other Italians. The grisailles of the Woman taken in Adultery (1565, London, Count Seilern) and the Death of the Virgin (c. 1564, Upton

House) show on a wide stage rationally grouped figures of equal size. The Adulteress stands in contrapposto: the composition reveals knowledge of Raphael's cartoons. The Adoration of the Magi of 1564 (London) also betrays Italian ideas (Plate 267). But the later figure-compositions are still accompanied by landscape, and this is now of the same monumentality. Mightily shaped by geological forces, the earth lies in restrained movement in the View of Naples (c. 1562(?), Rome, Galleria Doria) and in the Flight to Egypt (1563, London, Count Seilern). In 1564 came the Bearing of the Cross (Vienna); its tumultuous drama is doubly telling in comparison with the slightly earlier pictures of the same subject by the Brunswick Monogrammist (Louvre) or by Aertsen (formerly Berlin). Its early spring atmosphere is as clearly shown as if the picture were part of a series of the months. A pair apart is the Towers of Babel of 1563 in Vienna (Plate 269) and Rotterdam. Life swarms as in illuminated manuscripts, but it does not govern the pictures. We see the work of human hands that has taken on the greatness and character of a mountain massif and long since slipped out of the hands of men; it is not even straight any longer. The whole factual business of building looks absurd, because it is doomed to senselessness.

Of 1565 is the series of the Months, the five remaining panels of which are now preserved in Vienna, Prague, and New York. The comparison with earlier Months, either in print or in the calendars of the illuminators, shows how, in Bruegel's work, nature rules all that man is busy with; the real subject of his pictures is not typical actions but typical atmosphere and vegetation, nature in her yearly progress rather than the year's work of the peasant. Human beings occupy only a modest place in the epic of nature. As in the drawings of the Alps, the landscape is profoundly true without ever becoming realistic. The most remarkable of the series of the Months is probably the homecoming of the herd in January, a winter piece of suggestive truth (Plate 272). Bruegel also occasionally painted biblical scenes in winter landscape, and they are again exquisitely rendered in atmosphere, and subtler in colour than in any painter's work before. The paintings in question are the Massacre of the Innocents (Hampton Court and Vienna), the Taxing of the People at Bethlehem (1566, Brussels), and the Adoration of the Magi in the Snowstorm (1567, Winterthur, Reinhart Collection). In his Winter Landscape with the Bird Snare (1565, Brussels, Delporte Collection), Bruegel reached pure landscape in its modern sense; it is of little consequence what supposed proverbial meaning the picture possesses. Similarly the Storm on the Sea (Vienna), in its elemental force, marks the beginning of seascape.

The late figure compositions are governed by tensely overcharged compositional lines. In the Wedding Dance (1566, Detroit), in the Village Wedding (Vienna), and in the Sermon of St John (1566, Budapest), the many figures form geometrical configurations. In the Conversion of St Paul (1567, Vienna), an army winds its way, rising and descending, through wild mountain scenery; the theme of the picture is only found after some search in the middle distance.

In his latest years, Bruegel also produced several pictures of single figures which are seen close at hand and present the subject plainly: in 1567 the Land of Cockayne (Munich), a strangely rotating composition, and in 1568 the Lepers (Paris), the Peasant with

the Bird's Nest Thief (Vienna), and the Unfaithful Shepherd, preserved only in copies, who seems to be falling towards us out of a desolate dream landscape, while the ground seems to be yielding under his feet. In the Parable of the Blind leading the Blind (1568, Naples; Plate 271) their stumbling progress gives an unprecedented feeling of blindness, and their fall in a sliding chain-reaction is agonizing.

Bruegel's work, whether discussed in detail or as a whole, is inexhaustible both in the particulars and in artistic and intellectual breadth. Intense research into his work during the last few decades, however, has made it difficult to arrive at a general estimate of his art. If we merely enumerate the subjects of his works, we become aware of a uniquely profound preoccupation with the spiritual and moral, rather than with the aesthetic, problems of his world. We are confronted with a master 'devoid of principles to the point of dilettantism who was always propelled into the future by his subject matter' (Max J. Friedländer). On the one hand we see a native archaism in the forms used, on the other a comprehension of Italy and the application of the latest principles and forms of the south. We are confronted with a moralist who gave unprecedented pictorial forms to profound ideas, and a landscapist with an eye the like of which his century never saw again; we see at one and the same time the national and the international master; we see, as we can otherwise see in the sixteenth century only in Dürer, an embodiment of the 'thinking artist', supreme in both thought and artistry, uniting the contrasts and turning them into art.

No actual pupil of Bruegel's is known to us from the guild records. But there was a whole group of imitators painting 'Bruegeliads' far into the seventeenth century. Little need be said about them except that they represent a peculiar phenomenon of posthumous stylistic life, and deserve gratitude occasionally because they have handed down to us lost compositions by Bruegel. One of them is Pieter Balten,[25] who was registered master in 1540 and died about 1598. His Feast of St Martin (Antwerp) reflects a lost picture by Bruegel. Pieter Bruegel the younger (1564–1638), who copied and varied his father's work even during the lifetime of Rubens and Brouwer, is another. This remained the situation until Teniers, Rijckaert, and others translated Bruegel's specialities into the new painterly style and the new compositional schemes of the seventeenth century. Beside Bruegel's imitators there were contemporaries with more individuality, such as Maerten van Cleve (1527–81),[26] who became master in 1551 after his apprenticeship with Floris, and had marked out his own way as a painter before Bruegel made his appearance. He painted large figures and reveals his knowledge of Aertsen, for instance, in the Peasant Household, and of Beuckelaer in the Slaughtered Ox of 1566 (both in Vienna). Later he was glad to take ideas from Bruegel, but his variants, for example The Brawl (also Vienna), point rather to personal emulation than to mere imitation.

Certain landscapists of the 'transitional style' must also be grouped as planets round the sun of Bruegel.

Pieter Aertsen (1508–75),[27] probably a native of Amsterdam and certainly trained there, is the only contemporary of Bruegel who can stand comparison with him in his own field in artistic invention and power. Like Bruegel in character and love of

simple native themes, he was on the other hand Bruegel's opposite in that he did not paint archaically but with modern 'Romanist' brushwork and modelling. All his pictures have the monumentality which, till his time, had been reserved for religious and mythological painting. He was moreover a pioneer of new types of pictures. His large-scale genre pieces, free of the innuendoes of Roymerswaele and Jan Sanders, his pictures of kitchens and markets and his still lifes laid the foundation of Flemish genre and still-life painting. The works of Snyders, Fyt, and others are directly derived from pictures such as the still life in the N. de Boer Collection (on loan to the Mauritshuis, The Hague; also attributed to Beuckelaer), in which the world of things was given the same grand presentation as the world of human beings, and in which the still life is not still, but in dramatic movement. Strangely enough still-life painting in the Northern Netherlands developed on quite different lines.

Aertsen's religious pictures cannot stand comparison with his genre pieces. But although the history pictures are conventional in composition, and although figures in movement were not his forte, these pictures meant much for the future by their spirited, free brushwork. Here too Aertsen outstripped all the Romanists with his brilliant colouring, and is the herald of the mature Rubens. He gave great variety to the juiciness of brushwork and the intensity of colouring, from the sketchy near-grisaille background to the firm and variegated colouring of the foreground. It is this that gives his pictures their immediacy and their almost oppressive realism. The flickering light and the blackish drawing and outline recall Venetian technique.

Aertsen was registered master at Antwerp in 1535, but before 1557 returned to Amsterdam for good. His activity in altarpieces was far more extensive than can be appreciated today, due to the image-breaking of 1566 and other orgies of destruction. The great Amsterdam altarpieces, which enjoyed an early fame, have unfortunately not been preserved, but fragments of similar work have come down to us, and also panels at Antwerp (the triptych of 1546) and Amsterdam (the Adoration of the Magi of 1555–60 from the Deutzenhofje), and others, along with small, many-figured scenes after the manner of the Brunswick Monogrammist, such as the Carrying of the Cross of 1552 (formerly Berlin). Portraits are also mentioned in the literature, but nothing certain has remained. His history pictures and portraits were continued with some talent by his son Pieter Pietersz. (c. 1543–1603).

Aertsen's pictures in this new style set in in 1543, as early as the earliest by the Floris generation. In 1543 there is an almost life-size picture of a farmer's wife surrounded by her wares – milk, butter, and eggs (Lille; Plate 277), so the note was already struck which was to characterize the later cooks and peasants in three-quarter- or full-length figure paintings (Brussels, Budapest, and Stockholm) and the representations of their world. These paintings endowed the simple with reality and dignity. Aertsen always remained descriptive and truly serious in the 'Romanist' manner, even when his subjects were gay. Unlike Bruegel and his group, he did not represent the fourth estate with irony but with benevolence and affection. His people stand before us with self-confidence; they are the equals in size of Mor's sovereigns and statesmen, even if they are not yet considered worthy of being portrayed as individuals. For of course Aertsen's figures are

305

not portraits but types, like the earlier lawyers and money-changers, and were probably suggested by them, if not by North Italian half-length pictures.

These portraits of types, a transition between still-life and figure composition, he extended into whole kitchen and market scenes. In some cases they were so composed that a religious or other traditional subject was placed in the background, while the foreground was given over to a glorification of God's gifts of nature – a reversal of the normal hierarchy. Examples are Christ and the Woman taken in Adultery (Stockholm), Jesus at the House of Mary and Martha (Rotterdam and Vienna), and the most astounding picture of the kind, the Butcher's Shop with the Flight into Egypt of 1551 (Uppsala; Plate 274). Some of these pictures, however, are without traditional subjects altogether, i.e. are pure genre: the figures move forward, grow into three-quarter or full length, and become again equivalent to things. At times they are set in the midst of rural plenitude like other exhibition pieces, for instance the Poulterer at Brunswick. The vista broadens into the interior or into free space in pictures such as the Peasants' Feast of 1550 (Vienna), the Farmers' Table (Antwerp, Mayer van den Bergh Museum), the Egg-Dance of 1557 (Amsterdam), the Peasant's Kitchen (Copenhagen), the Pancake Bakery of c. 1560 (Rotterdam; Plate 273).

Similar pictures, in which still lifes spread out into the foreground, are to be found in Westphalia in the work of Ludger tom Ring the younger, for instance the Marriage at Cana of 1562 (Berlin), and in Italy in the work of Francesco Bassano, for instance The Elements (Sarasota and Baltimore), The Forge of Vulcan, Summer (Vienna), and so on. A still more palpable influence can be seen in the work of Vincenzo Campi, who about 1580 painted Fish, Poultry, and Fruit Sellers (Milan and Kirchheim Castle, if they are actually by him), and also in Bartolomeo Passarotti's Fish and Butchers' Shops (Rome) and Annibale Carracci's Butcher's Shop at Christ Church, Oxford.

Aertsen's nephew, Joachim Beuckelaer (c. 1535–74),[28] who was registered master in 1560, painted as a junior partner in exactly the same fashion and with excellent technique the same rural themes. He has little new to offer, yet his Slaughtered Pig of 1563 (Cologne; Plate 276) is the first example of those reproductions of gutted animals which accompany painting in the Netherlands as macabre memento mori up to the time of the late Rembrandt.

Landscape and Architectural Painting

In landscape[29] after the middle of the century, the bird's-eye view and the three-colour scheme of the 'world landscape' was consistently abandoned for the first time for a more intimate and realistic presentation. On the other hand landscape was rescued from its subsidiary role as a background and scene of narrative to become a new type – pure landscape or, in other words, the landscape portrait for its own sake. Already in the first half of the century the figures in the landscape had often been reduced to insignificance, and the landscape itself had been more and more enriched with actually observed details and credible atmosphere. Cornelis Massys' Village with the Arrival of the Holy Family at Bethlehem of 1543 (Berlin) went very far in this direction. But land-

scape without narrative, however minutely rendered, had never in the Netherlands been subject matter in itself. Even Pieter Bruegel abandoned the use of figures only in his drawings, a current practice since Dürer's time. Moreover, in the search for the earliest Netherlandish landscape pictures it should be borne in mind that what we have may be fragments, for instance the River Landscape (London; no. 1298), the Dutch Farmhouse of 1546 (formerly Berlin, Kaufmann Collection), or the forest landscapes from the outer side of a triptych by Gerard David (The Hague, on permanent loan from Amsterdam). Landscape views which are truly free of the drama of the old manner of vision and make a claim to be appreciated as such are only to be found after the middle of the century. First come forty-one etchings by Cornelis Cort (1533–78),[30] published by Hieronymus Cock at Antwerp in 1559 and 1561; they had a great effect and still influenced the style of Goltzius's drawings after 1600, the first realistic landscapes in Holland. The title of the series is an eloquent description of what is being offered: 'Vele ende seer fraeye gheleghentheden van diverssche Dorphuysinghen, Hoeven, Velden, Straten, ende dyer ghelijcken, met alderhande Beestkens verciert. Al te samen gheconterfeyt naer dleven, ende meest rontom Antwerpen gheleghen sijnde' (Many and very handsome scenes of the most diverse village matters, farms, fields, streets, and other things of the kind varied with many kinds of animals. All reproduced from life and mostly of places situated near Antwerp).

Then came Cornelis van Dalem of Antwerp, registered master in 1556, documented till 1565, and he contributed new ideas.[31] As Van Mander relates, he painted very little and only for his own pleasure; the figures in his pictures were inserted by Gillis Mostaert, Beuckelaer, and Hans von Wechlen. The landscape with the Flight into Egypt of 1565 (formerly Berlin) was new in its rocky scenic wings, overgrown with trees and bushes of Düreresque character and poetry. Similar rocky panoramas are to be found at Rotterdam, Madrid, and elsewhere: especially fraught with feeling is the broad rock wall in the Beginning of Civilization in the D.P.R.A. Bouvy Collection at Bussum. The Farmstead of 1564 in Munich (Plate 275) was an innovation in its near and natural point of view and objective colouring, qualities which were not repeated till the next generation, i.e. by Abraham Bloemaert. Van Dalem, like the German Renaissance masters, described an isolated, primeval world, saw the wild, ravaging forces of nature, and reproduced them almost scientifically, with the unemotional delight of the explorer.

These beginnings of an autonomous and natural landscape painting by no means changed the taste of the time all at once. They were rather first advances, followed up only later by Coninxloo and the Frankenthal school. A fair-sized group of contemporaries and followers of Bruegel continued to paint in gay, light colours and with the optical formulas on which Bruegel had long since said the last word. Among the many names which we can only recognize with certainty in very few paintings and in engravings, a few may be chosen as characteristic of the category: Jacob Grimmer (c. 1525–90); the much-travelled, elusive brothers Lucas van Valckenborch (1530(?)–97), who made a speciality of mines and foundries in front of decaying, antiquated rock-faces after Patinir (Plate 278); and Martin van Valckenborch (1535–1612). A fresh realism in detail was shown in this period of transition rather by topographers, for instance

Hendrik van Cleve (*c.* 1525–89), who continued Heemskerck's preciseness in the reproduction of Italian *vedute* and impressions of travel.[32] Examples are several versions of Rome seen from the Vatican (Brussels; Paris, Lugt Collection; London, Weitzner Collection), and drawings for engravings. In the same context belong the landscapists of Malines, whose most famous master, Hans Bol (1534–93),[33] strewed Bruegel figures in antiquated brilliance in comparatively credible landscapes, or set them in well-organized mass-revelries.

The most novel subject in painting in the middle of the century was the architectural picture.[34] Its beginnings lay far back, in the architectural stages of Gothic scenes, which, in their turn, were connected to a certain extent with contemporary theatrical scenery and decorations for triumphal entries. After 1500 they had become a more important means of enhancing the scenes themselves. They had also grown more luxuriant as decoration. Moreover, the eye was sharpened for the peculiar charms of architecture by drawings of ancient Roman buildings. Architectural treatises multiplied. After Rewich and Breydenbach, topography was a subject which included realistic reproductions of architecture. Finally there were paintings of churches which were, however, made less with artistic intentions than as records, like the wooden models. The older artists never painted architectural pictures, as they never painted pure landscapes, although their sketches were often more than mere notes of architectural elements to be used on occasion. The decisive impulse to the architectural picture was given by the new liberation of imagination and of pure art; with elements correct in themselves the artist created buildable but functionally useless prospects. The constructive assurance of these fantasies relates them in their turn again to theatrical scenery and festival decorations.

It was not by chance that an architect and theoretician, Hans Vredeman de Vries,[35] engraved and painted the first architectural fantasies. In 1549 he was engaged on the triumphal arches at Antwerp for the state entry of Charles V, and this must have been a decisive stimulus. His first series of architectural engravings, *Scenographiae sive Perspectivae*, appeared in 1560 and proved to set a programme for the development of the architectural picture. Unfortunately very few of his paintings have been preserved. Christ at the House of Mary and Martha of 1566 (Hampton Court) is set in a splendid chamber (Plate 279). This and the four architectural pieces in Vienna, dated as late as 1596 but not far removed from the pages of the *Scenographiae*, are not enough to give any exact conception of Vredeman as a painter. Nothing now remains of the illusionist architectural decorations which, according to Van Mander, he did in various places.

De Vries's pupil Hendrick van Steenwijck the elder (*c.* 1550–1603) from the seventies onwards developed the type further.

PAINTING IN GERMANY

IN several places of long-standing tradition in the art of painting, family workshops continued active far into the second half of the century.[1] Traditions of this kind, handed on by sons, brothers, nephews, and so on, had formerly been met with rather in the decorative arts and must now be regarded as characteristic of the fact that painters' workshops were now working in a similarly commercial and self-sufficient fashion. The painters remained more closely connected with the place they had settled in; this was furthered by the guild rules, which were devised more and more rigidly to prevent outside talent from competing locally. Besides, there were far fewer artists travelling to Italy from Germany than from the Netherlands. Moreover, the absence of commissions from the old Church led to an impoverishment of the artistic patrimony. There is no case in the third quarter of the century like that of Holbein, where 'the younger' after his name indicates that he outgrew the workshop tradition of his father, 'the elder'. Quite the contrary is true. The proud, sculptural, colourful German Renaissance aged into a linear, pale, and frosty Mannerism, in which the merely decorative element often predominates. These changes may be regarded as a continuance or a reawakening of Late Gothic principles, but it can hardly be taken as a conscious reaction against Italian influences. The best work done by these latecomers – as in the Netherlands – was in the portrait. Besides, in Protestant cities portraits were the main commissions that remained to the artists over and above occasional history pictures, façade frescoes, and other decoration. All these talents contributed to the general picture of German history and art, and one would be sorry to miss them; but the artists – like those in England – lived unaware of what was going on in the Netherlands, and still less in Italy and France. Southern and western art reached Germany only in a weakened, filtered form.

At Cologne, Bartholomäus Bruyn the younger, documented from 1550 to 1606, inherited the clientèle of his father, who had died in 1555. Like countless ascribed portraits, his one signed work, the Peter Ulner diptych at Bonn of 1560, shows how he and his guild companions dragged out the late style of Bruyn the elder – provincial artistic grandchildren of Joos van Cleve, at a time when Joos's style had long been a thing of the past in the Netherlands. At Münster, the field of painting was dominated by the brothers Ludger tom Ring the younger (1522–84) and Hermann tom Ring (1521–96).[2] Their gaily coloured costume figures are somewhat more florid than those of the Cologne artists. At Wittenberg and Weimar, Lucas Cranach the younger (1515–86)[3] continued his father's style with hardly a perceptible break in the tradition. The separation of his works from those of his father after the late thirties is still extremely problematic. His own production only becomes clear after his father's death in 1553. The portraits, for instance the Couple of 1564 in Vienna, show gaunt, tense figures in light, broken colours (Plate 280). There is still greater preciosity in his female nudes. He added

new iconographic types to those of his father, for instance in the Redemption altar of 1555 in the parish church of Weimar, and the heart-shaped altarpiece of 1584 (Nuremberg).

Owing to its closer connexions with Italy and the Habsburg territories of the Netherlands, South Germany was closer to the latest developments in art there than any other part of the country. That came out most clearly in the portrait: the figures are for the most part larger in size, fuller in the modelling, more self-confident in their appearance. The figure compositions are often more effective in the southern sense, the figures more supple and active, anatomy is mastered, or at any rate attempted, the colouring has greater tonality. At the same time, however, the heritage of the German Renaissance was cared for all over the country. In Munich, for instance, Hans Muelich (1516–73) continued for many years to paint patrician portraits in which the delicacy of the draughtsmanship, the purity of the colour areas, and the clarity of the light he had developed in his mature years continued as before. His altarpiece for the Marienkirche at Ingolstadt of 1571–2 is, in its complexity, a late follower of the age of Dürer, though international currents have flowed into it. At Lauingen there still lived Mathias Gerung (c. 1500–68/70), who had been the only court painter in Ottheinrich's early Neuburg days. At Zürich[4] Hans Asper (1499–1571), who had begun under Holbein's influence, was the most outstanding portraitist and a descendant of German Renaissance ideas. At Basel there were Hans Hug Klauber (1535/6–78; some of his pictures, which reveal no more than provincial talent, are in the Basel Kunstmuseum), and Hans Rudolf Manuel (1525–71), Niklaus Manuel's son, who was also active at Bern, though we have no picture that can be ascribed to him with certainty. At Regensburg the artistically very provincial late works of Michael Ostendorfer (c. 1490–1559)[5] were as important for Protestant iconography as those of the Cranach workshop. At Augsburg, Jakob Seisenegger (1505–67) made important contributions to portraiture, either full-length or knee-length after the Venetian manner, and was inspired by the influx of Italian artists at the Diets till the end of his life.[6]

Nuremberg alone kept several masters of standing employed, not all of whom, however, were natives of the city. Beside painters who continued older styles, or graphic artists such as Hanns Lautensack (1524–61/6), Virgil Solis (1514–62), and Jost Amman (1539–91), who came from Zürich in 1560 and only painted on occasion, the Calvinist refugee Nicolas Neufchatel from Mons (before 1527–c. 1600?)[7] and Nicolas Juvenel of Dunkirk (before 1540–1597) introduced the italianized Netherlandish style of portraiture. Neufchatel's portraits, the most certain of which is the Writing-Master Johann Neudörffer and his son of 1561 at Munich (Plate 281), show that his artistic qualities, in comparison with those of his great compatriots, were no more above average than those of Lambert Sustris, in part because they did not keep to the traditional Netherlandish technique. But the quiet, self-confident attitude and the grey-brown tonality with which the linear, tense manner of the Dürer school was overcome are reminiscent of Mor, Moroni, and the Venetians, and they gained Neufchatel success with the patriciate.

In Bavaria, Johann Bocksberger the elder of Salzburg (first mentioned in 1536, d.

before 1569), his nephew(?) and pupil Melchior Bocksberger (first mentioned in 1558, d. 1587), and Johann Bocksberger the younger (mentioned from 1564 to 1579) were all decorative painters and correspondingly more versatile.[8] With them, i.e. with the appearance of Johann the elder in 1542–3 in the palace at Landshut, the knowledge of the contemporary Central Italian style becomes obvious which the Bocksbergers were in a position to acquire at the modern-minded court of the Bavarian dukes with their Italian marriages. Borrowings from Giulio Romano, Salviati, and Vasari are to be found in particular in Melchior's work, for instance in the fifteen ceiling paintings with gods of 1559–60 for Duke Albrecht V's summer house at his Munich palace. His chiaroscuro drawings recall Niccolo dell'Abbate and Jacopo Ligozzi just as much as the old German tradition and the Danube school. At Regensburg Melchior painted house-fronts which can be visualized from, e.g., five large, multi-coloured and agitated designs of 1573 in the Regensburg Museum. Painted façades, now lost, but preserved in designs, were also the main activity of Johann the younger.

PART FOUR

THE AGE OF PHILIP II,
MAXIMILIAN II, AND RUDOLF II:
LATER MANNERISM

THE AGE OF PHILIP II, MAXIMILIAN II, AND RUDOLF II, 1564/7–1598

IN the last third of the sixteenth century the two Habsburg Emperors Maximilian II (1564–76) and his son Rudolf II (1576–1612) pursued a policy of mediation between the religious extremes.

In the Netherlands on the other hand, Philip II was involved in a bitter war which was not even at an end when he died in 1598. His aim was to restore the One Catholic Faith in his territory and at the same time to prevent the secession or loss more especially of the northern parts of this territory which, deeply involved as they were in the religious conflict, would have been tantamount to a secession of the aristocracy and bourgeoisie from the sovereign. The heir of Charles V was soon faced with the problem which Charles had still been able to avoid in his territories: the rise of new national states. The revolt of the provinces began in 1572; in 1579 the Estates of the Southern Netherlands united in the Confederation of Arras and those of the North in the Union of Utrecht. In 1581 the North formally declared its independence from Spain. In 1585 the capitulation of Protestant Antwerp to the Spanish troops actually meant the partition of the Netherlands, for in 1588 the defeat of the Armada by the English made it impossible for Philip to regain the North.

What had been prevented for the Empire as a whole, namely the establishment of a huge republic of the princes, had nevertheless come to pass in the narrow confines of the Northern Netherlands. Not the least factor in the coherence of this new state was the menacing enemy. At the same time, however, it was precisely here that Calvinism showed its power of endurance, its sanctification of action and labour, and its virtues of sobriety and discipline. Very soon a new form of society was being built up on a modern basis of economic efficiency. The old powers of the Dutch bourgeoisie put out new shoots, which, however, also reinforced its individualistic tendencies. Disunion threatened, especially when William of Orange, who might or might not have succeeded to a monarchy, was assassinated in 1584.

Philip, harsher from a distance than in reality, was almost on the perpetual defensive against this new nation. Educated on the principles of Erasmus, Philip was, in spite of many differences, Charles V's intellectual heir. Without being an absolutist in the full sense of the word, he had to attempt to impose on his territories what Charles had never succeeded in imposing on Germany: a uniform administration. But given the traditional Estates of the territories this programme could only mean one thing – a strengthening of the central government. Once again, but in greater loneliness and hopelessness, the tragedy of Charles V was enacted. In the Netherlands Philip had to act as sovereign, especially in religious questions. Thus he had to side with the Catholic party, which he

belonged to in his heart anyhow. He was shrewd and hard-headed; though humane by
nature, he became intolerant in religion, not for lack of human feeling, but from his
profound convictions as a ruler.

Hence the determining development for Europe was bound to be an alliance of the
centrifugal and conservative interests of the Estates with their Protestant, national, and
economically modern tendencies. On the other hand the supra-national centralization
of the monarchy joined forces with the fresh strength given to Catholicism by the
Counter-Reformation. However, the Catholic and monarchic side had no new economic
conception with which to oppose the rise of capitalism. The Counter-Reformation
made its way into Flanders and re-catholicized large territories there. Refugees came to
Holland and the Empire.

What was felt there, not only by Friedrich III of the Palatinate and the Calvinist
princes, was indignation that the Netherlands, a part of the Empire, had been overrun by
Spanish troops. Even August of Saxony and the Lutherans were inclined to intervene.
Philip had demanded an imperial ban on Orange, but the emperor refused to issue it.
But all the same Germany was startled when it learned of an alliance between the free
Netherlands and the French Calvinist co-religionists under Coligny. There seemed to
be danger that if the Protestants should be the victors in the entire Netherlands, the only
result would be a French supremacy instead of a Spanish one. The Germans refrained
from action.

Thus this war of religion, though it was carried out in imperial territories, was
localized. Both the Lutheran policy of Saxony and that of the emperor aimed at pre-
venting it from spreading to the rest of the Empire. Actually the Netherlands war of
liberation was not the cause of the Thirty Years' War in Germany, though it too was not
concluded till 1648. The protagonists of a mediatory policy in the rest of the Empire
succeeded in preventing full-scale war till the end of the century and after.

Maximilian II, Philip's cousin and brother-in-law, and at the time of Charles's plan
for the imperial succession something of a rival to the emperor's son, was actually
Lutheran in sympathy, but in order to become and remain emperor conventionally
practised Catholicism. Yet on his death-bed he refused the consolations of the Church.
In his ambiguous situation he cannot stand as a hero in history. But he did during his
period of activity fulfil imperial duties honestly and realistically.

He was an opponent of any radical religious and political trends. His aim was to give
depth to spirituality and the spiritual life, to improve the understanding between the
religions, and in particular to reduce the tensions in the relationships between Catholics
and Lutherans. Hence he was an opponent of Calvinism, which he declared illegal at
the Diet of 1568. But he opposed all the Counter-Reformation policy of the newly rising
Catholicism.

On the other hand he favoured the Jesuits, since he expected from them a moral and
spiritual elevation of the clergy. Himself a humanist of standing, he hoped that tolerance
would come of culture. Even on the side of the new faith there were great improve-
ments necessary in this respect. As Melanchthon had seen, what many Protestants mainly
wanted was revolution, the relaxation of moral codes, and material advantage. More-

over the worldliness of the old clergy had been superseded by the *furor theologicus* of the reformed clergy.

The first thing that was necessary was to instil a higher sense of responsibility into the nobility; for since the Augsburg Confession, the ruler determined the religion of his territory, in so far as it was not of itself a clerical territory. Hardly any change of religion came about without the political and spiritual representatives of the subjects having been previously consulted. And if an individual remained faithful to his previous religion, he did not suffer, for the most part, either in life or limb, as was the rule in many other European countries. A right of emigration was the custom. Nor was any loss of property inevitable. Given the extreme intricacy of territories in Germany, co-religionists were generally not far away.

When this emperor devoted to mediation died in 1576 and was succeeded by his son Rudolf II, the Empire entered on a more critical stage. The religious parties had become more radical. On the one side, territories and cities previously Lutheran fell more and more under the sway of Calvinism and Calvinistic sects, and their rulers adopted, openly or secretly, these more determined and modern forms of the new faith. On the other hand, the Catholic party, led by Bavaria and mainly in league with the Jesuit Order, succeeded in re-catholicizing indeterminate and controversial districts and securing in particular the great spiritual principalities of Cologne, Mainz, Trier, Würzburg, Augsburg, Strassburg, Speyer, and Worms. At the same time, the establishment of Catholic churches in the territories, for instance in Bavaria, was not carried out without friction with the episcopate.

The young emperor did not succeed in following his father's *via media* with any vigour. Having been educated at the court of Madrid, he had been stamped with the Erasmian spirit like his father and uncle, but he was, like his uncle, profoundly convinced of his Catholic duties as a prince. But it was just that which had alienated them from the tolerant spirit of the great humanist. Montaigne, the free genius of their time, lived in France, in the camp of their adversaries.

Rudolf, twice a great-grandson of Joan the Mad, had inherited her lack of stability: irresolute, melancholy, he was seldom able to avail himself of his great gifts and moral convictions. Thus his policy, as a whole, was passive. Where he took action, it was anti-Calvinist like that of his father, but unlike his father's, thoroughly in the spirit of the Counter-Reformation. He observed the Peace of Augsburg only to the letter, and merely avoided infringing the declared rights of the Lutherans. He was no emperor devoted to mediation.

When the Calvinistic cities and princes, living in a condition of absolute absence of religious rights, finally refused to pay taxes or give help against the Turks, Rudolf to all intents and purposes abandoned them and let things go their way. That was why the Diet and its functions were *de facto* paralysed from 1591 on. Round about the emperor there was still an intact administrative core, but it had no real power and no real prospect of seeing its resolutions implemented. When Rudolf, in 1600, suspicious and misanthropic, finally dismissed his best advisers, he became dependent on lesser men.

At the end of the century the conflict between the religions was harsher than ever.

There were certainly on both sides men who were faithful to the emperor, such as Duke Julius of Wolfenbüttel, a follower of Melanchthon, who died in 1589, his son Heinrich Julius, and also the Protestant Wilhelm IV von Kassel who died in 1592. But the appointed intermediary, the emperor, had more or less retired from government, and lived, embittered and gloomy, for his alchemistic and chemical, astrological, and astronomical studies (assisted by Tycho Brahe and later by Kepler), promoted anatomical research, and devoted much of the energy he still had to his great love of music and still more of painting, sculpture, and goldsmiths' work. He was not only a collector of antiquities, acquired, like Philip II, works by Bosch, Dürer, and Bruegel, and was interested in the Isenheim altar, but was also the greatest patron and promoter of living artists.[1] One can speak of the Art of the Age of Rudolf II for the time of the turn of the century more definitely – if in a more limited sense – than of the Art of the Age of Maximilian I.

In the last third of the century, the German regions were more exclusive and self-contained and the religious rift deeper than ever before. For now there were three religions to be reckoned with, not two, since all attempts to unite the Reformed parties had failed. But the states took shape largely in the aftermath of religious separation. The foundation for this had been laid in the late Middle Ages; the Habsburg ancestors and the loyal princes, the city leagues and the Hansa had only been able to check, not to prevent, the process. Thus German history in the sixteenth century appears as a development which runs entirely counter to the historical process in other countries. Neither national union nor centralization, neither royal absolutism nor a united Church were achieved in Germany, or even really striven for.

Thus there was no other part of Europe in which the late Middle Ages could be revived so vigorously, or could indeed survive, as in the Empire. The result was not only an intensification of provincial character, but also an almost hopeless narrow-mindedness. In the newly established communities, down to the smallest, local egoism and short-sightedness went so far as even to affect their own interests. Even Ferdinand I's matter-of-fact policy had not succeeded in imposing an Imperial order on coinage. Prohibitions of imports which – corresponding to the abolition of Hanseatic privileges in England in 1558/9 – should have been of advantage to the German cities as a whole, came to grief on the individual interests of some of them. The internal economy of Germany declined steeply. The richest cities were deep in debt. Some ports, such as Bremen, Hamburg, Danzig (Gdańsk), Emden, stood their ground, welcomed the competent Calvinist refugees, and became rich because they admitted English and Dutch goods against the Hanseatic blockade. The Dutch fleet ruled the northern seas. In every case this new, hard, economic spirit with its sober blend of religion, politics, and economics proved superior.

This development did not affect the cultural efflorescence of the South German cities straight away. Nuremberg, Frankfurt, Augsburg, and Strassburg had plenty of artists and produced art-lovers in their bourgeoisie. But the capitals of the larger territories gained steadily in relative importance. Munich and Prague seemed by way of outstripping Augsburg and Nuremberg, Brussels vied with Antwerp. A great deal of building

was commissioned by Julius Echter, the Counter-Reformation Bishop of Würzburg. The court director of music and the court painter often rose above the municipal craftsman-artist. The greater capitals, such as Dresden, naturally stood in the front rank. But while in the liberated Netherlands, now in separate development, the splendid garland of single vigorous art centres began to come to the fore, in the interior of Germany it was the smaller capitals, even the moated castles and fortified manor houses, which developed a culture of their own. Even in places like Schaffhausen and Frankenthal artists could make a living: the latter, like Freudenstadt, which came into being in 1599, was founded solely for the purpose of receiving religious refugees. In a general way the age saw a good deal of true city-planning. Wolfenbüttel is an instance. It was there that Duke Heinrich Julius wrote the first German comedies, and first invited English companies to act in Germany. From the south and west the Jesuits spread their theatres over Germany and revived with their new churches the long-suppressed feeling for sacred building, while on the other hand refugees from the Netherlands made contributions to secular art. Thus a number of main currents in art vied with each other in giving colour to the old, multifarious pattern of the Empire. A highly variegated picture of cultural life grew up in Central Europe as an almost gay reverse to the distressing intricacy of the political organization.

CHAPTER 37

SCULPTURE IN THE NETHERLANDS

IN the Netherlands[1] the Floris style survived into the early years of the seventeenth century, enriched by new influences from followers of Michelangelo such as Cellini and Ammanati who introduced more slender forms and more graceful movements. Here and there connexions with France, for instance with Goujon, can be felt. No master of rank is to be found among the busy producers of memorial tablets, tombs, altarpieces, elaborate portals, choir-screens, architectural sculpture, and so on. In a general way it may be noted that in comparison with the contemporary Mannerism in graphic art and painting, not to speak of the fantastic two- and three-dimensional ornament, in figure sculpture the pendulum of taste did not swing so far in the direction of movement and artificiality of motifs – on the larger scale at any rate. The sober 'Romanist' tradition remained the predominant power into the seventeenth century. It was not until the second decade of that century that the Italian Baroque, which served the aims of the Counter-Reformation, began to invade the south of the country. Even when Hendrick de Keyser (1565–1621)[2] began the monument for William the Silent in the Nieuwe Kerk at Delft in 1614, he took his inspiration from Germain Pilon's tomb of Henri II in Saint-Denis, completed in 1570, and from South Netherlandish forerunners, and the monument was nowhere like the stylistic revolution which painting had seen long before. On the other hand Hendrick de Keyser was no Romanist either; it is the Baroque that entered Holland with him, though it led to no true development. The fault may be with Calvinism or the lack of suitable commissions. Hendrick de Keyser does not belong to the present volume, but he continued many traditions, for instance that of Van der Schardt's portrait busts in his bust of a man of 1606 (Amsterdam), which is made of polychrome terracotta but tapers like a bronze. Was it intended to be a substitute for bronze?

There was, however, not only the grave Roman tone of the sculpture on monuments or the choir-screens, for instance the one that Coenraed van Norenburch made for St Jan at 's-Hertogenbosch (Bois le Duc) in 1610–13 (London). In pictorial reliefs the Malines tradition of Guyot de Beaugrant and Blondeel lived on, side by side with inspiration from the recent Florentine works of Cellini (for instance the Perseus Fountain of 1545–54 in Florence) and of Giambologna. In still smaller forms, in bronze, alabaster, and wood statuettes, carved ivories, mirror frames, for instance the Dutch one of 1580–90 in Munich,[3] in plaques and goldsmiths' work, even in wax busts and similar works for connoisseurs, there was both in Holland and Flanders throughout the sixteenth century no lack of sentiment, sensuous charm, delicate detail, and spontaneous, realistic expression. All these things were peculiar to the Renaissance, which streamed steadily northward, carried by travellers returning from Italy. After the turn of the century their emotional content intensified and so passed into the Baroque, or even

anticipated the eighteenth century. An instance is Willem van den Broecke's small marble group of Cypris and Eros of 1559 at the castle of Hamal near Tongeren.

In the second half of the century the Wars of Religion and the image-breakings of 1566–7 and 1578–84 brought untold destruction. Very often works just completed were smashed. To judge from documents, nearly all that would have been decisive for an adequate record of Netherlands sculpture has disappeared. Willem Tetrode of Antwerp or Delft, documented *c.* 1549–77,[4] is a typical figure of the time, a master held in high esteem by his contemporaries who has practically vanished from our sight. He was active in Italy (1549–62), London (?), Delft, and Cologne. In 1568–71 he executed the ornate high altar of the Oude Kerk at Delft, which was probably destroyed in the Reform movement of 1574. Many statuettes by him have been described, and some engraved, but no certain original has come down to us.

We can on the other hand gain some idea of Jacob Jonghelinck of Antwerp (1530–1606), medallist and Spanish court sculptor; he returned to the Netherlands in 1555 after three years in Italy, mostly under Leone Leoni at Milan. In 1558–66 he executed the tomb of Charles the Bold, who had died in 1477, in O. L. Vrouwekerk at Bruges; he had, however, to adapt his work to a Gothic tomb in the same chapel, that of Charles's daughter Mary of Burgundy, who had died in 1482, and indeed the tombs are amazingly similar. His life-size bronze statue of the hated duke of Alba, of 1571, in the citadel of Antwerp, was destroyed during the revolt in 1577.[5] The bust of Alba of 1571, now in the Frick Collection in New York (Plate 282), and medals contribute to the impression of haughty presence which Jonghelinck, thanks to Leoni's teaching, was able to give his sitters.

CHAPTER 38

SCULPTURE IN GERMANY

In North Germany[1] a few representatives of the local and surviving tradition of wood-carving about 1600 are worth mention. They represent local urban craft beside the imports of the territorial rulers. At Lüneburg, Albert von Soest, documented between 1567 and 1587/90,[2] undertook the decoration of the City Hall, a traditional kind of commission which had always offered plenty of scope. In 1567–84 he decorated the newly built Hall of the Great Council with allegorical, biblical, and Antique figures and scenes, richly ornamented in every manner from the Early to the Late Renaissance, which he unabashedly put side by side. On the bench ends of the councillors' bench and on five ornate doors there is displayed a Protestant, humanistic programme which is, however, medieval in origin. In his style too Albert von Soest was a descendant of the indefatigable Late Gothic wood-carvers. He was a great craftsman, but his imagination was limited. Prints by Jost Amman and other German minor masters served him as patterns. At Lübeck, Tönnies (Anton) Evers the younger (1550/2–1613)[3] continued his father's work on church furnishings and in the town hall (decoration of the senate chamber; remains now in the Annenmuseum).

Ludwig Münstermann (b. 1570/80, master 1599, d. 1637/8)[4] had his workshop in Hamburg, but worked for the province of Oldenburg. Strictly chronologically, he has no place within the bounds of the century, but he was a latecomer in his figure style. He was moreover an astounding eccentric without any very clear connexions, whether with North Germany or with the Netherlands (though there is a relation to the latter in his ornament) or with the south. Like so many of his contemporaries, he could only display his gifts in small, traditional commissions – fonts, pulpits, organ-fronts, altarpieces, and memorial tablets for Protestant churches. His main work is the altarpiece in the parish church of Varel of 1614, retarded in comparison with the south, like Jörg Zürn's Überlingen altarpiece of 1613–19, and an amazing parallel to El Greco in its singular and strange expressiveness. Agitated, curiously proportioned, gaunt figures with deeply under-cut drapery, lavish ornament, and ecstatic faces reveal Münstermann's relationship to the Baroque phase of the Late Gothic and to Late Baroque itself at one and the same time. Late Gothic, though pointing forwards to the Baroque, are also his colouring and the openwork or painted backgrounds of his altarpieces and their figures grouped as in Christmas cribs.

In the Protestant lands of Thuringia, Saxony,[5] and Silesia[6] there were busy producers of strapwork in the taste of the Netherlands who poured out their indefatigable delight on good, honest figures, on ornament, memorial tablets, and altarpieces, and often equated sculpture with cabinet-making. They were represented at Magdeburg[7] by Christoph Kapup – well above the average – in the dignified alabaster figures and reliefs after Netherlandish engravings on the pulpit in the cathedral of 1595–7.[8] At Dresden there was the Silesian and Saxon Walter family, the best of whom was Christoph II

(1534–84). On the other hand the court had available the versatile superintendent of art Giovanni Maria Nosseni of Lugano (1544–1620), active in Saxony from 1575.[9] Like Sustris in Bavaria he only made designs, executing little himself. The Florentine sculptor Carlo di Cesare in 1590–2 worked for the Elector Christian I of Saxony on the bronze and stucco sculpture in the memorial chapel of the Wettin dynasty in the cathedral choir at Freiberg, which had been designed by Nosseni. But Carlo di Cesare's working span was too short to leave a mark on the unprepared minds of Saxony. He had been in the service of the grand duke of Tuscany, and is thus a typical case of the borrowing of artists among courts; but so is Nosseni, who in 1609 executed a model for the mausoleum of Count Ernst of Schaumburg at Stadthagen, which was not finished till 1625. It is on a strictly Palladian central plan and almost entirely devoid of decoration – utterly alien in North Germany; the tomb was executed, also without any ornament, by Adrian de Vries in 1618–20. In western Germany, Hans Ruprecht Hoffmann (c. 1545–1616)[10] was active in the archbishopric of Trier from 1568 and had a very busy workshop. His memorial tablets and large works like the pulpit of 1570–2, one of the richest of its kind in Germany, or the monument-cum-altarpieces such as those of the Trinity, completed in 1597, and of All Saints, completed in 1614 (Plate 284), all in Trier Cathedral, reveal a typical successor of Floris and Vredeman de Vries, with a bent to over-decoration, who often copied Netherlandish engravings in painterly reliefs, but displayed in portraits an independent mastery of physiognomy. At Aschaffenburg and Mainz, his rather more gifted and modern opposite number at the court of the elector of Mainz was Hans Juncker (1582–after 1623), who moved on into the Baroque with virtuosity yet warmth in his works in the chapel of the recently built palace at Aschaffenburg. Between 1609 and 1618 he provided an altar in black and red marble and red sandstone and statues and Passion reliefs in grey-green alabaster, a pulpit in grey tufa and reddish marble with alabaster figures and reliefs, and a portal in a dramatic, not merely decorative manner, with virtuosity but without coldness.[11]

In South Germany,[12] by tradition and under Italian influence, bronze figures and cabinet pieces for collectors continued to be made in considerable quantities. At Nuremberg, Georg Labenwolf's pupil Benedikt Wurzelbauer (1548–1620) came forward as the last important representative of local bronze-casting. His Fountain of the Virtues of 1585–9, next to St Lorenz (Plate 283), the only one to be preserved of many fountains of its kind in these years,[13] shows, in the interaction of its over-slender figures, how the traditions of the South German Renaissance were yielding to a precious agility of a Netherlands–Jamnitzer kind. The successors of Jamnitzer kept alive the great reputation of the Nuremberg goldsmiths. Christoph Jamnitzer (1563–1618) was, after Wenzel, the most independent member of the family, and executed figures of a restless, Italian elegance and luxuriant grotesques.[14] At Konstanz, Hans Morinck (d. 1616)[15] had been active since 1578; he had come from Holland, and executed, especially for local churches, lightly-toned and gilded, softly modelled painterly reliefs, with vigorous movement but controlled gestures, in well-rounded forms. A follower of Floris, fresh from his experiences at Florence and his encounter with Sansovino at Venice, he, like Hoffmann and Juncker, made the transition to the Baroque.

While at Nuremberg the old traditions were being carried on in works such as the Fountain of the Virtues or in the etchings of Wendel Dietterlin's pattern book *Architectura* (Nuremberg, 1593/4–8), the future was being born at Augsburg and Munich. The princes and patricians with their Italianate taste were promoting a fundamentally novel style. From the eighties there developed a monumental metal sculpture parallel to that of the Italian Cinquecento. The main impulse came from Netherlandish artists trained in Italy who transplanted to South Germany the style of Giambologna and of the generation of Cellini and Ammanati. They worked into the 1620s, when the Thirty Years' War and economic and political chaos put an end to this development which had held so much promise for a future German Baroque sculpture, different from the classicism of the north and the Mannerism of other local German schools.

In 1581–3, Christoph Fugger commissioned the Dutchman Hubert Gerhard (1540/50–1620),[16] who had come from Italy, to make the models for the brass sculpture of an altarpiece over his sepulchre in the Dominican church at Augsburg (now lost). In 1583 Hans Fugger, who had already in 1580 commissioned from Alessandro Vittoria a bronze altar for the chapel of his castle at Kirchheim (under construction from 1578 to 1585), took Hubert Gerhard into his service for the same castle. With some intervals, Gerhard continued till 1595 to execute small and large pieces for Kirchheim, among others, before 1585, twelve over-life-size figures of famous rulers, men and women, in fired gypsum, in collaboration with an assistant, the Florentine stuccoist Carlo Pallago, who had been active at Augsburg since 1569. Gerhard also did door-knockers and handles for Kirchheim, and in 1587 a large chimneypiece with three stucco figures – Vulcan, Mars, and Venus – which are composed like Michelangelo's Medici tombs, and, like them, in purely Italian forms. The most important work was the fountain in the courtyard, executed from 1584 to 1594. The task, which had recently found monumental solutions at Bologna, Florence, and Rome, was now for the first time solved north of the Alps in the spirit of Italy. Of all the many figures, animals, and heads, the only thing to survive is the over-life-size bronze central group of Mars, Venus, and Cupid on a marble pedestal with four termini at the corners, completed in 1590 (Munich; Plate 285). But this group suffices to show that Gerhard was doing vastly different work from the popular, outsize épergnes after the fashion of the contemporary pieces by Wurzelbauer and Jamnitzer. The group has Italian predecessors, for instance the Theseus and Helen, by Vincenzo de' Rossi, which was set up in the Boboli Gardens at Florence in 1561. But what is new, elemental, and northern is the expressive contrast in the embrace and the supreme expression of passion, which is all the same weakened in Mannerist fashion by the dallying of Venus with Cupid. Gerhard incidentally only modelled the group; it was cast by others. This arrangement was usual in Italy and in Germany. The master made the model, the casting was often executed in a gun foundry, and in the end came the finishing and chasing after casting, done again by someone else. In 1584 Gerhard made the wax model for Hans Fugger's monument in the castle of Kirchheim, which was executed with mellow delicacy in marble, by Alexander Colijns at Innsbruck. The type is Gothic, but the modelling of the face, which Gerhard executed himself from the life in 1587 – Fugger died in 1598 – is firmer and more generalized.

The city of Augsburg now began to take notice of Gerhard and commissioned him in 1589 to do the Augustus Fountain which it wished to dedicate to its founder on its sixteenth centenary in 1594; it was punctually set up opposite the town hall (Plate 286). Gerhard's design is related to Giambologna's Neptune Fountain at Bologna, which was executed between 1563 and 1567. The Emperor Augustus stands on top of the high pedestal over-life-size as a monument *all'antica* in the attitude of the Imperial *allocutio*, elegant and precise. The figure is modelled with exact observation of nature, yet with sculptural force and a convincing greatness. The slender personifications of the four rivers of Augsburg gliding down the rim of the basin are probably borrowed from Ammanati's Neptune Fountain at Florence of 1571–5. The most modern, the purest Italian ideas were here introduced for the first time into monumental German sculpture, in perfect clarity and early Baroque economy of figures and ornament. The motif of the four rivers was to have its influence still in 1737 on Georg Raphael Donner's fountain in the Mehlmarkt in Vienna.

The artists employed by the Fuggers often moved on to Munich, where Duke Wilhelm V had been replanning his palace since 1579, enriching it with more courtyards, gardens, and wings. He also had the church of St Michael built for the Jesuits in 1583–97, an artistic enterprise as many-sided as his palace. After 1584 Gerhard was active at Munich – the first outstanding master the city had had for many years. From 1588 he worked particularly hard for St Michael, the most important building of its time in Germany. Its sculptural ornaments came mainly from Gerhard's workshop – several dozen agitated, monumental stucco figures of apostles, saints, and angels in niches in the choir and nave. Till 1597 he also did most of the models for the bronze statues for a sepulchre of Wilhelm V, designed by Sustris but later abandoned. The four kneeling knights made for this funerary monument, late successors of those of the sepulchre of Engelbert at Breda, now mount guard over the tomb of Emperor Ludwig IV in the Frauenkirche; four heraldic lions from the sepulchre stand in front of the palace, and a solemn, life-size angel stands like a caryatid in St Michael by the holy water stoup. Between 1588 and 1592 Gerhard executed for the main niche of the façade the over-life-size bronze group of St Michael and Lucifer, which, while supremely precise in the detail, blends grave Italian drama with Gothic motifs.

As for work by Gerhard for the palace, less can be accounted for than he must have done. About 1590 is the date of the over-life-size Bavaria, a fountain figure from a pool in the great palace garden, Gerhard's finest female nude, composed fully in the round and Italian in its grace; it is now in the Residenz-Museum. About 1590 and later, Gerhard and his workshop executed the figures of the Wittelsbach Fountain in the palace, though the composition is not his own. The crowning figure of Count Otto of Wittelsbach recalls the Late Gothic statues of Emperor Maximilian's tomb at Innsbruck. Gerhard's Perseus Fountain, executed about 1595 after a design by Sustris,[17] still stands in the Grotto Court of the palace, a less imposing variant of Cellini's statue at Florence.

Owing to a lack of commissions after the abdication of Wilhelm V in 1597, Gerhard entered the service of Archduke Maximilian at Innsbruck, remaining there from 1598 to 1613, though he continued to work at Munich too, where he probably lived again from

1613 to 1620. Before 1613 he executed, for instance, for the high altar of the Frauenkirche a Virgin which in 1638 was placed on a column in the Marienplatz as a devotional image. In 1604, Maximilian's brother, the Emperor Rudolf II, applied for the 'loan' of Gerhard to Prague, but all he received was a bronze of the type of Gerhard's Mars and Venus and Hercules and Dejanira, now in Vienna.

A Dutch friend of Gerhard, Adrian de Vries (recte Fries; c. 1545–1626),[18] was, on the other hand, closely connected at the same time with the artistic milieu of Prague both personally and spiritually. He too was a pupil of Giambologna and founded his reputation in the north on fountains at Augsburg. In 1596 he was there and received the commissions for the Mercury Fountain, completed in 1599, and the Hercules Fountain, completed in 1602 (Plate 288), the latter after a drawing by Hans von Aachen. Both are parts of one series with Gerhard's Augustus Fountain: the founder of the city stands beside personifications of trade and virtue in its main street.

De Vries only made the models ready for casting. He did so while in Rome. They were cast by others at Augsburg, and finished there by yet others. This division of labour, which we have just met, was maintained by De Vries even for small bronzes;[19] the restriction to the idea, i.e. to the *bozzetto* as the truly creative act, was typical of the conception of art about 1600. The figure of Mercury is a variant of a statue by Giambologna in the Bargello in Florence, treated with greater emphasis on the serpentine movement. Hercules in his fight with the Hydra also derives from Giambologna, but is more compact in conception. The bursting energy of the body forms an effective contrast to the full, sleek bodies of the mermaids on the pedestal.

De Vries's earliest known monumental works were executed as early as 1593 in Rome for the Emperor Rudolf II; the life-size Psyche borne up to Olympus by three Cupids (Stockholm) and the over-life-size bronze Abduction of Psyche by Mercury (Louvre). Both groups are indebted to Giambologna. The first, artfully hovering, is a sculptural transposition of the Raphael fresco in the Farnesina: the second is poised even more daringly than Giambologna's Mercury, for the foot on which he tiptoes carries visually two figures, not one, and actually a far more than double weight. The group has no principal side, though Jan Muller, a relative of De Vries then living in Prague, made an engraving of it in a drastic side view during the very year when it was completed (Plate 287). In 1601 De Vries was appointed sculptor to the emperor, went to Prague, and now worked mainly for Rudolf. His bust (Vienna) was executed by De Vries in 1603 – an expansive, noble companion piece to Leone Leoni's bust of Charles V, which was in the possession of Rudolf. In 1603 De Vries also executed the bust of Elector Christian II of Saxony (Dresden, Albertinum). His corpulence is used to express his force, sensuality, and narrow-mindedness. A second life-size bust of Rudolf (Vienna), eminent for its sensitiveness and noble in spite of a more intimate realism in the characterization of the massive head, was executed in 1607, the year which also saw a nearly life-size Christ in Distress [Liechtenstein Collection], which goes back to the title page of Dürer's Great Woodcut Passion. It is a monumental, startling testimony to the resurgence of older styles and attitudes about 1600. Of 1609 are painterly reliefs with allegorical representations of Rudolf as a patron of the arts (Windsor Castle) and as

victor over the Turks (Vienna), the diffuse modelling coming as near as possible to the effects of painting. Paulus van Vianen the goldsmith reached the same goal at the same time with the delicate chasing of his silver reliefs. Probably the designs for De Vries's reliefs were made by a painter, as was usually the case, the painter here being Hans von Aachen, who has similar motifs in his representation of the same subject and made many sketches for sculptors. Generally speaking De Vries's forms and motifs are very close to those of the painters of Rudolf's entourage and Netherlands artists of their type.

After the death of the emperor in 1612 and the removal of the court to Vienna, De Vries found new patrons. The first was Count Ernst of Schaumburg, a typical representative of those enterprising German princes who ruled small territories but turned their remote capitals into centres of art for a short time.[20] These princes and their capitals are eminently characteristic of the German sixteenth century. Before De Vries's arrival the count had given employment to three wood-carver brothers from Hildesheim, of the name of Wolf. Their art, and especially that of Ebert the Younger (d. 1608/9), was inspired at a distance by Giambologna. Ebert carved the altar table for the chapel in the count's palace with life-size angels in an intricate Mannerist tangle, a Protestant effort all'*antica* to attain liberation from the Catholic tradition. In 1615 De Vries executed for the count the elegantly adorned font of the parish church of Bückeburg; for King Christian IV of Denmark he made the Neptune Fountain for Frederiksborg Palace in 1617–23. (In 1660 the sculpture was removed by the Swedes and taken to Drottningholm.) Then, once more for Count Ernst, he made the bronze figures for his mausoleum at Stadthagen in 1618–20, a monumental, theatrically conceived Resurrection, placed in the middle of a small centrally planned building. Its contour, like that of a monstrance, can be taken in fully from the entrance. The guards sit on the edge of the sarcophagus in a precarious balance – only the one right in front is awake. The sarcophagus itself plays a remarkable double part as the resting-place of the count and as the sepulchre of Christ. In 1621 there followed two bronze groups for the bridge of the palace of Bückeburg; the originals, formerly in Berlin, are lost. Then De Vries was working again at Prague, after 1622, on figures for the fountains and parks in the palace of Duke Albrecht of Wallenstein; they were also removed to Drottningholm by the Swedes in 1648. De Vries's style, which till 1600 had been characterized, like Gerhard's and Giambologna's, by vigorous rotundity, firm lines, and closed outlines, later tended towards increasingly loose surfaces, more intricate movement, and more open contrasts. By this means his groups were now more spatial and played over by light and shade. The modelling grew fuller, the brio and the precision of the Mannerism of Italian derivation passed into a washed-out 'Impressionism', which might belong to the nineteenth century. Terse turns of the body unfold into unusually wide gestures or are squeezed into acrobatic poses. This last, restless Germano-Dutch sculptor to enjoy an international reputation left no school behind him.

The Bavarian Hans Reichle of Schongau (*c.* 1570–1642)[21] was of importance in South Germany and the Tyrol due to his introduction of the Giambologna style. From 1588 to 1593 he was Giambologna's assistant in Florence. In 1595 he executed for St Michael at Munich a Magdalen to accompany a crucifix by Giambologna. The figure,

in its restrained torsion, was the first of a long series of beautiful penitents in the German Baroque. In 1596–1601 Reichle did forty-four terracotta statues of Habsburg princes for the courtyard of Cardinal Andreas of Austria's palace at Brixen (Bressanone), in which the statues of Maximilian's tomb rise again in an Early Baroque transposition. Yet, as they were in armour and elaborate costumes, all done from pattern books, they were not rewarding artistically. From 1603 to 1606 Reichle created his main work, St Michael with Lucifer above the main portal of the façade of the new Augsburg Arsenal (Plate 290). It is an over-life-size bronze on a precariously narrow base with flanking angels, and it forms the dramatic culmination of Elias Holl's massive building. The motif of the group may have had a predecessor in a group of angels of 1588 in the Salviati Chapel in S. Marco at Florence which must have come from the Giambologna workshop. But a comparison with Gerhard's statue in Munich of fifteen years before is more important. Reichle entered into conscious rivalry with it. His saint is more active, his group more 'Antique', less gothically horrible and more triumphant, since the archangel is not planted firmly on two feet thrusting his lance, but swings his victorious sword in a rising movement. At the same time as the group of St Michael, Reichle completed (by 1605) the Crucifixion altar for SS. Ulrich and Afra at Augsburg, the four life-size bronzes of which, in the ponderous monumentality of the folds and the emotionalism of the gestures, are Reichle's other chief work.

But at Augsburg there was more to see than the austere forms of the Giambologna trio Gerhard–De Vries–Reichle. Hans Steinmüller (c. 1554–1619),[22] who had immigrated from Saxony, executed in 1585–6 to the commission of Octavian Fugger a cycle of under-life-size terracotta statues of Christ and the twelve apostles for the screen of the Chapel of SS. Simpertus and Andreas in SS. Ulrich and Afra (Plate 289). The bodies, after the Mannerist fashion, are slender. Some tortuous poses and drapery motifs betray knowledge of Gerhard's and Pallago's figures at Kirchheim, but the deep grooves in their full draperies, the greater freedom of their gestures, and their brooding expressions are variants of the international style closely related to the coming South German Baroque and therefore used several times later on as models. In SS. Ulrich and Afra there were also executed between 1604 and 1607, in addition to Reichle's Crucifixion altar, three more huge altarpieces. The carver was Hans Degler, a Bavarian, who died in 1637. Piled up in Mannerist fashion, they are coloured acrobatics of joinery, a most impressive illustration of the fact that beside all the great art of the Early Baroque deriving from Italy the traditional carved altar had lived on beyond Late Gothic times in a Mannerist transposition and could now give the Baroque altarpiece a native context. A like-minded contemporary of Degler and of Münstermann was Jörg Zürn (c. 1583–c. 1635);[23] he worked at Überlingen on Lake Constance. He came from a South Swabian family of sculptors which has several other important masters to its credit, for instance his younger brothers Martin and Michael, who were still active in the family business in 1665. Jörg Zürn's high altar in St Nicholas at Überlingen, of 1613–19, is the principal work of the South-West German transition to the Baroque. It is vast in size, like the Augsburg altarpieces, and is equally lacking in that monumental clarity which was by then accepted for the strictly architectural portal surrounds of the southern Late Renaissance, nor can

the Überlingen altar claim a unity in multiplicity in the sense of the future German Baroque. The legion of carved figures and the monstrance-like frame, in openwork and full of shimmering light effects, thin and decorative rather than structural, recall contemporary furniture. A Netherlandish technique and Netherlandish motifs, probably gained from an apprenticeship with Morinck, motifs from Wendel Dietterlin's *Architectura*, motifs from the circle of Rudolf II, and echoes of courtly bronze sculpture are all mixed in Zürn's work in an artisan's rather than an artist's eclecticism.

Hans Krumper of Weilheim (*c.* 1570–1634),[24] like Reichle and Zürn, found a way to a regional Baroque out of the international tradition. Wilhelm V trained him from his youth to be his court artist. From 1584 to the end of his life he worked for the Munich court. In 1587 he is mentioned as an apprentice of Gerhard, and soon he was sent to Italy for further training. In 1599 he succeeded his father-in-law, Sustris, as surveyor, architect, and sculptor to Wilhelm V. He was continued in the job by Wilhelm's successor Maximilian I. Thus his early life was passed entirely in the spirit of international Mannerism, but in his later work he reveals less southern emotionalism than a dignified regionalism after the manner of the wood-carving schools of Weilheim and Augsburg. A particularly characteristic comparison can be drawn between his comfortable Virgin as Patrona Boiariae, i.e. as spiritual ruler of Bavaria, of 1615, in the middle of the façade of the then most recent wing of the palace and Gerhard's slightly earlier, more graceful Virgin for the Frauenkirche.

About 1600, the Utrecht goldsmith Paulus van Vianen (1565/70–1613/14)[25] was working at Munich and Prague along with the bronze sculptors. He is recorded as resident in Munich in 1596, working for the court, and was registered master in 1599. In 1601 he is named as court goldsmith of the archbishop of Salzburg; from 1603 to his death he was active in Prague as Rudolf II's court goldsmith. Side by side with the Nuremberg and Augsburg goldsmiths, he was the most distinguished and perhaps the chief representative of courtly small-scale sculpture. He hammered and cast for the most part painterly reliefs in silver and lead with mythological and biblical scenes in very delicate landscapes, in which – he is also documented as a painter – he seems to have vied with contemporary landscapists, and which he prepared by landscape studies like those in Berlin and Budapest. These plaques can be of considerable size, and are always made with such skill, especially as regards landscapes and nudes, that they can no more be dismissed as minor art than the work of Jamnitzer. In the reliefs the bodies are occasionally detached entirely from the ground and fixed afterwards to it. In Minerva with the Muses of 1604, at Amsterdam, even musical instruments have been mounted in this way (Plate 292). Beside the precisely chased backgrounds, the planes of which merge in masterly fashion, his works contain exquisite nudes in the style of Rudolf II's circle, joined into ornamental groups. In the early works the landscapes dominate, and there are more borrowings than later on. In his years at Prague the figures come to govern the composition; they are reduced in number and move forward, while the details of the locality become sparser: it is all part of the development to the Early Baroque, and this is also expressed in the subordination of ornament. Moreover, probably under the influence of the Prague group and the corresponding graphic art of

Utrecht, Paulus van Vianen started the change from strapwork to gristle-work or the so-called auricular style,[26] the style which was going to have a great future and which culminated in Paulus's younger brother Adam van Vianen (*c.* 1569–1627), who worked in Holland and made this the Dutch goldsmiths' style *par excellence*.

PAINTING IN THE NETHERLANDS

UP to the death of Rubens, Antwerp remained the metropolis of art in the Netherlands. Second to Antwerp, at a certain distance, Brussels had its own standing. The Flemish figure-painters continued the style spread by Floris with amazing conservatism, painting variations on it till after 1600. Meanwhile the generation which had come to maturity between 1570 and 1580 were no longer satisfied with the Antique and humanistic apparatus. They sought for something deeper and more personal, and for that expressive stylization which could be seen among their Central Italian contemporaries. Moreover, this grand manner of Romano-Florentine origin was (literally) coloured by a current of Venetian painting. This current, which also flowed into South Germany, created in the Netherlands something which might be accepted as consciousness of the possibilities of colouring when seen by the side of the marble bodies and washed-out draperies of the conservatives.[1] The most influential representative of the later trend was Maerten de Vos (1532–1603).[2] Like Floris, he gave his name to a generation. After his apprenticeship at Antwerp he went on with his training till 1558, in Rome, Florence, and in particular with Tintoretto. After his return he can be followed from 1562. He was very much in demand and very prolific in invention; it was not without success that he had enjoyed in Venice the training of the greatest 'improvvisatore' of the age. He put his master's compositional schemes, the striking diagonals, the cross-wise poses and flights of perspective to the service of the unwieldy, cumbersome forms of the Floris style. His vibrating, gleaming colouring and his reckless brushwork – in both these points he was like the later Heemskerck and Aertsen – also came from Venice, but the longer he remained in the north, the more his colours became broken and cold and characterized by a porcelain-like sheen. Maerten de Vos and all the artists of his kind in Flanders after the late seventies profited very much by the fact that the image-breakers had emptied the churches and left them free for new commissions. When the country was at last subdued by the duke of Alba and the Roman Catholic service was re-established, churches, orders, brotherhoods, and guilds created larger altarpieces than ever, and the Counter-Reformation made the Southern Netherlands give preference to the emphatic and declamatory style of Italy. De Vos fulfilled such requirements in his main works, from the St Thomas altar of 1574 (Plate 291) to the Tribute to Caesar triptych of 1601 and the St Luke altar of 1602 (Plate 293), all now at Antwerp, and also with a host of separate panels, most of them in panoramic oblong form. Also about 1570 he delivered from his workshop to the castle chapel of Celle the oldest cycle of Lutheran church painting to have been preserved. As nearly always with painters of his kind, De Vos's portraits are outstanding, for instance the Gillis Hoffman couple of 1570 at Amsterdam and the Anselmo family of 1577 at Brussels. Like Mor's portraits they have the neutral background and easy manner of the Venetians. There are countless engravings after

inventions by De Vos. Many of his drawings for the engravers have come down to us, for the most part hastily outlined and washed.

History painting in Antwerp round De Vos was practised by many disciples of his who caught his colouring, his versatility, and his movement with more or less intention and skill. But there also remained 'academicians' who condemned colour and clung to the sculptural ideal and the study of anatomy, and whose works look chilly for want of commitment and creative dramatic feeling. Visits to the churches and the galleries and their stores in Belgium will soon show why this whole production has hardly yet been reduced to order and why there are hardly any monographs on the painters concerned. Besides, even for the famous names of those decades, few certain records have come down to us, and works like the altarpiece of the Schoolmasters and Soapboilers by Frans Francken the elder (1542–1616) of 1586 (Antwerp, O. L. V.), the Feeding of the Five Thousand by Ambrosius Francken the elder (1544–1618) of 1598 (Antwerp, Museum), the altar-wings of 1575 showing the Last Supper by Adriaen Key (c. 1544–after 1589), who holds a higher rank as a portraitist, or the Last Judgement of 1571 by Crispiaen van den Broeck (1524–c. 91), both now at Antwerp, round which many others could be grouped, are as easy to confuse as the routine production of the Late Gothic decades. In other cities of Brabant, competent but provincial masters were active, for instance at Bruges Pieter Claeissins the younger (c. 1550–1623), one of whose works is the Allegory of the Treaty of Tournai of 1584, now in the Groeninge Museum at Bruges.

Among the younger generation there are also important emigrants. Denijs Calvaert (c. 1540–1619)[3] went to Italy about 1562 and settled at Bologna about 1574. In spite of his fame among early authors, he was a mediocre member of the Correggio–Parmigianino discipleship, yet Reni, Domenichino, Albani, and other natives of Bologna passed through his workshop, and it was these painters who, along with the Carracci, were soon to make the school of Bologna great. Joos van Winghe (1544–1603) of Brussels[4] moved to Frankfurt in 1585. Such works as Samson and Delila (Düsseldorf) and Apelles and Campaspe (Vienna) show that his bent was not to Antwerp but to Spranger's style and to Haarlem. Winghe's fellow-citizen Aert Mytens (c. 1541–1602) spent nearly all his working years in Italy. In his gloomy Crowning with Thorns in Stockholm[5] the variegated, cold colouring is of the Netherlands, but the flickering nocturnal lighting is an anticipation of Caravaggio and the early Rubens. Frans Pourbus the younger (1569–1622), who was made master at Antwerp in 1591, was soon at work for the Brussels court, was then active at Mantua from 1600 to 1609, with occasional absences, and from 1609 on lived in Paris. Like Mor he acquired deserved international fame as a court portraitist. Hieronymus Francken the elder (1540–1610), a pupil of Floris, was also mainly active in France: he is found there from 1566. The Venetian Ball of 1565 in the Aachen Museum (Plate 295), an early bourgeois genre-piece, is more important for us than his altarpieces. It is not colourful in the Bruegel manner; its tonality is Italian, and the costumes too are Italian and not representative of his real surroundings. Gillis Congnet (c. 1535–99) moved from Antwerp to Amsterdam in 1586, and later to Hamburg. His link with North Italy can be seen not only in his Drummer Pierson la Hues of 1581 and his St George (both Antwerp), but in his night scenes, already singled out by

Van Mander, in which, like Joris van Cleve, Gillis Mostaert, Joos van Winghe, and others, he anticipated Elsheimer. Wenzel Coeberger (1554/61–1634), a pupil of De Vos, was active from 1583 to 1604 in Paris, Naples, and Rome.

An exception among the history painters of Brabant was Otto van Veen (1556–1629).[6] He was a native of Leiden, had worked under Federico Zuccari in Rome from 1575 to 1580, and was then, from 1585 on, active in Brussels and Antwerp. From 1589, the date of the Mystic Marriage of St Catherine (Brussels; Plate 294), and 1597–9, the date of the altarpiece in St Andries at Antwerp, to the time when Rubens returned from Italy, his great natural feeling expressed itself in works very different from the prolix story-telling of his contemporaries. While their compositions fall to pieces, his pictures are more moderately filled with figures and every figure serves the whole. His paintings possess true emotion rather than artful movement, intimate sympathy rather than any didactic play of gesture. His colouring is warmer, his light renders atmosphere, his thick-set figures are more sculptural, and proportioned more naturally. It was perhaps no chance that after two years under the lesser Adam van Noort (1562–1641) Rubens went into apprenticeship with Van Veen (1594/5–8). He could not have found a more adequate master.

Towards the end of the century important developments took place in Netherlandish landscape painting,[7] though primarily among emigrants in Protestant countries abroad. The two most important centres were Frankenthal and Amsterdam. At Frankenthal, the elector palatine had, in 1562, placed the former Augustinian canons' house at the disposal of sixty Netherlands refugee families, and the stream of refugees swelled so much that in 1577 Frankenthal was raised to the rank of a town. More than 600,000 people had taken refuge in Holland after the duke of Alba had subdued all the important cities in the south in 1584.

At Frankenthal, Gillis van Coninxloo (1544–1606)[8] arrived in 1587 from Antwerp, where he had been accepted as master in 1570. He went by way of Amsterdam. Van Mander already praised him in 1604 as the best landscapist of his time, and noted his influence on the Dutch, and the rules which Van Mander set forth for true landscape in the *Grondt der edel vry Schilder-Const* might be a description of a landscape by Coninxloo. True, only a couple of dozen engravings after paintings, and still fewer originals, have come down to us, and the earliest picture to have been preserved, a landscape with the Judgement of Midas, now in the Gemäldegalerie in Dresden, dates only from 1588 (Plate 296). Coninxloo's development from then on can only be traced by a mere handful of dated works; from the Judgement of Midas by way of landscapes, of 1598 (Plate 297) and 1604 (Vaduz), down to a landscape of 1605 (Speyer).

Coninxloo explored a new speciality in forest pictures. In these views, at first still traditional, grand, and panoramic, later crowded and entangling the eye, there is the expression of a personal experience of nature such as had not been seen since the masters of the Danube school. His subject matter was not the contours of the earth, but its vegetation, woods, leafy labyrinths and crusty barks, wild growth, the charm of strangeness, especially in oak trees, and the transience displayed in fallen trunks and marshy hollows. He also found new expressions for what is or seems in motion in nature

– waterfalls, steps, winding paths – and also for light effects, of sunshine and of light and shade contrasts in their free, irrational play. One of his successors in this use of light was Rubens, about whose 'false' lighting in the landscape in the Pitti Palace Goethe wrote so perceptively. Coninxloo reduced the figures in his compositions almost to the point of disappearance. The horizon sank, the composition became more irregular. He transformed the still common Gothic scheme of three planes in brown, green, and blue into an equally unreal, still narrower scale of blue and green which was, however, more delicately graded than ever. Thus there is tonal and formal unity in his pictures, a peculiarity which had a great future and also makes them look 'romantic' to us.

Yet, in spite of many realistic details, he remained on the whole faithful to certain fantastic schemes. The Dutch of the first seventeenth-century generation were to observe nature with far fewer preconceptions. Among the artists of the Southern Netherlands the landscape remained for a long time more a 'work of art' than a portrait of nature; for instance, until the time of the followers of Rubens the scenic wings were kept in the foreground, as 'repoussoirs', just as repoussoirs dominated figure painting, because they could suggest distance.

In 1595 Coninxloo went back to Amsterdam and settled there. He had only a few pupils, but one of them was Hercules Seghers. Perhaps Pieter Schoubroeck (c. 1570–1607) was his only real pupil at Frankenthal. Schoubroeck had a taste for larger vistas and more complicated effects, and a greater sense of the fantastic went hand in hand with bright colours for his figures. The circle of painters, however, whose minds were enriched by Coninxloo's ideas was large. The Frankenthal style developed into more than a 'school' localized in time and space; it lasted far on into the seventeenth century, and even Dutch painters like Ruysdael were to a certain extent among his followers. Within the limits of the present volume it is impossible to follow up all the radiations of Coninxloo's influence. In Flanders it was above all Jan Breughel (1568–1625) who carried on what Coninxloo had begun.[9] In Germany his tradition was continued by Anton Mirou (before 1586–after 1661?) for instance, who is documented at Frankenthal till 1620, and Frederik van Valckenborch (1566–1623) of Antwerp, who settled at Nuremberg in 1602.[10] Adam Elsheimer too (1578–1610), a native of Frankfurt, received his first impressions at Frankenthal. That can be seen for instance in his Sermon of St John the Baptist at Munich. In Holland Coninxloo's successors included a number of talented refugees from Flanders, for instance David Vinckboons of Malines (1576–1629),[11] who arrived in Amsterdam in 1591 at the latest, or Roelant Savery (1576–1639),[12] who had fled from Courtrai (Kortrijk). Vinckboons was more than a landscapist; in his landscapes with figures he was also, like his fellow-citizen Hans Bol, an intermediary between the genre of Bruegel and the new Dutch peasant-piece. It was Savery's speciality to fill his landscapes of forest and mountains, his pictures of Orpheus and Paradise, with a superfluity of animals, and he thus became a stimulating predecessor of the Dutch animal picture.

The landscape tradition of Bruegel and the earlier painters of the Netherlands, the encyclopedic, spreading view, the greater value given to geology than to vegetation and broad grandeur instead of luxuriating fantasy were continuing in full force in the

Southern Netherlands about 1600. Its main representative was Joos de Momper (1564–1635),[13] strictly specialized and classified as *pictor montium* even during his lifetime (Plate 298). The figures in his landscapes were mostly painted in by other hands. Nothing is known of journeys on which he might have made studies for his mountains, like Bruegel. His *œuvre* is obviously very extensive, but hardly reducible to order owing to an almost total lack of dates and signatures. Nor does any great stylistic development appear. Probably the pictures with antiquated compositional schemes and a wide range of bright colours, and with sharply outlined scenic wings in brown, green, and blue, are early works. The brushwork would then have developed from short and vigorous strokes into broader dots and a yet greater juiciness which looks as if it was intended for canvas. More delicate transitions and blends of colour would seem to mark the later works, while the compositions remained bold and simple, and details were sacrificed to the point of perfunctoriness in favour of the general effect; the term Baroque may well be applied to these compositions because, though schematic, they possess unity. Beside Momper there was also for instance Kerstiaen de Keuninck (*c.* 1560–1635), who was registered master at Antwerp in 1580 but remains a mere shadow. Tobias van Haecht (1561–1631), who became master at Antwerp in 1590 after a visit to Rome and Florence, painted 'encyclopedic landscapes', like Momper, but with less talent. His name has only remained alive because he was Rubens's first master.

In Italy too a large number of excellent landscapists from the Netherlands were active at the end of the century. They exercised a determining influence on Italian painting, which the northern painters of subject pictures had never been able to do. The foreigners who entered into the history of Italian art cannot be dealt with here. But it must be remembered that the heroic and ideal landscapes of the first generation of the Bolognese and Roman Baroque – not only of Annibale Carracci, Domenichino, and Agostino Tassi, but also Claude Lorraine, Poussin, and Gaspar Dughet – built on foundations which masters such as Lodewijk Toeput (*c.* 1550–1603/5), Pauwels Franck (1540–96), Matthäus Bril (1550–83), Paulus Bril (1554–1626), Jan Breughel, Elsheimer, and others had laid.[14] Toeput[15] painted from about 1580 at Treviso and in Venice landscape scenes and genre pieces in Venetian colours (examples in the Gemäldegalerie at Kassel and the Accademia Carrara at Bergamo), and fantastic mountain landscapes (one is now at Hannover). Franck[16] arrived in Venice before 1573. The Bril brothers[17] began their activity in Rome in the mid seventies. Jan Breughel was working in Rome and Milan from about 1589 to 1596. Occasionally the Italian romantic ruins came back to the north, for instance to Amsterdam through Willem van Nieulandt the younger (1584–1635/6).[18] The Dutch, however, soon abandoned the heroic and fantastic style which their fathers and grandfathers had popularized in Italy, and another generation of 'Italianists' created a fresh kind of peaceful, sunbathed, ideal landscape.

Towards the end of the sixteenth century yet another type of easel picture became popular, the flower piece.[19] Its first outstanding representatives were natives of Antwerp: Ambrosius Bosschaert (1573–1621) (Plate 299), who, however, had been active in Holland since 1593,[20] Jan Breughel, and Roelant Savery. Such pictures by these masters as are dated belong to the period after 1600, so that we can only grope for their

beginnings. The immediate predecessors of these flower panels were paintings on parchment, pages in illuminated manuscripts, and botanical illustrations, and there existed even earlier albums of botanical engravings and single engravings in the Netherlands. Thus the flower-pieces of the first generation retained something of pure illustration and were governed by no compositional principle. The painters simply added up brightly coloured specimens. Further, there generally was an allegorical intention, especially Vanitas or Memento Mori: 'He cometh forth like a flower and is cut down: he fleeth also as a shadow and continueth not' (Job 14). Of course, ever since Dürer's water-colours there had been single representations of plants interpreted as microcosms; also on the backs of diptychs vases of flowers were common, and Ludger tom Ring the younger was already painting genuine flower-pieces in 1562, though in 'applied' form for the doors of an apothecary's cupboard (Münster). Van Mander relates that about 1580, during his short apprenticeship with Gillis Congnet, Cornelis van Haarlem painted a 'pot met alderley Bloemen na 'tleven' (a pot with sundry flowers, from life). But the real impulse to the painting of large numbers of these panels came from the greater ease and wealth of the bourgeoisie towards the turn of the century.

Still-life painting at the end of the century offers, except for the flowers, nothing that could compare in historical significance with the early work of Aertsen and Beuckelaer. The real successors of these masters in the Southern Netherlands did not appear till Snyders and Fyt, while in the north out of dark, linear Vanitas still lifes and tables with food a new and peculiar style developed. Such new departures in Holland are a phenomenon which we encounter also in other fields, for instance the genre piece.

Architectural painting, on the other hand, received its first great impetus in the last quarter of the century.[21] Hendrick van Steenwijck the elder (c. 1550–1603) was the outstanding master of the time. He executed the first independent, memorable church interiors, and so ushered in a development which culminated in Saenredam, De Witte, and others. From the outset Steenwijck set himself against the fantasy and virtuosity of his teacher and contemporary De Vries. His subject was space, not clever perspective. A youthful work, the view of the interior of Aachen Cathedral of 1573 (Munich), is a factual view, and a little dry, while the interior of Antwerp Cathedral (Budapest) is informative and at the same time so delicate in its colouring that its like was not to be seen again till Saenredam. Later, Steenwijck set himself more and more strictly pictorial problems; the interior of St Pieter at Louvain (Brussels) has a determinedly slanting central axis, and the lighting is full of contrasts (Plate 300). These innovations were continued in a pedestrian fashion by such minor artists as Hendrick van Steenwijck the younger (c. 1580–1649), who settled in London in 1617, and by the two Pieter Neeffs (the elder lived from 1578 to 1656/61).

About 1600 seascape began to become a Dutch speciality. To a large extent it was an expression of the concern with the sea and ships on which the power and well-being of the States General depended more and more. One founder of the genre was the much-travelled Hendrik Cornelisz. Vroom (1566–1640) of Haarlem. But there were predecessors, for instance Pieter Bruegel's Storm at Sea (Vienna), and a large, tempestuous seascape by an unknown Flemish artist, dated 1556 and now in Munich (inv. no. 11146).

These pictures were already descriptions of nature in the sense, if not in the spirit, of the seventeenth century, while Vroom was still mainly interested in ships and in historical narration.

In the last quarter of the century, the North also developed new centres of figure painting,[22] especially Haarlem and Utrecht. There were in these centres associations of artists of an academic kind who, unlike those of the more conservative South, had opened their minds completely to contemporary Italian Mannerism. To a certain extent these emphatically intellectual 'gheestelijcke schilders' (spiritual painters) were the first to react to recent events in Italy and France. They included not only natives of Holland but also artists of Brabant who cast off the artistic tradition of Antwerp and Brussels, and brought with them from Italy and France a new restlessness and a new virtuosity in drawing the moving body.

At Haarlem, where Heemskerck was active till 1574, and Jan Sanders van Hemessen till 1575 or later, they, and others with them, created an artistic environment in which similarly spirited younger masters could develop with ease. Hendrik Goltzius (1558–1617) of Mühlbrecht near Venlo arrived in 1577. However, till 1600 he devoted himself exclusively to drawing, engraving, and woodcuts, and only turned to painting at the height of his fame because those fields offered him too little opportunity. Karel van Mander (1548–1606) of Meulebeke near Courtrai, who was in Italy from 1573 to 1577, settled at Haarlem in 1583, and there became the theorist and historian who deserves all our gratitude for his *Schilder-Boeck* of 1604 (second edition, 1617). This group was joined by Cornelis Cornelisz. (1562–1638) of Haarlem, who returned from France and Antwerp before or in 1583, and Jacques de Gheyn (1565–1629) of Antwerp, who was at Haarlem from about 1585 to 1591, at first as a pupil of Goltzius.

At Utrecht too there was a promising situation. Anthonis Blocklandt of Montfoort, a pupil of Floris, for instance, was there from 1577 at the latest. Joos de Beer of Utrecht, active at Delft in 1550 (d. 1591), also a Floris pupil, worked in his native city from 1582. Their pupils were the two main representatives of the new style at Utrecht: from 1583 Abraham Bloemaert (1564–1651), who had been in Paris and Fontainebleau in 1580–3, and from 1592 at the latest Joachim Wtewael (c. 1566–1638), who had been apprenticed in France and also spent some time there later, and moreover two years at Padua.

One remarkable fact which characterizes this intellectual, linear, and speculative art is that the artists of the schools both of Haarlem and Utrecht were influenced by Italian art and by that of the two capitals Vienna and Prague not by way of actual journeys but solely by the engravings of Bartholomeus Spranger or by engravings after him. Spranger, it will be remembered, though of Flemish origin, had left the Netherlands for good as early as 1564.

The spiritual climate of Holland began to change in the nineties as a result of political consolidation and the growing cultural division from the South. That was one of the most important reasons why by 1610 it was all over with the esoteric ideals of the 'academicians', whose history paintings derived neither from Antiquity nor from nature, but, according to Van Mander, solely 'uyt den Gheest' (out of their own mind). The realists came to the fore in all genres, and soon also Caravaggism and the new

idyllic painting, which made their entrance by way of Utrecht. No more support came from Flanders after the emergence of Rubens and the new 'Romanists' such as Abraham Janssens. The ageing Bloemaert and Cornelis Cornelisz. were astonishingly able to change their styles, but then the 'academicians' were from the outset much more versatile than would appear from their theoretical statements. They enriched the portrait and the landscape with perfectly natural and poetic works, for instance Van Mander's Adoration of the Shepherds of 1598 at Haarlem. The study of the nude, which had until that time been unheard of in Holland, was now established. Cornelis Cornelisz. planted a milestone in the history of the group portrait with the lively and varied composition of his Civic Guard of 1583 (Haarlem), which influenced Frans Hals and the later portrait groups of Amsterdam. Bloemaert was one of the first Dutch landscapists.

In the North, the best-known portraitists of the new bourgeoisie and the court of the stadholder were already established about the turn of the century: from 1583 at Delft, for instance, Michiel van Mierevelt (1567–1641), after having been Blocklandt's pupil at Utrecht; from 1596 at Utrecht itself, Paulus Moreelse (1571–1638), after having been Mierevelt's pupil. Both did history painting in the Utrecht style, but only as a sideline.

Amsterdam, where, as we have seen, Aertsen was active till 1575, remained full of life. Dirck Barendsz. (1534–92), who had worked under Titian from 1555 to 1562, but, unlike his fellow-citizen Lambert Sustris, had returned to Holland ten years before, was regarded, with Aertsen, as *the* representative of the Italian style (witness the triptych of *c.* 1565 in the Gouda Museum). In 1581, a still more modern artist, Cornelis Ketel of Gouda (1548–1616), settled in the town. He had been active as a portraitist in London from 1573 to 1581, and there for instance painted Martin Frobisher (Oxford, Bodleian Library, 1577). It was Barendsz. and Ketel who were responsible for the first efflorescence of the group-portrait at Amsterdam. Ketel established the full-length group and single portrait in Holland, perhaps under the fresh impression of his years in England. His Rosencrans Company (Amsterdam), unfortunately rather mutilated by cutting, was done in 1588, i.e. five years after Cornelis' Civic Guard at Haarlem, with the same lively and varied figures. It was epoch-making in its field; for though it is still academically posed and uncertain of stance, it yet appears entirely momentary and topical, and it demonstrates very clearly the point from which Hals and Rembrandt started. Pieter Pietersz. (*c.* 1540–1603), who had first worked at Haarlem, and Aert Pietersz. (*c.* 1550–1612), another son of Aertsen, continued his style, but with less artistic appeal. While Pieter's subject pictures are in the international taste, his Fleet Commander (Amsterdam, inv. no. 1881 – B4) is purely national. The painting is open and many-coloured, with strong lighting effects and a background restlessly enlivened with escutcheons, masonry, and vistas. His portraits of the Steyn couple (Amsterdam, inv. no. 1881 – B2–3) are more traditional in conception. Aert's portraits of 1595 at Amsterdam are, on the other hand, although large in size and rich in colour, provincial in their unwieldy composition and harsh modelling. Many an anonymous Dutch portrait is, as we have seen also in earlier decades, superior to the work of the masters whose names have been preserved by the chance of history, for instance the portrait of a Standard-Bearer of 1590 (Munich) which brings home to us the feeling of new national dignity and self-confidence.

PAINTING IN GERMANY

On the Upper Rhine, Tobias Stimmer[1] (1539–84) towered above Bocksberger and other kindred Italianist painters on the one hand, and the later graphic Kleinmeister on the other. His inexhaustible gift of invention was governed by eminent artistic judgement. His show of moods was genuine. His figures are not posed, and there is a monumental feeling even in his smallest woodcut illustrations. Rubens, who, as a young man, had copied religious woodcuts by Stimmer of 1576, recommended them as late as 1627 to Sandrart as 'a special jewel of our art'. Stimmer's contemporary Fischart placed him, in 1573, with Holbein, and wrote that both had 'done without the foreign southern way of painting, which is aped by most of the painters of our day'. There was, however, in that remark, less national feeling than scorn of the painstaking efforts of provincials. Stimmer was, of course, as much bound up with his Italian contemporaries as all the rest, but they had not succeeded in subjecting him. He shunned the mere agitation of his contemporaries and returned to old German traditions – a sane realism and a robust type of figure. These qualities he could then pass on to the Baroque.

Stimmer's activity as a painter was on the whole on large decorative schemes which can now be visualized from little more than drawings and written sources. In 1568–70 he painted on the Haus zum Ritter in his native city of Schaffhausen lively frescoes of illusionistic architecture with mythological figures which follow Holbein's work in the same category; these frescoes are now in the Schaffhausen Museum (Plate 301). In 1570 he settled at Strassburg, and there, in 1571–4, he designed and decorated the astronomical clock in the minster. In 1578–9 he executed ceiling paintings for a banqueting hall in Baden-Baden Castle. The thirteen canvases of the coffered ceiling, conceived, unlike his 'old German' façade designs, in the Venetian manner, were presages of the German Baroque. A great many of Stimmer's designs were for small-scale stained-glass panels, for escutcheons and so on.

In his portraits, Stimmer shows himself a keen psychologist and a craftsman in the old German tradition, for instance in the Schwytzer couple of 1564 at Basel. They are full-length, while the other portraits by Stimmer are all half-length. But whereas the clear directness of expression and composition may recall Holbein, the broader brushwork, the more forceful modelling, and the broken colours reveal just as clearly the taste of a later artist who had not remained blind to the Italian developments which had taken place since.

But Stimmer's fame was spread abroad first and foremost by his work for the printers. Strassburg, where he delivered his first designs in 1568–70, became through him once again for a short time a centre not only of painting but also of illustration. The best-known specimens of his graphic art are these: the hundred and twenty nine reproductions of portraits of famous men from Paolo Giovio's Museum at Como, of 1575, which

he drew while in Italy; the hundred and seventy 'New Illustrations of Bible Stories', done in 1576, which are a cornucopia of novel compositions in slightly oppressive scroll-work cartouches; illustrations to Flavius Josephus and Livy; and the Ages of Man in ten large sheets. Stimmer's production was so prolific that his publisher was able to have drawings he left behind worked up long after his death. Stimmer worked exclusively in woodcut, at a time when engraving was generally considered more appropriate to ambitious undertakings in illustration. Compared with contemporaries such as Amman, Stimmer was not only richer in motifs, but also technically more effective by the thickening and thinning of the lines and their bold modelling. These things had not been seen since Dürer, and Stimmer owed much to Dürer, in his style of drawing too. Stimmer's influence proves that his time, like Dürer's, understood that here was, even on a small scale, a painter of great mind and no mere illustrator.

The best of Stimmer's successors were, especially as draughtsmen for graphic repro-duction and designers for stained glass, Daniel Lindtmayr[2] (1552–c. 1606) of Schaffhausen, and Christoph Murer (1558–1614) of Zürich. At Strassburg, on the other hand, Wendel Dietterlin the elder (1550/1–99)[3] made a career as an 'aper of the Italian style'. He took his lead from the most recent Mannerists, but the few remaining compositions give no attractive idea of his talent. The only painted panel of his to have been preserved, the Resurrection of Lazarus (Karlsruhe), is also inferior as painting. His most important achievement was an architectural treatise, *Architectura*, which appeared in 1593/4 and 1598 and was republished in 1655. With an imagination which cast into the shade all similar writers since Vredeman de Vries, Flötner, Solis, and others, Dietterlin etched on two hundred and nine plates not only a book of patterns, but symbolic representations of the potentialities of the orders of columns. The book contains suggestions for en-hancing effects and expression in architecture. It is entirely the work of a painter – of a painter of house-fronts – not of an architect, and it has been exploited not by architects but by sculptors, for instance by Jörg Zürn for his Überlingen altar of 1616.

At Basel, the modest Mannerist Hans Bock the elder (c. 1550–c. 1623) was chiefly active on murals; at Salzburg, at the archbishop's court, Kaspar Memberger (active from 1588, d. before 1626) continued the style of his father Philip, who may have been the teacher of Dietterlin too. Everywhere in Germany there were small centres where artists of individuality and competence worked for bourgeois and court patrons. At Nuremberg, Würzburg, and Stuttgart, for instance, was Andreas Herneisen (1538–1610) and at Nuremberg the Dürer imitator[4] Hans Hoffmann (mentioned from 1576 to 1592), at Dresden Cyriakus Röder (c. 1560–98), at Danzig (Gdańsk) Anton Möller (1563–1611),[5] at Lübeck Johann Willinges (registered master in 1590, d. 1625),[6] at Cologne Gortzius Geldorp (1553–c. 1616), the portraitist, an immigrant from the Netherlands, at Frank-furt Philipp Uffenbach (1566–1636), who was the teacher of Elsheimer. There are also a number of anonymous pictures such as the North German Parable of the Unjust, now in Berlin (no. 1839), which correspond to the more appreciable products of the end of the century in England.

All these cities were outdone in the last quarter of the century by the courts of Munich and Prague, whose rulers, Dukes Albrecht V and Wilhelm V, and Emperor Rudolf II,

were specially devoted to art. They attracted many foreign artists, who responded to their really scholarly 'Italian' taste, particularly masters from the Netherlands and Italy. True, they could not keep the more important Italians for long, but could only borrow them from other courts. The best artists from the Netherlands, on the other hand, had been so long in Italy that they could almost count as Italians, whereas the artists of South Germany were less able to satisfy this cosmopolitan taste. The Italo-Netherlanders did not only import the latest 'true' art into the country; through the cultivated taste of the patrons, and by their close collaboration with the artists, a homogeneous court style came into being. But it became no more a pattern for general taste than that of Fontaine-bleau.

At Augsburg, the traditional gateway from the south to Southern Germany, the Fuggers and other great families had prepared the way for the art at the court of the dukes of Bavaria by bringing the first Italians into the country, and the connexions between Augsburg and Munich remained close; both the artists and their designs travelled between the two cities. Giulio Licinio the younger painted the façade of the Rehlinger House at Augsburg as early as 1560-1 (destroyed in 1944). Hans Fugger[7] summoned Friedrich Sustris (c. 1540-99)[8] from Italy to decorate the library, the art cabinet, and other state rooms in his mansion at Augsburg (1569-73). Friedrich was the son of Lambert Sustris, who had been active at Augsburg in 1548, 1550, and 1552. He had worked in Florence from 1563 to 1567, and his pale, broken colours, like his generous brushwork, mark him as a pupil of Vasari. Sustris's Italian assistants Antonio Ponzano and Alessandro Scalzi painted with him; Carlo Pallago was the stuccoist. In 1580 we learn from one of Hans Fugger's letters that he had not been able to find an efficient portraitist at Augsburg and had to call one in from elsewhere.

Just as Fugger recommended his sculptors when the demand for modern artists grew at court, so he also recommended Sustris.[9] In 1573 Sustris entered the service of Wilhelm V, and in 1578-9 he executed at Trausnitz Castle above Landshut a large number of frescoes of the *commedia dell'arte* in the Florentine style, yet with an unmistakable northern flavour (burnt in 1961). He was assisted especially by Alessandro Scalzi, who from then on also remained in court service. In 1580 Sustris went to Munich, and there he displayed more multifarious talents; above all, he became an architect and *surintendant*, i.e. designer and adviser for the artistic enterprises of the court. In addition to written sources this is proved by drawings of all kinds, for instance the design for Hubert Gerhard's Perseus Fountain in the Fountain Court of the palace, which is a variation of Cellini's group at Florence (Munich, Staatliche Graphische Sammlung). In 1581-6 he also directed the building of the Grotto Court of the palace. The Jesuit church of St Michael, the great building of the period in South Germany, the foundation stone of which was laid in 1583 and which was consecrated in 1597, was his conceit.

In 1563-7 Wilhelm Egckl had built the Coin Court in the palace for Albrecht V; on its first and second storeys it contained the art collections of this first *Hofmuseum*. Very soon the rooms proved inadequate; in particular it was necessary to find a worthy setting for the Antique statuary, since bought on a generous scale in Italy, and for Johann Jakob Fugger's former library. Thus in 1569-71 the Antiquarium was built, the first museum

of antiquities in modern times. The plans were mainly provided by Jacopo Strada, the antique dealer. Wilhelm V commissioned Sustris to decorate the ground floor, a huge, tunnel-vaulted hall with niches and benches under the windows for the sculpture, and to brighten up the hall with paintings *all'antica* (1586–1600) (Plate 302). The decorative scheme was slightly old-fashioned. In contrast to the latest illusionist painting in Italy, Germany as a whole did not yet take to great ceiling paintings: pictures in the coffers of coffered vaults and ceilings were considered enough (destroyed, like the whole Antiquarium, in the Second World War), and ornaments in stucco panels, similar to the ceiling paintings which had been executed already about 1545 in the Landshut palace. The grotesques were again the work of Antonio Ponzano. Hans Donauer the elder (*c.* 1521–96) executed views of one hundred and two Bavarian cities and castles from nature in the penetrations between vault and windows and on the window-jambs. Very soon, however, Munich caught up with the development. Hans Werle, the court painter, who did the ceiling in the Black Hall of the palace (built *c.* 1590, destroyed in 1944) after a design by Christoph Schwarz, opened it up in illusionistic architectural vistas, created abrupt frog's-eye views, and brought the whole into a central perspective system. This ceiling may be regarded as the beginning of the South German Baroque.

In 1586, another painter from the Netherlands arrived from Italy to paint coffer pictures in the Antiquarium side by side with Sustris: Pieter de Witte, known as Peter Candid (*c.* 1548–1628).[10] He was probably a native of Bruges, and from 1570 till he was called to Munich he was active in Florence, Rome, and Volterra. He was also familiar with Venetian painting. It was the same training as that of Sustris, whose cool, broken colours he appreciated. But while Sustris was closer to the Central Italian ideal of the slender figure, Candid's bodies were more natural in their proportions and more sculpturally elaborated, after the manner of Veronese. He too, according to Sandrart, was 'a diligent and understanding practitioner of all genres', and so he was at once engaged in Munich for the most varied and important commissions. In addition to the Antiquarium, he worked in the Grotto Court in 1587, and in 1588 he did a Martyrdom of St Ursula for St Michael (Plate 304). From 1604 he worked on designs and cartoons for tapestries of events in the life of Otto of Wittelsbach, and a series of Months (Munich, Bayerisches Nationalmuseum and Residenz-Museum). In 1619 he delivered the designs for the ceiling paintings to be executed by the Augsburg artist Matthias Kager (1575–1634) in the Golden Hall of the Augsburg Town Hall (burnt in the Second World War). In 1620 he did the high altar for the Frauenkirche in Munich (now Bayerisches Nationalmuseum). He may also be the author of the portrait of Duchess Magdalena (Munich), whose heavy-lidded haughtiness in her strangely modish costume reveals, at any rate, a knowledge of the Italian Mannerist court portrait. Candid's style was still dominant in Munich when, in 1619 at Neuburg on the Danube, Rubens's altarpieces had come to adorn the Jesuit church.

The third outstanding artist of Munich, Christoph Schwarz (*c.* 1545–92),[11] was a native of the city. From 1560 to 1566(?) he had been taught by Melchior Bocksberger, the years 1570 to 1573 he probably spent at Venice in perfecting his art. Ridolfi speaks of him as a pupil of Titian, and his works bear eloquent testimony to his knowledge of

Venetian painting, for instance the Crucifixion altar of 1578–81 for the Fugger Chapel in SS. Ulrich and Afra at Augsburg. From the early eighties he was almost exclusively and very fully occupied on the Munich palace and the Jesuit church. In 1584, Rudolf II tried to get him for Prague, but Wilhelm V refused to release him. His chief work was the gigantic Fall of the Angels for the high altar of St Michael (1586–90; Plate 303). The composition and colouring owe much to Italy, especially to Tintoretto, but in the more obvious tightening-up of the composition and in the treatment of light, Schwarz was a descendant of the Venetian High Renaissance. His types and the prominence he gives to landscape testify to his South German origins. As a whole, his art was more seminal for the future than the Central Italian internationalism of Sustris and Candid.

It was not by chance that Schwarz, of all the Munich artists of the period, made the deepest impression on his contemporaries and on later generations, down to the nineteenth century. The fresco-like openness of his brushwork also attracted attention early, as well as the fact that the colouring of his oil paintings was in no way different from that of the frescoes. These features also made him the forerunner of South German Baroque painting.

Beside Schwarz, and long after him, Hans Rottenhammer of Munich (1564–1625)[12] continued the style of the late Venetian Cinquecento in Bavaria (Plate 305). After his apprenticeship to Hans Donauer, which lasted till 1588, he went to Rome and was in touch with Paul Bril and Jan Breughel, who painted the landscapes in some of his compositions. The years 1596 to 1606 he spent in Venice, where he acquired the rich, phosphorescent colouring of Tintoretto and of his friend, Palma Giovane, through which he became famous. In 1606 he returned to the north, to Augsburg, where he was active till his death. Ceiling panels in the Munich palace, the Augsburg Town Hall, Bückeburg Castle, and altar paintings for churches at Augsburg and Munich show the lively, but not *outré* figure style and the full forms of Venice. He was the first artist in Germany to transpose the great Italian history painting into miniature-like cabinet pieces, and he was highly appreciated as a specialist in those elegant and conscientious paintings on copper which he had already produced in Italy to the amazement of his contemporaries. Side by side with Jan Breughel, he also stimulated cabinet-painting in the Southern Netherlands. He seems to have done night-scenes earlier than Elsheimer, who occasionally worked with him at Venice, and to have suggested ideas to Elsheimer which became the mainspring of the latter's fame. In these night-scenes he followed up the Venetian Bassano tradition, like other painters in the Netherlands whose night-scenes owed nothing to Caravaggism.

The character of Bavarian court art was determined by two factors: the decoration of buildings, old and new, with great series of scenes, and the service of the Roman Catholic Church, which it helped with all its power to establish the aims of the Counter-Reformation. At the imperial court at Prague[13] neither of these factors was operative. Religious art practically vanished, and secular commissions were mainly for easel pictures, since Rudolf II neither built nor had the medieval buildings of his palace painted; he merely stuffed the palace with his collections. His sculptors were subject to similar limitations. What made the short-lived 'School of Prague' more unified and

characteristic was that the artists had, to all intents and purposes, only one patron, whose taste was very pronounced. Rudolf's taste was not so amateurish and singular as his superstitious peculiarities and his religious and political escapism might lead one to believe. At any rate he was at the heart of intellectual events, and his artists worked in a web of connexions and influences which spread yet farther than that of the Bavarians. On the other hand, Rudolf's mind was manifested by his artists in a way which affected the whole Empire. As long as he resided at Prague, i.e. between his coronation and his abdication, from 1576 till 1611, there radiated from it, as over two hundred years before in the age of Charles IV, the brilliance of an international art centre.

The name of the emperor may awaken in many minds the idea of a collector rather than a patron. In actual fact, the emperor's delight in collecting was, quite in accordance with the spirit of the century, not only boundless, spreading as it did from curiosities of nature to Dürer's altarpieces; it was also of dimensions which justify calling it a mania. Yet, all the same, the emperor was a passionate patron of new artists and always had an eye on their work. He summoned them from Vienna, Munich, Augsburg, Italy, and the Netherlands. The majority came from the Southern Netherlands.

One of the first painters to arrive was the most important: Bartholomeus Spranger (1546–1611).[14] He was a native of Antwerp, where he had studied landscape painting in 1557–64 under Jan Mandijn and Cornelis van Dalem; two of his landscapes are at Karlsruhe, one dated 1569. From 1565 he was in Italy, and in Milan, Parma, and Rome he became a follower of Parmigiano and Federico Zuccari in figure-painting. By way of Vienna, where he was active from 1575, he came to Rudolf, who gave him a fixed appointment in 1581. At Prague he executed mythologies and allegories to the emperor's taste, a number of which are still preserved in Vienna, and are the true core of his œuvre – Minerva conquering Ignorance (Plate 306), an allegory referring to Rudolf, Ulysses and Circe, Salmacis and Hermaphroditus, Venus and Mars, Glaucus and Scylla, Hercules and Dejanira, Venus and Adonis, Hercules and Omphale, Vulcan and Maia. In his better works, in compositions rich in contrasts and unresolved tensions, he showed greater artistic refinement than the Italians; imaginative allusions alternate with outspokenness. Spranger's pagan loves of the gods followed the Italian manner, yet were northern in their restless diabolism, and were in that way flamboyant successors to Cranach. If there is one feature common to all Prague art, it is an eroticism both intentional and inhibited. It corresponds not only to the spirit of the age, but also to the emperor's inclinations, for he expressly demanded this feature. We know too from ambassadors' reports that he was often presented with licentious pictures. In Spranger's work human bodies, as decorative forms, are interlocked in artful, fleeting poses to become an ornament of a higher order. Van Mander also emphasizes the fact that Spranger did not make a single drawing in Rome after the Antique or the recent Italians. As wayward as Bruegel, Spranger aimed at a subjective rendering of form instead of the 'Romanist' presentation of nature filtered through the study of Antiquity and the Renaissance.

Spranger never trained pupils, yet he became a European influence in Germany, the Netherlands, where the artists of Utrecht and Haarlem were his followers, France, and

even Italy. His inspiration acted by means of engravings and copies after his drawings, paintings, and engravings.

In 1597, Hans von Aachen (1552–1615; Plate 307),[15] who had been appointed court painter at Prague *in absentia* already in 1592, settled there, though his travels often took him away. He was a native of Cologne, had lived in Venice in 1574–88, had been in Rome, where he painted the Adoration of the Shepherds for the Gesù, and in Florence, and after his return had won fame with history pictures and portraits at Cologne, Munich (Crucifixion and Martyrdom of St Sebastian for St Michael), and Augsburg (Coronation of the Virgin for St Ulrich, and portraits of the Fuggers). What he brought to Prague was a greater smoothness of modelling, the *grazia* of Correggio, and the warm colouring of the Venetians. At Prague he was given the same kinds of commissions as Spranger (cf. his pictures in Vienna), and his softer temperament even had some influence on Spranger. Like Spranger, he made a large number of designs for engravers, which spread his influence far and wide. His preliminary drawing for De Vries's Hercules Fountain at Augsburg (cf. p. 326), now in the Albertina in Vienna, is an impressive testimony to his versatility.

Venetian features are still more marked in the work of Joseph Heintz (1564–1609),[16] a native of Basel who was Hans von Aachen's pupil in Rome in 1584. In 1591 he also became court painter at Prague, but he continued to visit and work in Italy and at Augsburg. Pictures such as the Venus and Adonis in Vienna and the Satyr with Nymphs at Munich show that his mythologies were adapted to the Rudolfine style in subject and composition. But his painting has a sheen in the modelling and a warm harmony which betray an uninhibited interest in painterly appeal lacked by both Spranger and Hans von Aachen; the same is true of the landscapes in Heintz's pictures.

This trio of figure painters was a counterpart to the Prague sculptors, and each group had a fertilizing influence on the other. At the same time a stream of painters of other specialities came to the capital for longer or shorter periods. One of them was Joris Hoefnagel, the miniaturist and topographer (1590–1600); in 1594 he illustrated Georg Bocskay's book of calligraphy (Vienna) and he also did miniatures of natural history. Other painters to appear in Prague were the landscapist Roelant Savery (c. 1604); Jan Breughel (c. 1604; a drawing from Prague: Paris, Lugt Collection); Pieter Stevens (1590–1612); and the architectural painters Hans Vredeman de Vries and Paul de Vries (1596–7). Matthäus Gundelach (c. 1566–1653),[17] who had been Heintz's successor since 1609, maintained the Rudolfine figure style till well on into the new century; after the emperor's death he continued his activity at Augsburg.

CHAPTER I

3 1. As far as division into art-historical periods according to sovereigns is at all possible, it seems to some extent useful in German history during the reign of Maximilian I, although in a somewhat different sense than during the time of Rudolf II (cf. Part 4). 'Rudolfinisch' signifies in the first instance an art circle, 'maximilianisch' multiplicity of styles during a given phase of styles.

4 2. L. von Ranke, *Deutsche Geschichte im Zeitalter der Reformation* (Munich, 1914) (title of the first book). This work should also be consulted for Chapters 16 and 31. See also J. Haller, *Die Epochen der deutschen Geschichte* (Munich, 1957), chapters 6–8, and H. Rössler, *Europa im Zeitalter von Renaissance, Reformation und Gegenreformation 1450–1650* (Munich, 1956).

5 3. Carl F. Burckhardt, *Bilder aus der Vergangenheit* (Frankfurt, 1956), 62 f.

6 4. *Erasmus von Rotterdam, Briefe* (Bremen, 1956); cf. the introduction.

7 5. See also L. von Baldass, *Der Künstlerkreis Kaiser Maximilians* (Vienna, 1923).

8 6. R. Bruck, *Friedrich der Weise als Förderer der Kunst* (Strassburg, 1903).

 7. Pinder, *Dürerzeit*.

NOTE: For further comments on the events treated in Chapters 2–7, cf. another volume of the *P.H.A.*: T. Müller, *Sculpture in the Netherlands, Germany, France, and Spain: 1400–1500* (Harmondsworth, 1966).

CHAPTER 2

 1. E. Lutze, *V.S.*, 3rd ed. (Munich, 1952), 8; T. Müller, in Th.-B.; P. Skubiszewski, *Rzeźba Nagrobna Stwosza* (Warsaw, 1957); U. Boeck, in *Das Münster*, XII (1959), 101–8 (*Nachrichtenblatt der Denkmalpflege in Baden-Württemberg*, II (1959), 61–7); S. Dettloff, *Wit St.* (Wrocław, 1961); S. Sawicka, *Ryciny Wita Stwosza* (Warsaw, 1957); L. Behling, in *Pantheon*, XXIII (1965), 31–40; H. Kohlhaussen, *ibid.*, XXIV, 83–7.

2. Ks. B. Przybyszewski, *Biuletyn Historii Sztuki*, XIV (1952), no. 2, 62–6. The general relationship of Stoss's engraving of the Madonna of the Pomegranate to the figure of the Virgin at Horb in Swabia (Sawicka, *op. cit.*, figure 51) is not sufficient evidence that this Horb was Stoss's place of birth; see also A. Jaeger and O. Puchner, *V.S. und sein Geschlecht* (*Freie Schriftenfolge der Ges. f. Familienforschung in Franken*, IX, 1958).

3. E. Lutze, *op. cit.*, 11, plate 27.

4. G. Barthel, *Die Ausstrahlungen der Kunst des V.S. im Osten* (Munich, 1944).

5. H. Decker, *Salzburger Flügelaltar des V.S.* (Salzburg, 1950). Although of excellent quality, not a work by Stoss but by a member of his school.

6. S. Dettloff, in *Z. d. dt. Ver. f. Kwiss.*, V (1938), 16 ff.; G. Barthel, *op. cit.*, 39; E. Lutze, *op. cit.*, 7.

7. E. Lutze, *op. cit.*, 27 f. p. 10

8. The Salzburg altar of 1498, as shown by Decker (*op. cit.*, 23), was also unpainted apart from lips and eyes. It can therefore be presumed that Stoss left some wood carvings unpainted already at Cracow; although, on the other hand, even his stone sculpture there, apart from monuments, is painted.

9. The stone figure of St Paul of 1513 in St p. 11 Sebald is not after Dürer's sketches W591, 592, 611, in preparation for the engraved St Paul dated 1514, but, as emphasized by T. Müller (*Münchner Jb.*, N.F., X (1933), 27 ff., 56), only related to them because derived from a common root, namely Schongauer B45.

10. Basic: J. Bier, *T.R.*, I and II (Würzburg- p. 12 Augsburg, 1925–30); *idem*, in Th.-B. Further *idem*, *T.R., ein Gedenkbuch*, 6th ed. (Vienna, 1948); T. Demmler, *Die Meisterwerke T.R.s* (Berlin, 1939); K. Gerstenberg, *T.R.*, 3rd ed. (Munich, 1950); F. Winzinger, in *Das Münster*, IV (1951), 129–37; M. H. von Freeden, *T.R.* (Munich, 1954); G. Poensgen and others, *Der Windsheimer Zwölfbotenaltar von T.R.* (Munich, 1955), as well as numerous articles by J. Bier. The following are important for the early period: J. Bier, 'Die Anfänge T.Rs.', *Kunstgeschichtliche Gesellschaft zu Berlin. Sitzungsberichte*, 1956/7, 9–12; E. Redslob, 'Erfurt als

künstlerische Heimat T.Rs', *Winkler Festschrift*, 171–80.

p. 13 11. Cf. J. Bier, in *Art Bull.*, XXXVII (1955), 103 ff., 112.

12. Model for the Virgin at Volkach by Riemenschneider himself at Dumbarton Oaks (Washington). The Volkach Virgin was made in 1521 by an assistant (Bier, *loc. cit.* (1948), no. 107). Cf. also Riemenschneider's wooden figures of St Matthew and St James the Greater in Berlin and Munich which are closely connected with the stone sculpture of the Marienkapelle. Further on this problem: J. Bier, in *Art Bull.*, XXXVIII (1956), 215 ff.

p. 15 13. Cf. Hubert Schrade's view (*T.R.* (Heidelberg, 1927), 84 ff.) that Grünewald's sketch at Stockholm incorporates a portrait of Scherenberg, independent of Riemenschneider. L. Behling, *Die Handzeichnungen des Matthis Gothart Nithart* (Weimar, 1955), no. 35, see also p. 63, avoids the problem by dating the sketch *c.* 1525, undoubtedly too late. Further to the problem of the portraits by Riemenschneider J. Bier, in *Münchner Jb.*, III. Folge, VII (1956), 95 ff.

14. Cf. J. Bier, in G. Poensgen, *op. cit.*, 105 ff.; cf. also G. F. Hartlaub, in *Z. f. Kwiss.*, X (1956), 28.

p. 17 15. On the development of style see in particular K. Mugdan, in G. Poensgen, *op. cit.*, especially note 82.

16. Possibly originally planned as a relief for a memorial tablet: cf. M. H. von Freeden, *T.R., die Beweinung in Maidbronn* (Stuttgart, 1956).

p. 18 17. D. Stern, *Der Nürnberger Bildhauer A.K.* (*Studien zur deutschen Kgesch.*, CXCI) (Strassburg, 1916); *eadem*, in Th.-B.; W. Schwemmer, *A.K.* (Nuremberg, 1958); A. Schädler, in *Anzeiger des Germanischen Nationalmuseums* (1963), 84–8.

p. 20 18. Also for Kraft and Vischer: D. Stern, in Th.-B.; Pinder, *Hb.*, II, 428; S. Meller, *Peter Vischer d. Ä. und seine Werkstatt* (Leipzig, 1925), 66, 104, 106, 120; L. Fischel, *Nicolaus Gerhart und die Bildhauer der deutschen Spätgotik* (Munich, 1944), 135. Cf. N. Pevsner, in *B.M.*, LXXX (1942), 90–3; G. von der Osten, in *Anzeiger des Germanischen Nationalmuseums* (1963), 71–83.

19. E. F. Bange, in *Jb. P.K.* (1929), 167; R. Berliner, 'Peter Vischer-Probleme', *Münchner Jb.*, N.F., VIII (1931), 133 ff.; Bange, *Bronzestatuetten*, 12 f. Cf. T. Müller, in *Wissenschaftliche Zeitschrift der Karl Marx-Universität Leipzig*, V (1955/6), *Gesellschafts- u. sprachwiss. Reihe*, H. 2, 223–7; Pinder,

Dürerzeit, 237 ff.; H. R. Weihrauch, *Die Bildwerke in Bronze* (Munich, 1956), 14 ff.; G. von der Osten, *loc. cit.* For general literature on Vischer see the following note.

20. Comprehensive: F. T. Schulz, in Th.-B. See also S. Meller, *loc. cit.*, and E. F. Bange, *loc. cit.* (1929); H. R. Weihrauch, in *Münchner Jb.*, III. Folge, I (1950), 204–14; H. Stafski, in *Z. f. Kgesch.*, XXI (1958), 1–26; *idem, Der jüngere Peter V.* (Nuremberg, 1962); D. Wuttke, in *Z. f. Kgesch.*, XXII (1959), 324–36; *idem*, in *Forschungen und Fortschritte*, XXXIX (1965), 144–6; K. Pechstein, *Beiträge zur Geschichte der V.-hütte in Nürnberg*, thesis (Berlin, 1962).

21. The term 'altfränkisch' may mean simply 'old-fashioned' or more literally 'ancient Franconian'.

22. Cf. J. Bier, in *Mitteilungen des Vereins f.* p. *Geschichte der Stadt Nürnberg* (1928), 349–58.

23. A. Mayer, *Die Genreplastik an P.V.'s Sebaldus-* p. *grab* (Leipzig, 1911).

24. Cf. V. Oberhammer, *Die Bronzestandbilder* p. *des Maximiliangrabmales in der Hofkirche zu Innsbruck* (Innsbruck, 1935), 404 ff.

CHAPTER 3

1. W. Vöge, *N.H.* (Freiburg, 1930), 34 and p. *passim*; K. Gerstenberg, *Die deutschen Baumeisterbildnisse der Mittelalters* (Berlin, 1966), 192–4.

2. C. Sommer, in *Oberrheinische Kunst*, III (1928), p. 98–104; I. Schroth, in *Z.A.K.*, XXII (1962), 87–92.

3. For literature see Th.-B., XXXVII, 54 f.; C. Sommer, in *Z. d. dt. Ver. f. Kwiss.*, III (1936), 245 ff.; G. von der Osten, *ibid.*, II (1935), 430 ff.; *idem*, in *Jb. der Staatlichen Kunstsammlungen in Baden-Württemberg*, III (1966), 69–82; I. Schroth, in *K. Chronik*, XIII (1960).

4. Cf. G. Lill, *Hans Leinberger* (Munich, 1942), p. 242; T. Demmler, in *Deutsche Literaturzeitung*, LXIV (1943/4), col. 742; F. Dworschak, in *Jb. K.S.*, N.F., XIII (1944), 387; *Das Münster*, IX (1956), 51. For the Master HL's later period see Chapter 29, p. 261.

5. J. Baum, in Th.-B.; *idem*, in *B.M.*, LXIX (1936), 252–7; R. Schnellbach, *Spätgotische Plastik im unteren Neckargebiet* (Heidelberg, 1931); H. Rott, in *Zeitschrift f. die Geschichte des Oberrheins*, N.F., XLIII (1930), 74 f., figure 2; W. Fleischhauer, in *Schmitt-Festschrift*, 203–10; Rott, II, lvi, III, c., 16, 31–3, 121; L. Böhling, *Die spätgotische Plastik im Würt-*

tembergischen Neckargebiet (Reutlingen, 1932), 72, 90.

6. J. A. Schmoll, gen. Eisenwerth, in *Festschrift für Karl Lohmeyer* (Saarbrücken, 1954), 54–64; Th.-B.; K. Gerstenberg, *op. cit.*, 199–201.

29 7. P. Kautzsch, *Der Mainzer Bildhauer H.B. und seine Schule* (Leipzig, 1911); G. Braune-Plathner, *H.B.*, thesis (Halle, 1934); A. Schmidt, in *Trierer Zeitschrift*, XII (1937), 137–48.

30 8. Further to wood sculpture of the Middle Rhine: the Virgin in the Victoria and Albert Museum (A. 86 – 1927) is close to Backoffen. See also R. Kautzsch, *Der Mainzer Dom und seine Denkmäler*, I (Frankfurt, 1925), plates 104 f. Also R. Schnellbach, *op. cit.*, 110–14; *idem*, in *Oberrheinische Kunst*, IV (1930), 40 ff. Two figures in the Darmstadt Museum are connected with the Bishop in the Liebieghaus in Frankfurt: John the Baptist from Fahr near Neuwied and Wendelin from Kiedrich(?), cf. below, p. 263.

9. G. Troescher, *C.M. von Worms* (Freiburg, 1927); D. Stern, in Th.-B.; R. Schnellbach, *op. cit.*, 21; J. Duverger, *C.M.* (Brussels, 1934) (in *Académie Royale de Belgique, Classe des Beaux-Arts, Mémoires*, coll. in 4°, 2. série, tome 5, fasc. 2); K. Oettinger, *Anton Pilgram und die Bildhauer von St Stephan* (Vienna, 1951), 27 ff.; T. Müller, in *Sitzungsberichte der Kgesch. Gesellschaft Berlin* (1955/6), 11–15; L. Fischel, *op. cit.* (Chapter 2, Note 18), 145 f.

10. The Lamentation in the Victoria and Albert Museum (A. 15 – 1912) is closely related to Meit.

31 11. For Meit's later period see Chapter 25, p. 238.

CHAPTER 4

2 1. J. Baum, in Th.-B.; G. Otto, *Die Ulmer Plastik der Spätgotik* (Reutlingen, 1927), 97 ff.; *eadem*, in *A.S.A.*, N.F., XXXVII (1935), 233 ff.; E. Poeschel, *ibid.*, N.F., XXXIV (1932), 226 ff.

2. K. Gröber, *Schwäbische Skulptur der Spätgotik* (Munich, 1922), plate 61; Rott, III, xxiii–xxvi, 106–10, plates 7, 8, 28, 29.

3. Cf. T. Müller, in *Münchner Jb.*, N.F., IX (1932), 253 ff.; *idem, ibid.*, N.F., XIII (1938/9), 55 ff.; Rott, II, xxxii f.; H. Dussler, *J.L.* (Kempten, 1963).

4. J. Baum, *Die Bildwerke der Rottweiler Lorenzkapelle* (Augsburg, 1929), no. 93; M. Weinberger, in *Münchner Jb.*, N.F., IV (1927), 23 ff., 478; L. Böhling, in *Kunst- und Antiquitäten-Rundschau*, XLII (1934), 460–2; *eadem, loc. cit.* (1937); T. Müller,

in *Münchner Jb.*, N.F., XIII (1938/9), 64. A connecting link with Loscher is a little-known boxwood statue of the Virgin in the Metropolitan Museum (190.356).

5. J. Baum, in Th.-B.; G. Otto, *op. cit.*, 112 ff.; *eadem*, in *A.S.A.*, N.F., XXXVII (1935), 283 ff.

6. K. Feuchtmayr, in Th.-B.; G. Otto, *op. cit.*, p. 33 263 ff.; Schaffner Cat., 29.

7. J. Baum, *Altschwäbische Kunst* (Augsburg, 1927), 82 ff.; *idem*, in *Mitteilungen des Vereins f. Kunst- und Altertum in Ulm und Oberschwaben*, XXVIII (1932), 35–7; G. Otto, *op. cit.*, 311 ff.; *eadem*, in *Pantheon*, VI (1930), 560 ff.; *eadem*, in *Schwäbische Heimat*, V (1954), 251–7; L. Göbel, *Beiträge zur Ulmer Plastik der Spätgotik* (Tübingen, 1956), 9 ff.

8. G. Otto, *G.E.* (Berlin, 1943); *eadem*, in *Schwäbische Heimat*, V (1954), 251; J. Baum, *ibid.*, 174–6; K. Feuchtmayr, in Lieb, I, 433, note 54; J. Schlosser, *Präludien* (Berlin, 1927), 314, plate 69; N. Lieb, in *Festschrift Julius Baum* (Stuttgart, 1952), 128–33; B. Ulm, in *Christliche Kunstblätter*, IV (1964), 116–21; Cat. of the Holbein exhibition, ed. B. Bushart (Augsburg, 1965), 43–5.

9. Compare the ivory in the Metropolitan Mu- p. 34 seum (17.190.305). The old hag alone reflects the statue in Frankfurt attributed to Syrlin the elder but also the Upper Rhine (Bange, *Kleinplastik*, no. 53, middle; A. Schädler, in *K. Chronik*, VII (1954), 339).

10. Victoria and Albert Museum, 6994/5 – 1861.

11. The figure in the Cleveland Museum of Art p. 35 is ungilded.

12. Halm, I, 102 ff.

13. K. Feuchtmayr, in *Münchner Jb.*, N.F., XII (1921/2), 98 ff.; H. R. Weihrauch, *ibid.*, III. Folge, III/IV (1952/3), 199–215.

14. K. Feuchtmayr, in Lieb, I, 433 ff.; H. R. p. 36 Weihrauch, *loc. cit.*; *Augsburger Renaissance*, 63 ff.; H. Müller, in *Lebensbilder aus dem bayerischen Schwaben*, III (Munich, 1954); J. Baum, *Meister und Werke spätmittelalterlicher Kunst in Oberdeutschland und der Schweiz* (Lindau, 1957), 88–97, objects to the disintegration of Adolf Daucher's sculptural *œuvre* which resulted from the introduction of Loscher; H. Müller, *op. cit.*, 256 f. For Loscher's later period see Chapter 28, p. 256.

15. E. F. Bange, in *Jb. P.K.*, XLIV (1923), 107 ff.; p. 37 *idem*, in *Z. f. Kgesch.*, V (1936), 63; *idem, Bronzestatuetten*, 49; but cf. Lieb (and Feuchtmayr), I, 245, note 120.

p. 37 16. Lieb (and Feuchtmayr), 1; Halm, II, 189–249; Bange, *Kleinplastik*, nos. 2 ff.; O. von Falke, in *Pantheon*, XXVI (1940), 270; J. Baum, *op. cit.*; H. Reinhardt, in *Jahresbericht des Historischen Museums* (Basel, 1965), 26–32. For Daucher's later period see Chapter 28, p. 256.

p. 38 17. For Hering's later period and for literature see Chapter 28, p. 257.

18. T. Müller, in *Phöbus*, III (1950/1), 25–30.

CHAPTER 5

p. 39 1. P. M. Halm, *E.G.* (Augsburg, 1928); M. Hasse, in *Jb. P.K.*, LX (1939), 47–55; P. Frankl, in *A.Q.*, V (1942), 242 ff.; T. Müller, *Alte baierische Bildhauer* (Munich, 1950), 40 ff.; see also p. 19.

2. S. Kruckenhauser, *Das Meisterwerk von Kefermarkt* (Salzburg, 1941); Feulner–Müller, 339; M. Hasse, in *Z. f. Kwiss.*, I (1947), 89–97; *idem*, in Th.-B., XXXVII, 178; O. Kastner and B. Ulm, *Mittelalterliche Bildwerke im Oberösterreichischen Landesmuseum* (Linz, 1958), 15–18.

p. 40 3. G. Lill, *Hans Leinberger* (Munich, 1942); T. Müller, *op. cit.* (Note 1); *idem*, in *Z. f. Ästhetik und allgemeine Kunstwissenschaft*, XXXVII (1943), 88–91; F. Kriegbaum, in *Jb. P.K.*, LXII (1941), 38 ff.; B. Ulm, in *Christliche Kunstblätter*, IV (1964), 116–21; *Donauschule*, 256 f.

p. 41 4. For Leinberger's later period see Chapter 27, p. 252.

p. 42 5. Bange, *Kleinplastik*, no. 39; T. Müller, *op. cit.* (Note 1), plate 111; Boston, Museum of Fine Arts, 45, 474.

6. K. Oettinger, *Lorenz Luchsperger* (Berlin, 1935), cf. review by B. Fürst, in *Kritische Berichte zur Kgesch. Literatur*, VII (1938), 66–90; H. Stafski, in *Z. d. dt. Ver. f. Kwiss.*, V (1938), 62–76.

7. K. Oettinger, *A.P. und die Bildhauer von St Stephan* (Vienna, 1951); R. Feuchtmüller, *Ein Wunder gotischer Schnitzkunst* (Vienna, 1955); O. Benesch, in *Jb. B.M.*, I (1959), 198–217, but cf. above and Chapter 29, Note 3; A. Macku, in *Festschrift Karl M. Swoboda* (Vienna, 1959); K. Gerstenberg, *op. cit.* (Chapter 3, Note 1), 202–10.

p. 43 8. H. Hammer, *Kgesch. der Stadt Innsbruck* (Innsbruck, 1952), 94–109.

9. Halm, I, 176–224; Rott, III, text, 28.

p. 44 10. V. Oberhammer, *Die Bronzestandbilder des Maximiliangrabes in der Hofkirche zu Innsbruck* (Innsbruck, 1935), reviewed by E. F. Bange, in *Z. f.*

Kgesch., V (1936), 60–4, and H. Hammer, in *Kritische Berichte*, VI (1937), 26–32, cf. also H. Hammer, *op. cit.*, 109–34; Bange, *Bronzestatuetten*, 47–54; Lieb, II, 7–9, 326 f.; L. Behling, in *Pantheon*, XXIII (1965), 31–40.

11. For Magt's later period see Chapter 27, p. 4 p. 253.

CHAPTER 6

1. W. Hentschel, *Hans Witten, der Meister HW* p. 4 (Leipzig, 1938), reviewed by G. von der Osten, in *Z. f. Kgesch.*, VIII (1939), 290 ff. See further: W. Hentschel, in Th.-B.; R. Hünicken and G. von der Osten, in *Jb. P.K.*, LVII (1936), 75; G. von der Osten, *ibid.*, LXIII (1942), 90 ff.; von der Osten (1957), 110; L. Behling, *Die Pflanzenwelt der mittelalterlichen Kathedralen* (Cologne, 1964), 162–7; K. Oettinger, in *Festschrift Hans Sedlmayr* (Munich, 1962), 201–28.

2. W. Pinder, in *Das Werk des Künstlers*, I (1939), p. 3 ff.

3. W. Hentschel, in *Winkler Festschrift*, 217 f. p.

4. *Idem*, *P.B.* (Dresden, 1951).

5. G. Barthel, *Die Ausstrahlungen der Kunst des Veit Stoss im Osten* (Munich, 1944); J. Pašteka, *Meister Paul von Leutschau* (Prague, 1961); O. Schürer and E. Wiese, *Deutsche Kunst in der Zips* (Brno, 1938), nos. 261 ff.; H. Braune and E. Wiese, *Schlesische Malerei und Plastik des Mittelalters* (Leipzig, 1926), in particular no. 109; K. Bimler, *Die schlesische Renaissanceplastik* (Breslau, 1934), 8–10.

6. Stuttmann–von der Osten, 26–34; von der p. Osten (1957), 144.

7. Stuttmann–von der Osten, 34–55; von der Osten (1957), 144–8.

8. For the later period of the Master of St Benedict see Chapter 26, p. 244.

9. W. Paatz, *Bernt Notke*, 2 vols (Berlin, 1939), p 39–168; S. Karling, *Medeltida Träskulptur i Estland* (Stockholm, 1946), 193–216; M. Hasse, in *Niederdeutsche Beiträge zur Kgesch.*, III (1964), 285–318.

10. H. Deckert, in *Marburger Jb.*, I (1924), 55–98; M. Hasse, in *Jb. P.K.*, LIX (1938), 173 ff.; *idem*, *Lübecker Museumsführer*, I (1964), 145–52; G. von der Osten, in *Niedersächsisches Jb. f. Landesgeschichte*, XXIII (1951); von der Osten (1957), 131 f.; *idem*, *Festschrift Peter Metz* (Berlin, 1965), 305–14; W. Meyne, *Lüneburger Plastik des XV. Jahrhunderts* (Lüneburg, 1959), 140–2.

p. 52 11. For Dreyer's later period see Chapter 26, p. 246.

12. F. Fuglsang, *Der Bordesholmer Altar des H.B.* (Schleswig, 1959), reviewed by M. Hasse, in *K. Chronik,* XIII (1960), 155–8.

p. 53 13. Th.-B., XXXVII, 256–8; von der Osten (1957), 138–41.

p. 54 14. B. Meier, *Das Landesmuseum der Provinz Westfalen,* I, *Die Skulpturen* (Berlin, 1914), 27 ff.; K. Döhmann, in *Westfalen,* VII (1915), 33–87; H. Beenken, *Bildwerke Westfalens* (Bonn, 1923); T. Rensing, in *Westfalen,* XXII (1937), 207–8; *Inv. Westfalen, Münster,* V, 44; H. Melchers, *Die westfälische Steinskulptur* (Emsdetten, 1931), 8; S. Fliedner, in *Bull. M.R.,* VII (1958), 141–86; H. Eickel, in *Westfalen,* XL (1962), 286–99.

CHAPTER 7

56 1. Witte, 180–1, plates 177, 185, 267; H. Appel, in *W.R. Jb.,* XXIV (1962), 251–60.

2. Witte, 163–4, plates 190 ff.; J. Leeuwenberg, in *O.H.,* LIX (1942), 164–9; Timmers, 28–30.

3. H. Schnitzler, *Das Schnütgen Museum,* 2nd ed. (Cologne, 1961), nos. 121, 131.

57 4. Borchgrave (1942); *idem,* in *Bull. de la Société royale d'archéologie de Bruxelles* (1939), 40–4; *idem, Le Retable de St Georges de Jan Borman* (Brussels, 1947); *idem, Œuvres de nos imagiers romans et gotiques* (Brussels, 1944); P. Pradel, *La Sculpture belge de la fin du moyen-âge au Musée du Louvre* (Paris, 1947); J. Roosval, *Schnitzaltäre in schwedischen Kirchen und Museen aus der Werkstatt des Brüsseler Bildschnitzers Jan Borman* (Strassburg, 1903); *idem,* in *R.B.,* III (1933), 136–58; G. Brett, in *G.B.A.,* ser. 6, XLIV, 96th year (1954), 47–56; J. Lavalleye, in *La Revue d'art* (Brussels), XXVIII (1926), 141–8; *idem,* in *Annuaire des Musées Royaux des Beaux-Arts de Belgique,* I (1938), 73–88; *idem,* in *Bernard van Orley* (Brussels, 1943).

5. J. de Borchgrave d'Altena, in *Bull. de la Société royale d'archéologie de Bruxelles* (1938), 31–9.

58 6. F. Rademacher, in *Pantheon,* XXIII (1939), 81–8.

7. J. de Borchgrave d'Altena, *Notes pour servir à l'inventaire des œuvres d'art de Brabant, Arrondissement Louvain* (Brussels, 1940), 270–3, plate 76.

8. Devigne, 148–50, plates 271–3.

9. J. de Borchgrave d'Altena, *Notes et documents pour servir à l'histoire de l'art et de l'iconographie en Belgique,* I, *Sculptures conservées au pays Mosan* (Verviers, 1926), 110–16; Devigne, plate 172.

10. Borchgrave (1957), 2–114; G. von der Osten, in *Festschrift Hermann Schnitzler* (Düsseldorf, 1965), 249–51.

11. J. de Borchgrave d'Altena, in *Bull. de la Société royale d'archéologie de Bruxelles* (1936), 139–42.

12. A. Jansen and C. van Herck, *Kerkelijke* p. 59 *Kunstschatten* (Antwerp, 1949), 61, no. 83.

13. J. de Borchgrave d'Altena, in *B. van Orley (op. cit.),* plates 60, 64.

14. For a summary of the not very close framework of dates: Borchgrave (1942), 22, and *idem* (1957), 2–4.

15. C. de Tolnay, *Michelangelo,* I (Princeton, 1943), 156–9.

16. M. Konrad, *Meisterwerke der Skulptur in Flandern und Brabant* (Berlin, 1928), plate 41; Demmler, 346 f.

17. G. van Doorslaer, *Annales de l'Academie royale d'archéologie de Belgique* (1930).

18. *Oudheidkondig Jaarboek,* IV. Folge, I (1932), 7 ff.

19. G. Troescher, *op. cit.* (Chapter 3, Note 9), p. 60 plate 7; T. Müller, *loc. cit.* (Chapter 3, Note 9), 14.

20. Timmers, plates 104–7; also von der Osten (1957), no. 208.

21. Timmers, plate 110.

22. Timmers, plates 76–9.

23. Vogelsang, II, no. 103.

24. For the later period of the Master of the Stone Female Head see Chapter 25, p. 236; for literature see that chapter, Note 3.

25. J. Leeuwenberg, in *O.H.,* LIX (1942), 164–9; Timmers, 28–30, plates 34–5.

26. Timmers, plates 32, 33, 40, 41, 43; D.P.R.A. p. 61 Bouvy, *Middeleeuwsche Beeldhouwkunst in de noordelijke Nederlanden* (Amsterdam, 1947), plates 141, 142.

27. Witte, 223–4; H. P. Coster, in *Bull. van den Oudheidkondigen Bond* (1909), 196; D. Bierens de Haan, *Het Houtsnijwerk in Nederland tijdens de Gothiek en de Renaissance* (The Hague, 1921), 105–9.

CHAPTER 8

1. S. Sawicka, *Ryciny Wita Stwosza* (Warsaw, p. 62 1957).

2. Stange, IX, 51–85.

3. Rott, III, text.

p. 63 4. Basic is E. Panofsky, *A.D.*, 2 vols (Princeton, 1948), with select bibliography. Further: Rupprich; H. Wölfflin, *Die Kunst A.D.s* (ed. K. Gerstenberg, Munich, 1943); H. Tietze and E. Tietze-Conrat, *Kritisches Verzeichnis der Werke A.D.s*, 3 vols (Augsburg, 1928, Basel, 1937 f.); J. Meder, *D.-Katalog* (Vienna, 1932); F. Winkler, *Die Zeichnungen A.D.s*, 4 vols (Berlin, 1936–9); *idem, A.D.* (Berlin, 1957); H. T. Musper, *A.D.* (Stuttgart, 1952); *idem, A.D.* (Cologne, 1965); T. Hetzer, *D.s Bildhoheit* (Frankfurt, 1939); Hollstein, VII, 2–277. Recent special literature: A. Stange, in *Festschrift Werner Noack* (Konstanz, 1958), 113–17; K. Oettinger, in *Z. f. Kwiss.*, VIII (1954), 153–68; F. Winzinger, *ibid.*, 43–64; E. Schilling, *ibid.*, 175–84; A. Stange, in *Z. f. Kgesch.*, XX (1957), 1–24; J. Q. van Regteren Altena, in *Winkler Festschrift*, 181–6; G. Arnolds, *ibid.*, 187–90; F. Winkler, in *Pantheon*, XVIII (1960), 12–16; *idem*, in *Münchner Jb.*, III. Folge, I (1950) 177–86; *idem*, in *Z. d. dt. Ver. f. Kwiss.*, VIII (1941), 197–208; E. Marx, in *Festschrift Edwin Redslob* (Berlin, 1955), 301–10; L. Grote, in *Anzeiger des Germanischen Nationalmuseums 1954–59*, 43–67; L. Oehler, *ibid.*, 91–127; P. Strieder, *ibid.*, 128–42; K. Steinbart, in *Z. f. Kgesch.*, XIV (1951), 32–9; J. Bialostocki, in *G.B.A.*, 6th ser., 99th year, L (1957), 195–202; K. A. Knappe, *A.D. und das Bamberger Fenster in St Sebald in Nürnberg* (*Erlanger Beiträge zur Sprach- und Kwiss.*, IX) (Nuremberg, 1962); A. M. Vogt, in *Festschrift Kurt Badt* (Berlin, 1961), 121–34; Fiensch, *passim*; P. Strieder, in *Z. f. Kgesch.*, XXVI (1963), 169–80; K. Martin, *A.D.*, *Die vier Apostel* (Stuttgart, 1963); L. Grote, in *Festschrift f. Hans Liermann* (*Erlanger Forschungen*, A, XVI) (Erlangen, 1964), 26–47; *idem*, in *Z. d. dt. Ver. f. Kwiss.*, XIX (1965), 151–69; G. Kauffmann, in *Meilensteine europäischer Kunst*, ed. E. Steingräber (Munich, 1965), 257–77; H. C. von Tavell, in *Münchner Jb.*, III. Folge, XVI (1965), 55–120; F. Winzinger, in *Pantheon*, XXIV (1966), 283–7; W. Kurth, *The Complete Woodcuts of A. D.* (New York, 1963).

p. 65 5. M. Müller and F. Winkler, in *Jb. P.K.*, LVIII (1937), 241–57.

p. 66 6. H. Ladendorf, in *Förster Festschrift*, 21–35.

p. 72 7. G. Dehio, *Kunsthistorische Aufsätze* (Munich, 1914), 157.

p. 75 8. G. von der Osten, in *Kölner Domblatt*, XXIII–XXIV (1964), 344.

p. 84 9. Held.

p. 85 10. Rupprich, I, 289, cf. 325. Translation by E. Panofsky, *op. cit.*, 230.

11. E. Buchner, in Th.-B.; F. Stadler, *H. v. K.* p. 8❖ (Vienna, 1936); F. Winkler, *Die Zeichnungen Hans Süss v. K's und Hans Leonhard Schäufeleins* (Berlin, 1942); *idem*, 'H. v. K.', in *Die Plassenburg, Schriften f. Heimatforschung und Kulturpflege*, XIV (Kulmbach, 1959), reviewed by K. A. Knappe, in *Z. f. Kgesch.*, XXIII (1960), 184–7, cf. L. Oehler, *loc. cit.*; Dürer Cat., nos. 149–233.

12. E. Buchner, in Th.-B.; *idem*, in *Festschrift* p. 8 *Max J. Friedländer* (Leipzig, 1927), 46–76; L. von Baldass, in *Pantheon*, XXVI (1940), 225–8; F. Winkler, see preceding Note; E. Schilling, in *Z. f. Kwiss.*, IX (1955), 151–80; Rott, II, xliv, 180–2; Dürer Cat., nos. 289–328; P. Strieder, in *Pantheon*, XIX (1961), 99 f.; *idem*, in *K.Chronik*, XIV (1961), 43; F. Winzinger, in *Z. f. Kwiss.*, XVI (1962), 183–8; B. Müller, in *Z. d. dt. Ver. f. Kwiss.*, XVII (1963), 89–98; M. C. Oldenbourg, *Die Buchholzschnitte des H.S.*, 2 vols (Baden–Baden, 1964).

13. F. T. Schulz, in Th.-B.; G. von der Osten, p. *Katalog der Gemälde alter Meister* (Hannover, 1954), no. 371; Rott, I, 70, plates 31 f., 35, 76; Dürer Cat. nos. 329–57.

CHAPTER 9

1. Zülch, 262–4; Buchner, no. 44; E. Schilling, p. in *Jb. P.K.*, LIV (1933), 140–50.

2. W. K. Zülch, *Der historische G., Mathis Gothardt-Neithardt* (Munich, 1938); *idem, G., Mathis Neithardt genannt Gothart* (Leipzig, 1954); L. Grote, *Matthias G., Die Erasmus-Mauritiustafel* (Stuttgart, 1957); G. Schoenberger, *The Drawings of Mathis Gothart Nithart called G.* (New York, 1948); P. Fraundorfer, in *Würzburger Diözesangeschichtsblätter*, XIV/XV (1952/3), 373–431; R. F. Burckhardt, in *Jahresbericht des Historischen Museums* (Basel, 1952), 25–32; L. Behling, *Die Handzeichnungen des Mathis Gothart Nithart genannt G.* (Weimar, 1955) (quoted as B); *eadem*, in *Z. f. Kwiss.*, XVI (1962), 41–62; G. Jacobi, *Kritische Studien zu den Handzeichnungen von Matthias G.*, thesis (Cologne, 1956); A. M. Vogt, *G., Mathis Gothart Nithart, Meister gegenklassischer Malerei* (Zürich, 1957); *idem*, in *Z.A.K.*, XVIII (1958), 172–6; H. Grasser, *ibid.*, 177–80; M. Meier, *G., Das Werk des Mathis Gothardt Neithardt* (Zürich, 1957); E. Ruhmer, *Matthias G., Die Gemälde* (Cologne, 1959); L. Donati, in *W.R. Jb.*, XXII (1960), 87–114; G. Scheja, in *Festschrift Hubert Schrade* (Stuttgart, 1960), 199–211; A. Weixlgärtner, *G.* (Vienna, 1962); A. Feigel, in *Archiv f. Mittelrheinische*

Kirchengeschichte, xiv (1962), 3–36; E. Holzinger, in *De artibus opuscula XL, Essays in Honor of Erwin Panofsky* (New York, 1961), 238–53; A. Schaedler, in *Münchner Jb.*, iii. Folge, xiii (1962), 69–74; K. Arndt, in *B.M.*, cv (1963), 344–51; M. Lanckorońska, *Matthäus Gotthart Neithart* (Darmstadt, 1963).

90 3. F. Winkler, in *Jb. B.M.*, N.F., ii (1952), 32.

91 4. Cf. below, Part 2, p. 249 and p. 263.

5. These paintings with the Saints of Intercession on the wings of the carved altar from Bindlach (Upper Franconia), dated 1503, now at Lindenhardt, are probably original work. But this is not quite definite, as they were later painted over. Therefore in those days Grünewald's influence reached as far as the area north-east of Nuremberg.

6. L. Behling, *Die Pflanze in der mittelalterlichen Tafelmalerei* (Jena, 1957), 140 f., 196.

92 7. G. F. Hartlaub, in *Nova Acta Paracelsica*, vii (Einsiedeln, 1954), 147; H. von Einem, in *Festschrift Hans Kauffmann* (Berlin, 1956), 152–71; C. D. Cuttler, in *A.Q.*, xix (1956), 100–24; F. Andzelewsky, in *Sitzungsberichte, Kunstgeschichtliche Gesellschaft zu Berlin* (1958/9), 11–13.

95 8. E. Panofsky, *op. cit.* (Chapter 8, Note 4), 146; H. Wölfflin, *op. cit.* (Chapter 8, Note 4), 13–15; F. Winkler, *op. cit.* (Chapter 8, Note 4), 179 f.; A. Weixlgärtner, *Dürer und G.* (Göteborg, 1948); F. Andzelewsky, in *Festschrift Edwin Redslob* (Berlin, 1955), 292–300; G. Scheja, *op. cit.* (Note 2).

97 9. O. Fischer, *H.B.G.* (Munich, 1939); C. Koch, *Die Zeichnungen H.B.G.s* (Berlin, 1941) (abbreviated: K); Hollstein, ii, 66–158; Baldung Cat., cf. reviews of this exhibition by H. Möhle, in *Z. f. Kgesch.*, xxii (1959), 124–32, H. R. Weihrauch, in *Pantheon*, xviii (1960), 44–6, and P. Halm, in *K.Chronik*, xiii (1960), 123–40; C. Koch, in *Winkler Festschrift*, 197–200; Rott, iii, text, 86–7, sources, i, 217–19; Dürer Cat., nos. 1–29; K. A. Knappe, in *Z. f. Kwiss.*, xv (1961), 60–80; M. C. Oldenbourg, *Die Buchholzschnitte des H.B.G.* (Baden-Strasbourg, 1962); K. Oettinger and K. A. Knappe, *H.B.G. und Albrecht Dürer in Nürnberg* (Nuremberg, 1963); G. von der Osten, in *Festschrift f. Herbert von Einem* (Berlin, 1965), 179–87; G. Bussmann, *Manierismus im Spätwerk H.B.G.s* (Heidelberg, 1966).

10. For Baldung's later period see Chapter 23, p. 219.

11. Baldung Cat., 134–7.

12. E. Bock, *Holzschnitte des Meisters DS* (Berlin, 1924); H. Röttinger, in *Gutenberg Jb.* (1951), 94–

100; H. Koegler, in *Mitteilungen der Gesellschaft f. vervielfältigende Kunst* (Supplement to *Graphische Künste*), iv (Vienna, 1926); H. Wescher-Kauert, in *Pantheon*, x (1932), 284 f.; L. Fischel, in *Münchner Jb.*, iii. Folge, v, 111–19; Rott, iii, text, 147, ii, lix; E. Graf zu Solms, in *Z. f. Kwiss.*, xvi (1962), 63–80.

13. E. Major and E. Gradmann, *U.G.* (Basel, p. 100 1942) (quoted in the text as MG); Rott, iii, text, 162, sources, ii, 111–13; Schmidt–Cetto, 31–3, nos. 51–9.

14. A. Stange, in *Festschrift Werner Noack* (Kon- p. 101 stanz, 1958), 117; Holbein Cat., 26 f., no. 131; Rott, iii, sources, ii, 49–51, 58, text, 142–4; L. Lang, in *G.B.A.*, vi pér. lviii, 103rd year (1961), 313–24; L. H. Wüthrich in *Neue Zürcher Zeitung*, cc (1966), 11.

15. Holbein Cat., 23 f., nos. 80–130; Rott, iii, sources, ii, 59 f., text, 144 f.

16. Holbein Cat., 20, nos. 443–5, 155; Rott, iii, sources, ii, 243.

17. Holbein Cat., 24 ff., nos. 131 ff.; Rott, iii, text, 179, sources, ii, 59–62, 193.

18. For Holbein's later period see p. 223; cf. p. 102 literature there.

19. W. Hugelshofer, in *A.S.A.*, N.F., xxv (1923), 163–79, N.F., xxvi (1924), 28–42, 122–150; *idem*, in Th.-B.; Altdorfer Cat., 124 f.; Schmidt–Cetto, 33–6, nos. 10, 60–3; Baldung Cat., 125–7; Stange, vii, 72, 76; C. H. Shell, in *Z.A.K.*, xv (1954), 82–6; Winzinger, 54; Rott, i, text, 209 f., sources, 300 and iii, 230; F. Gysin, *Das Schweizerische LM 1898 bis 1948* (Zürich, 1948), colour plate ii, plate 13.

20. Cat. 'Expositions du huitième centenaire' (Fribourg, 1957), plates ii–iv, nos. 6–31; A. Kelterborn-Haemmerli, *Die Kunst des H.F.* (Strasbourg, 1927); Schmidt–Cetto, 19–21, nos. 6, 33–8; G. Schmidt, *Fünfzehn Handzeichnungen deutscher und schweizerischer Meister des 15. und 16. Jahrhunderts* (Basel, 1959), 15–17; Rott, iii, sources, ii, 44, 242, 278–81, text, 145 f., 251–3; E. Fabian, *Holbein-Manuel-Schmid-Studien (Schriften zur Kirchen- und Rechtsgeschichte*, xxxii) (Tübingen, 1965).

21. C. von Mandach and H. Koegler, *N.M.D.* p. 103 (Leipzig, n.d.); Schmidt–Cetto, 24–31, nos. 7–9, 39–50; M. Huggler, in *Jahresbericht der Gottfried Keller-Stiftung* (1958/9); C. A. Beerli, *Le Peintre Poète N.M. et l'évolution sociale de son temps* (Geneva, 1953); O. Fischer, in *Pantheon*, xvii (1936), 18 ff., 41 ff.; Rott, iii, sources, ii, 241 f., 256, 284; Hollstein, vi, 191–6.

CHAPTER 10

p. 105 1. Buchner, nos. 102–7; Rott, II, 101 f.; Stange, VIII, 134–51; B. Bushart, in *Z.f.Kgesch.*, XXI (1958), 230–42, XXII (1959), 133–57; E. Rettich, *ibid.*, 158–67; G. Otto, *B.S.* (Munich, 1964).

2. Rott, II, 20–2; Stange, VIII, 23–36.

3. Stange, VIII, 21–3.

4. Rott, II, xix f., 27 f.; Schaffner Cat., reviewed by H. Börsch-Supan, in *K.Chronik*, XIII (1960), 3–7.

5. Schaffner Cat., 29. Cf. p. 32.

6. Cf. Buchner, nos. 72–82.

p. 106 7. Rott, II, 220 f., 283, III, text, 43; Zülch, 176–8; *idem*, in Th.-B.; *idem*, in *W.R. Jb.*, XII–XIII (1943), 165–97; H. T. Musper, in *Münchner Jb.*, III. Folge, III/IV (1952/3), 191–8; Buchner, nos. 40 f.

p. 107 8. Cf. Buchner-Feuchtmayr, II; Lieb, I, II.

9. K. Feuchtmayr, in Buchner-Feuchtmayr, II, 97–132; Buchner, nos. 86 f.; Stange, VIII, 53–6, 80; J. Lauts, in *Pantheon*, XVIII (1960), 57–61.

p. 108 10. Buchner, nos. 88–91; Holbein Cat.; C. Beutler and G. Thiem, *H.H. der Ältere. Die spätgotische Altar- und Glasmalerei* (Augsburg, 1960); N. Lieb and A. Stange, *H.H. der Ältere* (Munich, 1960); E. Schilling, in *Winkler Festschrift*, 157–66; L. von Baldass, in *Z.f. Kwiss.*, XV (1961), 81–96; K. A. Knappe, in *Z.f. Kgesch.*, XXV (1962), 74–8; O. Pächt, *Vita Sancti Simperti* (Berlin, 1964); Cat. of the H.H. exhibition, ed. B. Bushart (Augsburg, 1965); W. Pfeiffer, in *Pantheon*, XXIV (1966), 140–6; B. Bushart, *H.H. der Ältere* (Bonn, 1965).

11. Cf. p. 101; Holbein Cat., nos. 439–45, 155; E. Buchner, in *Münchner Jb.*, III. Folge, VI (1955), 153–60; Stange, VIII, 77 f.

p. 110 12. Winkler, *Dürer*, 321; Friedländer, V, no. 58, XIV, 93.

13. Cf. p. 37.

14. H. Rupé, K. T. Parker, and C. Dodgson, in Buchner-Feuchtmayr, II, 194–228; K. T. Parker, in *Old Master Drawings*, VI (1931), 22; K. Feuchtmayr, *Das Malerwerk H.B.s von Augsburg* (Augsburg, 1931); A. Burkhard, *H.B. d. Ä.* (*Meister der Graphik*, XV) (Berlin, 1932); *idem*, *H.B. d. Ä.* (Leipzig, 1934); F. Winkler, in *Z.f. Kwiss.*, I (1947), 39–50; Buchner, nos. 92–100; *idem*, in *Z.f. Kwiss.*, X (1956), 35–52; E. Schilling, in *W.R. Jb.*, N.F., II/III (1933/4), 261–72; *idem*, in *Schmitt Festschrift*, 233–6; E. Baumeister, in *Z.f. Kwiss.*, III (1949), 73 f., plates 1–8; *Augsburger Renaissance*, 28–37; R. Oertel, in *Winkler Festschrift*, 191–6; H. T. Musper, *Kaiser*

Maximilians I. Weisskunig, I (Stuttgart, 1956); Hollstein, V, 27–174; Winkler, *Dürer* (1957), 271–4, 280, 283; P. Halm, in *Münchner Jb.*, III. Folge, XIII (1962), 75–162; A. Neumeyer, in *Münchner Jb.*, N.F., V (1928), 64 ff.; F. Anzelewsky, in *Festschrift Peter Metz* (Berlin, 1965), 295–304; T. Falk, *B.-Studien*, thesis (Berlin, 1964); H. B. and others, *The Triumph of Maximilian I* (ed. S. Appelbaum) (New York, 1964).

15. Cf. C. von Mandach and H. Koegler, *op. cit.* p. (Chapter 9, Note 21), viii.

16. Cf. p. 99.

17. E. Panofsky, *op. cit.* (Chapter 8, Note 4), 236–8; H. Möhle, in *Z.f. Kgesch.*, XXII (1959), 127.

18. K. T. Parker, in Buchner-Feuchtmayr, II, nos. 13, 29, 37.

19. Th.-B. p.

20. Friedländer, X, 101; J. S. Held, in *B.M.*, LX (1932), 308.

21. *Augsburger Renaissance*, 54–6; W. Wegner, in p. *Z.f. Kgesch.*, XX (1957), 239–59; Th.-B.; M. Epstein, in *Genava*, 2e sér., XIV (1966), 29–36.

22. Cf. p. 109 and the preceding Note; E. Buchner, in Buchner-Feuchtmayr, II, 388–413; Stange, VIII, 64–8, 82; *Augsburger Renaissance*, 19–21; S. Laschitzer, in *Jb. K.S.*, IV–VI (1886–8), *passim*; Benesch-Auer, 98–102, 105 f.; Th.-B.; Hollstein, II, 163–72; A. Stange, in *Pantheon*, XXI (1963), 158–63; *idem*, in *Alte und moderne Kunst*, XI (1966), 15–19.

23. F. Winkler, *Augsburger Malerbildnisse der Dürer-Zeit* (Berlin, 1948); L. von Baldass, in *Pantheon*, VI (1930), 395–402.

24. F. Roth (ed.), *J.B., Chronik* (*Chroniken der* p. *deutschen Städte*, XXIX) (Augsburg, 1906); O. Benesch, E. Buchner, W. Hugelshofer, in Buchner-Feuchtmayr, II, 229–387; F. Antal, in *Z.f. b. K.*, LXII (1928/9), 29–37; *Augsburger Renaissance*, 22–6; E. Baumeister, in *Z.f. Kwiss.*, XI (1957), 45–54; Buchner, no. 205; W. Wegner, in *Z.f. Kgesch.*, XXII (1959), 17–36; Altdorfer Cat., 69–73; Hollstein, IV, 157–84; Stange, *Donauschule*, 59–62; *Donauschule*, 27 f.

25. E. Panofsky, *op. cit.*, no. 732, is in favour p of Breu's workshop; on the other hand, see H. T. Musper, in *Pantheon*, XXI (1938), 103–10.

26. H. Röttinger, 'B.-Studien', *Jb. K.S.*, XXVIII (1909), 31; F. Antal, *loc. cit.*

27. Cf. D. de Chapeaurouge, in *Z.f. Kwiss.*, XIV (1960), 144.

28. Buchner–Feuchtmayr, II, plates 283, 147; K. T. Parker, *ibid.*, 24.

29. Cf. Chapter 28, p. 258.

CHAPTER 11

18 1. Stange, X, 81–92; Buchner–Feuchtmayr, II, 274; Buchner, nos. 112–19.

2. Buchner–Feuchtmayr, II, 274 f.; F. Winkler, *Die Zeichnungen Hans Süss von Kulmbachs und H. Leonhard Schäufeleins* (Berlin, 1942), 14; Altdorfer Cat., 170–4; F. H. Hofmann, in Buchner–Feuchtmayr, I, 120 f.; Th.-B.

3. Stange, X, 124–30; F. Schubert, *M. von Landshut* (Landshut, 1930); W. Hugelshofer, in Buchner–Feuchtmayr, I, 111–19; Altdorfer Cat., 125–33; Cat. of the Holbein exhibition, ed. B. Bushart (Augsburg, 1965,) 16 f., 149 f.

4. Stange, X, 150 f., 127.

19 5. Stange, X, 129; P. Wescher, in *Münchner Jb.*, III. Folge, VIII (1957), 101 f.; C. Graepler, *ibid.*, 103–14; E. Buchner, in *Z. f. b. K.*, LXI (1927/8), 106–12; Altdorfer Cat., 165–70; Buchner–Feuchtmayr, I, 276; Th.-B.

20 6. L. von Baldass, *Conrad Laib und die beiden R.F.* (Vienna, 1946); Buchner–Feuchtmayr, I, 97–102, II, 275, plates 190–2; H. Swarzenski, in *Bull. Boston*, XLVIII (1950), 52–9; Stange, *Donauschule*, 62–7; *Donauschule*, 28 f.

7. Cf. p. 65; Stange, IX, 70–2.

8. E. Egg, in *Z. f. Kwiss.*, XIV (1960), 1–18; Altdorfer Cat., 162 f.; *Gotik in Tirol*, 49–54, plates 62–70; O. Pächt, *Österreichische Tafelmalerei der Gotik* (Augsburg, 1929), 57–9, 73, 80 f.; Z. Ebenstein, in *Mitteilungen der Österreichischen Galerie*, VII (1963), 19–24, no. 51; Stange, *Donauschule*, 43 f.

21 9. O. Pächt, *op. cit.*, 59, 84, plate 96.

10. Altdorfer Cat., 103–21; L. von Baldass, *A.A. Studien über die Entwicklungsfaktoren im Werke des Künstlers* (Vienna, 1923); *idem, Der Künstlerkreis Kaiser Maximilians* (Vienna, 1923); Th.-B.; Winkler, *Dürer*, 273; Benesch–Auer, 32, 101–12; O. Benesch, in Buchner–Feuchtmayr, II, 268–71; Stange, *Donauschule*, 44.

11. Cf. p. 43.

22 12. Codex 8329 Nationalbibliothek; cf. pp. 45, 122, and 253.

13. F. Winzinger, *A.A. Zeichnungen* (Munich, 1952), 115 f. with literature; *idem*, in *Wiener Jb. f.*

Kgesch., XVIII (1960), 7–27; Altdorfer Cat.; L. von Baldass, *op. cit.* (Note 10); *idem*, 'A.A.'s künstlerische Herkunft und Wirkung', *Jb. K.S.*, N.F., XII (1938), 117 ff.; *idem, A.A.* (Vienna, 1941); O. Benesch, *Der Maler A.A.* (Vienna, 1939); Benesch–Auer, 32, 37 f., 84–8, 90, 110–13; M. J. Friedländer, *A.A.* (Berlin, 1923); Halm, 58–61; *idem*, in *Münchner Jb.*, III. Folge, II (1951), 127–78; *idem*, in *K.Chronik*, VI (1953), 73; Fiensch, *passim*; K. Oettinger, *Datum und Signatur bei Wolf Huber und A.A.* (*Erlanger Forschungen*, Reihe A, VIII) (Erlangen, 1957), reviewed in *B.M.*, C (1958), 255–6, and *K.Chronik*, XI (1958), 226; *idem, A.-Studien* (*Erlanger Beiträge zur Sprach- und Kwiss.*, III) (Erlangen, 1959); H. Tietze, *A.A.* (Leipzig, 1923); Winkler, *Dürer*, 273, 279, 281; L. Behling, *Die Pflanze in der mittelalterlichen Tafelmalerei* (Weimar, 1957), 168; Hollstein, I, 146–269; F. Winzinger, *A.A.'s Graphik* (Munich, 1963); *idem*, in *Jb. K. S.*, LXII (1966), 157–72; Stange, *Donauschule*, *passim; idem*, in *Pantheon*, XXV (1967), 91–6; *Donauschule*, 35–74.

14. Quotation from F. Winzinger, *A.A.*, 12 f.; p. 123
cf. L. Grote, 'Die "Vorder-Stube" des Sebald Schreyer', *Anzeiger des Germanischen Nationalmuseums* (1954/9), 43–67; O. Benesch, *op. cit.* (1939; Note 13), 5 and *passim*.

15. For example Riccio, Satyr Family, bronze relief, Washington, National Gallery, A415, 138B; also in the same gallery Venetian painting of *c.* 1500, No. 1028, Allegory with Sleeping Woman, Boy with Compasses, a Pan Figure holding a Jug, another Figure walking towards the Woman.

16. For Altdorfer's later period see Chapter 21, p. 128
p. 210.

17. K. Oettinger, in *Winkler Festschrift*, 201–12; cf. *idem, A.-Studien* (*op. cit.*).

18. *Idem*, in *Pantheon*, XXIII (1939), 89–94; E. Buchner, in Buchner–Feuchtmayr, I, 240–4.

19. Cf. Chapter 20, p. 209.

20. Benesch–Auer, *passim*; Winzinger, 54; Altdorfer Cat., 147 f.; cf. K. Oettinger, *A.-Studien* (*op. cit.*); Stange, *Donauschule*, 111–16; *Donauschule*, 96–104.

21. Cf. Chapter 27, p. 251.

22. O. Benesch, in *Jb. K.S.*, LVII (1936), 157–68; Winzinger, 56; *idem*, in *Wiener Jb. f. Kgesch.*, XVIII (1960), 7–27; Hollstein, I, 270–6; K. Oettinger, *A.-Studien* (*op. cit.*); Benesch–Auer, 85–97, 132; M. Hasse, *Lübecker Museumsführer*, I (1964), 156–60; Stange, *Donauschule*, 87–92; *Donauschule*, 74–9.

p. 129 23. Cf. Stange, *Donauschule*, 146; *Donauschule*, 113, 145 f.

24. Altdorfer Cat., 86–102; P. Halm, *passim; idem*, in *Münchner Jb.*, III. Folge, II (1951), 127–78; *idem*, in Cat. of the W. H. Memorial Exhibition (Passau, 1953), vii–xi; M. Weinberger, *W.H.* (Leipzig, 1930); T. Müller, in *Z. f. Ästhetik und allgemeine Kwiss.*, XXXVII (1943), 90; E. Heinzle, *W.H.* (Innsbruck, 1953); *idem, Der Sankt-Annen-Altar des W.H.* (Wiesbaden, 1959); F. Winzinger, in *Z. f. Kwiss.*, XII (1958), 71–95; *idem*, in *Z. d. dt. Ver. f. Kwiss.*, XX (1966), 135–42; K. Oettinger, in *Jb. K.S.*, LIII (1957), 71–100; *idem, Datum und Signatur bei W.H. und Albrecht Altdorfer (Erlanger Forschungen*, Reihe A, VIII) (Erlangen, 1957); A. Legner, *Salzburger und Passauer Bildnerei zur Zeit Leinbergers und der Donaumaler*, thesis (Freiburg, 1954), 38; G. von der Osten, in *Pantheon*, XVIII (1960), 145–9; *idem*, in *W.R. Jb.*, XXX (1968); G. Künstler, in *Jb. K.S.*, LVIII (1962), 73–100; W. Pfeiffer, in *Z. f. Kgesch.*, XXVI (1963), 37–51; Stange, *Donauschule*, especially 96–108; *Donauschule*, 110–35.

25. Rott, I, sources, 216 f., text, 176–8.

p. 131 26. M. J. Friedländer, *op. cit.* (Note 13), 50.

27. For Huber's later period see Chapter 21, p. 212.

CHAPTER 12

p. 132 1. C. Glaser, *L.C.* (Leipzig, 1921); M. J. Friedländer and J. Rosenberg, *Die Gemälde von L.C.* (Berlin, 1932); Cat. of the exhibition 'L.C. d. Ä. und L.C. d. J.' (Berlin, 1937) (text and illustrations); H. Lüdecke (ed.), *L.C. d. Ä.* (Berlin, 1953) (with bibliography); J. Rosenberg, *Die Zeichnungen L.C.s d. Ä.* (Berlin, 1960) (quoted as R); J. Jahn, *L.C. als Graphiker* (Leipzig, 1955); Hollstein, VI, 1–120; A. Giesecke, in *Z. f. Kwiss.*, IX (1955), 181–92; *Donauschule*, 31–4, 174 f.; D. Koepplin, in *Z. d. dt. Ver. f. Kwiss.*, XX (1966), 79–84. In addition see the general literature on the Danube style in the Notes for Breu, Altdorfer, the Historia Master, and Huber.

2. Rott, I, text, 13; E. von Schenk zu Schweinsberg, in *Z. f. K.*, IV (1947), 26–30; Stange, IX, 3.

3. O. Benesch, in Buchner-Feuchtmayr, II, 246–66; E. Buchner, *ibid.*, 274.

p. 135 4. For the word 'altfränkisch', cf. Chapter 2, Note 21.

5. For Cranach's later period see Chapter 20, p. 205.

6. W. Hentschel, *Hans Witten* (Leipzig, 1938), 162–9; cf. p. 47.

7. W. Drost, *Danziger Malerei vom Mittelalter bis zum Ende des Barock* (Berlin, 1938), 77–97; P. Strieder, in *Z. f. Kwiss.*, XIII (1959), 15–26.

8. Stange, VI, 107–9; H. Busch, *Maler des Nordens* p. 1 (Hamburg, 1940), 41–50.

CHAPTER 13

1. Friedländer, IX, 9–19, 60 f., XIV, 114; *idem*, in p. O.H., LVII (1940), 160–7; C. P. Baudisch, *J. J. von Kalkar* (Bonn, 1940); Witte, I, 152, 335, 337; C. R. Post, in *G.B.A.*, 6th ser., 84th year, XXII (1942), 127–34; Gerson, 17 f.; Hoogewerff, II, 426–49; Stange, VI, 63–71; *idem*, in *Westfalen*, XXXVII (1959), 236–40.

2. T. Rensing, in *Westfalen*, XXII (1937), 247–9; p. K. Steinbart, *ibid.*, 255–64; A. Stange, *ibid.*, XXX (1952), 198–200; Stange, VI, 56; Th.-B., XXXVII, 173.

3. Stange, V, 61–73; K. vom Rath, *Der Meister des Bartholomäus-Altars* (Bonn, 1941); G. Ring, in *O.H.*, LVI (1939), 26; P. Pieper, in *W.R. Jb.*, XXI (1959), 97–158; Cat. of the exhibition 'Kölner Maler der Spätgotik: Der Meister des Bartholomäus-Altars, Der Meister des Aachener Altars', ed. G. von der Osten (Cologne, 1961), *passim*.

4. Stange, V, 73–89. p.

5. Stange, V, 91–115; O. H. Förster, in *Kunstgabe des Vereins f. christliche Kunst im Erzbistum Köln* (Cologne, 1930), 13.

6. Pinder, *Dürerzeit*, 222, for the St Francis. p.

7. Stange, V, 115–23; Cat. of the Cologne exhibition, *op. cit.* (Note 3), *passim*; T. Rensing, in *W.R.Jb.*, XXVI (1964), 229–34.

CHAPTER 14

1. Friedländer, VI, 71–113; K. S. Boon, *G.D.* p. (*Paletserie*) (Amsterdam, n.d.); F. Winkler, in *Pantheon*, III (1929), 271 ff.

2. Panofsky, 350–8. This book should also be compared for the other masters discussed in this chapter and in Chapters 15, 17, and 18.

3. P. Johansen, in *Jb. P.K.*, LXI (1940), 1–36; F. p. Winkler, in *Th.-B.*, XXXVI, 531–4; *idem*, in *Pantheon*, XXXI (1943), 98–104; S. Karling, *Medeltida träskulptur i Estland* (Göteborg, 1946), 252 ff.; M. Weinberger, in *B.M.*, XC (1948), 247–53; G.

Kubler and M. Soria, *Art and Architecture in Spain and Portugal . . . (P.H.A.)* (Harmondsworth, 1959), 199; Puyvelde, 355–62; C. T. Eisler, in *Art News*, LXIV (1965), 34–7, 52–4.

4. J. Gudiol, in *Miscellanea D. Roggen* (Antwerp, 1957), 113–19; G. Hulin de Loo, in *Trésors de l'art flamand* (Brussels, 1932), I, 49–51; G. Glück, in *Pantheon*, VIII (1931), 313–17; H. Isherwood Kay, in *B.M.*, LVIII (1931), 197–201; M. J. Friedländer, in *Cicerone*, XXI (1929), 249–54, and XXII (1930), 1–4; F. Winkler, in Th.-B.; G. Kubler and M. Soria, *op. cit.*, 199; Puyvelde, 350–5; E. Bermejo, *J. d. F.* (Madrid, 1962).

5. Friedländer, IX, 74–92; F. Bologna, in *Bull. M.R.*, V (1956), 13–31; F. J. Sanchez Cantón, in *Miscellanea D. Roggen* (Antwerp, 1957), 249–55; F. Winkler, *ibid.*, 285–90; S. Speth, in *Bull. M.R.*, XIV (1965), 15–26.

6. Friedländer, IV, 115–22, XIV, 95 f.; J. Maquet-Tombu, *Colyn de Coter* (Brussels, 1937); Puyvelde, 369.

7. J. Tombu, in *G.B.A.*, 6th series, 71st year, II (1929), 258–91, 72nd year, I (1930), 190–3; Friedländer, XII, 15–24, XIV, 127.

8. E. Dhanens, in *G.B.*, XI (1945–8), 41–146; D. Roggen and E. Dhanens, *ibid.*, XIII (1951), 127–52.

9. Friedländer, VIII, 78–144; J. de Borchgrave d'Altena and others, *B. v. O.* (Brussels, 1943), *passim;* Puyvelde, 317–28.

10. For Orley's later period see Chapter 18, p. 199.

11. Friedländer, VII, 105–11; W. R. Valentiner, in *A.Q.*, VIII (1945), 197–215; A. J. J. Delen, in *Miscellanea Puyvelde*, 74–83.

12. G. Hulin de Loo, in *Jb. P.K.*, XXXIV (1913), 59–88; Friedländer, VII, 98–100, XI, 31–4; Puyvelde, 366.

13. Friedländer, VII, 80–7; W. R. Valentiner, in *G.B.A.*, 6th series, 97th year, XLV (1955), 5–10; Winkler, 192; Davies, 92–3.

14. Friedländer, VII, also XIV, 108 f.; *idem*, in *Cicerone*, XIX (1927), 1 ff.; L. von Baldass, in *Jb. K.S.*, N.F., VII (1933), 137 ff.; W. Vanbeselaere, *G.B.*, IX (1943), 255–67; E. P. Richardson, in *A.Q.*, IV (1941), 162–77; G. Marlier, *Erasme et la peinture flamande* (Damme, 1954), *passim;* K. G. Boon, *Q.M.* (*Palet-Serie*) (Amsterdam, n.d.); L. von Baldass, in *Hulin de Loo*, 24–32; J. de Figueiredo, in *R.B.*, III (1933), 1–16; A. Gerlo, *ibid.*, XIV (1944), 33–45; *idem, Erasme et ses portraitistes* (Brussels,

1950); P. Wescher, in *Pantheon*, XVIII (1960), 242–4; S. Sulzberger, in *Bull. M.R.*, XIV (1965), 27–34.

15. I disagree with the usual dating in the twenties. The New York Magi which Friedländer (59 ff.) relates to the painting is compositionally entirely different. p. 148

16. Bialostocki–Walicki, no. 128, plate VI. p. 149

17. Cf. E. Panofsky, *op. cit.*, 353–6; E. Tietze-Conrat, *Dwarfs and Jesters in Art* (London, 1957), 16–19 f., 94. p. 151

18. For the affiliations cf. E. Larsen, in *R.B.*, XIX (1950), 171–4.

19. Cf. also K. G. Boon, *op. cit.* (Note 14), 53.

20. L. von Baldass, *J. v. C., der Meister des Todes Mariä* (Vienna, 1925); Friedländer, IX, 20–73; J. Bialostocki and H. Gerson, in *O.H.*, LXX (1955), 121–31; J. G. van Gelder, in *Berliner Museen*, II. Folge, XV (1965), 57, cf. *ibid.*, 12 f. p. 152

21. The Netherlandish or Lower Rhenish *œuvre* of the Master of the St John panels in Genoa and the fact that Philipp von Cleve-Ravenstein ruled this town from 1501 to 1506 give only weak hints at Joos's and also Jan Joest's early periods.

22. For Joos's later period see Chapter 18, p. 191. p. 153

23. L. von Baldass, in *Jb. K.S.*, XXXIV (1918), 111 ff.; Friedländer, IX, 101–24; Puyvelde, 221–4.

24. Cf. w800, 801, B51. p. 154

25. Although the dates recorded for paintings by the Antwerp Mannerists are all after 1513, and although works of the so-called Jan Wellensz. de Cock group of pictures now attributed to one of Engelbrechtsz.' sons would require a later dating, I cannot find the conclusion drawn anywhere (cf. e.g. Friedländer, *passim*, L. von Baldass, *op. cit.* (1925), 12) that this group of Antwerp paintings should be dated about 1520, corresponding with the date of the identical style then predominating north of the Alps. That some of the painters, who could be considered as the originators, had already been Masters at Antwerp since 1503, is irrelevant. Mannerism was the style of the time, not a personal characteristic. Cf. Chapter 18, p. 194 and Note 3. p. 155

26. Friedländer, VIII, 9–77, XI, 73–8, XIV, 111 f.; H. Schwarz, in *G.B.A.*, 6th series, 95th year, XLII (1953), 145–68; J. G. van Gelder, in *O.H.*, LIX (1942), 1–11; G. von der Osten, in *De Artibus Opuscula XL. Essays in Honor of Erwin Panofsky* (New York, 1961), 454–75; F. Winkler, in *Pantheon*, XX (1962), 145–55; Hollstein, VIII, 145–50; p. 156

W. H. Vroom, in *O.H.*, LXXIX (1964), 172–5; Puy-velde, 307–17; H. Pauwels, H. R. Hoetink, and S. Herzog, *J.G. genaand Mabuse* (Rotterdam–Bruges, 1965); A. Misiag-Bochenska, in *Bull. M.R.*, XIV (1965), 35–48; P. Wescher, in *A.Q.*, XXVIII (1965), 154–66.

p. 157 27. E. Panofsky, in *Wiener Jb. f. Kgesch.*, N.F., I (1921/2), 43–92.

28. Panofsky, 58.

p. 158 29. For Gossaert's later period see Chapter 18, p. 189.

CHAPTER 15

p. 159 1. C. de Tolnay, *H.B.* (Basel, 1937); *idem, H.B.*, 2 vols (Baden-Baden, 1965); Friedländer, v, 79–130; *idem, H.B.* (The Hague, 1941); L. von Baldass, *Jheronimus B.*, 2nd ed. (Vienna, 1959); cf. Charles Sterling's forthcoming *P.H.A.*; D. Bax, in *N.K.J.*, XIII (1962), 1–54; Hollstein, III, 129–48; Puyvelde, 28–64.

p. 161 2. Friedländer, x, 10–32; Gerson, 16–18; Hooge-werff, II, 449–503; R. van Luttervelt, in *N.K.J.*, II (1948/9), 104–17; J. Held, in *Pantheon*, XVII (1936), 93–6; *Middeleeuwse Kunst*, nos. 77–86; F. Winkler, in *Z. f. Kwiss.*, XIII (1959), 177–214; K. G. Boon, in *O.H.*, LXXXI (1966), 61–72.

p. 163 3. Friedländer, x, 33–44, XIII, 133; Hoogewerff, II, 346–88; Gerson, 20; N. F. van Gelder Schrijver, in *O.H.*, XLVII (1930), 97–121; P. Wescher, *ibid.*, LXI (1946), 82–95; J. E. Snyder, *ibid.*, LXXVI (1961), 61–7; J. Bruyn, *ibid.*, LXXXI (1966), 197–227; *Middeleeuwse Kunst*, 89, nos. 87–93.

4. Friedländer, x, 114–18.

5. Friedländer, XII, 96–117; K. Steinbart, *Die Tafelgemälde des J. C. van Amsterdam* (Strassburg, 1922); *idem, Das Holzschnitzwerk des J. C. van Amsterdam* (Burg, 1937); *Middeleeuwse Kunst*, 94, 59, nos. 97–111; W. Wegner, in *K.Chronik*, XII (1959), 5–12; Hollstein, v, 2–38.

6. Friedländer, x, 45–52; Gerson, 19. p.

7. J. Q. van Regteren Altena, in *N.K.J.*, VI (1955), 101–17; Hoogewerff, II, 285–306; Gerson, 16; *Middeleeuwse Kunst*, nos. 62–5.

8. Friedländer, x, 53–77, 121 f.; Hoogewerff, III, 144–206; Gerson, 22–4; G. van Camp, in *Bull. M.R.*, I (1952), 43–6; E. Pelinck, in *N.K.J.*, II (1948/9), 40–74.

9. Friedländer, x, 78–113, XIV, 122; *idem, L. v. L.* p (Berlin, 1963), reviewed by E. I. Reznicek-Buriks, in *O.H.*, LXXX (1965), 241–7; Hoogewerff, III, 207–320; Gerson, 27–9; E. Pelinck, in *O.H.*, LXIV (1949), 193–6; J. G. van Gelder, in *O.H.*, LXI (1946), 101–6; *idem*, in *Miscellanea D. Roggen* (Antwerp, 1957), 91–100; Held, 22–9, 33–6, 45–8; Hollstein, x, 57–244; C. Müller-Hofstede, in *Winkler Festschrift*, 221–38; *Middeleeuwse Kunst*, nos. 124–40; J. Lavalleye, *L. v. L., Pieter Bruegel d. Ä., das gesamte graphische Werk* (Vienna, 1966).

10. Hoogewerff, III, 286–8. A. E. Popham, *Cata-logue of Drawings in the British Museum*, v, no. 11, plate 11, and Hollstein, x, 153, consider the drawing close in date to the engraving with Virgil in the Basket (B136) of 1525, but there is an important stylistic difference. For Lucas's later period see Chapter 17, p. 177.

CHAPTER 16

71 1. K. Brandi, *Kaiser Karl V*, 2 vols (Munich, 1937).

75 2. P. Redlich, *Cardinal Albrecht* (Mainz, 1900).

76 3. Cf. Lieb, I.

4. Paul Volz, Abbot of Königshofen at Schlettstadt (Sélestat), to Beatus Rhenanus, 6 September 1525, concerning the woodcarver Sixt Schultheiss: 'Ecce adest Xystus ille, statuarius, cuius caessatio ab ingenio et arte paenitenda est...' (Rott, III, sources, I, 334). At that time Christoph Bockstorffer lost a large part of his wealth in Protestant Konstanz: he paid taxes on 300 Pfund in 1523, 150 Pfund in 1524, but only 45 Pfund in 1525 and 30 Pfund per year from 1530 to 1543 (Rott, I, 90). Erasmus, writing in 1526 from Basel to Thomas More, gave as the reason for Holbein's departure: 'here the arts are freezing'.

5. Pinder, *Dürerzeit*, 396 f.; Stange, v, 127.

6. Third Sermon to the Enthusiasts, 1522: 'Here and now we must confess that people may possess and make paintings, but worship them they must not; and if they are worshipped, they should be torn up and thrown away'; Martin Luther, *Werke* (*Weimarer Ausgabe*, x), III, 28, 3; cf. *ibid.*, 26, 29, 32.

CHAPTER 17

7 1. For Lucas's earlier period see Chapter 15, p. 166; cf. literature there, Note 9; cf. also N. Beets, in *O.H.*, LXVII (1952), 183–99, and Antal, 239.

9 2. Friedländer, x, 66–73, XI, 16, 59–72; *idem*, in *Miscellanea Puyvelde*, 84–8; Hoogewerff, III, 321–87; Gerson, 23 f.; N. Beets, in *O.H.*, LII (1935), 49–76, 159–73, 216–28, LIII (1936), 55–78; E. Pelinck, in *N.K.J.*, II (1948/9), 68–74; W. R. Valentiner, in *A.Q.*, XIII (1950), 60–5; Hollstein, IV, 192 f.; Puyvelde, 159 f.; but cf. W. S. Gibson, 'Pieter Cornelisz. Kunst as a Panel Painter', in *Simiolus, kunsthistorisch Tijdschrift*, I (1966/7), 37–45.

3. H. W. Janson, in *Worcester Art Museum Annual* I (1935–6), 27 ff.; Hoogewerff, III, 204 f.; W. Braunfels, in *Festschrift Hans Kauffmann* (Berlin, 1956), 206.

4. K. G. Boon, in *B.M.*, C (1958), 377 f.; C. Müller-Hofstede, in *Winkler Festschrift*, 233 ff.

5. F. Winkler, in *Jb. P.K.*, LVI (1935), 117–30; p. 181 *idem*, in *Festschrift Peter Metz* (Berlin, 1965), 337–44; J. Q. van Regteren Altena, in *O.H.*, LVI (1939), *passim*; Hoogewerff, III, 389–419; E. Pelinck, in *La Revue des arts*, IX (1959), 61–4; *idem, Johannes Cornelisz. Vermeyen* (Leiden, 1962).

6. Friedländer, XII, 118–56; Hoogewerff, IV, 22–244; Gerson, 30–3; C. H. de Jonge, *J. v. S.* (Amsterdam, n.d.); P. Wescher, in *Jb. P.K.*, LIX (1938), 218–30; Cat. of the S. exhibition (Utrecht, 1955); E. R. Meyer, J. Bruyn Hza, K. G. Boon, S. Sulzberger, in *O.H.*, LXX (1955), *passim*; P. T. A. Swillens, in *Miscellanea D. Roggen* (Antwerp, 1957), 267–77; M. Chamot, in *B.M.*, CI (1959), 49, plates 5–6; J. Guillouet, in *O.H.*, LXXIX (1964), 89–98; J. G. van Gelder, in *Simiolus, kunsthistorisch Tijdschrift*, I (1966/7), 5–36.

7. K. G. Boon, in *O.H.*, LXIX (1954), 51–3. p. 182

8. Friedländer, XIII, 133–40; Hoogewerff, III, p. 183 480–548; N. Beets, in *O.H.*, LVI (1939), 160–84, 199–221.

9. Friedländer, XIII, 71–83; Hoogewerff, IV, 290– p. 184 386; C. H. de Jonge, in *O.H.*, LVIII (1941), 1–5; Gerson, 33–5; E. K. J. Reznicek, in *O.H.*, LXX (1955), 233–46; H. W. Stopp, in *Förster Festschrift*, 140–8; Hollstein, VIII, 228–48; R. van Luttervelt, in *N.K.J.*, XIV (1963), 56–9.

10. E. Panofsky, *Renaissance and Renascences in* p. 185 *Western Art* (Stockholm, 1960), 190.

11. Friedländer, XII, 69–76; *idem*, in *Pantheon*, XIII p. 187 (1934), 33–6; Cat. of the exhibition 'L'Art flamand' (Bruges, 1956), no. 47; Held, 83; Hoogewerff, III, 454–72; H. van Werveke, in *G.B.*, XII (1949/50), 43–58; Puyvelde, 166–71.

CHAPTER 18

1. For Gossaert's earlier period see Chapter 14, p. 189 p. 155; cf. literature there, Note 26.

2. For Joos's earlier period see Chapter 14, p. 152; p. 191 cf. literature there, Note 20.

3. Friedländer, XI, 9–78; J. Destrée, in *R.B.*, I p. 194 (1931), 289–302, esp. 299 ff.; J. Roosval, *ibid.*, IV

(1934), 311–20; P. Philippot, in *Bull. M.R.*, v (1956), 157–66; P. Vanaise, in *Bull. Institut Royal du patrimoine artistique, Bruxelles*, I (1958), 132–45; E. Schaffran, in *Pantheon*, XX (1962), 48–50. On the dating, see above, Chapter 14, p. 155 and Note 25; also G. von der Osten, in *De Artibus Opuscula XL. Essays in Honor of Erwin Panofsky* (New York, 1961), 460–4; Puyvelde, *passim*.

p. 195 4. Friedländer, XIII, 36–45; E. and L. Larsen-Roman, in *O.H.*, XLVII (1940), 21–8; Friedländer, *ibid.*, 78 f.; Hollstein, II, 58; Puyvelde, 224–8.

5. Friedländer, XII, 42–51; J. Vuyk, in *O.H.*, LXI (1946), 20–2; Puyvelde, 366–8.

p. 196 6. Friedländer, XII, 52–68; A. Corbet, *P.C. van Aelst* (Antwerp, 1950); W. Krönig, in *Miscellanea D. Roggen* (Antwerp, 1957), 161–77; L. Ninane, in *Bull. M.R.*, II (1953), 3–10; H. Gerson and E. H. ter Kuile, *Art and Architecture in Belgium: 1600–1800 (P.H.A.)* (Harmondsworth, 1960), 12; Hollstein, IV, 195–9; S. Schele, in *O.H.*, LXXVII (1962), 235–40; Puyvelde, 328–32; G. Marlier, *P.C. d'Alost* (Brussels, 1966).

p. 197 7. Friedländer, XII, 77–95, XIV, 128; R. Genaille, in H. Bédarida, *À travers l'art italien* (Paris, 1949), 17–42; *idem*, in *G.B.A.*, 6th period, 94th year, XXXIX (1952), 243–52; *idem*, in *R.B.*, XIX (1950), 147–53; L. van Puyvelde, *ibid.*, XX (1951), 57–71; S. Bergmans, *ibid.*, XXIV (1955), 133–57; G. Glück, in *A.Q.*, V (1942), 45–56; Puyvelde, 182–94; S. Bergmans, in *Bull. M.R.*, XIV (1965), 143–62.

8. Friedländer, XII, 25–32; O. Benesch, in *G.B.A.*, 6th ser., XXIII (1943), 269–82; Puyvelde, 367 f.

p. 199 9. For Orley's earlier period see Chapter 14, p. 144; cf. literature there, Note 9.

10. Held, 105 ff.; Krönig, 39–40.

p. 200 11. Friedländer, XII, 55, 157–64, XIV, 129 f.; K. Steinbart, in *Marburger Jb.*, VI (1931), 83–113; O. Benesch, in *Münchner Jb.*, N.F., VI (1929), 204–15; G. Glück, in *Jb. K.S.*, N.F., VII (1933), 183 ff., VIII (1934), 173–210; Hoogewerff, IV, 256–89; P. Wescher, in *A.Q.*, XVII (1954), 171–5; E. Pelinck, *Johannes Cornelisz. V.* (Leiden, 1962); B. Haak, in *Bull. van het Rijksmuseum*, XI (1963), 11–19; Puyvelde, 290–3.

p. 201 12. G. J. Hoogewerff, in *Annuaire des Musées Royaux des Beaux-Arts de Belgique*, III (1940/2), 17–27; O. Benesch, *ibid.*, I (1938), 37–9; G. J. Hoogewerff, in *Miscellanea D. Roggen* (Antwerp, 1957), 137–48; F. Horb, *Zu Sellaers Eklektizismus (Antikvariskt Arkiv, VII)* (Stockholm, 1956).

13. M. J. Friedländer, in *Jb. P.K.*, XLII (1921), 161–8; T. Musper, *ibid.*, LXIII (1942), 171–9; G. de Boom and A. J. J. Delen, in *R.B.*, II (1932), 41–8, 154–6; J. G. van Gelder, in *Miscellanea D. Roggen* (Antwerp, 1957), 96–8; Hollstein, V, 63–95, IX, 57–64; F. Winkler, in *Z. d. dt. Ver. f. Kwiss.*, XVIII (1964), 54–64; Puyvelde, 370 f.

14. Friedländer, XI, 102–7, XIV, 124–6; W. Krönig, in *Berliner Museen*, LIII (1932), 60 f.; R. A. Parmentier, in *R.B.*, XII (1942), 7–8; G. Marlier, *Ambrosius Benson* (Damme, 1957).

15. Friedländer, XI, 108–15; P. Bautier, *L.B.* (Brussels, 1910); P. Clemen, in *Belgische Kunstdenkmäler*, II (Munich, 1923), 1–40; P. Wescher, in *Berliner Museen*, N.F., XII (1962), 55–9; J. Duverger and E. Roobaert, in *G.B.*, XVIII (1959/60), 95–105; Puyvelde, 160–6.

CHAPTER 19

1. Th.-B.; Friedländer, IX, 36, 55; *idem*, in *O.H.*, p. LVII (1940), 160–7; Cat. of the B.B. exhibition (Cologne, 1955); H.-J. Tümmers, *Die Altarbilder des älteren B.B.* (Cologne, 1964); H. Westhoff-Krummacher, *B.B. der Ältere als Bildnismaler* (Munich, 1965).

2. Witte, 225.

3. H. Kisky, in Th.-B.; W. Braunfels, in *W.R.* F *Jb.*, XXII (1960), 115–36; O. H. Förster, *Das Wallraf-Richartz Museum in Köln* (Cologne, 1961), nos. 84–6.

4. G. Ring, in *Jb. f. Kwiss.* (1924/5), 110–15.

5. N. von Holst, in *Z. f. Kgesch.*, I (1932), 32; Hollstein, IV, 12–113; cf. below, p. 242.

6. J. B. de C. M. Saunders and C. D. O'Malley, *The Illustrations from the Works of Andreas Vesalius of Brussels* (Cleveland, 1950); Van Mander, 151; Hollstein, IV, 84; P. Kristeller, in *Die graphischen Künste*, XXXI (1908), Beilage, 17–24.

CHAPTER 20

1. T. Riewerts and P. Pieper, *Die Maler tom Ring* (Munich, 1955); P. Pieper, in *K.Chronik*, XIII (1960), 295 f.

2. M. Geisberg, in *Westfälische Lebensbilder*, III (1933); Hollstein, I, 6–145; Van Mander, 213–15; R. Fritz, *H.A. als Maler* (Dortmund, 1959); *idem*, in *Berliner Museen*, N.F., X (1961), 15–17; A. H. Mayor, in *A.Q.*, XVII (1954), 176–8; A. Stange, in *Nieder-*

deutsche Beiträge zur Kgsch., II (1962), 187–90; E. Meyer-Wurmbach, in *W.R. Jb.*, XXIV (1962), 393–400; Antal, 244, note 3.

3. For Cranach's earlier period see Chapter 12, p. 132; cf. literature there. See also G. Werner Kilian, in *Forschungen und Fortschritte*, XXXIII (1959), 53–6.

4. Geisberg, 613, 614.

5. Winzinger, 27.

6. G. von der Osten, *Der Schmerzensmann* (Berlin, 1935), 35.

7. O. Thulin, *Altäre der Reformation* (Berlin, n.d.); N. von Holst, *loc. cit.* (Chapter 19, Note 5). The Gotha allegory was perhaps first formulated by Gefroy Tory; cf. A. M. Göransson, in *Tidskrift f. Konstvetenskap*, XXX (1957), 59–85.

8. N. von Holst, *Die deutsche Bildnismalerei zur Zeit des Manierismus* (Strassburg, 1930), 9.

9. E. H. Zimmermann, in *Z. d. dt. Ver. f. Kwiss.*, IX (1942), 23–31.

10. Friedländer–Rosenberg, 49.

11. L. Grote, *G.L.* (Leipzig, 1933); Th.-B.; Altdorfer Cat., 122; F. Winzinger, in *Z. f. Kwiss.*, XII (1958), 71–95; *idem*, in *Z. d. dt. Ver. f. Kwiss.*, XVIII (1964), 81–90; E. Schilling, in *Pantheon*, XXI (1963), 206–9; *Donauschule*, 80–2.

CHAPTER 21

1. For Altdorfer's earlier period see Chapter 11, p. 122; cf. literature there, Note 13.

2. Rupprich, I, 210.

3. Cf. E. Buchner, *A.A., die Alexanderschlacht* (Stuttgart, 1956).

4. For Huber's earlier period see Chapter 11, p. 129; cf. literature there, Note 24.

5. B. H. Röttger, *Der Maler H.M.* (Munich, 1925); *Münchner Jb.*, N.F., XI (1936), xxxiv; Altdorfer Cat., 154–6, no. 339, plate 45; B. Degenhart, in *Pantheon*, XXIII (1939), 208 f.; E. Tietze-Conrat, *Dwarfs and Jesters in Art* (London, 1957), 103, plate 52; Th.-B.

6. K. Löcher, *J.S.* (Munich, 1962).

7. Cf. E. Waterhouse, *Painting in Britain 1530 to 1790 (P.H.A.)* (Harmondsworth, 1953), 11 f.; K. Löcher, *op. cit.*, 32–40.

8. Cf. p. 204.

CHAPTER 22

1. The identity of Weiditz with the 'Petrarch p. 215 Master' is disputed in the relevant literature. T. Musper, *Die Holzschnitte des Petrarca-Meisters* (Munich, 1927); *idem*, in *Gutenberg-Jb.* (1951), 110–17; M. J. Friedländer, *Holzschnitte von H.W.* (Berlin, 1922); E. Buchner, in *Wölfflin Festschrift* (Munich, 1924), 209–30; Rott, III, text, 87; W. Rytz, *Die Pflanzenaquarelle des H.W. aus dem Jahre 1529* (Bern, 1936), 42 f.; H. Röttinger, in Th.-B., XXXV (cf. XXXVII, 250 ff.); E. Schilling, in *Schmitt Festschrift*, 233–6; W. Scheidig, *Die Holzschnitte des Petrarca-Meisters* (Berlin, 1955); *Augsburger Renaissance*, nos. 672–8, 680–2. Further literature there, in particular several essays by M. Lanckorońska, who tries to identify the Master with Hans Brosamer the elder.

2. *Aufgang der Neuzeit*, CII–12; *Augsburger Re-* p. 216 *naissance*, 26 f., nos 689 f.; Cat. of the Metropolitan Museum, *Early Flemish, Dutch and German Paintings* (New York, 1947), 225–7; C. Dodgson, in *Münchner Jb.*, N.F., XI (1934/5), 191 ff.; Hollstein, IV, 185–206.

3. A. Feulner, in Buchner–Feuchtmayr, II, 442–8, cf. plates 101 f.; L. von Baldass, in *Pantheon*, IX (1932), 177 ff., cf. *ibid.*, XIII (1934), 125 f.; E. Auerbach, in *B.M.*, XCI (1949), 218; Bialostocki-Walicki, plate IV; K. Feuchtmayr, in *Münchner Jb.*, N.F., XIII (1938/9), 78–86; Hollstein, II, 2–5; V. Oberhammer, *Die Bronzestandbilder des Maximilian-Grabmales in der Hofkirche zu Innsbruck* (Innsbruck, 1935), 232–40.

4. L. von Baldass, in *Pantheon*, XVII (1936), 143–7; A. Dieck, *Niederdeutsche Beiträge zur Kgesch.*, II (1962), 191–218.

5. H. von Mackowitz, *Der Maler H. v. S.* p. 217 *(Schlern-Schriften*, CXCIII) (Innsbruck, 1960); A. Stange, in *Jb. der Staatlichen Kunstsammlungen in Baden-Württemberg*, III (1966), 83–106.

6. Rott, I, text, 91, 137, 161–72, II, liv; H. Feuerstein, in *Oberrheinische Kunst*, VI (1934), 93–162; Th.-B., XXXVII, 228–30; *Baden-Württ. Priv. Bes.*, 51; C. zu Salm, *Der Meister von Messkirch*, unpublished thesis (Freiburg im Breisgau, 1950).

CHAPTER 23

1. For Baldung's earlier period see Chapter 9, p. p. 219 97; cf. literature there, Note 9; see further F. G. Pariset, in *Revue des arts*, VII (1957), 209–14; G. F. Hartlaub, in *Antaios*, II (Stuttgart, 1960), 13–25.

p. 220 2. G. Dehio, in *Kunsthistorische Aufsätze* (Munich, 1914), 157.

3. L. von Baldass, in *Münchner Jb,*, N.F., III (1926), 17–24.

4. G. F. Hartlaub, *Zauber des Spiegels* (Munich, 1951), 168 ff.

p. 221 5. L. F. Fuchs, in *Weltkunst* (1 October 1959), 11.

p. 222 6. C. Koch, in *Z. f. Kwiss.*, V (1951), 68.

p. 223 7. For Hans Holbein the younger's earlier period see Part 1, pp. 101–2; cf. E. Waterhouse, *Painting in Britain 1530–1790* (*P.H.A.*) (Harmondsworth, 1953), 5–9.

p. 224 8. H. Reinhardt, *H.* (Paris, 1938); *idem*, in *Jahresbericht des Historischen Museums* (Basel, 1965), 26–39; H. A. Schmid, *H.H. der Jüngere*, 3 vols (Basel, 1945–8); P. Ganz, *H.H., Die Gemälde* (Basel, 1950); Holbein Cat., with bibliography; J. Gantner, in *Vernissage der Ausstellung die Malerfamilie H. in Basel* (Basel, 1960); H. von Einem, 'H.s "Christus im Grabe"', *Akademie der Wissenschaften und der Literatur. Abhandlungen der geistes- und sozial-wissenschaftlichen Klasse* 1960, no. 4 (Mainz, 1960); L. von Baldass, in *Z. f. Kwiss.*, XV (1961), 86–96; F. Grossmann, in *B.M.*, CIII (1961), 491–4.

p. 225 9. J. A. Schmoll gen. Eisenwerth, in *Annales Universitatis Saraviensis*, I (1952), 352–66.

p. 226 10. H. A. Schmid, *op. cit.*, 345; A. Stange, *Die deutsche Baukunst der Renaissance* (Munich, 1926), 96 f.; Holbein Cat., nos. 159, 266–72.

11. K. T. Parker, *The Drawings of H.H. at Windsor Castle* (Oxford, 1945).

p. 227 12. M. Riemschneider-Hoerner, in *Zeitschrift f. Ästhetik und allgemeine Kwiss.*, XXXIII (1939), 27 ff.

p. 228 13. E. Panofsky, *Galileo as a Critic of Arts* (The Hague, 1954), 14, figures 5–6; J. Baltrusaitis, *Anamorphoses ou perspectives curieuses* (Paris, 1955), 58–70; C. G. Heise, *H.H. d. J., die Gesandten* (Stuttgart, 1959); cf. Chapter 24, p. 235.

p. 230 14. Zülch, 308–10; G. von der Osten, in *Festschrift W.F. Volbach* (Mainz, 1966); W. Brücker, *C.F. v. C.* (*Schriften des Hist. Mus. Frankfurt am Main*, XI) (1963).

CHAPTER 24

p. 231 1. A. L. Mayer, in *Pantheon*, XI (1933), 1–4; L. von Baldass, *ibid.*, XXVI (1940), 253–9; S. Poglayen-Neuwall, in *Z. d. dt. Ver. f. Kwiss.*, VII (1940), 249–

54; Hollstein, II, 173–252; E. Waldmann, *Die Nürnberger Kleinmeister* (Leipzig, 1910); Dürer Cat., nos. 30–68.

2. G. Pauli, in Th.-B.; E. Waldmann, *op. cit.*; p. Geisberg, nos. 163–349; Winzinger, 54; Dürer Cat., nos. 69–141; Hollstein, III.

3. Cf. Part 1, p. 80. p.

4. E. Buchner, in *W.R. Jb.*, N.F., II/III (1933/4), 273–9; *idem*, in Th.-B.; P. Wescher, in *Pantheon*, XVIII (1936), 280–4; L. von Baldass, *loc. cit.*; F. Winkler, in *Jb. P.K.*, LVII (1936), 65–74, 254; Bialostocki–Walicki, nos. 108 f., 117; H. Röttinger, *Die Holzschnitte des G.P.* (Leipzig, 1914); Dürer Cat., nos. 253–87; H. G. Gmelin, in *Münchner Jb.*, III. Folge, XVII (1966), 49–126.

5. P. Wescher, *loc. cit.*, illustration on p. 281. p.

6. H. Röttinger, *E.S. und Niklas Stör* (Strassburg, 1921); *idem*, in Th.-B.; J. Baltrusaitis, *Anamorphoses ou perspectives curieuses* (Paris, 1955), 15 f.; cf. E. Waterhouse, *P.H.A.* (*op. cit.*, Chapter 23, Note 7), 11 f.; N. Beets, in *O.H.*, LVI (1939), 211–13. Cf. Chapter 23, p. 229.

7. H. Röttinger, *op. cit.* (Note 6), no. 205; Geisberg, no. 1197.

CHAPTER 25

1. Cf. W. Vogelsang, in *Kunstgeschiedenis*, 149; P Witte, 149; further for the Weseler Archivalien of the period round 1541, 80, 99.

2. *Middeleeuwse Kunst*, no. 342.

3. For the earlier period of the Master of the Female Stone Head see Chapter 7, p. 60. Cf. J. Leeuwenberg, in *O.H.*, LXX (1955), 82–95; *idem*, *O.H.*, LXXII (1957), 56 f.; *idem*, *O.H.*, LXXIV (1959), 79–102; *idem*, in *Aachener Kunstblätter*, XXXIV (1967), 175–93; *Middeleeuwse Kunst*, nos. 317–26.

4. Vogelsang, II, nos. 67, 66; Timmers, plate 45.

5. Timmers, 40–2; *idem*, in *O.H.*, LVII (1940), 75–8; Devigne, 151 f., figures 186–8; *eadem*, in *B.M.*, L (1927), 315–22; *Middeleeuwse Kunst*, no. 357.

6. J. de Borchgrave d'Altena, in *Bull. de la Société Royale d'Archéologie de Bruxelles* (1936), 69 ff., figures 39–42.

7. Devigne, 151, figures 246, 250–3; D. Bouvy, *op. cit.* (Chapter 7, Note 26), 189; Timmers, 36–7, figures 56–9; Vogelsang, I, no. 98; D. Bouvy,

Beeldhouwkunst Aartsbisschoppelijk Museum Utrecht (Utrecht, 1962), nos. 213–16.

8. Borchgrave (1942), 22, figures 24, 25; *idem* (1957), *passim*.

238 9. J. Couto, *Os Paineis flamengos de Ilha da Madeira* (Funchal, 1955).

10. For Meit's earlier period see Chapter 3, p. 30 ff.; cf. literature there, Note 9. See further: J. de Borchgrave d'Altena, in *R.B.*, XXIII (1954), 225–8; T. Müller, in *Sitzungsberichte der Kunstgeschichtlichen Gesellschaft* (Berlin, 1955/6), 13; D. Roggen and E. Dhanens, in *G.B.*, IX (1943), 127–32; E. Dhanens, *ibid.*, XI (1945/8), 60–78; E. Panofsky, *Tomb Sculpture* (New York, 1964), 78 f.

39 11. J. Duverger, in Th.-B., XXVIII, 576; *idem*, *C. Meit* (Ghent, 1934); *idem*, in *O.H.*, XLVII (1950), 1–27.

40 12. T. Müller, in *Festschrift Erich Meyer* (Hamburg, 1957), 191–9; Müller (1959), no. 127; Bange, *Kleinplastik*, plate 75.

13. D. Roggen, in *G.B.*, XIV (1953), 207–46; J. Duverger, M. J. Onghena, and P. K. van Daalen, in *Mededelingen van de koninklijke Vlaamse Ac. voor Wetenschap, Letteren en Schone Kunsten van Belgie, Kl. d. Schone Kunsten*, XV, 2 (Brussels, 1953); E. Hensler, in P. Clemen, *Belgische Kunstdenkmäler*, II (Munich, 1923), 91–112; J. Duverger, in *Kunstgeschiedenis*, 366–8; S. Brigode, in P. Fierens, *L'Art en Belgique* (Brussels, 1947), 193–6; M. E. Gómcz-Moreno, *Bartolomé Ordóñez* (Madrid, 1956); G. Kubler and M. Soria, *Art and Architecture in Spain and Portugal (P.H.A.)* (Harmondsworth, 1959), 127 f.

14. D. Roggen and M. Casteels, in *G.B.*, V (1938), 31–50; P. Clemen, *op. cit.* (preceding Note), 1–40; Puyvelde, 165.

1 15. A. Corbet, *P.C. van Aelst* (Antwerp, 1950); J. Leeuwenberg, in *Bull. van het Rijksmuseum Amsterdam*, II (1954), 35–9; J. Duverger, in *Kunstgeschiedenis*, 378.

16. Demmler, 343.

17. J. de Borchgrave d'Altena, *Notes pour servir à l'inventaire des œuvres d'art du Brabant, Arrondissement Louvain* (Brussels, 1940), 279 f., figures 81–4; *idem*, in *Annales de la Société Royale d'Archéologie de Bruxelles*, XLI (1937), 255–7. Destroyed in 1944.

18. Devigne, 157, figure 257.

19. J. de Borchgrave d'Altena, *Œuvres de nos imagiers romans et gothiques* (Brussels, 1944), plate 87;

M. Fransolet, in *Bull. de la Société Royale d'Archéologie de Bruxelles* (1928), no. 3, 8–10.

20. Bange, *Kleinplastik*, 71–2; H. Schnitzler, *Das* p. 242 *Schnütgen-Museum*, 2nd ed. (Cologne, 1961), no. 145; F. Winkler, in *Jb. P.K.*, LX (1939), 46, no. 43, figure 15; cf. p. 204.

21. Witte, 168–72; R. Hetsch, *Die Altarwerke von H.D.*, thesis (Munich, 1937); C. Louis, *H.D.*, thesis (Münster, 1936); L. Behling, *Die Pflanzenwelt der mittelalterlichen Kathedralen* (Cologne, 1964), 161 f.; F. J. Nüss, *H.D.* (Duisburg, 1963). For Douvermann's earlier period, see Chapter 7, p. 57.

22. Witte, 232–3; A. Kamphausen, in *Z. f. b. K.*, p. 243 LXIV (1930/1), 49–58; *idem, Die niederrheinische Plastik im 16. Jahrhundert* (Düsseldorf, 1931).

CHAPTER 26

1. *Inv. Münster*, V, 66, figures 1386–7; H. Beenken, p. 244 *Bildwerke Westfalens* (Bonn, 1923), no. 77; Devigne, 157; it is possible that a foreign donor would make it his business to re-instate the cathedral's original patron in the re-catholicized cathedral.

2. *Inv. Münster*, V, 106–16.

3. For the earlier period of the Master of St Benedict see Chapter 6, p. 50; cf. literature there, Note 7.

4. Stuttmann–von der Osten, 83–90; G. von der p. 245 Osten, in *Z. d. dt. Ver. f. Kwiss.*, VII (1940), 197–216; von der Osten (1957), nos. 179–201.

5. For Dreyer's earlier period see Chapter 6, p. p. 246 51; cf. literature there, Note 10; also W. Paatz, in *Pantheon*, III (1929), 258–60; W. Mannowsky, *ibid.*, XVI (1935), 407–10; E. S. Engelstad, *Senmiddelalderens Kunst i Norge ca. 1400–1535* (Oslo, 1936), no. 121.

6. H. Deckert, in *Marburger Jb.*, III (1927), 1–76; R. Struck, in *Mitteilungen des Vereins f. lübeckische Geschichte und Altertumskunde*, XV, no. 2 (1929); W. Paatz, *Bernt Notke*, 2 vols (Berlin, 1939), 146; V. Thorlacius-Ussing, *Danmarks Billedhuggerkunst* (Copenhagen, 1950), 114–22; S. Karling, *Medeltida Träskulptur i Estland* (Stockholm, 1946), 217–26; E. S. Engelstad, *op. cit.*, no. 3; but cf. M. Hasse, *Lübecker Museumsführer*, I (1964), 145 f.; *idem*, in *Niederdeutsche Beiträge zur Kgesch.*, IV (1965), 137–56; E. Fründt, *Spätgotische Plastik in Mecklenburg* (Dresden, 1963).

p. 248 7. H. Deckert, *loc. cit.*, 53–60; M. Hasse, in *Niederdeutsche Beiträge zur Kgesch.*, I (1961), 201–17.

8. L. Behling, in *Kunst*, I (1948), 36 ff. Relief in the Sigmund Morgenroth Collection, Los Angeles.

p. 249 9. E. Ruhmer, in *Z. f. Kgesch.*, XXI (1958), 209–29.

10. G. Barthel, *op. cit.* (Chapter 6, Note 5), nos. 28–31; see further Roth and others, *Die deutsche Kunst in Siebenbürgen* (Berlin, 1934), no. 159.

CHAPTER 27

p. 250 1. H. Seiberl, in *Jb. K.S.*, N.F., X (1936), 105–30; *idem, ibid.*, N.F., XIII (1944), 193–242; F. Dworschak, *ibid.*, 387–404; K. Oettinger, *op. cit.* (Chapter 5, Note 7), 64–72.

p. 251 2. H. Seiberl, *loc. cit.* (1944), 230–42; K. Oettinger, *op. cit.*, 73–5. See further O. Kastner and B. Ulm, *Mittelalterliche Bildwerke im Oberösterreichischen Landesmuseum* (Linz, 1958), nos. 97–100.

3. A. Feulner, in *Jb. P.K.*, L (1929), 186–94; K. Garzarolli von Thurnlackh, *Mittelalterliche Plastik in Steiermark* (Graz, 1941), 84 ff., 125–7, 145; *idem*, in *Das Johanneum*, I, 2 (1940), 36–54; F. Fuhrmann, in *Salzburger Museum Carolino-Augusteum*, IV (1958), 62–76; G. Lill, *op. cit.* (Chapter 5, Note 3), 276 f.

4. A. Legner, *Salzburger und Passauer Bildnerei zur Zeit Leinbergers und der Donauschulmaler*, MS. thesis (Freiburg, 1954); *idem*, in *Salzburger Museum Carolino-Augusteum. Jahresschrift* (1956), 47–70; A. Walzer, in *Münchner Jb.*, N.F., XIII (1938/9), 68–77; W. Stechow, in *Berliner Museen* (1922), 84 ff.; W. Kris, in *Belvedere*, IV (1923), 47–53; Bange, *Kleinplastik*, 45 ff.; T. Müller, in *Schmitt Festschrift*, 225–32; Th.-B., XXXVII, *passim*; A. Kurz, in *B.M.*, XCI (1949), 217 f.; H. Seiberl, in *Jb. K.S.*, N.F., XII (1938), 157–73; M. Liebmann, in *Münchner Jb.*, III. Folge, XII (1961), 197–202; *Donauschule*, 235–40, 267, 278–91.

p. 252 5. W. Vöge, in *Z. f. b. K.*, LXV (1931), 129–36.

6. For Leinberger's earlier period see Chapter 5, p. 40; cf. literature there, Note 3, and G. Lill, *op. cit.*; T. Müller, in *Z. d. dt. Ver. f. Kwiss.*, X (1943), 255–64; *idem*, in *Z. f. Kgesch.*, XII (1949), 67–73.

p. 253 7. *Inv. Bayern, Oberpfalz*, XXII, I, 302; K. Oettinger, *op. cit.*, plate 97. Cf. p. 111.

8. For Magt's earlier period see Chapter 5, p. 45; cf. literature there, Note 10.

CHAPTER 28

1. For Loscher's earlier period see Chapter 4, p. 36; cf. literature there, Note 14. M. Bernhart, in *Münchner Jb.*, N.F., X (1933), xlii–xlvi; Halm, II, 67–70. p. :

2. For Daucher's earlier period see Chapter 4, p. 37; cf. literature there, Note 16. Bange, *Kleinplastik*, 15–26; K. Feuchtmayr, in Lieb, I, 435 ff.

3. Bange, *Kleinplastik*, 32 f. p.

4. For Hering's earlier period see Chapter 4, p. 37; cf. Bange, *Kleinplastik*, nos. 19–22; L. Bruhns, in Th.-B.; F. Dworschak, in *Wiener Jb. f. Kgesch.*, IV (XVIII) (1926), 86–110; Müller (1959), 298–310.

5. H. R. Weihrauch, in *Münchner Jb.*, III. Folge, III/IV (1952/3), 199–215; *idem, Die Bildwerke in Bronze* (Munich, 1956), nos. 56–8. p.

6. Bange, *Bronzestatuetten*, no. 134.

7. Bange, *Kleinplastik*, no. 31. p.

8. L. Böhling, in *Jb. P.K.*, LVIII (1937), 26–39, 137–52; *eadem*, in *Z. f. Kgesch.*, VII (1938), 22 ff.; Müller (1959), 255–9.

9. J. Baum, *Die Bildwerke der Rottweiler Lorenzkapelle* (Augsburg, 1929), nos. 94–7.

10. L. Böhling, *loc. cit.* (1937), 152–71; J. Baum, *Niederschwäbische Plastik* (Tübingen, 1925), nos. 80–5; H. Koepf, *Der Besigheimer Altar* (Stuttgart, 1954); H. Rott, *Kunst und Künstler am Baden-Durlacher Hof* (Karlsruhe, 1917), 10–16; A. Schahl, in *Das Münster*, XII (1959), 167–74. p.

CHAPTER 29

1. For the Master HL's earlier period see Chapter 3, p. 27; cf. literature there, Note 3. p.

2. Bange, *Kleinplastik*, nos. 54–6.

3. Th.-B., XXXI, 108; W. Hugelshofer, in *Oberrheinische Kunst*, IV (1930), 44 ff.; M. Meier, in *Festschrift Werner Noack* (Constance, 1958), 118–24, but cf. O. Benesch (Chapter 5, Note 7). p.

4. Cf. C. Sommer, in *Z. d. dt. Ver. f. Kwiss.*, III (1936), 272.

5. A. A. Schmid, or *idem* and F. Monteleone, Cat. of the exhibition 'Trésors de Fribourg XIe–XVIIe siècle' (1955), and 'Expositions du huitième centenaire de la Fondation de Fribourg' (1957).

6. Bange, *Kleinplastik*, 58 f.; G. Habich, in *Jb. P.K.*, XXVIII (1907), 181–96, 230–72.

263 7. Bange, *Kleinplastik*, nos. 96 f.; *idem, Bronze-statuetten*, 86–8; Th.-B.; T. Müller, in *Münchner Jb.*, III. Folge, VIII (1957), 115–22.

8. A. Feigel, in *Münchner Jb.*, XI (1909), 132–42; Dehio–Gall, *Handbuch der deutschen Kunstdenk-mäler*, IV, *Rheinfranken* (1943), 296. Cf. Chapter 9, p. 89, also Chapter 26, pp. 249 ff. Cf. also W. Hotz, *Meister Mathis der Bildschnitzer* (Aschaffen-burg, 1961); M. Lanckoronska, *Matthäus Neithart Sculptor* (Munich, 1965).

264 9. R. Freyhan, H. Deckert, and K. Steinbart, *Religiöse Kunst aus Hessen-Nassau* (Marburg, 1932), no. 112, plate 118.

10. P. Kautzsch, *op. cit.* (Chapter 3, Note 7), figure 63.

11. P. Kautzsch, *op. cit.*, 56; R. Kautzsch, *op. cit.* (Chapter 3, Note 8), 17, plate 127.

12. Witte, plates 260, 337, 338.

13. R. Schnellbach, *op. cit.* (Chapter 3, Note 5), 60–76; L. Böhling, *op. cit.* (Chapter 3, Note 5), 78–9; H. Rott, in *Oberrheinische Kunst* (1927/8), 82; Rott, *Quellen*, III, c. 38; E. Herzog, in *Schriften des Historischen Museums*, IX (Frankfurt, 1958), 19–35.

65 14. Pinder, *Hb.*, 460 – formerly attributed to Moritz Lacher, but in fact, according to Irnfriede Lühmann (verbal communication), by Peter Schror of Mainz.

CHAPTER 30

1. Bange, *Kleinplastik*, 84–7; G. Lill, *Hans Lein-* p. 266
berger (Munich, 1942), 262 f.; *Donauschule*, 277 f. According to Justus Bier (verbal communication), Dell was not apprenticed to Riemenschneider in 1501 but at a considerably later date. In the list of apprentices which was started in 1501, he appears comparatively late.

2. To see the problem in a new and different light, cf. also H. R. Weihrauch, *Die Bildwerke in Bronze* (Munich, 1956), 20 ff.

3. Cf. H. Stafski, in *Z. f. Kgesch.*, XXI (1958), 17; *idem, Der jüngere Peter Vischer* (Nuremberg, 1962), esp. 41.

4. Bange, *Kleinplastik*, 75 f.; *idem, Bronzestatuet-* p. 267
ten, 28 f.; O. von Falke, in *Pantheon*, XI (1933), 189–94; *ibid.*, XII (1933), 222 f.; *ibid.*, XXVI (1940), 269 f.

5. Bange, *Kleinplastik*, 82–3.

6. Müller (1959), nos. 191 f.

7. E. F. Bange, in *Jb. P.K.*, LVII (1936), 169–92, LIX (1938), 231 f.; *idem, P.F. (Meister der Graphik, XIV)* (Leipzig, 1926); Bange, *Bronzestatuetten*, 27–9, 38–41; *idem, Kleinplastik*, 77–82; E. W. Braun, in *Münchner Jb.*, III. Folge, II (1951), 195–203; W. Pfeiffer, in *Z. f. Kwiss.*, X (1956), 53–6; C. L. Kuhn, in *A.Q.*, XVII (1954), 108–15.

NOTES TO PART THREE

CHAPTER 31

p. 276 1. G. Poensgen and others, *Ottheinrich, Gedenk-schrift* (Heidelberg, 1956).

2. J. Stockbauer, *Kunst am Hofe Albrechts V. von Bayern* (*Wiener Quellenschriften zur Kunstgeschichte*) (Vienna, 1874); M. G. Zimmermann, *Bildende Kunst am Hofe Herzog Albrechts V.* (Strassburg, 1895); B. P. Baader, *Der bayerische Renaissancehof Herzog Wilhelms V.* (Leipzig, 1943).

NOTE: For further comments on the events treated in Chapters 32, 34, 37, and 39, cf. two other volumes of the *P.H.A.*: H. Gerson and E. H. ter Kuile, *Art and Architecture in Belgium: 1600–1800* (Harmondsworth, 1960), and J. Rosenberg, S. Slive, and E. H. ter Kuile, *Dutch Art and Architecture: 1600–1800* (Harmondsworth, 1966). For Chapters 38 and 40, cf. E. Hempel, *Baroque Art and Architecture in Central Europe* (Harmondsworth, 1965).

CHAPTER 32

p. 277 1. General discussions, with literature: A. E. Brinckmann, *Barockskulptur* (*Handbuch der Kwiss.*) (Berlin, 1917; 3rd ed., 1932), 133–8, 176–80; C. Horst, *Die Architektur der Renaissance in den Nieder-landen*, I, 1 (The Hague, 1930); J. Steppe, *Het Koordoksaal in de Nederlanden* (Louvain, 1952); J. Duverger and M. J. Onghena, in *Kunstgeschiedenis*, I, 362–87; D. Roggen, in *Geschiedenis van de Vlaamsche Kunst* (Antwerp, n.d.), 511–21; C. H. de Jonge, in *Kunstgeschiedenis*, II, 153–73; A. Jansen, in *Kunstgeschiedenis*, III, 116–17.

2. R. Hedicke, *Jacques Dubroeucq von Mons* (Strassburg, 1904); R. Wellens, *Jacques Du Broecq* (Brussels, 1962), with literature. Dubroeucq, like Mone, also worked as an architect – which, just as in Italy (cf. Michelangelo and Sansovino), was a familiar combination for sculptors. In 1560 he took part in the competition for the building of the Town Hall of Antwerp, which was won by Floris.

p. 278 3. Cf. e.g. L. Planiscig, *Venezianische Bildhauer der Renaissance* (Vienna, 1921), *passim*, and H. R. Weihrauch, *Studien zum bildnerischen Werke des Jacopo Sansovino* (Strassburg, 1935); cf. also C. Sey-

mour, *Sculpture in Italy: 1400–1500* (*P.H.A.*) (Harmondsworth, 1966).

4. W. Gramberg, *Giovanni Bologna* (Berlin, 1936); E. Dhanens, *Jean Boulogne* (Brussels, 1956), reviewed by H. Keutner, in *K.Chronik*, XI (1958), 325 ff.

5. R. Hedicke, *Cornelis Floris und die Florisdekora-tion* (Berlin, 1913); D. Roggen and J. Withof, in *G.B.*, VIII (1942), 79–171, and *ibid.*, IX (1943), 133–5; A. Corbet, *Pieter Coecke van Aelst* (Antwerp, 1950), 84–9. It is not possible to discuss Floris as an architect here, although his buildings are of great importance, and the experienced architect can be traced in all his decorative schemes (choir-screen at Tournai). With regard to the Town Hall of Ant-werp, his (?) most important work (1561–5), see A. Corbet, in *R.B.* (1936), 223–64; J. Duverger, in *G.B.*, VII (1941), 37–72; D. Roggen and J. Withof, *ibid.*, VIII (1942), 129 ff. For Floris as an architect in the wider context see E. Forssman, *Säule und Orna-ment* (Stockholm, 1956).

6. M. Casteels, *De Beeldhouwers De Nole te p. Kamerijk, te Utrecht en te Antwerpen* (Brussels, 1961).

7. J. Duverger and M. J. Onghena, in *G.B.*, V (1938), 75–140, and VIII (1942), 173–204.

8. E.g. L. Pulvermacher, *Das Rollwerk in der süddeutschen Skulptur und seine Entwicklung bis ca. 1620* (Strassburg, 1931), with a summary of the literature on strapwork. See also M. Deri, *Das Roll-werk in der deutschen Ornamentik des 16. und 17. Jahrhunderts* (Berlin, 1906), and the relevant chap-ters in books on ornamental engraving: P. Jessen, *Der Ornamentstich* (Berlin, 1920); R. Berliner, *Ornamentale Vorlageblätter des 15. bis 18. Jahrhunderts* (Leipzig, 1926); *Katalog der Ornamentstichsammlung der Staatlichen Kunstbibliothek Berlin* (Berlin, 1936); S. Schéle, in *O.H.*, LXXVII (1962), 235 ff.

9. R. Hedicke, *op. cit.* (Note 5), 127 ff.; further F G. Schoenberger, *Reallexikon zur deutschen Kgesch.*, I (Stuttgart, 1937), 311–18, with literature.

10. C. Ahmels, in *Oldenburger Jb. f. Altertums-kunde* (1916/17), 258–307.

11. D. von Schönherr, in *Jb. K.S.*, XI (1890), 212–22; G. Lill, *Hans Fugger und die Kunst* (Leipzig, 1908), 121 ff., plate 22; G. F. Hartlaub, in *W.R. Jb.*, XIV (1952), 165–81; *Ottheinrich, Gedenkschrift*, ed. G. Poensgen (Heidelberg, 1956).

12. For his architectural paintings, cf. Chapter 34. For his ornamental engravings see H. Mielke, *Hans Vredeman de Vries*, (Berlin, 1967), the literature in Note 8, and R. Hedicke, *op. cit.* (Note 5), 128–31, 148–53. For his work as an architectural theorist, architect, engineer, etc., cf. E. Forssman, *op. cit.* (Note 5), and F. Thöne, in *Braunschweigisches Jb.*, XLI (1960), 47–68.

CHAPTER 33

83 1. For general treatments of the subject, cf. Chapter 32, Note 1; further G. Lill, *Deutsche Plastik* (Berlin, 1925), 166 ff.; A. Feulner, *Die deutsche Plastik des 17. Jahrhunderts* (Munich, 1926), with literature; G. Dehio, *Geschichte der deutschen Kunst*, III (Berlin, 1926), 186–202; Bange, *Kleinplastik*; G. Habich, *Die deutschen Schaumünzen des 16. Jahrhunderts*, 2 vols in 4 pts (Munich, 1929–34), with literature; Bange, *Bronzestatuetten*; H. R. Weihrauch, in *K. Chronik*, IV (1951), 56–60. For dates and illustrations see the volumes of the *Kunstdenkmäler* series, i.e. the official German inventories of works of architecture and art, of which there are several hundred.

84 2. A. Kamphausen, *Die niederrheinische Plastik im 16. Jahrhundert* (Düsseldorf, 1931); Witte, 223–45; H. Appel, *Niederrheinische Skulptur von 1560–1620 und ihre Beziehungen zu den Niederlanden* (Emsdetten, 1934), with literature.

3. E. Panofsky, *G.B.A.*, LIII (1959), 257–70 (two designs for chimneypieces, Justice and Prudence).

4. R. Klapheck, *Die Meister von Schloss Horst im Broiche* (Berlin, 1915).

5. Compare for example T. Demmler, *Die Grabdenkmäler des württembergischen Fürstenhauses und ihre Meister im 16. Jahrhundert* (Strassburg, 1910).

5 6. G. Habich, in *Münchner Jb.*, IX (1914/15), 68–86 (Deschler); G. Habich, *op. cit.* (Note 1), I, 2, 240 (Schro).

7. H. Kahle, *Studien zur mittelrheinischen Plastik des 16. Jahrhunderts* (Bonn, 1939), 79–85 (for Schro), 85–129 (for other masters of the Middle Rhine school in the second third of the century).

8. M. Rosenberg, *J.* (Frankfurt, 1920); E. Kris, in *Jb. K.S.*, N.F., I (1926), 137–208; K. Pechstein, in *Jb. B.M.*, VIII (1966), 237 ff. The Four Seasons (i.e. the models) have also been attributed to J. G. van der Schardt.

6 9. R. A. Peltzer, in *Münchner Jb.*, X (1916/18), 198–216; J. Leeuwenberg, in *Bull. van het Rijks-*

museum Amsterdam, V (1957), 14–19; L. Möller, in *Heydenreich-Festschrift* (Munich, 1964), 191 ff.; I. Himmelheber, in *Jb. der staatlichen Kunstsammlungen in Baden-Württemberg*, I (1964), 164 ff.

10. *Augsburger Renaissance* gives a survey of patrons and works of art of the middle of the century and includes literature on Weiditz, Kels, and others. Further G. Lill, *Hans Fugger und die Kunst* (Leipzig, 1908).

11. Cf. L. Bruhns, *Würzburger Bildhauer der Renaissance und des werdenden Barocks 1540–1650* (Munich, 1923). p. 287

CHAPTER 34

1. L. Guicciardini, *Descrittione di tutti i Paesi Bassi* (Antwerp, 1567, 2nd ed. 1581), and even more C. van Mander, *Het Leven der Doorluchtighe Nederlandtsche en Hooghduytsche Schilders*, 2nd ed. (Haarlem, 1617), are the most important sources and at the same time evidence of what seemed significant to the period itself. H. Floerke's edition of Van Mander (Munich–Leipzig, 1906) supplies the original text with German translation and comments; the translation into modern Dutch by A. F. Mirande and G. S. Overdiep (Amsterdam–Antwerp, 1950) offers more recent literature and illustrations of works by lesser known masters. There is an English translation by C. van de Wall (New York, 1936). R. H. Wilenski, *Flemish Painters*, 2 vols (London, 1960), contains long lists of literature, a presentation of events in art and history in the Netherlands year by year over the centuries, and a short dictionary of artists. Further F. Winkler, *Die altniederländische Malerei* (Berlin, 1924); Antal; Hoogewerff; F. Baumgart, in *Marburger Jb.*, XIII (1944), 187–250; *Kunstgeschiedenis*, I–III, *passim* (several authors); M. J. Friedländer, *Essays über die Landschaftsmalerei und andere Bildgattungen* (The Hague–Oxford, 1947); H. W. v. Löhneysen, *Die ältere niederländische Malerei. Künstler und Kritiker* (Eisenach–Kassel, 1956); R.-A. d'Hulst, *Vlaamse Wandtapijten* (Brussels, 1960); Cat. of the exhibition 'Le Siècle de Bruegel' (Brussels, 1963); F. C. Legrand, *Les Peintres flamands de genre au XVIIᵉ siècle* (Brussels, 1963). p. 288

2. J. Puraye, *Dominique Lampson, Les Effigies des peintres célèbres des Pays-Bas; édition critique* (Liège, 1956).

3. Cf. A. Blunt, *Artistic Theory in Italy*, 2nd ed. (Oxford, 1956), with literature. The first edition of Vasari's *Lives* appeared in 1550.

p. 289 4. A. J. J. Delen, *Histoire de la gravure dans les anciens Pays-Bas*, II (Paris, 1934/5), and Hollstein (so far published up to letter P).

p. 290 5. D. Lampsonius, *Lamberti Lombardi . . . vita*, . . . (Bruges, 1565); A. Goldschmidt, in *Jb. P.K.*, XL (1919), 206–40; Friedländer, XIII, 46–58; Hollstein, XI, 93–4; J. Yernaux, in *Bull. de l'Institut archéologique liégeois*, LXXII (1957–8), 267–372; Cat. of the exhibition 'Lambert Lombard et son temps' (Liège, 1966).

p. 291 6. J. Puraye, in *R.B.*, XVI (1946), 27–45; Cat. of the Lombard exhibition (Liège, 1966), *passim*.

7. D. Zuntz, *F.F.* (Strassburg, 1929); Friedländer, XIII, 59 ff.; Hollstein, VI, 254–5; C. van de Velde, in *Jaarboek Kon. Mus. v. Sch. Kunsten Antwerpen* (1961), 1 ff., and *idem*, in *B.M.*, CVII (1965), 114 ff.

p. 293 8. Friedländer, XIII, 94–106; *Deutsche und niederländische Malerei zwischen Renaissance und Barock* (Munich, 1963), 40, with literature.

9. Friedländer, XI, 112–14; G. Marlier, in *Annuaire des Musées Royaux des Beaux-Arts de Belgique*, II (1939), 63 ff.; R.-A. d'Hulst, in *G.B.*, XIII (1951), 209–58; J. Schouten, in *N.K.J.*, X (1959), 51–70. On the antecedents of the 'Feast of Love': G. Glück, *Rubens, Van Dyck und ihr Kreis* (Vienna, 1933), 82–93.

p. 294 10. M. J. Friedländer, in *O.H.*, LXII (1947), 60–7.

11. The attribution to De Heere by J. G. van Gelder of The Liberal Arts dormant during a War (Turin, Galleria Sabauda) enriches his *œuvre* with an interesting subject. Cf. most recently Cat. of the exhibition 'Triomf van het Maniërisme' (Amsterdam, 1955), no. 66; F. A. Yates, *The Valois Tapestries* (London, 1959).

12. Friedländer, XIII, 24–32. The latest contributions to his *œuvre* by A. P. de Mirimonde, in *G.B.A.* (1962), II, 543–64.

13. C. Justi, in *Jb. P.K.*, V (1884), 154–79; D. A. Iñiguez, *Pedro de Campaña* (Seville, 1951).

14. L. Burchard, in *Hulin de Loo*, 53–65; Friedländer, XIV, 115–18; *idem*, in *O.H.*, LX (1943), 7–14.

p. 295 15. J. A. F. Orbaan, *Stradanus te Florence 1553–1605* (Amsterdam, 1903); G. Thiem, in *Mitteilungen des kunsthistorischen Institutes in Florenz*, VIII (1957–9), 88–111, 155–65, with literature.

16. R. A. Peltzer, in *Jb. K.S.*, XXXI (1913–14), 221–46; G. J. Hoogewerff, in *Mededeelingen van het N.H.I. te Rome*, XXII (1943), 97–117; R. A. Peltzer, in *Arte Veneta*, IV (1950), 118–22.

17. Cf. Chapter 17; further *De Goudsche Glazen* (The Hague, 1938); J. Q. van Regteren Altena, in *O.H.*, LV (1938), 107–14; A. van der Boom, *Monumentale Glasschilderkunst in Nederland* (The Hague, 1940).

18. I. Jost, *Studien zu A.B.* (Cologne, 1960).

19. On portraits in particular: A. Riegl, *Das p. holländische Gruppenporträt* (Vienna, 1931); A. B. de Vries, *Het Noord-Nederlandsch Portret in de tweede Helft van de 16e eeuw* (Amsterdam, 1934); A. Wassenbergh, *L'Art du portrait en Frise au XVI^e siècle* (Leiden, 1934); Cat. of the exhibition 'Le Portrait dans les anciens Pays-Bas' (Bruges, 1953); P. Philippot, in *Bull. Kon. Mus. v. Sch. Kunsten Brussel*, XIV (1965), 163 ff.

20. For these artists cf. E. Waterhouse, *Painting in Britain 1530–1790* (*P.H.A.*) (Harmondsworth, 1953), 11–31, and E. Mercer, *English Art, 1553–1625* (Oxford, 1962). Recently on Ewouts (Eworth): Cat. of the exhibition 'Hans Eworth. A Tudor Artist and his Circle' (Leicester and London, 1965–6); R. Strong, in *B.M.*, CVIII (1966), 225 ff.

21. H. Hymans, *Antonio Moro* (Brussels, 1910); G. Marlier, *Anthonis Mor* (Brussels, 1934); Friedländer, XIII, 118–32; F. J. Sanchez Cantón, in *Archivo Español de Arte*, XIV (1940/1), 79–80; L. C. J. Frerichs, *Antonio Moro* (Amsterdam, 1947); K. Langedijk, in *G.B.A.* (1966), 233 ff., has most recently attributed a Risen Christ with St Peter and St Paul at Chantilly to Mor, with good reasons.

22. M. Dvořák and L. Baldass, in *Jb. K.S.*, XXXVI (1923–5), 1–46; Friedländer, XII–XIV, *passim*; L. Baldass, in *G.B.A.* (1955), I, 143–60. The literature mentioned in Note 24 also gives references.

23. Cat. of the exhibition 'Le Fantastique dans l'art flamand au XVI^e siècle' (Antwerp, 1962).

24. References to literature here have to be limited to a few titles. These however will present Bruegel's work fully and indicate some fields of recent research. All works contain numerous references to further literature. R. van Bastelaer and G. Hulin de Loo, *P.B. l'ancien* (Brussels, 1907); R. van Bastelaer, *Les Estampes de P.B. l'ancien* (Brussels, 1908) (also Hollstein, III, 253 ff.); G. Glück, *Das grosse Bruegel-Werk* (Vienna–Munich, 1955); F. Grossmann, *B. The Paintings* (London, 1966); L. Münz, *B. The Drawings* (London, 1961); A. L. Romdahl, in *Jb. K.S.*, XXV (1905), 85–169; M. J. Friedländer, *P.B.* (Berlin, 1921); Friedländer, XIV, 1–62; F. Grossmann, in *Encyclopedia*

of World Art, II (New York–Toronto–London, 1960), 632–51; J. Grauls, *Volkstaal en volksleven in het werk van P.B.* (Antwerp–Amsterdam, 1957); F. Würtenberger, *P.B. d. Ä. und die deutsche Kunst* (Wiesbaden, 1957); C. G. Stridbeck, *Bruegelstudien* (Stockholm, 1956); M. Auner, in *Jb. K.S.*, LII (1956), 51–122; F. Grossmann, in *Festschrift Kurt Badt* (Berlin, 1961), 135–43; H. A. Klein, *Graphic Worlds of P. B. the Elder* (New York, 1963); J. de Coo and A. van Lennep, in *Bull. Kon. Mus. v. Sch. Kunsten Brussel*, XIV (1965), 83 ff. and 105 ff.

25. G. Marlier, in *Bull. Kon. Mus. v. Sch. Kunsten Brussel*, XIV (1965), 127 ff.

26. L. von Baldass, in *Jb. des kunsthistorischen Institutes der k.k. Zentralkommission f. Denkmalpflege*, XI (1917), 9–15; G. T. Faggin, in *O.H.*, LXXX (1965), 34 ff.

27. J. Sievers, *P.A.* (Leipzig, 1908); Friedländer, XIII, 107–17; Hoogewerff, IV, 488–544; R. Genaille, in *G.B.A.* (1954), II, 267–88; I. Bergström, *Dutch Still-Life Painting* (London, 1956), 16–26; J. Bruyn, in *Master Drawings*, III (1965), 355–68.

28. J. Sievers, in *Jb. P.K.*, XXXII (1911), 185–212; for the Cologne still life, cf. M. Dvořák, *op. cit.* (Note 22).

29. L. von Baldass, in *Jb. K.S.*, XXXIV (1918), 111–57; G. J. Hoogewerff, *Het landschap van Bosch tot Rubens* (Antwerp–Amsterdam, 1954); Cat. of the exhibition 'Bloem en tuin in de Vlaamse kunst' (Ghent, 1960); Cat. of the exhibition 'Le Paysage aux Pays-Bas de Bruegel à Rubens' (Breda–Ghent, 1961), with introduction by H. Gerson and literature.

30. R. van Bastelaer, *op. cit.* (1908), nos. 19–69; the attribution to Cort was made for the first time by L. Burchard, in Th.-B., VII (1912), 475; J. C. J. Bierens de Haan, *L'Œuvre gravé de C.C.* (The Hague, 1948), nos. 248–89; cf. also K. Arndt, in *K. Chronik*, XX (1967), 19.

31. L. Burchard, in *Jb. P.K.*, XLV (1924), 66–71; F. Grossmann, in *B.M.*, XCVI (1954), 42–51; C. Sterling, in *Studies in the History of Art dedicated to William E. Suida* (London, 1959), 277–88; E. Brochhagen, in *Münchner Jb.*, XIV (1963), 93–104.

32. Vicomte Terlinden, in *Bull. Kon. Mus. v. Sch. Kunsten Brussel*, IX (1960), 165–74, and *ibid.*, X (1961), 101–4.

33. H. Vey, in *A.Q.*, XXII (Spring 1959), 63–70; H. G. Franz, in *Jb. des kunsthistorischen Instituts der Universität Graz*, I (1965), 21 ff.

34. H. Jantzen, *Das niederländische Architekturbild* (Leipzig, 1910).

35. Cf. Chapter 32, Note 12.

CHAPTER 35

1. On portrait painting in particular: N. von Holst, *Die deutsche Bildnismalerei zur Zeit des Manierismus* (Strassburg, 1930). p. 309

2. T. Riewerts and P. Pieper, *Die Maler tom Ring* (Munich–Berlin, 1955); P. Pieper, in *Westfalen*, XXXIV (1956), 72–101, and *ibid.*, XXXVI (1958), 192–212; *idem*, in *Anzeiger des Germanischen Nationalmuseums* (1964), 57 ff.; *idem*, in *Münchner Jb.*, III. Folge, XV (1964), 113 ff.

3. Cf. the literature on Lucas Cranach the elder (Chapter 12, Note 1), above all the monographs by Glaser and by Friedländer and Rosenberg, the Cat. of the Cranach exhibition in Berlin (1937), and J. Rosenberg, *Die Zeichnungen Lucas Cranach d. Ä.* (Berlin, 1960). Further: A. Giesecke, in *Z. f. Kwiss.*, IX (1955), 181–92; G. F. Hartlaub, *Lucas Cranach d. J.: Der Jungbrunnen* (Stuttgart, 1958); several essays by E. H. Zimmermann.

4. On painting in Switzerland generally: B. Haendcke, *Die schweizerische Malerei im 16. Jahrhundert* (Aarau, 1893): E. Frölicher, *Die Porträtkunst Hans Holbeins des Jüngeren und ihr Einfluss auf die schweizerische Bildnismalerei im XVI. Jahrhundert* (Strassburg, 1909); W. Hugelshofer, in *Mitteilungen der Antiquarischen Gesellschaft in Zürich*, XXX (1929), 82–110 (in particular on Asper); Schmidt-Cetto. p. 310

5. A. Wynen, *Michael Ostendorfer (um 1492–1559)* (Freiburg, 1961).

6. Cf. K. Löcher, *Jakob Seisenegger* (Munich–Berlin, 1962).

7. R. A. Peltzer, in *Münchner Jb.*, N.F., III (1926), 187–231.

8. M. Goering, in *Münchner Jb.*, N.F., VII (1930), 185–280. On façade painting in general: M. Baur-Heinhold, *Fassadenmalerei. Ihre Entwicklung in Süddeutschland vom Mittelalter bis zur Gegenwart* (Munich, 1952). p. 311

CHAPTER 36

p. 318 1. B. Dudik, 'Die rudolfinische Kunst- und Raritätenkammer', *Mitteilungen der K.K. Central-kommission*, XII (1867), 33 ff.; H. Zimmermann, 'Das Inventar der Prager Schatz- und Kunst-kammer', *Jb. K.S.*, XXV (1905), xiii–lxxv; G. Händler, *Fürstliche Mäzene und Sammler in Deutsch-land 1500–1620* (Strassburg, 1933); G. von Sch-warzenfeld, *Rudolf II., der saturnische Kaiser* (Munich, 1961).

CHAPTER 37

p. 320 1. Cf. the literature in Chapter 32, Note 1. Further: Cat. of the exhibition 'Het Beeld in de Nederlandse Barok' (Utrecht, 1963).

2. Cf. E. Neurdenburg, *Hendrick de Keyser* (Amsterdam, 1930); *idem, De zeventiende eeuwsche Beeldhouwkunst in de Noordelijke Nederlanden* (Amsterdam, 1948); K. Bauch, *Der frühe Rembrandt und seine Zeit* (Berlin, 1960), 79–83.

3. G. F. Hartlaub, *Zauber des Spiegels* (Munich, 1951), 52, plate 47, with an outline of the complex emblematic meaning of the carving.

p. 321 4. H. Appel, *op. cit.* (Chapter 33, Note 2), 25–33; M. Devigne, in *O.H.* (1939), 89 ff.; K. G. Boon, *ibid.* (1965), 205 ff.

5. Illustration of the monument after an en-graving of 1636 in H. Keutner, *Münchner Jb.*, III. Folge, VII (1956), 157, plate 17. Cf. there also note 23 on Willem van den Broecke's base. For the tomb of Charles the Bold cf. D. Roggen and J. Withof, in *G.B.*, VIII (1942), 115–19, plate.

CHAPTER 38

p. 322 1. For literature referring to Germany in general, cf. Chapter 33, Note 1 ff.; further: A. E. Brinck-mann, *op. cit.* (Chapter 32, Note 1), 152–75, 181–212; H. Mayer, *Deutsche Barockkanzeln* (Strassburg, 1932), 15–69; K. Stork, *Zeitschrift der Gesellschaft f. Schleswig-Holsteinische Geschichte*, LXI (1933), 191–217; P. J. Meier, *Das Kunsthandwerk des Bildhauers* *in der Stadt Braunschweig seit der Reformation* (Bruns-wick, 1936).

2. W. Behncke, *A. v. S.* (Strasbourg, 1901); H. Wentzel, *Die Lüneburger Ratsstube von A. v. S.* (Hamburg, 1947).

3. K. Hinrichsen, *Tönnies Evers* (Hamburg, 1937).

4. M. Riesebieter, *Jb. f. Kwiss.* (1929), 1–60; some more illustrations in S. Fliedner, *Welt im Zwielicht* (Oldenburg, 1962).

5. B. Haendcke, *Studien zur Geschichte der säch-sischen Plastik der Spätrenaissance und Barock-Zeit* (Dresden, 1903); W. Hentschel, *Meissner Bildhauer zwischen Spätgotik und Barock* (Meissen, 1934); *idem, Dresdner Bildhauer des 16. und 17. Jahrhunderts* (Weimar, 1966).

6. K. Bimler, *Die schlesische Renaissanceplastik* (Breslau, 1934–7).

7. G. Deneke, *Magdeburger Bildhauer der Hoch-renaissance und des Barock* (Halle, 1911); *idem*, in *Monatshefte f. Kwiss.*, VI (1913), 99–110, 145–59, 205–12.

8. P. J. Meier, *Niedersächsisches Jb.*, V (1928), 176–8, attributed the alabaster and wood reliefs of the chancel to the journeyman Lulef Bartels of Magde-burg.

9. W. Mackowsky, *G.M.N. und die Renaissance in Sachsen* (Berlin, 1904). With illustrations of the statues of Carlo di Cesare.

10. F. Balke, *Über die Werke des kurtrierischen Bildhauers H.R.H.* (Trier, 1916); W. Jung, in *Aachener Kunstblätter*, XVII/XVIII (1958/9), 70–7.

11. O. Schulze-Kolbitz, *Das Schloss zu Aschaffen-burg* (Strassburg, 1905), 106–21; L. Bruhns, *Würz-burger Bildhauer . . . 1540–1650* (Munich, 1923). All the works mentioned were considerably damaged during the Second World War.

12. W. A. Luz, *Die Münchner Erzplastik um 1600* (Munich, 1921); A. E. Brinckmann, in *Jb. P.K.*, XLII (1921), 147–60; K. Feuchtmayr, *Schwäbische und bayerische Bildhauer der Spätrenaissance und des Frühbarocks* (Munich, 1922); A. E. Brinckmann, *Süddeutsche Bronzebildhauer des Frühbarocks* (Munich,

1923); W. Pinder, *Deutsche Barockplastik* (Königstein, 1933).

13. In Nuremberg, for example, the fountain by Georg Labenwolf, dated 1582, for King Frederik II of Denmark. On the other hand, also of importance is the stone fountain of St Peter by H. R. Hoffmann in Trier, dated 1595, whose Virtues, and, in fact, whose arrangement as a whole are calmer, more compact and more Baroque.

14. Cf. Chapter 33, Note 8; further: P. A. Wick, in *Museum of Fine Arts Boston Bull.*, LX (1962), 83–104, with literature.

15. H. Mahn, in *Z. d. dt. Ver. f. Kwiss.*, VI (1939), 162–206; E. F. Bange, *ibid.*, VII (1940), 152–5.

24 16. R. A. Peltzer, in *Kunst und Kunsthandwerk*, XXI (1918), 109–52; W. A. Luz, in *Monatshefte f. Kwiss.* (1922), 81–95; G. Habich, in *Münchner Jb.*, N.F., V (1928), 252–66; F. Dworschak, in *Jb. K.S.*, N.F., I (1926), 231–8; J. Schlosser, *Präludien* (Berlin, 1927), 320–9. For the statues on the façade of St Michael, cf. P. Schade, in *Das Münster*, XIII (1960), 238–60; for the Fugger altarpiece of 1581, cf. M. Baxandall, in *Victoria and Albert Museum Bull.*, I (April 1965), 1 ff., and in *Münchner Jb.* (1966), 127 ff.

25 17. Staatliche Graphische Sammlung, Munich; cf. P. Halm, B. Degenhart, and W. Wegner, *Hundert Meisterzeichnungen* (Munich, 1958), no. 69, with illustration and earlier literature in which the actual execution was erroneously attributed to Sustris.

26 18. L. O. Larsson, *Adrian de Vries* (Vienna–Munich, 1967).

19. Cf. the listing by E. V. Strohmer in *Nationalmusei Årsbok* (1947/8), 93–138, the Amsterdam Cat. (1955), and the Cat. of the exhibition 'Sechs Sammler' (Hamburg, 1961), nos. 56–8 and 65. Most of the small bronzes by De Vries are only attributed to him by comparison of style and combination with early documents, and there is no agreement yet on some of the most interesting ones. Indications by De Vries's contemporaries that he also painted have not been confirmed.

27 20. R. Bruck, *Ernst zu Schaumburg* (Berlin, 1917).

21. R. A. Peltzer, in *Kunst und Kunsthandwerk*, XXII (1919), 1–22; F. Kriegbaum, in *Jb. K.S.*, N.F., V (1931), 189–266.

8 22. K. Feuchtmayr, in *Das Schwäbische Museum* (1926), 38–47.

23. H. Möhle, in *Jb. P.K.*, LI (1930), 61–93; H.

Rudolph, *Die Beziehungen der deutschen Plastik zum Ornamentstich in der Frühzeit des 17. Jahrhunderts* (Berlin, 1935), 20–33; Cat. of the exhibition 'Barock am Bodensee. Plastik' (Bregenz, 1964).

24. A. Feulner, in *Münchner Jb.*, XII (1922), 61–89; W. A. Luz, *Belvedere*, XII (1928), 82–95; H. Schnell, *Das Münster*, XV (1962), 169–204. p. 329

25. H. Modern, in *Jb. K.S.*, XV (1894), 60–102; R. Verres, in *Pantheon*, I (1928), 291–9; J. W. Frederiks, *Dutch Silver*, I (The Hague, 1952), 111–61, and IV (The Hague, 1961), 38–41. Numerous publications of single finds, smaller groups of works of art, and attributions are listed in Th.-B.; further *N.K.J.*, VI (1955), 185–90, and *Mitteilungen der Gesellschaft f. Salzburger Landeskunde*, XCVI (1956), 207, and XCVIII (1958), 219.

26. Cf. the literature in Chapter 32, Note 8; further W. K. Zülch, *Entstehung des Ohrmuschelstiles* (Heidelberg, 1932). p. 330

CHAPTER 39

1. General literature partly in Chapter 34, Note 1; further H. Gerson, *Art and Architecture in Belgium 1600–1800* (P.H.A.) (Harmondsworth, 1960), 47–69; J. Müller Hofstede, in *Münchner Jb.*, III. Folge, XIII (1962), 188–99. p. 331

2. V. Dirksen, *Die Gemälde des M. d. V.* (Parchim, 1914).

3. S. Bergmans, *D.C.* (Brussels, 1934), reviewed by C. Brandi, in *B.M.*, LXVI (1935), 149; Hollstein, IV, 85. p. 332

4. G. Poensgen, in *Z. f. b. K.*, LIX (1925/6), 324–30; R.-A. d'Hulst, in *Bull. Koninklijke Musea voor Schone Kunsten*, IV (1955), 239–48.

5. O. Benesch, in *B.M.*, XCIII (1951), 351–3.

6. F. M. Haberditzl, in *Jb. K.S.*, XXVII (1907/9), 161–235; J. Müller Hofstede, in *Bull. Koninklijke Musea voor Schone Kunsten*, VI (1957), 127–72; idem, *O. v. V.* (Freiburg, 1959). p. 333

7. Cf. Chapter 34, Note 29; further E. Plietzsch, *Die Frankenthaler Maler* (Leipzig, 1910); J. A. Graf Raczyński, *Die flämische Landschaft vor Rubens* (Frankfurt, 1937); Y. Thiéry, *Le Paysage flamand au XVIIe siècle* (Paris–Brussels, 1953); Cat. of the exhibition 'Die Frankenthaler Maler' (Mannheim–Frankenthal, 1962).

8. H. Wellensiek, *Gillis van Coninxloo* (Bonn, 1954); Hollstein, IV, 221; O. Münch, in *Mitteilungen des historischen Vereins der Pfalz*, LVIII

(1960), 275 ff.; H. G. Franz, in *Bull. Museum Boymans–Van Beuningen*, XIV (1963), 66 ff.

p. 334 9. On him H. Gerson, *P.H.A.* (*op. cit.*), 56–61; further M. Winner, in *Jb. B.M.*, III (1961), 190–241.

10. G. T. Faggin, in *Bull. Museum Boymans–Van Beuningen*, XIV (1963), 1–16 (also on Frederik's younger brother Gillis).

11. K. Goossens, *D.V.* (Antwerp–The Hague, 1954), reviewed by O. Benesch, in *K.Chronik*, X (1957), 285 ff.; K. Goossens, in *Jaarboek van het Koninklijk Museum voor Schone Kunsten te Antwerpen* (1966), 56–106.

12. Cat. of the exhibition 'R.S.' (Ghent, 1954).

p. 335 13. More on him in H. Gerson, *P.H.A.* (*op. cit.*), 65–6; further O. Koester, in *Artes*, II (1966), 5 ff.

14. Cf. R. Wittkower, *Art and Architecture in Italy: 1600–1750* (*P.H.A.*), 2nd ed. (Harmondsworth, 1965).

15. L. Menegazzi, *L.T.* (Venice, 1958); *idem*, in *Arte Veneta*, XV (1961), 119–26; W. Wegner, *ibid.*, 107–18.

16. R. A. Peltzer, in *Münchner Jb.*, N.F., I (1924), 126–42; E. Haverkamp Begemann, in *Bull. van het Rijksmuseum* (*Amsterdam*), X (1962), 68–75; S. M. Rinaldi, in *Arte Veneta*, XIX (1965), 95 ff.

17. A. Mayer, *Das Leben und die Werke der Brüder ... Brill* (Leipzig, 1910); R. Baer, *Paul Bril* (Munich, 1930); G. T. Faggin, in *Paragone*, CLXXXV (1965), 21 ff.

18. G. J. Hoogewerff, in *Mededelingen van het Nederlands Historisch Instituut te Rome*, XXXI (1961), 57–69.

19. M. L. Hairs, *Les Peintres flamands de fleurs au XVII^e siècle* (Paris–Brussels, 1955); I. Bergström, *Dutch Still-Life Painting in the Seventeenth Century* (London, 1956); S. H. Pavière, *A Dictionary of Flower, Fruit, and Still Life Painters*, I (Amsterdam, 1962).

20. L. J. Bol, *The Bosschaert Dynasty* (Leigh-on Sea, 1960).

p. 336 21. Cf. Chapter 34, Note 34. Further: Cat. of the exhibition 'Nederlandse Architectuurschilders 1600–1900' (Utrecht, 1953).

p. 337 22. Late Mannerism and other international trends in the Northern Netherlands are discussed in detail in Chapter 3 of the volume of the *P.H.A.* by Rosenberg, Slive, and Ter Kuile. We have therefore ended our chapter with an outline of the most important names and associations only and refrained from giving an account of the literature referring to these decades and their masters (which has increased tremendously, especially over the last forty years).

CHAPTER 40

1. F. Thöne, *T.S. Handzeichnungen* (Freiburg, p. 3 1936); M. Bendel, *T.S.* (Zürich–Berlin, 1940).

2. Cat. of the exhibition 'D.L. ... Handzeich- p. 3 nungen' (Schaffhausen, 1952). For Lindtmayr and the Swiss painters mentioned in the following, cf. Chapter 35, Note 4, especially B. Haendcke, *op. cit.*, and Schmidt–Cetto; most recently F. Thöne, in *Schweizerisches Institut f. Kwiss. Jahresbericht 1965*, 78 ff.

3. K. Ohnesorge, *W.D.* (Strassburg, 1893); M. Pirr, *Die Architectura des W.D.* (Berlin, 1940); K. Martin, in *Festschrift Karl Lohmeyer* (Saarbrücken, 1954), 14–29; E. Forssman, *Säule und Ornament* (Stockholm, 1956); W. Pfeiffer, in *Jb. der Hamburger Kunstsammlungen*, VI (1961), 54–71. New ed. of the *Architectura* by H. G. Evers (Darmstadt, 1965).

4. He was the main representative of a 'posthumous Dürer school' in southern Germany at the end of the century. We cannot enlarge on this phenomenon of historicism here; the reader may be referred to H. Kauffmann, in *Anzeiger des Germanischen National-Museums 1940–1953* (1954), 18–60, with literature. With regard to Hoffmann also: M. Walicki, in *Bull. du Musée National de Varsovie*, IV (1963), 71 ff.

5. W. Drost, *Danziger Malerei* (Berlin–Leipzig, 1938).

6. T. Riewerts, in *Z. d. dt. Ver. f. Kwiss.*, III (1936), 275–302.

7. G. Lill, *Hans Fugger und die Kunst* (Leipzig, p. 1908).

8. P. Frankl, in *Münchner Jb.*, X (1916–18), 1–63; J. Braun, *ibid.*, N.F., X (1933), 247–69; M. Hock, *F.S.* (Munich, 1952). For the Trausnitz disaster: H. Brunner, in *Deutsche Kunst und Denkmalpflege*, XX (1962), 35–46.

9. K. Steinbart, in *Marburger Jb. f. Kwiss.*, IV (1928), 89 ff.; O. Hartig, in *Münchner Jb.*, N.F., X (1933), 147 ff.

10. P. J. Rée, *P.C.* (Leipzig, 1885); K. Steinbart, p. in *Jb. P.K.*, LVIII (1937), 63–80; B. Knüttel, *P.C.* (Frankfurt, 1964).

11. H. Geissler, *C.S.* (Freiburg, 1960); *idem, in Münchner Jb.*, III. Folge, XII (1961), 192–6.

12. R. A. Peltzer, in *Jb. K.S.*, XXXIII (1915/16), 293–365.

13. K. Chytil, *Die Kunst in Prag zur Zeit Rudolfs II* (Prague, 1909); G. von Schwarzenfeld, *Rudolf* (Munich, 1961).

344 14. E. Diez, in *Jb. K.S.*, XXVIII (1909–10), 93–151; A. Niederstein, in *Rep. f. Kwiss.*, LII (1931), 1–33; K. Oberhuber, *Die stilistische Entwicklung im Werk B.S.* (Vienna, 1959); *idem, in Jb. der Staatlichen Kunstsammlungen in Baden-Württemberg*, 1 (1964), 173 ff.; E. K. J. Reznicek, 'B.S. als Bildhauer', *Festschrift Ulrich Middeldorf* (Berlin, 1968), 370 ff.

15. R. A. Peltzer, in *Jb. K.S.*, XXX (1911–12), 59– p. 345
182; *idem, in W.R. Jb.*, V (1928), 75–84; Hollstein, 1–5.

16. B. Haendcke, in *Jb. K.S.*, XV (1894), 45–59; J. Zimmer, *Joseph Heintz d. Ä. als Maler* (Heidelberg, 1967).

17. H. Möhle, *Winkler-Festschrift*, 268–79.

LIST OF THE PRINCIPAL ABBREVIATIONS
AND BIBLIOGRAPHY

This list is designed to serve the additional purpose of a summary bibliography of the most important works. Other references will be found in the Notes.

Altdorfer Cat.	Catalogue of the exhibition 'Albrecht Altdorfer und sein Kreis', ed. E. Buchner. Munich, 1938
Antal	F. Antal, 'Zum Problem des niederländischen Manierismus', *Kritische Berichte*, II (1928/9), 207–56
A.Q.	*The Art Quarterly*
A.S.A.	*Anzeiger für schweizerische Altertumskunde*
Aufgang der Neuzeit	Catalogue of the exhibition 'Aufgang der Neuzeit', ed. L. Grote. Nuremberg, 1952
Augsburger Renaissance	Catalogue of the exhibition 'Augsburger Renaissance', ed. N. Lieb. Augsburg, 1955
B	A. Bartsch, *Le Peintre-Graveur*. 21 vols. Leipzig, 1854–76
Baden-Württ. Priv. Bes.	Catalogue of the exhibition 'Meister aus Baden-Württembergischem Privatbesitz'. Stuttgart, 1958
Baldung Cat.	Catalogue of the Hans Baldung Grien exhibition, ed. J. Lauts. Karlsruhe, 1959
Bange, *Bronzestatuetten*	E. F. Bange, *Die deutschen Bronzestatuetten des 16. Jahrhunderts*. Berlin, 1949
Bange, *Kleinplastik*	E. F. Bange, *Die Kleinplastik der deutschen Renaissance in Holz und Stein*. Leipzig, 1928
Baumgart	F. Baumgart, *Renaissance und die Kunst des Manierismus*. Cologne, 1963
Benesch–Auer	O. Benesch and E. M. Auer, *Die Historia Friderici et Maximiliani*. Berlin, 1957
Bernhard	M. Bernhard, K. Martin, and K. P. Rogner, *Verlorene Werke der Malerei*. Munich, 1965
Bialostocki–Walicki	J. Bialostocki and M. Walicki, *Europäische Malerei in polnischen Sammlungen 1300–1800*. Warsaw, 1957
B.M.	*Burlington Magazine*
Borchgrave (1942)	J. de Borchgrave d'Altena, *Les Retables brabançons 1450–1550*. Brussels, 1942
Borchgrave (1957)	J. de Borchgrave d'Altena, 'Notes pour servir à l'étude des retables anversois', *Bulletin des Musées Royaux d'art et d'histoire*, 4e série, 29e année (1957), 2–114
Buchner	E. Buchner, *Das deutsche Bildnis der Spätgotik und der frühen Dürerzeit*. Berlin, 1953
Buchner–Feuchtmayr	E. Buchner and K. Feuchtmayr, *Beiträge zur Geschichte der deutschen Kunst*, I and II. Augsburg, 1924 and 1928
Bull.	*Bulletin*
Bull. M.R.	*Bulletin des Musées Royaux*
Cat.	Catalogue

Cranach Cat. Catalogue of the exhibition 'Lucas Cranach d. Ä. und Lucas Cranach d. J'. Berlin, 1937

Davies M. Davies, *National Gallery Catalogues: Early Netherlandish School*. 2nd ed. London, 1955

Demmler T. Demmler, *Die Bildwerke des deutschen Museums*, III, *Die Bildwerke in Holz, Stein und Ton: Grossplastik*. Berlin, 1930

Devigne M. Devigne, *La Sculpture mosane*. Paris, 1932

Donauschule Catalogue of the exhibition 'Die Kunst der Donauschule'. Stift St Florian and Linz, 1965

Dürer Cat. Catalogue of the exhibition 'Meister um Albrecht Dürer' (*Anzeiger des Germanischen Nationalmuseum*, 1960–1). Nuremberg, 1961

f. *für*

Feulner–Müller A. Feulner and T. Müller, *Geschichte der deutschen Plastik*. Munich, 1953

Fiensch G. Fiensch, 'Die Anfänge des deutschen Landschaftsbildes – Formgeschichtliche Voraussetzungen', *Münstersche Forschungen*, IX (1955), 71–121

Förster Festschrift *Mouseion, Studien aus Kunst und Geschichte für Otto H. Förster*. Cologne, 1960

Friedländer M. J. Friedländer, *Die altniederländische Malerei*. 14 vols. Berlin–Leiden, 1924–37

Friedländer–Rosenberg M. J. Friedländer and J. Rosenberg, *Die Gemälde von Lucas Cranach*. Berlin, 1932

G.B. *Gentse Bijdragen tot de Kunstgeschiedenis*

G.B.A. *Gazette des Beaux-Arts*

Geisberg M. Geisberg, *Der deutsche Einblattholzschnitt in der ersten Hälfte des 16. Jahrhunderts*. Munich, 1930

Gerson H. Gerson, *Van Geertgen tot Frans Hals*. Amsterdam, 1950

Gotik in Tirol Catalogue of the exhibition 'Gotik in Tirol', ed. V. Oberhammer. Innsbruck, 1950

Halm P. M. Halm, *Studien zur süddeutschen Plastik*. 2 vols. Augsburg, 1926–7

H, or P. Halm P. Halm, 'Die Landschaftszeichnungen des Wolfgang Huber', *Münchner Jahrbuch der bildenden Kunst*, N.F., VII (1930), 1–104

Held J. Held, *Dürers Wirkung auf die niederländische Kunst seiner Zeit*. The Hague, 1931

Holbein Cat. Catalogue of the exhibition 'Die Familie Holbein in Basel'. Basel, 1960

Hollstein F. W. H. Hollstein, *Dutch and Flemish Engravings, Etchings and Woodcuts c. 1450–1700*, I–XIV (including Ossenbeeck). Amsterdam, 1949 ff.*

Hollstein F. W. H. Hollstein, *German Engravings, Etchings and Woodcuts c. 1400–1700*, I–VII (including Hans Dürer). Amsterdam, 1954 ff.*

Hoogewerff G. J. Hoogewerff, *De Noord-Nederlandsche Schilderkunst*. 5 vols. The Hague, 1936–47

Hulin de Loo *Mélanges Hulin de Loo*. Brussels, 1931

Jb. *Jahrbuch*

Jb. B.M. *Jahrbuch der Berliner Museen*

Jb. K.S. *Jahrbuch der kunsthistorischen Sammlungen, Wien*

Jb. P.K. *Jahrbuch der preussischen Kunstsammlungen, Berlin*

K. Chronik *Kunstchronik*

Kgesch. *Kunstgeschichte*

Krönig W. Krönig, *Der italienische Einfluss in der flämischen Malerei im 1. Drittel des 16. Jahrhunderts*. Würzburg, 1936

* In the Notes, the reference 'Hollstein' only is given; it will be obvious from the nationality of the artists under discussion – Netherlandish or German – which of the Hollstein series is meant.

Kunstgeschiedenis	*Kunstgeschiedenis der Nederlanden van de Middeleeuwen tot onzen Tijd*, ed. H. E. van Gelder. Utrecht, 1946 ff.
Kwiss.	*Kunstwissenschaft*
Lieb	N. Lieb, *Die Fugger und die Kunst*. 2 vols. Munich, 1952, 1958
Van Mander	C. van Mander, *Das Leben der niederländischen und deutschen Maler*, ed. H. Floerke (*Kunstgeschichtliche Studien, der Galeriestudien*, IV Folge). 2 vols. Munich, 1906
Middeleeuwse Kunst	Catalogue of the exhibition 'Middeleeuwse Kunst der Noordelijke Nederlanden'. Amsterdam, 1958
Miscellanea Puyvelde	*Miscellanea Leo van Puyvelde*. Brussels, 1949
Müller (1959)	T. Müller, *Die Bildwerke in Holz, Ton und Stein* (*Kataloge des bayerischen Nationalmuseums München*, XIII, 2). Munich, 1959
Müller (1963)	T. Müller, *Deutsche Plastik der Renaissance*. Königstein, 1963
Münchner Jb.	*Münchner Jahrbuch der bildenden Kunst*
N.K.J.	*Nederlandsch kunsthistorisch Jaarboek*
Oettinger	K. Oettinger, *Die Bildhauer Maximilians am Innsbrucker Kaisergrabmal*. Nuremberg, 1967 (this book is not taken into consideration in our text)
O.H.	*Oud Holland*
von der Osten (1957)	G. von der Osten, *Katalog der Bildwerke in der Niedersächsischen Landesgalerie Hannover*. Munich, 1957
P	J. D. Passavant, *Le Peintre-Graveur*. 3 vols. Leipzig, 1860–4
Panofsky	E. Panofsky, *Early Netherlandish Painting. Its origin and character*. 2 vols. Cambridge (Mass.), 1958 (especially I, 351–8)
P.H.A.	*Pelican History of Art*
Pinder, *Dürerzeit*	W. Pinder, *Die deutsche Kunst der Dürerzeit*. Leipzig, 1940
Pinder, *Hb.*	W. Pinder, *Die deutsche Plastik vom ausgehenden Mittelalter bis zum Ende der Renaissance* (*Handbuch der Kunstwissenschaft*), II. Wildpark-Potsdam, 1929
Puyvelde	L. van Puyvelde, *La Peinture flamande au siècle de Bosch et Brueghel*. Paris, 1962
R. B.	*Revue belge d'archéologie et d'histoire de l'art*
Rep. f. Kwiss.	*Repertorium für Kunstwissenschaft*
Rott	H. Rott, *Quellen und Forschungen zur südwestdeutschen und schweizerischen Kunstgeschichte im 15. und 16. Jahrhundert*, I–III. Stuttgart, 1933–8
Rupprich	*Dürer. Schriftlicher Nachlass*, ed. H. Rupprich. 2 vols. Berlin, 1956, 1966
Schaffner Cat.	H. Péc and S. Lustenberger, *Martin Schaffner, Maler zu Ulm* (*Schriften des Ulmer Museums*, N.F., II). Ulm, 1959
Schmidt–Cetto	G. Schmidt and A. M. Cetto, *Schweizer Malerei und Zeichnung im 15. und 16. Jahrhundert*. Basel, 1940
Schmitt Festschrift	*Festschrift für Otto Schmitt*. Stuttgart, 1950
Stange	A. Stange, *Deutsche Malerei der Gotik*, V–X. Munich, 1952–60
Stange, *Donauschule*	A. Stange, *Malerei der Donauschule*. Munich, 1964
Stechow	W. Stechow (ed.), *Northern Renaissance Art, 1400–1600, Sources and Documents*. London, 1966
Strieder	P. Strieder, *Deutsche Malerei der Renaissance*. Königstein, 1966
Stuttmann–von der Osten	F. Stuttman and G. von der Osten, *Niedersächsische Bildschnitzerkunst des späten Mittelalters*. Berlin, 1940
Th.-B.	U. Thieme and F. Becker, *Allgemeines Lexikon der bildenden Künstler*. 37 vols. Leipzig, 1907–47*
Timmers	J. J. M. Timmers, *Houten Beelden*. Amsterdam, 1949
Vogelsang	W. Vogelsang, *Die Holzskulptur in den Niederlanden*. 2 vols. Berlin, 1911–12

*Where not otherwise indicated, references are to be found under the name of the artist under discussion.

Walicki M. Walicki, *Malarstwo Polskie, Gotyk, Renesans, Wczesny Manieryzm.* Warsaw, 1961
Weihrauch H. R. Weihrauch, *Europäische Bronzestatuetten 15.–18. Jahrhundert.* Brunswick, 1967 (this book is not taken into consideration in our text)
Winkler (1924) F. Winkler, *Die altniederländische Malerei.* Berlin, 1924
W or Winkler (for Dürer) F. Winkler, *Die Zeichnungen Albrecht Dürers.* 4 vols. Berlin, 1936–9
Winkler Festschrift *Festschrift für Friedrich Winkler.* Berlin, 1959
W or Winzinger (for Altdorfer) F. Winzinger, *Albrecht Altdorfer. Zeichnungen.* Munich, 1952
Witte F. Witte, *Tausend Jahre deutsche Kunst am Rhein.* 5 vols. Berlin, 1932
W.R. Jb. *Wallraf-Richartz-Jahrbuch*
Z.A.K. *Zeitschrift für schweizerische Archäologie und Kunstgeschichte*
Z. d. dt. Ver. f. Kwiss. *Zeitschrift des deutschen Vereins für Kunstwissenschaft*
Z. f. b. K. *Zeitschrift für bildende Kunst*
Z. f. Kgesch. *Zeitschrift für Kunstgeschichte*
Z. f. Kwiss. *Zeitschrift für Kunstwissenschaft*
Zülch K. W. Zülch, *Frankfurter Künstler 1223–1700.* Frankfurt, 1935

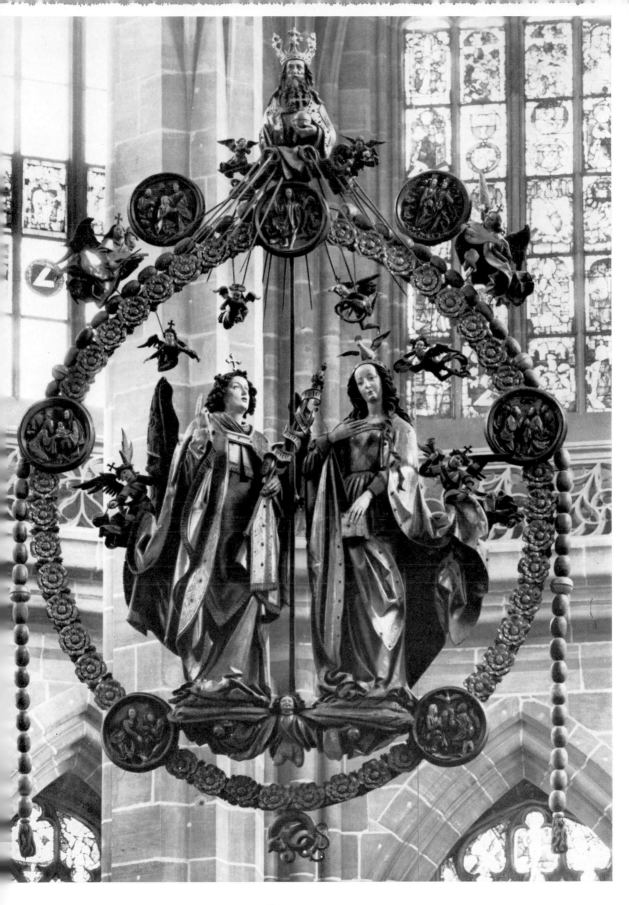

1. Veit Stoss: Annunciation, 1517–18. *Nuremberg, St Lorenz*

2. Tilman
Riemenschneider:
The Virgin, St
Cyriacus, and St John,
from the Gramschatz
altar, *c.* 1510.
Hannover,
Landesmuseum

3. Veit Stoss: Raphael
and Tobias, 1516.
Nuremberg,
Germanisches
National-Museum

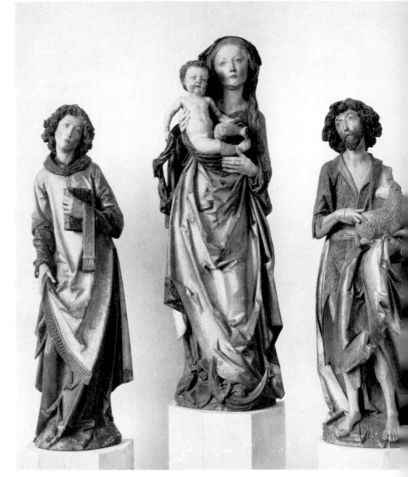

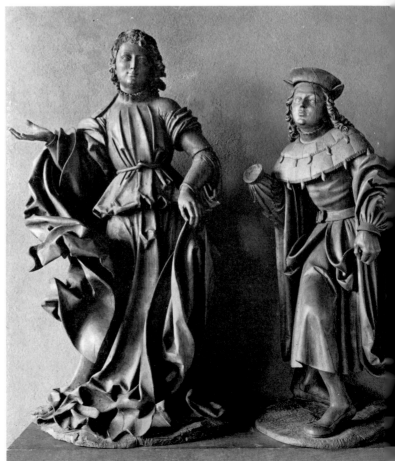

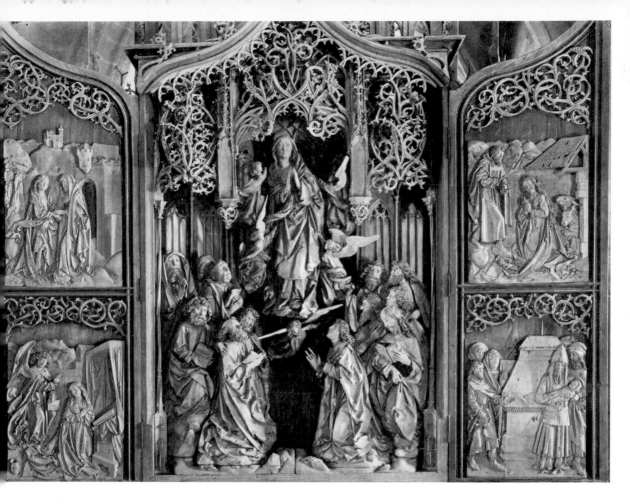

4. Tilman Riemenschneider: Assumption and Life of the Virgin, *c.* 1505–10. *Creglingen, Herrgottskirche*

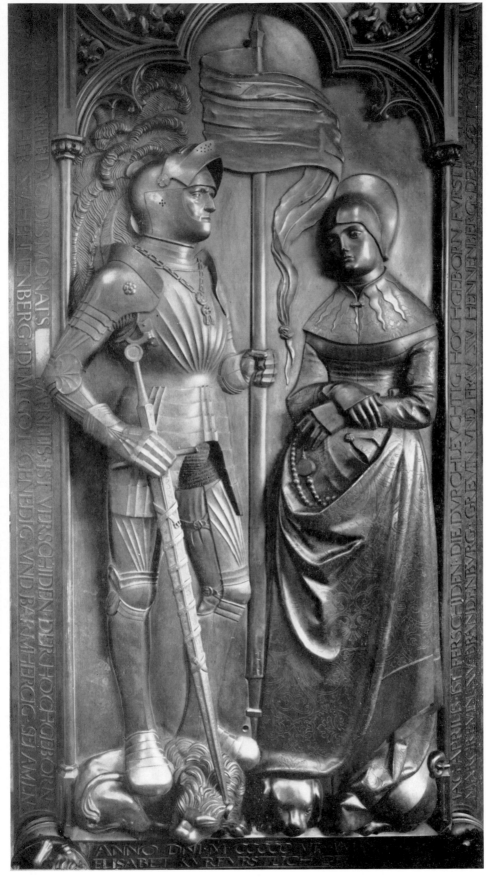

5. Hermann Vischer the younger: Monument of Elisabeth and Hermann VIII of Henneberg, probably after 1507. *Römhild, Stadtkirche*

6. Tilman Riemenschneider: Monument of Rudo von Scherenberg, 1496–9. *Würzburg Cathedral*

7. Hans Backoffen: Monument of Uriel von Gemmingen, d. 1514. *Mainz Cathedral*

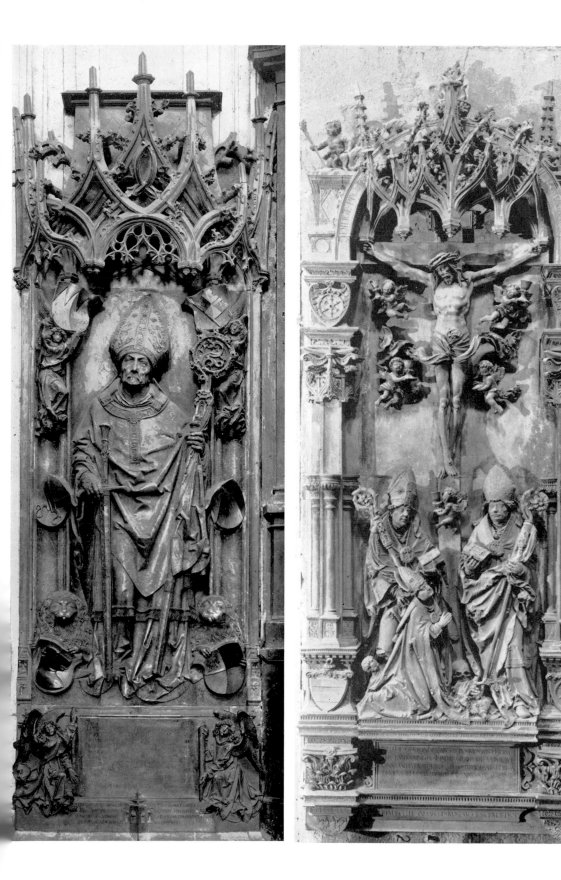

8–9. Peter Vischer the younger: Figures on the Shrine of St Sebald, 1507–19. *Nuremberg, St Sebald*

10. Peter Vischer the younger: Healing of a Blind Man, detail of the Shrine of St Sebald, 1507–19. *Nuremberg, St Sebald*

11. Peter Vischer the elder and his sons: Shrine of St Sebald, 1507–19. *Nuremberg, St Sebald*

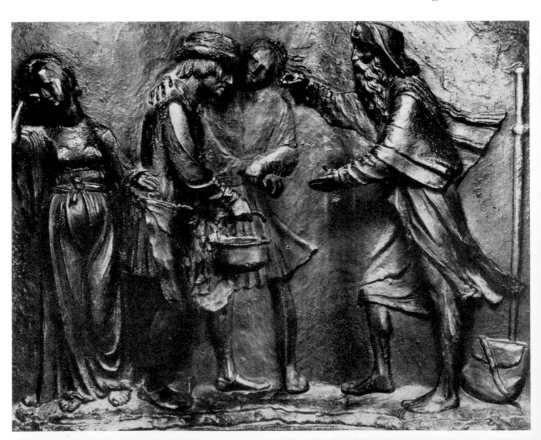

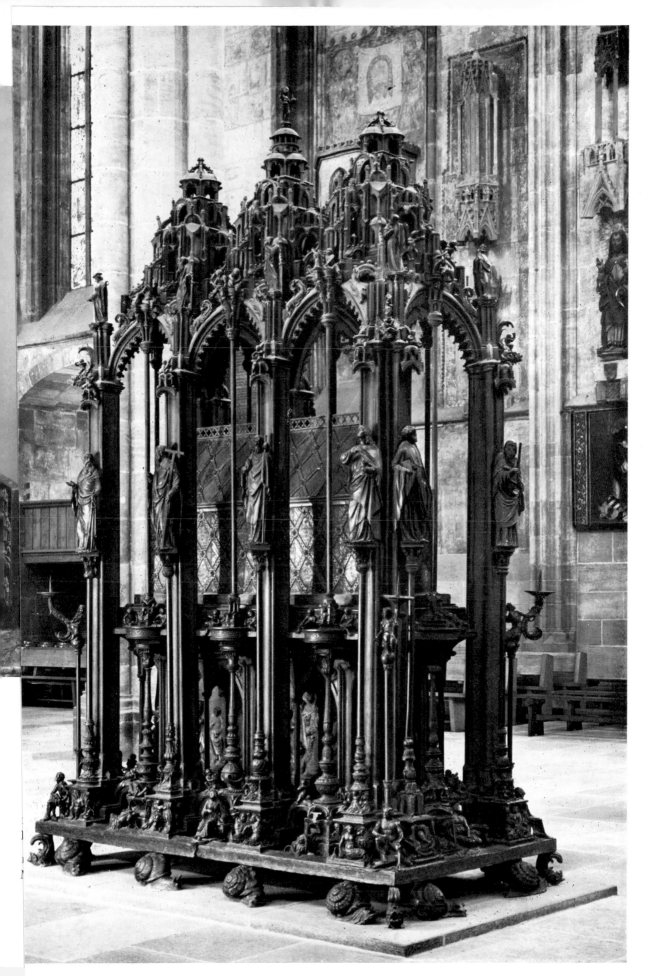

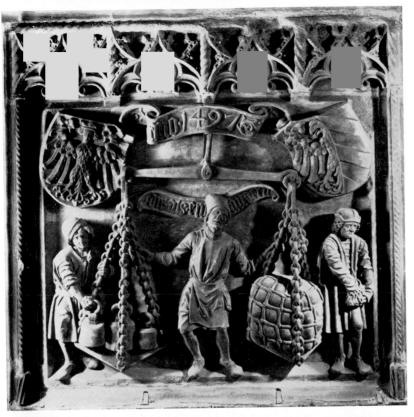

15. Adam Kraft: The Weighmaster, from the old city weigh-house, 1497. *Nuremberg, Germanisches National-Museum*

16. Adam Kraft: The Master, on the tabernacle, 1493–6. *Nuremberg, St Lorenz*

17. Sebastian Loscher: Putti, *c.* 1515. *Vienna, Kunsthistorisches Museum*

18. Conrat Meit: Judith (?), *c.* 1510. *Cologne, Kunstgewerbemuseum*

19. Conrat Meit: Judith, *c.* 1510–15. *Munich, Bayerisches Nationalmuseum*

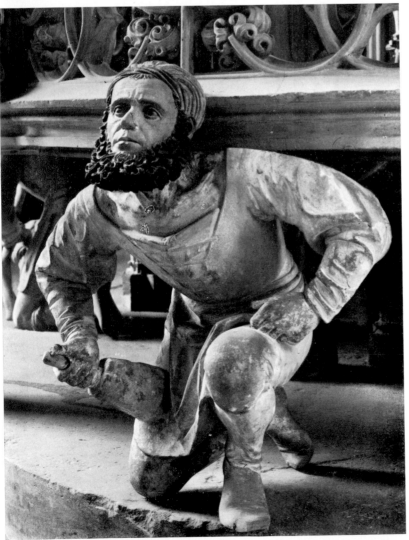

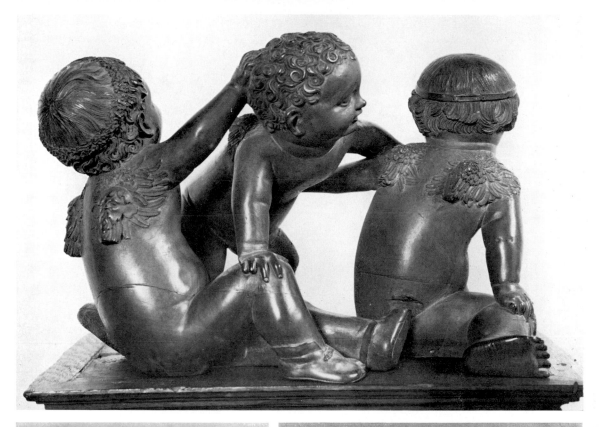

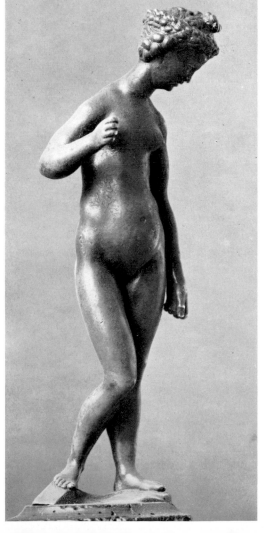

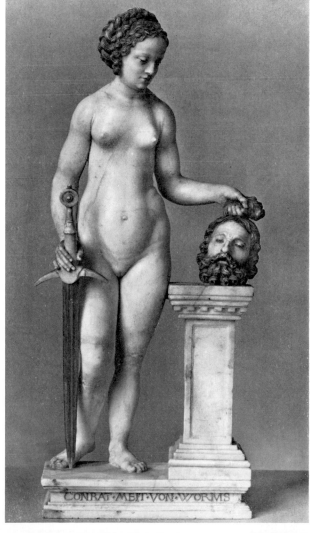

CONRAT·MEIT·VON·WORMS·

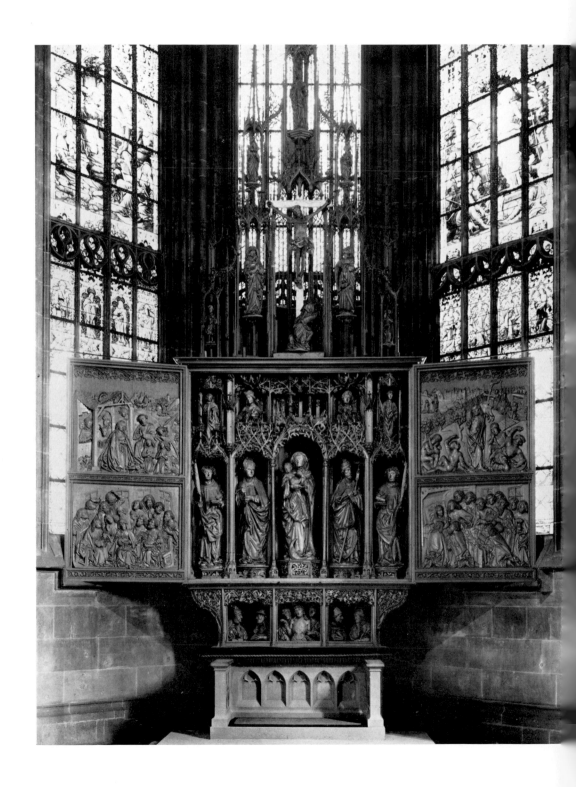

21. Niclas Hagnower: St Anthony, St Augustine, and St Jerome, central part of the Isenheim Altar, c. 1500–10. *Colmar, Musée d'Unterlinden*

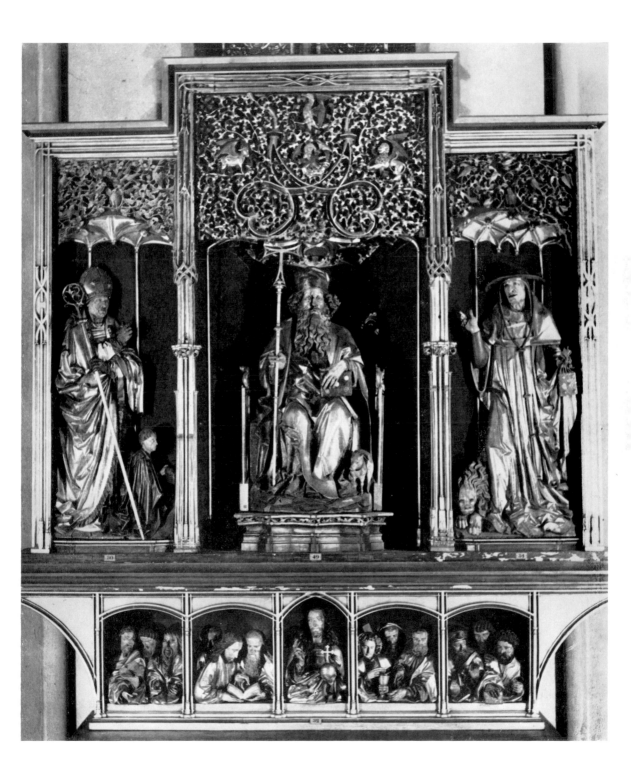

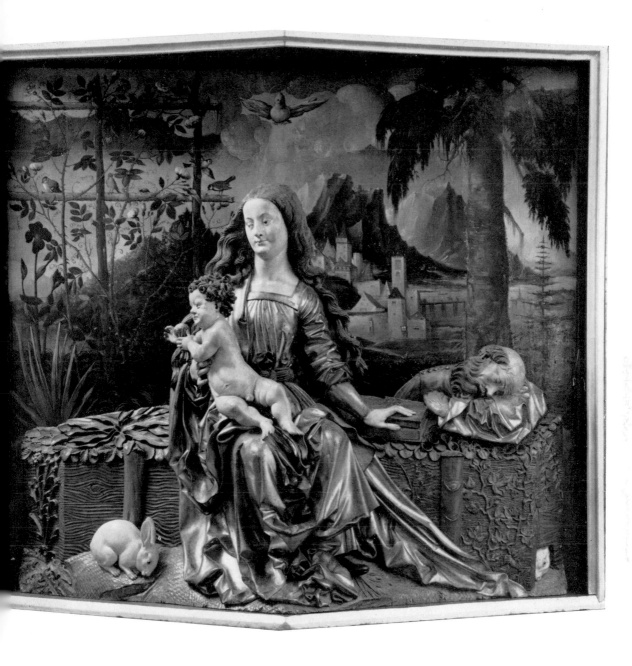

22. Middle Rhenish: Figure from Crucifixion from Mosbach, *c.* 1520–5. *Darmstadt, Hessisches Landesmuseum*

23. Master HL: St George, *c.* 1510–15. *Munich, Bayerisches National-Museum*

24. Hans Wydyz the elder: Rest on the Flight into Egypt, from the Schnewlin altar, *c.* 1514/15. *Freiburg, Minster*

25. Sebastian Loscher:
Bust from the choir-stalls
in the Fugger Chapel at
Augsburg, *c.* 1510–18.
*East Berlin, Staatliche
Museen*

26. Gregor Erhart: Model
of a horse for the
equestrian statue of
Maximilian I, *c.* 1508–9.
*West Berlin, Staatliche
Museen*

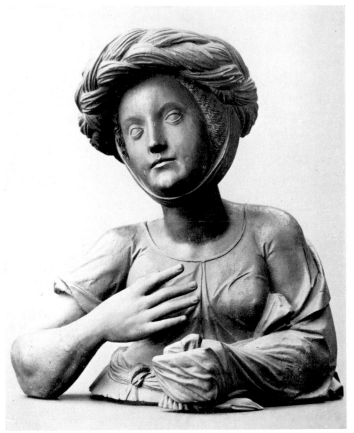

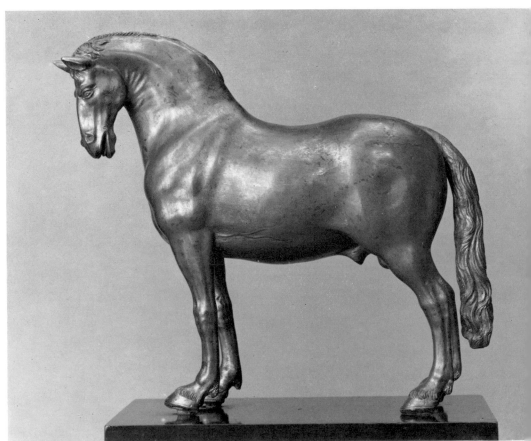

27. Jörg Muscat:
Maximilian I, *c.* 1500.
*Vienna, Kunsthistorisches
Museum*

28. Netherlandish(?):
Charles V, *c.* 1517. *Bruges,
Musée Gruuthuse*

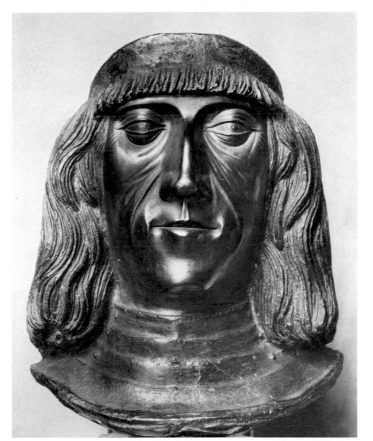

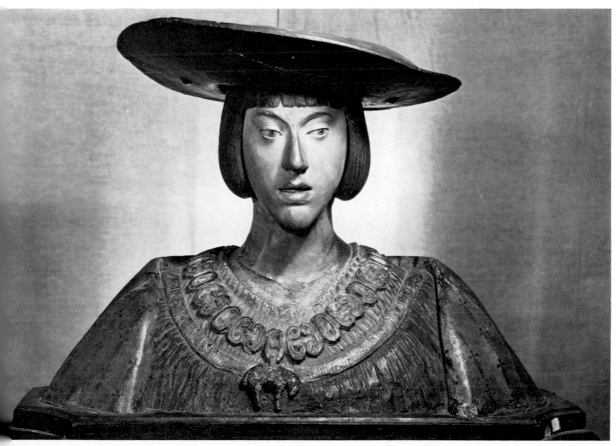

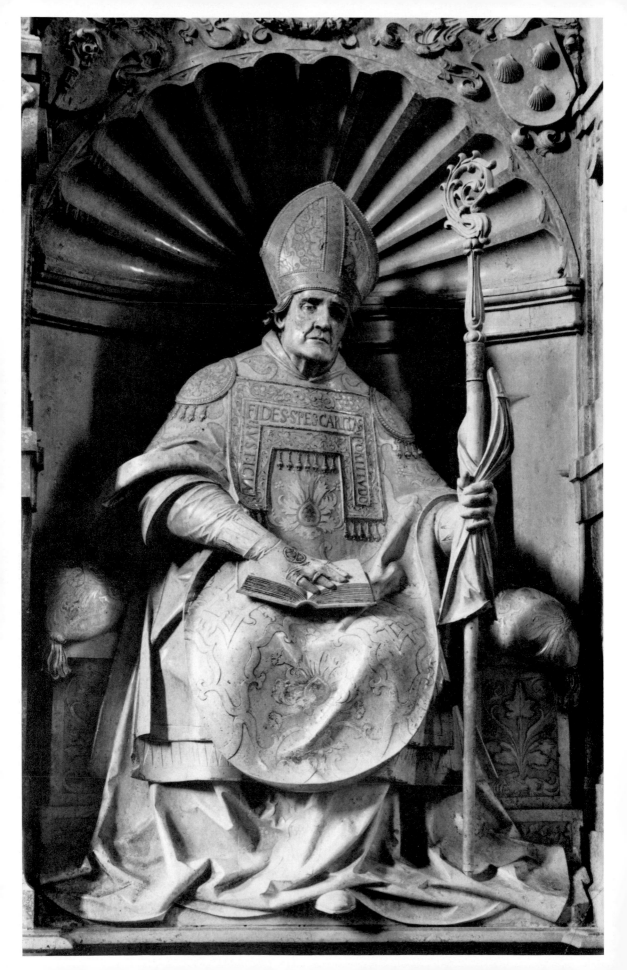

29. Loy Hering: St Willibald, 1514. *Eichstätt Cathedral*

30. Hans Daucher: Christ supported by the Virgin, St John, and an Angel, from the altar, complete by 1518. *Augsburg, Fugger Chapel*

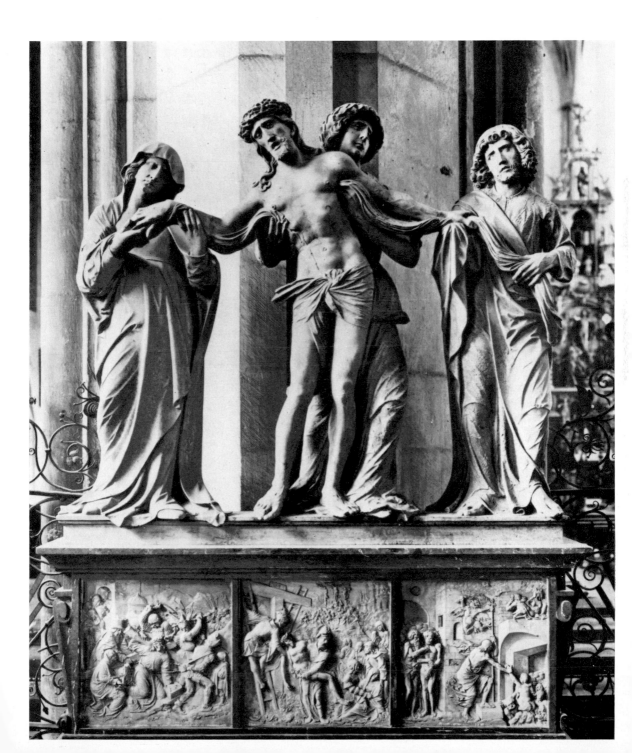

31. Hans Leinberger: Virgin
and Child, *c.* 1518–20.
Landshut, St Martin

32. Hans Leinberger:
Albrecht von Habsburg,
on the monument of the
Emperor Maximilian,
c. 1514–18. *Innsbruck,
Hofkirche*

33. Gregor Erhart:
Virgin of the Misericord,
c. 1510. *Frauenstein an der*
Steyr, Pfarrkirche

34. Hans Leinberger:
Crucifixion, 1516.
Munich, Bayerisches
Nationalmuseum

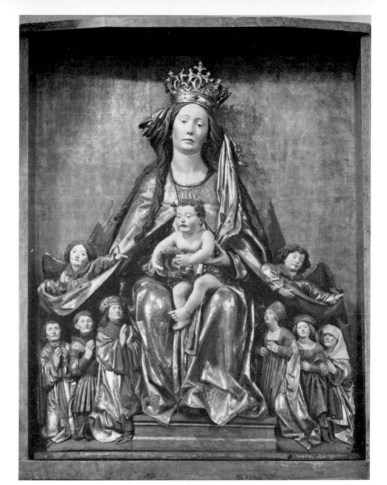

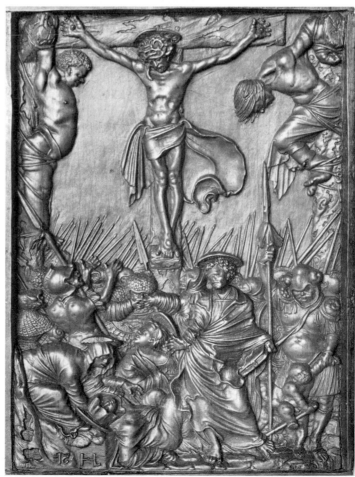

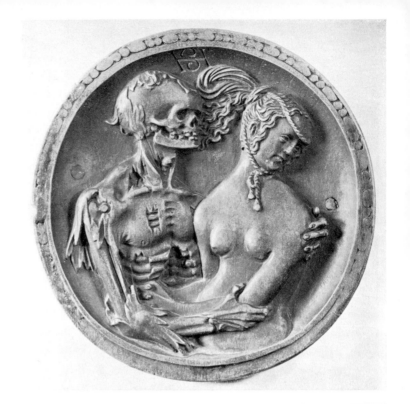

35. Hans Schwarz:
Death and the Maiden,
c. 1520. *West Berlin,
Staatliche Museen*

36. Master of Mauer:
Altar of the Virgin,
c. 1510–20(?). *Mauer,
near Melk*

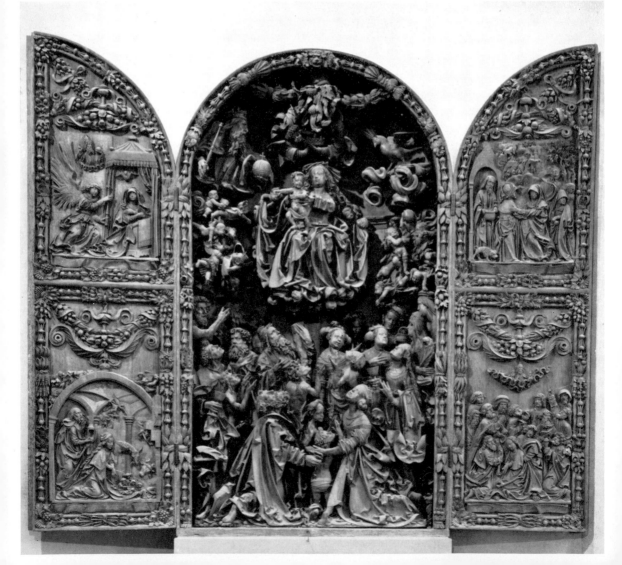

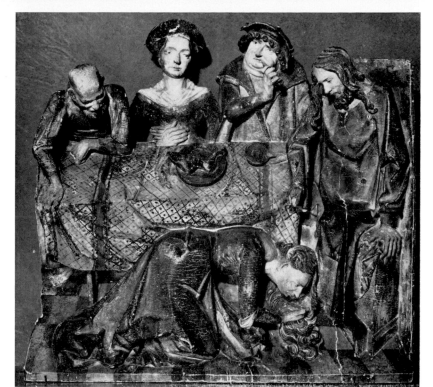

37. Benedikt Dreyer:
Feast at the House of
Simon, from the
Lendersdorf altar,
*c. 1515. Providence,
Rhode Island School of
Design*

38. Hans Leinberger:
High altar (central
panel), 1511–14.
*Moosburg, collegiate
church*

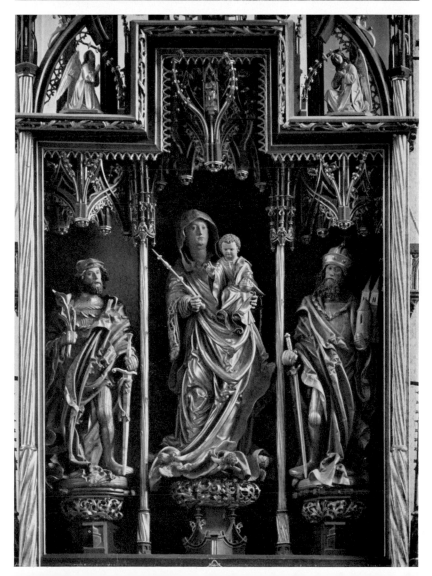

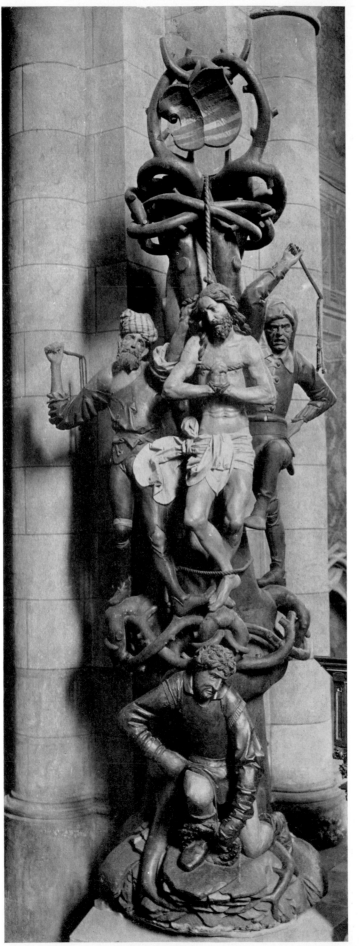

39. Hans Witten: Scourging of Christ, *c.* 1515. *Chemnitz, Schlosskirche*

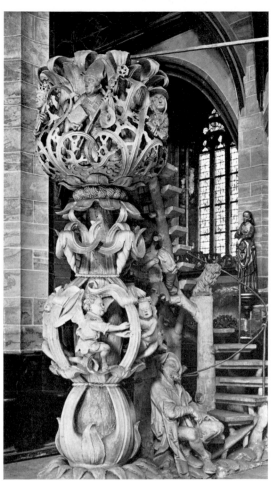

40. Hans Witten: Tulip Pulpit, *c.* 1510–15. *Freiberg Cathedral*

41. Hans Witten: Pietà, *c.* 1510–15. *Goslar, Jakobikirche*

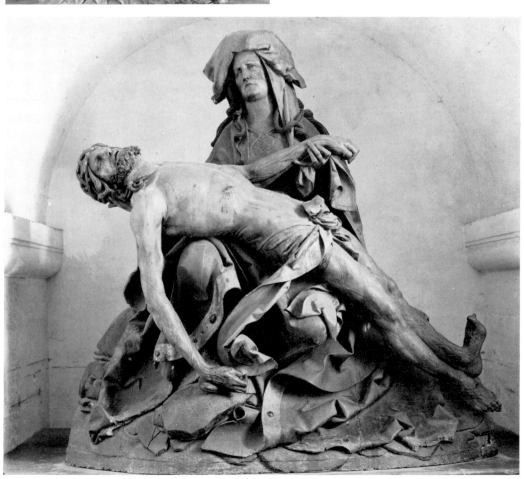

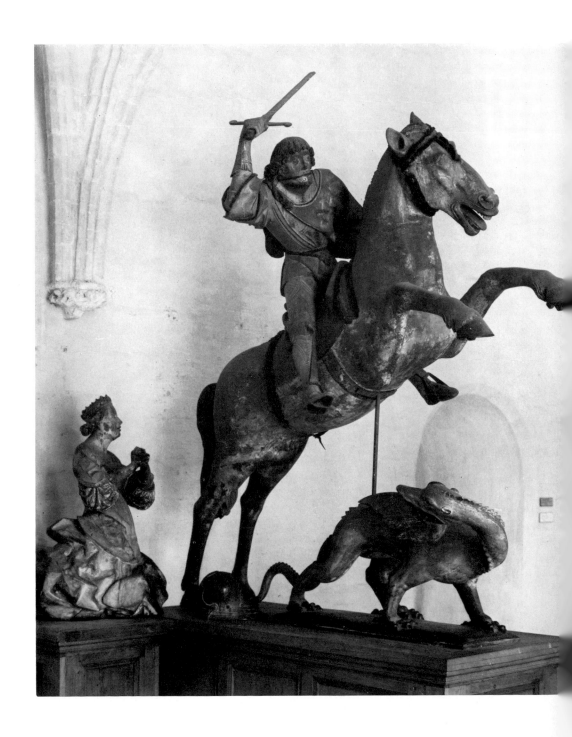

49. Henning von der Heide: St George and the Dragon, 1504–5. *Lübeck, Annenmuseum*

50. Hans Brüggemann: St George and the Dragon, from Husum, *c.* 1520–5. *Copenhagen, Nationalmuseet*

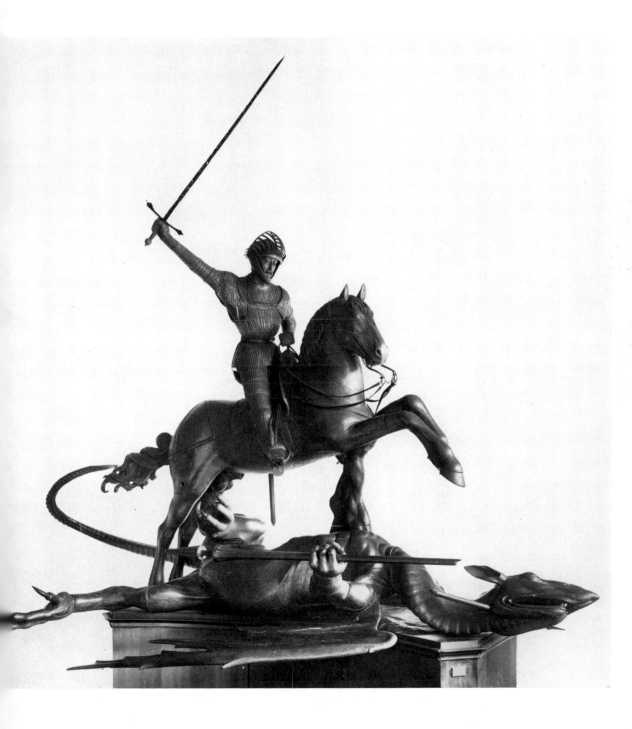

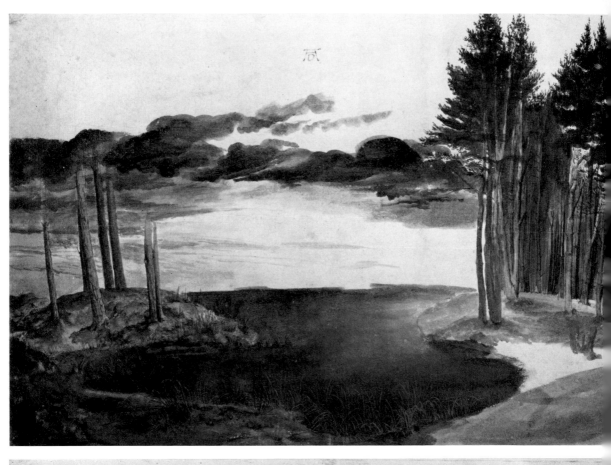

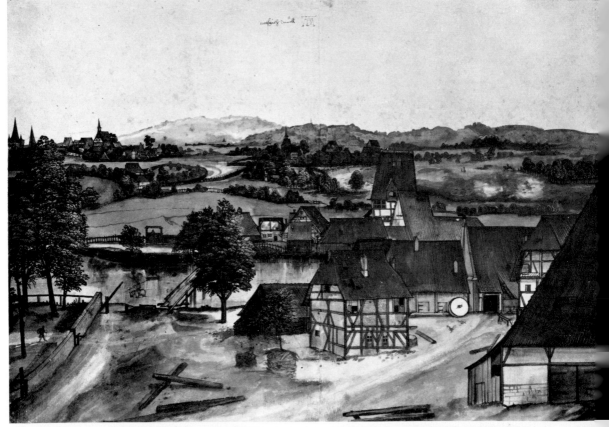

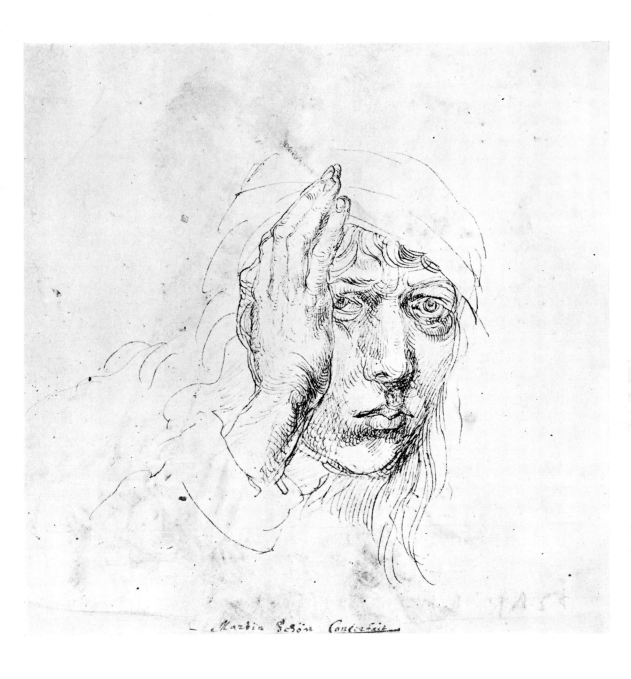

51. Albrecht Dürer: Pool in the Woods, c. 1497–8. Water-colour. *London, British Museum*

52. Albrecht Dürer: Wire-drawing Mill, c. 1489–90. Water-colour. *West Berlin, Staatliche Museen*

53. Albrecht Dürer: Self-portrait, 1491(?). Drawing. *Erlangen, Universitätsbibliothek*

54. Albrecht Dürer: Nude Woman from the back, 1495. Drawing. *Paris, Louvre*

55. Albrecht Dürer: Portrait of his Mother, 1514. Drawing *West Berlin, Staatliche Museen*

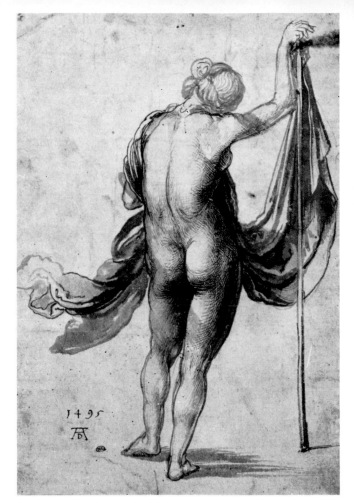

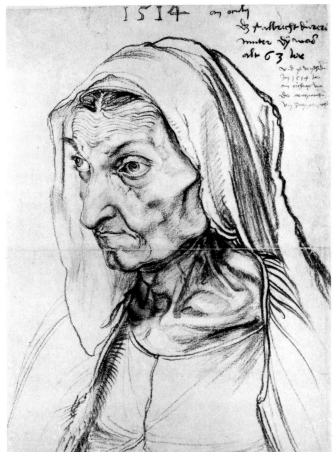

56. Albrecht Dürer: St Apollonia, 1521. Drawing. *West Berlin, Staatliche Museen*

57. Albrecht Dürer: Lucas van Leiden, 1521. Drawing. *Lille, Musée des Beaux-Arts*

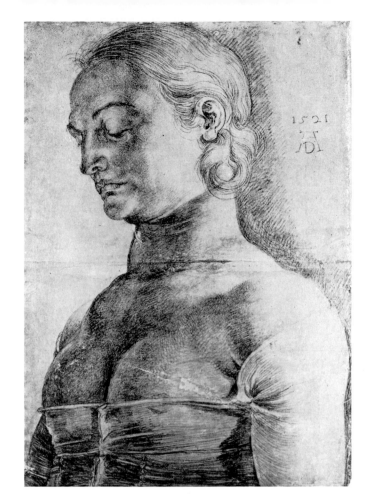

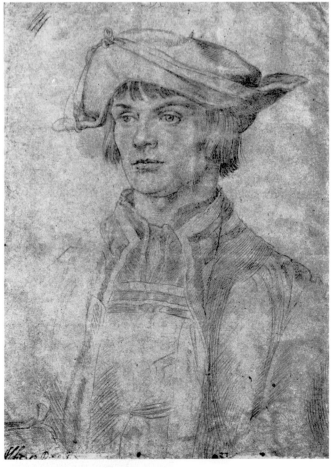

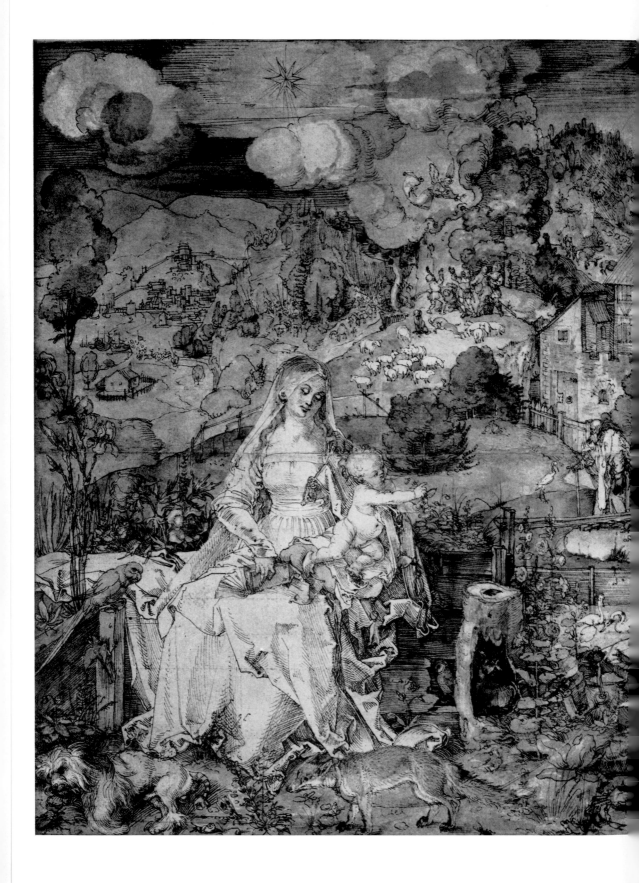

62. Albrecht Dürer: Virgin with many Animals, 1503. Drawing and water-colour. *Vienna, Albertina*

63. Albrecht Dürer: The Emperor Maximilian's prayer-book, fol. 46, 1515. Type and drawing. *Munich, Staatsbibliothek*

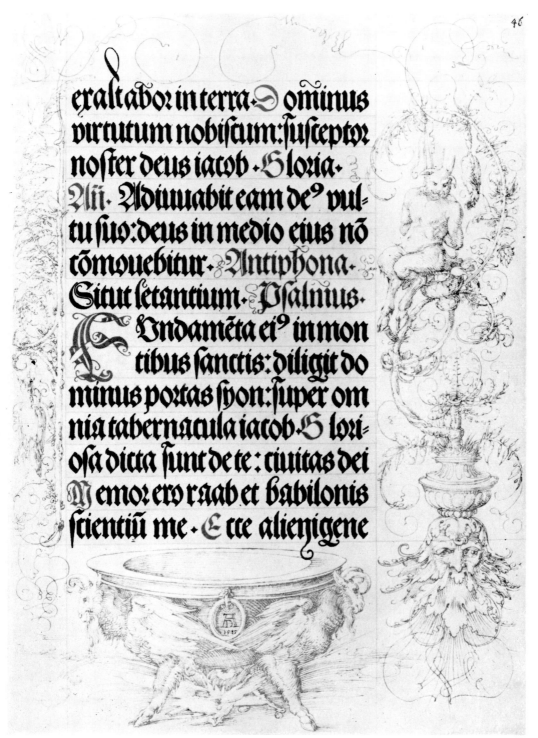

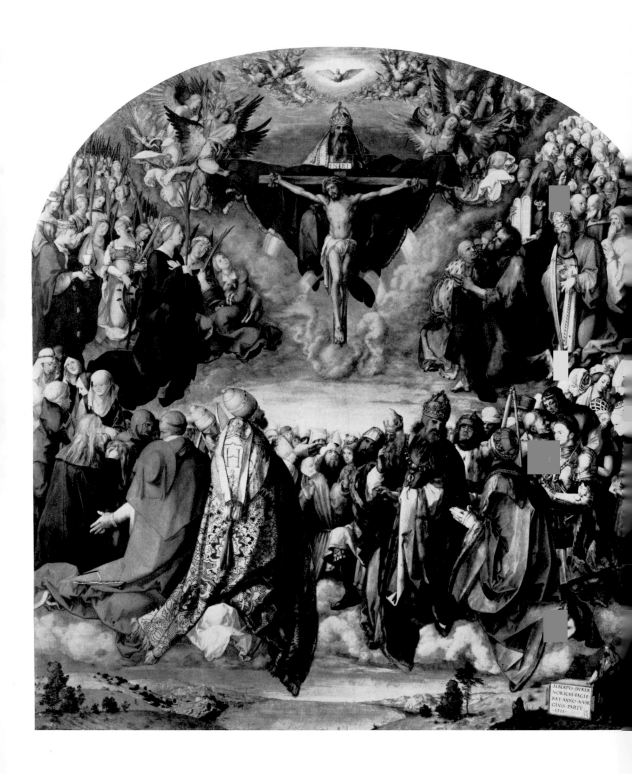

67. Albrecht Dürer: All Saints, 1508–11. *Vienna, Kunsthistorisches Museum*

68. Albrecht Dürer: Four 'Apostles', *c.* 1525. *Munich, Alte Pinakothek*

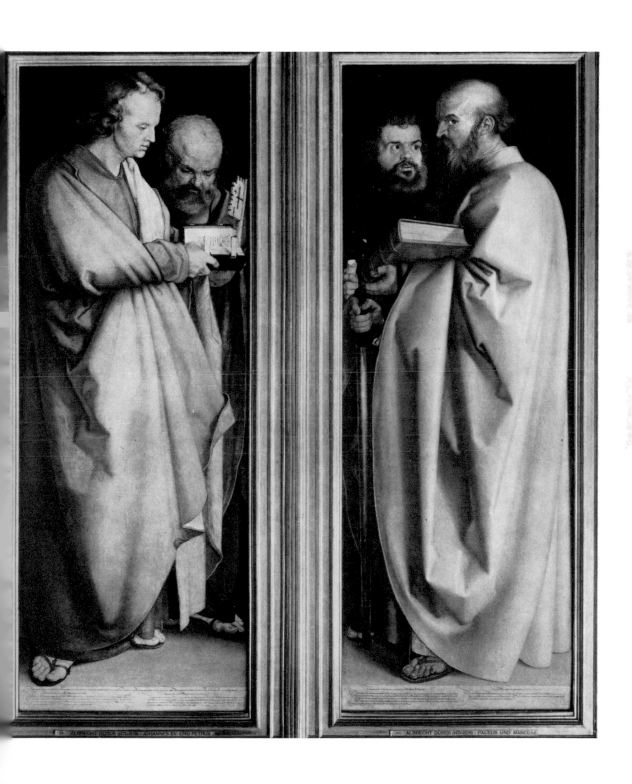

69. Albrecht Dürer:
Hieronymus Holzschuher,
1526. *West Berlin,
Staatliche Museen*

70. Albrecht Dürer: Jacob
Muffel, 1526. *West Berlin,
Staatliche Museen*

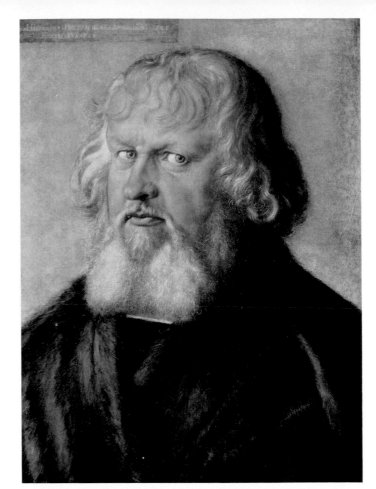

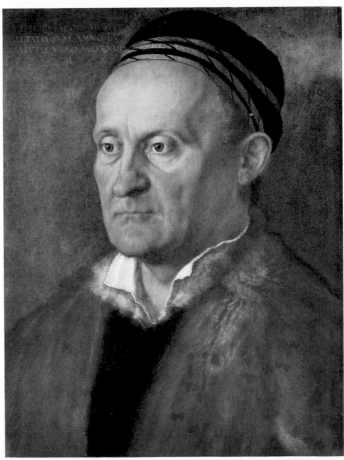

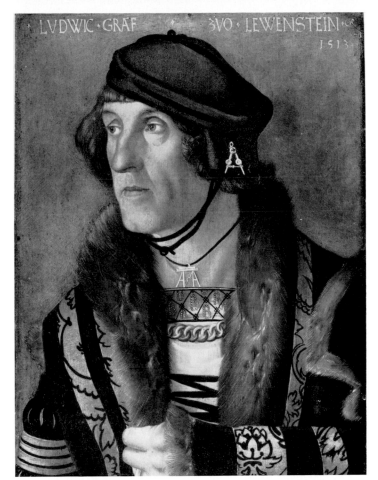

71. Hans Baldung: Count
Löwenstein, 1513. *West
Berlin, Staatliche Museen*

72. Hans von Kulmbach:
Margrave Casimir of
Hohenzollern, 1511.
Munich, Alte Pinakothek

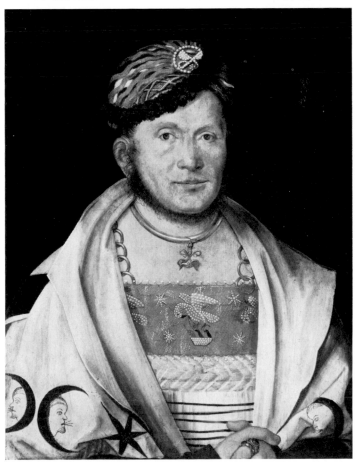

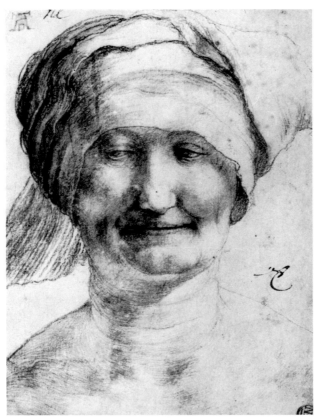

73. Mathis 'Grünewald':
Portrait of a Smiling Woman.
Chalk drawing. *Paris, Louvre*

74. Hans Baldung: Saturn, 1516.
Drawing. *Vienna, Albertina*

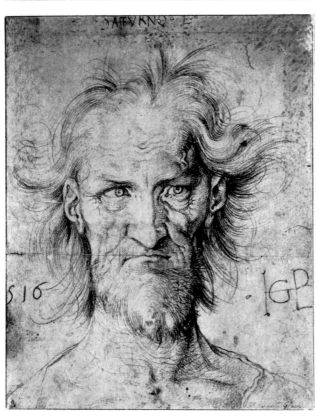

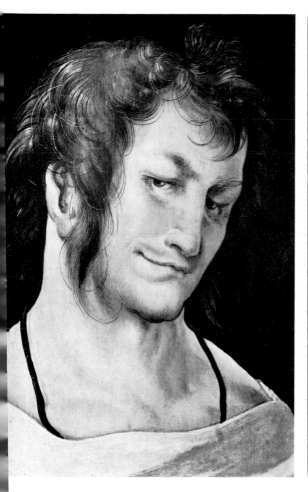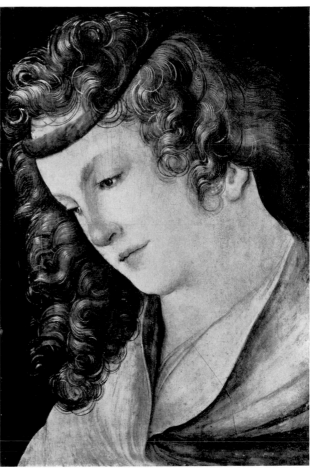

75. Hans Schäufelein: Head of a Young Man, 1511. *Vienna, Kunsthistorisches Museum*

76. Hans Schäufelein: Head of a Young Woman, 1511. *Vienna, Kunsthistorisches Museum*

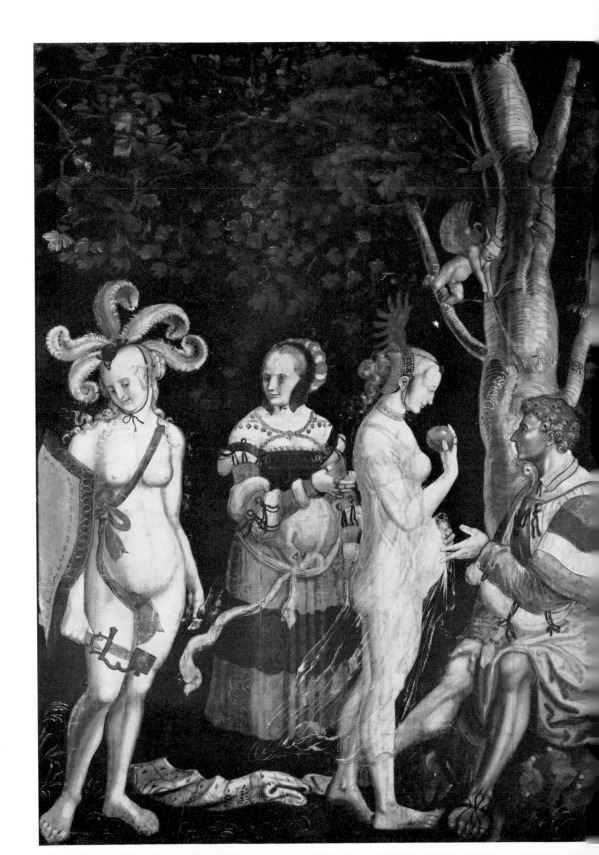

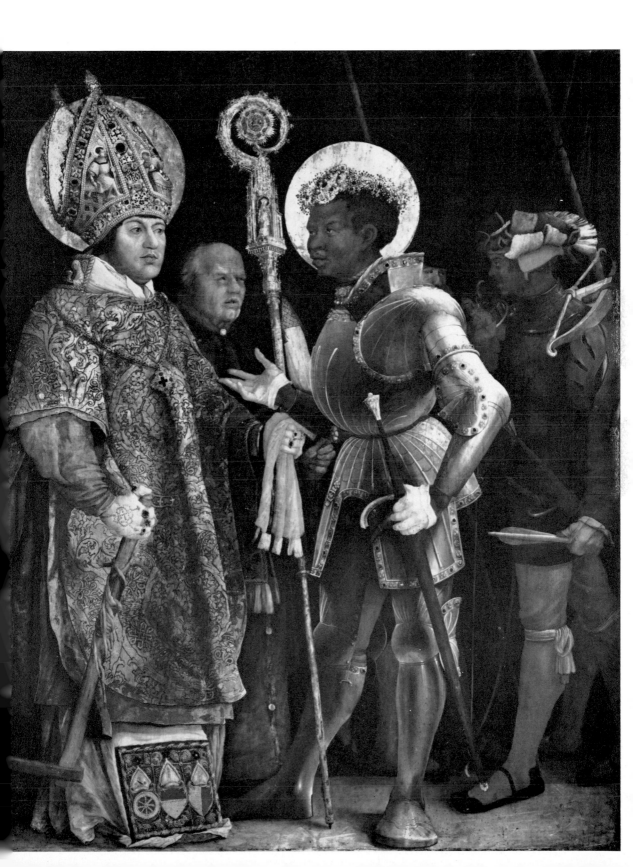

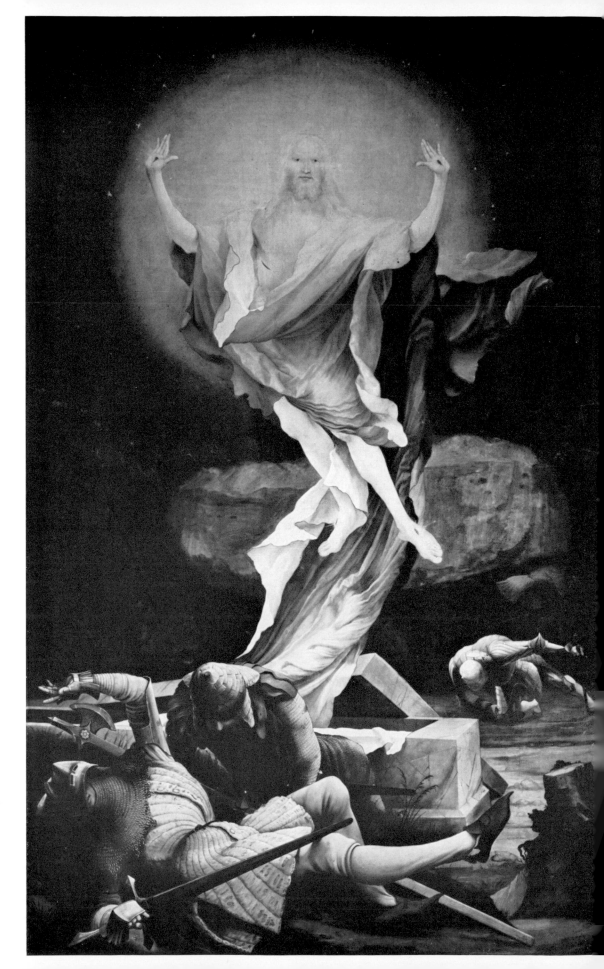

85. Mathis
'Grünewald':
Resurrection from
the Isenheim Altar
(detail), *c.* 1513–15.
*Colmar, Musée
d'Unterlinden*

86. Ambrosius
Holbein: Boy with
Brown Hair, *c.* 1518.
Basel, Kunstmuseum

87. Sigmund
Holbein (?):
Xilotectus, 1520.
*Nuremberg,
Germanisches
National-Museum*

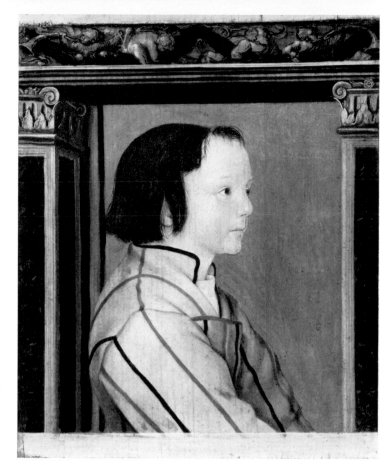

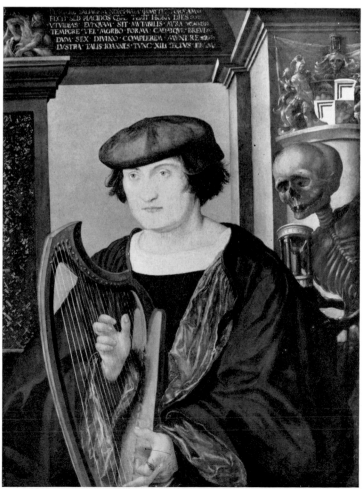

88. Nikolaus
Manuel Deutsch:
Beheading of St
John the Baptist,
c. 1515–20. *Basel,
Kunstmuseum*

89. Hans Leu the
younger: Orpheus
and the Animals,
1519. *Basel,
Kunstmuseum*

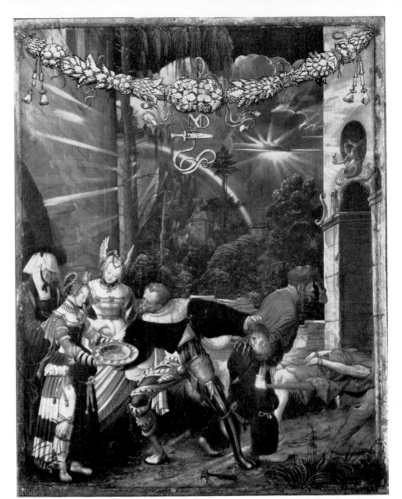

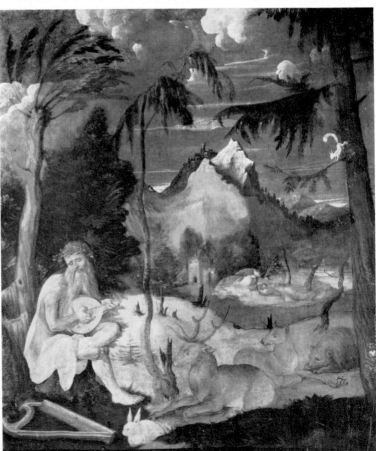

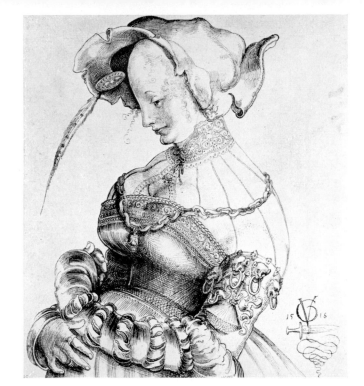

90. Urs Graf: Girl in her
Finery, 1518. Drawing.
*Basel, Kunstmuseum,
Kupferstichkabinett*

91. Jörg Ratgeb: Flagellation
and other scenes from the
Herrenberg altar, 1519.
Stuttgart, Staatsgalerie

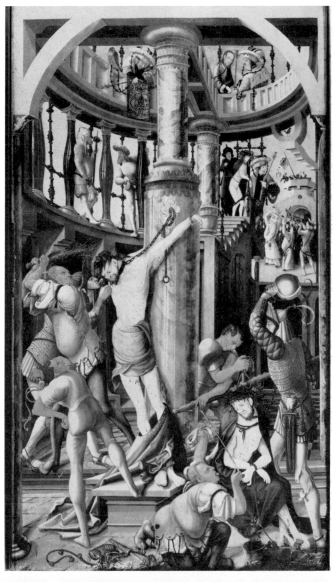

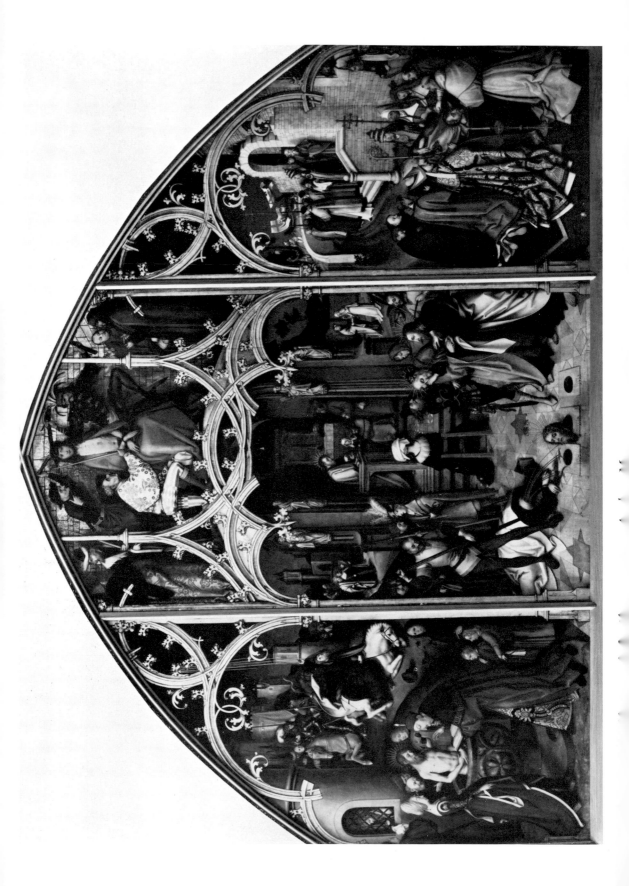

93. Hans Burgkmair the elder: Altar of St John, 1518. *Munich, Alte Pinakothek*

94. Hans Burgkmair the elder: Virgin and Child, 1509. *Nuremberg, Germanisches National-Museum*

95. Hans Holbein the elder: Fountain of Life, 1519(?). *Lisbon, Museu Nacional de Arte Antiga*

96. Ulrich Apt the elder: Adoration of the Shepherds, from Augsburg, 1510. *Karlsruhe, Kunsthalle*

97. Hans Burgkmair the elder: Anna Laminit, *c.* 1503–5. *Nuremberg, Germanisches National-Museum*

98. Hans Holbein the elder: Portrait of a thirty-four-year-old Woman, *c.* 1512. *Basel, Kunstmuseum*

99. Hans Burgkmair the elder: Sebastian Brant, *c.* 1508. *Karlsruhe, Kunsthalle*

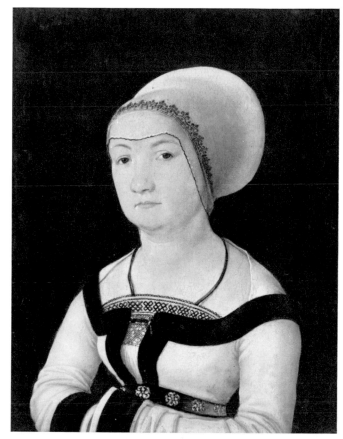

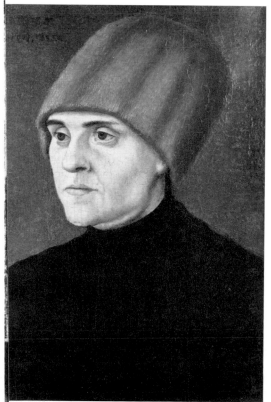

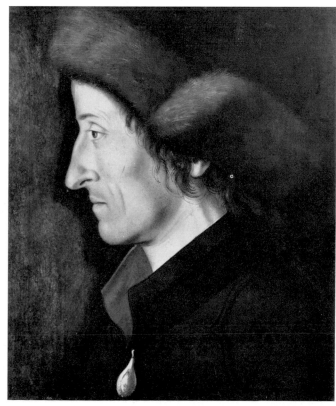

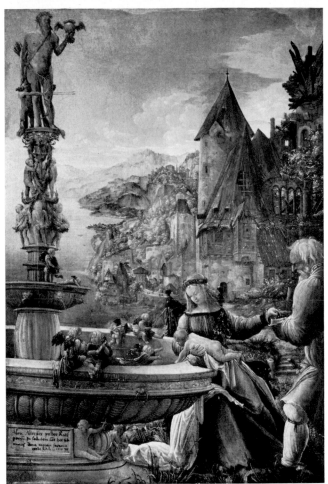

104. Albrecht Altdorfer: Rest on
the Flight into Egypt, 1510.
West Berlin, Staatliche Museen

105. Albrecht Altdorfer:
Nativity, *c.* 1515. *West Berlin,
Staatliche Museen*

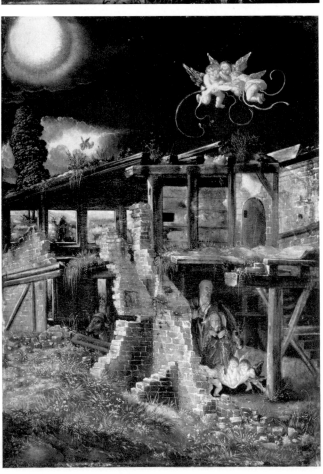

106. Albrecht Altdorfer: Last Supper, 1517. *Regensburg, Museum*

107. Albrecht Altdorfer: Resurrection, 1518. *St Florian*

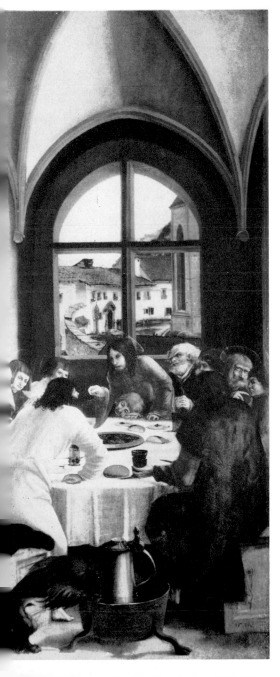
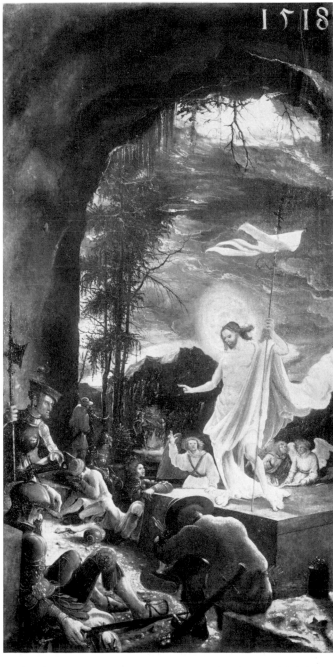

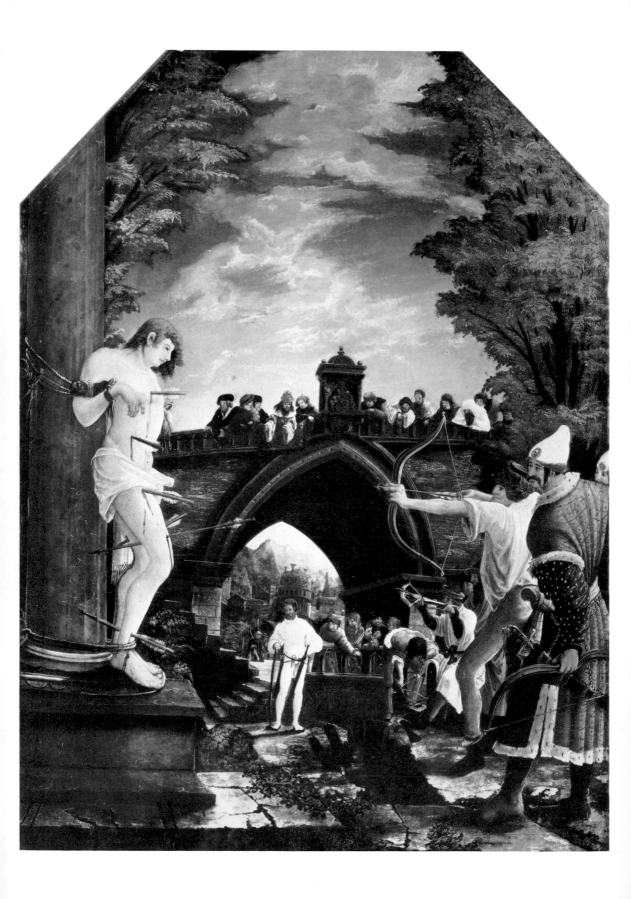

108. Albrecht
Altdorfer:
Martyrdom of St
Sebastian, 1518.
St Florian

109. Albrecht
Altdorfer:
Crucifixion, *c.* 1510.
*Kassel,
Gemäldegalerie*

110. Albrecht
Altdorfer: St John
the Evangelist and
St John the Baptist,
c. 1510. *Munich,
Alte Pinakothek*

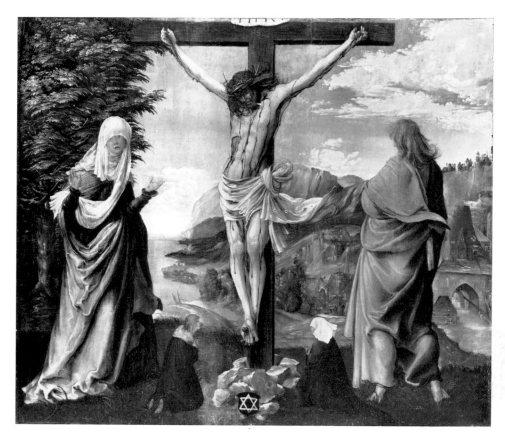

111. Albrecht Altdorfer:
Lovers in the Cornfield,
1508. Pen drawing. *Basel,
Kunstmuseum*

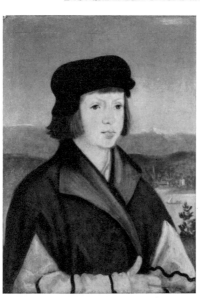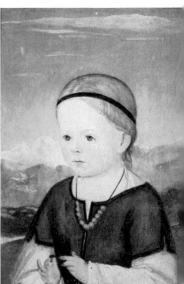

112. Master of the Portraits of the Thenn Children: The Thenn Children, 1516. *Frankfurt,
Städelsches Kunstinstitut*

113. Wolfgang Huber: Mondsee, 1510. Drawing. *Nuremberg, Germanisches National-Museum*

114. Albrecht Altdorfer: The Danube at Sarmingstein, 1511. Pen drawing. *Budapest, Szépmüvészeti Muzeum*

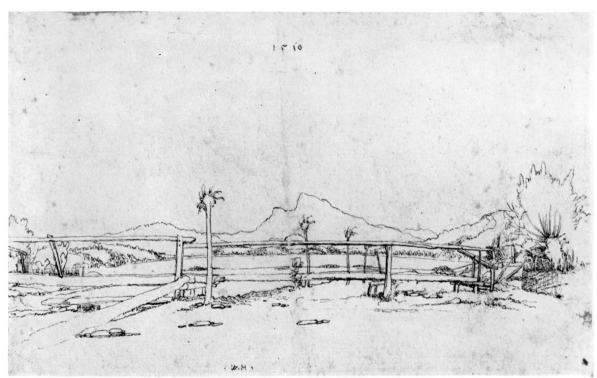

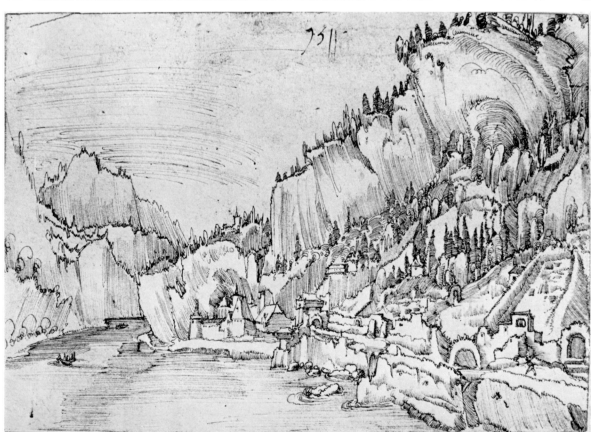

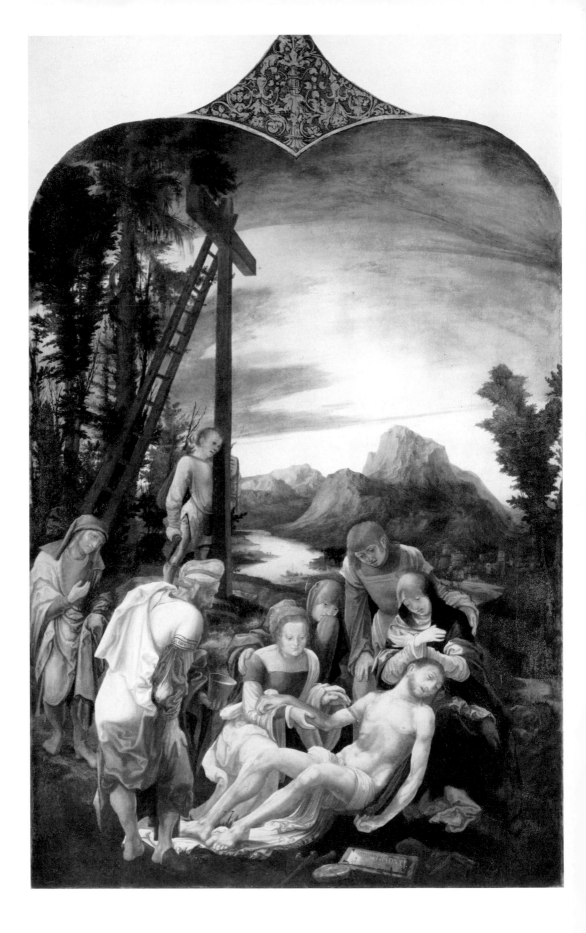

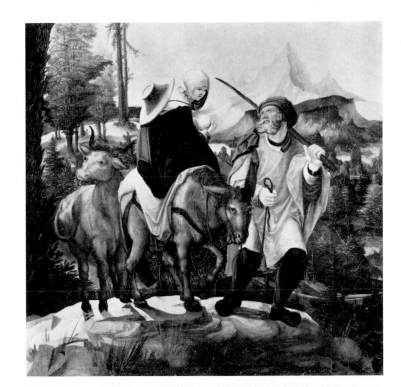

115. Wolfgang Huber:
Lamentation, 1521. *Feldkirch,
Stadtpfarrkirche*

116. Wolfgang Huber: Flight into
Egypt, *c.* 1515. *West Berlin, Staatliche
Museen*

117. Lucas Cranach the elder:
Stigmatization of St Francis,
c. 1500–5. *Vienna, Akademie*

118. Lucas Cranach the elder:
Crucifixion, 1503. *Munich, Alte
Pinakothek*

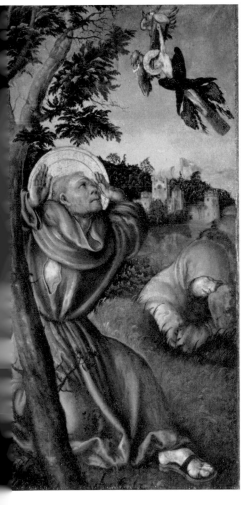

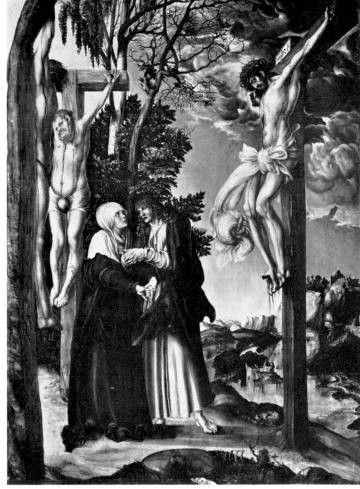

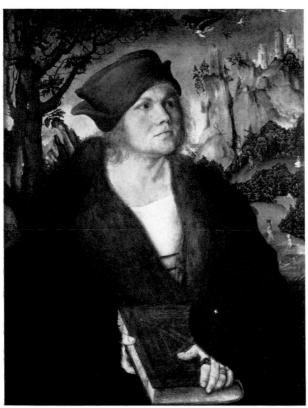

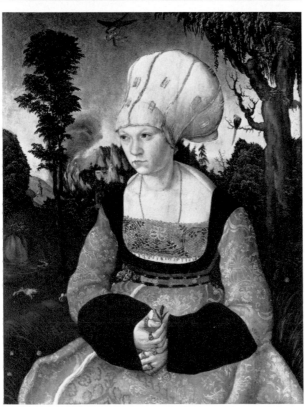

119. Lucas Cranach the elder: Johann Cuspinian, *c.* 1503. *Winterthur, Oskar Reinhart Collection*

120. Lucas Cranach the elder: Frau Cuspinian, *c.* 1503. *Winterthur, Oskar Reinhart Collection*

121. Lucas Cranach the elder: Rest on the Flight into Egypt, 1504. *West Berlin, Staatliche Museen*

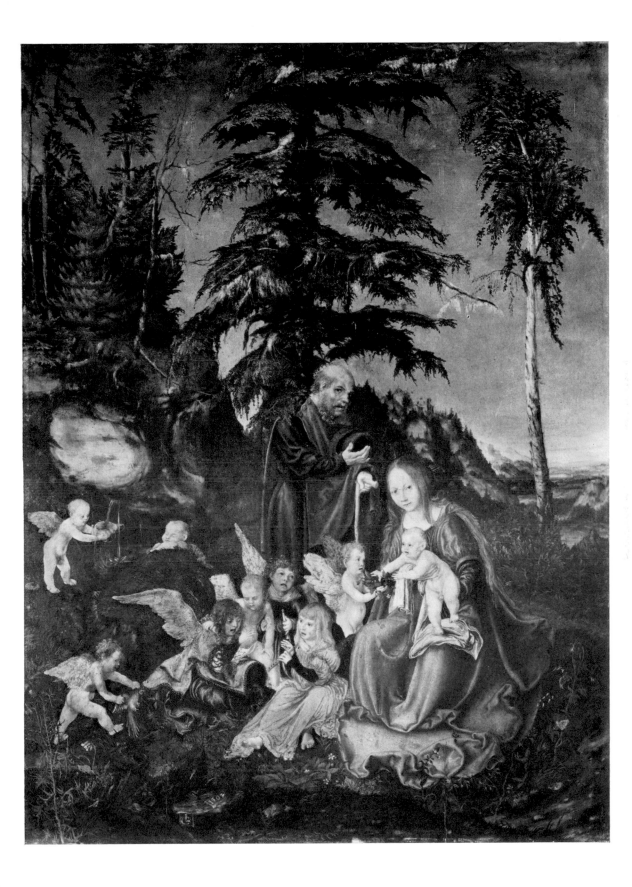

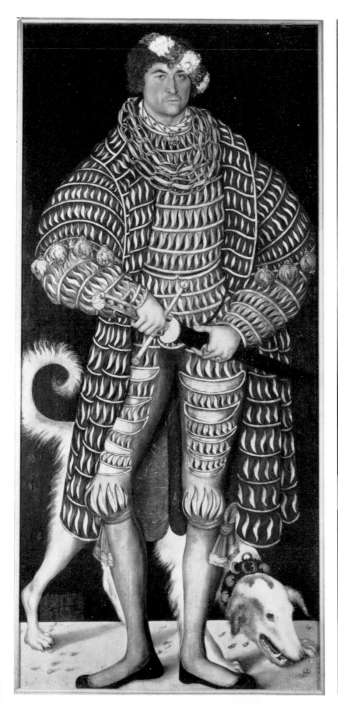
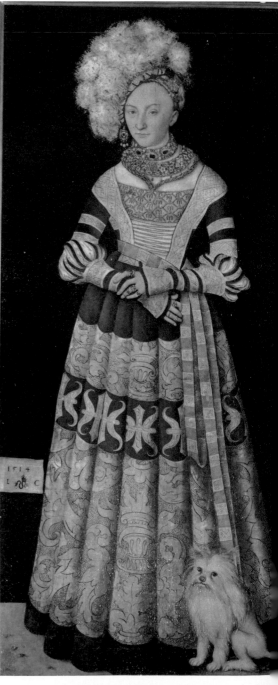

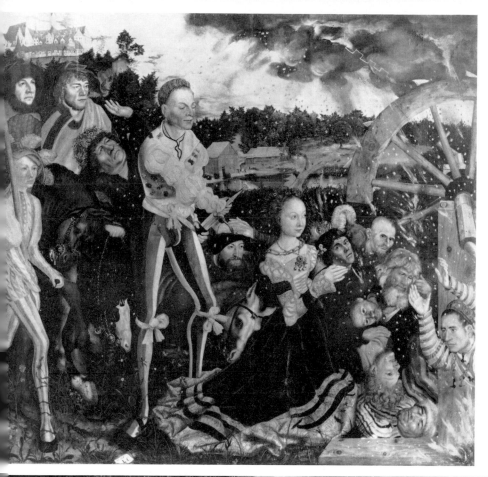

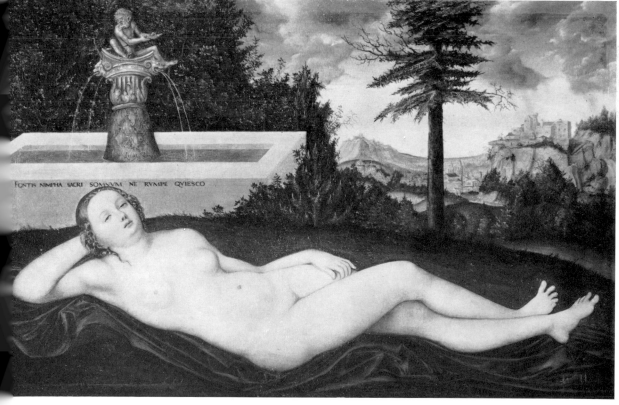

FONTIS NIMPHA SACRI SOMNVM NE RVMPE QVIESCO

126. Master of St
Severin:
Stigmatization of
St Francis,
c. 1500–10. *Cologne,
Wallraf-Richartz-
Museum*

127. Quentin
Massys: Betrothal
of St Catherine,
c. 1500. *London,
National Gallery*

128. St
Bartholomew
Master: Altar of
St Thomas, *c.* 1501.
*Cologne, Wallraf-
Richartz-Museum*

129. Quentin
Massys:
Lamentation altar,
1507–9. *Antwerp,
Koninklijk Museum
voor Schone Kunsten*

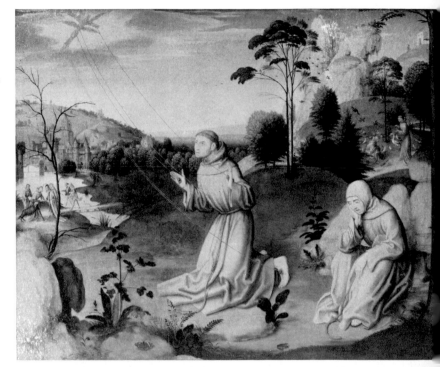

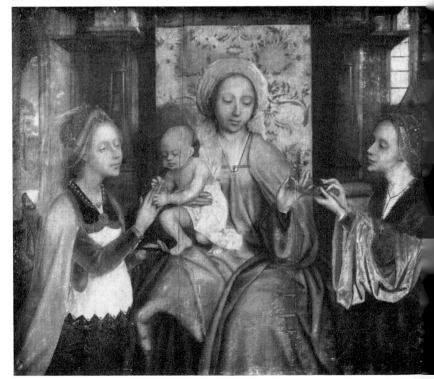

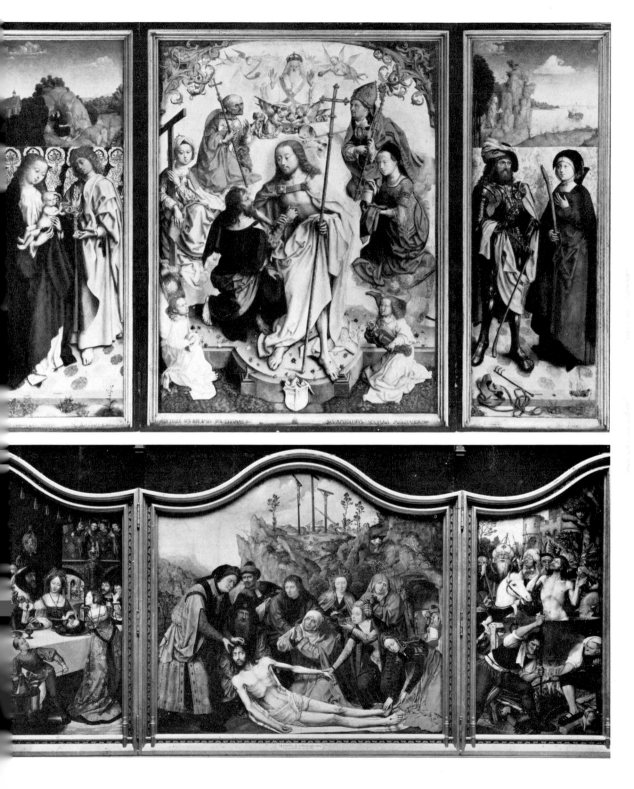

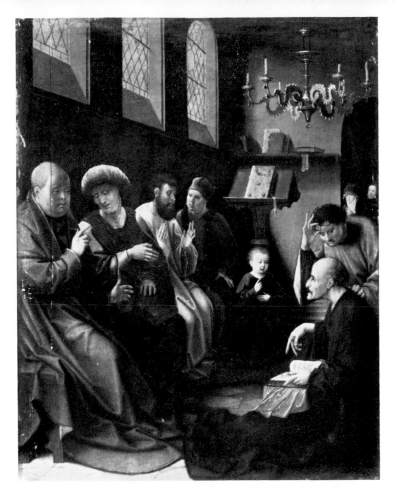

130. Jan Joest von Kalkar: Christ in the Temple, 1505. *Palencia Cathedral*

131. Jan Joest von Kalkar: Arrest of Christ, 1505–8. *Kalkar, Nikolaikirche*

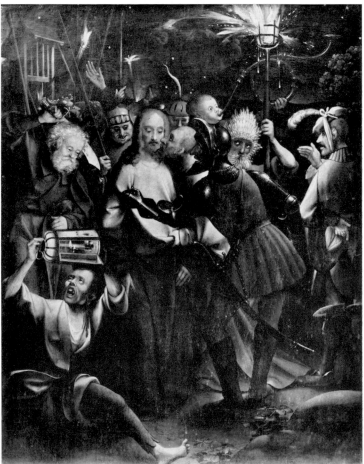

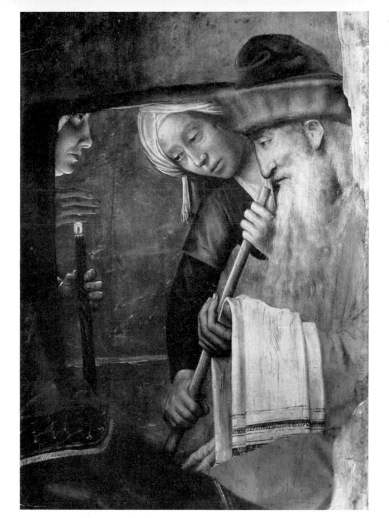

132. Quentin Massys:
Lamentation altar (detail),
1507–9. *Antwerp,
Koninklijk Museum voor
Schone Kunsten*

133. Gerard David:
Deposition, *c.* 1500–5.
New York, Frick Collection

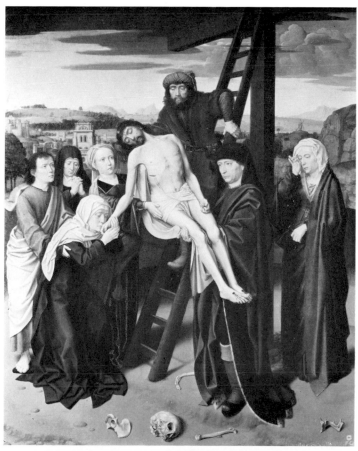

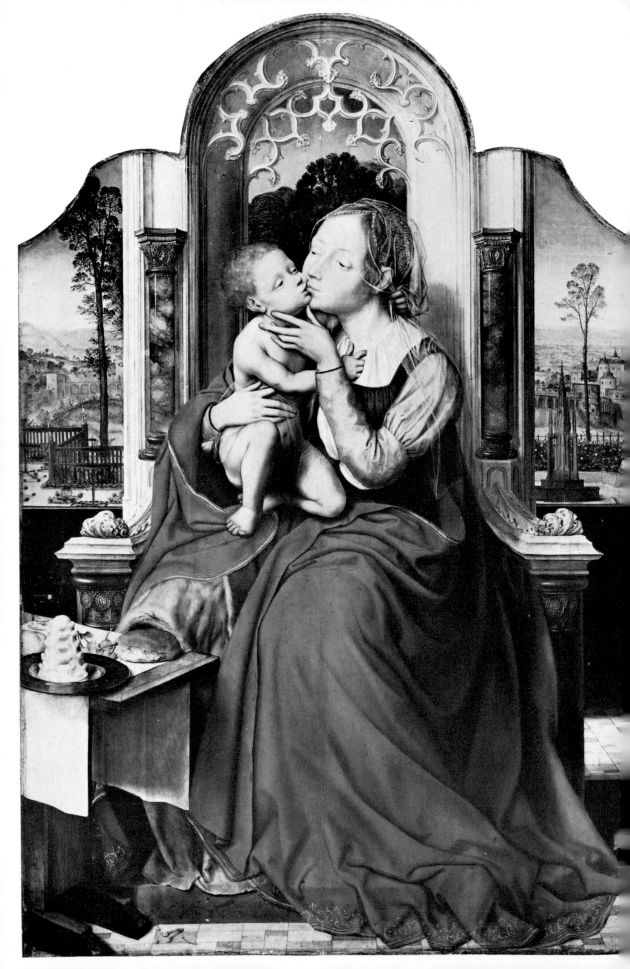

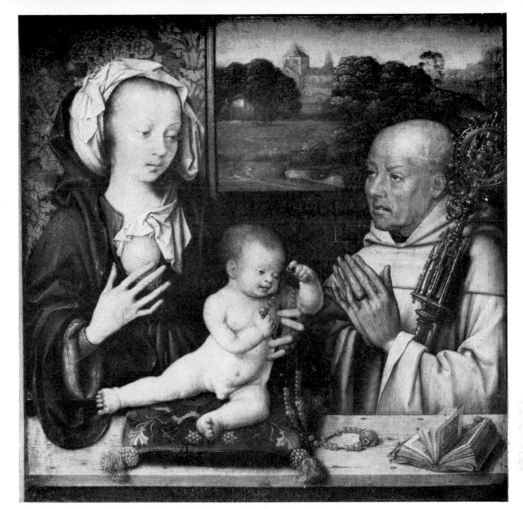

134. Quentin
Massys: Virgin
and Child,
c. 1520. *West
Berlin, Staatliche
Museen*

135. Joos van
Cleve: Adoration
of the Virgin by
St Bernard,
c. 1505–10. *Paris,
Louvre*

136. Quentin
Massys and
Joachim Patinir:
Temptation of
St Anthony,
c. 1515–25.
Madrid, Prado

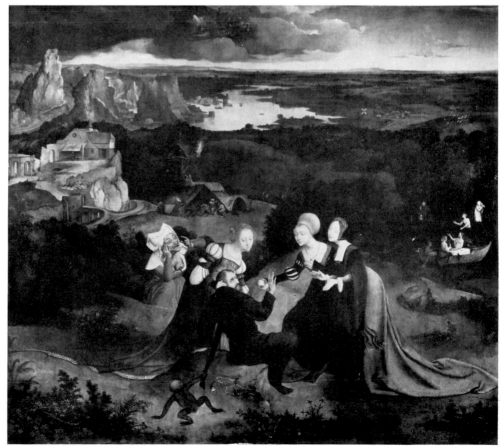

137. Michel Sittow:
Knight of the Order of
Calatrava, *c.* 1500–10.
*Washington, National
Gallery of Art*

138. Bernart van Orley:
Charles V, *c.* 1518.
*Budapest, Szépmüvészeti
Muzeum*

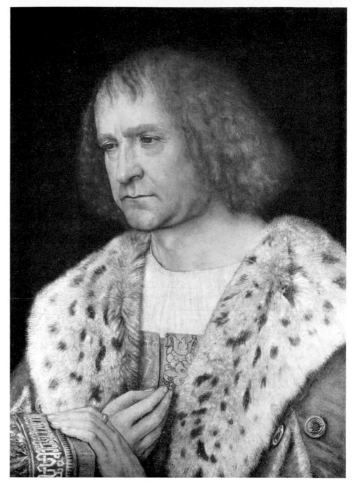

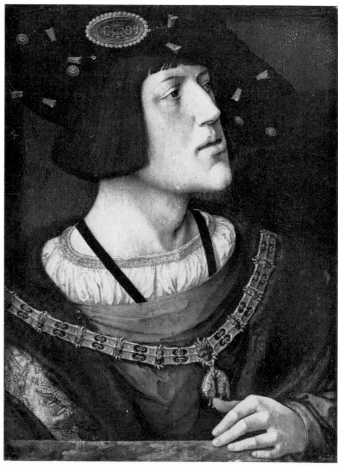

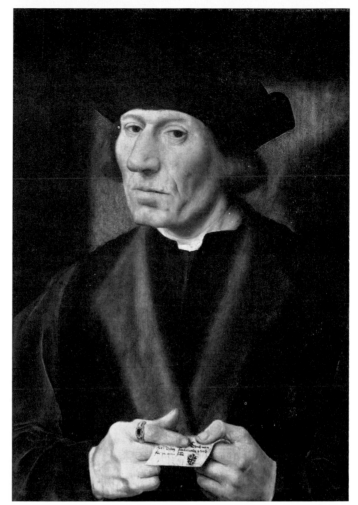

139. Quentin Massys: A
Pilgrim to Jerusalem, 1509
or later. *Winterthur, Oskar
Reinhart Collection*

140. Quentin Massys:
Portrait of an old Woman,
c. 1510–20. *London,
National Gallery*

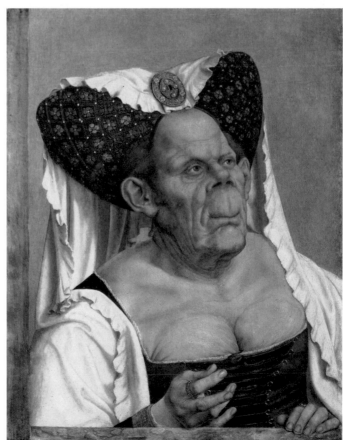

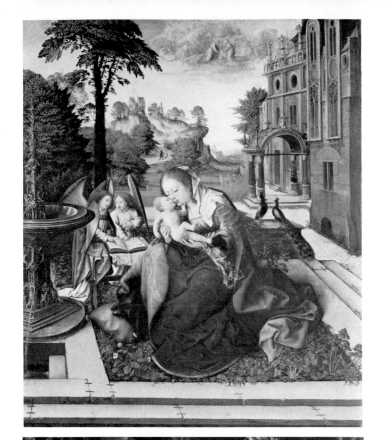

141. Bernart van Orley:
Virgin and Child with
Angels, *c*. 1515. *New York,*
Metropolitan Museum of Art

142. Jan Provost:
Disputation of
St Catherine, *c*. 1515–25.
Rotterdam, Museum
Boymans-Van Beuningen

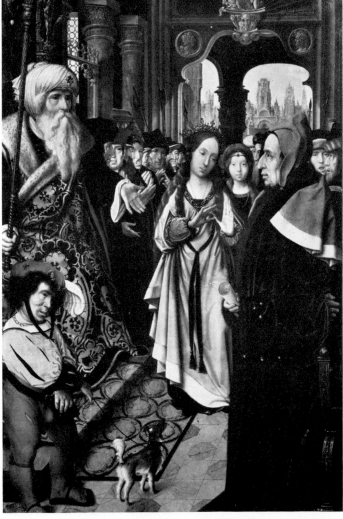

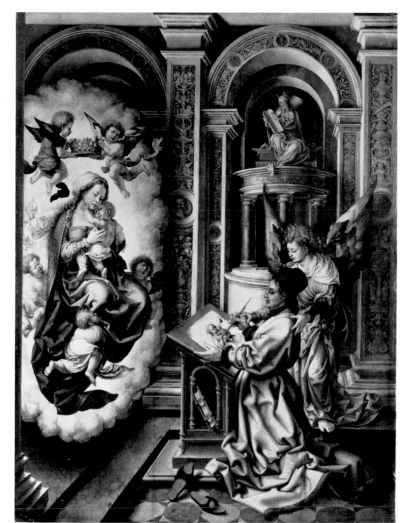

143. Jan Gossaert:
Virgin with St Luke,
c. 1515. *Vienna,
Kunsthistorisches
Museum*

144. Jan Gossaert:
Adoration of the
Magi, *c.* 1505.
*London, National
Gallery*

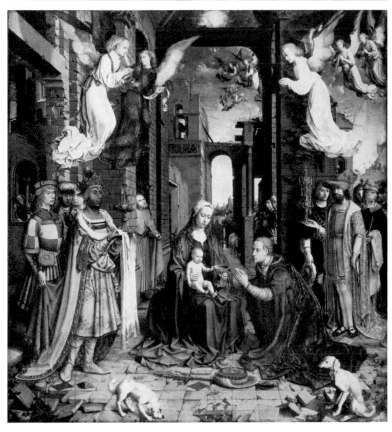

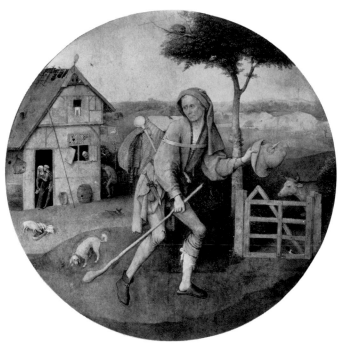

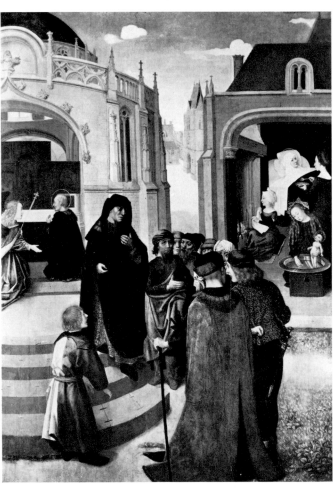

148. Hieronymus Bosch:
Tramp, *c.* 1510. *Rotterdam,
Museum Boymans-Van
Beuningen*

149. Hugo Jacobsz.: St John
altar. *Rotterdam, Museum
Boymans-Van Beuningen*

150. Hieronymus Bosch:
Crowning with Thorns,
c. 1500–10. *London, National
Gallery*

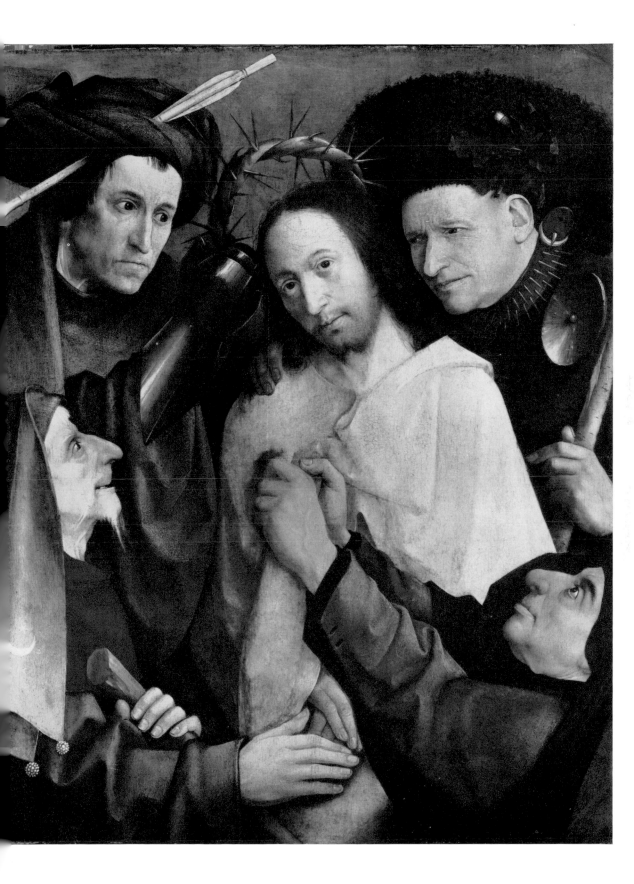

151. Jacob Cornelisz.
van Oostsanen: Christ
the Gardener, 1507.
Kassel, Gemäldegalerie

152. Jacob Cornelisz.
van Oostsanen: Self-
portrait, 1533.
Amsterdam, Rijksmuseum

153. Jan Mostaert: West Indian
Landscape, 1542 or shortly after.
Haarlem, Frans Hals Museum

154. Jan Mostaert: Holy Family under
the Apple Tree, *c.* 1515–20. *Rome,
Palazzo Venezia*

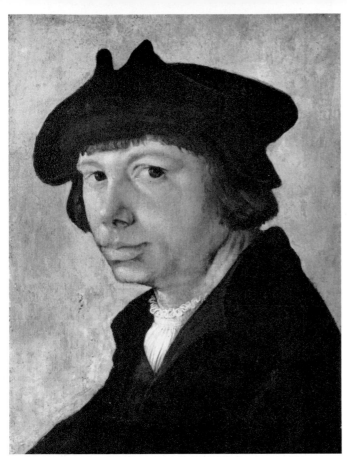

155. Lucas van Leiden: Self-portrait, *c.* 1515–20. *Brunswick, Anton-Ulrich-Museum*

156. Cornelis Engelbrechtsz.: The Emperor Constantine and St Helena, *c.* 1515–20. *Munich, Alte Pinakothek*

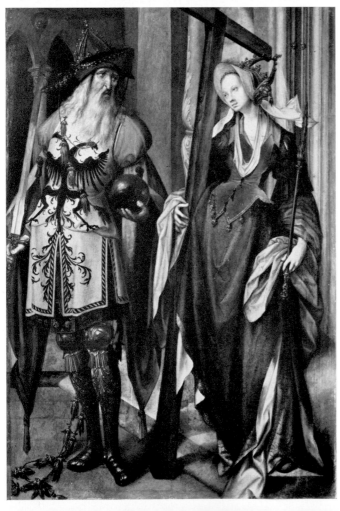

157. Cornelis Engelbrechtsz.: Ottens Couple, 1518. *Brussels, Musées Royaux des Beaux Arts*

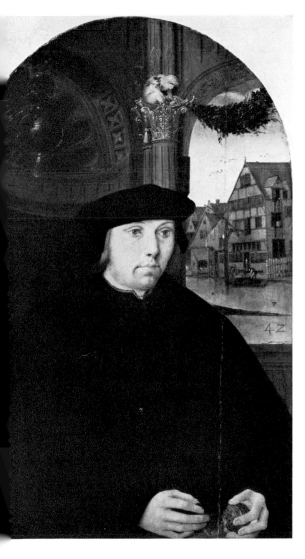
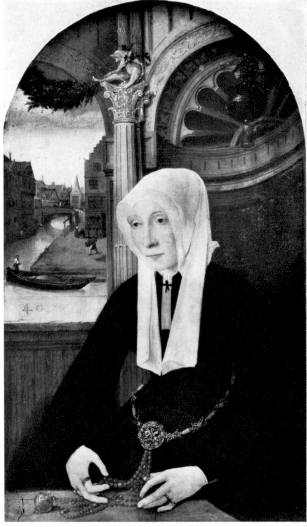

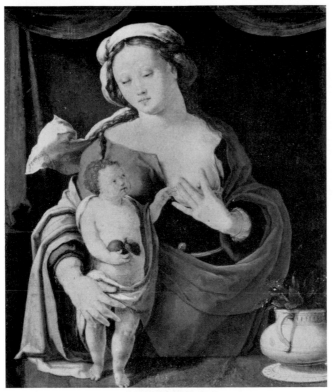

160. Lucas van Leiden: Virgin and Child, *c.* 1520–30. *Oslo, Nasjonalgalleriet*

161. Lucas van Leiden: Virgin and Child, *c.* 1520. *West Berlin, Staatliche Museen*

162. Jan van Scorel: Lochorst Triptych (central panel), *c.* 1525–7. *Utrecht, Centraal-Museum*

163. Jan van Scorel: Rest on the Flight into Egypt, *c.* 1530. *Washington, National Gallery of Art*

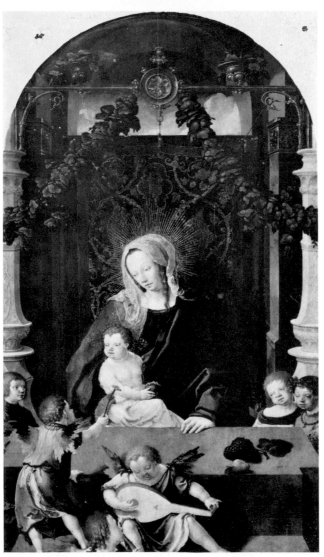

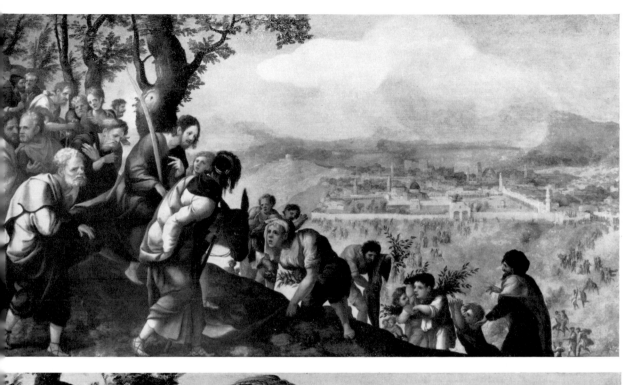

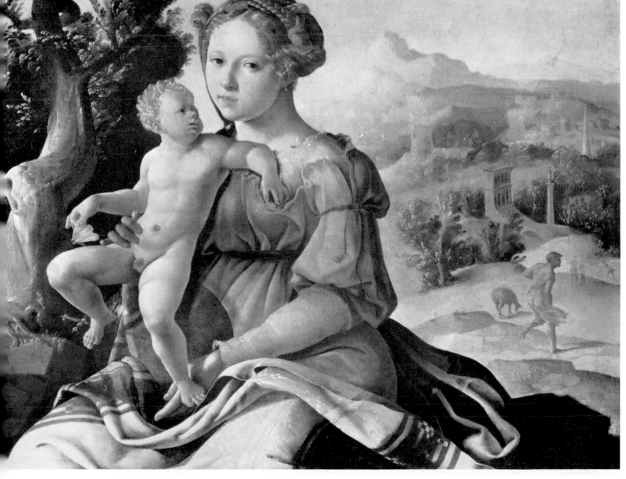

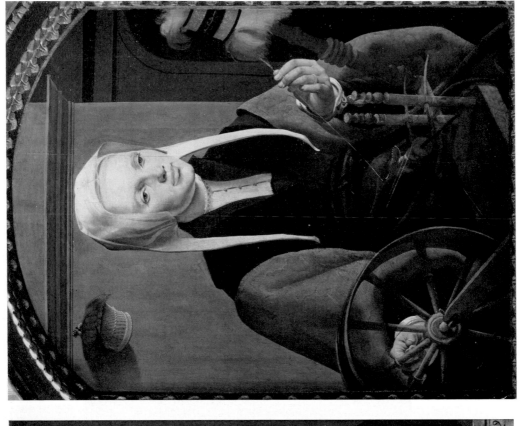

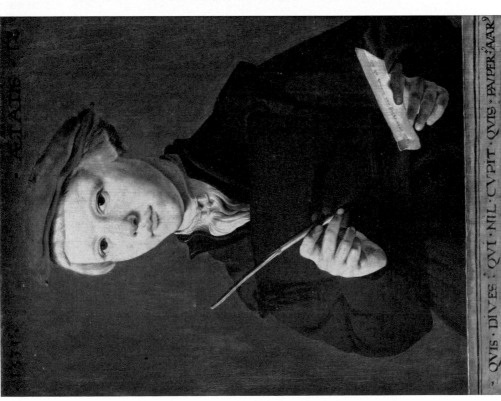

168. Jan van Scorel: Schoolboy, 1531. *Rotterdam, Museum Boymans–Van Beuningen*

169. Marten van Heemskerck: Anna Bicker, 1529. *Amsterdam, Rijksmuseum*

170. Marten van Heemskerck: Virgin and St Luke, 1532. *Haarlem, Frans Hals Museum*

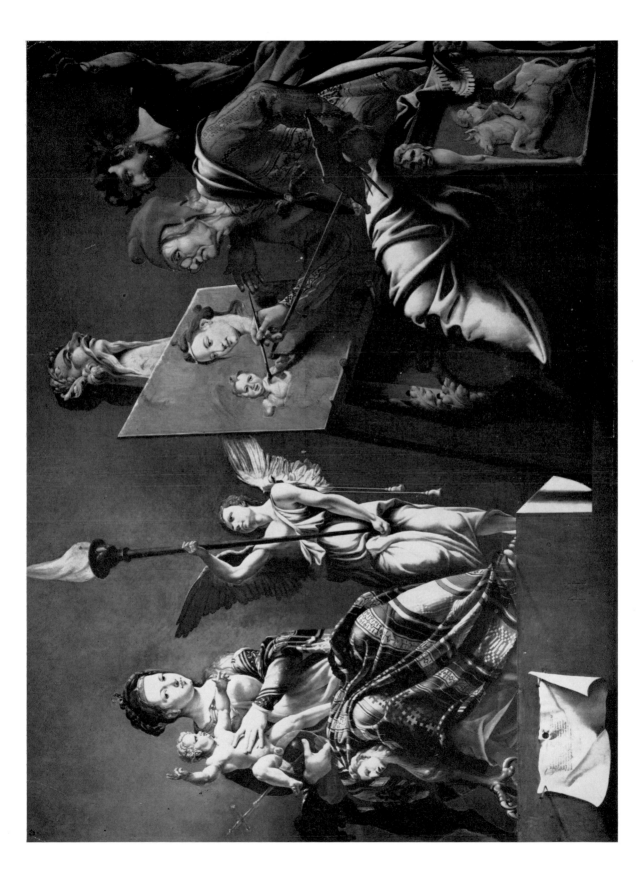

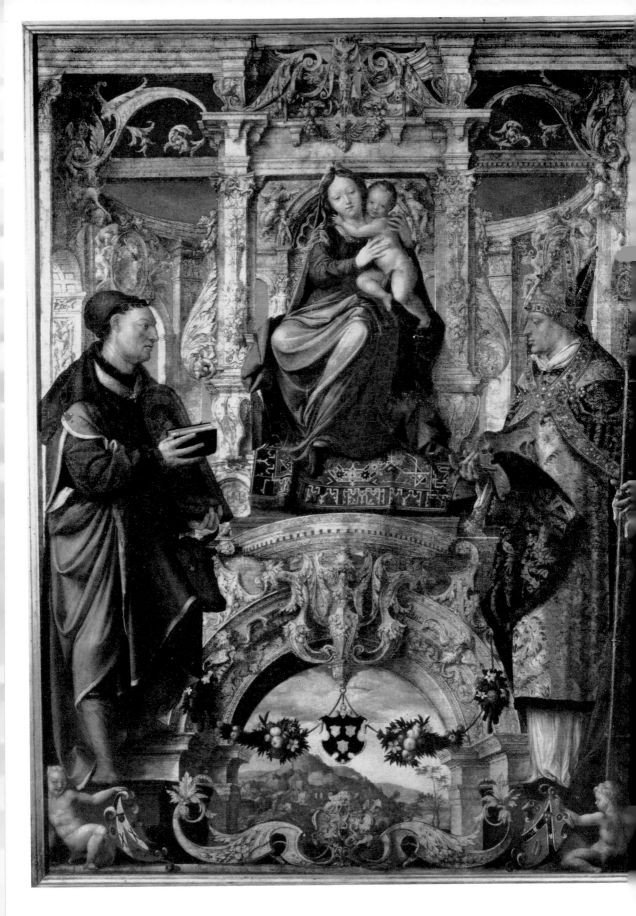

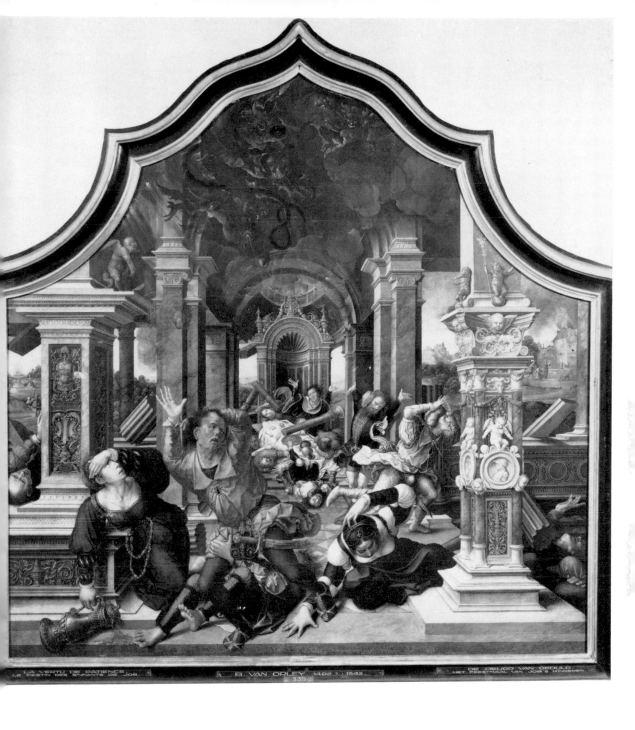

179. Lancelot Blondeel: Virgin with St Luke and St Egidius, 1545. *Bruges, St Salvator*

180. Bernart van Orley: Job altar, 1521. *Brussels, Musées Royaux des Beaux Arts*

184. Bartel Bruyn the elder:
Arnold von Brauweiler, 1535.
Cologne, Wallraf-Richartz-
Museum

185. Lucas Cranach the elder:
Luther on his Deathbed, 1546.
Hannover, Landesmuseum

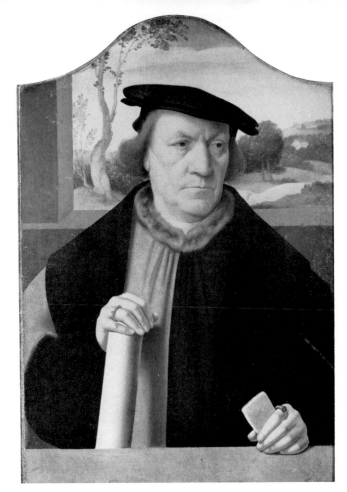

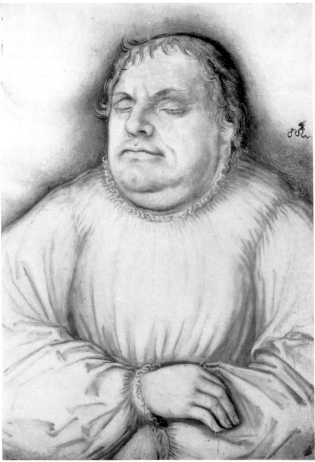

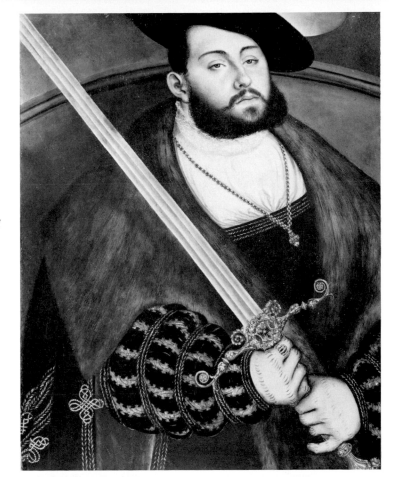

186. Lucas Cranach the
elder: Johann Friedrich
von Sachsen, c. 1535.
*West Berlin, Staatliche
Museen*

187. Lucas Cranach the
elder: Moritz von
Sachsen, 1526.
*Darmstadt, Prinz Ludwig
von Hessen und bei
Rhein*

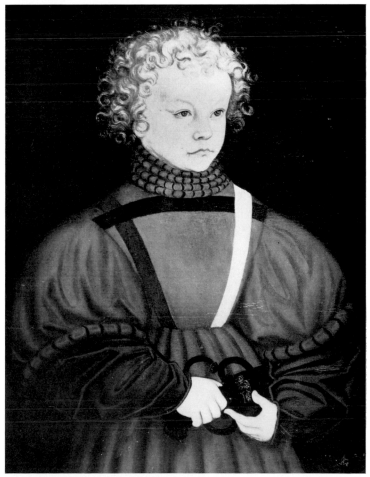

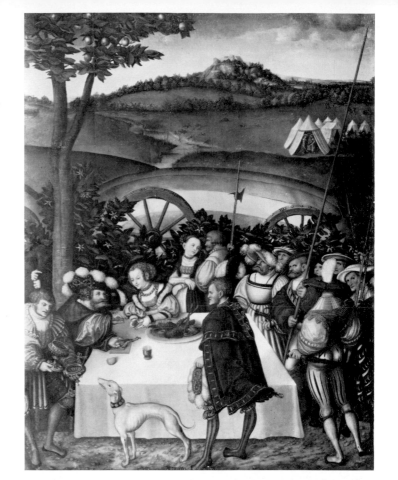

188. Lucas Cranach the
elder: Judith at the Table
of Holofernes, 1531.
Gotha, Schlossmuseum

189. Lucas Cranach the
elder: The Three Graces,
1535. *Kansas City,
William Rockhill Nelson
Gallery of Art*

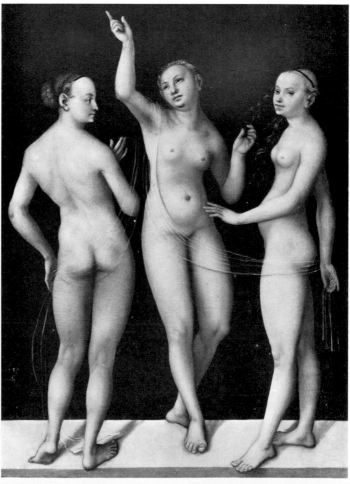

190. Hans Baldung: Pyramus and Thisbe, *c.* 1530–1. *West Berlin, Staatliche Museen*

191. Hans Baldung: Hercules and Antaeus, 1531. *Kassel, Gemäldegalerie*

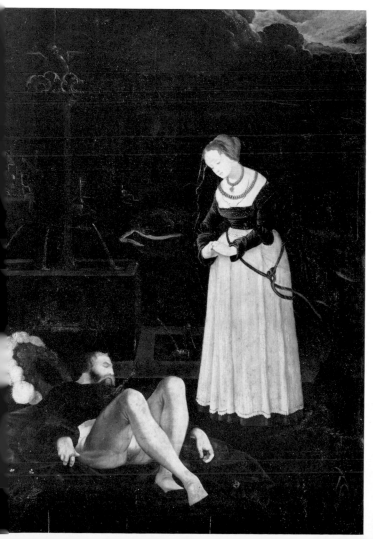

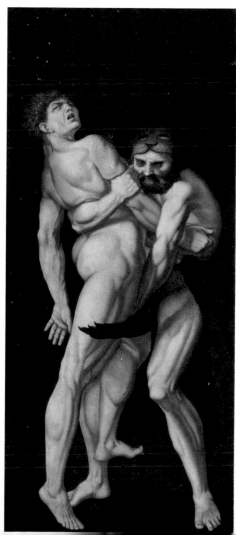

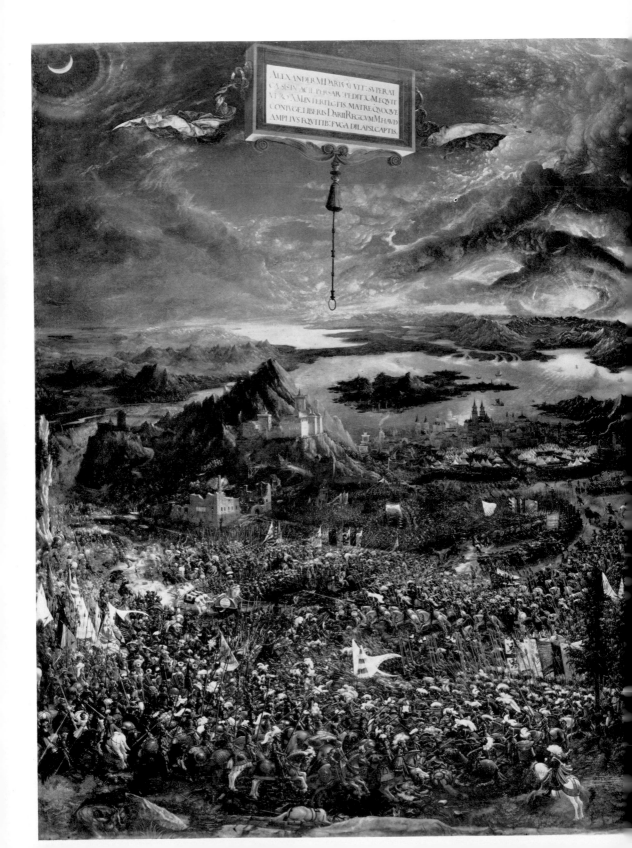

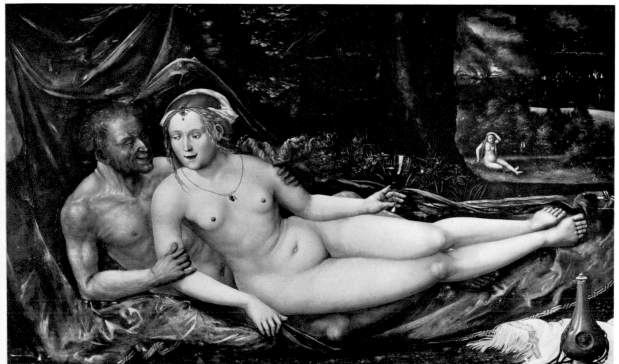

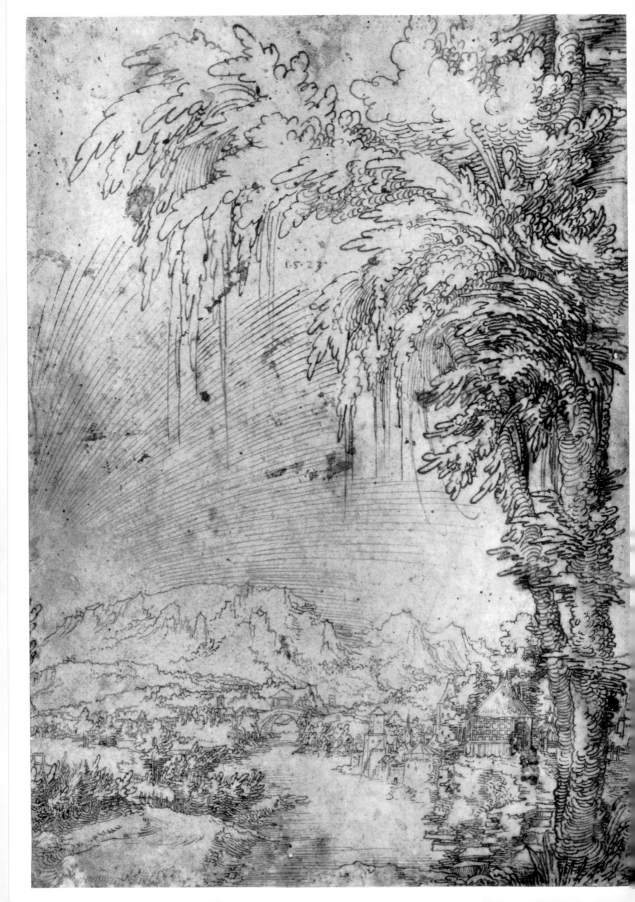

198. Wolf Huber:
View of Feldkirch,
1523. Pen and ink.
London, British Museum

199. Christoph
Amberger: Charles V,
c. 1532. *West Berlin,*
Staatliche Museen

200. Hans Holbein the
younger: Niklaus
Kratzer, 1528. *Paris,*
Louvre

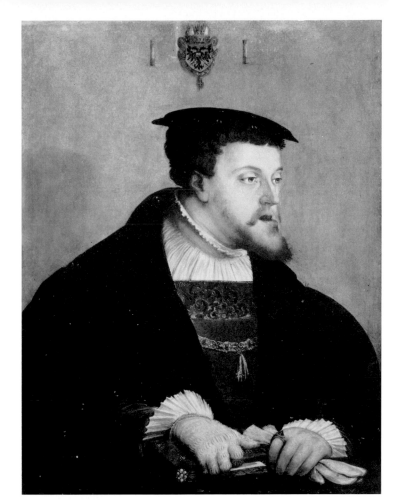

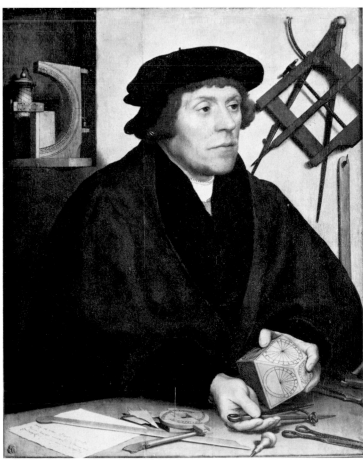

201. Hans Baldung: Two Witches, 1523. *Frankfurt, Städelsches Kunstinstitut*

202. Hans Baldung: The Seven Ages of Woman, 1544. *Leipzig, Museum der bildenden Künste*

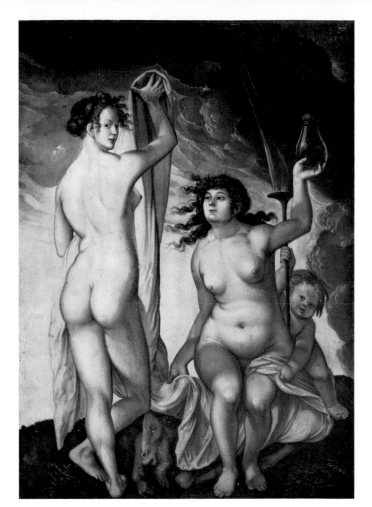

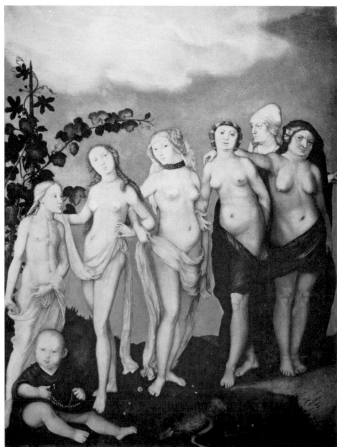

203. Hans Holbein the younger: Thomas More, 1527. *New York, Frick Collection*

204. Hans Holbein the younger: Erasmus of Rotterdam, *c.* 1523. *Longford Castle, Earl of Radnor*

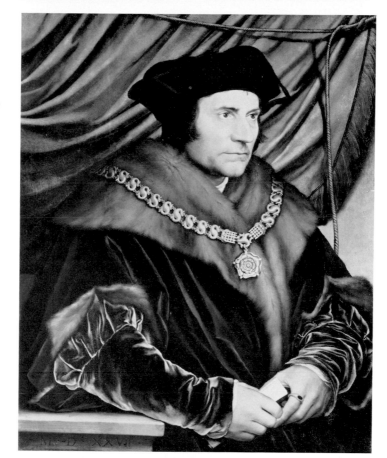

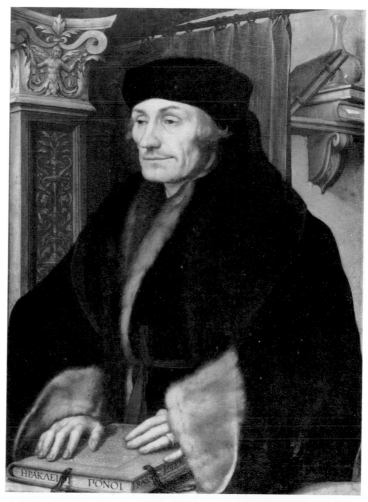

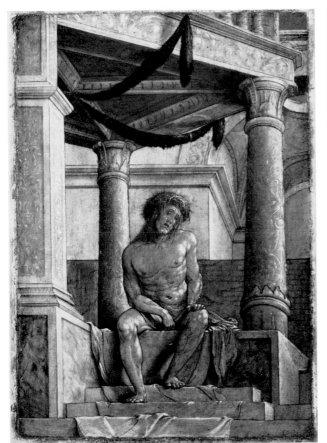

205. Hans Holbein the younger: The Man of Sorrows and the Mater Dolorosa, *c.* 1519–20. Tempera. *Basel, Kunstmuseum*

206. Hans Holbein the younger (after ?): Design for the frescoes on the Haus zum Tanz, *c.* 1520–5. Water-colour. *West Berlin, Staatliche Museen*

207. Master of Messkirch: St Benedict, 1538 or later. *Stuttgart, Staatsgalerie*

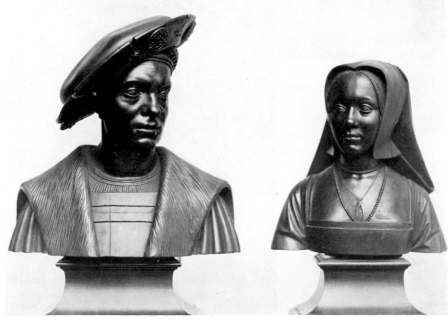

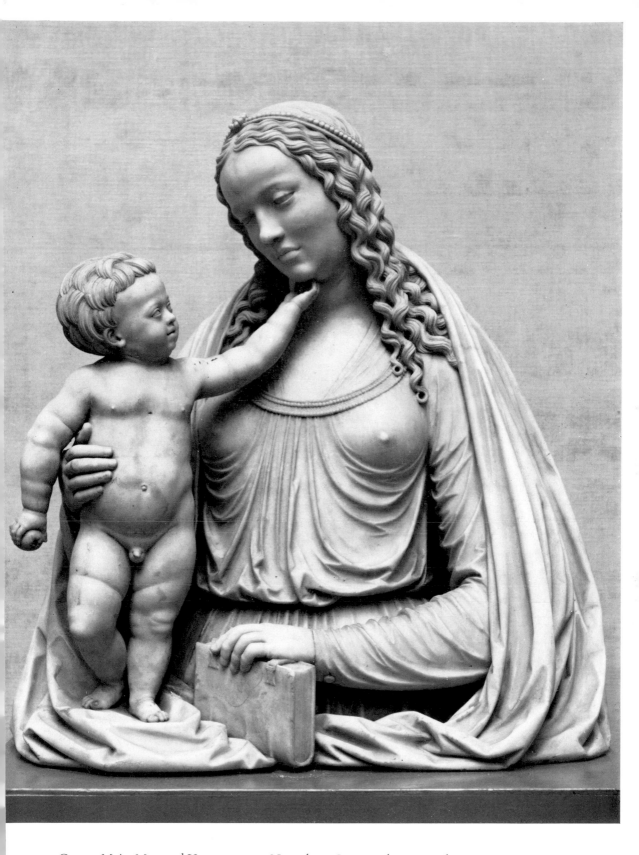

217. Conrat Meit: Mars and Venus, *c.* 1520. *Nuremberg, Germanisches National-Museum*

218. Conrat Meit: Portraits of a Man and of Margaret of Habsburg (?), *c.* 1518. *London, British Museum*

219. Conrat Meit: Virgin, *c.* 1520–5. *Brussels, Sainte-Gudule*

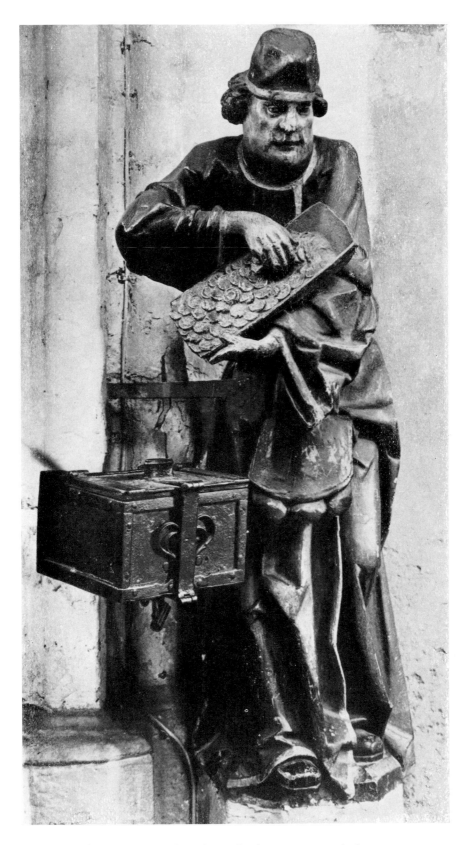

229. Benedikt Dreyer: Monk with an Almsbox, c. 1520. *Lübeck, St Marien*

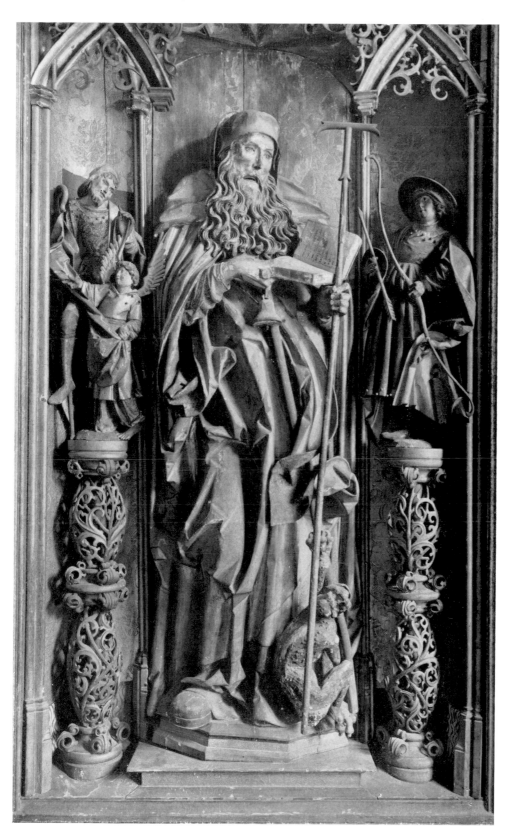

230. Benedikt Dreyer: St Anthony altar (central part), 1522. *Lübeck, Annen-Museum*

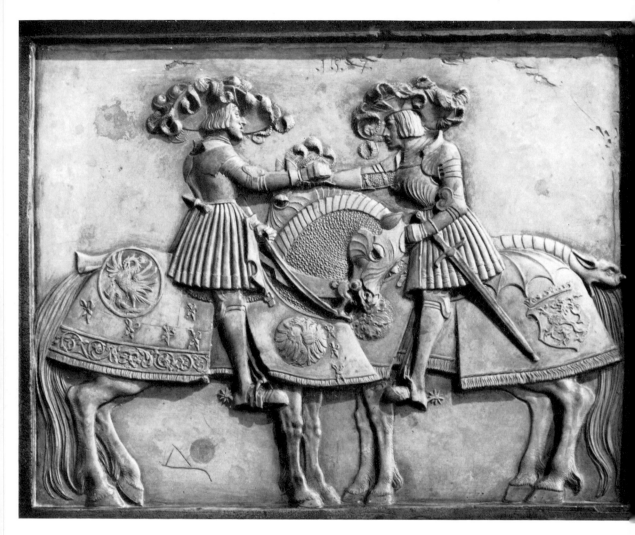

241. Hans Daucher: Meeting of the Emperor Charles V and his brother Ferdinand, after 1526.
New York, Pierpont Morgan Library

242. Loy Hering: Adam and Eve, *c.* 1520–5. *London, Victoria and Albert Museum*

243. Ludwig Krug: Adam and Eve, *c.* 1520–5. *Munich, Bayerisches Nationalmuseum*

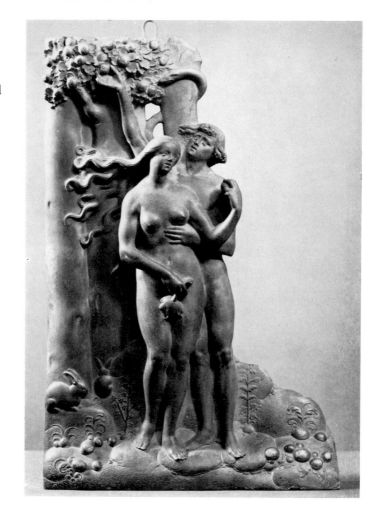

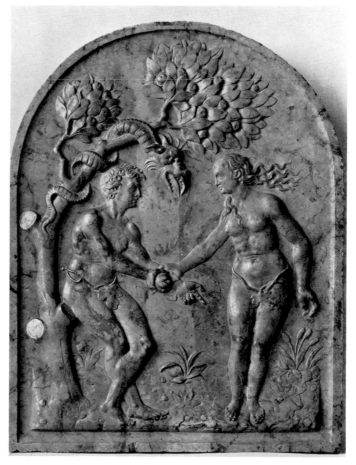

253. Nuremberg: Goose-Bearer Fountain, from the Fruit Market, *c.* 1550–60. *Nuremberg, Town Hall*

254. Wenzel Jamnitzer: Spring, before 1578. *Vienna, Kunsthistorisches Museum*

255. Frans Floris: Fall of the Angels, from the cathedral, 1554. *Antwerp, Koninklijk Museum voor Schone Kunsten*

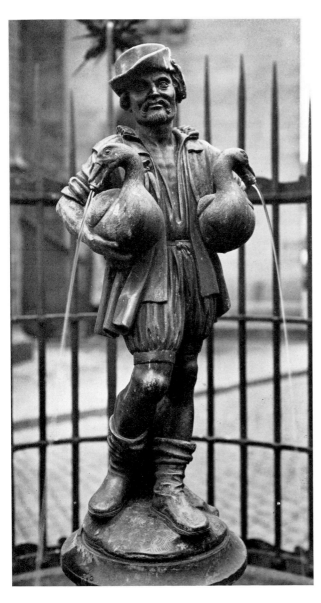

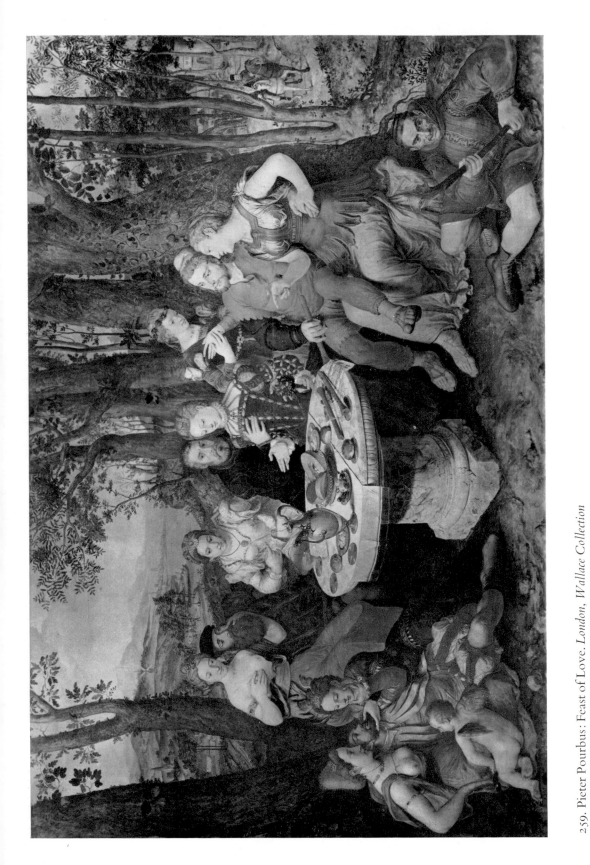

259. Pieter Pourbus: *Feast of Love. London, Wallace Collection*

260. Pieter Bruegel: *Netherlandish Proverbs, 1559. West Berlin, Staatliche Museen*

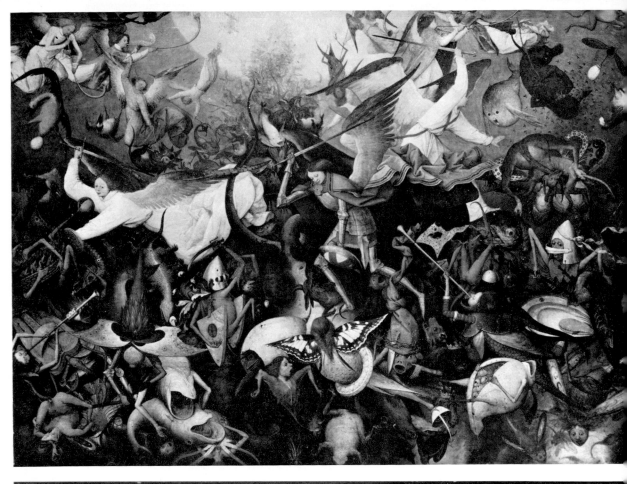

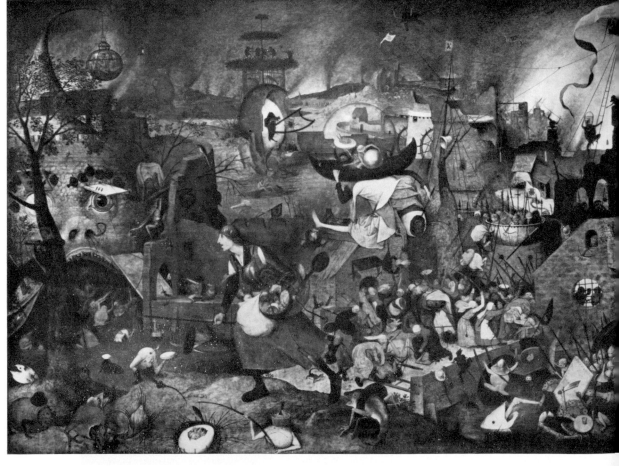

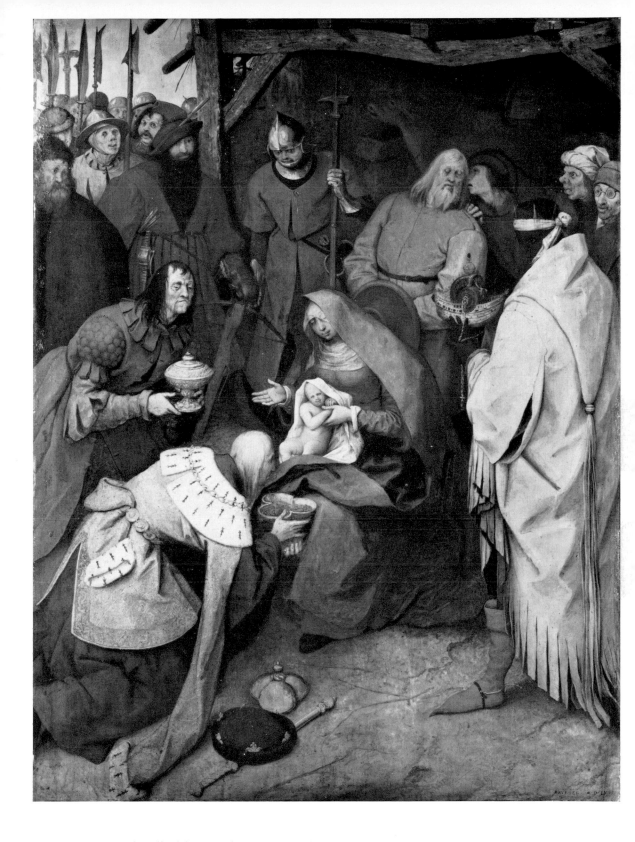

265. Pieter Bruegel: Fall of the Angels, 1562. *Brussels, Musées Royaux des Beaux-Arts*

266. Pieter Bruegel: Dulle Griet, 1562(?). *Antwerp, Museum Mayer van den Bergh*

267. Pieter Bruegel: Adoration of the Magi, 1564. *London, National Gallery*

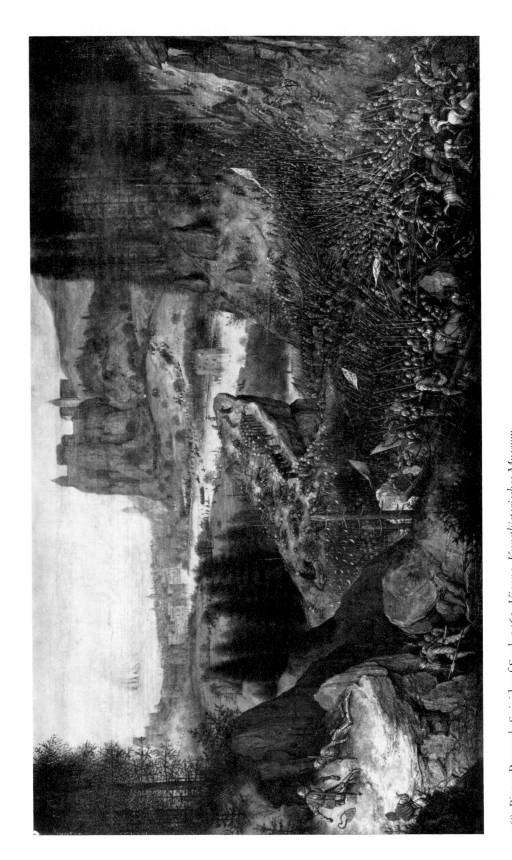

268. Pieter Bruegel: Suicide of Saul, 1562. *Vienna, Kunsthistorisches Museum*

269. Pieter Bruegel: The Tower of Babel, 1563. *Vienna, Kunsthistorisches Museum*

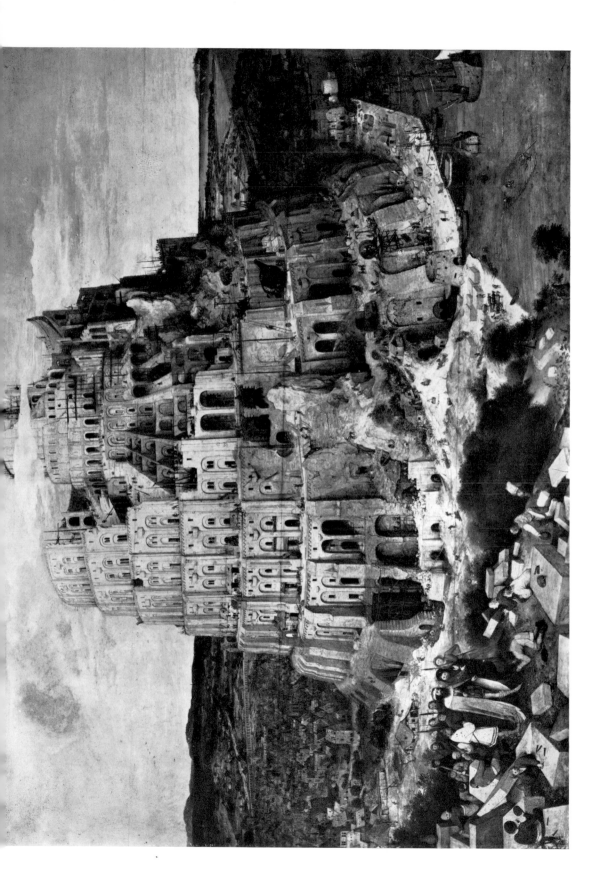

270. Pieter van der Heyden, after Pieter Bruegel: Pride, 1558 (drawing of 1557). Engraving

271. Pieter Bruegel: Parable of the Blind leading the Blind, 1568. *Naples, Museo Nazionale, Capodimonte*

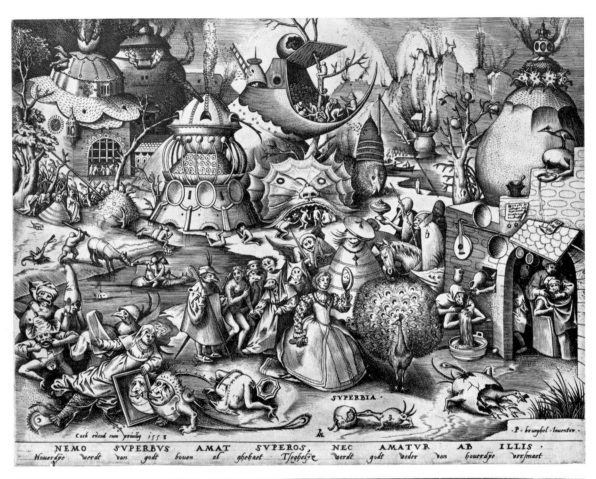

NEMO SVPERBVS AMAT SVPEROS, NEC AMATVR AB ILLIS·

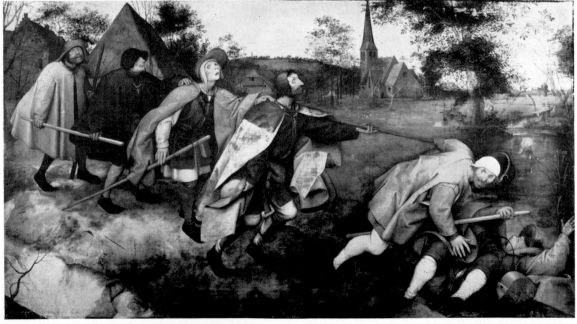

272. Pieter Bruegel: Homecoming of the Herd in January, 1565. *Vienna, Kunsthistorisches Museum*

273. Pieter Aertsen: Pancake Bakery, *c.* 1560. *Rotterdam, Museum Boymans-van Beuningen*

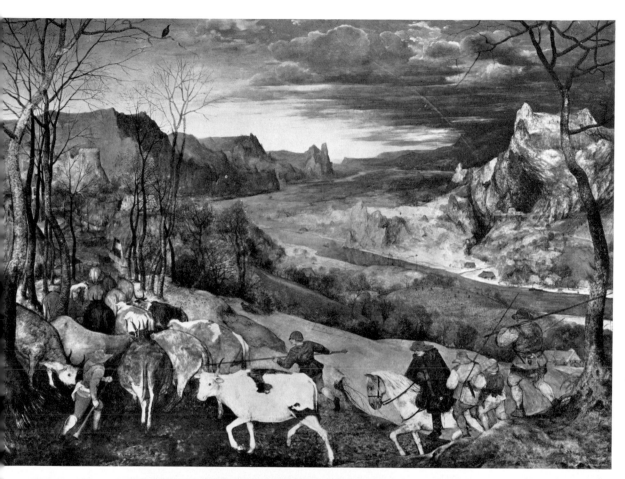

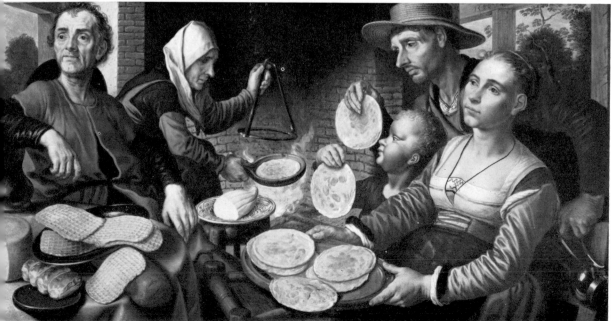

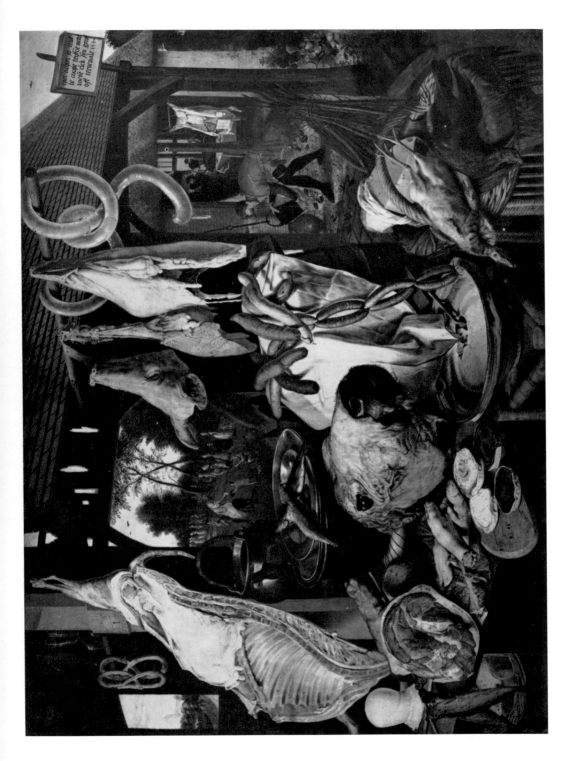

274. Pieter Aertsen: Butcher's Shop with Flight into Egypt, 1551. *Uppsala, University*

275. Cornelis van Dalem: Farmstead, 1564. *Munich, Alte Pinakothek*

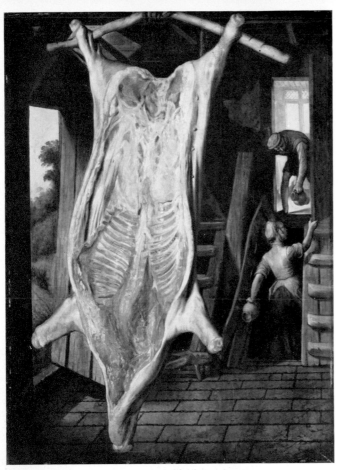

276. Joachim Beuckelaer: Slaughtered Pig, 1563. *Cologne, Wallraf-Richartz-Museum*

277. Pieter Aertsen: Farmer's Wife, 1543. *Lille, Musée des Beaux-Arts*

278. Lucas van Valckenborch: Landscape with Iron Foundry. *Paris, Frits Lugt Collection*

279. Hans Vredeman de Vries: Christ at the House of Mary and Martha, 1566. *Hampton Court*

291. Maerten de Vos:
St Thomas altar, 1574.
*Antwerp, Koninklijk
Museum voor Schone
Kunsten*

292. Paulus van
Vianen: Minerva
with the Muses, 1604.
*Amsterdam,
Rijksmuseum*

293. Maerten de Vos:
St Luke altar, 1602.
*Antwerp, Koninklijk
Museum voor Schone
Kunsten*

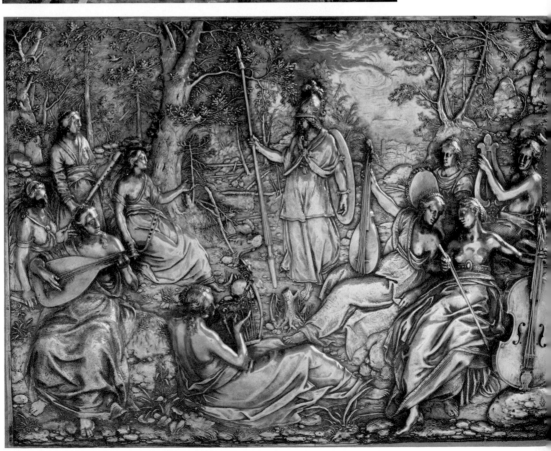

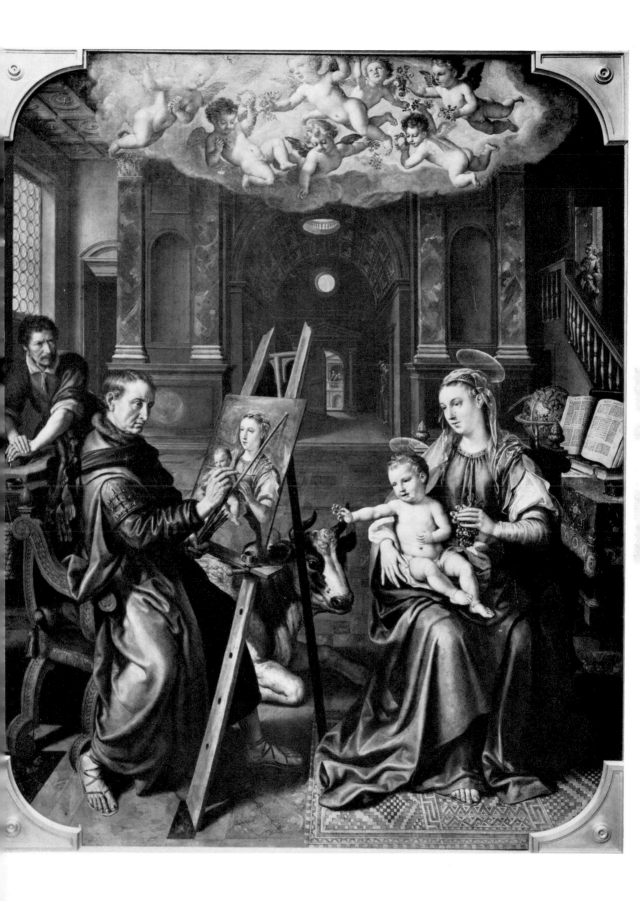

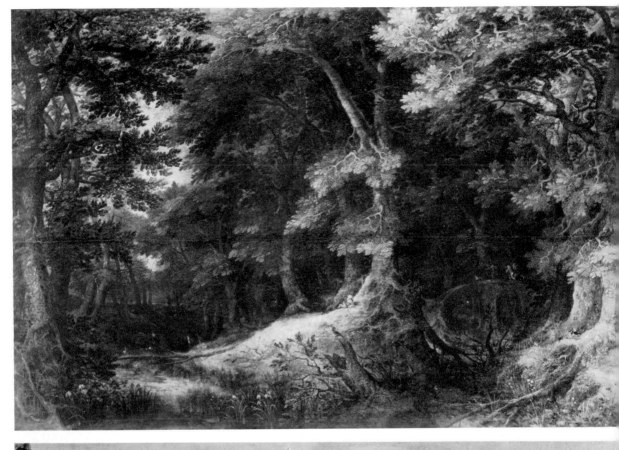

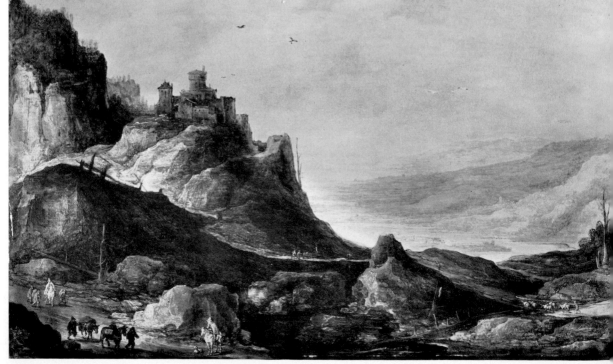

297. Gillis van Coninxloo:
Landscape, 1598. *Vaduz,
Liechtenstein Collection*

298. Joos de Momper: Landscape.
Vienna, Kunsthistorisches Museum

299. Ambrosius Bosschaert:
Flower-Piece, 1609. *Vienna,
Kunsthistorisches Museum*

300. Hendrick van Steenwijck the
elder: St Pieter at Louvain.
*Brussels, Musées Royaux des Beaux-
Arts*

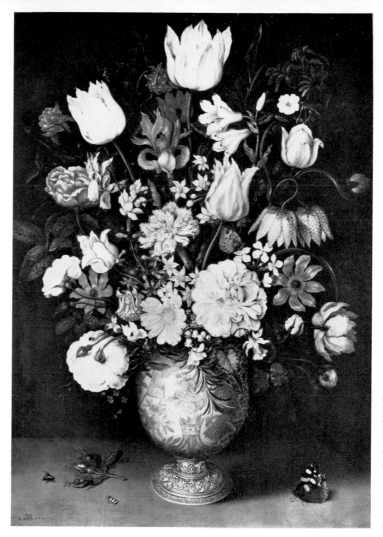

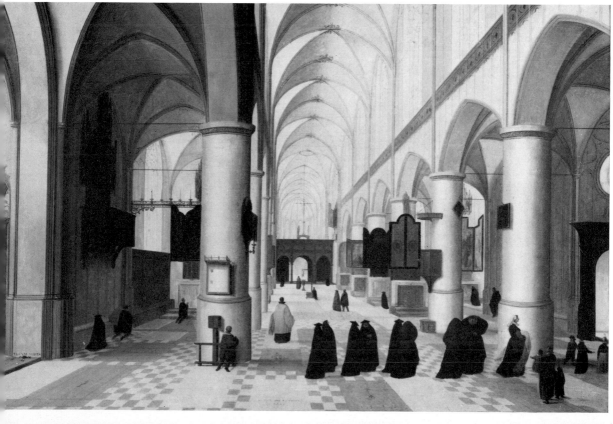

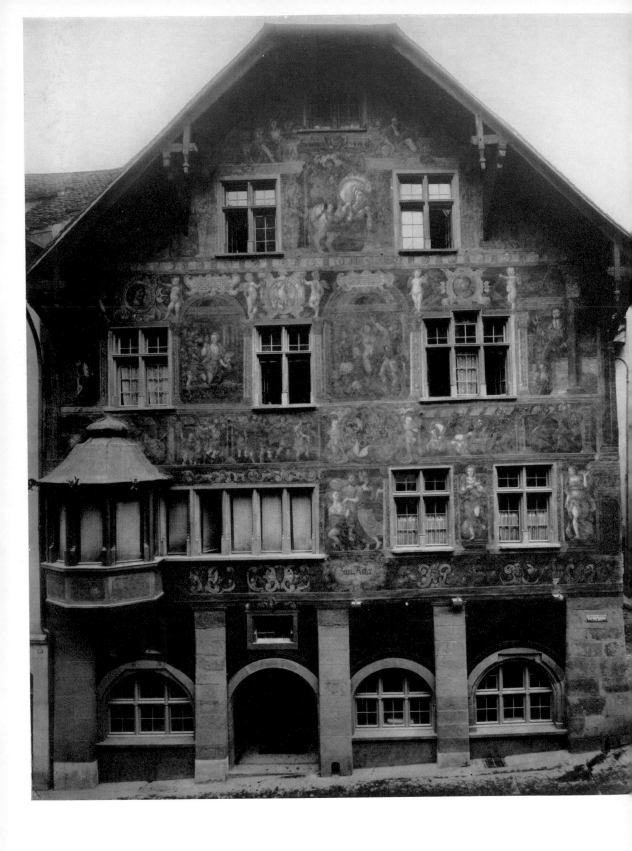

301. Tobias Stimmer: Frescoes *in situ* on the façade of the Haus zum Ritter, Schaffhausen, 1568–70. *Now in the Schaffhausen Museum*

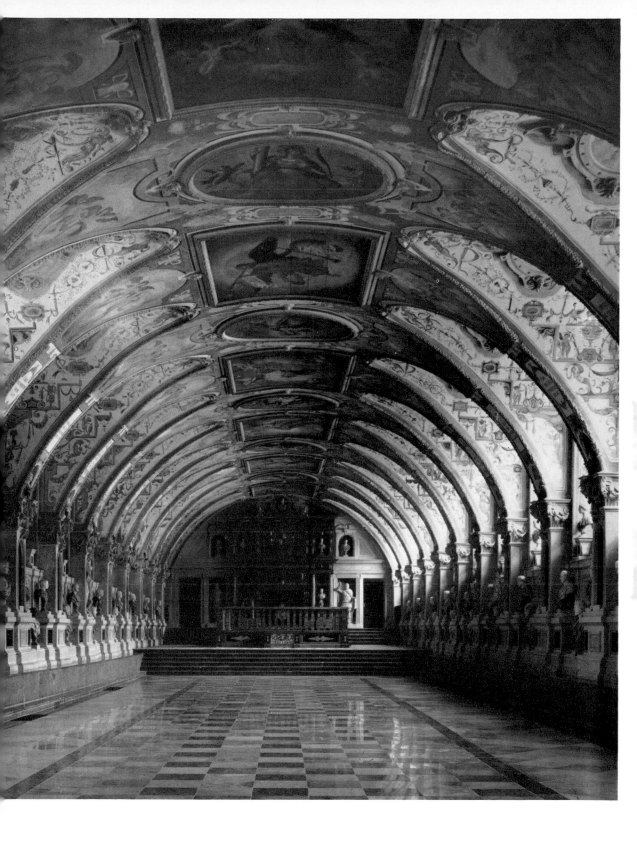

302. Friedrich Sustris and others: Ceiling of the Antiquarium, 1586–1600. *Munich, Residenz*

303. Christoph Schwarz: Fall of the Angels, 1586–90. *Munich, St Michael*

304. Pieter de Witte: Martyrdom of St Ursula, 1588. *Munich, St Michael*

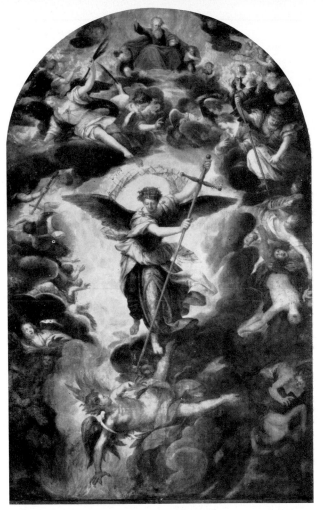

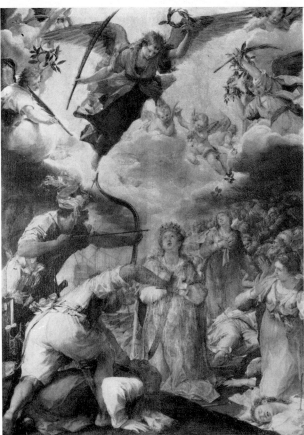

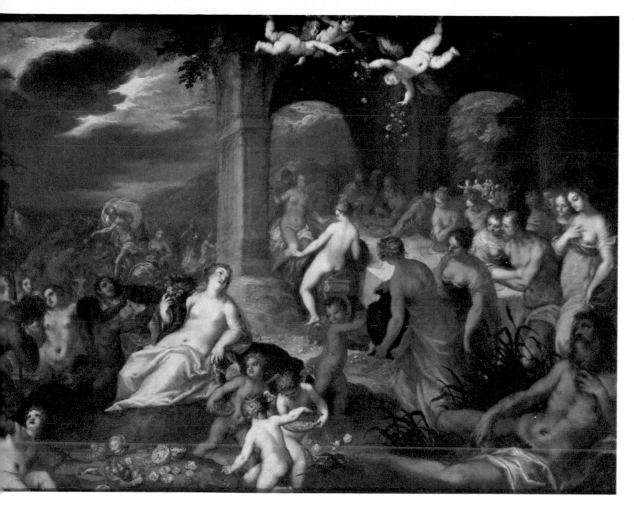

305. Hans Rottenhammer: Feast of the Gods, 1600. *Leningrad, Hermitage*

306. Bartholomeus Spranger:
Minerva conquering
Ignorance, *c.* 1591. *Vienna,
Kunsthistorisches Museum*

307. Hans von Aachen:
Bacchus, Ceres, and Cupid.
*Vienna, Kunsthistorisches
Museum*

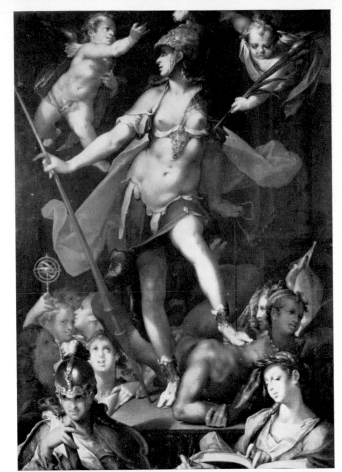

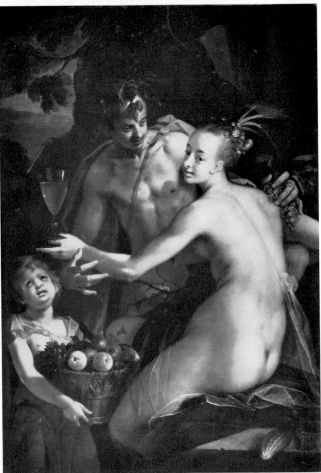

INDEX

Numbers in *italics* refer to plates; numbers in **bold** type indicate principal entries. References to the notes are given to the page on which the note occurs, followed by the chapter number in brackets and the number of the note; thus $347(2)^2$ indicates page 347, chapter 2, note 2. Only those notes are indexed which contain matter other than bibliographical and to which there is no obvious reference from the text. Names involving the elements de, van, von, etc., are indexed under the final element; thus Hans von Aachen will be found under Aachen. Works of art are indexed only when the subject is a portrait or a place.

A

Aachen, 64, 282
 Suermondt-Museum (H. Francken I), 332; *295*; (Master of Osnabrück), 54; *47*
Aachen Cathedral, View of (Steenwijck I), 336
Aachen, Hans von, 326, 327, **345**; *307*
Aachen Altarpiece, Master of the, 140
Abbate, Niccolo dell', 311
Abel, Florian, 281
Abtenau, church, St Blaise altar, 251
Adalberg III von Bärenfels, portrait (Baldung), 220
Adamov (Adamsthal), church, altar (Master of Zwettl), 250, 251; *231*
Admont, *Crucifixion* from (Lackner), 251
Adolphe of Burgundy, 156
Aegidius, Petrus, portrait (Q. Massys), 150–1
Aelst, 196
Aertsen, Pieter, 199, 288, 289, 295, 298, 299, 303, 304, **304–6**, 331, 336, 338; *273, 274, 277*
Aertsen, Pieter Pietersz., 305
Afflighem, abbey, altar from (Joseph Master), 144
Aggsbach, altar from (Breu), 115; *101*
Aix-en-Provence, 240
Ajtas, 63
Aken, Jeroen van, *see* Bosch
Alba, duke of, 275, 297, 331, 333; portraits (Jonghelinck), 321, *282*, (Mor), 297, *262*
Albani, 332
Alberti, Leone Battista, 76
Albrecht V, duke of Bavaria, 275, 311, 340–1, 341; portrait (H. Muelich), 214
Albrecht of Brandenburg, cardinal at Mainz and Magdeburg, 89, 175, 232, 249; mon., 285; portraits (Cranach I), 207, 208, (Dürer), 82, 84, (Grünewald), 95; *84*
Albrecht of Habsburg, portrait (Leinberger), 41, 44; *32*
Albrecht I, duke of Prussia, mon., 280
Albrecht von Wallenstein, duke, 327
Aldegrever, Heinrich, 205, 233
Aleman (Jean Mone), 240
Alfhausen, church, Virgin (Osnabrück Master), 53
Alkmaar, 163, 181, 185

Alkmaar, Master of, 163, 182
Altdorfer, Albrecht, 40, 42, 81, 102, 113, 119, 121, 122, **122–8**, 128–9, 130, 131, 132, 133, 154, 181, 199, **210–12**, 212, 213, 219, 223, 233, 250, 251, 252, 263, 269; *104–11, 114, 192, 194–5*; self-portrait, 124
Altdorfer, Erhard, **128–9**, 209; portrait(?) (A. Altdorfer), 124
Altdorfer, Ulrich, 122
Althorp (Mor), 297
Altmünster, church, altar (Master of Mauer), 43
Amberger, Christoph, 115, 214, **216**; *199*
Ambras, Schloss (Leinberger), 253
Amerbach, Boniface, portrait (Holbein II), 224, 226, 227
Amman, Jost, **310**, 322, 340
Ammanati, 285, 320, 324, 325
Amstel, Jan Aertsz. van, 199, 299
Amsterdam, 61, 138, 163–4, 183, 295, 299, 304, 305, 332, 333, 334, 335, 338
 Gebouw van Barmhartigheid Foundation (anon.), 296
 Rijksmuseum (Aertsen), 305, 306; (Master of Alkmaar), 163; (anon.), 60, 236, 237, 241; (St Anthony Master), 180; (Brunswick Monogrammist), 299; (Coecke), 241; *233*; (Master of Elsloo), 237; (Engelbrechtsz.), 166; (Master of the Female Stone Head), 236; *42*; (Heemskerck), 184–5, 186; *169, 173*; (Holthuys), *48*; (Jamnitzer), 285; (Ketel), 338; (H. de Keyser), 320; (A. van Leiden), 181; (L. van Leiden), 178, 179; (J. Mostaert), 161, 162; (Oostsanen), 164; *152*; (A. Pietersz.), 338; (P. Pietersz.), 338; (Schardt), 286; (Scorel), 182–3, 183; (Vianen), 329; *292*; (De Vos), 331
Amsterdam, Jacob van, *see* Oostsanen
Anabaptism, 173
Anamorphic design, 228, 235
Andorffer, Sebastian, portraits (Maler), 217
Andrea, Zoan, 123, 199, 225
Andreas of Austria, cardinal, 328
Angerer Master, 120
Anna, queen, portrait (Maler), 217
Annaberg, 47
 St Anna, font, 48; Schöne Tür, 47, 48